INVENTING
THE
RENAISSANCE

ALSO BY ADA PALMER

THE TERRA IGNOTA SERIES

Too Like the Lightning
Seven Surrenders
The Will to Battle
Perhaps the Stars

NON-FICTION

Reading Lucretius in the Renaissance

The Recovery of Classical Philosophy in the Renaissance: A Brief Guide, with James Hankins

Trace Elements: Conversations on the Project of Science Fiction and Fantasy,
with Jo Walton

INVENTING THE RENAISSANCE

Myths of a Golden Age

ADA PALMER

An Apollo Book

First published in the UK in 2025 by Head of Zeus Ltd,
part of Bloomsbury Publishing Plc

Copyright © Ada Palmer, 2025

The moral right of Ada Palmer to be identified
as the author of this work has been asserted in accordance with
the Copyright, Designs and Patents Act of 1988.

All rights reserved. No part of this publication may be: i) reproduced or transmitted in any form, electronic or mechanical, including photocopying, recording or by means of any information storage or retrieval system without prior permission in writing from the publishers; or ii) used or reproduced in any way for the training, development or operation of artificial intelligence (AI) technologies, including generative AI technologies. The rights holders expressly reserve this publication from the text and data mining exception as per Article 4(3) of the Digital Single Market Directive (EU) 2019/790.

9 7 5 3 1 2 4 6 8

A catalogue record for this book is available from the British Library.

ISBN (HB): 9781035910120
ISBN (E): 9781035910113

Cover design: Simon Michele

Printed and bound in Great Britain by
CPI Group (UK) Ltd, Croydon CR0 4YY

Head of Zeus Ltd
First Floor East
5–8 Hardwick Street
London EC1R 4RG

WWW.HEADOFZEUS.COM

For James Hankins and Alan C. Kors,
eruditissimis ottimisque magistris meis,
who opened the door to history's incomparable world for me,
Jim the Renaissance and Alan the Enlightenment.

May this effort to link the two keep that door open for others.

Jack Cade: "Thou hast most traitorously corrupted the youth of the realm in erecting a grammar school; and whereas, before, our forefathers had no other books but the score and the tally, thou hast caused printing to be used, and, contrary to the king, his crown and dignity, thou hast built a paper mill. It will be proved to thy face that thou hast men about thee that usually talk of a noun and a verb, and such abominable words as no Christian ear can endure to hear…"

Lord Say: "You men of Kent,—"

Dick the Butcher: "What say you of Kent?"

Lord Say: "Nothing but this; 'tis *bona terra, mala gens*."

Jack Cade: "Away with him, away with him! He speaks Latin."

<div style="text-align:right">Shakespeare, *Henry VI*, Part 2, IV, vii</div>

Contents

Family Trees xii

Prologue: The Great and Terrible Renaissance xvii

 1. Machiavelli the Patriot: SPQF 1

Part I: Why You Shouldn't Believe Anyone (Including Me) About the Renaissance 17

 2. Everybody Wants to Claim a Golden Age 21
 3. The Flexible X-Factor of the Renaissance 24
 4. Time for a Tangent About Vikings! (It's Relevant, I Swear…) 27
 5. The Quest for the Renaissance X-Factor Begins 32
 6. Super Sexy Secular Humanism 41
 7. A New X-Factor: The Baron Thesis and Proto-Democracy 45
 8. Another X-Factor: Enter Economists! 52
 9. Florence: A Self-Fulfilling Source Base 56
 10. What Makes People Start to Study the Renaissance 61
 11. Lorenzo de Medici: Hero or Villain? 64
 12. Or Were We Brought Here by Romance? 89
 13. The Invention of the Middle Ages 96
 14. The Un-Modern Renaissance 105
 15. Why Did Ada Palmer Start Studying the Renaissance? 107

Part II: Desperate Times and Desperate Measures 111

 16. Desperate Times 113
 17. Cruel Wars for Light Causes 120
 18. A Strange Peace, A Stranger War 124
 19. Rome: The Eternal Problem City 127
 20. Medieval but Ever-So-Much-More-So 131
 21. The Desperate Measure: Reviving Antiquity 134

Intermission: Are You Remembering Not to Believe Me? 142

22. Antiquity Was Not New Either 143
23. The *Umanista*'s Rival: Scholasticism 148
24. *Studia Humanitatis*—The Words That Sting and Bite 156
25. Italian Renaissance Becomes European Renaissance 168
26. The Supremacy of Antiquity 173
27. Is This About Virtue or Power? 178

Part III: Let's Meet Some People from This Golden Age 197
28. Patrons and Clients All the Way Up 199
29. Our Friends So Far 216
30. Alessandra Strozzi: Labors of Exile 219
31. Manetto Amanatini: There Is a World Elsewhere 227
32. Francesco Filelfo: Between Republics and Monarchies 231
33. Montesecco: An Assassin Fears for His Soul 241
34. Ippolita Maria Visconti Sforza: The Princess and the Peace 248
35. Josquin des Prez: The International Renaissance 257
36. Angelo Poliziano: Patronage Repays 271
37. Savonarola: Saint or Demon? 282
38. Alessandra Scala: The Girl of Our Dreams 297
39. Raffaello Maffei il Volterrano: A Scholar Fears for His Soul Too 309
40. Lucrezia Borgia: Princess of Nowhere 326
41. Camilla Bartolini Rucellai: Spirit of the Last Republic 361
42. Michelangelo: The Great and Terrible 378

Interlude: Let's Ground Ourselves in Time 417

43. Julia the Sibyl: A Prophetess in an Age of Science 422
44. Our Friend Machiavelli 435
 Machiavelli Part 2: The Three Branches of Ethics 436
 Machiavelli Part 3: Enter the Prince 451
 Machiavelli Part 4: Julius II the Warrior Pope 469
 Coda: Many Machiavellis 481

Part IV: What Was Renaissance Humanism? 485
45. What Was Behind the Curtain? Garin vs. Kristeller 487
46. Who Gets to Count as a Renaissance Humanist? 493
47. Back to Our X-Factors 497
48. Once Upon a Time at Vergil's House… 502
49. Follow the Money! 510
50. It's Getting Weird in Florence 518
51. Scraps of Philosophia 524
52. Was There Renaissance Secular Humanism? 534
53. How (Not) to Dodge the Renaissance Inquisition 547
54. Why We Care Whether Machiavelli Was an Atheist 555
55. Was Machiavelli a Humanist? Part 1 572
56. Virtue Politics 574
57. Was Machiavelli a Humanist? Part 2 581

Part V: The Try Everything Age 585
58. An Exponential Information Revolution 587
59. We Can't Just Abelard Harder Anymore 591
60. The Presumptive Authority of the Past 595
61. The New Philosophy 603
62. A Brief History of Progress 608
63. Progresses 621

Part VI: Conclusion – Who Has Power in History? 627
64. Great Forces History vs. Individual Choice History 629
65. The Papal Election of 2016 633
66. Which Horseman of the Apocalypse? 641
67. What Did the Black Death Really Cause? 647

Sources and Recommended Reading 651
Notes 683
Acknowledgments 714
Image Credits 719
Index 721
About the Author 745

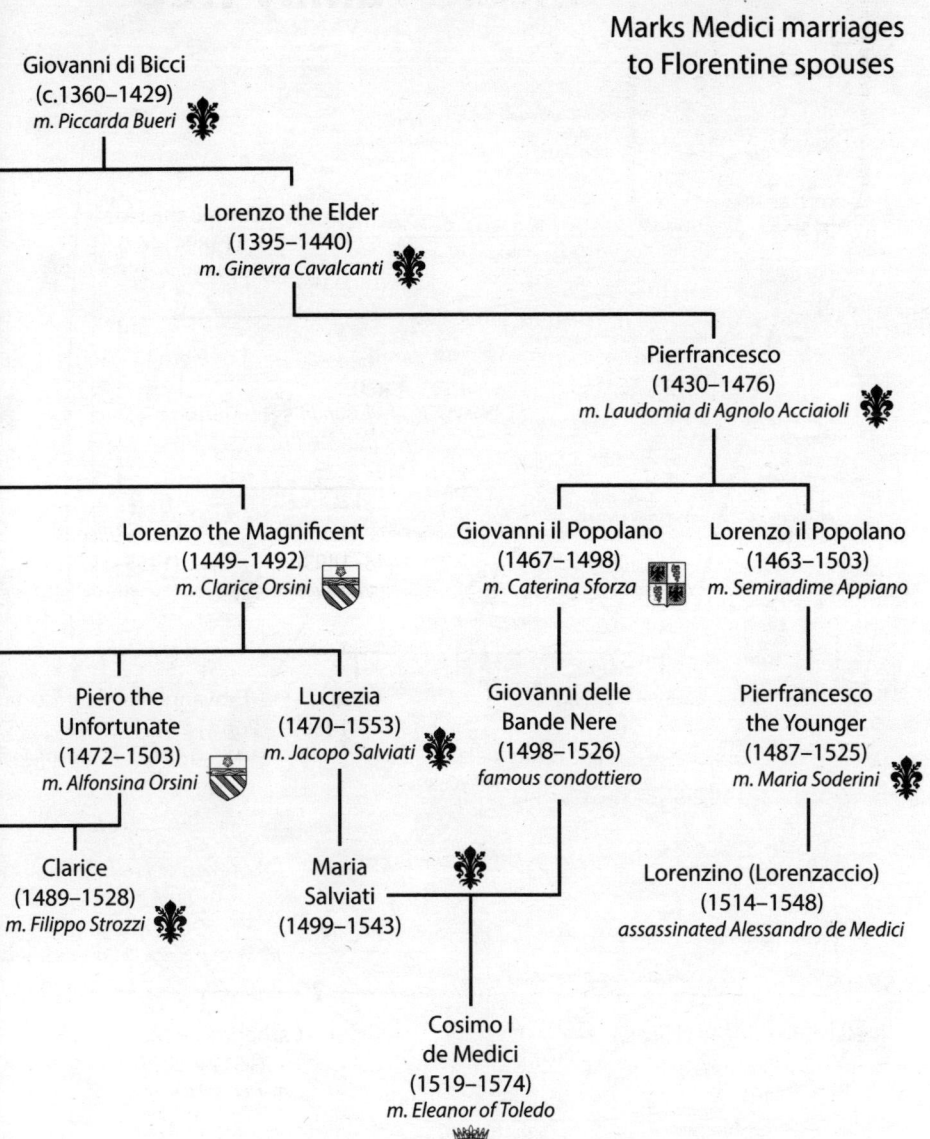

* Excludes children who died in infancy and early childhood

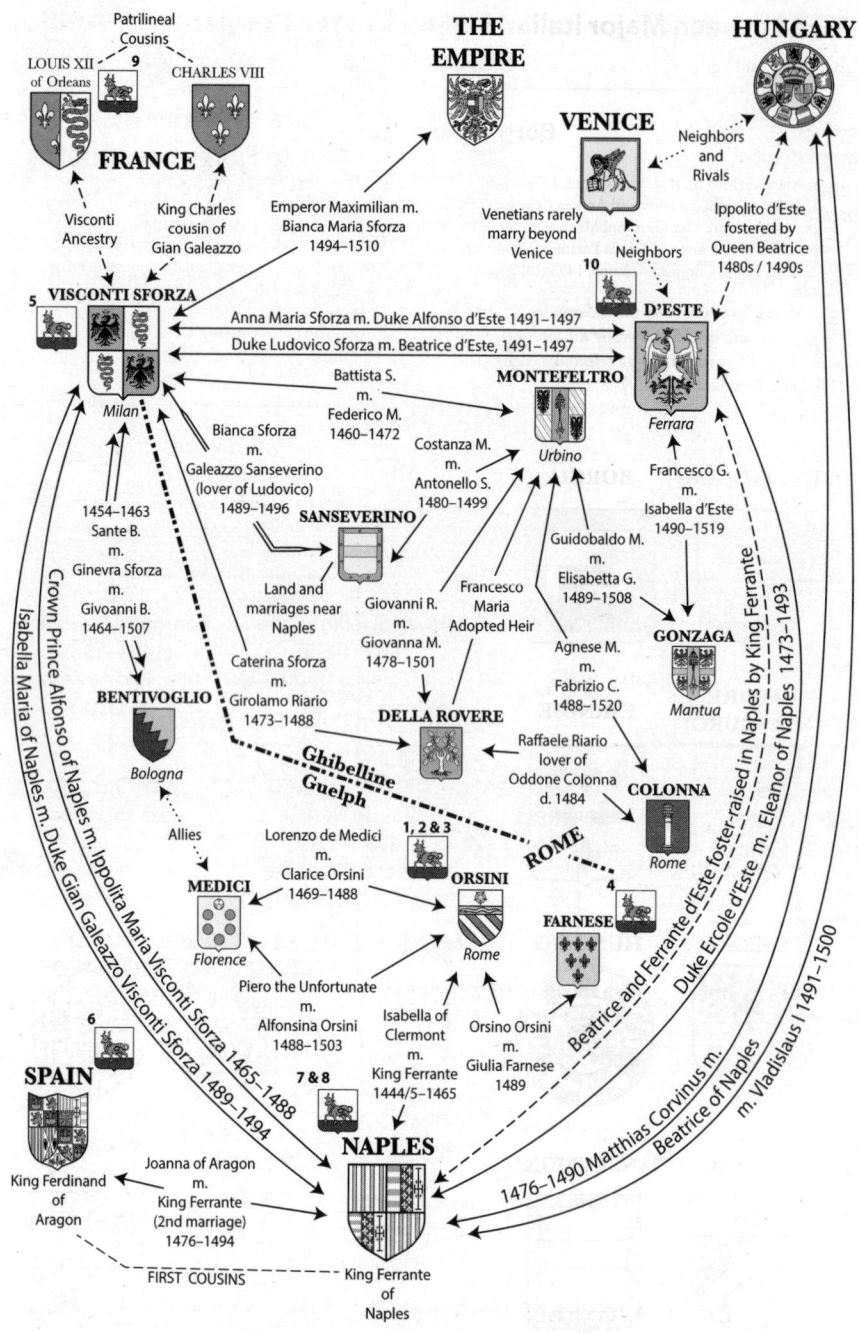

Ties Between Major Italian Families as the Borgias Enter Politics
Diagram Key

Borgia Marriages

1 - Adriana de Mila m. Ludovico Orsini, 147?–1489
2 - Girolama Borgia m. Giovanni Andrea Cesarini (Orsini ally) 1482
3 - Isabel Borgia m. Pier Giovanni Matuzzi (Orsini ally) 1483
4 - Rodrigo Borgia lover of Giulia Faranese 1492–1500
5 - Juan m. Maria Enriquez de Luna, 1493–1497
6 - Lucrezia m. Giovanni Sforza, 1493–1497
7 - Gioffredo m. Sancha of Aragon, 1494–1506
8 - Lucrezia m. Alfonso of Aragon, 1498–1500
9 - Cesare m. Charlotte of Albret, 1499–1507
10 - Lucrezia m. Alfonso d'Este, 1501–1519

Machiavelli's observation that Alexander VI broke a complex system, and the French invasion and Julius II kept it broken, is well shown by the later marriages between Felica della Rovere and Gian Giordano Orsini (m. 1503–17; made after she rejected a Sanseverino match) and between Caterina Sforza and Giovanni de Medici il Popolano (m. 1497–8).

Major Players

BENTIVOGLIO BORGIA COLONNA D'ESTE DELLA ROVERE

EMPIRE (HAPSBURG) FARNESE FRANCE CHARLES VIII LOUIS XII FLORENCE

GONZAGA HUNGARY MEDICI MONTEFELTRO NAPLES

ORSINI SANSEVERINO SPAIN VENICE VISCONTI SFORZA

Prologue

The Great and Terrible Renaissance

The Renaissance was like the Wizard of Oz: great and terrible, and desperate for us not to look behind the curtain.

In 1506, Machiavelli received a letter from a friend, who had recently read the first part of his history of the decade they'd just lived through. The friend urged Machiavelli to write more. Why? Because, he said, without a good history of these days, future generations would never believe how bad it was, and would never forgive their generation for losing so much so quickly.[1] This was the same decade in which Michelangelo carved the *David* and Leonardo painted the *Mona Lisa*, yet living through the years that laid these golden eggs felt like an apocalypse.

But isn't the Renaissance supposed to be a golden age? And the origin of so much modernity is proud of? Individualism? The rational exploration of nature and our world? The glittering masterpieces we admire in museums? Yet, for those living through it, this famous era felt so desperate one could barely hope the future might forgive its failures—how can both be true at once?

The simplest answer is that there's a well-kept secret about so-called golden ages: a time that left us golden treasures was not necessarily a golden time *to be alive*. A deep dive into Machiavelli's life, and the lives of his friends, acquaintances, bosses, and enemies, will show us how the same circumstances nurtured both matchless art and deep despair, in an era well characterized by the old saying *desperate times call for desperate measures*. And the same deep dive will show, in the coming pages, how the golden and grim extremes of the Renaissance, and the later mythmaking of

those extremes, in turn birthed larger myths which shape how we imagine history in general.

Today, ideas of dark ages and golden ages, of declines and falls, and of patterns and cycles of history saturate not only our textbooks and historical fiction, but the assumptions of op-eds, the boasts of politicians, the décor of theme parks, and the theories of economists.[2] Yet the entire concept of a golden age is an invention, and not one made by historians based on historical evidence. The golden Renaissance, and its rhetorical partner, the supposed Dark Ages, are an invention—invented in a particular moment to serve a particular agenda, and recycled and retold in later moments to serve different agendas. Over time they have become entrenched in our thinking, to the degree that even novelists inventing fantasy or science fiction worlds fill their imagined histories with cycles of golden ages and dark ages, rises and falls. And yet historians all agree, such imagined cycles have little connection with what evidence shows us about real history.

Claims about the specific achievements of the Renaissance are often contested. One book or thinker will celebrate the Renaissance as the birth of scientific thought, of the modern individual, of the humanist celebration of humanity, or of skepticism and the rational rejection of superstition. But a different book from the same shelf will say: *No! Scientific thought began with Roger Bacon in 1267, or didn't flourish until Newton in the 1680s! The humanist celebration of humanity started with Socrates'* Know thyself, *or didn't start until Spinoza, Diderot, or Auguste Compte! True rejection of superstition goes back to the medieval scholasticism of William of Ockham, or had to wait for Nietzsche or Darwin!* For every claim about some unique achievement of the Renaissance, a bookshop will offer rival dates identifying the phenomenon centuries earlier, or claiming it did not truly manifest until centuries later.

Arguments over which era or individual deserves credit for an innovation are history's version of another question: *What is the beginning of a river?* Is it the very first few drops of water entering the soil? The first spot where the water forms a tiny finger-wide channel? The first rivulet large enough for a leaf to float on it? The first part wide enough for a canoe? Or for a

PROLOGUE

ferry boat? Any of these definitions can make sense. Just so, the major features of the way we think usually have several dates that could be celebrated as beginnings: the first few mentions brief as water drops, the first ongoing dialog enough to flow, the first point that whole groups or movements start to talk about them, or the first point they became powerful enough to sweep the world on into major social change. The Renaissance is associated with many powerful ideas—secularization, rational science, humanism, civic participation, innovation and open-mindedness—and, for most of them, the Renaissance was not the beginning but the broadening of a stream, whose first drops fell in antiquity, collecting into trickles in the Middle Ages, which swelled enough in the Renaissance to catch our eye with their glimmer and motion, yet still needed centuries more to become major currents guiding the barque of history. That is how the answer to 'Didn't X begin in the Renaissance?' can so often be both yes *and* no.

Exploring the invention of the Renaissance helps us see where the myths of a golden age and dark age came from, and why they persist. It helps us understand how major innovations, like modern democracy or the scientific method, can have multiple celebrated origin dates, often centuries apart, all of them true. And it helps those of us who remember how the 2020 pandemic made many ask whether *Black Death => Renaissance* means *COVID => golden age*, produce a more robust answer than, "No!" While there is something sad about stripping the golden façade off of one of history's most celebrated eras, looking at the reality instead of the myth also helps if we want to ask what history can tell us about our present and come away with hope. Comparing our present world to the Renaissance does give me hope, but it's not the hope of sitting back expecting the gears of history to grind inexorably toward prosperity, nor the hope for something like the Renaissance—it's the hope for something better.

Only part of this is a story about the Renaissance. It is also about Victorian Britain, Italy's unification, the world wars, the Cold War, all the moments that found the myth of a golden Renaissance useful. Our journey won't be chronological—myths never flow in order, start to end. We'll start by meeting a friend

who'll walk with us through all the stages of our journey, as he walks with us today in reading lists, debates, theories, and speeches, so much a myth by now that it can be hard to recognize the human underneath: Machiavelli. And in meeting him we'll meet another big Renaissance name, an earlier one who was an enormous influence on Machiavelli and his world: Petrarch. After meeting them, we'll visit the mythmaking period, *after* the Renaissance, to understand why the myth of bad medieval and golden Renaissance ended up in our textbooks. Then we'll jump back to meet the Renaissance itself, and see how an era can be both great and terrible. We'll journey through the Renaissance fifteen separate times, looping like time travelers, following the lives of fifteen different Renaissance people—some famous, some obscure—from youth to death, living through the same years from different perspectives, and learning why some Renaissance figures became household names while others faded away, not because they weren't important, but because they didn't fit what later eras wanted the Renaissance to be. Once we know this world well, we'll look at *Renaissance humanism*, the big idea that gets invoked in so many conversations about modernity, religion, and secularization. And we'll wrap up with how the Renaissance ended and what came next, the changes in science and culture in the 1600s, and some final thoughts on how the great and terrible Renaissance does offer answers about our present, but only if we cut through the myths.

This book won't read like most histories you could pull off the shelf. Some parts will be dramatic, tragic, grave, but others funny, flippant, casual, or personal, as I lift the veil on how historians learn, and how we change our minds about it all, and bicker. I, the historian and storyteller, will be more visible than in most conventional histories. But books have authors. Every history you read was fashioned by someone, shaped by that author's personality, opinions, life, experience. The Renaissance is nothing if not an invention of historians—invented in its own day, reinvented ever since. So, as we talk about it, this is the moment to draw back the veil and expose the makers underneath, working away in our History Lab—my shorthand for those many conferences, scholarly societies, libraries, campuses, and excited e-mail exchanges,

PROLOGUE

where we historians mix our manuscripts and archival reports in test tubes to brew up new histories, just as my chemist colleagues down the hall mix proteins and solvents to brew new drugs. I want to show you historians at work. But how can I invite you to question, judge, and distrust historians without inviting you to distrust me too? So you'll see Ada Palmer in these pages: my jokes, my anecdotes, my favorites and grudges, and I'll trust you to judge me as you would any friend telling a story, an act of fun, nerdy enthusiasm, sharing the fruits of my labor of love. I hope dropping my own veil will help as I then pull the veil from my fellow historians who, over centuries, for good and ill, mythmade the Renaissance. And hopefully hereafter, when you pick up other histories whose careful authors stay concealed behind their veils, you'll see the hidden human underneath a little better.

In Florence, there are little kiosks near Michelangelo's *David* where you can buy small replicas of the statue. Alongside the plain white ones, they have copies dipped in glitter paint, so the details of Michelangelo's design are obscured with globs of sparkling goo in pink or gold or mermaid teal. That is what the golden age myth does to the Renaissance: eye-catching glitter obscures the details. So when I say the Renaissance was great but terrible, I don't mean that we should not love it, I just want to scrape off the glitter paint and show the hidden details: damaged, imperfect, a strange mixture of ancient and new, doing its best to compensate for mistakes and flaws in the material (Michelangelo was always dissatisfied with that right arm), and violent too—David is, after all, about to kill an enemy; this is a celebration of a battle, not of peace. Glitter drowns all that out. This is why, while the myth of the bad Middle Ages and golden Renaissance does terrible damage to how we understand the medieval world, it does just as much damage to how we understand the Renaissance itself, and even history in general. So together, let's peek beneath that suffocating glitter, and, just as important, explore how the glitter got there in the first place.

But first, as a brief dip into events we'll visit in more detail later on, let's meet a friend.

I

Machiavelli the Patriot: SPQF

One mistake many introductions to Machiavelli make is starting by talking about Machiavelli.* Instead, let's start with SPQR: *Senatus Populus-que Romanus,* the Senate and the People of Rome. Many know this motto, found on ancient inscriptions, modern storm drains, grand coats of arms, and sun-bleached baseball caps, a symbol of pride in the continuity of the Roman people and their republican heart. Textbooks place the Roman Republic's end in 27 BCE, when Augustus became emperor, but the Roman Senate and other offices of the republic continued to exist. The Senate continued under the Caesars. It continued when the Caesars moved east to Constantinople, and needed the experienced senatorial families to administer the Western Empire. It continued past 410 and 434 CE, when the Goths replaced the Western Emperors, and were delighted to find local administrators experienced in governing the region whose needs and customs were alien to its new conquerors. Even after the 600s, when the Roman Senate winked out for a while, Rome's old, powerful families were hailed as senators, and heeded by the people. New Roman Senates reconstituted periodically (the republic had a big moment in 1144)

* If you're looking for the giant scholarly footnote listing fifty books on Machiavelli, this isn't that kind of book. In the coming chapters, as appropriate in a public-facing history, endnotes will credit individual scholars at the moment I draw on each, and will recommend further reading on each topic, giving preference to books in print, books easily accessible via e-book editions and modest cover prices, and books with the kind of approachable prose one might read for pleasure. Comprehensive reviews of scholarship can be found in the sources I cite.

but even between them, the medieval and Renaissance popes who ruled *from* Rome could never quite rule Rome itself, since great families claiming ancient senatorial descent—like the Orsini and Colonna—commanded so much wealth, respect, and influence that they could always raise the riot-ready Roman mob. The popes' power to command or depose distant kings was nothing against 10,000 Roman patriots who knew the alleys of their city better than Swiss mercenaries ever could. In papal Rome, SPQR represented Rome's pride in the city's self-determination, whether that self-determination operated through a senate, an emperor, or a mob and its old-blood leaders, who always made the cardinals and pontiffs feel the people's power. No amount of bribery or pressure from the King of France was as persuasive as the certainty of death-by-Romans waiting just outside the Vatican.

In time, SPQR came to represent urban pride so deeply that other proud cities picked it up. London adopted SPQL, Bruges SPQB; one reads SPQS on the civic museum of the tiny two-gelateria town of Sassoferrato. Thus, in Florence, the inscription SPQF proclaims that Florentines love their city as much as Romans love Rome, and Machiavelli desperately wanted Florentines to love Florence as much as Romans had loved Rome.

Half a century after his death, Niccolò Machiavelli (1469–1527) will be colloquially called "Old Nick," a nickname for the devil, labeling Machiavelli as an archetype of the cunning, selfish politician, hence our modern term *Machiavellian*. But rather than Old Nick, we're here to meet Young Nick, growing up in the mid-Renaissance, in Medicean Florence, reading the *studia humanitatis*, a new educational movement focused on the Greek and Latin classics. In precious tomes—some manuscript, some fruits of that newfangled *printing*—Young Nick tasted the gorgeous, alien Latin of a long-lost world. He read of the Consul Lucius Junius Brutus (sixth century BCE), who executed his own sons for treason when they tried to make their families masters of the city—while down the block Florence's police needed a fortress (the Bargello) ready to endure siege when they arrested members of powerful families, since such families fought back. He read of Gaius Mucius Scaevola (fl. 508 BCE), who sacrificed his own right hand, burning it in a fire to prove Rome's courage

to his Etruscan enemies—even as Florence and her neighbors distrusted their own citizens so much that they hired foreigners to head their police. He read of the *Pax Romana*, the golden peace forged by Augustus, when one could walk in safety from end to end of the known world—even as he walked homeward through streets named after exiled and exterminated families (think Montagues and Capulets) whose civil strife had many times made Florence's gutters stream with blood. He read of hero after hero who sacrificed their lives for Rome, and also read recent authors, fellow Florentines, his predecessors, those who trekked through the Alps or sailed to distant Constantinople to gather ancient manuscripts and fill the libraries of Italy with the books that had reared Cicero, and Seneca, and Caesar—books they hoped would rear, in Young Nick's generation, a new crop of Christian Ciceros, who would serve and lead Florence as faithfully and successfully as the ancients had Rome. SPQF.

The libraries that raised Young Nick had been shaped by the influence of the most celebrated founding father of the Renaissance, who died almost a century before our Nick was born: Petrarch (Francesco Petrarca, 1304–74). Petrarch invented the Dark Ages, by which I mean he was the first person to talk about the era after the Roman Empire as a period of shadow, misery, darkness, and decay. A fellow son of Machiavelli's beloved Florence, Petrarch first achieved great fame with his Italian poetry, and popularized the sonnet, but later in his life he was part of a circle of Italian scholars who deeply *loved* Cicero, and read his political and philosophical works intensively as they thought about how to run and improve republican governments in Florence and other citystates. Building on the efforts of scribes and scholars of the century before, this community read and collected Latin and Greek classics, especially those they felt had political and moral applications. It was a group movement, but famous and charismatic Petrarch soon became its primary voice.

Petrarch always described himself as a man born in exile—an exile in *space*, but also in *time*. His Florentine parents had been banished in one of the city's endless faction fights, so their son was born in Arezzo and raised in Avignon, in France, where his father worked for the then-French-controlled papacy. But

Petrarch also felt lik an exile in time, from that community of ancient Rome which he read of in Cicero and Vergil, and which he said was the true home of his spirit. His sense of the degeneration of his own age was enhanced by lived experiences: by his feeling that France's control of the papacy had despoiled Rome and Italy, by the wars and feuds and bloody coups he lived through, and by the Black Death, which claimed almost all his Cicero-loving scholar-friends, one by one. The same year claimed the beloved subject of much of his poetry, Laura de Noves (1310–48), a woman whose virtue and beauty Petrarch made so famous that he even wrote a poem pitying we who would read about her in future centuries and weep that we were unable to meet her.[3] Soon after the main wave of plague had passed, two surviving friends wrote to Petrarch, to plan a precious reunion—the two were attacked by bandits en route, and one murdered, while the other escaped but was missing for many months. You can understand why Petrarch, reading of the *Pax Romana*, of walking in safety from France to Turkey, saw his own age as one of ash and shadow, but Petrarch projected that ash and shadow backward on everything since Rome, lumping together for the first time what we now call the Middle Ages, and ascribing to it everything terrible about his own lived experience. This, by the way, is why all my medievalist friends *hate* Petrarch.

Petrarch *did not* claim his era was a golden age, nor did he use the word Renaissance. He claimed his era *needed a transformation*, that desperate times called for desperate measures, and that, if Italy was to heal, it must look to its strongest days, to ancient Rome, that dream age when there were no bandits on the roads or pirates on the seas. (Ancient Rome was the *only* time there were no pirates in the Mediterranean—there are pirates in the Mediterranean *now*, and before you think of romantic movie pirates, remember in the Renaissance as much as 60 percent of all charitable giving went, not to orphans, nuns, or hospitals, but to ransoming fellow citizens from galley slavery.)[4] The lost arts that had made Rome's age of peace, the wisdom of Plato and Cicero which nurtured the good emperors, those secrets, Petrarch urged, were languishing on dusty library shelves waiting to be rediscovered, if only people reached for them. (We'll get to the deceptive

sides of Petrarch's propaganda in due course, for now we'll let him cast his spell of eloquence, so we can feel, as young Machiavelli did, the sense of awe and hope.)

Today, we know the Renaissance as the era that revived Roman technologies: geometry, engineering, art; those were important, but what Petrarch really wanted to change was *people*, not *technology*. When today we look at ancient Rome, we focus our TV miniseries on the scandals and intrigue, sagas of bloody wars and decadent corruption, but Petrarch saw mainly the good emperors, the good republicans. In his world where city after city was falling to monarchical coups, and (as Shakespeare shows us) nobles like the Montagues were used to having enough influence to let Romeo get away with murder, these tales of ancient dedication to the state felt like salvation. Petrarch and his friends wanted the library that educated Cicero, and Seneca, and Caesar, which they hoped would educate a new and virtuous generation who would rule with competence and wisdom, and put the good of the state before all.

They got Machiavelli.

Petrarch says we can become as great as the ancients by studying their ways! Let's do it! In the late 1300s, the call went out, and families, cities, kingdoms listened, pouring money into libraries, and Roman busts, and other desperate measures. War-wracked city-states like Florence invested in assembling the libraries which might make the next generation reliable, brave, and loyal. Rich families or newly risen tyrants who wanted their sons to be princely like Caesar had them read what Caesar read, and filled their courts with Roman objects to equate themselves with the authority, stability, and competence of Rome. And we're off! Fountains! Triumphal arches! Equestrian bronzes! Linear perspective! Mythological frescoes! Naked statues! Philosopher princes! Confusing carnival floats covered with allegorical ladies! Reenactments of Plato's *Symposium* where scholars lounge about debating the nature of the Highest Good! A hundred years of doing what the ancients did!

And a century into this project, we reach 1506, when Machiavelli got that letter from a friend urging that, without a good history of these years, future generations would never believe how bad it

was, or forgive Renaissance Italy for losing so much so quickly. How did such lofty aspirations go so wrong?

We'll spend a hundred pages answering that fully, but for the moment let's zoom out, for a glimpse of what Machiavelli's beloved Florence faces as the 1400s—the first century of reviving antiquity—come to a close. What powers dominate this world? France foremost, Europe's greatest power, strong again with its Hundred Years' War (1337–1453) settled and done, and with vast wealth, and a population of millions, capable of sustaining enormous armies. There are Aragon and Castile, the two halves of Spain, with vast naval resources, in the midst of merging their crowns through the marriage of Isabella of Castile to Ferdinand of Aragon. In central Europe there is the Empire (only we moderns call it Holy Roman), a complex federation of semi-independent polities under an elected emperor, currently Maximilian Habsburg. There are other strong, ambitious kingdoms: England recovering from the Wars of the Roses (1455–87) and freshly united under Henry VII, the first of the Tudors. There is Portugal, with its naval ambitions and long rivalry with Spain; Hungary, a close neighbor of Italy across the Adriatic; and Poland freshly enriched by the effective annexation of Prussia. There are also the two peculiar, impregnable powers: Venice with its modest land empire but huge sea empire of port cities and coastal fortresses peppering the Mediterranean, and the Swiss who live untouchable within their Alps, and base their economy almost entirely on hiring out their mercenary armies. And because Italy's world is the Mediterranean, not European, we must include the even richer powers: the powerful Sultanate of Egypt, the great Ottoman Empire, which has conquered Greece within Machiavelli's father's memory, and further south the impossibly wealthy powers of Ethiopia, now increasing their trade footprint in the Mediterranean.[5] With the sole exception of the Swiss (who profit from *all* wars), all these powers want more territory, and there is no territory juicier than Italy.

Why Italy? From 1300 to 1500, the Italian peninsula—an agricultural paradise, rich in wool, olive oil, wine, and other precious exports, positioned at the center of the Mediterranean and easily reached from every corner of its world—had five of Europe's ten most populous cities: Florence the cloth and banking capital,

Milan which dominated trade across the Alps, and the three great ports of Naples, Genoa, and impregnable Venice, with Padua as the anchor of its Italian land empire and its trade empire accessing wealthier and more advanced empires south and east. Each of these five cities maintained populations near or over 100,000, in Naples's case 200,000, urban giants rivaled in size mainly by Paris, Granada, and, for a time, Constantinople, since northern capitals like London, Prague, and Amsterdam would mainly gain momentum after 1500.[6] By modern standards 100,000 feels tiny, and there were larger cities in the richer regions of the world like China and what is now Mexico, but in 1450 100,000 was a dazzling metropolis by the standards of backwater Europe, where even the greatest kingdoms could rarely boast a million subjects. Plague periodically depopulated Europe's cities by a third or half, but trade and employment quickly refilled Italy's capitals, so that even when Naples was emptied by plague in 1495 it swelled back to 125,000—Europe's second largest city—within twenty years.

All these Italian cities were also financial powerhouses, centers of banking, textiles, and olive oil (used for lamps and industry as well as food). If our age has Big Pharma, Big Oil, and Big Finance, in this era think Big Wool, Big Olive Oil, and (eternally) Big Finance, all of them enriching the same few cities. Yet, unlike vast and growing Paris, with the millions of Frenchmen to defend it, these city-states commanded only small slices of countryside from which to levy armies. Smaller Italian powers like Bologna, Mantua, Siena, Pisa, and Urbino also contained great wealth, with even more limited defenses. Hiring mercenaries worked, but filled Italy with foreign troops, and gave many an ambitious general the means to turn on his employers, kill, and conquer.[7] To make this more unstable yet, Italy's cities all hated their neighbors, warring incessantly as they attempted to dominate each other, and pursue vendettas from past wars, the enmity between neighbors like Florence and Pisa growing more entrenched each generation.

Isolated, friendless Italian city-states with weak defenses, neighbors happy to see them burn, and literal piles of gold in the basements of their merchant princes—if you're a king and want to conquer something, do you choose *anywhere else*, or do you

choose Italy? There is a wrong answer to this question. So, while all Europe's borderlands saw wars in the Renaissance, and most of its big powers did too, Italy's wars—counting up those between city-states and those with invaders from beyond the peninsula—were so incessant and so plural that, while people living in the peninsula did experience patches of peace, they were much like the 1920s between the world wars, a very small slice of lived experience, with practically every summer bringing a new season of newly reshaped war.

1492. The Borgias come to power in Rome, Pope Alexander VI and his matchlessly famous son Cesare Borgia, whose ambitions start to redraw Italy's map.

1494. The French invade Italy. The pope's fault, Milan's fault, Spain's fault, the short-term trigger hardly matters; France, like every other major power, had hungered to expand in Italy for ages. Young Nick's Florence is one of Italy's most pluckable flowers. The Medici family, long-time leaders of the city... screw up and get kicked out. So, after some twists and turns we'll zoom in on later, the Florentine Republic recruits new leaders including Machiavelli—soon to turn thirty—toiling faithfully in his little office in the Palazzo Vecchio. His job?

- **Goal**: Prevent Florence from being conquered by any of 10+ different enormous foreign powers.
- **Resources**: 100 bags of gold, 10 sheep, 1 wood, lots of books, and a bust of Caesar.
- **Go!**

"Desperation" does not begin to cover it. By 1498, several different armies are rampaging through Italy expelling dukes and redrawing borders. Machiavelli has studied the *studia humanitatis*, knows all the moral maxims and examples of good government. He negotiates. He makes alliances. He activates Florence's twin strengths: cash and charisma. *We have the art! the books! the banks! the artists! The rare classics! You don't want to sack us; you want to be our friend, so you can have our stuff!* He backs it up with bribery: *We can't defeat you, but we can fund your wars against other cities*

and powers if you battle them instead. He negotiates alliances with the French. He negotiates alliances with Cesare Borgia, spending months at the side of this most fearsome of princes, watching Italy bow down before him town by town, while whispering into the conqueror's ear reason after reason why the Florence-shaped hole in the side of his conquests should not *yet* be next on his agenda. Machiavelli excels at this most dangerous game, his acumen and urgent letters a backbone of his boss Piero Soderini's regime, which earns Young Nick his first unflattering nickname: "Soderini's lapdog."

1503. The Borgias fall, and from the flames rise new dangers. The areas destabilized by the French invasion and Borgia ambitions are ripe for fresh conquest. We'll explore this moment (and the Borgia years) in detail through the eyes of other friends in the coming pages.

1505. With Soderini's backing, Machiavelli advances his radical idea of creating a *citizen army*, a Florentine militia, who will not, as mercenaries do, abandon the field when things look tough, but fight to the end to defend their homes and families: SPQF! The attempt, alas, could not match Machiavelli's hopes. A city with that much history of civil war was *very* suspicious of anyone who says: *Let me train a militia!,* so when Soderini let Machiavelli try, accusations that Soderini was doing it to protect his own power, not the state, immediately mired it in debate so deep that *Machiavelli's militia, sincere patriotism or covert coup?* is still an object of fresh articles here in the next millennium.[8] We have letters from friends consoling Machiavelli that he's right about the citizen militia idea, but, alas, that no one will let it happen.[9]

1508. Every crown in Europe hates their neighbors, and would rather fight it out through proxy wars in weak, lootable Italy than back at home. A new invading coalition is about to form. Nick is the expert now, it's his job to advise his frail republic: who to ally with, which kings to bribe. He must predict the sides for Florence to know where to commit its resources. Who will be fighting whom? France and Spain both want Naples. France and the Empire both want Milan. Will England's hatred of France mean they help Spain? Will England press its claim to the French

throne? Will Portugal press its claim to the Castilian throne? Will Burgundy rebel against the Empire? Will the Ottomans ally with somebody to slice up Italy? Will the Swiss finally wake up and notice that they have the best armies in Europe and could conquer whatever the heck they wanted if they tried? All the ambassadors from kingdoms and empires meet, and Machiavelli spends frantic months exchanging letters with colleagues evaluating the psychology of every prince, what each has to gain, to lose, to prove. He comes up with several probable scenarios and begins preparations. At last a courier rushes in with the news. The day has come! The alliance has formed! It is: everyone joins forces to attack Venice.

Machiavelli: WTF?!?!

Conclusion: must invent Political Science.

It's only a slight exaggeration. The War of the League of Cambrai is so incomprehensible its Wikipedia page had to develop a new table format to index the betrayals. Everyone switches sides, and what begins with the pope calling on everyone to attack Venice ends with Venice defending the pope from everyone else. Between this, and watching Cesare Borgia come so close to making himself master of all Italy but then falling disastrously, Machiavelli could only conclude that the tools his world had for thinking about politics just didn't work. A new system began to brew in middle-aged Nick's mind. But he did not drop everything and start working on grand treatises. He had a job to do, since the pope had just invited a dozen armies into Italy, and Machiavelli was mainly concerned with one, very specific posterity: SPQF.

1512. The Medici return to Florence, armed with new friends and mercenaries. Machiavelli's boss Soderini surrenders (too easily, Machiavelli will lament for years to come). The *signoria* (the S of SPQF) bows to new, fiercer Medici control. Machiavelli is expelled from government. Not long after, falsely accused of plotting against the Medici, he is arrested, tortured, and banished.[10]

Of course, everyone who's anyone is banished from Florence at some point: Dante, Petrarch, Cosimo de Medici, Benvenuto Cellini several times, the Strozzi family pretty constantly, so many more. When Florence banished important people, it often banished them to a specific place, often some distant city, to serve as trade contacts and unofficial ambassadors. A good and loyal Florentine in exile—staying where he was sent—might serve the city from a distance and thus earn his return.[11] But Machiavelli was not banished to some city where he could have used his skills, he was banished to a tiny hamlet in the Tuscan countryside where he could do nothing and meet with no one—a banishment with subtext *and stay down!* rather than a pathway back to favor.

Machiavelli was expected to run off. He's a well-known political expert, scholar, and veteran commander, with diplomatic experience in France and around Italy. Any cardinal in Rome would love to have a man like that, as would a dozen dukes, dozens of counts, the French king who saw him at work, the rulers of Urbino, Mantua, or Ferrara. No. He doesn't take a job. Machiavelli only works for Florence. SPQF.

So, after walking with princes, Machiavelli finds himself stuck in the country doing nothing. He describes in a letter taking long walks through the fields and catching larks, retiring to a pub to listen to the babble of his rustic neighbors.[12] At the end of a long, wasted day, he says, he returns to his little cottage, strips away the dirt and ragged day clothes of his new existence, and puts on his court finery. Attired to negotiate with kings and popes, he then enters his library to spend his evenings with the ancients.

And he starts writing a little book on princes.

For the Medici.

For the Medici?

Yes, for the Medici. When he finished *The Prince* he didn't publish it. He'd published other works (with less radical ideas), but with *The Prince* he only circulated a few copies among friends, plus one copy delivered and dedicated to the Medici family member he thought most likely to give him another chance.

Why the Medici? Didn't they destroy his precious republic? Torture him?

That didn't matter. What mattered was that they ruled Florence now, and Machiavelli wanted Florence to be strong. History and his own experience both showed that, when there's a regime change, people die. When Florence has a regime change, Florentines die, and non-Florentines have a good chance of stepping in for conquest. *The Prince* is a manual for stabilizing power. Machiavelli wrote it for his friends and for Florence's rulers, hoping at best that it might get him back where he should be, working for the city's safety in those little offices in the Palazzo Vecchio.[13] At worst, it would put his best advice in the hands of people who could use it to keep Florence safe—her rulers, and his friends. *And no one else*. Remember, Machiavelli's new method contains the secrets to military and political success, he didn't want to share them with any other government, not in a world where Florence can trust no one. No one can have Machiavelli's arts but Florence. SPQF.

And *The Prince* explains his conclusions from his terrible experience.

History and the classics should be studied, says Machiavelli, *not* as a series of moral maxims intended to rear good statesmen by simply saturating them with the stories about past good rulers that shaped Caesar and Cicero, hoping they become virtuous by osmosis. History should be studied for what it tells us about the background and origins of our present. Past events should be analyzed as a set of examples, to be compared to present circumstances in order to help plan actions and predict their consequences. Only in this way can disasters like the French invasion and the War of the League of Cambrai be anticipated and avoided. What worked? What didn't? What special characteristics of different times and places have led to success and failure? What made one particular tactic work for Hannibal and not for Mark Antony, or vice versa? Even bad people in history should be studied, not as negative moral examples of what to avoid, but as positive examples of the *specific things they succeeded at or did well*, things to be imitated regardless of whether the person's other deeds were terrible. This was far from the first time anyone said bad examples can be educational—a century and a half earlier we find Boccacio, in his defense at the end of the *Decameron*, saying to those critics who said that humorous tales of people behaving badly will make the

reader behave badly that they will rather make the reader laugh at those bad people and want to be *unlike* them. But that's very different from using the deeds of good and bad people coequally as models of *success alone*, based on what worked or didn't, without any consideration of whether a figure's virtue or vice may rub off on the reader. All events are equal objects for study, with virtue and vice irrelevant to their utility.

This is modern political science. It is how we all think about history now, and how it is approached in every classroom. We are, in this sense, all Machiavellian.

The word Machiavellian is often summarized as *the end justifies the means*. This isn't false, but in the original it wasn't *villainous*. For Machiavelli, the end justified the means only because the *end* in question was one specific end: a government ensuring the survival of its people. As he put it in his *Discourses*, the survival of a people and the maintenance of its liberty may require severity, deception, preemptive executions of potential rebels, disenfranchisement of immigrants, seeking out excuses to make war, even conquering neighbor states and depriving them of liberty, but that without such means the populace cannot stay safe.[14] We might paraphrase this with the Machiavellian principle: when choosing between virtue and survival, survival must come first, because, in order to practice any kind of virtue, a people must first be *alive*. And, since he kept the circulation of *The Prince* so limited, he meant his *survival justifies the means* principle even more specifically: such means are justified when the end is the survival of Florence, my home, those lively alleyways, those libraries, that grand cathedral dome. Petrarch would be happy that his classical revival taught one Florentine at least to love Florence as much as Romans loved Rome. SPQF.

Machiavelli died on June 21, 1527, not yet sixty years old. He left behind two daughters and four sons, one of whom, Lodovico, died in battle soon thereafter on the walls of Florence, guarding the republic in yet another Florentine-on-Florentine war for control, exactly the kind his father feared would happen if the new prince wasn't strong.

Do you ever play the game where you imagine sending a message back in time to tell some historical figure something you

really, really wish they could have known? To tell Galileo everyone agrees he was right? To tell Schwarzschild we confirmed black holes? To tell Socrates we still have Socratic dialogs after 2,300 years? I used to struggle about what to tell Machiavelli. That he's more famous than the popes and rulers of his day? That his name became a synonym for evil? That children in distant continents study his works to understand the minds of tyrants? That his ideas are now central to the statecraft of a hundred nations he doesn't have names for? But now I know what I would say:

Florence is on the UNESCO international list of places so precious to all the nations of the Earth that we have agreed never to attack or harm them, and to protect them with all the resources at our command.

Florence's seat of government, the Palazzo Vecchio (old palace), founded 1299, still safe and sound. The offices where Machiavelli worked were toward the front left corner, upper floors.

He would cry. I know he would. It's the only thing he ever really wanted. When I think about how much it would mean to him, and watch the sky's reflected colors changing in the window of his office in the Palazzo Vecchio, which he spent so many years desperate to return to, often I cry too.

So that's Machiavelli the patriot—SPQF.

And yet, by the 1590s (not even seventy years later) Shakespeare's Richard soon-to-be-III will boast:

Why, I can smile, and murder whiles I smile,
And cry "Content" to that which grieves my heart,
And wet my cheeks with artificial tears,
And frame my face to all occasions.
I'll drown more sailors than the mermaid shall;
I'll slay more gazers than the basilisk;
I'll play the orator as well as Nestor,
Deceive more slyly than Ulysses could,
And, like a Sinon, take another Troy.
I can add colors to the chameleon,
Change shapes with Proteus for advantages,
And set the murderous Machiavel to school.
Can I do this, and cannot get a crown?
Tut, were it farther off, I'll pluck it down.

<div style="text-align: right">Henry VI Part 3, III.ii</div>

What happened to Machiavelli the patriot? How did we get from Young Nick reading Cicero, through middle-aged Nick inventing political science, to Old Nick synonymous with the devil?

Answering this question will require us to look at several more facets of Machiavelli: Machiavelli the ethicist, Machiavelli the historian, Machiavelli the atheist, and Shakespeare's murderous Machiavel. And it will require a deep dive into the Renaissance: what it was, why it happened, what it aspired to be, and what many future eras have made out of it, and out of him. So we'll be patient. We'll dive into the glitter of propaganda reapplied decade by decade in the intervening centuries, then deep into the Renaissance itself, from Petrarch onward, meeting those who

populated Old Nick's world, before we return to Nick himself, to understand why he came to be seen as a villain, and his apocalyptic life as part of a golden age. And we must start, not with Nick's lifetime, but with his successors in the coming centuries, we who follow his methods and invent and reinvent his Renaissance: historians.

PART I

Why You Shouldn't Believe Anyone (Including Me) About the Renaissance

The Renaissance was, like the Middle Ages, loooooong. That terrible decade around 1500, which Machiavelli described in his history, was as far from Petrarch as Yuri Gagarin's space flight was from Napoleon, and Machiavelli was only half-way through what we call the Renaissance. We today understand how different those who lived through the Second World War are from the generation born with smartphones; lumping the generations of the Renaissance together is like assuming those born in 2020 have the same experiences as the generation that fought the US Civil War, and saw Queen Victoria and Prince Albert open the Crystal Palace in 1851. Change was always constant, in the Renaissance, in the Middle Ages, in antiquity, always. The long Renaissance had time to begin things, try things, fail at things, consider its failings and try new things, see those fail too, and then try more. Its aspirations stretched from "Can we make a golden age?" through "We have ten competing plans for a golden age!" to "What happened to our golden age?" all within what we now call one period. Our idea of the Renaissance is partly shaped by things Renaissance people did, partly by myths they told about themselves, but mostly by the way those myths proved useful in later centuries.

When did the Renaissance begin and end? Depends on where you are, and who you ask.

Let's pick something that feels really medieval: the Battle of Agincourt, Henry V on his foaming war horse, his army bright

with knightly banners as the haughty French learn that their sparkling armor is no match for the English longbow.

Now something that feels really Renaissance: Poggio Bracciolini, the great book-hunter celebrated as the launching point of modernity in Stephen Greenblatt's Pulitzer-winning *The Swerve: How the World Became Modern*.[1] Poggio risks life and fortune crossing the Alps to search monastic libraries for lost works of ancient Roman and Greek science (atoms! vacuum! atheism! natural selection!) which will ignite a new era. It is the spark of the golden age, the threshold of modernity.

Poggio then attended Henry V's wedding in 1420: same people, same year, same party favors.

Poggio even went to England and worked for Henry's uncle Cardinal Beaufort, and so loved the amazing English food (beef! always!) that he gained so much weight his friends didn't recognize him when he got back to Italy, and he spent the rest of his life boasting he feasted his friends in the English style.[2] This is not the Renaissance, the England, or the Italy we thought we knew.

What's going on?

All agree the Renaissance was the period of change that got us from medieval to modern, but people give it a different start date, because they start at the point *they* see something definitively unmedieval. If we leave the History Lab a moment and visit my friends across the yard in the English Department, they consider Shakespeare (1564–1616) the core of Renaissance, while Petrarch's contemporary Chaucer (1340s–1400) is, for them, the pinnacle of medieval. When I cross the walk to visit the Italian lit scholars, they say Dante (1265–1321), despite being dead before Chaucer's birth, is definitely Renaissance, and often that Machiavelli is the start of modern, even though he died before Shakespeare's parents were born.

The Renaissance is not a set of years, it's our name for the idea that there was a period of change between medieval and modern, during which some special innovation, some new ingredient, *some X-Factor*, arrived and made the world different. Its start and end dates shift with what different people see as the X-Factor, what we each think makes things modern. If you think the X-Factor was a change in art, you give it a different start date from if you

think it was an economic shift, or a political change, or a key idea or author. This is why there are Renaissance courses that go from 1300 to 1550 and others that go from 1520 to 1700, and back in the History Lab—where we brew up new timelines as colleagues down the street in molecular engineering brew RNA—we often see English literature students amazed that our Renaissance people look as early as Dante, while Italian lit students are amazed we look at someone as late as Thomas Hobbes.

To answer "When was the Renaissance?" you have to ask "What was the defining feature of the Renaissance?" And you're going to get a lot of different answers.

2

Everybody Wants to Claim a Golden Age

No matter how mythical golden ages are, they're incredibly useful to *later* regimes and peoples who want to make glorifying claims about *themselves*. If you present yourself, your movement, your business model, your political proposal, etc., as the return of a golden age, or the successor to a golden age, that claim can make you seem important, powerful. *Legitimate*.

Legitimacy is a word we'll need a lot.

The secret we all know is that governments, countries, laws, nations, none of them are real like hills or rivers, they're a bunch of stuff humanity invented. They exist only as long as we all keep agreeing they exist and act accordingly. Far more than Tinkerbell, regimes and governments need us to believe in them, or they die. Sometimes this death takes the form of people just ignoring them, like in the Hellenic age when a remote Greek colony might hear from its founding city so infrequently that it made its own government, achieving independence through the silence of distance. A more common consequence when people stop believing in governments is that some rival takes advantage of that lack of confidence and claims power instead, whether through an electoral challenge, a conquest, or a bloody civil war.

For this reason, regimes work hard to have *legitimacy*, things that make people agree the regime is real, and has the right to rule. When a usurper murders the old king but marries his widow, sister, or daughter, that's a bid for legitimacy in a world where people feel that rule goes with blood. If no local royal bride is available, the usurper might instead marry a princess from a mighty neighboring kingdom, and fill his court with exotic treasures and other

proofs that he's connected to foreign powers—this is a different way of securing legitimacy, showing that the new ruler, while lacking a blood claim, has strong allies and the means to bring prosperity to the nation. There are many ways to project legitimacy: getting trusted local elites to work for you, getting religious leaders to endorse you, publishing your pedigree (fake or real) of mighty ancestors, mounting a big parade, paying an astrologer to circulate your horoscope which predicts you'll be a great ruler, building an equestrian statue of yourself in the square, fixing bridges and feeding orphans so people talk about your generosity, cracking down on crime so people talk about your strength; even a modern city having a zoo and art museum aims to project legitimacy, an important city with the trappings of cultured power. Some sources of legitimacy tie into a specific culture's ideas about what makes power lawful (religion, local tradition), while others, like a zoo or palace, use broader languages of cultural and architectural power to make people feel that life under this regime will be good, and that overthrowing it would be difficult (the money spent to get that giraffe could be spent on an army).

One powerful tool of legitimacy is invoking a past golden age. *Under my rule, we will be great like [X] was great!* This claim can be made by a monarch, a ruling council, a political party, an individual, a movement, even a business. It can be made explicitly *(I am the new Napoleon!)* or implicitly by borrowing the trappings of an era. A bank that uses a Roman coin as its logo, names its mutual funds after Roman generals, and has a pediment and columns on its headquarters is trying to get legitimacy from the idea of antiquity as a golden age of power and stability. The newborn US, when it decided to make the Washington Monument a giant obelisk, was claiming legitimacy by invoking the golden ages of ancient Egypt and triumphant Rome, with the monument's aluminum tip (high-tech and more expensive than gold at the time) adding additional claims about wealth and science.

Because the Renaissance was already considered a golden age by the eighteenth century, it's on the list of eras you can invoke to gain legitimacy. This is why Mussolini, while he mostly invoked imperial Rome, made special arrangements to meet Hitler at the Uffizi Gallery in Florence, to show off its Renaissance treasures.[3]

This is why governments and elites in the eighteenth and nineteenth centuries raced to buy Italian art to display in homes and museums. And this is why the US Library of Congress building is painted inside with imitations of Renaissance classicizing frescoes, even though the figures they include and values they depict are more Enlightenment than Renaissance.

One consequence of golden ages being so powerful is that powers squabble over them: *"I'm the true successor of [X]!" "No, I'm the true successor!"* You see this in the dispute over the name *Macedonia*, since both Greece and the country now called North Macedonia want to claim Alexander the Great. Golden ages are mythical constructions (the events are real but the golden ageness is invented), so it's easy to claim you are the true successor, even if you have little historical connection. Nineteenth-century Germany and England, for example, claimed to be true successors of ancient Greece and Rome, by saying the spirits of Socrates and Cicero had died out under Ottoman rule in Greece and oppressive Catholicism in Italy, but flourished in their true successors, London and Berlin. Any place (past or present) that calls itself a new Jerusalem, new Rome, or new Athens is doing this, as is anyone who claims to carry the true spirit of something, as its original home languishes in some supposedly fallen state.

Ancient Rome is very easy to use this way because Rome had several phases (republic, empire, Christian Rome) so if some rival has done a great job declaring itself the New Roman Empire, you can simply say the empire was corrupt, and that you're the successor to the republic, the truly great period of Rome. Quote some Cicero and talk about wicked emperors and you can appropriate *good* Rome and make your rivals *bad* Rome. If republic, empire, and Christian Rome are all taken, you can get creative, like how the nineteenth-century romantic movement claimed the archaic pastoral Rome of Vergil's *Georgics*, replacing pediments and columns with garlands and shepherds to claim a version of Rome's golden age no one had been using lately.

The Renaissance has even greater flexibility than Rome, because its definition—in geography, time, and cause—is so deliciously vague.

3

The Flexible X-Factor of the Renaissance

During the centuries since the Renaissance, many have claimed it as a tool of legitimacy. But beyond the shared impression that the Renaissance was good, that it centered in Europe, and that it includes Michelangelo, Leonardo, Machiavelli, Shakespeare, and some lovely polyphonic music, the only fixed definition of Renaissance is that it's the period between medieval and Enlightenment, when something arrived and moved the world toward modern. Each time you propose a different X-Factor, a different cause for the Renaissance, you make it possible to claim the Renaissance in a new way. If you can argue the Renaissance was great because it did the thing *you* do, you can claim to be its true successor even if you don't resemble it in any other way.

Thus, if we're in the middle of the Cold War, and an influential historian publishes a book magnifying old discussions from Max Weber and Sombart arguing that the X-Factor that sparked the Renaissance was the rise of banking and the merchant class, triggered by the invention of double-entry bookkeeping, America can grab that book to say: *The Renaissance was the birth of capitalism! Clearly the Renaissance's true successor is modern western capitalist regimes! The fact that it was a golden age proves capitalism will make a golden age as well! And communism is the bad Dark Ages!* If, on the other hand, we're in the nineteenth-century rise-of-nationalism period, and someone argues that the X-Factor that sparked the Renaissance was the idea of Italy as a united nation first articulated in the late 1300s, and that the Renaissance golden age ended because Italy was conquered by outside powers, then the Renaissance can be claimed as a predecessor, not only by the

Italian unification movement, but by the German unification movement, and any nationalist movement, all claiming a golden Renaissance will come when peoples become nations. Thus, each time someone (usually a historian) proposes a new X-Factor for the Renaissance, it sparks a new wave of opportunities to claim the Renaissance as a source of legitimacy.

Even better, when you claim the Renaissance, you get to use the corresponding myth of the bad Middle Ages to smear your rivals and predecessors. The other political party, university, bank, ideology, whatever, *their* methods are medieval, *ours* belong to the Renaissance. The fact that the myth of the supposed bad Dark Ages is so useful makes it extra hard for scholars to correct. Medievalists started seriously challenging the term Dark Ages a full century ago,[4] and in history circles the term gradually went from meaning the Middle Ages, to meaning the early Middle Ages (fifth to tenth centuries), to being a term for those patches of the historical record where a lack of *surviving textual sources* (due to fires, floods, disasters, etc.) casts a shadow over our knowledge.* Today, the term appears almost exclusively in discussions of why a *dark age* is a bad concept, so we might best put it in our index as: *Dark Ages, Don't Call Them the*.

This brings us to *historiography*. Every history PhD student has to study historiography, that is, what past historians have said about your period. Think of how opinions vary over time about who was the best English monarch or US president, or whether a particular war or event was caused by A or B. Historiography is studying the *historians* who made those judgments, and why the consensus changed over time. Historiography is viewed as the tedious part of a PhD, but issues like the golden Renaissance and bad Middle Ages are why historiography really matters, since every new wave of theories about the Renaissance X-Factor ripples out into politics and beyond. Every day of our lives we're targeted by at least one lie about history, made in a newspaper

* For example, historians fear the present decades may become a dark age, if digital archiving goes badly and paper copies of sources aren't kept, since when proprietary software grows defunct it takes digital files with it, so 200 years from now there could be a major blank in the historical record from the years 1990–2090.

column, a political ad, a speech, a movie poster, a tweet, etc. Some are deliberate lies, others lies of ignorance, but all draw on history (often outdated history) to advance claims about the *real* America, the *real* Britain, the *real* Europe, the *real* Russia, the *real* liberalism, the *real* conservatism, the *real* democracy. To defend yourself against such lies, it's invaluable to know not just the history, but the *historiography*, so you can recognize common distortions and erasures, and know how historians use and evaluate evidence, so you can double-check claims you hear. Historiography is a great example of the kind of knowledge that is power—the *defensive* power to guard ourselves from lies.

4

Time for a Tangent About Vikings!
(It's Relevant, I Swear...)

One thing to understand about scholarship is how invaluable work can be while being completely wrong. We in the History Lab don't know a thing, so we examine it, brew up a theory, publish it, the theory stirs excitement, brings new people to the field, conferences, funding, and that's what enables further studies. Sometimes we discover we were totally wrong about the first thing, but we wouldn't have arrived at the later, better conclusion if the earlier wrong one hadn't drawn attention to the field. Scholarly errors are fruitful; unfortunately, though, old errors can be hard to replace in popular understanding, especially if they supported something people *want* to be true, or can use to claim legitimacy. This is why popular understandings of things like the Black Death are nearly a century out of date. But before we dive into the long, messy history of theories about the Renaissance, I want to give a mini-example of how this scholarly process works, drawn from a much smaller field where the sequence of theory to disproof to new theory is easier to follow. So, a micro-historiography of the question: *why did the Norse (Viking) settlements in Greenland die out?*

Greenland has had some human presence since *c.*2500 BCE, but around 1000 CE some Norsemen who'd left Norway and Iceland due to being on the losing sides of feuds settled there (the *Saga of Erik the Red* gives a date of 985). Their descendants lived in Greenland for 400 years, vanishing soon after 1410 and leaving an exciting archaeological mystery. But we're not visiting Greenland for its history, we're visiting its *historiography*, the history of its histories.[5]

In the 1920s, the modern countries of Denmark and Norway had an argument over which should own Greenland: Norway, whence the Greenland settlers had come, or Denmark, which had ruled Greenland at the point the settlements stopped existing (typically for the 1920s, any right to self-sovereignty by Greenland's indigenous population was ignored). Which claim counts, first or last? To strengthen its case, Denmark funded excavations of the settlement sites, since the ability to tour international inspectors through a museum of Viking Age Greenland could add *legitimacy* to Denmark's claim of having stronger *cultural* ties to Greenland than Norway had.

These politically motivated excavations dominated Greenland research until the 1960s–70s, when the larger field of Norse studies was transformed by the end of a feud—in this case an academic feud, between rival university departments: literary scholars vs. archaeologists. This feud—raging at Oxford, Cambridge, and many universities—meant that, for decades, those *reading* Norse *texts* rarely worked with those *digging up* Norse *stuff*. (Reminder, Norse = the people, Viking = a profession/activity, i.e. raiding places; we call them Vikings when they're sacking and looting, but when we mean the whole population who raided but also farmed, carved, wove, wrote poems, and raised babies, we say the Norse). The feud-born barrier between the studies of literature and archaeology was finally weakened in the 1960s when women entered the field in substantial numbers, thanks to the advance of feminism. These women were largely outsiders to old academic feuds (why not read *and* dig?), and were already being marginalized by their male colleagues, so had less to lose by breaking scholarly taboos.[6] Thus it was Anne Stine Ingstad with her husband Helge who took the *Saga of Erik the Red* and *Vinland Saga* seriously as historical sources for the first time, and, following their claims that Vikings from Greenland had reached Canada, found the Norse settlement in Newfoundland and sparked global excitement about Vikings having beat out Columbus.

Suddenly First Nations histories and Columbus's title were in play, so the national pride (legitimacy) of Denmark, Norway, Canada, the US, even Italy, Spain, and Portugal were all at stake, so in the later 1970s they all channeled big bucks into

the Viking sections of the History Lab. This is why there was funding available when Norse specialist Thomas McGovern participated in the Inuit-Norse Project, which proposed an exciting theory: unlike the sustainable methods of the Inuit who fished and used the sea, the Norse settlers had stubbornly clung to European farming traditions, as shown by the fact that the excavations didn't find any fishing equipment, or even fish bones, in the Greenland Norsemen's refuse piles (middens). The theory argued that this failure to adapt to the land proved unsustainable and failed. Feels right, right? Thomas McGovern is a hero of scholarly honesty, who joked in a 2017 Smithsonian interview, "It's a good thing they can't make you give your PhD back once you've got it," and he will be the first to admit: *We were completely wrong.*[7]

Environmentalism was growing in the 1970s, as were anti-colonial ideas, and both were supported by this narrative of bad, closed-minded Europeans vs. good, land-respecting indigenous peoples. Further studies of erosion damage from farming in Greenland seemed to support the thesis, and soon an even more exciting theory joined in: climate change. The 1400s, when the Norse settlements failed, had been the frigid first act of the Little Ice Age, a period of cooling *c.*1300–1850 which affected the whole globe. As Greenland grew colder, it stands to reason that stubborn farmers who refused to fish would face calamity. It feels right, a chilling warning of our fates if we don't take climate change seriously, which quickly made Norse Greenland popular in op-eds and interviews. This answer not only solved the mystery but proved that medieval studies can help us grapple with the big issues of today! As climate change became a hotter topic, History Lab funding flowed to Little Ice Age projects, bringing, for the first time, the ability to use expensive tools like radiocarbon analysis, which proved that...

...the Greenland Vikings were fishing after all.

Carbon isotope ratios in sea water are different from carbon isotope ratios on land, making it possible to analyze bones and tissue residue and determine what portion of the protein in someone's diet came from land vs. from the sea. A huge portion of Greenlanders' protein came from the sea, not only in the settlers'

own bones but in their animals' bones too. The reason there were no fish bones in the refuse (McGovern was right about that) is that they'd been using every part of the animal, grinding fish bones into paste for human consumption, and feeding heads and other waste to goats and pigs and even cows. The growing season in Greenland is so short you can't grow oats or even much hay, so in the last stretch of a long Greenland winter even the cows were fed on fish. Historians double checked this using legal archives (lawsuits from Greenland were sometimes adjudicated and archived in Norway and Denmark) and indeed found detailed laws about fishing rights, which confirm the Greenland settlers' use of nets, harpoons, fish traps, and seal traps. Why hadn't the excavations found fishing equipment? (A) Nets decay quickly, (B) fish hooks are iron and either get melted and reused or end up at the bottom of the sea, and (C) the stone sinkers used for nets and fishing poles look exactly like loom weights (both are doughnut-shaped rocks designed to have cords tied to them), so we did find them after all, but the earlier archaeologists just ignored them because they looked like weaving equipment, i.e. girl stuff (sigh). Better examinations of erosion patterns also revealed they weren't caused by the Norse, they were from Denmark's modern farming experiments (oops!), a different era of bad, colonizing Europeans harming the environment. Hence McGovern chuckling about giving his PhD back.

As for climate change, the theory of a slow decline has been undermined by better numbers for how many people lived in the Greenland settlements. We realized, for example, that the reason they stopped keeping pigs by 1300 likely wasn't a sign of poverty (lots of poor communities keep pigs) but that their livestock ate rancid fish for a quarter of the year, and while cow milk still tastes okay, pigs' flesh tastes like what they've been eating, so it's very likely that Greenlandic pig meat tasted so rancid that, to quote insect sting expert Justin Schmidt's description of getting a bee sting on the tongue, "for 10 minutes, life is not worth living."[8] The more we learn about Norse Greenlanders' fishing techniques, the more we realize the Little Ice Age didn't affect the *specific fish* they mainly depended on, nor would it have affected the cows whose milk (cheese, yogurt, butter) provided more than 50 percent of

their diet, so the climate change theory—sexy as it is—can't explain why the Greenland settlements went away.

What really happened? I'll circle around to our most recent theory later, but I don't want to give what seems like an answer now. The point of this tangent is to show how easily scholarship can end up at an answer which *feels right!*, fits things we want to be true, makes the topic exciting, and brings in funding and fresh scholars, whose work then shows that we were completely wrong. But we wouldn't have had those new studies if we hadn't been entranced by the old error. This is why history (and scholarship broadly) benefits *even from scholarship that is completely wrong*, but it's also why a theory we know is false but *feels so right* can continue to circulate for decades after we disprove it.

The Renaissance (all of Europe and beyond!) is much bigger and more complicated than two small settlements in Greenland, so evolving theories about the Renaissance X-Factor are much less cut-and-dried than Greenland's *oops, they were eating fish after all!* But I want you to have Greenland in mind to show how a single strand of scholarship works before we dive into a Gordian knot.

Welcome to *Loom Weight or Net Sinker?*—a game the best of archaeologists struggle to win. Above: Roman era loom weight (Dover Castle, photograph by Corinne Goss). Below: net sinker (Robbins Museum, Indigenous American artifact collection, Middleborough Mass.).

5

The Quest for the Renaissance X-Factor Begins

Okay, deep breath.

The name Renaissance is not Renaissance. The closest we have in the period is Giorgio Vasari (1511–74), artist, architect, Medici stooge, and Michelangelo super-fanboy, whose *Lives of the Artists* (1550) is the ur-text of art history, and uses the word *rinascita* (rebirth) to describe a rebirth *specifically of art* in the period around 1500, culminating with Michelangelo. Using Renaissance as a name for the *period* started in the nineteenth century, with French historian Jules Michelet (1798–1874). Michelet was a great champion of the French Revolution, of modern republicanism, of everything modern, making the Middle Ages the tyrannical bad guy, and in his giant multi-volume *History of France* (finished 1867) he used Renaissance to describe a rebirth *of art and culture* between medieval and Enlightenment.

Well before Michelet, in the 1700s and 1800s, everyone in Europe had already agreed there was a golden age *of art and music* in the 1400s through 1600s, especially in Italy. Any educated person had to have opinions on Raphael, Titian, Petrarch's poetry, and the polyphonic motets of Orlande de Lassus (c.1532–94); seriously, in the original Sherlock Holmes stories (1880s–1910s) *after* having Watson establish Holmes's "Knowledge of literature—nil. Philosophy—nil," when first introducing the characters in *A Study in Scarlet,* Doyle changes his mind about his ideal reasoner and has Holmes carry a "pocket Petrarch," because any smart, impressive person, *even one with little interest in philosophy or literature*, was, of course, familiar with Petrarch.[9]

The Renaissance was, at the same time, famous for terrible things: betrayals and assassinations, poisonings and corruption, dastardly deeds and wicked popes, and for the queen of femmes fatales Lucrezia Borgia, whom Doyle and Agatha Christie bring up whenever they hint a woman is a murderess.[10] Familiarity with these alluring Renaissance evils was equally expected of a cultured person in 1910, and they too were part of its golden age nature: the decadent underbelly generated by the gold and glory, elegant, cultured evils of palace and boudoir, not of famine and field. To this day, it's hard for the enchantment of blood and scandal not to color our understanding of the Renaissance; this period can teach us about the origins of modern economies, but it's also an age when an infamous murderer, the unforgettably named Guidarello Guidarelli (d. 1455–1501) was mysteriously stabbed to death at Cesare Borgia's masked ball. Such opera-worthy drama is still glitter, the sinister black glitter which throws the gold glitter around it into gorgeous contrast. This let those in the eighteenth or nineteenth centuries who wanted to claim to be a continuation of that golden age, or a new but comparable golden age, boast that theirs would be even better than the Renaissance, since it would not have decadent Lucrezia Borgias like the original.

The transition from people being excited about Renaissance *art and drama* to being excited about the Renaissance *as an era of major historical change*, and looking for the X-Factor that caused it, came in the mid-1800s, best represented by the work of Swiss historian Jacob Burckhardt (1818–97). His biggest seller was a learned travel guide, *Cicerone: or, Art-guide to Painting in Italy* (1855) which became mandatory reading for the Grand Tour, while his biggest impact came with his 1860 *The Civilization of the Renaissance in Italy*. This book aimed to be a history, not of a country, person, war, or event, but of an *era and its culture*, examining art and artists side by side with authors, soldiers, and statesmen as examples of the ways the people of a particular age thought, acted, and lived. The book helped pioneer *cultural history*: studying politics, art, culture, and daily life together, and addressing issues like "the effect of these political circumstances on the spirit of the nation at large."[11] That this style of history originated in German scholarship is in part due to the influence

of Herder and Hegel's concept of *volksgeist* (the spirit/mind of a people), the term which put the *geist* (spirit) in *geistesgeschichte*, the German term for what an Anglophone would call intellectual history, but it literally means the history of the spirit of a people, and has a very porous relationship with *kulturgeschichte* (cultural history). Cultural and intellectual history have grown a lot since 1860, largely casting off the idea of *spirit of the age* and recognizing that reconstructing details about past life and culture is valuable in itself, even if it doesn't create some lofty portrait of a collective spirit, so cultural history remains a major tool in the History Lab, one that has brewed up some of the best work on once-neglected topics like women, pop culture, and non-elites.

Burckhardt was also the first historian to widely use the terms *modernity* and *modern*, triggering a big increase in how much people used them. He said the Renaissance was *the birth of the Modern Man*, defined by a powerful confidence in human excellence and human potential. The X-Factor which made Renaissance different from medieval was *the rise of individualism*:

> In the Middle Ages both sides of human consciousness—that which was turned within as that which was turned without—lay dreaming or half awake beneath a common veil. The veil was woven of faith, illusion, and childish prepossession, through which the world and history were seen clad in strange hues. Man was conscious of himself only as member of a race, people, party, family, or corporation—only through some general category. In Italy this veil first melted into air; an objective treatment and consideration of the state and of all the things of this world became possible. The subjective side at the same time asserted itself with corresponding emphasis; man became a spiritual individual, and recognized himself as such. In the same way the Greek had once distinguished himself from the barbarian, and the Arabian had felt himself an individual at a time when other Asiatics knew themselves only as members of a race. It will not be difficult to show that this result was owing above all to the political circumstances of Italy.[12]

Focusing on carefully chosen figures (Dante, Petrarch, Leonardo da Vinci, Pietro Aretino), and giving pride of place to the republics of Venice and especially Florence, which he called "the most important workshop of the Italian, and indeed of the modern European spirit,"* Burckhardt credited the birth of this glorious individualism to politics and lived experience, writing: "the general political uncertainty in Italy, during the fourteenth and fifteenth centuries, was of a kind to excite in the better spirits of the time a patriotic disgust and opposition."[13] In other words, he thought the instability in the period made people realize that engaging deeply with ideas of good government was necessary to foster excellence, and that it made Italians think about the importance of their common fatherland, thus that the Renaissance saw a kind of nascent nationalism, manifest in Petrarch and his call for the restoration of Italy's lost glory.

The Renaissance Man was, in Burckhardt's terms, awake, ambitious, aware of his own power, desirous of remaking the world (all this in contrast with the sleeping and impotent Medieval Man), and was self-consciously engaged in fashioning himself into something excellent—not his surroundings or his works, *himself*. Renaissance Man was also rational and able to see through superstition to a broader, more open-minded theology, influenced by the classics but also proto-Protestant or proto-deist, and exemplified by the *Oration on the Dignity of Man* (written 1486) by genius polymath Giovanni Pico della Mirandola (1463–94), which contains the often-quoted passage, "Being unwilling to accept second place in the universe, let man vie with the angels in dignity and glory!" (Spoiler: we've since realized that Pico's *Oration* isn't an oration and isn't about the dignity of man, it's actually a coded manual on how to turn yourself into an angel, but we wouldn't have figured that out without the attention drawn to the *Oration* by scholars like Burckhardt being invaluably wrong.)[14]

* Ibid. ch. VII, "The Republics: Venice and Florence." Burckhardt's enthusiasm for Florence was partly due to the 1839 publication of the manuscripts of Florentine book-dealer Vespasiano da Bisticci (1421–98), who had helped supply manuscripts for Cosimo de Medici, and for the then new Vatican Library. On Vespasiano, see Ross King's delightful new study, *The Bookseller of Florence* (2021).

Nineteenth-century Europe, when Burckhardt wrote, *loved* individualism, democracy, nationalism, words like *zeitgeist* and *volksgeist*, and ideas of individual consciousness and national consciousness, so the idea that all the sparkly Renaissance art was the offspring of such factors stirred great excitement. Suddenly Renaissance studies was not just art history but modernity's formation, and all sorts of nineteenth-century movements wanted to fund it so they could claim the Renaissance golden age as an ancestor. Burckhardt located the Renaissance's highest peak in the first decades of the 1500s, but, in describing the days of artistic glory that left us the Michelangelos and Raphaels and beautiful polyphony, he lamented that it also grew decadent:

> ... the enjoyment of intellectual and artistic pleasures, the comforts and elegancies of life, and the supreme interests of self-development, destroyed or hampered the love of country. But those deeply serious and sorrowful appeals to national sentiment were not heard again till later, when the time for unity had gone by, when the country was inundated with Frenchmen and Spaniards, and when a German army had conquered Rome.[15]

In other words, according to Burckhardt, the spirit of modernity and individualism born in Renaissance Italy were spoiled by the Italian Wars, and Italy being sliced up by empire, so the *true* fulfillment of the Renaissance's modern ideas was to be hoped for in the present, as nations were being reunified, rationalism was triumphing, rational religion was advancing (i.e. northern European Protestantism against southern European Catholicism), and as democracies and republics like Burckhardt's own Swiss republic were at last realizing the abortive promise first attempted in the Renaissance republics of Florence and Venice.

Another major concept from Burckhardt is: *the state as a work of art*. Renaissance Italy, he argued, was the first point at which people had thought of themselves as actively creating and maintaining their states, and making strategic decisions about how to define and defend them. Rulers of Italian city-states—whether individual dukes or town councils—made active decisions about which factions or major powers (the pope or emperor) to ally

with, and how to self-fashion *as a state*, with deliberate selections of capital buildings, artworks, and the values they projected. Burckhardt saw Petrarch's Cicero-reading scholar circle and their peers as a big step toward modern deliberately planned governments, like the American constitution. Even the many despotic and vicious conquerors of the Renaissance, he argued, made calculated efforts to design and create their states: "the modern political spirit of Europe, surrendered freely to its own instincts, often displaying the worst features of an unbridled egoism..." but that this was still "... the state as the outcome of reflection and calculation, the state as a work of art."[16]

People who study the ancient and medieval worlds will tell you there are many examples of rational and deliberate state-fashioning long before the Renaissance, and more recent scholarship shows that the Renaissance texts which Burckhardt celebrated for using the word *stato* (state) actually used *stato* in a negative sense, a word meaning a structure of domination over the people, at least until shortly before 1600.[17] Yet, while the concept of the state as a work of art needs its grain of salt, it is useful as we consider why these cultures left us so much art, a symbiosis captured by Burckhardt's vivid descriptions of how Renaissance princes like the Montefeltro dukes of Urbino used calculated investments in architecture, art, literature, and their own costly dress to impress subjects and visitors alike with a sense of the inseparable grandeur of ruler and polity (just as modern cities invest in Renaissance art and costly giraffes). We'll return to the details of the art-state symbiosis in Part II, but Burckhardt's *the state as a work of art* remains a great example of how a concept can remain powerful, persuasive, and even useful long after the historical facts it was based on are disproved.

The nineteenth century, of course, was an age of nation-building, excited to feel that its states were works of art, and the century's particular flavor of nationalism was enamored of the idea of the *genius of a people* or *spirit of a nation*, and sought to identify the grand characteristics (*volksgeist*) that made each nation (Italians, Germans, "Anglo-Saxons") unique. They were especially excited to find artifacts which offered a *pure* window on a nation's spirit, and *pure* or *authentic* art and literature, in contrast

with what they saw as inferior, contaminated works which mixed influences of multiple nations (we can feel fascism brewing). For this reason, scholars of the period focused on literature written in the native language of a place, considering it authentic in a way that an English author writing in French or a medieval Spaniard in Latin could never be. The only *pure* Latin was ancient Latin, when Latin was the dominant language, and the Latin of the Renaissance was a twisted relic forced onto cultures by slavish imitators and the tyrannical and superstitious Catholic Church.

(Fun Fact: *dominant language* is an overstatement for classical Latin, since basically everyone in the Roman Empire was a polyglot, so one heard all sorts of languages in the streets of Rome: Aramaic, Hebrew, etc., with Greek serving as a *lingua Franca* used by an even a larger portion of the population than those who spoke Latin.)

(Fun Fact #2: contrary to popular belief, the phrase *lingua Franca* doesn't actually refer to the phase when French was the dominant language of European diplomacy, but to Mediterranean Franca, also known as Sabir, a vibrant pidgin used by sailors around the Mediterranean and Levant in the medieval and Renaissance eras, made from simplified Italian and Spanish with lots of loans from Slavic languages, Greek, Turkish, and Arabic, a modern historical linguist's delight and the kind of thing that made nineteenth-century nationalists' skin crawl.)

As a result of these nineteenth-century attitudes—as Christopher Celenza, a champion of the classics wing of the History Lab, helped us realize—while Renaissance Europe left us *millions* of pages of new Latin, nineteenth-century scholars not only ignored them but often denounced them, declaring that works in a non-native tongue could never contain the authentic spirit of a nation, which was the whole reason they wanted to study history.[18] Dramatic, spicy works might still be read for pleasure,* and historians would mine Latin works for *facts* (dates, events, doings, a scientist's inventions) but never for *ideas* or *ethos*,

* Burckhardt, for example, mentions the dramatic Latin language autobiography of mathematician-astrologer-gambler-polymath Gerolamo Cardano (1501-76) as ubiquitous reading for cultured people in his age, later displaced by the even more dramatic *vernacular* autobiography of goldsmith-sculptor-necromancer-assassin-polymath Benvenuto Cellini (1500–71).

while classicists and philosophers scorned such things entirely. Even vernacular works too similar to Latin ones could be sidelined as imitations of Latin, thus inauthentic and impure.*

(If seeing the concept of purity used like this is making *your* skin crawl, (A) good for you! (B) I recommend a trip down the hall to the Philosophy Lab where the wonderful Alexis Shotwell is brewing up work on the destructive effects of *purity* as a concept in our modern world.[19] Each lab brews different things to make our world better: Chem Lab, new meds; Physics Lab, new particles; History and Philosophy Labs, new proofs that Nazis are wrong.)

In sum, the Renaissance celebrated by nineteenth-century historians like Burckhardt focused on a narrow slice of the historical record (only a few texts, only a few languages, only a few places), which magnified what they wanted to find. The Renaissance as a nationalist awakening *felt right* to nineteenth-century readers in Germany and its neighbors, just as, a century later, the idea of Norse Greenland being wiped out by the Little Ice Age would feel right to climate scientists. And even more damage was done by how the bad Middle Ages could be used to characterize those colonized nations Europe claimed it could modernize, a new justification for imperialism. We're still working to repair the damage all this did, an uphill battle like replacing the old smooth dinosaur images with today's feathery ones, but without them we may not have started the projects that eventually proved them wrong, or protected the documents that did so.

Was Burckhardt wrong? Were our Vikings really eating fish? Alas, we can't track individualism with carbon isotope analysis. Updating this nineteenth-century understanding requires tons of work in dozens of cultures and languages. We in the History Lab have been working at it for a century, and found that a lot of things Burckhardt and his peers describe as modern existed in the Middle Ages (self-fashioning, rationalism, innovation), and that the Renaissance had plenty of supposedly medieval qualities

* Academic competition fed into this, and Burckhardt's denunciation of the inauthenticity of Renaissance Latin was partly a tactical criticism of his direct scholarly competitor Georg Voigt (1827–91) who did center the Latin.

(piety, traditionalism). Some historians have taken it on directly, notably John Jeffries Martin in his invaluable *Myths of Renaissance Individualism*, which meticulously lays out how modern ideas of the individual *do not* match what we see Renaissance people express in their own texts, and attempts a portrait of the Renaissance self, or rather plural selves, different ones for different facets of life.[20] But *individualism* is a slippery concept, easily hedged and nuanced, and the idea of the triumphant Modern Man is so entrancing that any refutation of one detail can be dodged by changing your definition of *modern*. So every year at big Renaissance conferences, some scholars give papers on how Renaissance people kept doing basically what medieval people did, while right next door others give papers debating whether Petrarch or Machiavelli was the First Modern Man. There is some variation by discipline here: it's usually historians I hear giving the papers on how Renaissance life wasn't very different from medieval, or how the Renaissance's innovations weren't big rivers yet, just rivulets floating a single leaf, while the First Modern Man question comes up more often among people with degrees in literature, political science, or philosophy. But the doors between the History Lab and the Literary Studies Lab, etc., are never closed, so there are always plural kinds of scholars in the room where redefining *modern* happens.

6

Super Sexy Secular Humanism

You've heard the word *humanism* in connection with the Renaissance, haven't you? So, alas, have I.

The nineteenth century was a moment of excitement about *secularism*, a term coined in 1851 by George Holyoake (1817–1906). These were the years of philosopher Auguste Comte (1798–1857), the revolutions of 1848, the Church of Humanity, and efforts to develop Reason-centered and human-centered systems of ethics to replace religion as an alternate foundation for humane thought. Ranging from actively anti-theist to simply nontheist (i.e. favoring the separation of ethics and philosophy from religious concerns), these nineteenth-century secularizing movements rejected theological justifications for law or moral codes, but felt that society could not function without charity, altruism, justice, and empathy, so sought to put humanity itself at the center of a new ethics. This gave the thrilling Burckhardtian portrait of Renaissance individualism a sexy nineteenth-century name, and the field of Renaissance studies was officially doomed:

- *Humanism* **(noun, English)**, from *humanismus*, coined in the nineteenth century by Bavarian theologian Friedrich Niethammer (1766–1848) when discussing the value of philosophical breadth in education,[21] now used to describe a philosophical stance taking the human being (individually and socially) as the center of ethics. Humanism is often associated with secularism, taking a nontheistic view centered on human agency and reliance on science and reason, exemplified by the "Religion of Humanity" of

Auguste Comte, who argued that no metaphysics or religious belief can be convincingly supported by logic or evidence, but that the world needs humane political and ethical values concordant with science that can be justified without religion.

- *Umanista* **(noun, Italian, pl.** *umanisti*): a professional teacher of the *studia humanitatis*, a variation on the classical *trivium* (grammar, logic, rhetoric) prioritizing rhetoric, in contrast with scholastic education (dominant in universities at the time) which favored logic. The classroom methods of *umanisti* focused on teaching rhetoric and ethics via classical Latin literature (and often Greek), and, especially after 1400, composing Latin in a style modeled on ancient authors and rejecting medieval Latin style. Most famous student produced by such classrooms: Young Nick Machiavelli.

- Put *umanista* into Google Translate (or a simple dictionary) => **humanist.**

- Put **"Renaissance Humanism"** in your course title, and your classroom fills with students eager to discuss secularization and the dignity of humanity. The students are then baffled when our Renaissance humanists are writing about whether Cicero or Quintilian is the best model for oratory, and the correct interpretation of future passive participles. Put *renaissance humanism* in your book title and you get eager requests for review copies from dozens of people very disappointed if your conclusion is about classroom annotations of Vergil.

If Pico wanted souls to vie with angels in dignity and glory, the term *humanism* certainly vies with *Renaissance* in misleadingness and vagueness.

This term *was not* an –ism in the Renaissance. *Humanism*, as a term, is from 1808, born from Enlightenment educational debates and projected back onto the Renaissance. The word *umanista* existed in the Renaissance, but while the *-ista* ending sounds ideological to us, in period Italian it was a practitioner

suffix, equivalent to the English *-er*, i.e. *legista* = lawyer; *artista* = artist; *musicista* = musician; *barista* = person who sells food and drinks at a bar, i.e. table, and so on. *Umanista* = a person who teaches the *studia humanitatis*. The term *studia humanitatis* itself comes from Cicero, his attempt to render the Greek *phil-anthrôpía*, i.e. love of humanity, in the same sense that philosophy is *philo-sophía*, love of wisdom. An *umanista* was a type of tutor one might hire, as one might hire a music tutor or a fencing coach, as we see in *The Taming of the Shrew*, when Bianca's father wants tutors for her, and her two suitors disguise themselves as a music tutor and a Latin tutor, i.e. *umanista*, two subjects which her father considers equivalently valuable for a refined young lady. (Why so many examples from Shakespeare? Because he has so much *legitimacy*.)

In modern English, scholars started using *humanists* as a translation of *umanisti*, those professionals who taught in schools, universities, or as private tutors. Some also used it for Renaissance figures who didn't teach but *studied* the *studia humanitatis*, and engaged in associated activities, like exchanging learned Latin letters or attending get-togethers, especially those who worked as secretaries, diplomatic attachés, or in branches of government where fluent Latin was an asset. Eventually I will release the kraken of discussing what Renaissance *humanism* might mean ideologically. (Spoiler: we're closer to cold fusion than we are to agreeing what the heck Renaissance humanism was!) The idea of humanism as an *–ism* was, and is, particularly important to Italian historians, like Eugenio Garin (1909-2004), who use it to argue for Italy's contributions to the history of thought, against philosophy timelines which tend to skip straight from ancient Greece (with maybe a pit stop for Augustine or Aquinas) to Descartes, Hobbes, Locke, Leibniz, Kant, Hume, and Rousseau, generally implying that Italy belongs in art and literature courses but not philosophy courses. I'll return to this debate, and the Italian side of it, in Part IV, but for now the important part is that *humanism* (emphasis on the *–ism*) is another proposed X-Factor. The sexiness of the term *Renaissance humanism* still sells lots of books and Italian tour bus packages, and can be used to argue for putting an Italian on your Philosophy 101 syllabus, but it also projects a

world of anachronistic modern ideas back 500 years before Kant, Comte, Sartre, Neil deGrasse Tyson, or what we mean by *modern secular humanism*.

Returning to the nineteenth century: the secularizing movements on the rise in the 1800s glommed onto the similarity between the word *umanista* and their word *humanism*, which let them claim the Renaissance (legitimacy!). It also let them claim that the best Renaissance thinkers had been secularizers, and that *the X-Factor had been secularization*. While, for Burckhardt, exemplary figures like Lorenzo de Medici had transcended Catholic dogma to reach a kind of spiritual rational religion anticipating Protestantism, his peers went further, claiming that even figures like Pico were closet atheists, and that discussions of God and angels like those in the *Oration* (not an oration, not about the dignity of Man) were insincere, added to placate the ever-watching Inquisition. This *innocent dissimulation thesis*[22] argues that Renaissance protestations of faith are often false, and that Renaissance figures camouflaged their secularism in their writings, trusting that wise, like-minded peers would read between the lines, both in their day and in the future.

Were there atheists in the Renaissance? My short answer: Yes. My long answer: Yes, but [insert-dissertation-length-evidence-pile-here] not as many as is often claimed, and not the kinds of atheists the word *humanism* makes us imagine. I'll return to Renaissance atheism once we have more examples to work with (the best questions deserve thorough answers) but first we have to get through more iterations of nineteenth-century people being fractiously, meticulously, and well-footnotedly wrong. We're still wrong today, of course, but in new ways with better footnotes, ready for the next scholarly generation to point out how we're wrong and improve our theory, as each new particle brewed in the Physics Lab helps push the Big Bang Theory toward the future's inevitable Better Than the Big Bang Theory.

7

A New X-Factor: The Baron Thesis and Proto-Democracy

The next major proposed X-Factor came with Hans Baron (1900-88), a Berlin-born German Jew and serious campaigner for democracy and against fascism in the Weimar Republic, who fled to Italy with Hitler's rise in 1933, then to the US in 1938. Like the rest of his generation, Baron watched nationalism metastasize into fascism, which exploited histories of the Renaissance and other eras to argue for the superiority of certain peoples over others, and to justify brutality, genocide, and the purging of dissent.

The idea which my field calls "the Baron thesis" appears in his work as early as the 1920s,[23] but it was in 1955, when the war's end had freshly exposed the true atrocities of fascism, that Baron published the book which would become its core articulation. The Renaissance X-Factor, he proposed, was not the pursuit of the supreme excellence of the individual, but rather *political participation*, partnered with free-spirited, deeply engaged *political discourse*. The Renaissance had flourished most in Venice and especially Florence, he argued, as everyone who had visited Italy could see from their stunning art and architecture. These republics had well-educated (upper- and middle-class) citizens with a powerful tradition of civic participation, who wrote histories of their nations, expounded political theories, and achieved true human fulfillment, not through individual excellence, but by being part of politics and debate, as Aristotle said humans actualize our potential by participating in a city-state (*polis*), hence Aristotle's "man is a political animal," whose full potential to do lots of things (art, poetry, library-building, hosting the

Olympics) can only be realized in a city, with what we now call *division of labor*.

For Baron, the Renaissance X-Factor was *republican civic participation*: an environment which fostered discussions of liberty, the first flourishing of what would later be perfected in modern democracies, the American Experiment, and constitutional monarchy. We might call this proto-democracy. Machiavelli's groundbreaking political innovations were the crowning glory of this republican tradition. And while Baron's book focused on the pre-modern past, his analysis placed the modern fascists who had claimed the Renaissance in the role of modernity's enemies, tyrants who, like the worst Renaissance popes, stamped out free discourse with fire and blood.

In German, Baron called his X-Factor *bürgerlicher Humanismus*. Consulting the same literal dictionary which rendered *umanista* as *humanist*, Baron's *bürgerlicher Humanismus* would give us *bourgeois humanism*—not a very appealing phrase in a 1950s America so fired with the Red Scare that using the words *bourgeoisie* or *proletariat* enraged those crowds actively picketing places like my University of Chicago for refusing to purge its communist faculty.[24] In his English version, Baron went instead with *civic humanism*, resulting in the publication in 1955 of his sensationally-popular-for-an-academic-history book, *The Crisis of the Early Italian Renaissance: Civic Humanism and Republican Liberty in an Age of Classicism and Tyranny*.[25] Fifties America loved it.

How could 1950s America *not* love it? When oversimplified by newspaper summaries, Baron's civic humanism presented the Renaissance golden age as the first test drive of modern democracy, the ancestor of the US and the other nations which had defeated the tyrannies of Hitler and Mussolini, and proclaimed themselves leaders of the free world. And while the fascists fell into the role of discourse-squashing Renaissance tyrants, the communist world could be compared to the backward, communal Dark Ages, while only the capitalist democratic West were true inheritors of the awakening of modernity, continuing from Leonardo's flying machines to the triumph of the moon landing. This was not Baron's argument, but demonstrates how easily the suggestion that a certain X-Factor caused a golden age can be

used to claim that the true successor to [a given age] is not its own country/people/region but [some totally different group].

Was Baron wrong? Were our Vikings eating fish again?

Yes and no, as is often the best answer. Baron was correct that amazing, world-changing things happened in Renaissance political thought, and that Florentine political thought (especially Machiavelli) has been vastly influential. But there are problems with portraying this as a broad, boat-bearing river rather than a trickle with a couple floating leaves. One problem is centering the republics. There were plenty of city republics in the Middle Ages with rich and thriving civic participation. Additionally, Florence and Venice were both oligarchies which, by modern standards, had very limited civic participation—generally only a few hundred fully participating citizens among, in Florence's case, 100,000 people—more participation than a monarchy, but far from the idea of universal participation.[26] Plus, the Renaissance also happened in monarchies. Milan (duchy), Urbino (duchy), Ferrara (duchy), Naples (kingdom), Bologna (mess), Rome (papal mess): these also had the art, the architecture, the orations, and the classical revival. There was the French Renaissance, the Spanish Renaissance, Portugal's golden age, Hungary's golden age, the Renaissance in England, all with monarchs and monarchal patronage. Royal courts hired Italians like Poggio to work for princes like Cardinal Beaufort, so while Italy still gets points for being an epicenter, if republican proto-democracy was the defining cause of the Renaissance, why would it also thrive in royal courts from Scotland to Székesfehérvár?

Some advocates of the Baron thesis argued that monarchies had *less* Renaissance, that the republics were the core, but evidence against has been mounting for decades. One of my PhD advisees, John-Paul Heil, just finished his dissertation on innovative political treatises written for the monarchs of Naples (kingdom) and Ferrara (duchy).[27] But so long as Machiavelli remains so famous, the claim that Florentine political thought was a defining moment in the advent of democracy will continue to *feel* right. Hence, Renaissance conferences host talks which treat the Baron thesis as definite truth next door to talks which treat it as dead as a doornail, just as friends up in the Astronomy Lab host talks on

dark matter next door to talks on whether dark matter is a useful concept anymore.²⁸

Another grain of salt we need to take with these expanded-from-Baron ideas of Renaissance republics as a flowering of democracy is to look at just how *undemocratic* these systems were. Most Renaissance republics—Venice, Genoa, Switzerland, many bits of the Germanies—kept all power in the hands of tiny, landed, noble-blooded minority, they just had a system of councils and offices so that that power was *shared* among these noble-blooded families instead of one family being duke/count/king-of-the-mountain. Having decision-making councils of seven, ten, or a hundred noblemen all from the same few dozen families *was* different from having a duke, but it was still aristocracy, and there's a whole century in the 1400s–1500s when every single Doge of Genoa (elected head of state) came from one of two top families, Campofregoso* and Adorno.

There were a few republics *without* landed noble-blooded aristocracy, Florence being the most prominent, and Machiavelli proudly declares that Florence had no nobility, thus allowing true civic participation, something later historians like Baron latched onto. But if we look at a slightly later Florentine, Benedetto Varchi (1502/3–65), his history gives a better breakdown of Florence's society.²⁹ The biggest social class was what he and his contemporaries called plebs or non-taxpayers, the laboring classes (weavers, butchers, builders, farmers, servants) who, Varchi says, in a well-ordered society *should not even think about* government *let alone aspire to participate in it*. The richer tax-paying minority (merchants, shop owners, entrepreneurs, bourgeoisie) was also divided, and the majority of these could not participate either. The participating elite was a small minority of well-established men who owned substantial investment capital and some farms and villas (but not enough land to be too much like landed nobility), and who were sufficiently connected to local power networks to join the city's exclusive merchant guilds, since only guild

* The family is alternately called Campofregoso, Fregoso, or Campo Fregoso, but is one family. Many Campofregoso Doges of Genoa were overthrown and replaced by other members of the same family.

members could hold office. This participating minority—at most a couple thousand men out of the city's 100,000, or post-Black Death 50,000—was the *popolo*, i.e. the people, a term *excluding* the vast majority even of the city's bourgeoisie. Makes SPQF feel different, doesn't it? More so when you remember the thousands of additional farming families and residents of hamlets and towns in Florence's Tuscan empire who were ruled by this same distant urban elite.

Within this elite, there were about a dozen top families, called *ottimati* (best), *grandi* (big), *uomini da bene* (men of good origin), or occasionally *nobili* (nobles) who owned vast fortunes from trade empires (in today's terms hundreds of millions), and who were legally the equals of all in the *popolo*, but in reality always wielded far larger influence in the decisions of the republic's various councils, except when a rivalry between two *ottimati* resulted in one family driving out the other for a time. Of these *ottimati*, some had zero noble ancestry and were just rich, others had noble ancestry but had renounced noble status and deliberately distanced themselves from their noble past (we're not the noble Tornaquinci family anymore, we're the Tornabuoni family!), and yet other families (subtly different) still had noble status in the eyes of the outside, and could visit France or Rome and be received as nobles, but carefully didn't *do* noble *things* near Florence (owning large areas of land, holding noble titles, styles of dress, marrying other nobles, etc.).

This Florentine system *was* different from the landed aristocratic systems of England or Naples, but when Machiavelli boasts how great it is that *all the people* participate in his republic and care deeply about their liberty, to him *popolo* means 10 percent or fewer of the richest old family elites of Florence, while he and his peers considered it *actively harmful to the state* if the 90 percent majority thought about or tried to be a part of politics. They also happily went to war to help their city conquer neighboring republics. Is Florence's system unique and awesome? Yes. Is it democracy? Every soul alive in 1776 or 1789 would answer: *No!*

Whether scholars today treat Baron's civic humanism as hot stuff or old hash is also, largely, disciplinary. A few years ago, I encouraged two of my PhD students to head down the hall to the

Political Science Lab to take a Machiavelli course with my dear friend and colleague John McCormick,[30] and around midterms they came to my office with the hurt shock of a kid who's just been told there's no Easter Bunny to tell me that everyone in poli sci still thinks the Baron thesis is current and unquestioned. This difference between my lab and John's is 100 percent appropriate, since historians and political science people have wholly different goals. Historians aim to offer cumulatively better descriptions of the past, so accuracy about how the past worked and what exactly happened is vital to us, and when we observe that Baron was wrong about many facts on which he based his conclusions, we move on, and publish books about the impact of Baron and ways to move past Baron, like my adviser's *Renaissance Civic Humanism: Reappraisals and Reflections*, and my friend Brian Maxson's *After Civic Humanism*.[31] Political science has a wholly different goal: to describe the workings of politics and governance. Baron's analysis of how civic participation makes people care more about their governments, and think differently about them, etc., contains a number of *theories* that are useful for describing politics and governance, *regardless* of whether his historical facts are true or false. A man can be wrong about history but still right in speculations about thought and politics, which is why my students are right to be wary of anyone treating civic humanism as the last word in Renaissance studies, but John down the hall is *also* right that Baron helps us understand, among other things, Machiavelli's *Prince*. So, even as the History Lab moves on from civic humanism, ideas connecting the Renaissance with citizens discussing liberty in the streets continue to disseminate, both via other disciplines and via older histories.

We in the History Lab still make all our students practice debating Baron. Why, if even my colleagues sometimes say it feels like beating a dead horse? Because this horse will not be dead—nor will Burckhardt, or any of these X-Factors—until I can spend an afternoon in Florence sitting in front of the *David* and *not* hear Baron and Burckhardt flowing out of the mouths of tour guides, into the ears of a new generation. Cradle of democracy, birth of individualism, a new rational age, first celebration of humanity—these versions of the Renaissance repeat themselves

a thousand times a day in Florence's town square, in the Uffizi, in the Sistine Chapel, in guidebooks, in the voiceovers of documentaries, and on standardized tests that try to squeeze three centuries of dynamism into a multiple-choice question. Every time someone wants to explain the Renaissance in easy, exciting, comfortable ways, these X-Factors are easily at hand, and we in the History Lab need to keep brewing up new antidotes.

8

Another X-Factor: Enter Economists!

Another favorite founding factor is *the birth of modern banking and finance*, what we can paint as *proto-capitalism*. The Renaissance saw huge economic change. Double-entry bookkeeping was invented in Tuscany, as was banking in the modern-ish sense (deposit your bag of gold in Milan, get it out in London *without* carrying it with you on bandit-invested roads!), and this resulted in the vast expansion of venture capital, investment systems, and insurance. (Sorry, Shakespeare, but Venice actually had ship insurance, which let investors avoid *Merchant of Venice*-type bankruptcy risks when boats went down at sea; new plot device required.) The more economic historians studied Florence's enormous archive of financial documents (documents = historian catnip), the more the Renaissance began to feel like the awakening of commerce's potential, a first test drive of modern capitalism.

The Black Death gets invoked here, since the loss of 30 percent of Europe's population in 1348 had huge economic consequences. The Renaissance can be characterized as the period of regeneration after the Black Death, and the Renaissance is generally agreed to have stopped by 1700, which is also when we think Europe's population finally matched pre-1348 levels. Seminal studies in the early twentieth century showed that wages rose after the Black Death, as labor grew scarce, and these findings sparked the exciting theory that the Renaissance was a consequence of the empowerment of labor, creating the day laborer who could, for the first time, pick and choose where to sell his hours instead of being tied in serfdom, and live the life of the liberated modern worker. Few serious economic historians called it proto-capitalism, they

ANOTHER X-FACTOR: ENTER ECONOMISTS!

know the differences, and some characterized this empowering of labor as a pro-socialist rather than a pro-free-market, but many agreed the Renaissance was the birth of key parts of the modern economy. Especially in the Cold War, such findings let capitalism claim the Renaissance, and cast communism as the supposedly bad, supposedly communal Middle Ages.

In popular reception, this proto-capitalist X-Factor and Baron's proto-democratic one amplified both each other and Burckhardt: Renaissance Florence was the birthplace of banking, *and* political science, *and* the liberated Modern Man. Even the art could be claimed: many artistic masterpieces of Florence were commissioned by guilds, merchant investors competing with each other to erect the best church or the most impressive statue. The building called Orsanmichele personified this—a former market in the heart of Florence, transformed into a church because an icon of the Madonna inside it (placed to keep buyers and sellers from

Orsanmichele from the street, with its strange combination of big market arches filled in later with church decoration.

scamming each other since *you wouldn't commit a crime with Mary watching would you?!*) miraculously cured some people during a plague outbreak, so it became the church of the merchant guilds, covered with statues of each guild's patron saint, and the guilds competed to hire the best artists and produce the most innovative works, producing the first life-sized monumental bronzes since antiquity.

Everything connected up: proto-corporate competition had produced the first Renaissance masterpieces, just as modern democracies competed at World's Fairs.

Was the economic reading wrong? Were Vikings eating fish again?

Our answer once again is: yes *and* no.

The Renaissance happened in lots of places where merchant guilds weren't very powerful, or very competitive (often guilds were *anti*-competitive, focused on choking out competition from outsiders and innovators).[32] And guilds also commissioned statues in places like London, far from the Renaissance republics. Recent studies have also complicated the claim that labor became freer after the Black Death, as more fine-grained analysis shows that wages only rose in a few places (notably bits of England which were the first places studied), while in other places (studied later) wages fell, or changed in other ways. We now realize that the aftermath of the Black Death actually birthed a fleet of new efforts to control labor and *prevent* its empowerment, including more restrictions on movement, and the creation of workhouses, different policies in different places, not just a universal empowerment of labor.[33] And in the economic history corner of our Lab—the section Scrooge McDuck-type free-market advocates *think* they'll like to visit until they see what the actual evidence shows—scholars like the indefatigable Richard Goldthwaite have counted every bean, and indexed every florin, and revealed the similarities and differences between Renaissance Florence and modern capitalism.[34] Historians agree that economic changes in the wake of the Black Death were huge, and separately that banking and trade had huge impacts, but both affected all of Europe, not just the Florentine Republic (the point is to deposit in Milan and

ANOTHER X-FACTOR: ENTER ECONOMISTS!

withdraw in London!). In sum, we keep discovering that *no*, that thing we used to think was just in Florence, or first in Florence, or biggest in Florence, was in other places too.

Verrocchio's *Doubting of Saint Thomas* (1467–83) on Orsanmichele. Thomas was the patron saint of Florence's merchant court, because a wise judge demands to see the evidence first hand.

9

Florence: A Self-Fulfilling Source Base

Here I want to remind the reader that I myself am a Florence specialist. I *love* Florence, I study Florence, I've spent years of my life in Florence. So, as a Florence specialist, it's my responsibility to understand how Florence's disproportionate presence in scholarship is a *big problem*.

How could so many historians have failed to think of the obvious fact that Renaissance stuff also happened outside Florence? The answer is that there is one incredibly persuasive source that will never stop telling us Florence is *obviously* the heart of the Renaissance: our own eyes.

In the 1700s and 1800s, visiting Italy on the Grand Tour was mandatory for Europe's elites: you come of age, you travel, buy Italian art to give your stately home *legitimacy*, then you begin your adult career. Florence was a center of this tour, because Florence had won the seventeenth-century self-advertising propaganda game, and had tons of amazing art and architecture which *stayed in Florence and was not for sale!* Upon the death of the last Medici duke Gian Gastone de Medici (1671–1737), his extremely smart sister Anna Maria Luisa de Medici (1667–1743) bequeathed the family's art treasures *to the city of Florence* with strict conditions that the art never, ever leave Florence. Thus, as other Italian cities had their best art bought by aristocratic tourists, or carried off to Vienna, Berlin, Paris, DC, or Madrid, Florence's stayed in Florence. And as Florence realized the value of tourism, it used museum proceeds to buy extra art from neighboring cities too.

Thus, as 1700 flowed on to 1800 and 1900, Florence stayed beautiful and full of art, and above all it stayed Renaissance.

FLORENCE: A SELF-FULFILLING SOURCE BASE

Tourism was already the heart of its economy in 1700, and tourists wanted *Renaissance* Florence, not anything new. As palaces crumbled and needed repairs, foreign money poured in to restore them, while in other Italian cities, Renaissance things (art, architecture) were more likely to be torn down and replaced by baroque things, or nineteenth-century things. As Milan, Rome, Paris, and London continued to add modern layers, Florence remained Renaissance, and every time damage threatened it, money flooded in to keep it looking untouched. Visitors who want the authentic Renaissance don't want Naples's baroque churches, they want the *pure* Renaissance most visible in Florence. Venice is similar to Florence in this, and when you walk around both cities today you feel like a time traveler, while in Milan or Naples—which had industry and trade and kept developing as urban centers—you glimpse a few Renaissance things amid the modern glass and steel.

This process became even more extreme as histories like Burckhardt's and Baron's made everyone so excited about Renaissance republics. Eager young scholars poured into Florence and Venice, not the "tyrannies" of Milan, Naples, or Rome. Scholars sorted the archives, which resulted in more papers being kept, more books being written, and soon every academic library had five shelves of Florence, two shelves of Venice, and one shelf for the whole of the rest of Italy. A glance at that bookcase proves to the young student that Florence is where it's at. And as interest surged, especially in England, Florence got more funds for restoration work, and new statues of Dante, or plaques explaining what great citizen lived here, funded by learned societies eager to celebrate the cradle of all they loved. The vogue for Florentine history filled Florence with more evidence of its own history.

Then came the Second World War. Florence was largely spared.

We're so, so grateful Florence was spared. On Florence's iconic Ponte Vecchio there's a plaque thanking Gerhard Wolf (1896–1971) and giving him honorary Florentine citizenship.[35] Wolf was the German commander in charge of Florence during the war. After a philosophy PhD, he had become a career diplomat working for the German foreign service in Italy, and joined the Nazi party late on, when it was clear this was the only way to maintain influence.

In Florence, he dedicated himself to protecting the city's Jews and other persecuted groups, saving many from the Holocaust, and guarding Florence's art by combating looting and preserving collections. When the Allies advanced through Italy and Wolf received the order to retreat, he also received the order to destroy Florence's bridges, including the iconic Ponte Vecchio, with its Vasari corridor filled with Medici art treasures. Wolf refused to carry out the order, barricading the bridge but leaving the art intact.

The Allies spared Florence too: one can find photos of the daylight bombing of the train station, since Allied command was so determined to protect Florence's historic center that they forbade any bombing of the city at all except a single careful strategic strike on the train station, which they ordered must be done in daylight (an *enormous* extra danger for pilots), to guarantee that the bombs did not miss and hit the art. There was street fighting, the advance of armies through the city, but a city both sides had orders to treat with kid gloves as much as possible.

Thanks to both sides caring so much about Florence, the city kept its art treasures, archives, frescoes, churches and palaces. And thanks to everyone believing that Florence was the heart of the Renaissance, they didn't take the same care with other Renaissance centers. Allied bombers did enormous damage to Milan, Bologna, and Naples, because they were transit hubs, and because they had been monarchies, mismatches for all the popular theories about the Renaissance X-Factor, so the Allies didn't take extra special steps to protect them as they did Florence. And Naples's main archive was *deliberately burned* by the city's Nazi occupiers in retaliation against the local anti-fascist resistance (in case you needed *another* reason to hate Nazis).

Historians study what's here to be studied, and the fact that we study Florence so much makes us take care of Florence, which in turn makes it easy to study Florence, making Florence seem more important in a self-reinforcing cycle. Florence is the propaganda winner, so it got protected more, studied more, and when you walk through the streets you see the Renaissance all around and fall in love—*clearly this is the cradle of the Renaissance!* But we would have glories like that in other cities too if intervening generations had taken the same care to protect them.

FLORENCE: A SELF-FULFILLING SOURCE BASE

The disproportionate protection of Florence keeps happening, to the frustration of other cities. Florence's 1966 flood, for example, inundated the city, damaging frescoes, artworks, and drenching the Renaissance archives which were on the ground floor of the Uffizi; after the flood every art historian on Earth jetted to Florence and unfathomable amounts of money poured in from Germany, the US, the UK, all over, to enable some of the fastest and most epic restoration work in Earth history.[36] When in 1997 a massive earthquake struck Assisi, damaging the Basilica of Saint Francis and its matchless Giotto frescoes, residents hoped for a similar burst of love and cash, but had no such luck, so it took Assisi years and great efforts to raise funds for the restoration.

The History Lab today is working hard to combat the old Florence problem. When we look at recent PhDs, and what academic presses are doing, the twenty-first century has seen a cornucopia of brilliant books about Renaissance Spain, Norway, Poland, Siena, Mantua, Naples, etc. Similarly, grant institutions like the Fulbright Program are preferentially funding understudied parts of Italy and Europe. But when you go to a library there are still more books about Florence than anywhere else except Shakespeare's England, and it will take another scholarly generation to rebalance that. When we look at the books stocked in a popular bookstore, it's clear how much the Florence problem persists outside the academy. Florence is what lay readers want most, buy books about most, the tourist destination where people fall in love with Italy, and feel in their bones that this is the true Renaissance.

As with Florence, so with the Renaissance in general: it was already embraced as a pinnacle of artistic taste by the 1700s, so we preserved more of its art, display and reproduce more of its works, believe it left us *more* glorious art than other eras, but how much of that is real and how much is because the Renaissance pieces were kept more carefully, and if museums have them they're the tourist centerpiece? All those great galleries have storage basements full of art from other centuries, but display less of it, and when art-hunters searched antique shops it was classical and Renaissance pieces they most sought and saved, not later or earlier art. As kids

when learning what art is we're shown Renaissance things, and, by gum, when we grow up and see things in galleries our eyes know what to like. A self-fulfilling source base—when we judge history by what *survives* and *remains on display*, the taste and judgment of the intervening centuries distort our understanding. Did Florence have *more* Renaissance wonders than her sister cities? Did the Renaissance have *more* art than sister centuries? As we visit museums and tourist sites our eyes say *yes*, so it's hard to believe when researchers say *no*.

10

What Makes People Start to Study the Renaissance

These X-Factors shape scholarship. No one today starts studying and writing scholarly history books unless you really, really care, enough to give your life to an exhausting, not very lucrative, high-effort career. Thus, no one starts to study the Renaissance without being drawn to it by a specific reason. And what first drew you to study a field often continues to color your interpretations.

I'm not talking about bias as much as *the palette of questions a scholar thinks to ask.*

There are so many questions you can ask of a source. If you have the unabridged Sherlock Holmes in front of you, you can mine it for details about what Doyle sees as the characteristics of a genius and write a great essay, but someone else might write about social class and how Doyle characterizes upper-class and lower-class crime, and someone else might write about race and nationality in Doyle's depictions of Germans and Italians and Black people. Someone else might analyze Doyle's discussions of colonies and empire, someone else his many depictions of domestic violence, someone else Watson's descriptions of architecture and landscape and how they establish mood. All these analyses—some conducted in the History Lab, others in English Lit, Comp Lit, or other Labs—would be valuable, all shaped by the different questions which excite the particular scholar.

Just so with the Renaissance, but the X-Factor question makes things sticky. Naturally, scholars who come to the Renaissance often choose to continue studying the aspect of the Renaissance they first fell in love with, be that the art, the music, the dramatic

tales, or something else. Scholars who fell in love with Florence often do the same. But when someone starts to study the Renaissance because of excitement over a proposed X-Factor, scholarship can get mixed with *teleology*, that is, the idea of a natural forward momentum to history, away from bad toward good. This can be a problem.

Since the Renaissance is so celebrated as a turn toward the modern, people's ideas of the Renaissance tend to be entangled with their ideas about humanity and modernity, and this entanglement tends to happen *before* people really study the topic. Documentaries, exhibit labels, tour guides, fiction, all sorts of things offer first contact with the Renaissance while repeating some X-Factor, which they claim pushed our world through Leonardo and Shakespeare to Wollstonecraft, Einstein, and NASA. Tales of progress, of a correct path forward, of the Middle Ages as a stagnant setback in humanity's true path—these teleological narratives are deeply moving, but are less about the Renaissance than about modernity and what people see as the defining features of *right now*.

This means that those who devote their lives to studying Renaissance economies are often drawn to it by a belief that banking, finance, capitalism, and the engine of the free market are the X-Factor that pushed us forward from dusty monasteries to towers of glass and steel. Those who devote their lives to Renaissance political thought are often excited by civic participation, the rise of democracy, Machiavelli's new uses of history, these are the X-Factors that launched us from those dusty monasteries to the *Declaration of the Rights of Man*. Those drawn to study Renaissance philosophy are often drawn by *humanism*, especially *secular humanism*, seeking the imagined moment Reason toppled Faith, which got us from dusty monasteries to the age of space stations.

The medievalists are here shouting: *You don't get any of it without the monasteries! They did science! Scholarship! Also, monasteries weren't dusty, they cleaned them regularly!* True. And there's a larger problem: those who come to the Renaissance to seek the birth of modernity tend to have a sense of forward and backward, good and bad, a belief that those who advanced the X-Factor

were good, heroic, right, and those who ignored or opposed it were adversaries, villains, on the wrong side of progress, slowing humanity down. This can introduce a lot of bias, and close minds against questioning whether those X-Factors have real evidence at all. You also get the opposite: people who dislike certain aspects of modernity, and present the Renaissance as the moment when a bad X-Factor broke everything: broke Faith, broke traditional community, unleashed atheism, unleashed decadence, unleashed capitalism, launched us from beautiful monasteries to smoke-spewing factories and obstreperous teenagers. Even Burckhardt himself had complaints about modernity, and while painting the golden vista of his Renaissance, included details of imperfection (decadence, complacency, corruption) presented as the fifteenth-century origins of what's wrong with Kids These Days.

The fact that many are drawn to the Renaissance by a particular X-Factor births many of the most confusing disagreements in Renaissance history writing, in which two books published by the same press in the same year might have totally contradictory depictions of the same event or person—not contradictory in fact, but in interpretation, presenting the same event as triumph or tragedy, or the same person as hero or villain. For example…

II

Lorenzo de Medici: Hero or Villain?

Lorenzo di Piero de Medici (1449–92), often called Lorenzo the Magnificent (*il Magnifico*), was the unofficial but universally recognized leader of the Florentine Republic from 1469 to his death. His father Piero had led the city before him, and his grandfather Cosimo before that. "Leader" is complicated, so let's buckle in for the ride.

After the Roman Empire fell (our rollercoaster must winch up slowly), innumerable little Italian city-states became self-governing. Many modeled themselves on Rome with senate-like city councils, using SPQF for Florence, SPQB for Bergamo, and so on. This worked somewhat, but city-states are very vulnerable to feuds and civil war, and coups and conquest. Because of their small populations, it wasn't very hard for a mercenary captain, or a powerful family that got tired of compromising with neighbors, to hire forces capable of seizing a city, ousting the local senate-like-thing, and bribing the pope or the (Holy Roman) Emperor to crown the conqueror Count or Duke of [X Place]. One by one, Italy's numerous city republics watched their neighbors turn into monarchies, and those which remained republics tried more and more desperate anti-tyranny measures to prevent such outcomes.

In these republics, the richest families—both nobles and those not-quite-nobles Machiavelli or Varchi would call *ottimati* or *grandi*—competed to gain power within the systems, secure seats on city councils and all the rest. Power wasn't just about ambition: it was also about safety. With power you could secure protections for your businesses, prevent rivals from weaponizing the tax system against you, and secure moderate sentences in the judicial

system. With power you could ensure that, if factions started to rise, your family wouldn't be purged.

In my Renaissance class, for extra credit, students can borrow one of my collection of Renaissance-themed board games, many mediocre, some loving yet disastrously overcomplicated, a few playable, but there is one that teaches this phase of Italy's history better than anything: *Siena*.[37] It's 1338, and you begin as a farmer with aspirations to become a merchant. You sell your crops, either locally or by sending wagons out of the city where, the farther you go, the higher the price you get, but the greater the odds of bandits murdering your wagoner and taking everything. As you gain wealth, you can invest in more lucrative trades: cloth and spices, whose profits are an order of magnitude higher. If successful, you soon earn so much in the cloth trade that you spend in every turn what you toiled rounds to earn as a farmer, and you become part of what Machiavelli and Varchi would call the *popolo*. As your money pile grows, you enter the final stage: Spend! Spend! Spend every penny you have on public works projects, art, bridges, building the cathedral, spend it all!!!!!! Why? To win public acclaim and secure a seat on the city's ruling council. That's right: the win condition of Siena is *not* to end rich, it's to end broke, turning all that money into *power*, since with *power* comes long-term security, influence, safety from taxation, from banishment; with power comes swarms of merchants and peasants who flock to you for protection and aid and pay well in return, in sum: stability. Because in a world without a list of rights, or social safety nets, money does nothing for you if you end up on the wrong side of power.

And in real history, beyond the board game, if you're on the ruling council, and beloved, and suppress your rivals, and hire private troops, and make friends with neighbors who have troops too, it's not hard to become de facto dictator of what remains a republic on paper, like the Bentivoglio family the "First Citizens" of Bologna; the line between republic and monarchy can blur.

Understanding all this, Florence, determined to preserve its republic, developed a system of government so bizarre you can't use it in fiction because it's not plausible. Most of the time when people attempted coups, they were people with noble blood since they had more wealth and *legitimacy*, so:

- **Step 1:** Execute or exile everybody in the city with a drop of noble blood. Also the political faction that just lost. And their friends. Bar everyone connected with them from holding public office. Burn their houses down, rake salt into the earth, celebrate. (This was a process, but events culminated in 1293 when Florence formally barred magnates (i.e. landed nobility) from political participation, and ended up with its system of laboring plebs, bourgeois *popolo*, and big wig *ottimati*.)

- **Step 2:** Immediately split into more factions, slaughter each other, banish Dante, banish Petrarch's parents, blood, blood, blood…

- **Step 3:** Okay, seriously, we need a plan. We started building this nice new palace (now the Old Palace, i.e. Palazzo Vecchio) on the square where we raked salt into the earth over the ashes of our enemies. We'll create a ruling council selected from the *popolo* and put them in the palace, but instead of being elected they'll be drawn at random out of a bag! After all, voters can be bribed! And influenced by people playing the *Siena* board game bankrupting themselves on public works projects! But drawing from a bag leaves it all up to God! Also, to make sure no one person has too much power, nine guys will share office and have to agree on everything. To make sure no single person has power long enough to sink their fangs into the state, the term of office will be two months. And to make sure no one can bribe them, or kidnap them, or exert pressure, we'll *lock them in the tower the whole two months* so they can't come out!

So began, in 1328, Florence's selection by "scrutiny and lot" in which the names of all merchant guild members (that means shop owners, not laborers, the man who owns the looms, not the men who work them) were put in bags and nine were drawn by lottery to serve as the *signoria*, locked in the Palazzo Vecchio for two months, living in princely comfort and governing through compromise with the eight other co-rulers of the city. No one could stay in office long enough to take over, no one ever had sole

power, the wealthy couldn't campaign for the council or get their factions entrenched in power: it was tyrant-proof.

Problem was, it was also, in some ways, action-proof.

Imagine for a moment that you're the Duke of Milan. You want to make a treaty with Florence for mutual defense in case France or Venice attack. You write to the *signoria* to propose a treaty. They write back, interested, asking terms. You send a detailed proposal. They write back with a revised proposal. You write back with some additional changes. They write back: "Hi, those guys are out of office now. We don't like those terms anymore; we want these other things which are the exact opposite of what our predecessors asked for. Also Giovanni's cousin Marco is from Venice and he's very nice so we may want to ally with Venice instead of you. Also we suddenly like France now, Pietro's cousin's wife Bona is French. Enclosed please find a totally different draft treaty that contradicts the previous draft you were considering. Have a nice day, signed, Nine Dudes in a Tower." Argh!

Now, the men whose names were drawn in Florence's lottery system were not neutral citizens, but elite business owners, just as aware of and enmeshed in politics as modern business magnates who lobby politicians and shape the policies of nations. These men had international trade empires, contacts and employees throughout Europe, the kinds of political knowledge big business brings, and strong individual opinions on Milan, Venice, France, and all such neighbors. They all understood the importance of a treaty with Milan, but had different interests in it, so getting a compromise out of our ever-changing Nine Dudes in a Tower was difficult. This could be, for neighbors, deeply frustrating. So if you're the Duke of Milan you don't want to just write to the *signoria* in the tower. You write to the head of one of Florence's big families, the *ottimati*, those stable power structures that will be *predictable* month after month, not volatile and ever-changing, as representative government always is. So, you write to Cosimo de Medici.

Cosimo de Medici (1389–1464) is playing the board game *Siena*. He's using the high-stakes Florence expansion board, but it's the same game, only this time we're bankers not just merchants, so money comes in an order of magnitude faster, and Cosimo manages

the super special rare play: banker to the pope. Now every time a coin clinks in a box in any church in Christendom, he gets a cut. As his grandson Lorenzo will put it, "Living in Florence is very dangerous for the rich unless you control the state."[38] Florentine families all fear their neighbors, and a ruling council filled with business competitors all terrified of coups is quick to crush and banish any family—especially *ottimati*—if a whisper says, "They're growing *ambitious*." So Cosimo invests. He decorates churches. He builds monasteries. He funds hospitals, foundling homes, and youth confraternities (think religious youth camps, or Sunday school programs). He fixes bridges, cleans streets, funds the city fire brigade. When the city decides they want to rebuild the very old church of San Lorenzo, Cosimo volunteers to pay for the sacristy; when the sacristy is done but the city hasn't found funds for the rest, he offers to pay for the whole thing. *Hooray, Cosimo! Thank you, Cosimo! Long live Cosimo!* More and more people like him, owe him, come to him when they need help, a loan, a job, a lawyer. Widows and orphans turn to him. Soon a quarter of Florence has Cosimo as a personal benefactor, and a good slice of those are directly on his payroll. Now, whenever the nine names for the new *signoria* are drawn at random, statistically three of the nine work for Cosimo; amid a sea of unique interests, he commands an organized plurality, so if he tells his people what he wants, he can effectively control the city. So, when the Duke of Milan wants something from Florence, he writes to Cosimo de Medici *who will still actually be there in six months!* And Cosimo takes care of it. This—outside powers working through him—is something Cosimo himself works very intentionally to cultivate, writing letters and offering help to nearby rulers and likely conquerors, a tactic which vastly increases his power, since the man in town who's friends with the rulers of your neighbors is a powerful man, and those neighbours want to keep him and his family in power.

Zooming out a moment, this process of corruption should not make you conclude that the Nine Dudes in the Tower system never worked, or that sortition (governance by lottery) is a dysfunctional idea. Florence's rule by lot thrived for a full 150 years before Cosimo began to seriously game the system—a lot longer than most modern electoral democracies have lasted before their first big run-ins with

corrupt capture. Any set of rules can be gamed with time and cunning, and in time inventions like jerrymandering and voter suppression are as inevitable as computer viruses and software hacks. When our friend Machiavelli observed that all institutions become gradually corrupted, requiring reform, he could as easily have been writing of 1990 as of 1490. When we examine the past, and look at institutions after their failure, the fact that we know they eventually failed makes it easy to forget how long and impressively they stood firm against slings and arrows which many other institutions succumbed to in much less time. That fact that we know the Roman Empire fell leads to the misleading question, *What was the fundamental flaw that made Rome fall?* instead of the more important question, *How the heck did it last so impressively long?!* Just so, when you hear that this fantastically bizarre Florentine system functioned 150 years basically as intended, and an additional century in various stages of mostly functional corruption and reform, remember that the US hasn't beaten that record yet, and neither have most states extant today, while Venice's comparably complex republic lasted 1,100 years (from 697 CE until Napoleon), a record practically no polity can beat. Sortition worked,* republics worked, but, as with all systems, the rich and powerful labored to make these methods work *for them.*

Zooming back in, Cosimo's grip on power grew gradually, starting in the 1430s and solidifying fully in the 1450s, after which even the other *ottimati* had little power compared to this sole *primus inter pares*. His rise to power was not without risk, complexity, negotiation, give-and-take with fellow *ottimati*, and, inevitably, resistance. In 1433, a new *signoria* was selected most of whom were people who hated or feared Cosimo, so they declared him a traitor-tyrant, and imprisoned him in the special prison cell high in the tower of the Palazzo Vecchio where Florence held its most dangerous political prisoners before hanging them off the

* Modern democratic reformers have advocated experiments in sortition, but notably all historical examples of government by sortition have had religious components, ancient Athens and Renaissance Florence alike basing their confidence in lotteries on the expectation that Providence guided the selections, so Fate or God would always choose the right people. Whether a more secular society can muster public support for sortition is an undertested concept.

battlements, so people could watch crows feast on their flesh. He bribed his way out. Cosimo paid 300 gold florins (three times the average man's annual income) to the cell guard and 700 to the guard captain, and wrote later that they were the two most foolish men he'd ever met, because he was Cosimo de Medici and would have paid them *tens of thousands of florins* to get out of there!!!

Cosimo then fled to Venice, which is where you flee when you have to flee in the Renaissance. Why Venice? It was where most Mediterranean voyages had their layovers, like a sail-era airport hub, full of mixing peoples, cargoes, and opportunities. Additionally, when the Roman Empire split back in the days of Constantine, Venice—unlike most of Italy—was part of the eastern empire, looking to Constantinople, not to Rome. A thousand years later, Venice was still aloof from Rome, looking to the Patriarch of Constantinople for religious authority—or more accurately it could strategically pick and choose which Church to look to at its convenience, like a kid who asks Mom when Dad says no. Since no higher power could order Venice to extradite heretics or exiles, it was the destination of choice for those with foes to fear.

Cosimo did not spend long in Venice. A cunning combination of lending wads of cash to the Venetians, waiting for his main rivals (the Strozzi and Albizzi) to quarrel, and bribing the impoverished Pope Eugene IV to intervene as a supposedly neutral arbiter who, of course, sided for the man who offered him $$$, Cosimo arranged his recall from exile. From then on, when the lotteries took place, the Nine Dudes in the Tower contained even more Cosimo supporters (what are the odds?!) while those who'd opposed him were accused of crimes and banished, or hit with giant tax bills which pushed them too deep into debt to be eligible to hold office. (Did Cosimo rig the lottery? Pro-Medici accounts often say no, while anti-Medici accounts say yes.*) Cosimo entrenched his power in

* To get one's name into a bag, one had to both be a guild member and pass a scrutiny system, and even after that the *Accoppiatori* whose job it was to put the final names in the bag were authorized to use their judgment in excluding a fixed number and adding in others who hadn't passed the standard scrutiny, so they could strongly influence who was in and thus likely to be picked; Cosimo and others, by influencing the scrutiny system and the *Accoppiatori*, could thus substantially influence, but not fully control, selection; see Butters, 16–17.

many ways, including strategic deployment of a Medici militia in the city's seats of government, and the old tactic of granting himself and his allies *temporary* emergency powers to deal with the supposed crisis—powers the family would see continually renewed for generations.* Cosimo was firmly in control. The city prospered (because of him? despite him? both?), the churches got grander, public works more ambitious. Florence advanced its conquests and ambitions, and families close to the Medici prospered, while those who weren't close to the Medici were squeezed out, and that vibrant political competition of the merchant guilds changed into a new and different Medici-dominated vibrancy. This mixture (prosperity *and* oppression) is why we have so much trouble answering the question: the Medici, tyrants or not?

So, as the 1430s flow on toward the 1450s, Cosimo is back in Florence, once more king of the mountain, but he has to work hard to stay there. One of the biggest things keeping him there is his relationship with Florence's powerful neighbors. They want him safe and strong so he can advance their interests in Florence, and their friendship makes him the one Florentines turn to if they need favors in Bologna or Milan, etc. But one problem Cosimo faces advancing his fortunes beyond the city walls is that he's merchant scum. He actually is merchant scum, the Medici family were one of the *ottimati* that had zero noble roots. But even if that weren't true, everyone involved in running Florence must perform the role of being merchant scum, as the city killed or barred from office all their landed nobility, making those few who remained play the *We aren't really nobles!* game like Cosimo's allies (and in-laws) the Tornabuoni family. Ever since banning nobles, all Florentines have been extremely wary of any princely behavior, reading it as suspiciously ambitious, so Cosimo must be *very careful* to always dress and act like a simple merchant, riding a donkey not a horse, greeting people humbly in the street, decorating his home *without* things people associate with traditional nobility, etc. This is essential to prevent suspicion and attacks from *within* Florence, but at the same time

* Machiavelli noted how the Medici renewed these powers every five years or so, *Discourses* III.1; he gives more detail in the *Florentine Histories*.

it's super inconvenient *beyond* Florence, because in this world you have to be a nobleman (by birth or elevated via a knighthood or title) to be taken seriously on the world political stage, or to command troops or do diplomacy. Florence (and many of its neighbors) hired noblemen from other cities one at a time to come be its chief of police (*podestà*) and arrest people and enforce the law, partly because a foreigner was more trusted to enforce law neutrally since he wasn't connected to any local family or faction, but also because no one would take an arrest warrant seriously if it wasn't signed by a nobleman. I mean, come on?! How can you take "*I arrest you in the name of Caesar!*" seriously if the man who shouts it doesn't have the blood of Charlemagne, and a fancy hat crowning his coat of arms? For this reason, for a long time, Florence didn't even have proper ambassadors—they have to be noble too—so if you're the King of England and you want to do business with this irritating republic (Big Wool = important for England!) you have to literally send a guy down to the docks to see if there are any banished Florentines hanging around working in bank branches, and ask if they can forward a letter to their ridiculous Nine Dudes in a Tower.

To mitigate this slightly, Florentine *popolani* (members of that elite bourgeois *popolo* who were in the merchant guilds) could receive *non-hereditary knighthoods*, and sometimes did so when they distinguished themselves in the armies of neighboring nobles or the city's service, but justifying this required a complicated intellectual project, Florentine thinkers of the first generation after Petrarch reimagining a knight to be, not a courtly champion or a step to higher ranks, but the military defender of a republic, Plato's guardians, Cicero's merit-elevated *eques*, the protectors Aristotle said were necessary to defend the *polis*, the only place where *man the political animal* could be fulfilled.[39] Donatello's 1417 statue of Saint George (the knightliest saint), created for Florence's armorer's guild, looks shockingly more like Caesar than like Lancelot or Charlemagne, challenging visiting nobles with the idea that the right to bear arms and the power to mete out justice might derive from a city and the valor to defend it, not from ancestry or chivalry.

Donatello's revolutionary *Saint George* dressed in classical armor, made for the armorer's guild niche on Orsanmichele, 1417.

This justification made the city tolerant of local knights, but if you dress a bit too much like Lancelot then within a day the whole city will be buzzing with suspicion, and such a wasp's nest cannot be un-kicked. As for the *podestà* the city hired each year to arrest people and enforce justice, he could be and act a nobleman during his stay, but at year's end he was escorted to the gates, paid and thanked lavishly for his service, *then banished forever from Florence on pain of death*, such was the city's fear of noblemen's ambition.

So, Cosimo and other Florentine *ottimati* families like the Strozzi and Pazzi are richer than the (Holy Roman) Emperor, and Cosimo is effectively ruling his country, but they remain legally merchant scum, and must carefully dress like merchant

scum and act like merchant scum or the wasp's nest that is their home city will unleash its hundred thousand wrathful stings. Florence and its powerful families worked hard to finesse this, playing complicated games with *guilds* having honor, and guilds having crests, and families having guild crests, a roundabout way of families gaining crests (an important step in being taken seriously), and they wore very modest *cuts* of garment but in very costly fabrics, or used classical grandeur which did not code magnate-type nobility. Documents from places like Milan and Mantua sometimes call Florence's top families *nobili* (nobles) or *zentilhomini* (gentlemen), showing that the outsider view did see them blurring into the generally noble-like political classes.[40] But still, a Florentine could not use the traditional routes to increased nobility, like marrying a neighboring noble, or working for a king in return for a title, or bribing the Emperor to give you a title, because, if you do that, your distrustful Florentine neighbors will declare you *ambitious!!!* and the mobs and banishments will flow.

A great way to trace this sequence is the letters Cosimo exchanged with Francesco Sforza (1401–66). At the beginning of their careers, Sforza is just a mercenary captain, one of seven sons of his mercenary father, so Cosimo is a decade older, higher in power, and close in status to Francesco, so addresses him politely but a bit paternally. But mercenaries conquer, and Francesco Sforza soon becomes a marquis, and receives more honors and titles as he fights for the Visconti Duke of Milan, even marrying the duke's sole heir, his brilliant illegitimate daughter Bianca Maria Visconti (1425–68). At that point, Cosimo is still more powerful (a city's ruler instead of a ruler's general and son-in-law), but now Cosimo begins to sign letters to his long-time friend as *Your Excellency's humble and unworthy servant*, etc. Then in 1450 the Visconti duke dies, and in the rush of rival claimants and a fleeting Milanese republic, Francesco and Bianca Maria, the Visconti-Sforza power couple, eradicate the rival claimants, seize the city, and make themselves masters of Milan. Now Cosimo and Francesco are finally equal in real power (both rulers of major cities), but Cosimo's letters have to spend virtually half their word count on apologies for being unworthy to address *Your Most Noble Grace*, etc., etc., while Francesco Sforza (who used to be nobody!) replies to Cosimo with the formulaic royal

condescension appropriate when a noble duke addresses merchant scum.

So Cosimo spends 32 million dollars on the education of his grandsons.

I can't quantify it quite so precisely, but he spends orders of magnitude more than that guard in the tower could aspire to see in his lifetime, investing it in tutors and in books. This is a period when a single manuscript book cost as much as a house, which is to say that a cheap paper manuscript cost as much as a cheap studio apartment, while a big, illuminated parchment tome could cost as much as a small mansion, and copying out a whole manuscript yourself cost as much in time and materials as building yourself a house on a vacant lot. Cosimo's father Giovanni di Bicci had owned only three books, all devotional, while Cosimo at age thirty owned seventy, including many classical works (Cicero, Martial, Tacitus) as well as Dante and Boccaccio.[41] He later picked up many more cheaply by agreeing to pay the debts of book collector Niccolò Niccoli at his death for the low, low price of 800 florins (roughly $800,000, more on the florin-to-dollar ratio later).

These books, and the nest of scholars Cosimo supports in Florence, are a genuinely large expense compared to what he spends building whole monasteries and having a third of the city on his payroll. But it means his grandsons Lorenzo and Giuliano de Medici grow up with the most princely possible education: they sing, compose music, choreograph dances, write poetry in multiple languages, read Latin and ancient Greek, joust (Lorenzo passably but Giuliano skillfully, at least according to Lorenzo), and are so impossibly good at absolutely everything that everyone who meets them describes being stunned by their wit and brilliance, so you forget they're merchant scum within five minutes when you're actually in a room with these youths who are more princely than princes. This is a great political advantage when dealing with non-Florentines. As Cosimo's son Piero and then his grandsons Lorenzo and Giuliano inherit his impossibly precarious power game, they continue to rule the city while holding no official office, but hoard and use those emergency powers and private militias, and continue to buy goodwill by spending lavishly on scholarship and art, building churches and taking in orphans,

a carefully calculated deployment of charity. A great example is the Youth Confraternity of Saints Cosmas and Damian, a charity youth group founded by Cosimo and funded by the family, which supported and educated generations of Florentine youths, guaranteeing that, even when the family's power was being challenged, there would always be hundreds of strapping Florentines who had grown up praying daily for the soul of their great benefactor Cosimo de Medici, ready to hoist the Medici banner and shout the Medici war cry—cash well spent.[42] Was there also a sincere and pious side to all this charitable spending?—we'll get to that thorny question in a couple chapters.

In Cosimo's grandsons' days of power, they spent and spent like this, until under Lorenzo the Medici bank actually had a bank failure as our *Siena* board game reaches its finale. Lorenzo spent lavishly on political influence, on legitimacy, and on turning banking capital into land, a kind of wealth which didn't yield as much annual profit (bad investment from a purely capitalist point of view) but which granted status and legitimacy, since land was what nobles/magnates* had, and was expected of political classes beyond Florence's peculiar republic. Through this process of turning money into power, Lorenzo managed to avoid several wars with great finesse, and made his second son a cardinal.

Is Lorenzo de Medici a tyrant? Let's ask our X-Factors.

For Burckhardt, Lorenzo is a hero, a philosopher prince who cunningly but brilliantly nurtures Florence's greatest artists and scholars and personifies its spirit. Burckhardt writes:

> In the hymns of Lorenzo, which we are tempted to regard as the highest product of the spirit of this school, an unreserved Theism is set forth—a Theism which strives to treat the world as a great

* Magnates, from *magnus* = great, were a loose category of noble families (roughly equivalent to Roman *equites*) characterized by owning hereditary lands and wielding military power, and who often had high clergy such as bishops in the family. For Machiavelli, a magnate was the kind of nobility which defined the politics of regions like France, the Empire, and northern Italy *excluding* Florence. What magnates did, Florence's *popolo*, and especially its *ottimati* like the Medici, must *not* do *within Florence*, but land ownership and military action were the main ways of being taken seriously beyond the city, a tricky balance.

moral and physical Cosmos. While the men of the Middle Ages look on the world as a vale of tears, which Pope and Emperor are set to guard against the coming of Antichrist; while the fatalists of the Renaissance oscillate between seasons of overflowing energy and seasons of superstition or of stupid resignation, here, in this circle of chosen spirits [i.e. the scholars, poets, and artists around Lorenzo], the doctrine is upheld that the visible world was created by God in love, that it is the copy of a pattern pre-existing in Him, and that He will ever remain its eternal mover and restorer. The soul of man can by recognizing God draw Him into its narrow boundaries, but also by love to Him itself expand into the Infinite—and this is blessedness on earth.[43]

That's not just any chunk of Burckhardt, that's the actual last paragraph of his field-making book, the finale of this *magnum opus* which thrilled a generation with its portrait of the true light of modernity.

But only a few years earlier, in 1859, Pasquale Villari's *Girolamo Savonarola and His Times*, which also made a big splash convincing people that the Renaissance was the birth of national spirit, had described Lorenzo as a disgusting, scene-chewing, villain-level tyrant, and the radical Dominican preacher Girolamo Savonarola (1452–98) as the Renaissance's true hero, for his courageous opposition to Medici despotism. Villari was from still Spanish-controlled Naples, had been banished for his activities in the failed revolution of 1848, and went on to be a key figure in the unification of Italy. In exile in Florence, he examined the archives, and what spoke to *him* from the musty pages were the Renaissance republic, *libertas*, and Savonarola's struggle with the Medici overlords which seemed to Villari to prefigure Italy's struggle for unification and self-rule. As for what Burckhardt called Lorenzo's "circle of chosen spirits," those long philosophic evenings debating Plato with poets are described here in Villari's version, focusing on Angelo Poliziano (1454–94), celebrated poet, scholar, and friend of Pico and Lorenzo, a beautiful man about whom romantic tales (heterosexual and homosexual) abound:

[Lorenzo] made [Poliziano] his private secretary, librarian, the

tutor of his children, and a constant resident in his palace. But in that new and luxurious life, the sacred flame of poetry appears to have been extinguished; his erudition alone increased, and in the course of time it became something quite extraordinary. Lorenzo derived no small advantage from the services and conversation of a man of such vast learning; but the fame of [Poliziano] has suffered much from that intimacy; for to that connection, in all probability, we may trace the strong charges brought against him by posterity—of vices so enormous, that history cannot record them without shame. The other intimate friend of Lorenzo was Luigi Pulci... a whimsical and gay spirit, if ever there was one; a sceptic abounding in irony; devoted to pleasure and the intoxication of the senses; devoting himself body and soul to Lorenzo; his constant companion in his nocturnal gaieties—in all his indulgences, lawful and unlawful.[44]

This split between hero Lorenzo and villain Lorenzo isn't confined to the nineteenth century (though the homophobic edge has at least diminished). Among books you'll often find in public libraries and museum gift shops today, Lorenzo is a villain in Tim Parks's *Medici Money* (2005), Lauro Martines's *Fire in the City* (2007) and *April Blood* (2004), and Paul Strathern's *Death in Florence* (2011), but a hero in Christopher Hibbert's *The House of Medici: Its Rise and Fall* (1999), Miles Unger's *Magnifico* (2008), and Guido Ruggiero's *The Renaissance in Italy* (2014), while in John Najemy's *A History of Florence 1200–1575* (2006) and Mary Hollingsworth's *The Family Medici* he's neutral.[45] Now, these books vary a lot in their approach to history and how neutral vs. how judgmental its tone should be, since some are from scholarly presses (Martines, Ruggiero, Najemy) and others from popular presses (Parks, Strathern, Unger, Hibbert, Hollingsworth) with different expectations of what history writing aims to be, but all of them have extremely similar covers and are shelved together in one part of the Uffizi bookstore, where a tourist waffling between *Medici Money* and *House of Medici* is unknowingly about to enter one of two parallel universes, meeting two Lorenzos, and two Renaissances. Some years ago in the History Lab (at an institute in Florence whose Jewish founder, Bernard Berenson, was saved by Gerhard Wolf during the Second World War) we held a

conference on the question *Are the Medici tyrants or not?* The papers, now published, came down *exactly fifty-fifty*, yes and no.[46]

The problem here is the X-Factors. Lorenzo is an ally of some X-Factors and an adversary of others. Depending on what you think the spirit of the Renaissance (and modernity) is, what questions you came to the Renaissance to ask, the same facts can seem totally different. If the key to the Renaissance is republican civic participation and proto-democracy, then Lorenzo and the Medici stifle that, distorting and constraining the republic, even banishing our boy Machiavelli, and replacing the art of vying merchant guilds with the self-aggrandizing art of a single family. If the key to the Renaissance is Reason breaking through the veil of ignorance (our problem-term *humanism*), Lorenzo is the philosopher prince who nurtured and epitomized that light. If the X-Factor is economics, and you're here for birth of modern finance, Cosimo and his dad are superstars, but you may balk at that point in the *Siena* board game where it's time to bankrupt yourself turning money into power—that's not the engine of wealth creation, that's failure. The Medici bank failed under Lorenzo, so in *Medici Money* he's the spendthrift who foolishly threw away *the important part*, the cash!, and if not for his foolish disregard for the matchless importance of finance the Medici might *still* be a bank today, like the Fugger family of Augsburg, instead of throwing the important part away for unimportant things like restoring Plato to the world, revolutionizing art and political thought, and landing their bloodline on every throne in Europe.[47] If you're here for some other X-Factor, like the awakening of Modern Man, or the first step toward breaking down aristocratic dominance and approaching the Enlightenment, Lorenzo merchant-scum-more-princely-than-princes can be your triumphant finale.

As with our Norse Greenlanders, old errors that *feel right* haunt our ideas of Lorenzo. Lorenzo's Vikings-eating-fish moment is the accusation that he embezzled from Florence's dowry fund. This was a fund run by the city, which let you deposit money when you had a baby girl, and if she survived to marry you received a much larger sum to be her dowry—the extra money came partly from investment, partly from the large portion of girls who died too young. Lorenzo, in his lifetime, was accused by enemies of embezzling from

the dowry fund, and his lavish spending on art and culture was cited as proof. Embezzling from young girls is terrible, and the Medici-as-tyrants camp latched onto this detail, using it to construct the character of Lorenzo the parasite who drained the city dry for his extravagance. But the thing about Florentines is that they kept *all* their receipts, and by 2009 historians including Alison Brown and Richard Goldthwaite had tallied every florin and determined that, nope, every penny that went into the dowry fund came out again, while every expenditure Lorenzo made tallies with his legitimate sources of income.[48] It took 500 years, but the verdict is *not guilty*. Yet X-Factors are still shaping the reception of this fact, because Goldthwaite is an economic historian, who doesn't particularly care whether Lorenzo is guilty or not, he's much more excited by wage ratios and bookkeeping methods, so his exoneration of Lorenzo is buried in small print 300 pages into a tome big enough to bludgeon *Clue* characters with. Since even Lorenzo specialists rarely stray deep into the economics wing of the History Lab, many new books continue to repeat the now disproven embezzlement charge.

Another common criticism of Lorenzo is the lawsuit. Lorenzo adopted two younger cousins, with the confusingly similar names Lorenzo and Giovanni di Pierfrancesco de Medici (grandsons of Cosimo's younger brother). When they came of age they sued Lorenzo over their inheritance, of which he was trustee. This was long described as proof of Lorenzo's greed (stealing from orphans he adopted!), but historians later realized it was standard practice for there to be a lawsuit for settling inheritance in the period, that's how inheritance for Florence's rich *popolani* families was normally resolved.[49] Lorenzo did, in fact, give them some inheritance, and said he spent the rest on their immensely expensive educations, as his father and grandfather had spent on his. In an era when a book cost as much as a house, we'd need another Goldthwaite to confirm or refute Lorenzo's claim that every florin of the boys' inheritance went where it should have. The two young Medici did become estranged from the main family, which many say was caused by Lorenzo's theft, and that is 100 percent plausible, but it's equally plausible that the young Medici cousins were personally alienated by Lorenzo's son and heir Piero, ten years their junior and raised with them, a complex figure whom many

accounts describe as domineering and entitled, very aware of his status as future almost-lord of the city, and likely to rub his elder cousins the wrong way.⁵⁰ Both versions get told in different books, whichever supports the Lorenzo that supports the X-Factor.

A detail which doesn't feel particularly tyrannical to modern sensibilities, but was seen as a major warning sign when it happened, was Lorenzo's marriage in 1469 to Clarice Orsini (1453–88), a Roman (not Florentine!) woman from a noble magnate (not merchant!) family. The Orsini were a very strategic choice: the most prominent Guelph family, long-time allies of Guelph Florence, and while many sons and cousins of the family were Baron of This or Count of That, the main family was a *republican* noble family, part of Rome's republican city government, with pedigrees tracing their ancestry to ancient senatorial families, supported by ancient documents supplied by Petrarch among others (SPQR). The marriage gave the Medici patronage network huge reach in the Papal City Where It Happens, which meant that Lorenzo's sons would have an uncle who was an actual voting cardinal, and Florence could now hire Orsini captains to lead its troops with much less fear of the constant problem of mercenaries switching sides if the enemy bid higher—blood was thicker than short-term cash.⁵¹ But Florentine *ottimati* were supposed to *avoid* being like magnates, not seek out marriages that give them brothers-in-law with troops and noble titles. So, while there were benefits for the whole city as well as for the Medici network, Florence's reaction is well summarized by Machiavelli's comment about the marriage, that, when you don't want your neighbors as kinsmen, it means you want them as slaves, and will lose them as friends, since they must fear that you are trying to make yourself a prince.⁵²

A moment which even Lorenzo agrees was a stain on his record was the sack of Volterra in 1472, also described in detail by Machiavelli. Volterra was an ancient and proud but small Tuscan town, self-governing but a protectorate of Florence, paying it annual tribute. A dispute arose over an alum deposit, a rare and extremely valuable chemical compound used to make dyes colorfast. At the time, a Medici near-monopoly on the alum trade was a major moneymaker for the family. This newly discovered alum source was claimed by a consortium of Florentines, Volterrans,

and Sienese, but the people of Volterra accused the consortium of obtaining the rights through fraud, and seized the mine by force. Lorenzo was asked to arbitrate, and found in favor of the consortium, but when they (with goons) attempted to reclaim the mine, violence escalated to riot, which struck the nerve of Volterra's resentment toward Florentine domination, resulting in the lynching of several Florentines and allies.

Florence had to respond, and all accounts agree it was Lorenzo who advocated a show of force, sending an army to frighten the city into resubmission, a method which had recently worked with the town of Prato. Lorenzo hired Federico da Montefeltro, a mercenary captain similar to Francesco Sforza who rose to the throne of Urbino as Sforza rose in Milan, and who was sufficiently badass that it's said, when he lost an eye in battle, he (in an era without anesthetic) had his surgeons remove the bridge of his nose so he could see across it better with his other eye (you may have seen his famous portrait in the Uffizi, and wondered about his weird-shaped nose).

Federico da Montefeltro was also Lorenzo's godfather—part of the family's efforts to make friends with neighboring powers with military strength—and at the time Lorenzo was using his scholarly connections to help the duke assemble Urbino's soon-to-be-famous library.[53] Federico besieged Volterra, which held out for a month, then surrendered, then… someone lost control of something, and soldiers sacked the town—*both* Federico's soldiers *and* the mercenaries Volterra had hired to defend the town (a not uncommon outcome of mercenary warfare, much discussed by Machiavelli).

Accounts of the sack of Volterra produced in the History Lab that you might meet in a library or bookstore vary enormously in how they present the incident, and Lorenzo's culpability:

Mary Hollingsworth, 2018: "Like the prince he desired to be, Lorenzo failed to make the distinction between his own private interests and that of the state."[54]

Lawrence Rothfield, 2021: "… he badly flubbed his first foreign policy test."[55]

John Najemy, 1993: "The Volterra massacre and the Pazzi Conspiracy had their origin in these dysfunctional aspects of the way the Medici used patronage as a means of holding power."[56]

Marcello Simonetta, 2008: "Lorenzo ordered lavish celebrations

Portrait of Federico da Montefeltro with his son Guidobaldo by
Pedro Berruguete and Justus van Gent, 1475. A portrait
suggesting you sit around in full plate armor reading costly
books mixes martial and Petrarchan legitimacy.

in Florence to honor Federico's deed... the manner in which [Lorenzo] dealt with the current crisis seems at the very least clumsy, and at the worst criminal. Late in his life Lorenzo confessed that the war with Volterra was his greatest blunder, a judgment that posterity has largely confirmed."[57]

Christopher Hibbert, 1973: "On learning what had happened Lorenzo immediately rode over to Volterra. He did what he could to reassure the people that his fellow citizens in Florence profoundly regretted the outrages, and he distributed money to those who had suffered loss. His regret was obviously sincere; but it was impossible to overlook the fact that it was he who had advocated the use of force."[58]

Janet Ross, 1910: "A philosopher, a diplomatist, a pagan much inclined to the worship of Venus as Machiavelli tells us, a Christian as shown in his *Laudi* and his *Capitoli*, evidently written *con amore*, a staunch friend, generous and kind, yet he is generally accused of having ordered the sack of Volterra—now, however, proved to have been instigated by the mercenaries engaged to defend the town."[59]

Guido Ruggiero, 2014: "the political realities of his day often left Lorenzo looking more like a tyrant than a prince. And Lorenzo's rule illustrates well how a ruler, even an unofficial one, could easily slide back and forth between the two... The role Lorenzo played in this episode has remained a subject of debate ever since... Tyrant or prince?"[60]

And over dinners after conferences in the History Lab I've had colleagues make candid comments ranging from, "A man like Lorenzo could turn this country around today," to "Of course Lorenzo the Magnificent never existed, he's a fabrication of later propaganda."

Lorenzo certainly spent the rest of his life regretting the Volterra massacre, but whether it was the deep, penitent regret of a man of conscience, or the selfish regret of a schemer whose reputation suffered, depends on which book you happen to take off the shelf. (We in the History Lab are trained to constantly re-question everything, and are even now debating whether Francesco da Montefeltro *really* had surgeons remove the bridge of his nose![61])

And there is the gout.

Lorenzo suffered from a chronic medical condition, described in the sources as gout. Descriptions and letters document severe pain which made it hard for him to walk, many days when he conducted business lying in bed, and many trips to hot springs for therapy. Lorenzo's mother Lucrezia Tornabuoni (from the *we're*

totally not the noble Tornaquinci family) also had gout, as did his father known as Piero 'the Gouty' (just him?! they all had it!!). His grandfather Cosimo also had it, and we have a letter from a Milanese envoy who describes meeting Cosimo and his two sons Piero and Giovanni all lying down side by side conducting a business meeting in bed while unable to stand.[62] Cosimo used to have servants carry him through the house, and would release a loud yell whenever they approached a doorframe—when a servant asked him why he yelled, he said if he waited and yelled after they slammed his head into the stone lintel it wouldn't help.

Gout is an inflammatory arthritis condition, caused by elevated uric acid in the blood which causes acidic crystals to build up in joints. Diet and kidney damage as well as genetics can cause it, and classic sources will tell you gout is caused by the unhealthy extravagant feasts and dissolute lifestyle of wealthy libertines. The "rich man's disease" or "disease of kings" was long seen as a proof of extravagance and wicked character, especially in regions influenced by moralizing Calvinism, so tales of Lorenzo's gout joined with robbing his nephews and the dowry fund embezzlement to prove him a villain. The idea of gout as proof of wickedness so saturates older histories of the period that it's often repeated without much interrogation.[63] But we now know there are genetic factors, and the condition—or at least similar conditions—ran in the family. Given the poor state of Renaissance medical knowledge, we don't even know if what they called *gout* was gout. A recent team of scholars examining Lorenzo's remains proposes acromegaly, a condition caused by an excess of growth hormone, often from a tumor on the pituitary gland, and is notably, not hereditary.[64] If we reframe Lorenzo's condition as acromegaly conjoined with a hereditary tendency toward debilitating arthritis,* or more

* A 2009 examination of the skeletons of two of Lorenzo's descendants (Cosimo I (1519–74) and his son Ferdinand (1549–1609)) yielded a diagnosis of diffuse idiopathic skeletal hyperostosis (DISH), a condition which may be linked to diet. See Gino Fornaciari et al., "The 'Gout' of the Medici, Grand Dukes of Florence: a palaeopathological study," *Rheumatology* 48 n. 4 (2009), pp. 375–7. Diagnosis from old remains is controversial among scholars, and there is a strong incentive to diagnose *something* after an expensive exhumation, so all this could be Vikings eating fish again.

generally as chronic illness and chronic pain, he stops feeling like a dissolute libertine and starts feeling like a disability case study.

Lorenzo's gout is usually mentioned *very conspicuously* in Lorenzo-as-villain accounts (much more often than Cosimo's, for example), and fits the stereotype of the rich, corrupt moneylender, but the same accounts frequently discuss other notables of the period without mentioning that they too had gout, major figures like Popes Innocent VIII, Pius II, Pius III, and Pius IV, Florentine political leader Bartolomeo Scala, Dukes Ludovico Sforza, Guidobaldo da Montefeltro, and Francesco Maria della Rovere, Emperor Charles V, and Sultan Mehmet the Conqueror. Their gout goes unmentioned in Medici books and Florence books, and even their biographies tend to confine it to a single footnote *without* being read as a comment on their moral character. Debilitating chronic pain vs. the "rich man's disease"—the difference lies in the historian's words. From a disability activism point of view, it's alarming how much more often books accuse Lorenzo of being a tyrant because of his gout than they bring up the fact that he kept exploiting those supposedly temporary emergency powers his grandfather Cosimo had secured for the family. It is fully appropriate that 50 percent of the presentations at that conference on whether the Medici were tyrants concluded *yes!*, but it's vital that such conclusions use good evidence, and not repeat bad evidence about gout, lawsuits, etc.*

Now, not all histories make a hero or villain of Lorenzo or figures like him. None of the books I quoted about Volterra is directly *about* Lorenzo, and certainly not about whether he is a hero or a villain. Nineteenth-century historians did write whole books whose thesis was *so-and-so was good or bad*, but more recent products of the History Lab that are directly about a figure—like, in Lorenzo's case, F. W. Kent's *Lorenzo and the Art of Magnificence*—tend to avoid black and white value judgments and to center examples that show a complex figure, like how Lorenzo

* I suspect a transitive antisemitism at work in some of the more extreme negative depictions of Lorenzo produced in English and German between 1850 and 1950, that, despite his lack of Jewish ancestry, the archetype of a strikingly large-nosed, dark-haired moneylender pulling the strings of government invited bigotry to manifest.

built a lot of houses in then-empty blocks east of Palazzo Medici, which Kent points out accomplished many things: creating much-needed jobs and housing, generating rental income, beautifying the city, increasing the number of people indebted to the Medici, but also preventing the rival Rucellai family from using that land, a blend of self-interest with benevolence.[65] Similarly, my dear friend Brian Maxson in his *A Short History of Florence and the Florentine Republic* is more negative about Lorenzo than some books (including this one), but puts it well that we need to understand Lorenzo as neither a hero nor a villain, but a person who had and wielded power through many fascinating means, legal and illegal, and who did both good and harm; he aptly adds that, if the Medici family hadn't hacked the system and dominated Florence, another of Florence's *ottimati* families (the Strozzi or Pazzi likely) would have, and would have done just as many legal and illegal things to keep their power.[66] But such nuanced treatment is often reserved for the core subject of a book—a book *about* Lorenzo—since when writing a history of something else—of art, banking, Michelangelo, elections, portrait busts, the Dominicans, Renaissance Prague—different figures who appear in the edges of a book often do have the relationship of hero or villain relative to that book's topic: a hero to art patronage, a villain to republican institutions. The most recent book I saw uncritically repeating old claims about Lorenzo's wicked miserly gout was a 2017 book about Machiavelli, where the Medici family that tortured and exiled him naturally surfaces in the role of villain.[67]

Broader books too, those about the whole Renaissance or European history in general, still often have chosen themes—the rise of banking, the antecedents of the Reformation—to which a particular figure briefly mentioned serves as foe or friend. And beyond this, the corners of the History Lab that produce academic and serious nonfiction are only a small portion of a larger space where ideas about history are brewed. Hero and villain questions are all over many kinds of history writing: playful pop histories, children's nonfiction, historical fiction (videogames, TV) which needs heroes and villains, textbooks which often resort to good and bad when aiming to simplify a century into

one multiple-choice question, etc. Since all people today get our first exposure from popular history (textbooks, children's books, novels, museums, games, TV), most of our first encounters with any historical figure are as something of a hero or villain, and more nuanced histories are always written for an audience which met such hero/villain portraits first.

Zooming back out, we get a different Lorenzo if we come to him seeking a different X-Factor. Just so, we get a different Renaissance if we have a different sense of what defines modernity.

Are we looking for individualism? Nationalism? Capitalism? Secularization? The rebirth of antiquity? The birth of liberal arts education? The rise of the middle class? Banking? Disability? Art? If art, is the art we fell in love with the statues on Orsanmichele commissioned by the merchant guilds, or the Botticellis commissioned by the Medici?

What we are seeking in the Renaissance also changes its chronology. Art and architecture, or theater, literature, and poetry, are often what bring people to it, which easily turn the Renaissance into a rise and fall narrative, a flourishing of genius advancing toward some pinnacle, different for each art form (Brunelleschi, Michelangelo, Ariosto, Shakespeare) and then degenerating from it. And since the Renaissance is looooooong, any shelf full of books on the Renaissance may offer a dozen different Renaissances, whose pinnacles might come as early as the 1401 competition between Ghiberti and Brunelleschi to make Florence's *Gates of Paradise*, or as late as the debut of *Hamlet* in 1600.

12

Or Were We Brought Here by Romance?

I've left a thread out of this history of histories—one of the threads that often gets left out: women.

I don't mean Renaissance women. I mean women historians.

Many who studied the Renaissance *c.*1900 were drawn in by *romance*, in the nineteenth-century sense: drama, intrigue, grand settings, love, suspense, the grim foreshadowing of downpour on the ivy-covered eaves of a ruined abbey. As late as 1922, Doyle has Sherlock Holmes complain that his housekeeper is reading a "love romance," because there were also *non-love* romances, while in another story Watson asks a woman, "Was there any *romance*, anything secret or mysterious, about the wedding?" since a wedding involves *romance* only if there is a grudging rival or a hidden past.[68] Romance was what happened in places one visited on holidays: the Grand Tour palazzos of Italy, or stark Swiss castles where so many Gothic romances are set. The enchantment of sinister glitter, of palatial decadence and femme fatale Lucrezia Borgia, is also part of *romance* meaning in this sense, an atmosphere of drama, which persists in historical TV dramas whose audiences want Renaissance palaces to host sex and violence along with fine doublets and voluminous gowns.

In the nineteenth and early twentieth centuries, while women struggled for presence in the university world, many women fell in love with Italy and wrote about it *outside* academia. Many of them went to live in Italy, expatriates from Britain or elsewhere. The film *Tea with Mussolini* (1999) depicts the *Scorpioni*, a group of English ladies in Florence in the 1930s–40s, who split their days between galleries, archives, and cafés. While largely

excluded from the university-controlled parts of the History Lab, such women, from the 1850s through the 1950s, restored art, pored through archives, and published *popular* history, filled with erudition and discoveries. They socialized with university men, often hosting them as guests or at salons. Such women also mixed with figures like John Addington Symonds (1840–93), Walter Pater (1839–94), and Herbert P. Horne (1864–1916), gay scholars excited by historical eras like the Renaissance and ancient Greece in which homoeroticism had been more acceptable or visible than in their own day, and who also debated X-Factors, and contributed to Florence's scholarly and romantic expat population.

What brings us to study something often shapes the questions we ask, and this was also true for those who fell in love with Italy through romance. As Burckhardt and Villari explored the birth of nationalism and the Modern Man, these women asked different questions: What was life like in these palazzos? How many people (family, servants, guests) lived in them? What did they wear and eat? How did they raise children? When women became nuns, what was that like? What lives, events, hopes, triumphs, and disasters occurred under these roofs?

Janet Ross (1842–1927) was one such woman. From a well-connected English political family, she was a literary correspondent in Egypt before moving to the famous villa in the hills above Florence where the *Decameron* takes place. Her home became a hub for Florence's Anglophone population, and she was affectionately called "Aunt Janet" by a generation of scholars. She helped the art historian Bernard Berenson buy the nearby Villa I Tatti, which he turned into the research institute where I wrote my first academic book. And she published, first a cookbook, *Leaves from Our Tuscan Kitchen* (1899), then meticulously researched histories, including *Florentine Villas* (1901), *Florentine Palaces and Their Stories* (1905), *The Story of Pisa* (1909), *Lives of the Early Medici as Told in Their Correspondence* (1910), and many more.[69]

Aunt Janet's neighbor in the next villa, Iris Origo (1902–88), was another daughter of an English diplomat, who married the illegitimate son of an Italian marquis. She published on the strange Roman revolutionary Cola di Rienzo (1313–54), Saint Bernardino

of Siena (1380–1444), Lord Byron's daughter Allegra (1817–22), and many others, and, after the war, published her influential war diary (1947) and *A Need to Testify* (1984) describing the lives of prominent anti-fascists.[70] She also wrote her brilliantly innovative *The Merchant of Prato* (1957), which used family papers to offer a stunningly researched window on the intersection of daily life, business, family, and statecraft, pioneering microhistory—a vital method in the History Lab today.[71]

There were many such women. Julia Cartwright Ady (1851–1924) published twenty-three books treating Botticelli, Raphael, Castiglione, Lucrezia Borgia, Isabella d'Este, Italian art and later figures.[72] Her daughter Cecilia Mary Ady (1881–1958) attended Oxford (just *before* women were given degrees), later tutored at Oxford, and published on the Sforza of Milan, the Medici, the Bentivoglio of Bologna (for which book in 1938 she received one of the very first PhDs granted to women), and *The English Church and How It Works* (1940) which was considered important enough to see print in the middle of the Second World War despite paper rationing.[73] Rosamond Joscelyne Mitchell also published many books, including her *History of Milan Under the Sforza* (1907), *Life and Adventure in Medieval Europe* (1934), and *The Laurels and the Tiara* (1962), which is still one of the best works on Pope Pius II, one of the most important scholars of the Renaissance; with her sister-in-law Mary Dorothy Rose Leys (1890–1967), who also tutored at Oxford, Mitchell co-authored *A History of the English People* (1959) and *A History of London Life* (1958).[74] While only *The Merchant of Prato* and *The Laurels and the Tiara* tend to be looked at much by current scholars, all these women had huge influence on all scholars (male and female) who *started* studying the Renaissance during the twentieth century. I've heard major historians say they were brought to the field by Iris Origo, but that they wouldn't admit it in public because *hers isn't formal scholarship*. These women's legacies parallel those of Burckhardt and Villari, yet none were on my reading list when I did my PhD, despite the fact that their labors in the archives to reconstruct the stories and lifestyles of Renaissance palaces were a lot closer to the modern academic project of making evidence-based portraits of the past than the spirit-of-the-age work of

Burckhardt or Baron.* The birth of cultural history is credited to Burckhardt, but its modern rebirth as the evidence-based method I was trained in descends more from the women I didn't read as a student than the men I did. That segregation in turn affects another.

Once upon a time, at a conference in the History Lab, I was tired. Conferences are long, and often by day three I just can't parse technical exegesis of Ficino's Neoplatonic hypostatic theurgic soul projection anymore. (I love my work, but it's a nerdy-within-nerdland topic; once I ducked out to the water fountain and heard two other historians passing by: "What's in there?" "Oh, that's the Ficino room; it's *weird* in there.") So, when tired, I look through the catalog for a nice Greek-free panel on murder, heraldry, or—that year—hats. I was excited for the hat panel. All my Renaissance dudes wear hats in their portraits, and those hats communicate things: rank, status, in-group, out-group. Machiavelli, for example, wears a black cap with little side flaps, similar to one his boss Piero Soderini (1451–1522) wears, but very different from the cone-shaped acorn caps—usually red—most of my scholars wear. So, off I went to a nice panel on hats, and entered an *enormous* room with at least a hundred people in it, *only three of whom were men* (two of those visibly queer). Which is when I realized that, all weekend in the much smaller Neoplatonism room, I had only seen two other women.

The gender balance at that conference was close to 50/50, but we had sex-segregated by topic, by *the questions we were asking*. It really was the questions, since the Neoplatonism room had panels on Pico, but one afternoon I noticed a Pico panel in a different room, and when I got there the speakers were all women, the audience mostly women plus a few (mostly queer) men, and the questions weren't about technical readings of Greek, they were

* In 2003, the list of seventy-some authors I was assigned to read for my PhD orals contained only six works by women, all recent: Erika Rummel, Susanne Saygin, Alison Brown, Valentina Prosperi, Nancy Siraisi, and Margaret Meserve. The earlier male figures on my list (contemporaries of Ross, Origo, and Ady) were Jacob Burckhardt (1818–1987), Pasquale Villari (1827–1917), Benedetto Croce (1866–1952), Giovanni Gentile (1875–1944), Hans Baron (1900–88), Eugenio Garin (1909–2004), and Charles Trinkaus (1911–99).

about Pico's relationships, his friends, his nearly deadly duel—the questions of *romance*.

What we now call *cultural history* is, in many ways, the descendant of those *romantic* histories, and has increasingly become the dominant activity in the academic portions of the History Lab: the project of producing **evidence-based portraits of what it was like to live in another time and place**. If you pick up the latest volume of *Renaissance Quarterly*, or the catalog from Something University Press, you'll find a lot more studies of things like the specific methods scholars used for transcribing Roman inscriptions, what we learn about literacy from what people wrote in the margins of their bibles between [date] and [date], how viceroys in Spanish-controlled Mexico used pomp and festivals to discourage opposition, or how the textiles depicted in a van Dyck portrait show Genoese nobility making a point of showing themselves with objects imported from far away.* The excitement of these studies, much like the excitement of a fantasy or science fiction novel, is glimpsing details of a different way people could live, except that the details of real history are a thousand times more complicated, fascinating and improbable than any author can invent (something I as an historian *and* novelist I can say with confidence). Humans are awesome, and the different ways we've lived are awesome, worth studying simply for themselves, like nudibranchs, glacier formation, the Basque language, or comets, even if they don't give us deep insights into our origins or how to live our lives. If you're wondering why the hats room at my conference was so much bigger than the Pico or Ficino rooms (even the women's Pico panel was tiny), hats are a key to making evidence-based portraits of life in the past: what they were made of, what people used them to communicate; while the Neoplatonism room—where evidence-based portraits of nifty Renaissance thinkers mingle with our wrangling of X-Factors—is now a much smaller corner of the History Lab, small but delightful. But because, 150 years ago, making portraits of Renaissance life was women's work, the X-Factors men's work, as we move from room

* These examples come from simply opening the latest *Renaissance Quarterly* now on my desk, 2023, 76.2.

to room at conferences today we feel that residue of genderedness, of who feels welcome where.

My bookshelves reflect this segregation too. The majority of *biographies* on my shelves are by women: Sheila Hale's gorgeous *Titian: His Life*, Elizabeth Lev's fantastic *The Tigress of Forlì* (about Caterina Sforza), books by Sarah Bradford and Emma Lucas on the Borgias, Anna Abraham on Leonardo da Vinci, Dianne Hales on the model for the *Mona Lisa*, Jane Stevenson on Federico da Montefeltro, Christine Shaw on Pope Julius II, Caroline Murphy on Felice della Rovere, Jeryldene M. Wood on Ippolita Maria Sforza, Ramie Targoff on Vittoria Colonna, Carol Kidwell and Susan Nalezyt on Pietro Bembo, Marina Belozerskaya on Cyracius of Ancona, Erica Benner on Machiavelli, even the new book I picked up on Pope Francis I is by Frieda Leone.[75] Why so many female biographers? Partly, because women still get fewer academic jobs, and biography is one of few kinds of history writing which sells enough to live on (other historians from marginalized groups, queer, POC, face this as well). Historical fiction also pays a living wage more easily than much history writing, and here too women dominate the gorgeously researched *romantic* novels that bring many students to my classrooms: Dorothy Dunnett's *Niccolò Rising*, Hilary Mantel's *Wolf Hall*, Phillipa Gregory's *The White Queen*, Rozsa Gaston's *Anne and Charles*, so many enchanting tales from my friend Jo Walton's 2019 *Lent* (about Savonarola) back to George Eliot's 1863 *Romola* (also about Savonarola). But in addition to the hope of selling enough to live on, biography—whether fiction or nonfiction—asks the kinds of questions Janet Ross and Iris Origo asked, about places, people, life, the *story* part of history.

This genderedness persists in the questions historians come to the History Lab to ask, with histories of life and lived experience drawing more women (also history of medicine, since bodies => gender => women), while histories of politics, ideas, and X-Factors draw more men. Among the Renaissance nonfiction books currently on my e-reader, 23 percent are by women, of which nearly half are biographies, while those which aren't bios are wonderful books but treat *romantic* topics: nuns, clothes, food, medicine, women's poetry, exotic pets in Renaissance palaces,

"the sacred home," plus Jane Tylus's *Siena: City of Secrets*, Allison Levy's *House of Secrets*, Ioanna Iordanou's *Venice's Secret Service* (a secrets motif?), Cecelia Ady on Sforza Milan, and four books by the invaluable Mary Hollingsworth on patronage (who pays for the stuff in the palaces?).[76] Meanwhile, the few biographies I have by men focus on politics, genius, and rivalry: five of Savonarola, four of Machiavelli, three of Michelangelo, four of Medici, three of Borgias, one of Sultan Mehmet the Conqueror, and one, recent, of Petrarch.[77] I have seen this pattern improve in my lifetime, but young people are drawn to history by $15 paperbacks not $180 academic monographs, so the segregation repeats in the topics young male vs. female PhD applicants already want to study when they enter the History Lab. We in the Lab work hard to encourage young women to look at politics and ideas, and young men to look at space and lived experience, but repairing the century-old split requires a thousand micro-battles, as large as the fight for women's suffrage, and as small as asking a poli sci student to think about what Machiavelli's hat is telling us.

And, of course, books affordably available for e-readers more often employ approachable, traditional, or crowd-pleasing ways of writing history (stories, heroes and villains, moral lessons, big takeaways) while a frustrating portion of academia's new evidence-based portraits of life in the past are only available as $180 hardcovers from Something University Press.

13

The Invention of the Middle Ages

By now we have several definitions of Renaissance, some of them outdated but all still active in shaping the imagined Renaissance we meet in TV dramas and travel guidebooks:

- The period between the Black Death and the Enlightenment
- The beginning of modernity, or the spot in history when some defining X-Factor appeared, which we use to make claims about what defines modernity, and the correct course for our present/future
- The moment humanity awoke from the stagnant Dark Ages (wrong!)
- An age of romance, dramas lived in grand palaces…
- A label we use mostly in European history scholarship for a period which started sometime between 1250 and 1400, and ended sometime between 1600 and 1700.

But we need one more definition, perhaps the most important:

- A golden age that people in Italy *c.*1400 invented *to describe themselves.*

Whenever I'm with medievalists, and the subject turns to bad things people say about the Middle Ages *(violent, backward, superstitious, stagnant)* I speak up and say, "Yeah, that's my Renaissance guys' fault. Sorry." It was a joke the first time, but

medievalists always get this special smile after the resulting chuckle, as if to say: *I've always felt I deserved an apology from the Renaissance; thank you.*

Because, before the part of all this that was Burckhardt's fault, came the part that was Petrarch's fault.

When most cultures tell their histories, they divide it into periods: reigns, eras, dynasties. These divisions have a huge effect on how we understand things. Putting on my science fiction writer hat for a moment, in one of my novels, people in my imagined twenty-fifth century debate whether the First World War ended in 1945 or in 1989.[78] That detail always makes readers freeze, then reflect: *I could see someone considering the First World War and Second World War one thing, like the Wars of the Roses.* My first exposure to this kind of challenge to traditional historical periods was watching a documentary as a kid in which historian Eugen Weber called the First World War and the Second World War "The Second Thirty Years' War."[79] Feels weird, right? That weird is powerful.

People in the European Middle Ages mainly divided history into two parts, BC and AD, before Christianity and after. For finer grain, you used reigns of monarchs, dynasties, or before or after a particular event, rise, reign, or fall. There were traditions subdividing further, such as Saint Augustine's six ages of the world (Adam to Noah, Noah to Abraham, Abraham to David, David to the Babylonian Exile, that to the Incarnation of Jesus, Jesus to present). And there was a sense of the Roman Empire as an important period now over, but tied to the BC-to-AD tradition, since the Roman Empire was seen as part of the arrival of Christianity. Rome had not only Christianized its empire through the conversion of Constantine, but the empire was the legal authority which executed Christ—in medieval eyes, Caesar appointing Pontius Pilate was a step as essential as the nails or the cross.[80]

Many medieval interpreters viewed the world and history as *didactic*, designed by God for human moral education. In this understanding, the events of the world are like the edifying pageant plays one saw at festivals: God the Scriptwriter introduces characters in turn—a king, a fool, a villain, a saint—and, as we see their fates, we learn moral lessons about fickle Fortune,

hypocrisy, the retribution that awaits the wicked, and the rewards that wait beyond the sufferings God sends to test the pious. God only created Earth in the first place as a place for human souls to live, learn, and eventually choose either Heaven or Hell, so Earth had no self-governing laws, it was the set for this moral pageant, and God the Author. The Roman Empire had been an act of this play (Act I: enter Adam and Eve… Act IV: enter Julius Caesar), scripted to teach humanity about imperial majesty, law, and justice, in sum to offer an earthly image of supreme power—the emperor—which people could use to understand God. Rome was *a teaching tool*, so the empire fell when that lesson was complete, the tool no longer necessary, like last year's textbook. Many medieval and indeed Renaissance interpreters viewed history this way, and to fully reject it we need our friend Machiavelli.[81]

The two people most directly responsible for inventing the Middle Ages—and who really owe medievalists an apology—are both from Tuscany: Petrarch (Francesco Petrarca, 1304–74), and Leonardo Bruni (1370–1444).

Petrarch—who called the days since Rome an age of ash and shadow—we met a few chapters ago as the main voice of the movement which shaped the libraries that in turn shaped young Machiavelli. The Italian peninsula was Petrarch's focus, more than Europe or the larger world. In the 1300s Italy was riven by feuds, coups, and factions. In Petrarch's poem *Italia Mia*, we see both the nascent concept of a Dark Age, and meat for historians like Villari who see the Renaissance's X-Factor as the birth of national consciousness. Here is the opening section:

> *My Italy, though words cannot heal*
> *the mortal wounds*
> *so dense, I see upon your lovely flesh,*
> *at least I pray that my sighs might bring*
> *some hope to the Tiber and the Arno,*
> *and the Po, that sees me now sad and grave.*
> *Ruler of Heaven, I hope*
> *that the pity that brought You to earth,*
> *will turn you towards your soul-delighting land.*
> *Lord of courtesy, see*

> *such cruel wars for such light causes:*
> *and hearts, hardened and closed*
> *by proud, fierce Mars,*
> *and open them, Father, soften them, set them free.*
> *and, let your Truth*
> *whatever I may be, be heard in my speech.*
>
> *You lords to whose hands Fortune entrusts the reins*
> *of the beautiful region*
> *for which you seem to show no pity,*
> *what is the purpose of these foreign swords?*
> *Why is our green land*
> *so stained with barbarous blood?*
> *Vain error flatters you:*
> *you see little, and think you see much,*
> *if you look for love or loyalty in venal hearts.*
> *He who has more troops*
> *is more entangled with his enemies.*
> *O waters gathered*
> *from distant deserts*
> *to inundate our sweet fields!*
> *If our own hands*
> *have done this, who can rescue us now?*
>
> *Nature provided well for our defense,*
> *setting the Alps up as a shield*
> *between us and the German madness:*
> *but blind desire, contrary to its own good,*
> *is so ingenious,*
> *that it brings plague to a healthy body…*[82]

Yes, plague was already Petrarch's metaphor *before* he lived through the Black Death.

It was post-Black Death Petrarch who fired imaginations across Italy with the idea of an intentional remaking of the age. The lost arts that birthed Rome's age of peace, the wisdom of Plato and Cicero which nurtured the best emperors (true images of God!), those secrets, Petrarch urged, were languishing in library back

shelves waiting to be restored if only people reached for them. (The power to change the world lies in the individual, you say?)

Our second culprit, Leonardo Bruni, was a child when Petrarch died, and grew up when many were excited to create the golden age Petrarch claimed could be enabled by the classics. Working in the early 1400s, Bruni studied the *studia humanitatis*, served as Chancellor of Florence, and imitated ancient Roman historians in writing biographies of Cicero, Dante, and Petrarch, and above all his *History of the Florentine People*, which was the first work to divide history into three parts: ancient, middle, and modern, i.e. what we call Renaissance.[83] Bruni also filled his history with analysis modeled on ancient historians, so many people call it the first modern history, the first *analytic* history of a post-classical time. Medievalists then pile up examples of medieval chronicles full of complex analysis,[84] and medieval historians did do incredible work, but Bruni's was also different. Why? Largely because Bruni *actively wanted his history to seem different*, and wrote with the feeling of difference as one of his goals, using classicizing Latin and structure in order to make readers say: *Wow, this feels like what the Romans did!*

With Bruni we had three periods—ancient, medieval, and new. The new age wasn't called *rinascita* until a century later, but the idea of three periods, and of a new, glorious period, caught on quickly because of its potential for... *legitimacy!* Claiming this *is* or *could be* a golden age is a great way to make your regime seem exciting, full of momentum, glorious. Other historians quickly adopted the three-part division, working in the exciting new classical style.* History writing was the new big thing, because you could awe people with a history of how great your city/people/family was (or aimed to be), and make your rule feel like a golden age.

A local scholar finishing a new style history may not seem like a big deal (today we'd imagine some splashy newspaper reviews,

* Flavio Biondo (also called Biondo Flavio) was another early user of the three-part division, sometimes called the first archaeologist, who transcribed ancient tablets and fragments and wrote new histories of the city of Rome in the new classicizing style. See the I Tatti Renaissance Library translations of his work, and *A New Sense of the Past: The Scholarship of Biondo Flavio (1392–1463)* (Leuven: Leuven University Press, 2016).

maybe the author does the round of talk shows) but the idea of this new history like the ancients wrote was *so* exciting that the whole city of Florence declared a special holiday when Bruni finished it, and had a giant parade to escort the manuscript to the city hall. They even got out the Madonna dell'Impruneta, Florence's most super special miracle-working Madonna, kept in a special sanctuary in the countryside and brought to the city only in extreme circumstances.[85] A procession of the Madonna dell'Impruneta didn't happen every year, or even every decade, and was usually done as an emergency request for help (Shit, a flood! Shit, the plague!)—doing it as a procession of *thanksgiving* for a *good* thing was usually reserved for the city winning a major battle and surviving a war. So, when thinking about how exciting Bruni's history was, think a giant reception in the capital, plus all the highest medals and awards a government can bestow, plus the parade of the decade, plus all the awards a people would lavish on a general who'd just saved his nation from conquest. Which, in an odd way, Bruni did, because of another very special power history writing has.

One figure in Bruni's history was Gian Galeazzo Visconti, the "Viper of Milan" (1351–1402), a man who lived up in every way to his badass family crest of a crowned serpent swallowing a helpless little dude. After ambushing and supplanting his uncle, the Viper seized the ducal throne of Milan, then conquered northern Italy clear to Padua on the shore by Venice, then turned south as far as Tuscany. Florence and its Guelph ally Bologna suffered a major defeat in 1402. In the desperate aftermath, according to Bruni, some brilliant Florentine statesmen made a series of impassioned and eloquent speeches to the Venetian ambassadors about the crimes and iniquities of the Viper, which convinced the Venetians to side with Florence against Milan, paving the way for Visconti's defeat, while at that same Providential moment the Viper himself fell ill, and, terrified of leaving his young sons to face the indomitable wrath of the united Florentine and Venetian republics, quickly sued for peace, completing the would-be conqueror's defeat, hooray! When Bruni's history circulated *c.*1444, the Viper's grandson Duke Filippo Maria Visconti of Milan did a spit take: *"What the?! We didn't lose that war! Granddad dropped dead of a f*ing fever and the troops had to go home! The Florentines never beat us in a single battle!*

The Venetians weren't going to help them, and those fancy speeches are pure fiction! They can't say they won the war!" They can. They did.

It turns out history isn't written by the winners; history is written by the people who write histories.

So, what are you going to do about it, grandson of the Viper of Milan? There's only one thing to do: hire one of these newfangled scholars to write a history of *your* city and *your* family framed *your* way, and replacing the defeated-your-uncle narrative with a glorious story where you constantly kicked Florentine ass!! That's what the duke did—that's what everybody did: Milan, Venice, France, England, Hungary, Naples, even Cosimo's ambitious friend Francesco Sforza. When he and his Visconti bride took Milan, he hired one of these Petrarch-type scholars to write an epic poem about *his* family. Everybody had to have a history, and all these new histories claimed there had been a bad middle age, and we were in the glorious classical-revival-powered new age whose rulers would rival great princes of legend. Even up in England, where it's Wars of the Roses time, baby King Henry VI's uncle Duke Humphrey tried to hire Leonardo Bruni to come to England and write a history that would shore up the tenuous Lancastrian claim to the throne, which is why, while Bruni stayed in Florence, our book-hunter Poggio Bracciolini did go to England and work for Humphrey's rival Beaufort and get plump on beef. All these new histories, and their soon-to-follow cousin genre the heroic family epic in Aeneid-style, *adjusted* details to make the current ruler(s) look great and legitimate (self-fashioning individualism, you say?), generally at the expense of making the newly invented Middle Ages look bad.

This is why all medievalists deserve an apology from the Renaissance.

From its inception, the word Renaissance was a smear on the age that came before, rebirth coming to fix something wrong. Historians have tried to change the name, but it's hard to find another label for the period. Normal parlance in the History Lab now is (sigh) *early modern*, which is (to paraphrase Churchill) the worst name for the period, except for all the rest.

Modern itself is a terrible word. Most people vaguely associate *modern* with the moment people took off their top hats and started driving cars, but every scholarly field has its own definition.

Strolling beyond the History Lab to poll friends in other Labs about what "modern" means to them, I got:

- Modern for studying the Americas 1492
- Modern English language 1500
- Modern philosophy and science 1600
- Modern political order 1648
- Modern agriculture 1700s
- Modern economies 1760
- Modern linguistics 1786 (or 1959)
- Modern politics 1789
- Modern music 1812
- Modern fashion 1858
- Modern art 1860s
- Modern neuroscience 1890s
- Modern archaeology late 1800s (or 1942)
- Modern physics and modern architecture 1900
- Modern baseball 1901
- Modern English literature 1918 (or 1970)
- Modern science fiction 1939
- Modern Japanese literature 1945
- Modern geometry 1950s
- Modern biology 1959
- Modern genetics 1962
- Modern women's gymnastics 1972 (or 2006)
- Modern comics and graphic novels 1983
- Modern poker 1988
- Modern machine learning 2012
- Modern geologic epoch 12,000 BCE
- Modern human culture 44,000 BCE
- Modern human species 200,000 BCE
- Modern biological life 65,000,000 BCE
- Modern DNA structures 530,000,000 BCE
- Modern warfare: dozens of answers from 1803 to 2001
- Modern computing: dozens of answers from 1820 to 2011
- *Moderna* in Italian: 1250+

And just in case you hoped we could see how Renaissance people used the word, they did talk about the *via antiqua* (old way) vs. *via moderna* (modern way), but *via antiqua* meant using Aristotelian syllogistic logic on the model of Thomas Aquinas and Duns Scotus from the 1200s, while the scandalous new *via moderna* started with William of Ockham in the early 1300s, who advanced nominalist arguments against Platonic Universals—kids these days.

In sum: the word *modern* needs to be fired.

Early modern is likewise all over the place. Many hear it and think steam engines and early skyscrapers, but in the History Lab we mean the period after medieval and before the French Revolution. What we get by using *early modern* instead of *Renaissance* is that we avoid implying that the Middle Ages were bad, but *early modern* worsens the degree to which choosing a start date involves a judgment call about what makes us modern.

14

The Un-Modern Renaissance

Another way to look at the Renaissance is as something *un*-modern. This era between the Black Death and Enlightenment didn't have the modern scientific method, industrialization, nation-states, democracy, hygiene, steam engines, the *Declaration of the Rights of Man*, etc., but it was still an era that existed, and had distinct characteristics, like aspiring to be a golden age. Let's look at what it was like, *not* arguing about what's modern, just describing what happened, modern or not.

One superstar of my corner of the History Lab is Paul Oskar Kristeller (1905–99). He's one of my academic grandparents, i.e. my adviser's advisers, and one of the great pioneers of seeing history as a discipline aimed at presenting evidence-based portraits of what it was like to live in another time and place. Like Hans Baron, Kristeller was a German Jew who fled to the US to escape the Nazis, and, in addition to his invaluable work cataloging thousands of manuscripts in Italy so others could find them, he looked at what Renaissance intellectuals did and said. In contrast with Baron's civic humanism, or the secularist idea of Reason breaking the yoke of Faith, Kristeller said the Renaissance was characterized by its *new educational movement*, focused on the classics, which gained momentum from and after Petrarch: the *studia humanitatis*. Kristeller strove to describe this movement, its networks of influence, classroom practices, its focus on rhetoric and style, but presented it as a set of shared practices, *not* an ideology. The men he studied were *umanisti*, which he translated as *humanists*, but for Kristeller this was a set of educational practices, and had nothing to do with the values of modern secular humanism.

Kristeller's approach did not make any claim about modernity, but it was not incompatible with one either. One could still argue that the new form of education was a modernizing step, the foundation of the modern liberal arts, and a formative moment of contact between the medieval and a rediscovered antiquity. And while his approach separated the Renaissance from modernity, and Renaissance humanism from modern secular humanism, most people who came to Kristeller's classrooms wanted to study the Renaissance, either because of art, or because they were excited about an X-Factor.

Thanks largely to Kristeller, the field of academic Renaissance history is now more careful about X-Factors, focused on exploring and depicting the un-modern Renaissance. In fact, the discipline of academic history as a whole has sided with Kristeller in valuing evidence-based portraits of what past people did over attempts to find the roots of modernity, define historical epochs, etc. In the History Lab we do still have fun quarrels about Renaissance-as-modern vs. Renaissance-as-totally-not-modern, like a few years ago at a roundtable celebrating the inestimable Chris Celenza's new Machiavelli biography, which turned into a warm, learned, decorous brawl between Chris and my wonderful colleague Rocco Rubini over whether Machiavelli is a fundamentally modern or pre-modern man.[86] We also have invaluable gadfly scholars like Robert Black, who brings forward batch after batch of evidence that many Renaissance *umanisti* were in it more for a high-paying job than lofty ideals, and John Monfasani, who pokes back at every lofty claim about the Renaissance with meticulous examples of practices we think of as medieval prospering merrily for centuries beyond.[87] We need such gadflies. And all this back and forth in the History Lab—*modern? Not modern? Good Lorenzo? Villain Lorenzo? Black Death => economy good? => economy bad?*—is why, even though every academic library already has a hallway of books about the Renaissance, the History Lab still pours out new ones every year. We do need them. Especially to teach us why we must always doubt our histories. Speaking of which…

15

Why Did Ada Palmer Start Studying the Renaissance?

I promised to tell you why the Renaissance is like the Wizard of Oz, great *and terrible*, with something weak and frail behind the curtain. But to do this with maximum honesty, I wanted to first show you why we get dozens of different ideas of the Renaissance—all real and based on facts!—depending on how each historian defines modernity, and what drew that scholar to study the period in the first place. So, before you begin to trust my version of the Renaissance, you should know how *I* define modernity, and what drew *me* to study the Renaissance.

Atypically, when I started my PhD on Renaissance history, I didn't care about the Renaissance. I'd never studied it, and couldn't have showed you Florence on a map. I was interested in *intellectual history*, the study of how ideas and events shape each other over time. I came to history via my school's Latin program, and documentaries on PBS. The documentary *The Great War and Modern Memory* left me enchanted by how the First World War shaped trauma studies and Freud's *Civilization and its Discontents*, how clearly you could see the war making Freud rethink his Eros-based theories and add the *death instinct* after (but not before) the war. I was also entranced by Barbara Tuchman's *The Guns of August*, which so movingly depicts how the worldviews of those making the decisions in those fateful weeks of summer 1914 shaped the war, not into what anyone wanted, but into the unintended horror which then birthed Freud's *death instinct*. Ideas were shaping history, and history was shaping ideas, in an unintended, fascinating cycle. I then saw this in other eras: how

political and scientific changes in the seventeenth century shaped America's *Declaration of Independence*, how the condemnation of Socrates shaped Plato's distrust of democracy, and how the Cold War was palpable in the golden age science fiction paperbacks I'd been pulling off Dad's bookshelves since I had to stand on tiptoe to reach them. I wanted to study history to discover, not what we think is true, but *why* we think those things are true *at a particular time*, and how events birth ideas. I loved realizing that key ideas don't burst like Athena from the heads of geniuses, that they result from lived experience, and sometimes—like the simultaneous invention of calculus by Leibniz and Newton—from a culture being ripe for an idea. I didn't care what time or place I studied, so when I found a man called James Hankins at Harvard who was asking *the kinds of questions I wanted to ask*, who said my classics background, decent Latin, and rusty French were a good combo for studying Renaissance Italy with him, I said okay.

I then spent the first year of my PhD sitting quietly in class trying to cover for the fact that I'd never heard of these places or people before.

By year two I was catching up, wrote a fun paper on historians' arguments over the origins of atheism, and decided to write my dissertation on Lucretius in the Renaissance, partly because a good friend gave me a copy as a gift, and partly because books on the Enlightenment often said that, when Poggio rediscovered Lucretius in 1417 (before he attended Henry V's wedding) the return of this radical Epicurean poem (which has the world be made of atoms and vacuum *without* a divine plan) helped spark modern science. So I set off to the archives seeking Lucretius-reading atheists (we'll meet them soon), and here I am twenty years later, working away in the History Lab still fascinated by how events and ideas shape each other, and especially by the big takeaway from my dissertation: that the impact of a book or idea often doesn't happen at the moment it arrives, it can happen decades or even centuries later, when circumstances have changed and made readers come to the same book with new questions. Think of how modern performances of *The Merchant of Venice* are powerful tools for exploring twentieth-century antisemitism in a way Shakespeare would never have anticipated—a text can serve

new needs in new eras, be it Shakespeare, Machiavelli, Lucretius, Plato, or Petrarch.

Now you understand my biases, and you'll recognize them peeking through as I give my best description of how *I* understand the Renaissance, and its relationship with the medieval world, the Black Death, and modernity.

PART II

Desperate Times and Desperate Measures

What caused the Renaissance? I'll tell you what I think, but only if you promise to keep in mind that ten other books on the shelf this one came from will give you different answers, and most of them are *also* right.

16

Desperate Times

Let's loop back to that letter from Machiavelli's friend about his unfinished history of their desperate decade—many times in this journey we'll loop back to a moment we've looked at before, to reconsider it from new perspectives. So: on February 25, 1506, the commander of Florence's armies, Ercole Bentivoglio (1459–1507), wrote urging Machiavelli to continue his *Decennale primo*, a history in verse of the events of that decade, a work Bentivoglio thought would not be for their generation, but for posterity, so:

> … knowing our wretched fortune in these times, they should not blame us for being bad defenders of Italic honor, and so they can weep with us over our and their misfortune, knowing from what a happy state we fell within brief time into such disaster. For if they did not see this history, they would not believe what prosperity Italy had before, since it would seem impossible that in so few days our affairs could fall to such great ruin. (Letter 107)[1]

Of these days of ruin, Burckhardt, founder of modern Renaissance studies, wrote:

> The first decades of the sixteenth century, the years when the Renaissance attained its fullest bloom, were not favorable to a revival of patriotism; the enjoyment of intellectual and artistic pleasures, the comforts and elegancies of life, and the supreme interests of self-development, destroyed or hampered love of country.[2] (*The Civilization of the Renaissance in Italy*, end of Part 1)

Burckhardt seems to be describing a different universe from Bentivoglio's despair. Yet in this decade Leonardo, Michelangelo, Raphael, Bramante, Josquin des Prez, and Ariosto were all working on their masterpieces, and Castiglione starting his time at the court of Urbino, soon to be celebrated in *The Courtier* as the ideal digest of Renaissance culture. This artistic outpouring does indeed suggest a world of artistic pleasure in stark contrast with Bentivoglio's despair. Can this be the same Renaissance?[3]

This double vision is authentic to the sources. If we read treatises, orations, writings on art, even most manuals of politics from these years, we see what Burckhardt describes, and what popular understandings of the Renaissance focus on: a self-conscious golden age, bursting with culture, art, discovery, and vying with the ancients for the title of Europe's most glorious era. This is even more true if we read works written *about* these decades a few decades later, like Vasari's *Lives of the Artists* (1550), the first book to call this age a *rinascita*, but in which the art appears *without* the background of lived reality. Think of our expert on Viking-era bones Thomas McGovern correctly observing there were no fish bones in the Greenland middens—just so, Burckhardt was right, if we look at the sources he was looking at, which were primarily formal literary works, and in Italian. If instead we read the private letters which flew back and forth between Machiavelli and his correspondents in those years, we see terror, invasion, plague deaths, a desperate man scrambling to even keep track of the ever-moving threats encircling his fragile homeland, as his friends and family beg for frequent letters, since every patch of silence makes them fear he might be dead. Serious histories, mainly written in Latin in the period, show much polished, elegant versions of the same.

The friend who wrote the letter, Ercole Bentivoglio, typifies the alluring sinister glitter of the political web which shaped these years. He was not a Florentine, but a mercenary commander Florence hired because they needed an outsider, someone troops would confidently follow, not merchant scum, and not a native son, since Florence was too coup-shy to trust one of its own with all its armies. Ercole's father had been Sante Bentivoglio (1426–62), who began as a blacksmith's apprentice and common laborer, but was identified as an illegitimate member of the Bentivoglio family that

dominated Bologna (remember Gendry in *Game of Thrones*?), so Sante was called to be "First Citizen" of Bologna for a while when all the adult Bentivoglios died in an ambush. In Bologna, little Ercole grew up in a quasi-princely court with all the grandeur we now see transplanted into museums. His mother was Ginevra Sforza (1440–1507), an illegitimate niece of our friend Francesco Sforza, the one who so cunningly made himself Duke of Milan in partnership with his wife Bianca Maria Visconti, the illegitimate last scion of the Viper of Milan, who had in turn seized the throne by treachery fifty-five years before. Renaissance politics isn't turtles all the way down, it's murders and betrayals all the way down.

The apocalyptic tone of Petrarch's *Italia Mia* is as remote in time from Machiavelli's *Decennale primo* as Robespierre is from NASA, with room for ups and downs as different as the 1848 revolutions and the Roaring Twenties. Yet Petrarch's and Bentivoglio's tones match eerily, Petrarch's "cruel wars for light causes," and a wounded Italy overrun with foreign mercenaries and sliced up by invading empires, recurring patterns in this golden-yet-bleeding age.

These were not the only constants.

Three years before Bentivoglio read the unfinished *Decennale*, Niccolò Machiavelli had written in anxiety to his brother Totto to say he'd been exposed to someone who had the plague, and Totto wrote back with advice based on other plague exposures he had seen or heard of from friends (November 7, 1503).[4] Yes, it's the same plague. The Black Death Petrarch lived through was an apocalypse, depopulating cities and bringing governments to a standstill, but the bubonic plague did not leave Europe. It remained endemic, like influenza or chickenpox today, a fact of life recurring in bursts so frequent that letters from mothers to their traveling sons regularly included, along with advice to be polite and eat your vegetables (usually fennel), advice on which towns to avoid this season because of plague outbreaks. In the History Lab, Carlo Cipolla has collected great data for the two centuries after 1348, in which Venice had major plague bursts in 7 percent of years, Florence 14 percent of years, Paris 9 percent of years, Barcelona 13 percent of years, and England (usually London) 22 percent in the earlier period, spiking to 50 percent in the later 1500s, when England saw plague in 26 out of 50 years between 1543 and 1593.[5]

Excluding tiny villages with little traffic, losing a friend or sibling to plague was a universal experience from 1348 to the 1720s, when plague finally diminished in Europe, not because of any advance in medicine, but because so many generations of exposure gave natural selection time to work, those who survived to reproduce passing on the genes that enabled their heightened immune response, a defensive adaptation bought over centuries by millions of deaths. Outbreaks persisted into the nineteenth century in the Ottoman world, and thousands of cases of *Y. pestis* still occur each year, most in sub-Saharan Africa and East Asia, where it was not endemic as it was in Europe. And if Mihai Netea—down the block in the Genetics Lab—is correct that the immune mutation which helps those of European descent resist *Y. pestis* also causes our greater rate of autoimmune disorders like rheumatoid arthritis, celiac, and (in my case) Crohn's disease, then the Black Death is still constantly claiming lives through the changes it worked into European DNA over 400 years.[6] As for the Renaissance, not only endemic plague but malaria, typhoid, dysentery, deadly influenza, measles, and the classic pox were old constants of life, which not only persisted but grew fiercer decade by decade.

Progress, strangely, was the cause. Not sudden progress, not a line we can draw across our timeline to say 1400 was a great leap for humankind. This was *incremental* progress, that little trickle at the river's start, which had been proceeding throughout the (not at all Dark) Middle Ages, and whose cumulative power was transforming Europe year by year, and lifetime by lifetime. Innovations in money-lending and insurance had been accumulating from the 1100s on, and by the 1300s these enabled merchant activities on a scale unmatched since antiquity, which increased decade by decade through the 1400s and beyond. Disease flowed as goods and people circulated, bringing contagions with them, old endemic diseases resurging more often, and the 1492 Columbian exchange bringing syphilis.

Wars too grew bloodier through progress. Richer, more centralized states could afford larger armies, while new weapons, especially artillery, made battles deadlier and city walls easier to breach, resulting in more sackings of towns, and more civilian casualties. The word *massacre* itself was born of the Renaissance, during

the French Wars of Religion in the later 1500s, forty years after Machiavelli's death.[7] Even Leonardo da Vinci's 1482 letter describing his skills and abilities to his new patron Duke Ludovico Sforza (a son of Cosimo's friend who seized the throne of Milan), devotes its longer first section to Leonardo's ability to build siege weapons and other tools of war, the real selling point of a master of geometry, turning to peaceful arts more briefly only toward the end. If Henry V at Agincourt in 1415 inflicted shocking casualties due to the unexpected effects of longbows on plate mail, such tech mismatches were something ambitious princes invested in attempting to achieve. Such efforts had mixed success, as we see in period manuscripts with illustrations of dragon-shaped balloons with rotating scythes underneath,* or indeed in Leonardo's non-viable tank, but if many inventions failed, others succeeded, with deadly results.

This change in warfare too was incremental.[8] An ongoing process of larger polities absorbing smaller ones, and overlords working to erode the independent rights of subordinate nobles, stretched back practically to Rome's fall, and continued steadily to the days of Louis XIV, each decade seeing wealthier rulers capable of funding larger armies and investing in more tech. The Renaissance fell in the middle of this process (as the river was widening from canoe-sized to admitting larger boats) so its people felt the increase in the scale of war at every stage.

In sum, average life expectancy in the solidly medieval 1200s was around thirty-five to forty, with most of those deaths coming in childhood, while those who made it to adulthood often lived to sixty. By the year 1500 (definitely Renaissance) the average life expectancy in Italian city-states had dropped to eighteen.

Yes, eighteen.

Let's zoom in on those numbers, since it's striking how consistently, when I quote them, the mournful silence is followed by an objection: those numbers are deceptive, you're including infant mortality. It's true that, in both the Middle Ages and Renaissance, plenty of adults lived to sixty or far older, but while Renaissance

* The dragon balloon is one of numerous implausible military contraptions illustrated in the *c.*1455 manuscript *Bellifortis*, by German military engineer Konrad Kyeser.

Italy's average of eighteen does indeed include infant mortality, the medieval average of thirty-five does too, so the *drop* is just as real. If we exclude kids who died before age twelve, we get a smaller drop, from a medieval adult life expectancy of fifty-four in the 1200s to one of forty-five in 1500, a 16 percent drop instead of 48 percent, but the more we zoom the grimmer the Renaissance half proves.[9] Infant mortality (within twelve months) averaged 28 percent both before and after 1348, so the biggest drop was in the kids who made it past the dangerous first year, only to die in years two through twelve from new diseases. Death from childbirth too stayed steady from medieval to Renaissance at (for Tuscany) one maternal death per forty births, while the increase in war and violence actually made adult male mortality far higher than female. If we look at the 20 percent of people who lived longest in the Renaissance, it's almost all widows and nuns, plus a few diehards like Titian, and Cardinal da Costa of Portugal, exiled to Rome and still begging his king to bring him home at age 102, with everyone he'd known in the first two thirds of his life long gone. Kids aged two to twelve died a lot more in the Renaissance, but adults died more too, men died more, yet it's telling how often people who hear these numbers try to discredit them. These facts rub against our expectations. We didn't want a wretched golden age. In fact, it's hard to find life expectancy numbers in books about the Renaissance at all; most of my numbers come from books on disease, plague, and the Black Death itself—beyond that we don't want to hear it. Progress killing people, death shaping our glittering golden age, this is not the story we came to the Renaissance to hear.

One group that *did* see slight life expectancy improvements over the course of the Renaissance was *the noble-blooded elite*. As economic historian Neil Cummins admirably demonstrated, those of noble blood died of plague and disease less often (they were able to evacuate more effectively when outbreaks surged), and had tools for outsourcing dangerous employments to others. Noble men who made it to adulthood saw their average age at death increase from forty-eight before 1500 to fifty-four for the remainder of the Renaissance—not a big increase, but an increase.[10] This elite longevity was *not* due to better diet; on the

contrary, elites ate more meat and fish and a wider variety of foods in general, thus contracting more diseases and parasites, and they also ate very few vegetables—middle-class diets were far healthier in the period. Nor was it elite access to costly medical treatment; by the mid-1500s the improved study of anatomy would start moving medicine in good directions,[11] but at the start of the Renaissance elite doctors were excited by such innovations as grinding up gemstones and feeding them to patients (causing internal hemorrhage as what was effectively ground glass went through the intestines), and the Renaissance also saw the great leap when doctors realized that, rather than examining the color of a patient's urine to diagnose them, it was much more sophisticated to take the patient's horoscope at the time that they peed.[12] A costly doctor and costly diet were more likely to kill you than help you, but that did not make up for how much elites were able to outsource both medically harmful labor and dangerous tasks to others. Even warfare began to take less toll on elites in this period, the portion of European noble-born men who died by violence dropping markedly at 1550, from 30 percent diminishing toward 5 percent, varying by region.[13] These increases in noble lifespans were *not* a difference between medieval and Renaissance, but came in the *middle* of the Renaissance, after 1500, when *The Prince* had been written and the *Mona Lisa* painted. The enormous change in how many noble lives were lost to war was not, alas, a sign of increased peace, but of rulers using new methods to guard themselves and foist off the lethality on others in an age of constant war.

17

Cruel Wars for Light Causes

Petrarch called it that, *cruel wars for light causes*, the endless violence that recurred, year in, year out, for lifetimes. Some were larger wars as major city-states vied with each other, others small ones between two towns competing to dominate a mountain pass or mine or valuable lake, and others in between as larger cities conquered smaller neighbors, creating province-sized mini-empires, the small imperialism within Europe that we rarely remember preceded and fed the later impulse to conquer beyond the continent. Italy's wars were seasonal—each winter, leaders in Florence, Siena, Milan, Urbino, tiny towns and mighty ones discussed what action was likely, planning, preparing. Armies mustered as the weather turned nice, battled throughout the clement months, then either finished and disbanded as frosts came, or camped out for winter in whatever spot was safe and near. Cities competed to hire the best mercenaries. Some were German, Spanish, French, the ever-present Swiss, others Italian. Whatever their homelands, most mercenary commanders were younger sons: the eldest gets the title, another brother goes into the Church, but extra brothers needed to earn their own titles and make their own fortunes, lest the family patrimony be divided and dwindle. Cash, treasures, knighthoods, land, and titles had long been the expected rewards of taking up arms in service of a higher noble: *You help make me King of Naples, and I'll make you count of a small town under my dominion.* Republics couldn't offer titles as monarchs could, setting them at a disadvantage, so they often had to pay more, or offer extra incentives, as when Florence promised Sir John Hawkwood an equestrian statue as part of his commission (and

shafted him by instead doing a *fresco of* an equestrian statue).[14] Circa 1400, successful Italian mercenary captains started seizing towns directly when the opportunity arose, and bribing higher powers to recognize them as counts or dukes (Renaissance individualism => personal ambition?), but in Petrarch's day most of the conquerors had blood claims of some sort to the towns and thrones they sought. The foot soldiers who served under such commanders were much the same on a small scale: younger sons of farmers, millers, innkeepers, and such, seeking income, since if they split the family property between the sons each would get too little to support a family. Machiavelli and Petrarch were far from alone in lamenting that, once warfare becomes a profession, many have an incentive to make sure there's always war. While individual conflicts have names, a friend from the History Lab, Guido Ruggiero, brilliantly calls 1350–1454 the Italian Hundred Years' War, which began as soon as cities had recovered enough from the Black Death to raise forces and take advantage of each other's weakness, and continued on from the medieval Guelph-Ghibelline faction wars which had begun way back in 1125.[15]

Question: *I've heard of Guelphs and Ghibellines, but what was that about?*

Answer: Sigh.

The most useful answer may be: *nothing*. Guelph-Ghibelline violence was usually just about sides, green team vs. purple, fighting because ancestors fought: *My name is [Family X], your grandfather killed my grandfather, prepare to die!* But the feud did have a semi-ideology. This was Italy, which—even after centuries—meant Roman law, Roman pride, Roman traditions, and if you broke the law you were arrested in the name of Caesar, as Gilbert & Sullivan characters are arrested in the name of Queen Victoria.

But who was Caesar?

Who was the lawful lord of Italy, in whose name remnant Roman law should be enforced? Guelphs say it's the pope, that on March 30, 315 CE (or maybe 317), Emperor Constantine (272–337) gifted the empire to the Bishop of Rome, and ever since the popes have been the Caesars, lawful Earthly masters of Italy and all that was once Rome's. But the Ghibellines say that on Christmas Day 800 CE, Pope Leo III (d. 816) crowned the Frankish conqueror

Charlemagne (747–814) Emperor of the Romans, a new imperial line, whose heirs, ruling from Germany, were Roman Emperors (we now say Holy Roman), lawful Earthly masters of all that was Rome's. Thus, in theory Ghibellines supported increasing the German emperors' influence in Italy, while Guelphs resisted it and supported papal supremacy. But, in reality, both sides were happier when their chosen lawful master stayed far away, too busy in Rome or Augsburg to interfere with the Italian towns, which remained free to run themselves, but gained *legitimacy* by displaying faction flags invoking distant Caesar.

In many ways the feud was more about backing than ideology. Let's borrow Shakespeare's fictitious but useful Montagues and Capulets: two families both alike in dignity are feuding, killing each other, and let's say that our star-crossed romance doesn't happen and Daddy Capulet succeeds in marrying young Juliet to the ruling Prince's cousin Paris. Now the Capulets have the Prince's ear and favor, and the Montagues are desperate. But let's say seventy years earlier a Montague fought for the Guelph party, so the Montagues write to the pope, saying, *"Your Holiness, the Prince of Verona is oppressing us, but we're super mega loyal to you, please give us money and troops and we'll uphold your rights here in Verona, and keep you master of Italy!"* So the pope writes a check, Montague hires goons, and the tide of violence turns, with the Capulets and Prince on the defensive. Next, Lord Capulet writes to the Emperor: *"Caesar, your terrible Guelph enemies are filling Verona's streets with blood and death! Send troops and funds to defend your city against these upstarts and we'll forever uphold your rights in Italy!"* So Caesar writes a check.

It's the same feud—the real motive is that Romeo killed Tybalt—it's just bigger, better funded, and maybe the Montagues beat the Capulets, oust the Prince, and Verona flies the Guelph arms henceforth. But Verona, [City A], is next to [City B], and, like all Italian neighbors, they hate each other, so if [City A] turns Guelph then [City B] writes to the Emperor, who writes a check supporting [City B], making it Ghibelline. Thus, feud by feud, Italy becomes a literal checkerboard, where every town joins the opposite faction from its neighbors, Guelph Florence battling Ghibelline Pisa and Siena, not because anyone actually cares

about the rights of Charlemagne, but because someone killed Uncle Tybalt sixty years ago. This is how Dante could be a loyal Guelph who helped Florence exterminate its Ghibellines and put their heads on pikes, yet in his *Commedia* and *De Monarchia* he says that only the return of a conquering Emperor can bring Italy peace. By party, Dante is Guelph enough to kill and die for it, but he actually believes the Ghibelline cause is the best political outcome; faction and ideology have parted ways entirely. In truth, no Guelph or Ghibelline wanted the pope or Emperor to actually *show up* and command them to *do* things, that could be a disaster, like in 1311 when Emperor Henry VII, visiting Milan to be crowned with the implausibly badass-sounding Iron Crown of Lombardy (part of the imperial coronation), ordered Milan to recall from exile the recently ousted Visconti, who promptly crushed their enemies and took over the city. Hence the old Ghibelline wish: *God bless and keep the emperor—on the far side of the Alps!*

This feud lent itself to gaming the system, polities calculating carefully which faction and distant patron to appeal to, Emperor or pope. It is this deliberation Burckhardt points to as what birthed *the state as a work of art.* Italy's political units did not have local overlords, but lay between two distant potential leader-supporters, so needed to make strategic decisions about which political identity to embrace. This politics-by-planning felt familiar and modern to Burckhardt, in the middle of nineteenth-century Europe's strategic alliance building (which had not yet erupted into the First World War).

Who won in the end, the Guelphs or Ghibellines? One faction or the other won in each town, and the vendettas merged into the bitterness of the next conflicts, and the next, without clear victory, so Ghibelline cities like Pisa and Siena *still* hate Guelph cities like Florence and vice versa (you can feel it in the viciousness at sports matches). But today, as we approach the feud's 900th anniversary, the *Parte Guelfa* has a website and the Ghibellines don't, so... victory?[16] Though if Caesar would write a web designer a check I'm sure we could get the feud going again...

18

A Strange Peace, A Stranger War

If we consider the Renaissance Italian Wars as a continuation of the same local enmities that fired the Guelph-Ghibelline faction wars, we could expand Guido Ruggiero's Italian Hundred Years' War to the Italian Three Hundred Years' War, from 1125 to 1454, but the conflict does take on new shapes and structures after the disruption of the Black Death, so restarting there makes sense. After 1454 comes the so-called Peace of Lodi, a forty-year truce between Milan, Venice, Florence, and Spanish-held Naples, ending in 1494. Now, *peace* is a strange label for forty years in which Genoa was conquered several times, Venice was battling the Ottomans at sea, and coups and assassinations toppled many regimes (Milan, Faenza, Cesena, Rimini), nearly toppling many others.* This "peace" included the warmongering Pope Sixtus IV (reign 1471–84) who, considering it his divine calling to reunite the Roman Empire, started a series of coups and annexations to strengthen the Papal States, including a brief war in Ferrara and an attempted coup in Florence, then tried to make the King of Naples attack Florence (the infamous Pazzi Conspiracy), a situation interrupted in 1480 by the Ottoman invasion of Otranto, on the heel of Italy, which left more than 10,000 dead. This "peace"

* The Peace of Lodi became famous among historians since it was celebrated as an important moment in the history of state-building by Pulitzer-winning diplomatic historian Garrett Mattingly in *Renaissance Diplomacy* (Boston: Houghton Mifflin, 1955). On how histories of diplomacy have evolved since, see Diana Carrió-Invernizzi, "A New Diplomatic History and the Networks of Spanish Diplomacy in the Baroque Era," *The International History Review* 36, n. 4 (2014).

still had wars every summer, but they were smaller wars, while the large powers who were signatories—Venice, Milan, Naples, and Florence—avoided *direct* battles, vying instead via proxy wars, spies, and assassinations (not unlike the twentieth century's Cold War). But it felt like peace compared to what came next.

We'll see the Italian Wars (1494–1559) in Part III through the eyes of several figures who lived through them, but they stem from wounds left by those small conflicts during the Peace of Lodi, combined with new ambitions and old grudges, like those between all those neighbors who still hated each other over mining rights and Uncle Tybalt. The true disaster sparked as some Italian powers, hoping to oust rivals with borrowed strength, *invited* France to invade Italy. France's armies were deadlier than Italy was used to, and peasants conscripted by their king *did not* stop for the winter like mercenaries, they wanted to get this finished and go home—a tactic Machiavelli points out was not often *successful* (they lost a lot of winter battles, winter's hard) but sure was *destructive*. So on France marched, slicing an inexorable path of carnage down to Rome, where everybody betrayed everybody, and on to Naples, where everyone died of plague again. It took one opera-worthy decade of this grinding on for Machiavelli to decide that we needed better tools to understand this mess, but even then the wars kept going, that stage now called the War of the League of Cambrai dragging so many forces into Italy that soon Englishmen were fighting Scotsmen on the shore by Venice, because Italy was where you went for wars.

In many ways, the character of these Italian Wars is best expressed by Shakespeare in *All's Well that Ends Well* (I.ii), when Florence has petitioned France to help them in a war against Siena, and the king refuses formal help, but gives permission for his young nobles to go fight *on whichever side they feel like!*

> King: *And Florence is denied before he comes:*
> *Yet, for our gentlemen that mean to see*
> *The Tuscan service, freely have they leave*
> *To stand on either part.*
> Second Gentleman: *It well may serve*

*A nursery to our gentry, who are sick
for breathing and exploit.*

It sounds absurd, a king not caring which country his people fight for so long as it gives them war experience, but Shakespeare's England *c*.1600 was full of veterans returned from Italy with tales of blood and glory. Petrarch's *cruel wars for light causes* were 300 years before Shakespeare's joke, but no generation in between knew Italy in peace.* As the Italian *Commedia dell'Arte* took form after 1550, basing its stock types on newly in vogue ancient Roman comedies (the direct bridge between Machiavelli's comic plays and Shakespeare's), its updated version of the braggart soldier of antiquity was *Il Capitano*, a braggart coward affecting a bad Spanish accent as he pretends to be a war veteran to pick up girls, a relatable type in an Italy where foreign soldiers had touched every town. As for Machiavelli, living in the thick of things, by his forty-fifth birthday every force in the wars around him had changed sides, most of them twice, and Machiavelli's letters to his friend Francesco Vettori trying to understand the tangle grow so desperate that one can feel him waking up in the middle of the night screaming: *What if the Swiss realize they could just conquer everything! We're all defenseless! Panic! Panic more!* That letter is dated June 20, 1513; by December 1513 Machiavelli will decide it's time to write *a little book on princes*.[17]

There were grim, protracted wars elsewhere in Europe in all these decades, of course: wars between France and England, Spain and Portugal, Hungary and the Empire, wars over the annexation of Brittany, the Burgundian succession, the crown of Spain, the Wars of the Roses, more. But for two centuries (or if we count our Guelphs and Ghibellines, *four* centuries) there were *always* wars in Italy, and Machiavelli's writings were largely an effort to understand why. One cause was obvious…

* In fact, the only extended peace recorded in thousands of years of Italian history was under the good gay emperors: Trajan, Hadrian, Antoninus Pius, and Marcus Aurelius, 98–180 CE.

19

Rome: The Eternal Problem City

The papacy's presence was Italy's pride, but also made bad things worse. Each election meant some unpredictable family from some unpredictable town could suddenly command armies, bestow and snatch away fortunes, grant titles, enrich allies, crush enemies, even command cities to go to war if the pope declared the target guilty of some transgression. Families, cities, and regimes reoriented around each new papacy, but within ten years, two years, sometimes a month, it could all melt away and power move from one rising family to their bitterest enemy.

As for the city itself, Renaissance Rome was not a vast trade capital like Naples or Milan; it had never recovered from the Plague of Justinian in 451–2 CE. Papal Rome was a shell, 20,000 to 50,000 residents clustered near the Vatican and at pilgrim sites around the major churches on the edges of the now hollow ancient city built to host a million souls. The papacy was Rome's economy, and as few as 20 percent of those in Rome were Romans, the rest pilgrims, priests in training, and foreign ambassadors with their entourages (foreign including other Italian cities) there to plead their causes with he who held the keys to Heaven, and to many Earthly needs. No industry or city center could take root. Plans changed with every pope, and since the pendulum of politics meant popes were usually replaced by their enemies, each pope hated his predecessor, so, out of sheer spite, dismantled whatever half-built urban reconstruction he'd begun. Nor could such an episodic government rein in the constant micro-war of feuding nobles, nor the city's ineradicable pride (SPQR!). Between popes was the worst, that patch of months (or years) as cardinals

gathered to vote, which meant Rome had no prince, so no law, courts, or police, and, by tradition, new popes were supposed to pardon criminals, so every pope's death was an open invitation to *do your murders now to get away with it!* each new election marked by celebratory looting.

What Rome did to itself and Italy, it did to Europe too. Shakespeare has another telling almost-joke in *King John* (III.i) when the English and French have just sealed a difficult peace, but out of nowhere a Roman cardinal appears to excommunicate King John for selecting an archbishop against the pope's wishes, and commands the King of France to break the peace and invade England. Shakespeare's anti-Catholic exaggeration reflects a real experience familiar to all in Christendom. The pope had a lot more power to start wars than to end them, as Shakespeare shows us later in *King John*, when John repents and the Cardinal commands the French to stop mid-invasion, but France says: *No, I just raised this giant army, I'm not going home!* Just so, when Julius II (with wide-eyed Machiavelli watching) invited all the powers of Europe to attack Venice, he soon discovered that, with the military and engineering techniques available, a land army actually *can't* hurt Venice, the best you can do is sit on the shore and fire cannons into the lagoon. This left every European power with a bored army in Italy, ready like Chekhov's gun, and not about to go home without looting a nice Italian town.

The Church's wealth—which had increased steadily throughout the Middle Ages—meant the papacy could not be apolitical. In every polity, from the smallest town to the greatest kingdom, if roughly 2/5 of the power and money was controlled by the ruler (let's say a duke), another 2/5 was in the hands of other powerful families who *hated* the duke, and 1/5 belonged to the bishop (or cardinal, abbot, abbess, etc.). If the pope makes the duke's brother the bishop, then the duke has 3/5 of the power and rules in peace. If the pope makes the duke's *enemy* the bishop, that's 3/5 to the enemy, cue civil war. If the pope makes his own cousin bishop, he and his family have the duke on a leash for a generation, and *even after that pope is dead* the bishop will still be there demanding bribes in return for not turning the bishop's treasures into bishop's troops. This problem reached far beyond Italy. Remember

our Norse Greenlanders? From 1124 on, the bishop was the greatest power in Greenland, but actually sat on his butt in Denmark sending delegates to carry out his orders, and was selected by a Danish archbishop in an appointment which had to be approved by a distant Italian who had never seen a Viking.

European history exams often have questions about the Investiture Controversy (1076–1122), Avignon Papacy (1309–76), Western Schism (1378–1417), and Henry VIII's break with Rome (1534), but these are just the named peaks of a struggle conducted at a thousand levels in a thousand places—even in the modern world Franco during his dictatorship (1936–75) struggled with the pope to secure the right to appoint and veto Spain's bishops and priests. The Church's wealth and power created a pan-European prisoner's dilemma: if either side in a conflict manipulated the Church, that side would win, so neither side could afford to leave Church offices uncorrupted. This prisoner's dilemma was fractal, operating from the appointment of mighty bishops of Paris, York, or Canterbury who could make or mar the reigns of kings, down to poor neighborhoods where parish priests and local bishops collected rents and decided questions like land rights and annulments, which were as make or break for small families as for Henry VIII. The more wealth Church offices accrued—abbeys growing rich through pious gifts—the more essential it was to send your second son into the Church for power, not piety. This is why young Thomas Aquinas's parents, when he said he wanted to join a Dominican monastery, locked him in a tower to pressure him to agree to join a corrupt and influential Benedictine monastery instead, since back then the Dominicans were nobody. Even the Machiavelli family played the game, and a letter to Machiavelli's brother Totto of January 23, 1503, talks very casually about the family's struggles to secure Totto a clerical appointment by prosecuting the current holder for bribery while also paying bribes themselves.[18]

The higher the stakes in Europe's conflicts, the more no crown in Europe could afford to let the papacy fall into a rival's hands. This brought more foreigners to Rome, more bribes, more wealth, more kings getting their half-brothers appointed cardinals, and—when things tipped too far—the election of a Spanish pope was one of many factors which made France judge

1492 a good time to invade Italy and pursue its old claim to Naples, since France had much to lose if its long-time rival held Saint Peter's throne. Petrarch had lamented that, in his day, Italy was wasting away with the papacy off in France, but Machiavelli, by whose day there were popes in Rome again, concluded that Italy could never be stable or united while the papacy remained lodged in its heart. And both were right.

The picturesque Castel Sant'Angelo, built on the mausoleum of Emperor Hadrian and flanked and crowned by statuary angels. It's easy to forget the Roman popes used this, not only as their prison, vault, and shelter in invasion, but to guard themselves against the Roman people, whose riots, protests, and faction skirmishes were constant in the Eternal Problem City. Pope vs. *popolo*, there's only room for one P in SPQR.

20

Medieval but Ever-So-Much-More-So

Remember: none of this was new in the Renaissance. Italian civil wars and faction fights went back centuries before the Black Death. So did mercenary captains and invasions, capitals like Naples conquered alternately by Norman, French, German, and Spanish dynasties. The other factors that made Renaissance Italy so volatile were also not new. The Middle Ages had seen plenty of changes in trade networks, commodities moving, diseases multiplying, and new war technologies. Banking innovations too had accumulated gradually since the first state-sponsored banks of the mid-1100s, and the tempting fortunes that filled Italian basements in the 1300s were built on smaller tempting fortunes of the centuries before. Certain *specifics* of Italy's woes were new—*specific* feuds, *specific* ways to maim people with cannons—but these continued changes already in motion long before.

Most X-Factors that make us call the Renaissance the birth of modernity are also medieval. Medieval Italy was full of republics with civic participation; young Petrarch's pre-Black Death friends were already reading Cicero. Political innovations were also constant, breaking new ground in law and statecraft; if you ever took history exams you may remember having to learn terms like the Carolingian Empire, the Gregorian Reforms, the Investiture Controversy, each of which was a major change, often involving central powers (like kings or popes) attempting to exert more power over rival powers (like dukes, abbots, or bishops), triggering innovation in spheres from law, administration, and currency to mapmaking and cultural exchange.[19] Those drawn to the Renaissance by art must likewise acknowledge that medieval

artists left their share of gorgeous paintings, literary masterpieces, and towering cathedrals.[20] Those who look to the Renaissance for the roots of secularization can also find key innovations in skeptical thought in such medieval figures as Duns Scotus and William of Ockham.[21] Nor can we call the Renaissance a great conjunction when these changes all combined, since the Middle Ages was full of such conjunctions, the ninth, tenth, eleventh, and twelfth centuries each seeing an explosion of culture. For a while in the History Lab, medievalists struggling to get people to believe the Middle Ages weren't dark and dire tried calling things medieval Renaissances, such as the Carolingian Renaissance and Twelfth-Century Renaissance.

In sum, for everything people have claimed was radically new in the Renaissance, medievalists have their examples, different in details, magnitude, different enough that one can usually propose a certain year as a dividing line, but one can also always argue against any such line. No one in the History Lab uses the term Dark Ages anymore, but our debates and deconstructions of ideas of medieval and Renaissance rarely make it beyond the Lab, so the Dark Ages thrive in movies and op-eds.

When I sit down to articulate the difference between Renaissance and medieval, I always think of the 1951 humor story "Ever So Much More So" by Robert McCloskey (of *Make Way for Ducklings* fame).[22] A traveling peddler comes to town selling a powder called Ever-So-Much-More-So. If you sprinkle it on something, it enhances all its qualities, good and bad. Sprinkle it on a comfy mattress and you get mattress paradise, but if it had a squeaky spring you'll never sleep again for the noise. Sprinkle it on a radio and you'll get better reception, but agonizing squeals when the signal flares. Sprinkle it in delicious coffee and it'll taste more delicious to coffee lovers, but more horrible to a kid who can't endure its bitter taste. Sprinkle it on the Middle Ages and you get the Renaissance. All the key qualities were already there, currents of trade, art, thought, finance, and statecraft, but add some Ever-So-Much-More-So and the intensity increases, birthing an era great and terrible. Many different changes reinforced each other, all in continuity with earlier centuries, just at a higher magnitude, the fat end of a wedge of cheese, but it's the

same cheese on the thin end too. The line we draw—our slice across the cheese—we started drawing because people living in the Renaissance started to draw it, claiming that it was different, and their claims reordered our ideas of history.

But if the Renaissance was so desperate and so terrible, why did it get etched into our history as a golden age? Answer: because they tried to make it one.

21

The Desperate Measure: Reviving Antiquity

Petrarch sent his poem *Italia Mia* out into the world, including in the final stanza his instructions to the poem itself:

> *Song, I warn you*
> *speak with courteous words,*
> *since you must go among proud people,*
> *whose will is already locked in*
> *by ancient and terrible attitudes,*
> *ever inimical to truth.*
> *Seek your fortune*
> *among the great-hearted few whom this message pleases.*
> *Ask them: "Who will defend me?*
> *As I go crying: Peace, peace, peace."*

Petrarch followed this iconic and moving cry of *pace, pace, pace,* with his Latin letters and visits to grand courts, where he plugged his solution: antiquity, antiquity, antiquity. The Romans—our ancestors—they conquered France, Spain, Germany. They united Italy, ending the violent struggles of her tribes. You want peace between Montagues and Capulets, Guelphs and Ghibellines, Florence and Pisa? You want the strength to beat those vast armies that loom across the Alps? You want statesmen who, like the Roman Brutus, would rather execute his sons than overthrow the state? Then raise your sons on what raised faithful Brutus, valiant Caesar, and brave Cicero whose golden tongue tamed mobs, who said a traitor is a plague, and that the safety of people is the highest law. Retrieve the *intellectual technology* that made the *people* who were

Rome, and who were *us*. Rome was a golden age—more golden in Petrarch's descriptions than in reality—when safe, paved roads stretched from Calais to Antioch. The secrets to attain all that waited in books on old library shelves. Technology (geometry, bridge-building, metallurgy) was there too, but the true treasure was the education. Raise the next generation of Italy's elite on the *studia humanitatis*, our counts and dukes, our merchant princes, and we can rear a crop of Ciceros.[23]

Petrarch did not think he lived in a golden age—he thought the next generations could.

That we keep invoking Petrarch in this creation myth is partly (a) the cult of fame, partly (b) that Petrarch genuinely was pretty great, but also partly (c) because so many of the partners of his hopes had died of the Black Death (or bandits), so what might have felt more like a movement largely dwindled to a man. The celebrity poet found many eager ears and friends over the years, especially the ears of wealthy merchants, who could not trust their tiny, friendless city-states to defend the literal piles of gold in their bank basements. It also caught the ears of precarious rulers, like King Robert of Naples (1276–1343), who fought hard against rival claimants, and had even spent time as a hostage and prisoner when the tumults of the Sicilian Vespers tried to oust his grandfather. Precarious monarchs like King Robert needed legitimacy and strength, as much as wealthy bankers needed stability and protection. New families made great by war or merchant gold could never compete in pedigree with descendants of Charlemagne, but the grandeur of the Caesars wasn't blood, it was antiquity.

This sounds abstract, but imagine for a moment that you're a French (or Spanish or Hungarian, etc.) envoy en route to Rome. It's 1430, and you have letters and instructions for your papal ambassador. Florence is on the way, so you're stopping off there, nominally for a rest, but also to scope it out and report back about strengths, weaknesses, and how worthwhile it would be to conquer. If you're an official envoy you're at least the son of a lord or a count, so there isn't anyone in this little merchant republic of sufficient rank to address you as an equal. You know Florence's reputation too, infamous as a center of sodomy, so much so that the verb *to Florentine*

is the word for anal sex in French (and several other languages), while back in Paris you can be indicted for sodomy simply on the grounds of being from Florence or having visited Florence.[24] So you ride into this wretched hive of scum and villainy, but at first glance it's a big city, impressive, dense houses, crowded streets. There's no duke or marquis to host you, so you've arranged to stay with your dad's banker (you have his address at least). On the way you pass a little square church called Orsanmichele with Roman statues integrated into it, big ones too, impressively intact, or… wait, they look new! Yes! They're still installing one, and… two are bronze? But… you didn't know people could *make* bronzes that big, the way the Romans did. That art was lost! Impressive! So you continue on, spotting the bell tower, though the tower's not plain stone like in Paris, it has green and pink marble, costly stuff, you've rarely seen it, from Arabia as you recall. And look at the size of their cathedral! It's not complete, crawling with workers, but you didn't think it possible to build a dome that big!

The cathedral was begun in 1296, but the dome section was built between 1420 and 1436; the trim around its base remains incomplete.

THE DESPERATE MEASURE: REVIVING ANTIQUITY

French cathedrals back at home are massive, but a tower is simple, a dome like that you would have called impossible! And you keep going, north, yes, there's your banker's house, he greets you humbly at the door, bowing and apologizing that his poor home is unworthy to host Your Excellency. But suddenly, as you step inside your breath catches: the inner courtyard is so bright and cool, clean sunlight streaming on white stone, with airy rounded arches, and the breeze so fresh it feels almost like stepping into open countryside from crowded streets. This space is like nothing you've ever seen before, or… wait, no! You have seen this before! It's like the Roman ruins in the backyard of your father's castle back at home. But those are ruins! No one knows how to build like the Romans did, except… Then how… And as the banker leads you further in, he has ancient Roman statues, busts of Caesars, gods, those stunning bodies real enough to spring to life, but, no, these aren't all ancient, some of them are new; that bronze statue of young *David* standing on the head of Goliath is obviously new, the metal hasn't even turned green yet! And also it's super naked!!! like Roman ones, and very sexy so you can't help staring (sodomy capital they say?), and… Wait, what's that sound? People, there in the corner, speaking in a language you don't know. So you ask, "Who are they?" and the banker answers, "Oh, they're Platonists, they're practicing ancient Greek." Your breath catches again. "But ancient Greek is lost! Plato is lost!" "Oh, no, we have lots of Plato here," he answers, "look, here's my nephew Francesco, he's just written a poem about the nature of the soul in mixed Latin and Greek, would you like to hear it?" And now there's a little boy reciting a poem at you in ancient Greek, and your brain is going: *Where am I? This… all this is impossible! These things do not exist!* And all the haughtiness and scorn are gone, as suddenly it's you who feels weak, small, uncultured, staggered by the presence of this power older, vaster, grander, far more real than jousts and battlements and all the trappings of French cities built on Roman ruins. And when he sees you staring and wordless, that's when Cosimo de Medici turns to you and says, "Would your king like to make an alliance?"

Donatello's bronze *David*, 1440s, Museo Bargello, Florence.

And you could say no.

You could say no, we're France, our royal armies just drove back even ambitious England, we're unstoppable. We're going to march in here, and crush these walls, and sack this puny town, and burn these palaces, and loot the gold sacks from within your vaults, and all of this, these impossible time treasures from another age, will vanish like a dream. Or you can say: Yes. Yes, let's make an alliance. Send me an architect, and a bronzesmith, and a Greek tutor, and a Platonist, and I'm going to take them to France, and we'll

do the royal court like this, and the next time envoys come from backwater England yammering about their title to our throne, they're going to *know* our king is Caesar, and they'll feel like uncultured bumpkins, *just like I do now.*

It's a defense mechanism.

If war is politics by other means, then the art, the Greek, the courtyards, all of it, it's war by other means, war waged by tiny city-states that will never win in wars of troops on troops or ships on ships, but Italy will always win the war to have the most antiquity.[25] Cosimo may not have the blood of Charlemagne, but he has busts of Caesars right beside the portraits of his sons, so our ambassador can feel the presence of a different nobility, which awes, intimidates, threatens (bronzesmiths don't just make statues, they make cannons), a nobility which projects power and legitimacy but requires no blood, no title, only the ability to *activate antiquity*. The classical revival has turned antiquity into *a language of power.*

Remember Lorenzo de Medici saying it's dangerous to be rich but not in power? Remember Petrarch saying that if we reconstruct the lost libraries of the ancients we could raise a generation of Caesars and Ciceros? Remember Paul Oskar Kristeller saying Renaissance humanism was an educational system based on the classics? Remember Cosimo de Medici deciding to spend 32 million dollars on the education of his grandson? This is a period when a single book costs as much as a house, so assembling a library is an investment like the moon landing, but if, like the moon landing, it has the power to tip the scales of politics, then it's worth every florin.[26]

So Poggio will learn Latin with Petrarch's friends, and trek across the Alps to search for manuscripts.[27] And his friend Niccolò Niccoli (1364–1437) will bankrupt himself collecting books.[28] And his friend Giovanni Aurispa (1376–1459) will voyage to Constantinople to study Greek and bring back Plato, Homer, and Thucydides. And Cosimo will pay Niccoli's debts if he can keep the books to make his library. And other major Florentine families—the Pazzi, Rucellai, Acciaiuoli, Pandolfini, etc.—will make similar investments in art and culture, and pull similar tricks as they host French allies and other envoys traveling to

Rome. And Cosimo, decades before our haughty noble envoy's visit, will spot that his family physician's son little Marsilio Ficino (1433–99) is clever, and he'll hire a Greek émigré to teach the boy and other bright young Florentines, and give such tutors a stipend and a house, and secure the complete works of Plato still in Greek ($$$$$), so that Ficino can grow up a Platonist, and someday teach Plato to Cosimo's grandsons *who haven't yet been born*. Because that's the scale of patience and planning it takes to raise philosopher princes and make a golden age—or try to. A scale of patience and planning Burckhardt will say makes such a state, or court, or individual *a work of art*.

The imagined vignette above with our visiting envoy is a compression, not an experience which happened once but repeatedly as new innovations arose in ever-more-impressive Florence and Italy. One visitor might see the beginnings of the cathedral, a later visitor Donatello's classical *Saint George*, a third might bring home new classical manuscripts or hire and bring home classical scholars. Poggio was already in England by the 1420s, and classical scholars hard at work in Paris, Barcelona, many places by 1450,[29] but the rich merchant metropolis where banking families competed via art and culture offered visitors glimpses of ever-renewing ostentatious *newness*: a statue here, a poem there, many families at first, mainly the Medici once their power coalesced, but always renewing the assault of art which tempted foreign powers to befriend, not to destroy. For Florence's *ottimati*, as they performed the complex role of non-noble nobility while hosting visiting magnates or mercenaries whom the city hoped to hire, there was eternal reason to invest in the art displays which made one feel noble to nobles but not *too* noble to Florentine citizens, a perfect tool for actually-originally-noble families like the Pazzi or Pandolfini, and more so for the genuinely-never-noble Medici.

This new, rival version of nobility could also be deployed beyond Florence. The election of a new pope was always marked by obedience missions, when every power in Christendom sent a super prestigious envoy—often a kinsman of the monarch—to take an oath of obedience to the new pontiff and deliver a speech of congratulations. How the pope received these speeches, and with what honors ambassadors were met, was a Big Deal

politically, and different ranked polities got different receptions: a special grand audience for the emperor, kings, Venice's royal republic,* and the few most powerful sovereign duchies like Burgundy, lesser receptions for more humble city-states. A pope might signal his diplomatic plans by hearing the envoy for the King of Aragon before the King of France or vice versa. The speeches themselves could be rather vacuous—at a talk in the History Lab, the inestimable historian Margaret Meserve once summarized them as all saying, "I come from the wonderful ruler of a powerful country, and he's so glad you're pope!"[30]—but in the 1400s Florentine *umanisti* started giving massively elaborate hour-plus Latin obedience orations, which generated such excitement that Florence started to be invited to give its speech in the elite chamber reserved for receiving kings and emperors, our dorky merchant republic receiving royal honors with the world's eye upon it, all because its Latin was just that good![31] Once Florence did it, other nations started hiring *umanisti* to capitalize on this momentum, until the scholar Enea Silvio Piccolomini (1405–64), on being elected Pope Pius II, had the hilarious experience of being greeted by one envoy with a plagiarized version of a speech he himself had written as a hired *umanista* for another pope years before.[32]

* Since, after 1473, Venice ruled Cyprus, which was a kingdom, the Republic of Venice was King of Cyprus, its envoys and heraldry entitled to the same status as those of Kings of France, Aragon, etc., a different approach from Florence's classicism but with the same goal of giving a republic diplomatic peer status with kings.

INTERMISSION

Are You Remembering Not to Believe Me?

At this point I must remind you that you promised to read this section keeping in mind that Ada Palmer started studying the Renaissance because she was excited by how the First World War shaped twentieth-century literature and Freud's *death instinct*. The shelf this book came from had ten other books which all agree the classical revival was core to the Renaissance, but which will give different versions of its cause. Most of them are *also* right.

Civilization-scale shifts don't happen for one reason, and if war and trauma were the only cause of the Renaissance, then the First World War would have caused a classical revival, and the War of the League of Cambrai would have caused Machiavelli to discover Freud's *death instinct*. Banking and finance, the gradual centralization of power in kingdoms and duchies, republican political thought, demographic changes after the Black Death, the Little Ice Age, a sense of national or regional identity. These causes are all also real, as are others I haven't yet discussed: changes in the Byzantine world, legal reforms, religious reform movements like that of Saint Francis of Assisi, many more. I'm showing you the Renaissance as a desperate time because it's what I see, what helps me understand, both what I'm looking at, and how to cut through the propaganda around the bad Middle Ages. But remember to believe in other causes too, just mixed with desperate times, just as the many cultural fruits of the Cold War were shaped by a range of factors, of which fear of global annihilation was a big one, but not the only one.

22

Antiquity Was Not New Either

Using antiquity for legitimacy and cultural intimidation was another case of Ever-So-Much-More-So. The Middle Ages used antiquity all the time, invoked it, made Ovid and Vergil* backbones of education, incorporated ancient statues into churches, and styled its new empires after Caesars.³³

Also, the Middle Ages (very important) *did have all these books!* Book-hunters like Poggio and Giovanni Aurispa didn't drag these books out of ancient tombs like Indiana Jones, or reconstruct them from the ashes of Vesuvius with X-rays like we're doing today. Poggio found the books in monastery libraries, sitting safe and sound, and Aurispa bought them in Constantinople which was *right there*, had always been right there, anyone could go there anytime and get them. *And they did.* The Middle Ages did seek out new ancient books, producing many manuscripts, especially in the ninth and twelfth centuries, which made great efforts to acquire new works of Aristotle, and the best Arabic commentaries too.³⁴ Henry Aristippus of Catania (*c.*1105–62) translated Plato's *Meno* and *Phaedo* in the twelfth century. Medieval scholars absolutely sought out new/old books that contributed to *their* moonshot

* You've often seen it spelled *Virgil*, but it was *Vergil* in antiquity. People started writing it with an i because it looks like virgin, and the ancient *Vita Virgilii* said the poet was nicknamed *Parthenias* (as in Athena's epithet *Parthenos* = virgin), though the Middle Ages added the association *virga* (magic wand), since by then many believed Vergil had been a master sorcerer, who could repel vermin, animate automata, make walls impregnable, curse people to shoot fire from their orifices, etc., while many in the Renaissance believed Vergil's ghost still walked the Earth teaching magic to scholars like Petrarch, who was accused of using necromancy to summon Vergil's spirit. Many such tales were recorded by chronicler Gervase of Tilbury (*c.*1150-1220); see the articles by Fabio Stok.

projects. The friends who read Cicero with Petrarch drew heavily, not only on manuscripts made by scholars of the century before, but on their methods, benefiting from a long continuity of classics study which had innovated throughout the Middle Ages, innovations largely erased by the Renaissance's propagandistic claim to be starting something new.

Renaissance *umanisti* did have different *goals* in their project from the goals of Cicero's readers in 1200 or 1100, so they looked for different books, and used the same books in new ways. They also changed the *status* of the classics compared to other disciplines and books. In many forms of medieval education, the classics were viewed as a lower subject than high philosophy, theology, or even law or medicine, Cicero, Ovid, Vergil and such serving as preparatory readings which one studied at an intermediate level, often in grammar courses, to master Latin well enough to be ready for the major stuff, like Aquinas or Galen. The kings and clerics who funded the great medieval libraries had put their theological collections foremost (most prominent shelves, most costly decorations) with classics sitting humbly on back shelves, present and used, but not in the spotlight. Big Renaissance collectors simply reversed that, still owning and using all the theological stuff (the Church was still big bucks) but now the theology sat in the back, the classics in the front in the newest, shiniest manuscripts; same texts reorganized for the new vogue of the era. Thus this self-conscious movement loudly declared that it was something *special, new, ambitious, daring, powerful*, distancing its activities from past uses of antiquity, whether through simple changes of shelving and decoration, or through tools like Bruni's history, and the new Latin style, which strove to feel different from other Latin, using rare vocabulary and irregular grammar *as much as possible* precisely because medieval Latin didn't.* They worked hard to seem different.

* What's medieval Latin like? Think of being in a language classroom, and the teacher explains, "You can express [grammatical thing] one of three ways: A and B which use complicated difficult verb forms, or C which is super simple." Medieval Latin—optimized for non-native-speakers—abandoned A and B and always used easy option C. It also preferred or created words that matched local vernaculars, just as an English speaker trying to communicate *especially* in French is more likely to say *exceptionnellement*, but a French speaker *comme tout*.

Renaissance neoclassical Latin—the Latin of the *umanisti*—remains the hardest Latin ever penned, because the goal was not to convey information but to convey mastery; if ordinary speech is the equivalent of walking, then the opening paragraphs of a Renaissance work is an elaborate gymnastic routine designed, not to get to the other side, but to show off how many back flips you could do while getting there. With the Latin of such *umanisti*, if your reader ends up thinking, *Boy, my Latin is not good enough!* you win. [*Brief rant:* Seriously, I once gave an entire conference paper on the opening sentence of Pomponio Leto's life of Lucretius and how many ridiculous unnecessary rare grammatical forms he uses just to make it hard to understand! It includes three different obscure participial constructions *for no reason*, and quotes Varro deceptively out of context, making a quote seem to be about taxonomies of knowledge that's actually about poultry farming! *Poultry farming!!!* Just to trick you into thinking Leto knows a source you don't![35] I collect Leto's cruelest sentences to send to Latin teacher friends who use them to punish classroom troublemakers, and boy does it work! *End rant.*] This practice is also what birthed the stock comedy character of the fatuous Latin pedant, as seen in *Commedia dell'Arte* and Shakespeare's *Love's Labour's Lost*, proof that even the general theater public was familiar enough with such Latin duels to laugh at a clown saying to a scholar's page, "I marvel thy master hath not eaten thee for a word; thou art not so long by the head as honorificabilitudinitatibus." (V.i).

Just as using the classics was not new but Ever-So-Much-Moreso, using art and architecture to project power was also nothing new. Medieval masterworks like the great Gothic cathedrals were built long before Florence's dome, and for the same reasons: to please God and the saints (the true deciders of all victories) and to display a city's wealth, power, and engineering skills, which both raise towers and topple them. Both Florence's project to build a new cathedral and its pink and green bell tower predated Petrarch, as did Giotto's innovative frescoes kicking off the shifts in painting. But as the classicizing project began, these developments—already underway—merged with the rhetoric of a golden age. Think of that funny square church in Florence, Orsanmichele, which used to be the grain market, a medieval

building, and it was (by most metrics) still the Middle Ages when the Madonna inside guarded people from the plague, but when the city decided to make it into a church, and the guilds competed to each make the best statue to decorate it, the decision to try *classically styled* statues draped in Roman grandeur—including Donatello's Caesar-esque *Saint George* with its new take on knighthood—merged this medieval space and project with the classicizing movement.

Florence's cathedral too was a project that spanned medieval and Renaissance. It was funded, partly by the city, but largely by the wool guild (Big Wool was huge, think of it like an auto manufacturer investing in a stadium). The plan called for a larger dome than had ever been built, a design Florence committed to in 1296, before Petrarch was born, but without a plan for how actually to do it: they just knew it would take a century to build the foundation and walls and figured that, by the time it was Dome O'Clock, some clever Florentine would figure out this hitherto impossible engineering miracle. They were right, but the dome executed by Brunelleschi was enabled by his study of Roman sites, and reading of Vitruvius, freshly recovered by book-hunting Poggio. Thus, the dome was a triumph of the classicizing project even though it had been started long before.

This is also how even the Renaissance innovations that didn't start in Italy get caught up in the Italian Renaissance. Polyphonic music was medieval, mature enough to be banned from liturgical music by 1322 by curmudgeonly clergy (kids these days with their vocal harmony...), and the Renaissance's main innovations in polyphony centered in the Burgundian Netherlands (Not Italy™). Yet the courts that could afford such costly music were the same ones that could afford expensive busts and frescoes, so many of the best composers moved from Burgundy to wealthy Italy, where patrons asked for classical themes, which became so standard that even the English polyphonic composers prospering in the 1500s wrote songs about Italian shepherds and bits of Vergil.

In sum, while art, music, and classicizing culture were absolutely tools of power in the Middle Ages, and in many centers beyond Italy, what made this new movement different was largely that people said it was different, believed it was different, and

claimed and felt that they were part of a project to transform the world on an unprecedented scale. This project aspired to social engineering, or at least era engineering, palaces being erected and orations written, not to glorify a single king, but to create an age of peace out of an age of strife. As "Can we have a golden age?" asked by Petrarch's generation became Bruni's three-part historical division, "Yes, we are making a golden age!" choosing to write *classicizing* Latin, or to build a *classicizing* church declared one's membership in a movement focused on change, hope, and the ambition to be the instruments of a new era. People and projects became Renaissance because they decided to start believing in a Middle Age, and that they were creating something different.

This difference was both small and not small. Dante—whose life overlapped with Petrarch's—had discussed history's events as God's doing, God the Playwright sending players out onto the stage (conquests, peaces, wars, declines) all scripted to teach humanity about God's power and about virtue, but with humans as the actors, not the shapers of events. Petrarch's idea that humans might change history *on purpose* was not a rejection of Providence—Petrarch's deep Christian piety shows all over, and he agonized all his life about whether he was sinning by loving Cicero (a pagan) so much, fretting as Saint Jerome had fretted centuries before. (You can find Renaissance paintings of the dream Saint Jerome had in which angels beat him as punishment for reading pagans, and of him beating himself with a rock to try to purge his love for Cicero.) Petrarch, like Dante and Jerome, believed in Providence, but he also felt that, when saints save people or heroes win battles, saints and heroes deserve credit for those deeds *even though* they were part of God's plan. Just so, *umanisti* could aspire to be instruments of renewal if the Creator willed it so. It would only work, in their view, if God was willing, but the project still had a sense of intentional change, of *anthropogenic* change, of humans choosing and causing change—the kind of anthropogenic change we now call *progress*. The difference between this and medieval aspirations was slight, our stream widening just a little, but each small widening transforms the river, and what life can thrive within.

23

The Umanista's *Rival: Scholasticism*

If we had had a time machine and asked someone in 1450 to define what the *umanisti* were doing, there's one answer we're pretty confident they'd give: *not scholasticism*.

Scholasticism was the new, hot, sexy, cutting-edge innovation that dominated late medieval education, and would continue to dominate schools and universities through the Renaissance and beyond.[36] The proto-version of the scholastic method (the scholastic before there were scholastics, as Petrarch was a Renaissance classicizer before there was Renaissance classicism) we locate in passionate theologian-statesman Saint Anselm of Canterbury, or of Aosta, or of Bec (1033–1109; everyone wants to claim him, so different people call him after the place where he spent time in *their* country). After Anselm, scholasticism was popularized by intellectual mega-rockstar Peter Abelard (*c*.1079–1142), and polished to a high art by subtle Duns Scotus (*c*.1266–1308), tricksy William of Ockham (1287–1347), and all-time world theology boxing champion Saint Thomas Aquinas (1225–74). The new scholastic method was *so exciting!* that when Peter Abelard got kicked out of his monastery (for proving its founding saint didn't exist—that pissed off the abbot, who'd have guessed?) and went to live as a hermit in the wilderness of Champagne, 100,000 people flocked there to form a tent city and listen to him teach. Abelard's crowd wasn't bigger than Woodstock but it was *twice the size of Paris* at the time, ample to make France fear that crowd + superstar preacher => private army? Later, when Thomas Aquinas was up for sainthood, his advocates argued that every single chapter in his

THE *UMANISTA*'S RIVAL: SCHOLASTICISM

Summa Theologica should be considered an individual miracle, and the judges agreed. (It's official folks, 3,000+ miracles in one compact paperback, only $12.99! Unless you want to buy it in the period, in which case it's $650,000; you don't get scholarship before the printing press unless wealthy elites believe it's really, really worth the $$$!)

What was so exciting? Scholasticism is going to sound really boring for the first paragraph, but will turn out to be the antidote to... certain death!

The seven liberal arts (*artes liberales*) were already well established by the days of Boethius (500 CE), and divided studies into the *trivium*—grammar, logic, and rhetoric, i.e. stuff that uses words—and the *quadrivium*—music, arithmetic, geometry, and astronomy/astrology, i.e. stuff that uses math. Scholasticism taught the *trivium*, but made *logic* queen, especially very technical chains of dialectical reasoning. Do you remember, in geometry class, when you had to write out a tedious thirty-two-step proof that the angles of a triangle had the ratio that you already knew from the start they had, so why bother? This is that method, but used for constructing thirty-two-step proofs that mercy is good, that truth is superior to ignorance, or that the universe exists. Scholasticism based its methods on one of the most influential books in world history: Aristotle's *Organon* (*The Instrument*), a collection of Aristotle's works on logic, consisting of (at its largest) the *Categories, On Interpretation, Prior Analytics, Posterior Analytics, Topics,* and *On Sophistical Refutations.* The *Categories* and *On Interpretation* were the most influential, and had been available throughout the Middle Ages in the Latin translation by Boethius, while other bits hit Europe later via manuscripts brought from Constantinople, like the *Posterior Analytics* translated by James of Venice in the mid-1100s. As you have likely heard, Aristotle had a lot of very important ideas about political thought, forms of government, ethics, law, the famous "golden mean," empiricism, animal taxonomy, how to refute Plato's insistence on immaterial *ideas*, the three parts of the soul and their balance, etc. *The* Organon *was not any of those things.* It was a manual for constructing meticulous multi-step proofs out of chains of syllogisms, thus:

- All animals are mortal. All humans are animals. Therefore, all humans are mortal.
- All humans are mortal. Socrates is a human. Therefore, Socrates is mortal.
- All mortal things change. Socrates is mortal. Therefore, Socrates changes.
- All things that change dwell below the celestial sphere of the Moon. Socrates changes. Therefore, Socrates does not live in outer space.

A real scholastic syllogism would've had a whole chapter carefully defining each of these terms (animal, mortal, change, superlunary vs. sublunary, etc.) and meticulously establishing how we know that all mortal things change, and that all things that change dwell below the sphere of the Moon, etc. (everything above that just goes in eternal circles, haven't you looked up?!).

Aristotle used this kind of logic, and very painstaking definitions of terms, as a way to reduce error and confusion in communication. He believed that most confusion in philosophy (and indeed in life) was caused by ambiguous terms:

- "Pass me my sweater." "Here you go." "No, the sweater! That's a cardigan!"
- "No fishing in the sanctuary." "I've caught an octopus!" "An octopus is a fish." "No it isn't!"
- "Was the court's sentence just?" "Yes, because the person was guilty." "No, because the sentence was too severe!" "What makes a sentence just anyway?"
- "A thing cannot both exist and not exist at the same time." "Aha, what about a doughnut hole!" "That's just a misleading name for a small spherical doughnut, it's not actually the same thing as the hole in a doughnut." "But it's called a doughnut hole!"

THE *UMANISTA*'S RIVAL: SCHOLASTICISM

Aristotle (who would have had no patience with doughnut holes) believed that if one developed a very clear technical vocabulary, in which each term was defined using a combination of empirical observation and chains of patient syllogisms (Is justice the absolute prevention of harm, or a balancing of harms to minimize harm? What is harm?) then a lot of philosophical questions, as well as legal and political questions, could be discussed clearly, with everyone understanding what all others mean, resulting in much less strife and error.

Contrary to what most people expect, while Aristotle was such a huge deal in the Middle Ages that you could say *The Philosopher* and people knew you must mean Aristotle, his was actually the least popular of the ancient philosophical schools (beaten out by Platonists, Stoics, Skeptics, and Epicureans). So, at the end of antiquity when the old papyri were crumbling and Boethius was racing to translate only the most precious works before they were lost, he didn't bother with any of the books about how Aristotle thought the world or soul or politics or ethics works, he focused on the works on logic, how to do meticulous proofs, something applicable to *any* philosophical system, even Christianity. It was this which left medieval Europe with the *Organon*, and which made *The Philosopher* a synonym for *logic* textbooks. So, in the 1000s, when scholastics got a hold of the *Organon*, they used its methods to prove things about theology—instead of twenty-seven steps to prove two angles in a triangle are equal, or that justice is a balance of harms, it was 127 steps to prove that God is Good.

Why was this so exciting to medieval people?

Well, when a kid sick of geometry class complains to Mom, if she's an architect she'll answer that it's really important to be absolutely sure those angles in the triangle are equal, because if you're wrong the building will fall down and everyone will die. If a kid in Aristotle's classroom complains to Aristotle, he'll say that if you come to a false conclusion about justice you might pass an unjust law. If a kid in scholastic logic class complains to Thomas Aquinas, he'll say that if you come to a false conclusion in theology, then you're *damned to eternal torment and Hellfire forever and ever and ever, and so is everyone who reads your book*. Medieval theology was higher stakes than Aristotle defining systems of

government, it was even higher stakes than architecture, it was super-mega-high-risk tightrope-over-a-lava-pit-with-alligators high-stakes, *and it was contagious!* It wasn't just your soul at risk, but thousands around you. So, when theologians saw that Aristotle's *Organon* had step-by-step instructions for how to do logical proofs *without the possibility of error*, they saw a safety net over the lava pit. (Note: Aristotle = *also* antiquity; medieval people *were* using it, just in different ways.)

Peter Abelard in particular was the master of coping when doctrine painted itself into a corner. By 1100 there had been a lot of theologian saints, and the stuff they said had entered the canon of the Church, but some of the stuff directly contradicts the other stuff, so... panic? Rather than arriving at God-is-unknowable-so-don't-try (which, contrary to a lot of claims, is mostly a Reformation innovation, *not* a common position in ancient or medieval Christianity), Abelard used logic chains to reconcile seemingly conflicting authorities. This passage from Saint Jerome *seems* to contradict this line from Saint Augustine (in that they say opposite things!), but if Abelard starts with a thirty-two-step proof that God is Good, and lands a triple-axel-triple-toe-loop combo jump, he can show that Jerome actually means the opposite of what he seems to say and Jerome and Augustine really agree! (Score 108.12, applause and sighs of relief as the Hellfire lava pit seems to recede.) Hence the title of Abelard's logic textbook, *Sic et non*, that is, *Yes and No*. Abelard was also as extraordinarily belligerent as he was glamorous and charismatic, and his talent at making an argument with an intellectual rival as dramatic as a cockfight or a bear baiting was a major reason this period saw philosophical and theological debates become a new form of thrilling public tournament. People in 1100 genuinely would line up to see monks from two orders, or a Christian and a Jewish theologian, debate in front of the king, and, love him or hate him, Abelard excited crowds like no one else.

In the next generation, Thomas Aquinas was even more exciting than Abelard, because he didn't just land triple axels and reconcile Church Fathers, he took on some of the biggest questions in medieval theology, like whether the *soul* is the self or the *body* is also essential to the self. Scripture says there will be a *bodily*

THE *UMANISTA*'S RIVAL: SCHOLASTICISM

resurrection at Judgment Day, which makes it sound like the body is important, but on the other hand people in Heaven right now don't have bodies and surely the saints can't be sitting around in Heaven saying, "Sure sucks having no body." So, do souls need bodies or not? Yes *and* no, as Peter Abelard might say: two triple jump combos later, with a bunch of technical vocabulary involving the components of cognition, Aquinas argues that the physical body (brain) is essential for cognition, but that God's essence *substitutes for* the missing physical parts while people are in Heaven, and the super special perfected bodies made at resurrection will be even niftier, allowing the resurrected blessed to function fully without God's help. Doctrinal Christianity can now have its cake and eat it too.

Thomas Aquinas and his Thomist followers soon developed a rival in Duns Scotus (c.1266–1308). Scotists (connected with the Franciscans) and Thomists (connected with the Dominicans) differed mainly on whether *knowing/understanding* God or *loving/desiring* God is the best route to Heaven, the Dominicans backing knowledge and the Franciscans love. While the Thomists were dominant enough that Dunce as in "Dunce cap" was coined from *Duns* Scotus, i.e. the kid in the class so foolish they believe Scotus over Aquinas; yet, as with many intellectual disputes, the rivalry itself was enormously fruitful, generating fame and awe for all involved.

So, scholasticism was supercalifragilisticexpialidociously exciting—or, as they would've said in the period, *honorificabilitudinitatibusly* exciting, from scholastic Latin's infamous longest word. But scholasticism was also interminably technical, and you had to study its tools and terminology for years, memorizing definitions and types of syllogism, to get your safety certification to be considered ready to handle the deadly toxic nuclear-enriched uranium that was high-stakes theology. Scholasticism's opacity was a feature, not a bug, impenetrable technical language keeping non-experts safe from texts which, if even very slightly misunderstood, could reopen the pit to certain doom. This impenetrability of scholastic writing did not go unchallenged in the period. William of Ockham (c.1287–1347), known today for Ockham's razor, argued that the whole system was much too complicated,

requiring too many elaborate definitions of things like the components of the cognitive organism, so he proposed... *to simplify it?* No! To replace it with a set of even more elaborate technical definitions for the components of concept formation! This was the *via moderna* in contrast with the Thomist/Scotist *via antiqua*. It doesn't sound very modern, and in most ways it wasn't, but Ockham's *via moderna* was actually a major step toward John Locke's *tabula rasa*, it just took another 350 years to catch on—a not uncommon wait time in the history of ideas.

The dukes and kings and wealthy abbots who could afford the libraries to do scholasticism were happy to pay for training experts, since there was nothing more useful personally (to your soul) or publicly (to your kingdom and its legitimacy) than understanding and pleasing the God who was the source of the universe, sender of plagues, granter of victories, planner of changes, and setter up and plucker down of kings. Elites funded monasteries, scriptoria, and grand libraries like the great University Library of Paris which, by 1300, had (brace yourself) 600 books! There's no corner book kiosk in an airport today that doesn't have more than 600 books, but remember that in 1300, 600 books cost at least $200 million dollars, and most of these were big, high-end books which cost a lot more than that.[37] Ambitious fathers were also happy to pay for their second sons to study scholasticism and go on to get good jobs. (For example, a Danish noble might study in Paris and someday be appointed Bishop of Iceland and Greenland! And get a handsome salary while totally slacking off in Denmark ignoring the needs of the Norse settlement!) But scholastic study could also be increeeeeeeeedibly boooooooring, so you had a lot of youths who hated it, and wanted something different. By 1400 scholasticism was ripe for a rival: the classicizing *studia humanitatis*. (Important: the *studia humanitatis* could *also* be incredibly boring, and had its fair share of classroom refugees in later decades...)

Scholasticism being ripe for a rival does *not* mean it was ripe for *replacement*. We tend to teach intellectual waves as if the old one stops when the next one starts, but this river is widening, not turning from one river into another. Scholastic education thrived throughout the Renaissance, and there were always more

scholastic classrooms than there were teaching the *studia humanitatis*. For a long time, historians accepted the claims of *umanisti* that they had replaced dry and pedantic medieval scholasticism, but even calling it *medieval* scholasticism is deceptive, since we have more scholastic material written *after* the Middle Ages than in them, and scholastic classrooms (many Jesuit-run) were all over Europe and its empires throughout the Enlightenment, and indeed today. Also, practitioners of the *studia humanitatis* read scholastic authors, studied them in school, treated them as authorities, and grappled with their ideas. Pico della Mirandola (of not-an-Oration not-on-the-Dignity-of-Man fame) even wrote a scholastic treatise just to prove he could. But *umanisti* wouldn't praise scholastics or quote their *ugly, un-classical* Latin, instead treating it as the rival they defined themselves against. Many scholastics also studied the *studia humanitatis*, and, as years passed, scholastic-dominated universities started hiring *umanisti* to teach ethics, rhetoric, Seneca, etc. Scholasticism thrived alongside (and often more broadly than) the *studia humanitatis*, but the self-consciously classicizing elements of the latter were a distinct innovation, which joined scholasticism as one more strand in the European intellectual braid.

24

Studia Humanitatis—*The Words That Sting and Bite*

Petrarch *hated* scholastics. He hated, hated, hated them. And at least a few very vocal scholastics hated Petrarch. Petrarch made this rivalry into a *big* *thing*, publishing invectives against the scholastics' invectives against him (fights make fame), in which he defined his classicizing educational model in contrast with bad, rigid, tedious, inelegant scholasticism.[38] To teach leaders to be virtuous and good, we didn't need plodding Aristotelian logic spinning out fifty-step proofs that it's beneficial to have a virtuous soul—those can persuade someone *intellectually* that it's good to be virtuous, but can't *move people's emotions* and make them *want* to be good. For that we needed passion, persuasion, the "words that sting and bite," as Petrarch called them, words that make you *want* to be good, make you love it, feel it, thrill inside at the thought of the great person you could become. Aristotle might be supreme in logic, Plato in philosophy, and Christian fathers like Augustine and Boethius in the truth of the religious life, but no one, Petrarch said, could match Romans like Cicero and Seneca in spurring the soul toward excellence. We needed *rhetoric*, not *logic*, to be queen of the *trivium*. Let the scholastics spin out their proofs, but to stabilize a world on fire we need tutors who can sting like gadflies and lure with sweetest honeyed poetry. History too, examples of great men to serve as moral exemplars, emotionally moving anecdotes of temperance, generosity, clemency, and prudence, contrasted with the vices of bad men; these stories stick in memory, move the imagination, and inspire the soul. This would be the focus of the *studia humanitatis*—this and extremely

thorough memorization of a hungajillion irregular Latin grammatical forms, which we will use all the time to make our Latin impossibly difficult and clearly different from those bad scholastics! (Thus, the *studia humanitatis* was just as capable of being super boring as scholasticism.)

The idea that the elegant words and lofty exemplars in Greek and Roman classics provided a potent *moral* education remained and still remains core to modern ideas of the humanities.[39] One can find descriptions of this power of the classics written centuries later. This, from Mary Shelley's *Frankenstein* (1818), could almost have come from Petrarch's pen, expecting that the monster, happening upon a book by a classical author *in the raw with no teacher, guidance, or educational structure*, nonetheless feels his intellect stirred to high things:

> The volume of *Plutarch's Lives* which I possessed contained the histories of the first founders of the ancient republics. This book had a far different effect upon me from *the Sorrows of Werther*. I learned from Werther's imaginations despondency and gloom, but Plutarch taught me high thoughts; he elevated me above the wretched sphere of my own reflections, to admire and love the heroes of past ages. Many things I read surpassed my understanding and experience. I had a very confused knowledge of kingdoms, wide extents of country, mighty rivers, and boundless seas. But I was perfectly unacquainted with towns and large assemblages of men. The cottage of my protectors had been the only school in which I had studied human nature, but this book developed new and mightier scenes of action. I read of men concerned in public affairs, governing or massacring their species. I felt the greatest ardor for virtue rise within me, and abhorrence for vice, as far as I understood the signification of those terms, relative as they were, as I applied them, to pleasure and pain alone. Induced by these feelings, I was of course led to admire peaceable lawgivers, Numa, Solon, and Lycurgus, in preference to Romulus and Theseus. The patriarchal lives of my protectors caused these impressions to take a firm hold on my mind; perhaps, if my first introduction to humanity had been made by a young soldier, burning for glory and slaughter, I should have been imbued with different sensations.[40]

A typical Florentine *Charity*: crowned, nursing an infant (as in ancient versions), holding the flame of patriotic passion. This one is the central panel of the *Seven Virtues* made for the merchant court (Piero del Pollaiolo and Botticelli, 1469–70). Other prominent Florentine depictions include Charity positioned directly below Christ in the Last Judgment inside the cathedral dome (Vasari and Zuccari, 1572–9), and the Charity in the *Seven Virtues* on the Loggia dei Lanzi, a roofed area for public ceremonies facing the Palazzo Vecchio, built 1376–82 using captive labor from Pisa.

Here virtue and vice flow from the ancients, examples of both peaceful and warlike heroes which, as Shelley acknowledges in the final sentence, could be used to justify war and conquest just as easily as Petrarch's longed-for peace—a fact which will matter much as this new movement spreads across a war-torn Europe where most of those wealthy enough to support a library were conquerors or aspiring conquerors, eager to justify their conquests. *Courage* and *fortitude* were—in the period—core virtues, and *charity* (especially in Florence) was associated with patriotism, faithfully aiding and giving to one's fellow countrymen, so even conquering a neighbor to make your country rich could be considered *charity*, since it helped *your people*, irrespective of the sufferings of the conquered (we can feel here the ideologies which Europe will use to justify the atrocities of its global empires).

But for Petrarch, and for many of the scholar-intellectuals of whom his voice is the most famous, the *studia humanitatis* was Cicero's *phil-anthrôpía*, love of humanity, its main aspiration *pace, pace, pace*.

So, hoping to raise peaceful Solons more than warlike Romuli, Petrarch and his friends wrote poems, letters, dialogs, and grand orations extolling patience, charity, prudence, modesty, and loyalty, while mocking and condemning selfishness, ambition, hate, and pride. The letters flew across Europe, copied over and over as they traveled from town to town, read by hundreds beyond the addressees.[41] Petrarch's *Remedies Against Fortune Fair and Foul* (*De Remediis Contra Fortuna*) is another great exemplar, offering moving and humorous dialogs, modeled on Socrates and Cicero, intended to armor the reader against harmful passions like fear and grief, and against the equally harmful passions of pride and overconfidence.[42] In the dialogs, Reason personified debates with either Joy personified or Sorrow personified, offering warnings. Paraphrased:

Sorrow: I have enemies.
Reason: Then make yourself a friend of justice, which is always the best defense.
Sorrow: But I have lots and lots of enemies, hounding me everywhere.

Reason: They too are being hounded by the passions inside them—fear, hate, envy—which drive them to do cruel things; remind yourself that these passions are already avenging you, and concentrate on more important things.
Sorrow: I'm afraid of war.
Reason: Then let that fear move you to work hard for peace! And if peacemaking fails, let that fear turn to caution, which will guide you toward the best actions in war.

Joy: I'm smart!
Reason: Then make certain to direct your mind toward good, for a cunning mind badly directed will lead you to do great evil, and suffer great misery.
Joy: My homeland is excellent and respected!
Reason: But is it respected for good reasons? Many call nations excellent because they possess much land, rich crops, strong armies, stores of gold, but isn't the most important thing to live in a land with fair judges, and just laws? When Vergil called Rome great, he did not boast of her empire, wealth, or conquests, only that she was blessed with excellent people.

Joy: I've got a ton of books!
Reason: Then you'll never finish reading them all.
Joy: So many books!
Reason: I bet those books are heavy and expensive to transport.
Joy: I possess countless books!
Reason: Then they contain countless errors, so you will never in your lifetime, or even in your heirs' lifetimes, correct them all.
Joy: I'm a popular author, and my books are being read in faraway lands!
Reason: Then people in faraway lands are criticizing you! And misinterpreting and nitpicking your well-meant words while you aren't there to defend yourself![43]

Such playful stings, said Petrarch, could prick the soul toward virtue better than plodding syllogisms, and it's true that jokes are rare in scholasticism. (Though I don't think I've laughed harder in

my life than when I was using Dr Ludwig Ott's 1952 compressed theology conspectus *Fundamentals of Catholic Dogma* and, when I looked up *beatific vision* in the index, it said "see, God.")

Moral education was the promise of the *studia humanitatis*, improvement of the soul through the acquisition of virtue. Beautiful Ciceronian Latin not only let you display how *different* you were—use of rare participles proof of being *umanista* not *scholasticus*—it would also make you more persuasive, able to craft words that sting and bite, and make souls *want* to be good. If this could sting the hearts of Italy toward virtue, we might soon see a generation when Montague and Capulet realize their rivals' internal griefs are vengeance enough, and let feuds end. Better yet, if kings like Petrarch's friend Robert of Naples trust their heirs to the *studia humanitatis*, we might see philosopher princes who recognize that the true glories which make a nation great are wise rule, just laws, and peace, not vainglorious conquest and spilled blood. *Tranquility of the soul* had been a goal of ancient thought from Plato well past Cicero, wisdom the armor against drowning grief, and storming rage, and quaking fear, and wracking pain, and even fiery ambition—princes free from these would rule with prudent calm. Here lay the balm for wounded Italy, hope for a golden age. A generation of pseudo-Romans would end the civil broils, and new Vergils and Ovids would charm Europe with immortal verses. It was an idealist's dream, but, in a desperate world that had no other plan, it was a lifeline. Upstart families without pedigree could raise sons on Latin and Greek, producing youths more princely than princes. Many beyond Florence wanted this alternate nobility, since Italy's rulers had a *major* paucity of blood legitimacy, so much so that the Knights Hospitaller, who required members to have four quarterings of nobility (proof of 100 percent noble ancestors back four generations) required only two generations for Italians, since every duke and prince in the peninsula had a low-born mercenary or merchant's daughter somewhere in their recent ancestry.

So envoys visiting Italy found themselves gaping at impossible bronze statues, struck dumb by ornate orations, and dazzled by bright, airy spaces like the Roman ruins that still studded Europe's countryside. These things were not grander than Gothic

cathedrals, nor were the works of *umanisti* more sophisticated than medieval literary traditions, but the in-your-face *novelty* of the new style (in art and text) was powerful, more so since it used the cultural vocabulary of antiquity. This cultural vocabulary was already legible to everyone in Europe, since it had been in use throughout the Middle Ages, but only now was it paired with the claim that it could make a golden age.

Important proviso #1: The ideas of virtue celebrated by classicizing *umanisti* were very Christian as well as very pagan. Scholars saw Seneca speak of temperance, charity, patience, forgiveness, and were excited by how much these matched Christian virtues. Rather than seeing these as separate from Christianity, they believed that, if wise ancients without the aid of revelation independently arrived at the same ethics as Christianity, this was proof of God's hand moving in the pagans too.[44] Seneca they saw as so quasi-Christian that, in the Middle Ages and Renaissance, it was popularly believed that Seneca was friends with Saint Paul, and a set of fake letters between Paul and Seneca more popular than real Senecan texts.[45] Even Saint Augustine had said Vergil was one of several divinely-inspired "Gentile prophets" and that his Fourth Eclogue (which we now think aimed to butter up the Emperor Augustus) prophesied the coming of Christ (step one of Vergil's reputation as a master sorcerer). Petrarch himself had anxieties lifelong about loving pagan writers was sinful, and fretted especially about Cicero: whether Cicero was damned, whether he himself was damned for loving Cicero too much, whether failures in Cicero's life (his temper, his political activities which Petrarch considered unphilosophical) were caused by his paganism, or—in Petrarch's most optimistic moments—whether the points when Cicero mentioned *deus* (god) singular instead of *dei* plural meant he might have been a secret Christian, as was said of Seneca. Efforts to Christianize favorite pagans went back to the early Middle Ages, and just kept going; I myself wrote an article about the introductions Renaissance scholars wrote to editions of the philosopher Epictetus, which from the mid-1400s toward 1700 go from saying "Epictetus is almost as virtuous as Christians!" to "He's just as virtuous as Christians!" to "He's practically

another Saint Paul!" to "He's even more effective at teaching Christian virtue than reading Saint Paul directly!" Excited as many Renaissance people were by pagan authors, it wasn't their non-Christian-ness that was advertised on title pages, it was how *close* their ideas of virtue seemed to Christian ones, which seemed like proof that, even without Revelation, wise people always found the truths of Christianity.[46]

Ah, you say, *but what if Renaissance people actually were excited by the non-Christian elements of these books, but were just covering it up, claiming it was compatible with Christianity to conceal their true beliefs? This was the era of the Inquisition, censorship. These people knew they could be tortured or executed for being too pro-pagan or...* (the concept of human<u>ism</u> hovers by our shoulder like the Ghost of Christmas Future)... *atheist?* That is a very important question, which I shall return to toward the end when we have the most shared knowledge and I can do the most justice to the issue—the best questions deserve the best answers.

Important proviso #2: This was a fundamentally elitist project. The dream of universal education is a signature of the Enlightenment (1700s), not the Renaissance. Plato and Aristotle both clearly said that only a tiny sliver of human souls are capable of being led by Reason, that the vast majority are doomed forever to be ruled by their base appetites (lust, hunger, laziness), or at the best by their passions (ambition, pride), while the philosopher prince is rare as gold. The *umanisti* did not doubt that. The whole population was excited by the project, invested in the project, hoped for great results, enough for Florence to celebrate Bruni's new history with a giant state parade, but everyone being proud of it was very different from everyone doing it, just as the millions who watch Olympic sports and cheer for local medalists vastly outnumber the athletes themselves. We aren't talking about a plan to educate the quarreling street thugs in the opening scene of *Romeo and Juliet*, we're talking about educating Romeo, Mercutio, Tybalt, Paris, a few elite servants to be their tutors and secretaries, and Juliet too, who should have had an *umanista* there to teach her moral maxims about lust and patience, instead of just her Nurse and Friar Faking-Your-Death-Can't-Possibly-Go-Wrong Lawrence.

Virtue in the ruling classes was supposed to bring wise decisions, good outcomes, prosperity, and divine blessings, benefiting everyone even if the slice of people in the *umanista*'s classroom was quite small. Virtue was also supposed to trickle down and saturate the state, since servants and subjects, glimpsing the great, would see their virtue as a light reflected by a mirror (yes this is coming from Plato) and be illuminated by it. Educating the few would transform the many, not through universal education, but through the presence of the virtuous who would dazzle and enrich the public eye, and helm the ship of state. The king, duke, and duchess should study the *studia humanitatis*, as should their courtiers and companions, and the sons and daughters of the ruling families of republics, but for the common people, the textbook of virtue was the presence of the special few among the many, and hearing about these innovative celebrities. A letter from a major *umanista* passing through a town en route from household name to household name might be the talk of the town for some time, much like the excitement when film stars arrive to shoot a movie on location. Many people might ask to read such a letter en route, or (if they couldn't read Latin) to hear others describe what it said.[47] Oral performances of classicizing speeches and orations, at a funeral or state event, also drew vast crowds, even among those who could not understand the Latin but were excited to *see* the practitioners of such exciting arts, and hear friends attempt ad hoc summaries. Everyone heard and most everyone cared, but for the majority, spectatorship rather than participation was the expected relationship with the new educational system. *Umanisti* were a presence to be proud of like a nation's Nobel laureates, but while many heard and cared about their public comments, only fellow experts truly understood their more technical work. The main avenue from the *studia humanitatis* to the masses was *literally perceiving the ruler*, in processions and state events when the virtuous prince, framed by images of the feats of Caesar and Alexander and allegorical statues representing Charity and Fortitude all carefully designed by *umanisti* and their artist friends, would present a mirror of virtue observed and absorbed by the people, who would then become more virtuous, just as they learned Bible stories from seeing the statues on the doors of the cathedral.

Humanist education was not *exclusively* for the nobility—merchant elites got it, rich middle-class families with ambition and *sometimes* a few lucky youths of no background but with exceptional minds, who were spotted like diamonds in the rough and raised to have the ears of princes (one of these, Poliziano, we will come to know at length in Part III). This too came from Plato, who says in the *Republic* that most of the time people with souls of gold (led by Reason) have children of gold, while people of iron (dominated by base appetites) have children of iron, but that *occasionally* a golden soul is born to base parents, or a base one to golden parents, and that these need to be identified and swapped, so the golden soul can have a golden education and join the ruling elite.[48] Renaissance people tried to spot these souls of gold among the peasants of iron, and bring them to court to be companions of the prince. This was the first glimmering of egalitarianism, not yet the idea of universal education but a step toward the world-changing Enlightenment moment of recognizing that all people are capable of serious understanding, study, political participation, and self-governance. It was *not* a *big* step toward it. It was a hairline crack, the suggestion that *a few rare souls* born to humble parents are capable of rising to the heights of the elite, a small but vital crack in the millennia-old belief that the hierarchy of nature—in which trees were greater than shrubs and lions greater than cats—applied as immovably to elites being greater than their subjects. It would take centuries and many more blows to the old order before such rags-to-scholarship stories could extend the crack enough to shatter the belief that human hierarchy is natural and inescapable; for now, we can simply smile when we see that crack, and know that the overthrow of hierarchy took many blows struck over many lifetimes.

Important proviso #3: This was all hope, not reality, not yet. "We must make a golden age" is something you say when you think it's *not* a golden age. Petrarch's circle of dreamers *did not yet have* most of these ancient books he urged others to find, and those they had in Greek—like Homer—they could not yet read. They did not know what they would find in the ancients, just that the Roman ruins and the legend of the *Pax Romana* showed there must be something there. If it was a moonshot, it was a moonshot planned and funded by people who couldn't actually see the moon, they

just trusted it must be out there if they searched. And a lot of their hopes were still more prayers than plans: the hope that a more virtuous world would receive more of God's blessings and less of God's wrath. There is a touching powerlessness in the Petrarchan project, compared with the vast confidence of modern science, in which we so confidently write of science fiction futures where X or Y problem is solved.

One of the most heartbreaking things I've ever read is Petrarch's letters *during* the Black Death.[49] When his first friend dies, he writes of his grief but also of his faith, trusting God's plan, knowing the friend is in a better place. When his second and third friends die, he writes of how hard a test this is, difficult to endure, but how important it is to still trust the Providential plan. But this is 1348, so it keeps going. Day after day, friend after friend. He breaks. In *Familiares* VIII.7, writing to his friend the Flemish Benedictine monk Ludwig van Kempen under the affectionate nickname "Socrates," Petrarch writes of feeling his reason failing in the face of such unending grief. What did our generation do, he asks, that was so much worse than every other generation that *we* deserve *this*? Where are our friends, their dear faces, sweet words, and delightful conversation? We used to be a crowd, now we are almost none. He writes of his shame, that all the consolations and strong armor of philosophy have shattered into nothing. He writes of the terror of not understanding the cause, that all the historians, doctors, and philosophers can offer nothing, that even the quacks who are usually happy to sell lies to any man are dumb with grief. He writes of his disbelief, fretting that posterity, if there is posterity, will not believe it possible that without fire, or war, or flood, so much human presence could be wiped from the Earth. He writes of a new friend, Paganino da Milano, a friend so delightful he was almost another Socrates, one Petrarch met so recently he hadn't had a chance to mention him yet, who contracted the plague, spent his last night with Petrarch, died in agony in the dark hours of the morning, and whose wife and children had all followed him in death within three days, *all between two letters*. Death seems like consolation, he says, their best hope that perhaps this is the end of the world, and they will not have to endure more. Trust in God's Plan is gone, the consolation that

lost friends are in a better place, all traces of the soul's tranquility, all gone.

Years later, in his *Remedies Against Fortune*, when Petrarch offers witty explanations of why you shouldn't fear siege, or conquest, or disgrace, his dialog on plague is different:

> *Sorrow:* I'm afraid of the plague.
> *Reason:* If you fear the plague because you love humanity and pity human suffering, I commend you, since pity is a noble thing. If you fear for your own life, plague only makes you do what all mortals must someday do, so why do you fear more to do it with much company?

Petrarch, survivor of many trials, shows through. The fear of plague can't be deflected like his other fears. The only hope the *studia humanitatis* can offer here is that *phil-anthrôpía*, love of humanity, will make people love and pity one another more, reducing—between famines, plagues, and deaths—the only Horseman of the Apocalypse humankind could aspire to control: war.

25

Italian Renaissance Becomes European Renaissance

The classical revival sparked in the desperate Italian peninsula, but spread beyond as quickly as Petrarch's stinging letters could fly, and envoys awed by Florence could rush back to tell their kings to stock up on antiquities. This is why, as early as the 1410s (twenty-five years after Petrarch's death), Henry V's brother Humphrey of Gloucester wanted to hire history-slicing Leonardo Bruni to come work for him, and Gloucester's rival Cardinal Beaufort brought Poggio to London before little Marsilio Ficino had even been born to be tutored in Greek on Cosimo de Medici's ambitious dime. Wounded Italy needed its desperate measures, but so did many parts of Europe: certainly France did as it patched itself together from the Hundred Years' War, Iberia as the Portugal-Castile-Aragon violence cycled on, and, of course, England when Henry V died in 1413, leaving infant King Henry VI with a weak claim to the throne, so ambition and vendetta rose in many nobles' hearts. If Gloucester or Beaufort could have an Italian secretary write their letters to the Duke of Somerset, not in easy everyday Latin, but in gymnastics routine Latin that reads like Cicero and takes Somerset's clerk an hour to even understand, suddenly the receiver of the letter feels like the sender is someone special, greater than rival nobles, royal. Imperial. And if you bring Italian art and architects, import antiquities, teach your sons and your allies' sons to quote rare Latin sources, you can intimidate and awe like Florence did, and even get historians to call your state *a work of art*. We say "Italian Renaissance" and Italy was a hatching place, but many places beyond the peninsula invested

in the classical revival before some parts of Italy did, producing their own innovations, and the entire project was the fruit of Italy's relationship with other powers—Spain, Portugal, Egypt, France, the Ottomans, the German emperor, England—whose trade funded and whose threats motivated the Italian-born yet international Renaissance.

The more unstable a state, the stronger the motive to adopt new tools for projecting legitimacy. Petrarch's friend King Robert of Naples (1276–1343)—who had seen his father nearly lose the throne—was eager to add a Roman luster to his crown by granting Petrarch's wish to be crowned the first poet laureate since antiquity, and Robert gets faux-Caesar points for this in his biographies to this day, even though he never actually did it (Petrarch had it done in Rome instead). A century later, Robert's descendants were driven out by Naples's new king, Alfonso the Magnanimous (1396–1458), whose numbering is Alfonso V of Aragon, Alfonso III of Valencia, Alfonso II of Sardinia and Corsica, and Alfonso I of Sicily and Naples (proof that numbering kings is sometimes the opposite of helpful, so we'll go with the Magnanimous). Alfonso knew his title was weak (troubled by attempts to retake the city by the French claimant René of Anjou,[50] the one whose daughter Margaret married England's Henry VI). So, King Alfonso flooded Naples with classicism, paying scholars three or four times what they earned in Florence if they would enhance his fame, and teach his son. The newly planted Sforza rulers of Milan likewise collected art, and commissioned *umanisti* to write works countering Bruni's Florence-beat-Milan-go-us! version of history. By Lorenzo de Medici's day, middle-class fathers from Transylvania and Bosnia were sending their sons to Italy to train in this new Latin,[51] a lucrative employment ladder for the middle class, which turned youths into tools of power for royal masters, who—sharing the observations of Frankenstein's wise monster—paid well for scholars who would compare them, not only to wise and peaceful kings like Solon, but to warlike Aeneas, Romulus, and Caesar, fathers of strong states whose examples could recast a tyrant as a founder, and an upstart's conquest as the dawn of a golden age.

If instability makes new tools of power spread faster, Europe in the 1400s could not have been riper for it. The whole region was

a game of musical thrones, in which webs of intermarriage meant that almost every throne in Europe had a rival out there with a better claim. In the 1490s, for example, Ferdinand of Aragon had a claim to Castile, Isabella of Castile had a claim to Portugal, João of Portugal had a claim to England, Henry of England had a claim to France, Charles of France had a claim to Naples, and Ferrante of Naples was close enough kin to Ferdinand of Aragon that you could basically rotate everyone clockwise one throne and have a stronger claim.

War-ravaged Iberia and tumultuous Hungary were early adopters of the classical revival, and many of the first humanist manuscripts created outside Italy were made for their grand libraries—*humanist* meaning manuscripts made for and by *umanisti*, so the texts were *not* about radical ideas of human excellence: most of them were shiny new copies of Vergil, Pliny, Seneca, or Bruni's history of how Florence totally beat Milan that time. In the 1460s, Matthias Corvinus the Raven King (1443–90) was newly risen to the throne of Hungary after long wars with local warlords and both empires (Ottoman and Holy Roman). King Matthias knew how desperately he needed to *seem* more kingly than the peers who had recently been his equals, so he built the first neoclassical buildings outside Italy, wrote to Lorenzo de Medici requesting books, and had his oak-crowned profile carved in marble like a Roman Emperor on a coin.[52] When his local Bohemian queen died, Matthias married Beatrice of Naples (1457–1508), daughter of King Ferrante of Naples and granddaughter of Alfonso the Magnanimous, an Italian princess educated in Greek and Latin, who filled his new palace with culture and won the hearts of Hungary so deeply that, when King Matthias died without an heir, the lords agreed to crown whomever Beatrice chose as her second husband, leaving the crown with her and birthing her unique title: Beatrice Twice Queen of Hungary.

Antiquity had become a language of power. Columns, pediments, Latin mottoes, marble busts, these were legible across Europe, projecting nobility, legitimacy, and the myth of two golden ages, ancient and reborn. They were legible *because* the Middle Ages had used them too, Latin mottoes and imperial busts familiar *before* they came to be part of a movement, as tie-dye and

safety pins both existed long before they were given new political meanings by the hippie and punk movements respectively.

Meanwhile, in the Ottoman world, even Mehmet the Conqueror (1432–81), who took Constantinople in 1453, was charmed by the art and innovations of the classical revival. Mehmet filled his court with Italian and European scholars of Greek and Latin, and hired Venetian painter Gentile Bellini to fresco his palace and grant it an exotic-to-his-region European luster, which would read as novelty to his neighbors farther east. But monarchs could vary as much as popes, and Mehmet's successor Bayezid II (1447–1512) expelled the European scholars, preferring to invest in the arts and architectures of power shared by the wealthier, more powerful empires of the East, instead of backward Europe. (*Umanista*: "But, Your Imperial Highness could aspire like the great Matthias Corvinus to have a thousand books!" Bayezid: "I already have 5,000 books, that's normal in the civilized world. Do you in Europe not know that?" *Umanista*: **head explodes**)*

Greco-Roman antiquity's dissemination then had another stage, as the 1400s gave way to the 1500s and beyond. Europe's imperial ambitions exported this language of power with its ships and conquests, so in 1600s Mexico (then called New Spain), the children of indigenous nobles educated at Jesuit schools wrote Ciceronian Latin orations about the grandeur of Aztec antiquity, to advance their own political status as scions of a different antiquity.[53] All civilizations have architectures of power: East Asian tiered pagodas, central Asian onion domes, Viking knotted carvings, Mesoamerican platformed pyramids, the stunning floral and calligraphic decoration on Sultan Bayezid's own mosque; but Greco-Roman antiquity became the language of power most consistently exported by the European empires which dominated the globe in the seventeenth through

* Bayezid might add that many of *his* manuscripts were on paper, and holding up very nicely, far more durable than papyrus and much lighter and cheaper than animal skin parchment. Europe had paper as early as 800 CE but was slow to trust it as a serious writing surface, using it mostly for unimportant letters, sketches, cheaper books, and disposable things, while a serious library was still expected to be composed mainly of costly dead sheep.

nineteenth centuries. This made European classical style the most broadly legible architectural language of power in the world, which is why to this day capital buildings and parliament houses from Uzbekistan to South Africa—even new ones—often have smooth white columns, Pantheon-like domes, and all the Roman details.

26

The Supremacy of Antiquity

Continuing, for a moment, this detour to later centuries, Europe's celebration of the *studia humanitatis* as a new form of nobility and source of legitimacy would go on to show its worst side in the Age of Empires. While the powers which conquered the different parts of Italy in the 1600s and 1700s respected and guarded its culture, the European ships which sailed out with the strength to conquer, and a need to justify those conquests, were armed with the idea that only the classics, i.e. *only European education*, made one virtuous, noble, and fit to rule.

Many textbooks give the impression that Europe always saw itself as superior, but now we have seen a Renaissance that saw itself in crisis and apocalypse, and was staggered to learn that Sultan Bayezid had 5,000 books. While medieval and early Renaissance Europe had a sense of *Christianity* being the most precious thing ever, in terms of wealth, science, culture, and technology, European peoples were very aware that regions to their east, and south in Africa, were wealthier and more splendid, the sources of imported luxuries, whose diplomats on visits casually traveled with more wealth than an entire European town contained.[54] Even our Vikings up in Iceland understood Europe's comparative poverty; Snorri Sturluson (1179–1241, whose life overlapped with Thomas Aquinas's) describes a geography in which, when you head north it gets colder and colder until the world is ice, when you travel south it gets hotter and hotter until the world is fire, and when you go east the world gets wealthier and wealthier until it is filled with gold.[55]

The framework of superiority which 1600s–1900s Europe used to justify its global conquests was a new development, an apparatus to understand and excuse its bloody deeds. It was enabled by many factors—for an excellent brief treatment see Robert Launay's *Savages, Romans, and Despots*[56]—but one tool was the classical revival, which defined European classical education as the main source of nobility and legitimacy, thus justifying the toppling of regimes and rulers which lacked it, and the erasure of indigenous cultures. Eddie Izzard has a famous comic bit about colonialism, where Britain claims India, saying: *Do you have a flag? No flag, no country*. Classics as power spawned a similar attitude: *no columns, no culture*. The scions of indigenous Aztec nobility who, in the 1600s and 1700s, composed Latin orations about *their* noble ancestors resorted to using the language of power recognized by the conquerors, who refused to recognize indigenous ones.[57] This legacy of complicity in imperialism is still an issue in classical and liberal studies today, and—much as I love my Homer—when I hear someone celebrate the Greek and Latin classics as a *unique* backbone of education, I make a point of bringing up classical Chinese, Arabic, Sanskrit, and other deep literary traditions, and the importance of recognizing that they are equally capable of honing a mind toward critical thinking and humane ideas. In my view, one major part of the utility of studying the Greco-Roman classics today is that it teaches us to recognize, resist, and dismantle the coercive uses of this language of power, while also teaching us to use this language to good ends.

Detouring even further forward for a moment (back to our X-Factor-hunting days), as modernity advanced, the supremacy of the classics shaped the rise of European nationalism. Competing to have the most of ancient Rome is a game that Italy will always win. Even Greece was no rival, since Italian and European imaginations of the Ottoman conquest of Greece presented Italy as the new home of the displaced Greek arts and Muses—one can see this vividly in Florence's Palazzo Pitti, which sports a seventeenth-century fresco depicting a grieving Apollo escorting the bedraggled refugee Muses to Italy to be welcomed by Lorenzo de Medici.[58] Tired of this losing game, in the eighteenth and nineteenth centuries, other parts of Europe, especially northern

Lorenzo welcoming the refugee Muses guided by grieving Apollo, from a fresco cycle of the fall of antiquity and creation of the Renaissance, commissioned by Lorenzo's descendants 143 years after his death. Which Lorenzo do they want us to believe in? (Palazzo Pitti, by Cecco Bravo aka Francesco Montelatici, commissioned 1635.)

Europe, started studying *local* antiquities—*their* classical paganisms, *their* heroic forebears, *their* national epics, etc. This was a reaction against 200 years of importing the trappings of antiquity from Italy—years in which Italy's present was conquered by other European powers, but Italy's *past* monopolized the path to victory through art and culture.

Increasingly over the 1700s and 1800s, governments and universities supported scholars who labored to construct local European antiquities, celebrating the heroic virtues showcased in *Beowulf*, the *Kalevala*, or the *Nibelungenlied*. While we should celebrate the fact that today we study and value local and indigenous cultures beyond the Mediterranean, damage as well as good was done when figures like Jacob Grimm (1785–1863), while investigating northern fairytales and the Norse sagas, not only

sought to legitimize northern paganisms by equating their figures to Mediterranean ones (if Odin = Mercury he is worth studying), but argued that northern paganism had been *more virtuous* than Homer's. The eagerness of such scholars to find a past to surpass Rome distorted their readings of texts, as we see again in Viking studies. Nineteenth-century analyses of the *Poetic Edda*, working with a manuscript known to contain both authentic medieval poems and seventeenth-century imitations, merrily judged that, since they knew their own ancestors must be morally superior to the Romans, Odin must be morally superior to Zeus, so the poems where Thor and Odin do terrible things must be the fakes.[59]

Below is part of the introduction to the 1880 edition of William Morris and Eiríkr Magnússon's 1870 translation of *The Volsunga Saga*, which shows how much the nineteenth century's refashioning of northern Europe's antiquity (still present in white supremacist movements today) was an effort to rebel against a legitimizing antiquity which privileged Greece and Rome:

> It would seem fitting for a Northern folk, deriving the greater and better part of their speech, laws, and customs from a Northern root, that the North should be to them, if not a holy land, yet at least a place more to be regarded than any part of the world beside; that howsoever their knowledge widened of other men, the faith and deeds of their forefathers would never lack interest for them, but would always be kept in remembrance. One cause after another has, however, aided in turning attention to classic men and lands at the cost of our own history. Among battles, "every schoolboy" knows the story of Marathon or Salamis, while it would be hard indeed to find one who did more than recognize the name, if even that, of the great fights of Hafrsfirth or Sticklestead. The language and history of Greece and Rome, their laws and religions, have been always held part of the learning needful to an educated man, but no trouble has been taken to make him familiar with his own people or their tongue. Even that Englishman who knew Alfred, Bede, Caedmon, as well as he knew Plato, Caesar, Cicero, or Pericles, would be hard bestead were he asked about the great peoples from whom we sprang; the warring of Harold Fairhair or Saint Olaf; the Viking kingdoms in these

(the British) Western Isles; the settlement of Iceland, or even of Normandy. The knowledge of all these things would now be even smaller than it is among us were it not that there was one land left where the olden learning found refuge and was kept in being. In England, Germany, and the rest of Europe, what is left of the traditions of pagan times has been altered in a thousand ways by foreign influence, even as the peoples and their speech have been by the influx of foreign blood; but Iceland held to the old tongue that was once the universal speech of northern folk, and held also the great stores of tale and poem that are slowly becoming once more the common heritage of their descendants[...] It is, however, becoming ever clearer, and to an increasing number, how supremely important is Icelandic as a word-hoard to the English-speaking peoples, and that in its legend, song, and story there is a very mine of noble and pleasant beauty and high manhood. That which has been done, one may hope, is but the beginning of a great new birth, that shall give back to our language and literature all that heedlessness and ignorance bid fair for awhile to destroy.[60]

A mine of pleasant beauty and high manhood (*virtù* => virtue) is very much how *umanisti* described the Greek and Latin classics, here transplanted onto Icelandic tales which are to replace Plato and Cicero as household names. Even the repeated twentieth-century excavations in Greenland, in which Danish, Swedish, and Norwegian scholars kept investigating whether it was true that Greenland's Norse settlers despoiled the land (very un-virtuous), were shaped by the legacy of the Renaissance conviction that having virtuous ancient predecessors makes one's government more legitimate. Thus the cultural legitimacy games, exploited by so many powers in the Renaissance, rippled forward to feed the post-Renaissance nationalisms visible in 1938 when Mussolini and Hitler jointly toured the masterworks in Florence's Uffizi gallery.

27

Is This About Virtue or Power?

Returning to the 1400s, lamenting Petrarch cried out that wounded Italy needed a crop of Ciceros whose Roman virtue would put truth and countrymen above vendetta and ambition, and a few decades later we have Hungarian warlords using classical wreaths and future passive participles to intimidate the heirs of Vlad the Impaler. Virtue, ethics, education, nobility derived from excellence of soul instead of lofty blood—did these ideals drop out?

Not from the rhetoric. Every dedication letter from the period extolls the classical virtues of [insert prince here], but when the dedicatee is Francesco Sforza, the new viper who swallowed up the old vipers of Milan, this feels less like cultivation of the soul and more like an attempt to cover up the blood stains with a classical throw rug. Frankenstein's wise monster may have preferred the peaceful ancient role models to violent ones, but a good friend of mine, Valentina Prosperi, has demonstrated brilliantly that *umanisti* and their patrons loved their pro-imperial *Aeneid*, and when they finally got Homer back—after centuries of merely seeing references to how he was the greatest of all poets—they were troubled by the anti-war messages of the *Iliad*.[61] *War is tragedy! Heroes are miserable! Even Achilles would rather be a sharecropper than the most renowned of heroes if it meant a longer life!* The *umanisti* spoke of the *Iliad* respectfully, quoted bits of it, used it for language study, observed the patterns in its structure, but shied away from actually imitating its model or quoting most of its messages, preferring imperial Vergil and the fun adventures of the *Odyssey*. So, was all this primarily a moral project? Or was it a kit for justifying Europe's momentum through an age of war toward an age of imperialism? Both?

IS THIS ABOUT VIRTUE OR POWER?

And as for the scholars—those reading the Plato and writing the manuals of kingship—if Ciceronian Latin is a fast track to a steady job, and one of few paths that lead from the countryside to having the prince's ear, are these really philosopher-idealists? Invaluable gadfly scholars like Robert Black and John Monfasani remind us of these questions every time we get too starry-eyed about Marsilio Ficino restoring Plato to the world: if being an *umanista* was so lucrative for both patron and scholar, was the moral education part sincere?

Approaching a real answer requires a humpback whale-deep dive into what Renaissance humanism really was (there's still a kraken down there), which we will take together in Part IV. For now, my short answer is: sometimes. There are cases where it really looks sincere, and others where it absolutely doesn't.

Our book-hunter Poggio Bracciolini went to London hoping, not only a fat check, but for Cardinal Beaufort's ear, to dispense the skill and wisdom of dear Cicero, perhaps even to tutor young Henry VI who, trained in virtue, might bring a golden age to England. Instead, Poggio found he was mostly there to draft fine Latin to intimidate the Duke of Somerset, and since his patron didn't keep him at his side, he had little taste of court gossip, leaving him homesick, with few friends, and no one in England was very interested in basing policy on Cicero.[62] This experience was not rare. *Umanisti* competed with many others for their patrons' ears: musicians, concubines, fencing masters, chaplains, jousting champions, even court dwarfs, who were major shakers in high politics in the 1500s and 1600s.[63] Scholars like Poggio found themselves treated as ornaments of the court, politically useful as objects of display, but so were fine horses, marble columns, and exotic animals. Lorenzo de Medici had Marsilio Ficino, the first true Platonist in Europe since antiquity, but he also had the first giraffe in Europe since antiquity (a gift from the Sultan of Egypt),[64] and both of them wandered the streets of Florence making people smile and advertising Medici wealth and power (though only the giraffe used to stick its head through people's second-floor windows to get snacks; the Platonist came inside). Which of these two living novelties did Lorenzo value more?

Two panels from the "Room of Lorenzo the Magnificent" in the Palazzo Vecchio, by Giorgio Vasari and Marco da Faenza, 1555. These were commissioned sixty-three years after Lorenzo's death by Duke Cosimo I, to advertise his famous ancestor. The central panel shows Lorenzo, with the giraffe, blessing his son Giovanni (future Pope Leo X) who had just been made a cardinal. The smaller wall image shows Lorenzo surrounded by umanisti, including Ficino. Which did Duke Cosimo value more?

IS THIS ABOUT VIRTUE OR POWER?

Some characters from the period smack pretty clearly of hypocrisy.

Cardinal Ascanio Sforza (1455–1505) was a younger son of Cosimo's friend Francesco Sforza and his wife Bianca Maria Visconti of Milan.[65] Ascanio became an abbot at age ten, was promised a cardinalship at sixteen, bribed and took bribes with Rome's worst, and was so comfortable displaying his lack of spirituality (a cardinalship isn't for praying, it's for wielding that other 1/5 of the power in Milan) that he had a pet parrot trained to recite the Latin Creed for him—not exactly what was hoped for by his childhood tutor Francesco Filelfo (1398–1481), a Greek expert who'd been one of the first *umanisti* to teach at a university, but moved to Milan for higher pay and a chance to rear virtuous princes like... oh, well...

Another family of big spenders on all things cultural was the House d'Este of Ferrara, the most legitimate, stable, we-weren't-just-mercenaries-a-year-ago, we could actually join the Knights Hospitaller, actual noble-blooded family in Italy. Duke Ercole d'Este (1471–1505) grew up at the court of King Alfonso the Magnanimous in Naples, tutored by his high-paid *umanisti*, and secured the same for his children. One of his sons, of course, was earmarked for the Church: Ippolito d'Este (1479–1520), an abbot aged *three*, archbishop at *eight*, Cardinal at *fourteen*, and partly raised in Hungary by his aunt Queen Beatrice.[66] In 1505, aged twenty-six, he had his half-brother Giulio's eyes gouged out in a quarrel over their mutual love for Angela Borgia (*c.*1486–*c.*1522, Lucrezia's cousin), which sparked a multi-decade feud—exactly what Petrarch wanted the next generation's leaders to *stop doing!* Not an exemplar of Roman virtue. Ippolito did hire scholars, including the poet Ludovico Ariosto, until in 1516...

> *Ariosto:* Your Eminence, I've just finished *Orlando Furioso*, the greatest epic poem of our age! And I've dedicated it to you!
> *Ippolito:* If you had time to write an epic poem, you should've spent it polishing my boots.
> *Ariosto:* What?! But...
> *Ippolito:* I pay you to wait on me, not scribble in your room.

Ariosto: But it will spread your fame! Immortalize your name!
Ippolito: Go fetch my riding coat, I want to go hunting.
Ariosto: You don't understand! This is going to be huge! We're talking *Aeneid*-level popularity! *Inferno! Harry Potter!*
Ippolito: I want the black riding coat, not the purple one, the shoulders are too tight.
Ariosto: You gotta read it, Your Eminence, it has some world-class epic flattery! It's full of prophecies about how awesome you and your family will be! I even threw in Merlin!
Ippolito: That's nice. Now, while I ride, get packing, we're going to Hungary to see my aunt.
Ariosto: You… This isn't how it's supposed to work! Where's my thanks and bag of gold?
Ippolito: Remember that time I had my half-brother's eyes gouged out?
Ariosto: Yes, Your Eminence. Thank you, Your Eminence. (Starts packing to *leave the service of this jackass!*)

Which is why we have Ariosto's lovely *Satire I* (1515) about how flattery is useless, and Ippolito d'Este is the worst patron ever (written *after* Ariosto had carefully secured his safety by taking up service with the one man Ippolito couldn't cross: his elder brother Duke Alfonso).

But while Ippolito d'Este's coldness toward Ariosto shows pretty clearly that Ippolito neither was nor wanted to be a philosopher prince, Ascanio Sforza's Latin-speaking parrot doesn't *prove* he didn't enjoy his Latin lessons. He might have enjoyed them. He might have had the parrot partly *because* he enjoyed them. He might have had the parrot to bring attention to the hypocrisy of men like himself, a satirical commentary on the Church corruption he couldn't avoid being part of. How could we know?

Follow the money!

Good idea—in lieu of a time-traveling telepath (the only way to know what people *thought*), we can see what people valued from how much they spent on art, architecture, *umanisti*, and the dream of a *Pax Romana*. What does it really mean to a royal budget for King Alfonso the Magnanimous of Naples to pay his *umanisti* 300 gold ducats a year?

IS THIS ABOUT VIRTUE OR POWER?

In the economics corner of the History Lab, the meticulous Richard Goldthwaite has run the numbers.[67] He determined that a day laborer in Florence in the period—someone hired to mix concrete or lay bricks, working outside guild life and medium-low on the economic ladder but not at the very bottom—earned about 35 gold florins per year, so we can use that as our grounding for a low-end living wage. If we call that income equivalent to about $35,000 a year, then one florin is about $1,000 here in 2025. An income of 70 florins ($70,000) was enough to support a wife and kids. Helpfully, the major gold coins of the period (the florin, ducat, and French crown) are mostly equivalent, all ~3.5 grams of gold with similar purity, though over time French crowns became more devalued, smaller and less pure, and florins and ducats were minted in many places so some, like Rome's, were slightly smaller, but their values close enough that one must multiply by 0.9 or 1.2, differences like that between the dollar, pound, and euro rather than between these and the yen.

Thus, Alfonso the Magnanimous in Naples paying 300 [ducats/florins] per year ($300,000) was three times what *umanisti* earned in Florence in government posts, but it was not *that* much against a royal budget, which might spend 100 florins on a painting by a famous artist, 1,000 on a night of music and revels, 1,500 on a suit of jousting armor, 15,000 on a set of tapestries, or 50,000 on a single diamond. As the scintillating Marina Belozerskaya, a scholar of luxury spending, points out, when Ottoman Sultan Suleiman the Magnificent commissioned a helmet from Venice which cost 150,000 florins, and spent another 100,000 on his horse's saddle and headdress, he was wearing $250 million as he rode down the street.[68]

A sultan's costume is extreme, but in one of the letters of Cardinal Ippolito's big sister Isabella d'Este (1474–1539) as Marchioness of Mantua, we have a snapshot of a more normal princely shopping spree: 10 for a fur muff ($10,000), 25 for a small silver statue of herself ($25,000), 30 for a portrait by Francesco Francia ($30,000), and 115 for a larger painting by Bellini ($115,000), while the artist Mantegna wrote to offer her an antique bronze sculpture of Faustina for 100 ($100,000), saying he had just bought a new house for 340 ($340,000) due in installments, and needed cash

to cover the next payment—Isabella tried to haggle him down to 60 for the sculpture, but in the end agreed to take on 100 of his debt.[69] In a similar letter, Isabella is excited at the prospect of buying a more modest antiquity: an ancient head of Plato with a broken nose replaced with one modeled in wax, cost: 15 ducats ($15,000).[70]

The invaluable inventory of the contents of Palazzo Medici at the time of Lorenzo's death in 1492, easily available thanks to the untiring Richard Stapleford, gives us another great glimpse of the comparative costs of things.[71] The Medici palazzo at the time contained not only the main family, but many servants and courtiers, whose furniture and bedding is counted among the property, though servants' personal effects (clothes, etc.) are not. The palace also contained many barrels of food and wine and bolts of fabric (linen for making shirts and undergarments), ready to supply the needs of a large household. In sum the palace contains 80,000 florins' ($80 million) worth of stuff (though the Medici also had a couple country homes to escape the heat, so this was at most a third of their physical household stuff). Within the main palazzo, 20 percent of the value of stuff ($16 million) was household goods (food, bedding, furniture), high-quality but normal for such a palace, while 80 percent ($64 million) was luxury goods. Most palaces had *some* luxury goods, but it was *not* normal for a palace to have $13 million worth of jewelry, $15 million worth of gems (many of them ancient Roman cameos believed to be magic), $10 million worth of vases plus the $9-million-by-itself Tazza Farnese[72] (an ancient cup possibly owned by Cleopatra), or a $5-million-dollar "unicorn horn" (likely narwhal).[73] It was, however, common to have collections like these in the households of the kind of people wealthy enough to support a whole circle of *umanisti*.

Excuse me, did you say a $5-million-dollar unicorn horn?

Yes. Things like that and the Tazza Farnese often changed hands as diplomatic gifts, like the giraffe Lorenzo had received from Egyptian Sultan Qaitbay (*c*.1416–96), and this was also an era when magic and alchemy were serious sciences. If your frail republic was constantly on the edge of conquest, and you and your family had an incurable hereditary illness, and you had watched your father die very young, you might invest heavily in

IS THIS ABOUT VIRTUE OR POWER?

the best-documented miracle cure your culture offered: unicorns. That $15 million worth of (mostly ancient Roman) gems, with the names and images of gods and mystic spirits on them, were medical and magical investments too, and in Lorenzo's dying days he kept them by his bedside, often running his fingers over them, while the most sophisticated doctors in his world were grinding up less ancient gemstones to use as medicine, since why not try the most potent and powerful substances in the world?

Costs of other objects in Palazzo Medici from the 1492 inventory (remember that cloth was *very expensive* in the period due to its intensive labor costs):

	Florins	Dollars
Storeroom full of kegs and jars of preserved food	4	$4,000
Storeroom full of garden and carpentry equipment	5	$5,000
Bolt of homespun linen (for making shirts and undergarments)	0.15/yard	$150/yard
For comparison, what Isabella d'Este said in a letter she was willing to pay per yard for extremely good black fabric for a mantle, demanding it be better than what rivals had[74]	10/yard	$10,000/yard
Spinning wheel	half	$500
Cheap straw mattress	1	$1,000
Doorkeeper's room: bed, down comforter, blankets, and lantern	8	$8,000
Feather bed	5	$5,000
Fine down comforter with two pillows	16	$16,000
Two crimson taffeta cushions with eight gold tassels each (the kind of thing the Virgin Mary often sits on in art)	8	$8,000
Green taffeta dog bed for Lorenzo's son Piero's dog	12	$12,000
Two leather chairs	1	$1,000
Pair of fancy dining tables	4	$4,000

	Florins	Dollars
Lorenzo's cypress wood and walnut bedstead decorated with inlay and horse-racing trophy lilies, with storage drawers	45	$45,000
Six linen cloths of the type women wrapped around their heads	2	$2,000
Plain "monk"-type cloak	8	$8,000
Piero's fanciest cape, red satin with gold details and sable lining	20	$20,000
Ten ordinary swords (for guards)	9	$9,000
Two fancy French swords with silver-decorated scabbards	6	$6,000
Suit of fancy jousting armor	90	$90,000
Two little silver boxes in a bag to hold soap	5	$5,000
Botticelli's Pallas and the Centaur (now in the Uffizi)	10	$10,000
Small round Madonna painting by Fra Angelico	5	$5,000
Large round Adoration of the Magi painting by Pesselino	20	$20,000
Large round Adoration of the Magi painting by Fra Angelico, with a fancy gilded frame (worth much more than the painting)	100	$100,000
Donatello panel of the Madonna, carved in marble	6	$6,000
Donatello panel of the Madonna, cast in bronze	25	$25,000
Small "Greek-style" mosaic of John the Baptist	25	$25,000
Set of six tapestries	80	$80,000
Ring with carved amethyst depicting sea monsters and horses	30	$30,000
The Tazza Farnese (onyx cup that belonged to Cleopatra)	10,000	$10 million
Total value of all non-luxury goods in Palazzo Medici, i.e. the cost of furnishing and stocking a large palazzo	15,000	$15 million

IS THIS ABOUT VIRTUE OR POWER?

	Florins	Dollars
Isabella d'Este's jewels and wardrobe when she married	17,000	$17 million
What an average, un-famous *umanista* tutor earned in a year	45+	$45,000+
Umanista Francesco Filelfo's early-career university salary[75]	66	$66,000
Francesco Filelfo's university salary when he had a reputation	350	$350,000
Francesco Filelfo's pay when he worked for the Duke of Milan	700	$700,000
Annual salary the King of France paid Leonardo da Vinci[76]	700	$700,000
Annual salary of one of Pope Leo X's choir singers[77]	100	$100,000
Annual salary of the Aragonese ambassador to Venice	300	$300,000
Annual cost of supporting a choir of 15 musicians (salary + new suit of clothes each year + bonus for choir director)	~3,000	~$3 million
Annual cost of supporting a circle of 15 *umanisti* (salary + new clothes + paying bonuses when one dedicates a new book to you)	~2,800	~$2.8 million
What Cosimo de Medici spent to get Niccolò Niccoli's library (a bargain since he got it by paying off the family's debts)	800	$800,000
Contracted annual payment when, in 1450, Francesco Sforza hired Marquis Ludovico Gonzaga of Mantua and his mercenary army of ~4,000 men, with the lower sum for years of peace and the higher sum for years of war[78]	47,000 85,000	$47 million $85 million
Value of contents of Palazzo Medici in 1492	80,000	$80 million
Value of goods looted from Duke Guidobaldo da Montefeltro's palace in Urbino by Cesare Borgia in 1500[79]	150,000	$150 million

Finally, to ground us at the extreme edges of how people were valued in the period, Egyptian Sultan Qaitbay once offered the pope 200,000 ($200 million) if Charles would send him Ottoman Sultan Bayezid's half-brother Cem as a hostage—the deal did not go through, but it was partly in return for Lorenzo helping with this negotiation that the sultan gave Lorenzo the giraffe. Sultan Qaitbay himself, originally a Circassian from the Caucasus, had been enslaved as a young man, and sold for 50 dinars (about $5,000, the value of one storeroom full of bulk food or one comfy feather bed).[80]

In sum, hiring a single Latin scholar was not a large investment for a wealthy patron, costing as much as a fancy garment or a new inlaid bedstead, or at most as much as a Roman statue or dainty summer home. Assembling a major library as Cosimo de Medici did, or supporting a whole circle of scholars, as he and King Alfonso the Magnanimous of Naples did, was a more substantial investment, roughly one-sixth the cost of furnishing a palace, to which one must add the substantial set-up costs of a library sufficient to attract excellent scholars.

On the whole, the scholarly side of the classicizing project was a much cheaper one than the architectural side, comparable in cost to the musical side (many instruments were costly), and to painting, with superstar celebrity scholars and superstar celebrity artists earning similar amounts. But all such expenses were nothing compared to the materials costs of sculpture, church-building, reliquaries, the fancy gold frames which, as you see above, cost five times more than the painting itself, or the amounts that nobles regularly spent on velvets, pearls, and jewels. The materials cost of a library was far greater than the personnel cost of *umanisti*, but supporting a whole circle of scholars cost less than a twentieth of what a duke might pay a mercenary as a retainer even in years of peace. The earlier Duke Gian Galeazzo Visconti of Milan had said of statesman-*umanista* Coluccio Salutati (Leonardo Bruni's friend and predecessor as Chancellor of Florence) that a letter from Salutati could be as effective as a troop of 1,000 horsemen.[81] If so, we can compare the investment in *umanisti* to the US State Department's investment in the Fulbright program, which operates on the principle that, since a year-long research fellowship

IS THIS ABOUT VIRTUE OR POWER?

costs the government less than a single cruise missile, you get a lot more diplomatic-relation-improving bang for your buck sending enthusiastic young scholars (like young Ada Palmer) overseas to be cultural ambassadors and win goodwill. But Milan and Florence (like the US) also spent on guns, and, as the delightful historian Guido Ruggiero observed about that much-quoted comment about Salutati,[82] we must be careful not to get too entranced by Salutati's rhetoric, since his goal in the passage is to claim that republics are the only places where one could live a full life of service to one's nation and society, battling with pen instead of sword. We know that trap by now, that Florence is biased, and that Baron's *civic humanism* is a partial, not a full, description of the Renaissance whirlwind of Ever-So-Much-More-So.

Useful as it is to compare the cost of an *umanista* to the cost of a Botticelli painting (or of Botticelli himself), none of this quite gets at our question: did King Alfonso the Magnanimous of Naples surround himself with *umanisti* because he genuinely valued an ideology of classical virtue? Or because his claim to the throne was weak and he wanted the legitimacy? Alfonso, more than anyone in Europe, knew that the classics had practical applications: while struggling to take Naples from his French rival René of Anjou, he had captured the city thanks to advice from his *umanista* and secretary of state Diomede Carafa (*c*.1406–87), who showed King Alfonso the ancient account of how Belisarius in 536 CE had taken Naples by sneaking in through the tunnel of an empty aqueduct.[83] *Hey, is that tunnel still there? Yup!* The old trick gave Alfonso Naples, but did Alfonso spend so much on *umanisti* thereafter because he genuinely thought his son Ferrante would rule better if he was a philosopher prince? Or because he hoped to find more tricks like that? The long answer is that historians are still debating, and—as the academic focus on evidence-based portraits of the past increases—we also debate whether debating this is useful, since motives and intent are so intangible. Yet often at conferences, dinners, and in print, we debate it anyway. The short answer is: I think King Alfonso's case was fairly sincere, from letters, anecdotes, the candor with which King Alfonso's humanists often addressed him, and the way they wrote about him to each other contrasted with the way they wrote about other

rulers, and his successor. But every time I start to give that answer, I remember those books where Lorenzo de Medici is hero or villain, and I know my answer won't be everyone's.

There's a much-quoted letter of Cosimo de Medici in which he remarked that, no matter how much money he spent on the Church, he could never give enough money to God to put Him down in his list of debtors.[84] Is this deep piety expressed in banker's terms? Or a joke about the money-grubbing Church? Historians have interpreted it as both, because even something as candid as a joke doesn't actually get us to the mind behind it. Cosimo had just paid for the construction of the splendid new Dominican monastery of San Marco in Florence, a project spearheaded by the zealous Dominican monk (now Saint) Antoninus of Florence. Dominicans were the scholar monks of the day, dedicated to reaching God through Reason and knowledge (Thomas Aquinas's order, despite the efforts of the parents who locked him in their tower). So I could tell you that Cosimo funded the monastery to support scholarship, or I could tell you that it was to ease his conscience about the sin of usury, or that it was for the fame and reputation. If I tell you Antoninus was Cosimo's long-time friend, so he did it to help his friend's dream of a thriving monastic learning center in the city's heart become reality, it feels different again. If I say that the books which have long said they were friends based that claim on the fact that Cosimo supported Antoninus's projects over many years, but they may have had a more complex relationship and Cosimo many motives for collaborating with this charismatic future saint, it feels different again. Cosimo's friend, the preeminent Florentine book-dealer Vespasiano da Bisticci (1421–98), describes Cosimo enjoying reading in detail Gregory the Great's *Moralia in Job* (composed 579–600), a long biblical commentary focused on ethical living, written in fairly easy semi-classical semi-medieval Latin, while Cosimo's personal reading library (as opposed to what he had for scholars) included Dante, Petrarch, classical Latin histories like Livy, and popular devotional literature in Italian and (easy) Latin—edifying reading with a moral flavor, but not *too* technical or hard.[85] Each new detail lets us paint portraits of a different Cosimo, and offers different motives for his many deeds.

IS THIS ABOUT VIRTUE OR POWER?

In each monk's cell in San Marco, the masterful painter-monk (now also a saint) Fra Angelico painted a unique fresco, a different facet of the Crucifixion or related scenes, for monks to contemplate at different stages of their lives. They're incredible images, many of them innovative, striving to capture complex ideas of touch and time, while others are just Saint Dominic watching the Crucifixion, but with subtle differences in where Dominic is looking, where Jesus is looking, how old Dominic is, paintings which capture the interiority of how such a complex story can mean different things to you (and to Dominic) in different moments of your life, as a young monk, as an old monk, how there's always more meaning to be worked out. And Cosimo had a cell made for himself, where he could retreat from hectic life for a few hours at a time to contemplate. He had his cell frescoed with the adoration of the Magi, a story popular with Florentine bankers, since it suggests that giving gifts of gold and precious goods to God might help the rich man attain that salvation which Scripture warns is as rare as a camel fitting through a needle's eye.

Still self-display! Propaganda! The cell is just another thing to boast of and look pious! Cosimo even got a papal indulgence in return for funding the monastery!

Fair. It did make him look good. Cosimo spent an enormous portion of his patronage budget on religious projects *(Today shall I fund a church or a bridge; a church!)*, but we don't know how Cosimo spent time in that cell.[86] We don't know whether he was praying fervently, or gloating about the good reputation his pious visit would earn, or reading correspondence, or weeping anew for his dead brother, or saying rote *pater nosters* in a kind of meditation that eased his chronic pain. Zooming far in, scholars give us a complex portrait of a complex man, but that doesn't stop online encyclopedias or travel books that have to give us Cosimo in fifty words from giving us a villain or a hero.

We do know that on his last day, when Cosimo lay dying, he called thirty-year-old Marsilio Ficino to him to translate Plato at his bedside, so he could hear as much as possible of the wisdom of antiquity before he died. The text was the *Timaeus*, about the origins of the universe and its divine Maker, and the *Phaedo*, where Socrates outlines the reasons he does not fear

death. That feels sincere. To me it feels sincere. I'll be honest. I can't un-feel it, can't devil's advocate another motive for the deathbed Plato the way I can with paying for San Marco or the other things. It feels sincere because it's private. Because there was no public-showing side to this, no audience of business contacts to watch, impressed. Or was it private? Was it whispered of by mouth to many influential ears? We know about the deathbed Plato from a letter Ficino wrote to Lorenzo years later, recalling the scene they had both witnessed, how courageously Lorenzo's grandfather had faced his death. Ficino wanted to remind Lorenzo of that courage, Ficino who—after twelve years studying Plato at Cosimo's side—had buried his great patron, then lived to bury Cosimo's sons, and Cosimo's grandson Giuliano, Lorenzo's younger brother, the other child Ficino had tutored in the arts of virtue and the ancients. Ficino would soon read Plato at Lorenzo's deathbed too. Ficino lived to sixty-six, which in this era meant seeing many dear friends die.

So, as when lonely Petrarch, trying to comfort us about the plague, couldn't sustain his stinging wit, and could only urge us to pity poor humankind and tell ourselves we should not fear to die with company, I can't read Ficino writing about deathbed courage after burying so many friends and not feel that it's sincere. Ficino's Cosimo, their intimacy, years watching lost Plato emerge from Greek like fossils under the excavator's brush—it feels sincere. This letter isn't young Ficino dependent on his salary. Nor is this 1478 Ficino, who did briefly have to fear Lorenzo's wrath, since he had been friends with one man and, years earlier, tutored another who proved Lorenzo's enemies in the Pazzi crisis which we'll visit in depth in time. This letter is 1480s Ficino, Ficino who had made it through that crisis, famous Ficino, Ficino who would have been welcomed by a dozen cities, who could easily have left Florence—as Ariosto left Ippolito d'Este—if he had found Lorenzo an indifferent pupil. Knowing the period, the people, their quest to know the soul feels real to me. I feel a *there* there in Ficino and in Cosimo, just as there's a *what?!* there in fascinating, eye-gouging, hypocritical Ippolito d'Este.

You don't need to agree with me. In fact, I don't want you to agree with me. I want you to remember that conference in

IS THIS ABOUT VIRTUE OR POWER?

the History Lab, where half the scholars set out evidence that the Medici were tyrants, and half that they were not. I want you to understand how hard the question is, and why so many books on the same shelf give opposite answers. The citizens who called Cosimo a tyrant, the enemies he crushed and banished, they are real, and as important as Ficino to our effort to understand Cosimo, just as the plague is as important as the *Mona Lisa* to our effort to understand this Renaissance, both terrible and great.

Below is Ficino's letter about Cosimo's death in full, for you to read and judge for yourself what feels sincere. It's Aunt Janet's translation, a letter full of Petrarch, full of tricks from Cicero. It's also full of partisan bias, since Ficino, writing this, could not be more pro-Medici, and still had much to gain even in late years from Lorenzo's favor. I could have cut the biased-sounding bits, quoted just the lines that would make you like Ficino, leaving out the parts that feel fawning or preachy. But if you've followed me this far, you know my goal is not to show you *my* Renaissance, it's to teach you to question everybody's version of the Renaissance, this so-called golden age that is so complicated, neither perfect nor an empty lie. If Burckhardt and Villari launched Renaissance studies then the field is 160 years old, but every time I go to a conference, or hear online what people are discovering, it feels dynamic, new, as if we're only just finding the right methods and questions to begin. We historians know how much we *don't* know.

That's why we still need historians to dig deeper into this age, which *wasn't* wonderful to live in, *wasn't* better than the age before, but was amazing in how hard it tried, how much it made, and changed, and failed. The Renaissance is extra hard to see under the glitter, and the romance, and modern attempts to claim it, and the propaganda it itself conceived. We can't ever dig through completely, since no one in our era gets to learn about the Renaissance without first meeting the cult of Leonardo da Vinci's genius, and the works of Raphael on greeting cards, and Venus on the half shell, and the Sistine Chapel's not-quite-touching fingers reproduced with context stripped away. But if we dig into the glitter with our biases in mind, we can glimpse something, not

the *one defining thing* that makes us modern (spoiler: there isn't one), but a puzzle piece which, like the Middle Ages and all ages, is part of the long accumulation of events and ideas, each shaping the other, which in turn shaped what we think is about our past, our future, and ourselves.

Marsilio Ficino to the noble Lorenzo de' Medici.

Even as harmony delights us more at the moment it strikes our ears than when we remember tunes we have heard, and the actual sight of war moves us more than any recital thereof, thus the great deeds of noble and illustrious men animate our courage far more than the words of orators and philosophers who dispute about valor. For it is ordered by nature that things themselves should be more potent than their names, and that real events should move the soul with greater force than what is either false or may have happened. Therefore, by imitating the deeds of Socrates we are taught better how to attain courage than by the art displayed by Aristotle in his writings on morality. And Christ solely by His example has done more to make us adopt a holy and virtuous way of life than all the orators and philosophers that ever existed. Therefore, my Lorenzo, whilst I applaud you for not despising the writings which teach morals, I beg you to prefer learning from reality instead of from description, as you would prefer a living thing from a dead. Particularly as you have decided to emulate that man on whom our Senate bestowed the title *Pater Patriae*, I mean the great Cosimo, your grandfather and my lord. A man prudent above all men, pious towards God, just and most charitable towards men, temperate in living, diligent in his care for his family, and still more so in the affairs of the Republic; a most honorable man who lived not only for himself, but for the good of his country and his God; whose soul was as humble as any man's, and yet great and exalted. I, my Lorenzo, for more than twelve years gave myself up to philosophy with him. He was as acute in reasoning as he was prudent and strong in governing. Certainly I owe much to Plato, but I must confess that I owe no less to Cosimo. Inasmuch as Plato only once showed me the Idea of courage, Cosimo showed it to me every day. For the moment I will not mention his other qualities. Cosimo was as avaricious and careful of time as Midas of money; he

spent his days parsimoniously, carefully counting every hour and avariciously saving every second; he often lamented the loss of hours. Finally, having like Solon the philosopher (even when occupied in most serious business) diligently studied philosophy, yet even till the last day when he departed from this world of shadows to go to the light, he devoted himself to the acquisition of knowledge. For when we had read together from Plato's book dealing with the *Origins of the Universe* [*Timaeus*] and the *Summum Bonum* [*Phaedo*] he, as you who were present well know, soon quitted this life as though he was really going to enjoy that happiness which he had tasted during our conversations. Farewell, and as God fashioned Cosimo according to the Idea of the world, do you continue as you have begun to fashion yourself according to the Idea of Cosimo.

Undated letter, likely 1480s, Janet Ross translation 1905.*

* Why Aunt Janet's translation, not the excellent new critical edition of Ficino's translated letters? (Shepheard-Walwyn, 1975–ongoing) Partly because hers is public domain, a factor which affects commercial press books like this one much more than academic press books, but equally because Janet Ross is a part of this history that shouldn't be left out.

PART III

*Let's Meet Some People from
This Golden Age*

We've encountered several intersecting threads: scholarship, cash, politics, feuds, war, plague, dynastic crisis, high blood and low; but to get a better feel of this era I want to introduce fifteen new friends, drawn from a wide array of walks of life. We'll meet a merchant banker, a master woodworker, a mercenary, a renowned composer, six erudite writers (two of them princesses), three artists, and three prophets. We'll visit each in turn, fifteen looks at very different lives, but their intersections will show us both the events and tumults of the 1400s into the 1500s, and the many ways the same events left footprints in art, texts, and other sources. In several lives we'll visit the same events from different points of view. Just as the airlifting of supplies to partitioned Berlin feels different if examined from the point of view of an East Berliner, a West Berliner, a pilot, a child, or a distant leader, so seeing moments like the War of the League of Cambrai from several perspectives shows how the modern history books which describe these events can use the same facts yet depict such different Renaissances. As we proceed, our dive into each life will get longer, since, once we know more about earlier events, we'll be ready to understand more details. The last of our fifteen new friends will be an old friend, Machiavelli, who's worth a linger, so we can share, not only griefs and triumphs (and some sex advice), but our shared project, begun by Machiavelli but still underway today: the effort to understand what happened to make Europe's

path toward 1500 so terrible yet great. Florence will be the most frequent intersection point in these lives, yet only half of these new friends are Florentines. The others come from many cities, regions, and kingdoms, and show how there was never an isolated Florentine Renaissance or Italian Renaissance, but always an international Renaissance, filled with immigrants, ambassadors, refugees, and exiles.

Before we meet these friends, however, we need two little prefaces: one a review of the people we have already met in getting to know the Renaissance, the other an introduction to the force which binds them, the great force which saturated all Renaissance lives, as formative of the Renaissance and medieval worlds as democracy or capitalism are of our modern era: *patronage*.

28

Patrons and Clients All the Way Up

What has to go wrong for someone to die in a gutter? You can learn a lot about any culture by asking that question: what mechanisms are in place to keep people from falling out of the social safety net, and what can make those mechanisms fail?

In the Renaissance, what had to go wrong was *patronage*, the multi-generational relationships between greater and lesser families which helped each other, fulfilling different functions that only high or low families could do.[1] Do you remember the opening scene of *Romeo and Juliet*? Those men who bite their thumbs at each other are *clients* of the powerful Capulet and Montague families, while Lord and Lady Capulet and Lord and Lady Montague are their *patrons*, and young Romeo and young Juliet their future patrons.

For men like that, either from a minor family of farmers or laborers, or from a middle-status family which might produce doctors or guild members, a powerful patron family, like the Montagues or the Medici, was the backbone of the social safety net. Patrons guaranteed employment, offering regular work at their many properties, hiring sons to follow in their fathers' trades, even setting up promising youths to enter new professions, or helping second sons get Church positions. Patrons were also one's legal guarantors for contracts or debts, even for one's tabs at shops and restaurants. They lent clients money with low or no interest, funded dowries for families with many daughters, and cared for families if the breadwinner suffered debilitating injury or death. They also helped with things like tax burdens—both Lorenzo de Medici and, when he was in political office, our friend

Machiavelli received letters from clients and allies asking them to intercede with taxes, as well as to help with getting jobs, etc.[2]

The client family, in return, not only worked for the patron—building furniture, tilling the farm, doing the paperwork, frescoing the palace—but did things the high-status patron couldn't, such as haggling over market goods, hosting low-status guests, teaching their trades to fellow clients, or taking on missions of trust in lower social spaces. When Lord and Lady Capulet are preparing the feast for Juliet's wedding, the barrels of wine and capers and sacks of grain they have on hand were either grown on their farms by client farmers, or purchased for them from markets by lower merchant-level clients who do the day-to-day dealing while Lady Capulet writes up a shopping list (like Isabella d'Este's). Clients could also help with details specific to one's government. Florence's tax system, for example, was more a wealth tax than an income tax, and for many years was based on officials interviewing your neighbors each year to ask them how rich they thought you were, based on what they saw you wearing, or what went in and out through your front door. Vicious neighbors could exaggerate your wealth to stick you with a huge tax bill, while loyal clients could claim your resources were low this year, even if they'd just seen your daughter married in a gown covered in pearls. (Exploiting this tax system was a tool big families like the Medici and Strozzi often used against each other, the Medici winning out.)

Another major service lesser families did was joining street action. Often this meant rioting in the patron's defense if things turned ugly. The Montague and Capulet clients who bite their thumbs at each other in the opening scene are willing to fight and die for the honor of patrons because those patrons have been their social safety net for generations, and because they know if they die defending Romeo, Romeo's family will care for their family for life. Numbers were power in a city-state, but street action also included peaceful gatherings: joining in parades organized by the great family for their patron saint's feast day, filling out the crowds at weddings, cheering for the family's sons in jousts or races, all of which served to make the patron family's power visible to the public. The invaluable social historian Richard Trexler described a great case where, during a rare snowfall in Florence, youths from three

Medici ally families set out to have a snowball fight with Marietta Strozzi, the famously beautiful sixteen-year-old heiress of a major Medici rival, and the families sent clients out to stand along the street with torches and trumpets to make sure everyone in Florence saw this interaction of their important heirs; soon thereafter, at the conclusion of carnival, her mother's family celebrated her beauty again with a giant 500-person torchlit parade and fireworks set off outside her home.[3] The volume of cheers at a joust, or the size of a crowd at a wedding, combined with the grandeur of the jouster's armor or the splendor of the bridal gown, could communicate the patron family's power. Spectators considering where to invest next, whom to approach for employment, or what marriages to arrange for themselves made careful assessments of such displays.

Days of danger were, of course, when street action mattered most, and it was a smart investment for a rich family to support a poor one for generations if, for example, the grateful clients helped Cosimo escape from Florence in 1433, and stayed loyal through his exile, enabling his return. Nothing showcased power and disheartened opposition like the Medici's ability to fill the streets with their war cry: *Palle! Palle!* which means *Balls! Balls!*, a reference to the ball-shaped medicine pills of the Medici crest (*medico* = doctor), though shouting *Balls!* has exactly the same double entendre in Italian as English. The ability to spread the family war cry and muster a mob in minutes was invaluable, and if Shakespeare's Prince of Verona had decided to execute Romeo for killing Tybalt, Lord Montague would have had his clients sound the Montague war cry and raided the city prison to bust Romeo out—a city-state's small guard could not have stopped them.

Trust enabled all of this, built up over lives and generations, so it's when trust breaks down that Renaissance people die in a gutter, be it the worker who helped his patron's enemies and thus forfeits protection, or the tyrannical Duke Galeazzo Maria Sforza (1444–76), eldest son of Cosimo's friend Francesco Sforza, who, inflicting cruel tortures for small offenses and carrying off the wives and daughters of his clients and nobles, soon found no one willing to stand between him and the assassins as he was stabbed to death on the steps of his own cathedral.

Patronage networks had many layers, not just top and bottom. Master craftsmen like Brunelleschi or Michelangelo were clients of the great families or mighty guilds who commissioned work from them, but were also patrons to their own apprentices, workmen, and servants. When Michelangelo began painting the Sistine Chapel ceiling, the scaffolding that had been prepared for him was so inefficient that, when he redesigned it, it produced enough surplus rope that selling it provided dowry money for several of his workers, since girls on such a low stratum needed only a small nest egg to start a family.[4] At the same time, great families worked to connect their networks up and out to distant and higher powers. Piero the Gouty de Medici (Cosimo's son, Lorenzo's father) lent an enormous amount of money to the King of France (to finance France's recovery from the Hundred Years' War), a loan Piero knew was unlikely to ever be fully paid back. What Piero asked in return was permission to put the French royal gold-on-blue fleur-de-lis on one of the balls in the Medici crest, to advertise the family's special relationship with the *primus inter pares* of Europe's monarchs.[5] When the king's letter arrived granting permission for this, Piero ordered his clients that very day to rush out and make the change to every set of Medici balls they could get at in the city, finally giving the family's modest crest a grandeur to compete with the nobler imagery[6] (lions, daggers, dolphins, fleurs-de-lis) of many rival families.*

It was more than worth tying up a few Medici millions in indefinite French loans to project the message: if you need a favor involving the richest country in Europe (a trade deal, a military commission, a job for your exiled nephew) you know who has the king's ear, and if you cross our family you know what dread power will hear of it.

* Other powerful Florentine families, mainly ones who *were* nobles such as the Acciaiuoli, Pandolfini, and Pazzi, also had French symbols on their arms as displays of power. These families had more illustrious backgrounds than the Medici, marked by having had these symbols for some time, making Piero's propaganda coup in gaining the fleur-de-lis for his crest even more substantial. The gold fleur-de-lis on blue was also used as a Guelph symbol in Guelph cities like Florence, Bologna and elsewhere, because the French House of Anjou had long been a Guelph ally against their mutual foe the Emperor. See notes for details.

Medici *palle* (balls) crest, with fleur-de-lis on the top ball.

Patronage was also integral to the legal system. We've all heard of the extreme severity of medieval and Renaissance laws (Death for stealing! Death for adultery! Death for sneezing near the prince's horse!), but they make more sense when you remember that it isn't until the eighteenth century that Europe developed the idea that justice systems should aim for equal enforcement, that justice is when a person who committed a specific crime receives the standard punishment, and that it's unjust or strange for the punishment to be lighter. Renaissance courts focused instead on mercy, expecting the judge to almost always give a lighter punishment than what was on the books—a fine, for example, instead of death—so that the extreme sentences proclaimed by law were actually the exception, not the rule. This was tied to Christian ideas about sin and salvation, expressed well in the speech about mercy that Portia gives in *The Merchant of Venice* (IV.i):

[The quality of mercy] is twice blest:
It blesseth him that gives and him that takes.
'Tis mightiest in the mightiest; it becomes
The thronèd monarch better than his crown.
His scepter shows the force of temporal power,
The attribute to awe and majesty
Wherein doth sit the dread and fear of kings;
But mercy is above this sceptered sway.
It is enthronèd in the hearts of kings;
It is an attribute to God Himself;
And earthly power doth then show likest God's
When mercy seasons justice. Therefore, Jew,
Though justice be thy plea, consider this:
That in the course of justice none of us
Should see salvation. We do pray for mercy,
And that same prayer doth teach us all to render
The deeds of mercy.

Earthly justice was designed to imitate divine justice, by threatening the absolute sentence—death, equivalent to damnation, i.e. eternal death—then showing mercy. Each time someone guilty of a capital crime was spared, the criminal and all who watched the trial received a moral lesson about God and the hope of salvation, the judge and criminal acting out the roles of God and soul. Thus, the period absolutely did have those showy public executions and ingenious tortures, as portrayed so many times by Hollywood, but scholars know these are the odd cases, not the norm. When we find a record of somebody actually going to the stake, our reaction isn't, "How typical of these cruel times!" it's "They actually killed them this time? Why?" Sodomy, for example, was a capital offense in Florence and many places, but our greatest Renaissance sodomy expert Michael Rocke, while going through Florence's trial records, found that the vast majority of sodomy convictions ended with a fine, not bloodshed.[7] Similarly the inestimable Inquisition scholar Nicholas Davidson, going through trial cases in Rome and Venice, found that the most common sentence in a heresy conviction, or even a witchcraft conviction, was being compelled to sit through a serious of tedious lectures from Dominican

Thomists using Aristotle to explain the best route to Heaven. Even in the case of one apprentice who tried to sell his soul to the devil to sleep with his master's wife, where the Inquisitors had the *actual fully signed demonic contract in their hands!* the sentence was lectures (That boy needs a firm talking to!).[8] Even homicide was usually punished with a fine or a period of banishment, and execution saved for what they saw as really serious crimes, like desecrating a church, or betraying the ruler or regime.

Executions did happen, sometimes mass executions like the big heresy trials one reads about, or the massacres and mass executions of the Reformation wars, but such incidents were symptoms of political strife rather than the judicial norm, moments when a regime or ruler either felt weak and wanted to make a show of force, or felt strong and wanted to take the opportunity to exterminate a perceived threat, and used the legal system to do it. When normal executions did happen, even then the system revolved around hoping the process would help the sinner repent and reach God. There were special charities devoted to helping the condemned prepare their souls for the hope of Heaven, and volunteers who spent the final nights with them and even walked with them to the scaffold, holding an icon of the Virgin Mary in front of the condemned's face to help them think about the hope of divine mercy, not the noose.[9] Executions were usually reserved for rulers' enemies, for extremely severe crimes, like treason, hurling horse poo at an icon of the Virgin (absolutely death!), or, most tellingly, for moments when patronage broke down.

It was the patron who secured the lesser sentence, the powerful family who vouched for you, who stood character witness, who talked to the judge on the side to make clear they'll be *grateful* if their virtuous and deserving servant is acquitted. If you got on the wrong side of your patron, angered them, let them down, stole goods, spread gossip that hurt their reputation, got caught doing a quick job for the Capulets when you were supposed to be on team Montague, *that's* when the same political influence which usually arranged for mercy pushed for severity instead. A letter to Machiavelli from his clerk Agostino Vespucci of July 16, 1501, describes Rome getting more strict about sodomy, saying that several poet friends, "if they had not had refuge in the protection, now of this cardinal, now of

that, would already have been burned at the stake," and that another poet, Raffaello Pulci, who may not have such protection, had hired four female prostitutes to hang around him all the time to deflect allegations of sodomy.[10] Vespucci then says that a high-status Venetian woman actually was burned at the stake a few days earlier in Campo dei Fiore for kidnapping and sodomizing a twelve-year-old girl, showing how the cases that made it all the way to execution were usually both extreme (a kidnapping), violated some societal norm (female sexuality eliciting more anxiety than male), and above all involved people with weak patronage protections, in this case a foreigner from a nation on bad terms with the pope. Public burnings like that did happen, but when they did people wrote home about them as exceptional events.

The anxiety in Vespucci's letter—very real for Machiavelli, who like many Renaissance men had sexual partners of both sexes—shows the coercive power of this system. Breaking with a patron left one naked before a hyper-severe law, making the justice system a tool to ensure those in service stayed in service, even if (as with Cardinal Ippolito d'Este and Ariosto) the patron was unkind. Cardinal Ippolito's elder sister Isabella d'Este (whom you'll remember from her shopping spree), writing in November 1491 to the artist Luca Liombeni, who was frescoing a room for her, threatened repeatedly to throw him in the city dungeon if the work was slow—cruel treatment, but less cruel than what the law could do to someone with no patron.[11] In another letter of 1498 she writes of a jester, Diodato, who, due to illness or injury, is refusing to travel from Isabella's court to her brother Alfonso's, and Isabella says she would tie the man up and send him by boat, but that Alfonso specified he didn't want this one sent unwillingly.[12] Supreme patrons like princes and princesses of the House d'Este write with equal casualness about sending someone a basket of citrons or a portrait painter, and mix people, garments, foods, and treasures coequally on lists of things their agents are sent to acquire; in Isabella's case she makes no distinction between how she writes urging an agent to acquire for her a legally free musician or an enslaved African girl. Nor is it only from above that such language comes, as we see in a striking letter of 1471 in which one Alessandro di Conio—a man too unimportant to leave

much other trace in the historical record—writes to Lorenzo de Medici's grandmother Contessina asking her to get Lorenzo or Giuliano to take his son as an attendant: "I give him to you entirely, and as you would accept a dog as a gift you can accept a human creature who is more faithful."[13] Such service was not slavery—that too was practiced* in the same courts and palazzos where Conio's son might serve—but being a client was not fully freedom either, one of many fine grades of unfreedom reinforced by the coercive social structures of the age.

In 1600, the Roman market square of Campo dei Fiori was the site of another burning at the stake, one of the most infamous in history, that of scientist-scholar Giordano Bruno, condemned for heresy by the Inquisition. The incident is often invoked as proof of an age-old conflict between faith and science (hint: not true!), but Bruno's case was *not* typical; in fact it was the only science-related execution the Inquisition ever carried out—tens of thousands for Lutheranism and witchcraft, one for science.[14] Bruno's execution happened because he had angered his patron, promising to teach memory skills that the patron found he couldn't teach, so the patron denounced Bruno as a swindler and arranged his extradition from Venice to Rome.[15] If not for that, the investigation (if one had happened at all) would likely have ended with nothing, like the previous two times Bruno was investigated by the Inquisition. The Inquisition also investigated Marsilio Ficino, who was doing stuff as weird or weirder than Bruno, but Lorenzo de Medici had his powerful Orsini in-laws put in a good word for Ficino, proving again the value of his controversial marriage to a noble Roman wife. Showy executions happened, but they happened when there was a special reason: when the ruler wanted to make a point, a show of strength to frighten enemies, and when the victims were people the patronage network did not protect, either because they had angered their patrons, or because their patrons had themselves fallen from grace.

Grace is our keyword here. The Latin *gratias*, often rendered as *grace*, also meant *political influence*, so, in fact, a perfectly valid

* Slavery in Renaissance Italy will be discussed in Part III, in the section on Alessandra Strozzi.

translation of the Archangel Gabriel's words at the Annunciation, *Ave Maria gratia plena*, is "Hail Mary full of political influence." After all, who can possibly have more political influence than the Queen of Heaven and mother of Heaven's eternal Prince? Grace was the ability to procure mercy, to blunt the sword of justice and placate the sovereign power. There's a telling little interruption early in *Richard III* (II.i), when Edward IV is lamenting having executed his brother George of Clarence, and a random lord named Derby bursts in demanding, "A boon, my sovereign, for my service done!" the boon being "my servant's life; / Who slew today a righteous gentleman / Lately attendant on the Duke of Norfolk." Derby isn't claiming that his servant is innocent, he's asking for the king to pardon a red-handed murderer as a favor. This unnamed murderer appealed to his patron, Derby, to ask him to cash in his grace/influence with the king to get him off the hook. King Edward then yells at everyone about how they made no similar efforts to dissuade him from executing Clarence, despite the things Clarence had done for him (emphasis mine):

> ... not a man of you
> Had so much <u>grace</u> to put it in my mind.
> But when your carters or your waiting-vassals
> Have done a drunken slaughter, and defaced
> The precious image of our dear Redeemer [i.e. a human life],
> You straight are on your knees for pardon, pardon;
> And I <u>unjustly</u> too, must grant it you...

Grace here is political influence and the willingness to use it. A king's brother, of course, has no patron above him but the king, so when that patron was angry, no one could save Clarence, no one dared try. Lack of grace was the inverse of favor, hence earlier in Shakespeare's sequence the rebel Jack Cade's corpse being dragged to a dunghill, "and there cut off thy most *ungracious* head," since the anarchist who looted London has the *least* political grace in all England (*Henry VI 2*, IV.x).

Unjustly is another keyword—King Edward knows that the pardon is unjust, but "must grant it," because the patronage system demands it, just or no. Catholic salvation wasn't about being *not*

guilty; it was about *everyone being constantly guilty* of sins but begging to be forgiven anyway.

Patronage also went all the way up, beyond the king or city council, to the afterlife and patron saints. "Hail Mary full of political influence" helps us understand how people in the period thought saints could aid one's prayers. On Earth, if an armorer's apprentice got into trouble, he might go to his guild master, who would in turn go to the local lord who employed him, who might approach a mighty count at court, or perhaps a royal secretary, someone who would approach the queen or duchess, the person best positioned to placate a wrathful monarch. As on Earth, so in Heaven: if the same apprentice fell ill, he would pray for healing to the patron saint of his profession (Saint George for armorers), or of his city (John the Baptist for Florence), who would in turn approach the Virgin Mary to ask her to plead for God the Father to send health.[16] This exact sequence is how Dante gets permission for his journey in the beginning of the *Inferno*: the heavenly spirit of Beatrice, already dead and admitted to the royal court of Heaven, sees her poor poet wandering lost, so she approaches Saint Lucy, patron saint of scholars, who in turn approaches the Virgin, who secures permission for our tour of Hell.[17] The petition is to the divinity, while the saints are patrons whose grace/influence advances the petition at the heavenly court (which is both a royal court and a judicial court), securing mercy, overriding justice.

Anyone believed to be in Heaven could be appealed to as an intermediary, even a pious friend or relative, but the process of canonization required proof of miracles partly as official confirmation that, yes, this particular heavenly patron is listening and has the influence to get things done in Heaven. This is why throwing horse poo at an icon of the Virgin was a more severe offense than murder: it endangered the whole city by angering humanity's most powerful patron who, like an insulted empress, might turn a deaf ear to the whole city's prayers if they failed to avenge her honor. Every church and chapel that could afford it had a Last Judgment painting, showing a tribunal familiar from any court, with wrathful Christ as judge, grim John the Baptist on His left reading the charges out, and gentle patron Mary on His right asking for mercy. As Florence's ambitions had grown,

it had upgraded its patron saint from the minor patroness Santa Reparata to the more imposing John the Baptist, and depicting him on Florentine state buildings advertised the city's dread protector, just like the French royal fleur-de-lis on the Medici balls.

Divine patronage was deadly serious in this period, and heresy and sinful conduct were feared largely because of the anxiety that offending the saints would forfeit protection for the whole area. In Venice for a time, the legal penalty for any crime was doubled if you committed it where an icon of a saint could see you. When, in 1501, Antonio Rinaldeschi, drunk and cranky after a day of gambling, really did throw horse manure at an icon of the Virgin Mary, he attempted suicide for fear of being ripped apart by the mob, and the case was celebrated as an instance of exceptional mercy when he was instead given some hours in prison to repent and prepare his soul for Heaven before facing the hangman.[18]

Counter to what many might expect, a big goal of executions, as of all punishments at the time, was to give the guilty person's soul the best shot at getting into Heaven. Christians in this period believed (from Plato, though few knew it was Plato) that the soul was like an eye and looked in a direction, and whether you were damned or saved depended on what direction your soul looked *at the moment of death*. When thinking about Heavenly things (Truth, Virtue, Beauty, Love, Philosophy, Saint So-and-so) souls pointed upward and *moved* upward, so a soul that died thus would rise to Heaven like a helium balloon. When thinking about Earthly things (war, dinner, money, family honor, next month's election, ouch my knee) your soul pointed downward, heavy like a balloon without its helium, and dying thus your soul would fall to Hell. This, not deeds, determined salvation, so you could be Jack the Ripper but still go to Heaven if your final thoughts were of the hope for Heaven's *Grace*. Augustine's idea of the *corruption of the will* argued that the ability to turn one's soul-eye upward was inherently broken in humanity by Original Sin, and had to be healed by *Grace* before one could look upward—like surgery repairing a dysfunctional eye.* Later Christians debated

* This would be a major factor in the development of Calvinist and Puritan ideas of the Elect.

endlessly how this worked and whether it meant that, without baptism, looking upward was impossible (something Petrarch really worried about with dear Cicero!).

You may wonder, *if that's what the Church thought, why bother telling people to do virtuous deeds and go to mass and such?* Two reasons: (1) Sins weighed down your soul, like lead weights tied to your helium balloon, so if you were Jack the Ripper and died thinking of Heaven you still had to spend centuries in Purgatory getting those weights purged off before your soul could float to Heaven; the infamous indulgences that Luther so hated were get-out-of-Purgatory-faster cards, they did nothing for those whose souls pointed toward Hell. (2) Practicing upward thoughts in life, through prayers and deeds, would *build a habit* of your soul pointing upward, making it more likely to point in the right direction in the final moment when it mattered, so a nun who spent all day praying had a 90 percent chance of her soul pointing upward at the end, a virtuous king 50 percent, an average weaver maybe 20 percent, Jack the Ripper 0.00001 percent. We see this in early Shakespeare plays where he kills off lots of characters (he had to give up large casts after plague outbreaks in the 1590s killed most of London's actors): Shakespeare knows his audience is wondering where souls are going, so always indicates it in their last words, so virtuous types like Salisbury can get hit in the face with a cannon and still piously blurt out, "O Lord, have mercy on us, wretched sinners!" while complex characters like York mix up and down in their last words, "My soul to heaven, my blood upon your heads!" and villainous Richard III dies shouting of his kingdom and his horse.[19] We see this even more clearly in *Hamlet* III.iii, when he has the chance to kill his father's murderer Claudius while Claudius is praying, but Hamlet stops himself, saying it would be no revenge to kill Claudius then:

> *Now might I do it pat, now he is praying;*
> *And now I'll do't. And so he goes to heaven;*
> *And so am I revenged. That would be scann'd:*
> *A villain kills my father; and for that,*
> *I, his sole son, do this same villain send to heaven.*
> *O, this is hire and salary, not revenge.*

He took my father grossly, full of bread;
With all his crimes broad blown, as flush as May;
And how his audit stands who knows save heaven?
But in our circumstance and course of thought,
'Tis heavy with him: and am I then revenged,
To take him in the purging of his soul,
When he is fit and season'd for his passage? No!
Up, sword; and know thou a more horrid hent:
When he is drunk asleep, or in his rage,
Or in the incestuous pleasure of his bed;
At gaming, swearing, or about some act
That has no relish of salvation in't;
Then trip him, that his heels may kick at heaven,
And that his soul may be as damn'd and black
As Hell, whereto it goes.

Criminals facing execution were assumed to have souls that usually pointed down, like wicked Claudius's, so their best shot at Heaven was the execution process itself, a meticulously choreographed death focused on trying to get that soul-eye aimed upward. After final nights of prayer and repentance, one was escorted to the gallows by a buddy from one's church group, another escort holding an icon of the Virgin in front of the condemned's face, keeping one's thoughts aimed upward at Heaven's Queen, the friendliest, most forgiving, *gracious* facet of Heaven, likely to persuade the Lord to repair the damaged soul-eye of a sinner even in the ultimate moment.

Ideas of Earthly kingship tapped this celestial patronage network as well. Monarchs, as Earthly vassals of the King of Kings, claimed a special power to plead with God, much as popes did. An especially pious monarch might move on, like Dante's Beatrice, to advocate for subjects at Heaven's imperial court. These verses from a hymn to the ghost of King Henry VI of England, preserved on the flyleaf of a 1408 primer at St Cuthbert's College near Durham, show how the author believes that the dead king—whom many considered a martyr saint—has earned or "conquered" a position of "grace" in Heaven's imperial kingdom.[20] Reminding dead Henry of the charity and mercy he

had shown in life, the author asks him to share the same from Heaven via Henry's special access to the Trinity:

> O blessed King, so full of virtue,
> The flower of all knighthood that never was soiled,
> Thou pray for us to Christ Jesu,
> And to his mother Mary mild.
> In all thy works thou wast never wild,
> But full of grace and charity,
> Merciful ever to man and child—
> Now, sweet King Henry, pray for me.
> O crowned king, with scepter in hand,
> Most noble conqueror I may thee call,
> For thou hast conquered, I understand,
> A heavenly kingdom most imperial,
> Where joy aboundeth and grace perpetual
> In presence of the Holy Trinity,
> Of which grace thou make me partial—
> Now, sweet King Henry, pray for me.*

Just over a century later, when the Reformation begins, this entangled understanding of Earthly hierarchy with Heavenly hierarchy will be much of how religious reform triggers social upheaval. When Luther and his peers say priests and saints are not needed as intermediaries, that even a peasant can pray directly to God Himself without needing the *grace* of a favored saint or living priest to endorse the suit, this translates quickly into mass rebellion against the aristocratic masters whose function as tools of political influence between peasant and king was the same as that of priests and saints between peasant and God. Eroding the belief that all things naturally work through chains of intermediary grace is one way that the Reformation will contribute,

* In Jane Howell's brilliant production of *Henry VI* for the BBC Shakespeare Project, the first play opens with the actor who plays Henry VI singing this song at the funeral of Henry V, mourning his father's death with a song written to mourn his own, and contrasting martial with spiritual conquest: William Shakespeare, *The First Part of Henry the Sixt [Sic]*, BBC (New York, N.Y.: Ambrose Video Pub., 1987).

along with many other shifts, to the egalitarian movements of the Enlightenment, which required the breakdown of Europe's belief—as old as Aristotle—that hierarchy was an inextricable part of Nature: God over saint over soul; tree over bush over weed; lion over weasel over mouse; king over lord over farmer.

Long before Luther, ideas of grace and mercy created a tricky puzzle for our strict scholastic logicians. Mercy is the *suspension* of Justice, the moment when someone who *is guilty and does deserve it* is released from punishment. Justice stops and Mercy reigns instead, patrons (Earthly or Heavenly) waiving the sentence, not because of extenuating circumstances, but because of *gratias* alone. But Justice and Mercy are both good—how can two good things contradict? And worse, God is both Just and Merciful— how can He be both Just and Merciful if Justice and Mercy are opposites, like left and right? Perhaps on Earth a judge's sentence can be partly just and partly merciful, but God is 100 percent absolutes, He's *absolutely* Good, *absolutely* Wise, *absolutely* True, so He must be *absolutely* Just and *absolutely* Merciful at the same time. Doesn't that contradict? Like saying something can be True and False at the same time. Or that God could be Good and Evil at the same time? The doughnut hole can't both exist and not exist! Solving this, and establishing how God can be both perfectly Merciful and perfectly Just at the same time, is another of Thomas Aquinas's gold medal-winning long programs packed with quintuple jumps and certified miracles.

As we wrap up our quick dive into patronage, this is a useful moment to remember that, in the centuries after the Renaissance, the West underwent whole revolutions to move on from patronage-dominated justice systems to more egalitarian ones. Modern justice systems are often far from fair and far from perfect, with many systemic injustices we must strive to fix, but they do come much closer to equality than a system in which guilt and innocence were irrelevant compared with favor and disfavor.

In addition to asking what has to go wrong for someone to die in a gutter, another great question that gives us an entry into any place and time is: *What portion of the population can commit murder with no consequences?* In the Renaissance, anyone could do so as long as the victim was of equal or lower status, and you had

someone above you to pull strings. In the implausibly interesting autobiography of Benvenuto Cellini (1500–71), the Florentine goldsmith-sculptor-assassin-jailbreaker-necromancer (actually!), Cellini boasts in several passages about how he waits to get a big commission from a king or the pope and then brutally murders a rival, knowing his patron will pull strings to let him get away with it, rather than lose a precious artist and the unfinished art. When working for the King of France, Cellini was renting his shed to some men to store their stuff, but they didn't get it out on time when the lease ended, so he explains (very proudly) how he burst into their homes at night and stabbed them in all four limbs to leave them disabled for life. A courtier of the King of France doesn't face consequences, he's in a place of *grace*. The opposite was equally true: when the pope who employed Cellini became displeased, no power on Earth could save the artist from being imprisoned without trial for months on end. Compared to that, a jury of our peers, often as they do fail, is absolutely worth a revolution.

Humanity has yet to achieve a justice system that's immune to being exploited by the powerful to entrench their power, but, far as we are from achieving that aim, at least we are *aiming* at it. Our twenty-first-century ideas of justice have moved far from the era when, not only was the punishment for crime dictated by the whim of those with *gratias*, but *everyone accepted that as normal*, and believed that the whole cosmos worked that way. More on such changes later, when we look at the Renaissance's legacy.

29

Our Friends So Far

Patronage, then, as well as shared events, will link the fifteen new friends we're about to meet. But before we plunge in, here is a quick list of the friends we've met already: the poets, scholars, kings, and others who served as our examples as we entered this desperate time. This lists them with their dates, not for you to memorize (I haven't memorized these dates and this is my job!), but so you can put a bookmark here and check back easily as you read on and catch yourself wondering *how long after Petrarch is this?* or *Wait, which Alfonso?* Names are hard in an era when they repeat so often (it was common for fully a third of the College of Cardinals to be named Giovanni), so quick reference lists are indispensable, and this review should also launch you forward with a fresh command of what we know already, the threads of art, and politics, and Church, and bankers' gold, that form our tapestry.

*

Our friends so far:

In art and literature, we've met the "Three Crowns of Florence": Dante Alighieri (*c.*1265–1321) banished in the Guelph-Ghibelline mess, Francesco Petrarch (1304–74) born in exile, and Giovanni Boccaccio (1313–75) of *Decameron* fame; the latter two both lived through the Black Death and the years the papacy was up in France. We've met art rivals Lorenzo Ghiberti (1378–1455) and Filippo Brunelleschi (1377–1446) plus Brunelleschi's beloved Donatello (*c.*1386–1466), who all worked on the Roman-like statues on

Orsanmichele, and on Florence's ambitious cathedral. And we've met several scholars: book-hunting Poggio Bracciolini (1380–1459), book-collecting Niccolò Niccoli (1364–1437), Giovanni Aurispa (1376–1459) who trekked east to learn Greek and find Plato and Homer, and history-slicing Leonardo Bruni (1370–1444).

As art leaks into politics, we've met Cosimo de Medici (1389–1464) starting the endgame of turning money into power, his son Piero de Medici called the Gouty (1416–69), who lent that money to the King of France, and Piero's son Lorenzo the Magnificent (1449–92), our hero/villain of many histories. We've also met Cosimo's friend Duke-conqueror Francesco Sforza (1401–66), who seized Milan along with his wife Bianca Maria Visconti (1425–68), the illegitimate granddaughter of Gian Galeazzo Visconti "the Viper of Milan" (1351–1402) whose attempt to conquer northern Italy was (according to Bruni) brilliantly thwarted by Florence cleverly waiting for him to drop dead of a fever.

Still in politics, we've briefly met Francesco Sforza's eldest son, tyrannical Duke Galeazzo Maria Sforza (1444–76), who forgot that patronage requires trust and abused his vassals until they assassinated him on the steps of his cathedral, and we've met two of his younger brothers, Cardinal Ascanio Sforza of Milan (1455–1505) with his Latin-speaking parrot, and Ludovico Sforza (1452–1508) who became Duke of Milan through another series of feuds and betrayals. We've also met Francesco Sforza's illegitimate niece Ginevra Sforza (1441–1507), who married the equally illegitimate Sante Bentivoglio (1426–62), who started as a blacksmith's son, but was identified as a Bentivoglio bastard, educated by clever Cosimo de Medici (a good chance to strengthen ties with another important Guelph family) and who ruled Bologna for a while after all the other adult Bentivoglios were massacred in 1445. Sante and Ginevra's son, mercenary commander Ercole Bentivoglio (1459–1507), was the one who urged Machiavelli to finish his history of these desperate times.

We've met kings too: Up in England we've met Henry VI (1421–71) who was an infant when his father Henry V (1386–1422)

died, creating a power vacuum in which the young king's uncles Cardinal Beaufort (*c.*1375–1447) and Humphrey of Gloucester (1390–1447) raced to hire Italian secretaries like Bruni and Poggio. A long lifetime and many wars later we've also met Charles VIII of France (1470–98) who invaded Italy in 1494, and his contemporaries Ferdinand of Aragon (1452–1516) and Isabella of Castile (1451–1504), whose marriage united Spain. And, just as closely intertwined with Italy, we've met Ottoman Sultans Mehmet the Conqueror (1432–81) who took Constantinople in 1453, and his successor Bayezid II (1447–1512) who had 5,000 books.

We've met several Kings of Naples, whose prominence reminds us that Renaissance Naples was not—like modern Naples—just a city, but a powerful kingdom comprising the southern half of Italy plus Sicily, a major power to rival Aragon or Portugal. Way back, before the Black Death, we met Petrarch's friend King Robert of Naples (1276–1343), from the ancestrally French royal house of Anjou, who offered to crown Petrarch poet laureate. Four tumultuous dynasty changes later, we met the high-paying *umanisti*-hiring Spanish conqueror of Naples King Alfonso the Magnanimous (1396–1458), whose numbering is confusing because he was king of Aragon and Valencia and then conquered Naples, Sardinia, and Corsica, and has a different number for each. Magnanimous Alfonso had no legitimate offspring, so his lands in Spain passed to his brother John II, whence they passed to John's son Ferdinand of Aragon (the one married to Isabella), while Alfonso left his fresh conquests in Naples to his illegitimate son Ferrante of Naples (1424–94). It was Ferrante's daughter Beatrice of Naples (1457–1508) who married Matthias Corvinus the Raven King (1443–90) and became Twice Queen of Hungary. And we've briefly met Queen Beatrice's niece and nephew from Ferrara, Isabella d'Este (1474–1539) with her big shopping spree who threatened to give her slow artist a tour of the dungeons, and her brother Cardinal Ippolito d'Este (1479–1520) who had his half-brother's eyes gouged out over a love quarrel, and didn't thank Ariosto for his epic *Orlando Furioso*.

Now, for our new friends…

30

Alessandra Strozzi: Labors of Exile

Alessandra Macinghi Strozzi (*c.*1408–71) was a Florentine matron, who ran Florence's end of the vast Strozzi banking empire while her sons were in exile, an example of one of the city's *ottimati* driving out another for a time. The many surviving letters she wrote to her banished family members are a treasure for historians, since their details about everything, from prices and purchases to doctors and illnesses, to weddings and heartache, are perfect for our quest to make evidence-based portraits of life in another age.[21]

Alessandra's birth family, the Macinghi, were a new power in the city, and had only become high-status enough to supply one of the Nine Dudes in the Tower (the *priori* of the *signoria*) twenty years before her birth—newcomers to Florence's politically enfranchised *popolo*. Yet, the Macinghi were rising, and rich enough to give Alessandra a dowry of 1,600 florins ($1.6 million). Unlike in England, where women did not own property and the dowry became the husband's, in Italy a woman's dowry was hers for life, capital which her husband could *invest* but could not *spend*, and which she retained exclusively on widowhood. In the 1400s, Florence's elites had the highest dowry rates in Europe, and such a dowry was investment capital, intended to let the new couple establish themselves in business. A poor girl's dowry might finance a loom for a weaver, a few cows for a farmer, or for a merchant a wagon load of trade goods to yield the first profit which would in turn fill the next wagon, while a rich bride like Alessandra might bring enough capital to launch a new import-export business, or start a new bank branch.

With such assets, in 1422 Alessandra (aged ~14) married Matteo Strozzi, a member of the richest *ottimati* family in the city, then even richer than the Medici. Heading a large Florentine household was like managing a corporation, with staff, servants, and dozens of dependants living in subsidiary properties, such as the farms which produced the grain, oil, wine and other goods to feed the household. It also meant caring for the needs of many clients in the Strozzi patronage network, with bank branches across Italy and Europe, and coordinating with other family members, including Palla Strozzi, the richest man in Europe at the time, with taxable assets in 1427 of 163,000 florins ($163 million) plus many non-taxable assets and resources beyond Florence (so let's say ~$250 million).[22]

To get a sense of scale, since in 2020's world of billionaires $250 million does not seem *that* huge, Palla Strozzi's fortune was basically unrivaled within Europe in his day, if we exclude royal courts, which are hard to compare to a banker's fortune since royal assets and expenditures on war and diplomacy were enormous, but many of their assets were expected taxes or heritage relics, so their real bank wealth was often negative. Richard Goldthwaite's numbers show that, in 1427, the top 1 percent of Florence's families (famous for extreme wealth!) owned 27 percent of the wealth; in comparison in the US in 1995 the top 1 percent owned 38 percent of the wealth.[23] In the Renaissance as today, wealthy families worked hard to game the tax system and guard their wealth, but since Florence's taxes were wealth taxes, not income taxes, it was harder to hide stockpiled wealth from taxation. Additionally, the incentive structures of patronage, and the ways families gained legitimacy and even safety by funding art, culture, architecture, public works, and public events, encouraged a wealthy man like Palla Strozzi to spend heavily and directly from his private purse on city infrastructure, public art, national defense (wealthy Florentines were expected to build and staff at least one fortress on the city's periphery, to slow down approaching armies as people from the countryside evacuated to the safety of the city walls), and on providing a social safety net for that slice of the population

which fell under his patronage.* When we compare the Strozzi family's spending on public art and orphanages to billionaire spending on high-tech fads and superyachts, we may remember what Machiavelli himself observed in the *Discourses* when comparing ancient Roman religion with Christianity: that the different ways a culture incentivizes elite spending has a huge impact on whether or not the wealth that accumulates in elite hands still benefits society more broadly.[24]

In her early twenties, Alessandra was already running things during the periods that her husband traveled on diplomatic missions for the city. In 1433, when Alessandra was around twenty-six years old, her husband Matteo, as well as Palla Strozzi and other Strozzi family members helped lead an effort to oust the Medici from Florence (the time Cosimo was locked in the tower, but bribed his way out), so all the Strozzi men were banished upon Cosimo's return in 1434, including Alessandra's husband and her sons.

Banishment, as we saw with our friend Machiavelli, was not an end of one's ties with home. Rather, exiled Florentines were expected to work to earn their return, by serving the city and taking part in trade and finance in their places of banishment, a vital part of Florence's pan-European economic presence, and an unofficial ambassadorial corps for the nobility-lacking merchant republic.[25] Women, having a different legal status from men, could not be banished in the same ways men were, so were free to choose whether to leave with their husbands or remain in the city (as Mrs. Machiavelli did). In Alessandra's case, she and all the children at first went with her husband Matteo into exile in the port of Pesaro, on Italy's eastern coast near Urbino and Rimini, a spot whose importance was on the rise due to the

* Florence also incentivized the rich to pay taxes via a system in which the less affluent paid direct taxes, but the super-rich instead gave forced loans to the state—loans which were gradually paid back, and generated state debt that could be traded as if today's wealthiest were required to buy a certain quota of government bonds as their form of paying taxes. Since this generated a commodity (debt) which elites could buy, sell, and speculate with, they were more willing to pay than if the taxes were direct. See Goldthwaite, pp. 391–2, 406, 58–73, 536.

growing power of the Malatesta and Montefeltro mercenary families, strengthened by a visit from (Holy Roman) Emperor Sigismund of Luxembourg (1368–1437), who stopped there in 1433–4 en route home from being crowned in Rome. In Pesaro, Alessandra and her family were well positioned to be important envoys for their city, but a bout of plague killed Matteo and three of their eight children. The surviving boys spread out to different cities to strengthen their fortunes, and Alessandra and the girls returned to Florence to help run the bank and the Strozzi patronage network, and work to get her sons' banishments repealed. Women's effective immunity to banishment is also why, in 1464, Alessandra's cousin-by-marriage Marietta Strozzi, granddaughter of the super-wealthy Palla Strozzi, was still in Florence to have a snowball fight with those pro-Medici boys, and why young Marietta's presence in the city was such an important embodiment of a family whose power could not be banished even if its men were. Alessandra, her daughters, other Strozzi women, the Strozzi men in exile, all were partners in the project to restore the family.

Alessandra's letters show her forcefulness in business, her touching spirituality as she lost friends to plague, her careful navigation of the web of patronage, and her cold practicality as she discussed chilling questions, such as whether to take out life insurance on her daughters when they became pregnant.[26] Florence's tax system (asking neighbors to guess how rich you are) was easy for those in power to exploit, and much of the Strozzi family's wealth was punitively fined or taxed away through Medici pressure (the tyrant side of Cosimo), but such methods could not touch a woman's dowry, and Alessandra invested her untouchable 1,600 so successfully that it helped carry and stabilize the family fortunes. After Alessandra's sons returned in 1466, her eldest, Filippo Strozzi—who had used his time in exile well and secured a commission as banker to the King of Naples—had wealth enough to build Palazzo Strozzi, an over-scale palace in the heart of Florence which, to this day, protrudes into the streets and skyline, as if to say: you may exile our bodies, never our power.[27] Several memorable letters also mention slavery, especially an enslaved servant girl called Cateruccia working in Alessandra's house, a reminder for

us of the moment when Europe's practice of slavery* had not yet expanded to the large-scale agricultural exploitation that would come with the African slave trade; in Alessandra's day most of the enslaved persons in Italy were brought from eastern Europe and used as household servants, or, in Venice, gondoliers.[28]

Marriage alliances were one of the most important ways to rebuild power, and Alessandra's oldest surviving letter (August 1447) details the process. She could not muster the 1,500 florins necessary to match her sixteen-year-old daughter Caterina with a top-tier family, so chose a young man from the Parenti family, much less powerful than the Strozzi, but with an established silk manufacturing business, some political influence, and a recent office-holder in the family (one of the Nine Dudes in the Tower), so part of the *popolo* but far from the *ottimati*. The Parenti were excited enough to marry into the powerful Strozzi network that they would accept a more modest 1,000-florin ($1 million) dowry, half from the dowry fund (the return on money invested when a girl was born), the other half in cash and trousseau.

The trousseau included the bride's wedding clothes, plus other clothes and linens carried with her in the wedding procession, and since cloth in the era was so labor-intensive and expensive, the trousseau might constitute much of the family's nest egg in itself. The number of hours that went into making even a shirt with pre-industrial technology was enormous. Depending on how one calculates—i.e. comparing period prices to period income, or

* In this period, enslaved girls were usually renamed and re-baptized by their enslavers (even if already baptized) and 80 percent received one of four names: Caterina (of which Cateruccia is a variant), Lucia, Marta, or Maddalena, the last chosen for women whose enslavers intended to use them as concubines, overwriting their identities with signs of their exploitation. Galley slavery, and a large ransoming economy of Christian-Muslim prisoner exchange, was the other main form of enslavement affecting Italy at the time, and most *umanisti* had friends who had spent time as galley captives before ransom, or had done so themselves, and encountered corresponding enslaved Muslim people in Rome and elsewhere. In Renaissance Italy, dark-skinned African enslaved persons were mainly a luxury trade, brought to elite courts, usually in childhood, to be raised as exotic personal attendants for nobility, as we see in two letters of Isabella d'Este written in June 1491 directing a servant to purchase for her various fabrics, ribbons, caps, and a girl of two years or less "pretty and very black." See notes for sources.

comparing the number of labor hours that went into a garment to the cost of that labor at modern minimum wage—one arrives at a shirt costing somewhere between $300 and $4,000. The inventory of Palazzo Medici valued bolts of lowest-quality home-spun linen, the cheapest fabric you could get (used for shirts, bedsheets, and undergarments), at about 0.14 florins ($140) per yard, but wools were much costlier; remember Isabella d'Este being willing to pay 10 per yard ($10,000) for very fine black fabric. The inventory lists several chests of plain, everyday clothing or bedlinens whose contents were worth several thousands. Even at more modest income levels, when estimating the cost of purchasing what was on someone's body as they stepped out the front door, don't think of buying an outfit, think of buying a car, and if it was an outfit nice enough for a Florentine from a decent family then think about buying a Ferrari or other luxury car.

This also helps you understand why the wool trade, and Florence as Europe's wool capital, was a *big deal*—think of the political and buying power of the auto industry, Henry Ford upending labor as we know it, and you'll understand why a letter from the Florentine wool guild mattered even to the King of England, whose people really need to sell that wool!

(Fun fact: in the 1300s into the 1400s, Florence bought 100 percent of England's wool exports.[29] Processing wool to make fine, *not-itchy* cloth required, in the period, a lot of oil, and England's only oil crop was walnuts, not an efficient choice. Olive oil was ideal, but England's frequent wars with Spain made getting industrial levels of olive oil up to England so costly that it proved more profitable to sell all of England's wool to oil-rich Florence, to turn into high-profit high-quality fabric, rather than to try to export itchy English cloth. The other thing you need for good wool cloth is the mineral alum, to make your dyes colorfast, which could only be acquired from three known mines, one in the Byzantine (later Ottoman) Empire, one (after the 1460s) belonging to the pope, and the third (after 1472) in Florentine-controlled Volterra. This kind of interdependency was why even far-off England had to care when feuds and tumults threatened cantankerous Italy.)

In the same letter, Alessandra calculated that between the trousseau she provided, and the extra clothes, and jewels bought

for young Caterina by her groom's excited family—which included furs and two sixty-florin strings of pearls—the bride would have 400 florins' worth of wealth ($400,000) on her body as she walked across the city to her husband's home. This was not simple conspicuous consumption: all Florence would see the bridal procession and estimate the power of these families by the wealth they saw. By supplementing the trousseau provided by the Strozzi with even more costly robes and pearls, the Parenti family—new to the *popolo* and excited to secure a bride from one of the *ottimati*—was making a modest dowry look larger, and once the bride reached her new home, the pearls and other reusable materials would be resold to buy equipment for the newlyweds' silk business. Returning to our auto industry simile, for this wedding dress think of the kind of Lamborghini that sets the whole town gossiping when someone parks it on the street, except that it can be trivially disassembled and the parts turned back into investment capital. For the pearls, think stock market shares or savings bonds, high-value investments infinitely resalable. Indeed, the choice of pearls as a form of display was itself strategic: costly embroideries and cut gemstones were both unique and recognizable, so if one resold a particular ruby or yard of brocade, others would recognize it and comment, *Ah, X-family is poor enough to need to sell!* Not so the smooth homogeneity which made pearls as anonymous as coins, and who would notice if a string that had sixty pearls on it yesterday today has fifty-eight?[30]

Alessandra also writes of her struggles with oppressive taxes, describing her life as one long string of visits to (Medici-controlled) officials to keep them from stripping her of the standard tax exemption for widows (they knew how powerful she was). She writes of her hopes that the special temporary war tax (remember those emergency powers Cosimo passed on and kept on renewing?) might go away with the death of the last Visconti Duke of Milan, which she hopes will bring true peace unless ambitious King Alfonso the Magnanimous causes fresh wars in the Italian peninsula. Alas, neither Medici use of not-so-temporary powers nor the ambitions of powerful neighbors would ease up in Alessandra's lifetime, or her children's. Like plague, the threat of war among the big Italian powers—Florence, Milan,

Naples, and Venice, often also involving popes and Genoa—had become a constant of a Florentine's everyday reality, and, through an interconnected Europe, everyone's. At Alessandra's death in 1471, Europe was just entering the phase of outward-reaching conquests that would be its Age of Empires, but the same political attitudes which viewed a power defeating and dominating its neighbors as proof of strength and *legitimacy* were already venting that empire-building impulse within Europe, as rising powers strove to conquer nearby powers, and rising families to subjugate rival families, like Alessandra's.

31

Manetto Amanatini: There Is a World Elsewhere

Manetto di Jacopo Amanatini (*c.*1388–*c.*1450/2), known as Grasso, or "the fat woodcarver" was a Florentine woodworker, best known for being the butt of a strange prank, but recently revealed to be a window on much more, thanks to the fantastic work of historian Katalin Prajda.[31] Amanatini's father died young, so in 1409—when the famous story takes place—our young breadwinner was in his twenties, a newish member of one of the merchant guilds which constituted Florence's ruling class. I will refer to Manetto by his surname Amanatini, since his story involves an impossible surplus of names starting with M, though it would be more standard to use his given name, Manetto, as we do with Leonardo, Michelangelo, Raphael, Cosimo, Poggio, etc. We're certainly *not* going to continue the fat shaming of his day and call him "Grasso" as the main source does.

Guild members like Amanatini were not mere laborers but the masters of workshops, owners of the means of production with apprentices and laborers in their employ, toward the bottom of the politically enfranchised *popolo*, so occupying one of the many middle strata in the patronage network, with ties both up to great *ottimati* families and down to ordinary workers and to those lesser business owners who did not have *grace* enough to join the guilds. Such workshops served Florence's (classicizing) construction boom, and most master woodworkers could support large households with servants and apprentices, and owned assets worth 100–200 florins, 600 for the richest (so $100,000 to $600,000 in the bank; contrast this with Alessandra Strozzi's personal $1.6 million fortune *separate from* her husband's and extended kinsmen's property).

Running a workshop required literacy, mathematics, and accounting skills as well as woodworking ability, but it did involve putting hand to chisel, and in the period any job which involved manual labor of any kind was lower status than jobs which didn't. Woodworking was thus a middle-status occupation, above common labor but below the richer guilds that dealt in wool or silk, and far below the high-status hands-off trades of banking, law, or medicine. Even Michelangelo's family considered him a shameful black sheep because he went into (hands-on) art instead of respectable (hands-off) banking, and only forgave him when he got mega-famous. (*Wait, doesn't medicine involve touching the patient?* No, doctors' assistants or barber surgeons touched the patient, the doctor stood nearby holding a volume of Galen and *maybe* looking at the color of your urine, but it was more scientific to take your horoscope instead.[32])

The prank which made Amanatini famous was masterminded by Brunelleschi (who was not yet working on the dome), along with Brunelleschi's equally famous lover Donatello and several of their friends. Our account comes from a text written a number of years later by admirers of Brunelleschi, so we need to keep that bias in mind, but the details are as clear as they are implausible. Together, Brunelleschi and his friends conspired to convince Amanatini that he had gone mad and was actually someone else. Through their influence, one morning suddenly *everyone in the entire city* started addressing Amanatini as Matteo Mannini, an unskilled day laborer (the kind that earns 35 florins a year). Brunelleschi and friends locked him out of his house, and hid inside the house loudly impersonating the "real" Amanatini, with their befuddled victim listening outside. They got everyone in on this, and even got the city watch to arrest Amanatini for Matteo Mannini's debts and throw him in jail, where visitors pretended not to recognize him. They then had two men bail him out, claiming to be his brothers, who took him to their home and spent the evening convincing him that he really was the day laborer Matteo Mannini, and that his memory of being a master woodworker was a fit of madness. Once their victim finally fell asleep, the pranksters returned him to his real bed, and in the morning pretended nothing had happened, trying to convince him it was a strange, elaborate dream.

Core to this stunningly thorough prank (in modern terms *harassment* might be better?) was the enormous influence Brunelleschi was able to exert, not only over his and Amanatini's friends, but the whole city, and even the police. Major artists who secured big commissions were celebrities, known throughout the city and beyond, and their fame and popularity gave them enormous social power. The year 1409 was early in Brunelleschi's career, before his big commissions, so he and Amanatini were economic peers and competitors, not one above the other, but Brunelleschi was already gaining fame with his studies of *antiquity*, the fashionable new big thing. In a patronage system, a quick word from someone full of *grace* went far, and fame and charisma were another source of grace, making charismatic mastermind Brunelleschi as dangerous a rival to Amanatini as the Medici to Alessandra Strozzi.

Shortly after the 1409 incident, Amanatini emigrated to Hungary. Period accounts, which celebrate the prank as proof of Brunelleschi's brilliance, claim that it was the subsequent public mockery which drove Amanatini to leave Florence out of pure shame, making the move to Hungary feel like fleeing to a funk hole at the ends of the earth. But here we must look deeper. Hungary was not some distant backwater, but a near and important neighbor of Italy, easily reached across the Adriatic via the Venetian-ruled Dalmatian coast. Amanatini went there to work for a far more impressive patron than Florence could offer: the very same Sigismund of Luxembourg, King of Hungary and later Emperor, whose visit enhanced the prominence of the area Alessandra Strozzi and her family first went in exile, who was spending lavishly to glorify Hungary's court, for the same reasons Matthias Corvinus the Raven King would do so four kings later. Kings paid *very* well, and soon after he got established in Hungary, Amanatini started sending massive amounts of money home to his family, who rapidly rose to a tax bracket well above any of Florence's resident woodworkers, far outstripping the wealth of Brunelleschi and Donatello. Amanatini would have had little opportunity to rise in Florence where Brunelleschi's clique of cruel rivals had *grace* with the city, and dominated the cathedral construction and other high-profile woodworking projects

to the exclusion of those they disliked. These details, Katalin Prajda's meticulous contribution to the slow work of the History Lab, make Amanatini's supposed shameful flight feel more like an act of spite, a declaration like that of Shakespeare's Coriolanus, "Despising / For you the city, thus I turn my back. / There is a world elsewhere" (III.iii). This well-calculated emigration of an ambitious Italian craftsman shows how the patronage network shaped mobility, those who lost *grace* in local networks seeking new patrons, and carrying their skills throughout the broader Renaissance.

32

Francesco Filelfo: Between Republics and Monarchies

Francesco Filelfo (1398–1481) was the longest-lived professional *umanista* of the early days of the classicizing movement, educated when Greek was rare and the new Latin truly new, but who survived to see two more generations grow up on the *studia humanitatis*.[33]

Filelfo was a fierce, proud character, who styled himself a cynic philosopher destined to wander the world stinging and poking at elites and establishments, like a Socratic gadfly. He was outspoken, arguing for what we might call a very early version of free speech, at least for those with a philosophical calling. He made enemies easily, not only of fellow scholars, but of patrons, so oscillated between patches of high pay and near poverty, but his fame and skill meant there was always some university or patron willing to employ him. Filelfo frequently boasted about the fact that he had three testicles—for which he invented a Greek word τριόρχης (tresticular)—and also proudly boasted that he had sired twenty-four children, thirteen by his three wives, the rest through numerous infidelities. By fifty years after his death, his collected letters had been printed forty-one times and were popular as far afield as Paris and Antwerp, and in later centuries he was largely forgotten and ignored for very telling reasons.

Born near Ancona, a bit south of Rimini and Pesaro, young Filelfo studied in Padua, the mainland city facing Venice. His Latin skills made waves, and in 1417—when he was only eighteen, and Poggio was still crossing the Alps about to find his

Lucretius—Filelfo was invited to Venice to teach the *studia humanitatis*, specifically Latin eloquence and ethics (notice the expectation that teaching Latin and teaching virtue should be intertwined?). At this stage, Venice was a young scholar's best hope of learning Greek, since its ties with Byzantium meant there was a substantial Venetian presence in Constantinople, with regular diplomatic missions. By impressing Venice's patricians, young Filelfo secured enough *grace* to land the post of notary for the Venetian community in Constantinople, a scholar's dream chance to travel east, with status and a salary to boot.

In Constantinople, Filelfo studied with John Chrysoloras (1360–1422), one of the most renowned Greek scholars of the day. In the early 1420s, the Ottoman Empire had a succession conflict, and Filelfo aided Venetian diplomacy with the rival sultans, which ended badly with Sultan Murad II besieging Constantinople in 1422. A teacher-pupil relationship was also a patronage relationship, one of the deepest and most inviolable of the period—even the original Hippocratic Oath, 2,000 years old by Filelfo's time, had included the stipulation to honor one's teacher equal to one's parents, to honor the teacher's family as family, and to teach one's teacher's children if they wished "without fee or indenture." So when Filelfo's teacher John died during the siege, Filelfo became caretaker and tutor to John's daughters, one of whom, Theodora Chrysoloras (a kinswoman of the Byzantine Emperor), Filelfo married. Constantinople endured the siege, and afterward Filelfo took service with his imperial in-law, Byzantine Emperor John VIII Palaeologus. He even accompanied the Emperor on an embassy to King Sigismund of Hungary to advance a Venice-Hungary-Byzantium alliance, a trip on which he likely met our Florentine woodcarver Amanatini, and certainly saw many of his creations.

In 1427, with masterful Greek and forty rare manuscripts in hand, Filelfo returned to Venice to find the city emptied by a bout of plague. He then went south to teach at Bologna, Europe's oldest university, leaving his treasured Greek manuscripts with a friend in Venice who—despite years of pleading letters—never returned them. Bologna, in turn, had just endured the massacre of the Bentivoglio family, and its government was in the shaky

hands of that illegitimate blacksmith's son Sante Bentivoglio (whose son would write to Machiavelli), so Filelfo found Bologna too unstable, and moved on to Florence. There, Filelfo was welcomed and supported by both Cosimo de Medici and Palla Strozzi, of the not-yet-banished Strozzi family. As a new arrival, Filelfo would have had to live and work a long time in the city to earn *grace* enough to be invited to join the politically enfranchised *popolo*, but some *umanisti* had managed it (Bruni for one) and even without enfranchisement, the enthusiasm of the public and the support of two of Florence's richest *ottimati* could make an immigrant comfortable even if his name was not in the lottery bags.

Filelfo's erudition was much admired in the city, but he soon began quarreling with the Florentine *umanisti* of Cosimo's network, especially our book-hunters Niccolò Niccoli and Poggio Bracciolini, whose Latin skills he persistently belittled, boasting of his Greek. Filelfo circulated biting satires about rival scholars, who bit back in turn, and the quarrel turned serious as Filelfo took an anti-Medici position. By 1431, Filelfo was dismissed from his teaching position by a board which included Cosimo's brother, and as things got tense in 1433 a Medici partisan slashed Filelfo's face in a (possibly murderous?) attack. Filelfo drifted more into the Strozzi network, burning bridges with the Medici one, so when Palla Strozzi and others arrested Cosimo and tried to break his power, Filelfo loudly endorsed executing Cosimo. When Cosimo bribed his way out and returned in 1434, the same crisis which banished the Strozzi banished Filelfo too. This experience sparked Filelfo's book *On Exile*, modeled on Cicero's dialogs and intended to be therapeutic as well as instructive, describing exile's griefs and offering consolation. In *On Exile*, Filelfo declares that it is the right and duty of philosophers to publicly criticize rulers and their actions, as a tool of moral guidance for leaders and peoples of the world.

After leaving Florence, Filelfo taught in Siena briefly, but they paid only ~66 florins a year ($66,000), not even double a day laborer's salary, so Filelfo moved on to Milan. There the Visconti duke paid him a princely 700/year plus additional rewards each time he completed a pleasing work, and he had *grace* at court,

the ear of the duke, and the hope of an *umanista*'s dream job: the opportunity to tutor and influence the heir to the throne.[34] Alas, this Visconti had no heir, so at his death Filelfo and the city endured rocky days until Francesco Sforza took the throne. Filelfo then tutored the new duke's children, especially young Ascanio Sforza (who would go on to become a cardinal and have that Latin-speaking parrot, but at this time instead had a well-documented pet bunny given to him by his big sister Ippolita Maria).[35] Filelfo had begun a book about how terrible the Medici were, and a book celebrating the Visconti duke and urging him to drive the Medici from Florence, but the new duke Francesco Sforza was friends with Cosimo, so Filelfo abandoned these and began a grand epic poem about the Sforza family, the *Sforziad*, imitating the *Iliad*.

Let's zoom in for a moment on Milan's Visconti-to-Sforza transition, since this is a good moment to ask whether the *Sforziad* really was so different from a *Viscontiad*, and to prove the important History Lab maxim that, when you zoom in on a moment in the past, it's always (A) messier than you thought, and (B) includes more women.

In the 1300s, the Visconti family had taken Milan away from its previous Torriani rulers, through a pretty typical combo of (A) getting a pope who disliked the current rulers to give them the archbishop position and the power that came with it, (B) exploiting Guelph-Ghibelline factional violence, and (C) bribing the Emperor to confirm their rule. Fast forward to the 1440s and the last Visconti duke, Filippo Maria Visconti, had no *legitimate* heir, but raised his *illegitimate* daughter Bianca Maria Visconti as a princess with a brilliant education, 100 percent prepared to Rule Stuff™. At that time, the Visconti were fighting a messy war with Venice over disputed towns between Milan's empire and theirs (the zone around Verona). Both sides used mercenaries, and Italy's premier mercenary at the time was Cosimo's friend Francesco I'm-Better-At-Using-Artillery-Than-Anyone Sforza. Sforza fought for both sides alternately, since a hired sword is content to switch when the other side bids higher, or (as often happened to him) when his current employer didn't pay as much as was promised. Sforza was very good at taking towns, and in

the course of this mess he often took the same town four or five times for different sides, and became so good at it that both sides started to fear him.

Duke Filippo Maria Visconti attempted to bind Sforza to his side by letting him marry his daughter Bianca Maria—interpreted widely as a signal that Visconti intended to adopt Sforza as his heir and *merge* the families—though Visconti actually strung out the engagement for many years to reserve it as a carrot to keep Sforza in check. When Visconti finally did let Sforza marry Bianca Maria, he (still scared of Sforza?) didn't give Sforza the two towns he'd promised as her dowry, so Sforza took them by force (I'm here to read Latin and take towns, and I'm all out of Latin). His annoyed father-in-law then made a will *which he never intended to actually go into effect* leaving the Duchy of Milan to… (any guesses?)… King Alfonso the Magnanimous of Aragon the humanist-loving conqueror of Naples. Why? As a stick to go with the carrot, that Sforza had better be loyal if he wanted his father-in-law to rescind that will and leave him the duchy. Why Alfonso? Short version, he and Visconti had been allies in some wars. But Fortuna is a fickle goddess, and decided it would be hilarious if Duke Filippo Maria Visconti made this will he didn't actually intend to implement, and then *dropped dead unexpectedly the very next day.*

Chaos.

Agents of King Alfonso immediately took the opportunity to seize Milan's ducal palace and force its nobles to swear fealty to Alfonso, while, in the confusion, the city of Milan decided to declare *the Restoration of the Milanese Golden Ambrosian Republic!* Milan hadn't been a republic since the pre-Visconti Torriani tyrants took the city nearly 200 years before, but Machiavelli will tell you republics are a rash that even the most monarchal cities break out in from time to time. And Machiavelli will tell you that, unless managed *very carefully*, such republics don't last. The messy republican revolution meant Milan was too busy to defend its empire, so Venice took the chance to conquer back those border territories they and Visconti had been fighting over. Imagine now our timid and conspicuously Venetian Filelfo *living in the contested ducal palace*, with the manuscripts of his anti-Medici and

pro-Visconti poems in hand, hiding in side corridors as Spanish agents of King Alfonso battle republican revolutionaries, and enduring suspicious stares as Milan and his homeland enter yet another war. What next?

Machiavelli: Okay, newborn Milanese Ambrosian Republic, you've elected your first government, but be careful: there are a lot of dangerous nobles around with cash and soldiers who all think *they* should rule Milan. Also Venice is invading and taking your territory again. What will you do next?

Ambrosian Republic: What? Sorry, we weren't listening, we're too busy having Guelph-Ghibelline faction fighting again. The Guelphs just got into power so it's persecute-the-Ghibellines-o'clock!

Machiavelli: *Sigh.* You are being invaded, you need a war plan.

Ambrosian Republic: Right! Um… hire that dude who's great at taking towns!

Francesco Sforza: *Starts taking towns*

Machiavelli: Okay, he's conquering the border towns very efficiently, aided by his wife Bianca Maria Visconti whom the previous duke raised to be his heiress. She and her husband are proving brilliant battle partners, with her leading the defense of their conquests while he leads armies in the field.

Ambrosian Republic: Oh, shit, we forgot about her. What if they try to overthrow our republic and declare themselves duke and duchess?! Panic!!

Machiavelli: Indeed. What's your plan now?

Ambrosian Republic: Betray them preemptively before they betray us!

Machiavelli: Um, okay, but now the Power Couple is pissed at you, and are switching sides to fight for Venice against you in return for Venice promising to make them duke and duchess.

Ambrosian Republic: Argh! Panic more!!!

Francesco Filelfo in the palace: **Quietly puts his epic about the Visconti in a bag and hides in a closet.**

Ambrosian Republic: What do we do now? Um… write to Venice warning them that the Power Couple is too powerful!

Venice: Ah, indeed, the Power Couple is alarmingly powerful. We shall *also* preemptively betray them.

Power Couple: We remain the best there is at taking towns. **They take all the towns.**

Ambrosian Republic: Panic!

Machiavelli: **Facepalm**

Ambrosian Republic: Venice! Help! Panic!

Venice: Sorry, we don't panic, our city is literally impregnable, not like your super-vulnerable republic whose defenses are intimately known to the scary Visconti battle princess who grew up there. Bye!

Ambrosian Republic: Keep panicking! Also: keep persecuting the Ghibellines!

Power Couple: Dear Milanese Ghibellines, we're also Ghibellines, would you like to help us overthrow your oppressors?

Milanese Ghibellines: Hooray! All hail our new Sforza-Visconti duke and duchess!

Milanese Guelphs: Curse your sudden but inevitable betrayal!

Power Couple: **Conquer Milan with help from Ghibellines**

Milanese Guelphs: Help! The Ghibellines will kill us all!

Power Couple: As our first act as duke and duchess we have decided *not* to purge the Guelphs.

Milan: Really? These are the nicest tyrants ever. All hail the Sforza-Visconti duke and duchess!

Francesco Filelfo: **Emerges from closet and takes his pro-Visconti poem out of his bag.**

Bianca Maria Visconti: I'll handle the courtly diplomacy, sweetheart, I've been doing it since I was ten.

Francesco Sforza: Thanks, dear, that frees me up to take more towns.

Nineteenth-Century Historians: Thus the Visconti dynasty died out completely due to lack of heirs, and was replaced by the cunning conqueror Francesco Sforza.

> *Bianca Maria Visconti:* Excuse me, I'm right here!
> *Nineteenth-Century Historians:* Yes, but you're a woman, and a bastard, so you don't exist.
> *Bianca Maria Visconti:* I'm his battle partner! I led armies! I'm doing tons of diplomacy!
> *Nineteenth-Century Historians:* What a cunning man Francesco Sforza was. But he couldn't do it alone, of course, he had help...
> *Bianca Maria Visconti:* From me?
> *Nineteenth-Century Historians:* ... from Cosimo de Medici.
> *Bianca Maria Visconti:* I'm right here!!!

So it goes. I've already introduced you to three of the Power Couple's children: their eldest Galeazzo Maria, who was tyrannical and assassinated on the steps of his cathedral, and their younger sons Cardinal Ascanio (with the parrot) and Ludovico (who will be duke), all three of whom textbooks refer to by the surname "Sforza," but their mother was from the nobler line, and all three sign letters and documents *Visconti* or *Visconti Sforza*. Contemporaries writing to them—Lorenzo de Medici for example—often say just "Cardinal Visconti," meaning Ascanio. The family even continued keeping the Visconti family vow (mentioned by Chaucer) made by the first Visconti duke in 1385 to thank the Virgin Mary for his success by always putting "Maria" in the names of his descendants (hence Galeazzo Maria, Ippolita Maria, Ascanio Maria, etc.).[36] So should we really be saying "Sforza"? Or is "Visconti Sforza" more accurate, and "Sforza" yet another artifact of nineteenth-century gender bias?

Filelfo gets erased just like Bianca Maria, by another equally distorting bias of historians. Which bias? Well, Filelfo turned his back on Venice, Florence, and Siena (republics), seeking higher pay which he found at Milan's ducal court, where, for him, the brief Venice-fearing Ambrosian Republic was an episode of terror disrupting the stable monarchies which paid so well. He chose a monarchy over republics, so scholars in the nineteenth and earlier twentieth centuries dismissed him as wrong-headed and backward as they focused on the proto-democratic Renaissance X-Factor they expected to find in the republics. Filelfo chose

wrong, from their point of view, leaving his homeland for foreign fields and republics for tyrannies, so while they celebrated Florentine heroes, they let his name drift into obscurity.

Meanwhile, patronage: in 1441, Filelfo's second year in Milan, his wife Theodora Chrysoloras died, so he married Orsina Osnaga (dates unknown) from a wealthy Milanese family, and, after her death, married another wealthy heiress, Laura Magiolini (d. 1476). In 1453, thirty years after the siege Filelfo had endured in Constantinople, news came of another army ringing the Byzantine capital, and this time Sultan Mehmet the Conqueror succeeded—the end of the Byzantine empire. Remembering his patronage obligations to his long-dead teacher and father-in-law, Filelfo used his *grace* with Milan and former patrons in Venice to reach out by letter all the way to Constantinople, and secure the safety and release of his teacher's widow, the mother of his first wife Theodora Chrysoloras—sultans too were in the favor-trading web of patronage.

Filelfo outlived both members of the Power Couple, and faced the reign of their heir, the infamously cruel Galeazzo Maria Visconti Sforza. A history by one scholar who served at his court, Bernardino Corio (1459–1519), paints Galeazzo Maria a full-on Ye Olde Dungeon Tour Hollywood tyrant, bricking people behind walls, carrying off handsome boys and women for his pleasure, torturing priests and peasants, cutting off a testicle of his lover and favorite Giovanni Veronese as a way of forever dominating him, and other wild tales. Certainly Duke Galeazzo Maria was unpopular enough to be assassinated by the kinsman of a noblewoman he had wronged, and for the crowd to joyously mutilate his corpse afterward, but Corio's account, while *begun* under Sforza rule, was *finished* under the regime that supplanted them, so while it is clear Galeazzo Maria was disliked and sexually violent, the otherwise little-documented specifics about his tyranny must be taken with a grain of salt.[37]

In 1475 Filelfo left Milan (good timing since the duke was murdered the next year) and went to Rome to teach at papal invitation. It didn't last, alas, since this was Pope Sixtus IV, a great investor in art and architecture, determined to leave Rome a city of more marble, but also an unscrupulous warmonger (Rome means

conquests as well as marbles). Filelfo wrote such a ferocious letter denouncing His Holiness's dastardly deeds, specifically his actions against Florence and the Medici (more on those soon), that he burned his *grace* in Rome and had to flee. Since the letter took the Medici side against the pope, Lorenzo de Medici forgave Filelfo for having called for the execution of his grandfather Cosimo (the enemy of one's enemy is a friend?) and invited him to come teach Greek in Florence.

Within months of reaching Florence, Filelfo died of dysentery at the age of eighty-three. He left behind an unfinished book about how terrible the Medici are, an unfinished epic poem about how great the Visconti Sforza are, many Greek translations and poems, a large collection of satires which he dedicated to high-paying King Alfonso the Magnanimous of Naples, and many students, some of whom went on to be great scholars, others great players on the political stage, for good and ill. Filelfo's works, so celebrated in his day but stamped by monarchy, remained largely out of print until the twenty-first century.

33

Montesecco: An Assassin Fears for His Soul

Giovanni Battista da Montesecco (*c*.1450–78) was a mercenary used by Pope Sixtus IV in the infamous Pazzi Conspiracy.[38] Papal service was a high-risk but lucrative career path for sons of minor noble families, and Montesecco's family owned a small castle and lands near the town of Pergola, between Urbino and Ancona— they were, in sum, exactly the kind of minor landed nobility that Florence had gotten rid of, that the ~~Tornaquinci~~ => Tornabuoni family used to be, and that could use nobility to pursue wealth through mercenary work in a way a humble merchant family (even if far wealthier) could not.

Montesecco distinguished himself in several battles aiding or opposing coups in towns within the Papal States (all during the so-called "Peace" of Lodi). He was rewarded for his service with the title of count, and made commander of the infantry of Castel Sant'Angelo, the personal fortress within the Vatican where popes shelter from attacking armies or, more often, from the angry Roman mob (SPQR!). Having the pope as one's patron was a huge asset, bringing not only wealth but opportunities to get brothers and nephews Church appointments, but it has one big drawback: popes don't last.

The papal election of 1471 was tricky. His late Holiness Pope Paul II (1417–71) had been a Venetian, elected on condition of signing a contract (A) to limit the creation of new cardinals, especially cardinals related to him, (B) to give out Church offices only in limited ways, and (C) to call an ecumenical council for theological reform. He had also promised to buy every cardinal who voted for him a summer home in the Alps, but that wasn't in the contract.

Once on Saint Peter's throne, Pope Paul blatantly broke his contract, filling the Vatican with his relatives, Venetian friends, and (in return for bribes) appointing an unprecedented number of cardinals tied to the interests of foreign kings (England, France, Naples, Portugal), vastly increasing the capacity of outside powers to pull strings in Rome for the next decades. Peculiar Pope Paul also used Church funds to build an enormous Venetian-style palace in Rome where he lived instead of the Vatican, refused to make any public appearances, vanished by day appearing only at night, wore rouge to make his cheeks look red (my students joke he was a vampire), and commissioned an enormous new million-dollar gem- and diamond-studded version of the papal tiara, which he wore around the house. Reclusive and paranoid, he (a man who *knew no Latin!*) also hated the new classicizing movement, fired most of the scholars working at the Vatican, and had a major group of Rome's *umanisti* arrested and tortured, charging them with pagan worship and conspiring to assassinate him (the latter charge focusing on their fondness for anti-monarchal Cicero). Records claim Pope Paul's unexpected death at age fifty-four came either (A) while eating a melon, (B) while being sodomized by a page boy, or (C) while daringly attempting both at the same time.

Paul II's reign left the College of Cardinals eager for a change, so they elected Francesco della Rovere (1414–84), a Franciscan scholar-theologian and former university lecturer, famous for his piety and aversion to earthly wealth, who (even better) came from an unimportant family of Savona, on the outskirts of Genoa, with few political interests beyond perhaps strengthening Genoa against Venice (a good balance after a Venetian pope). Nineteenth-century accounts will tell you Francesco della Rovere was born in humble poverty, a rare true case of the path from nothing to greatness, but if we pull out the tools of the History Lab (zoom in on the women!), we find that his commoner father Leonardo della Rovere was wealthy enough to own a fishing fleet and endow a family chapel, while his mother Luchina Monleone came from a major noble family of Genoa then in exile; wealth on one side + nobility on the other makes his origins no higher than those of Montesecco, but far from the rags-to-glory story that

has often been told.[39] Old blood ruling families like the d'Este, Orsini, and Visconti Sforza certainly sneered at the della Rovere, but their sudden rise was from the bottom rung of the elite to its zenith, not from the laboring majority our Florentine civic thinkers would say should not even think about politics.

Famous at the time was the story that Francesco della Rovere owned an ancient Roman gemstone ring with a demon inside, and that he made a deal with this demon to make him pope, after which it either corrupted him or possessed him entirely. Demonic possession is as plausible an explanation as any, since, upon becoming Pope Sixtus IV, della Rovere immediately abandoned his humble Franciscan ways, and became determined to reunite the Roman Empire by war (surprise, it's Battle Pope!). Pope Sixtus made an unprecedented number of his relatives and cronies cardinals (even compared to Paul), entrenched della Rovere power in everything he could touch, kicking out the rulers of towns in the Papal States to give them to his nephews and grand-nephews, and making marriages to major families, including the Visconti Sforza of Milan and Montefeltros of Urbino. He also attempted to break the so-called Peace of Lodi by fomenting war among the big powers of northern Italy, so he could use the chaos to expand the Papal States. Montesecco found himself suddenly serving under one of this warlike pope's nephews, the haughty and incompetent Girolamo Riario (1443–88) as the papal armies prepared to spark wars among the neighbors whose dominions limited papal expansion: Spanish-held Naples, fierce Visconti Sforza-ruled Milan, aloof Venice, and rich, Florentine-dominated Tuscany.

Lorenzo de Medici, working closely with his brother Giuliano and his Visconti Sforza allies in Milan, offered polite but firm resistance to Sixtus's expansionist ambitions,[40] especially the pope's effort to annex the town of Imola (a back door to Florence), and to make one of his relatives Archbishop of Pisa. The port city of Pisa was Florence's fiercest adversary within Tuscany, tenuously under Florence's control, but an archbishop (with 1/5 of the power in the town) could easily foment rebellion, making such an appointment a knife at Florence's back. Imola, meanwhile, was a good staging post for an attack on Tuscany from the east,

and Milan (which ruled it) had offered to sell it to Florence to help the city secure its back door, but the pope (A) demanded they sell it to him instead, and then (B) when he couldn't pay for it, demanded that the Medici lend him the money to buy it. *(With respect, Your Holiness, we will not finance you buying a fortress designed to stab us in the back. Signed, Your Holiness's most obedient servants Lorenzo & Giuliano de Medici, sons of Piero the Gouty Got-Fleur-de-lis-For-Our-Balls.)* By 1477, enraged by this disobedience, and likely hoping to add Tuscany to the Papal States, Sixtus's faction determined to exterminate the defiant Medici: Lorenzo, his brother Giuliano, Lorenzo's young sons, the whole family, the young cousins who would later sue Lorenzo over their inheritance, everyone, and to hand Florence to factions friendly to their side. They allied with the Pazzi, a semi-noble Florentine banking family which, like the Strozzi, had long been squeezed out of power by the once-lesser Medici, and the pope called on trusted veteran Montesecco to plan the assassination.

Refusing orders from your patron was not an easy thing, but documents tell of Montesecco's shock and reluctance, refusing to believe the order until he heard it from the pope's own mouth. After several attempts by poison and other means fell through, Sixtus's impatient relatives proposed extreme measures: kill the Medici brothers *in the cathedral during mass*, by lining up behind them when they go for communion. Montesecco refused, saying that, if they did it in the cathedral, God would see them (remember the icon of Mary in the market to deter fraud?). Sixtus and his faction failed to persuade Montesecco to enter the cathedral, but insisted on the plan, giving him the parallel task of seizing the Palazzo Vecchio (home of the nine *priori* in the tower, and Machiavelli's future office, though Young Nick was only eight at the time) while others more willing carried out the bloody deed.

Pope Sixtus also hired the celebrated mercenary Duke Federico da Montefeltro of Urbino (the same one who had sacked Volterra, and had the peculiar nose) to position hidden troops around the city, ready to strike. That Montefeltro was willing to take part, when he had so recently fought *for* the Medici, and was Lorenzo's godfather and had gotten books from him, etc., shows how quickly and completely the ever-morphing papacy could cause the tides

of mercenary force to change, and why Lorenzo's marriage to an Orsini meaning Orsini mercenaries at least would never fight against them had been such a coup.[41] On the other hand, that very marriage to a noble magnate family was a major part of what made the Pazzi and other Florentine families fearful enough of Medici ambition to join with Sixtus in this bloody strike.

Thus on April 25, 1478, under Brunelleschi's dome, the assassins struck, killing the younger brother Giuliano de Medici, but the wounded Lorenzo escaped, protected by his guards and courtiers long enough for help to arrive. The conspirators had expected an anti-Medici revolt to aid them, but instead Florence erupted in anger. The mob of Medici clients—supported over generations in anticipation of such days of danger—cried *Palle! Palle!*, but were joined by a much greater mass of Florentines who weren't necessarily pro-Medici but were whipped into a frenzy by the coup attempt and violation of *their cathedral* and their *seat of state! Unthinkable! Unforgiveable!* The mob dismembered, lynched, or seized for execution more than eighty people linked with the conspirators, and even hurled Sixtus's kinsman, the Archbishop of Pisa, out a window with a rope around his neck to guarantee death. Montesecco had been right to hesitate at striking in the cathedral—*some* Florentines were ready to take up arms for the Medici, but the whole city was ready to defend the violation of its most sacred space, and Florentines write of the subsequent months of strife and turmoil as divine retribution, both against Florence for failing to secure its sacred space, and on its enemies.

This, by the way, was the moment when even Ficino, who had translated Plato at Cosimo's bedside, had to fear losing his *grace* with Lorenzo, since as a teenager in 1450 Ficino had briefly been tutor to young Piero di Pazzi, was friends with Jacopo Bracciolini who took part in the conspiracy (son of our book-hunting Poggio), and had been close with and invited to work for Sixtus's nephew Cardinal Raffaele Riario.[42] Patronage webs overlap, so a moment of major strife puts many lives and livelihoods at risk as two webs rip apart, making palpable how even warm and intimate relationships, like a student and the tutor who raised him, retain the inescapable coercive power of master and dependant, and the ever-present threat of a fall from *grace*.

As for Montesecco, he was captured and confessed everything, his detailed written confession exposing the plot and even the pope (his patron!) in exchange for the mercy—not of being spared—but of being honorably beheaded by a professional executioner, with last rites and a chance to prepare his soul to point upward at death, gazing at that icon of the Virgin held before him, instead of being handed over to the mob. No Earthly patron could help him now, not even if the warlike pope had cared about so recently acquired and disposable a client (no multi-generation trust bond here). So it was time to appeal to the Heavenly court, among them certainly Saint Julian, patron saint of repentant murderers, a very popular saint at the time—whenever I walk through Florentine chapels and see how many Saint Julians there are, I get a chill remembering that those who commissioned paintings of him often had *very personal* motives. Montesecco received confession and last rites, and after death his severed head was displayed above the gates of Florence's palace of justice, whose walls were then frescoed by Botticelli with images of his co-conspirators' corpses. In a world where patrons were the social safety net, a too ambitious patron could bring deadly disaster, and yet betraying a patron—even as extreme a man as Pope Sixtus—was only worth considering when death already loomed, so one was certain not to live to face that patron's wrath.

Before we leave Montesecco, an important anecdote.

The first time I stayed long-term in Rome, I lived across the river in Trastevere, walking every day to museums in the morning and to Reggie Foster's Latin class in the afternoon (the brilliant monk and teacher whose unwillingness to turn any student from his door, tuition or no tuition, led to the unforgettable 2006 headline, "World's Greatest Latinist Fired"). It was a long hot August, and I remember learning Rome's summer survival mechanism from a grandfather, who leaned down to ask his five-year-old grandson: *How many gelati have you had today?*, and when the boy put up four fingers grandpa declared: *Not enough! Time for gelato.*

There was a beautiful bridge that I crossed at least twice a day as I walked to class or to gelato, elegant arches of white marble with classical proportions, flanked by trees. One day while strolling home—I think that was a watermelon, sour cherry, and yogurt

gelato day—I noticed a crest of the pope who built the bridge, and I remember leaning over to read it, thinking: thank you for the nice bridge, you must be a very nice pope mister... Sixtus IV. *Reader: wait, isn't that the Battle Pope?* He is indeed, a great patron of art, who loved Renaissance culture much the way Shakespeare's Henry V loved France, "so well that I will not part with a village of it, I will have it all mine!" (V.ii). But I didn't know that as a first-year grad student, I just knew I saw a lovely bridge, gifted to me and to posterity by what seemed like a lovely man. If you meet Sixtus by studying Rome's architecture first, he seems like a generous man, who rebuilt and revitalized the ancient city, bringing employment, growth, and urban renewal. A couple weeks ago I was chatting with my warm and erudite friend Barry Torch, who studies Rome, who said he'd always thought of Sixtus as a "good guy" but could see how, for someone who worked on other cities, he could indeed feel like a Battle Pope. Similarly, Montesecco is often discussed as a hardened assassin, but can also be understood as a victim trapped in inescapable service to a terrifying patron. Just as with Lorenzo becoming a hero or a villain, different writers of history first meet the period we love through different entrances (art, books, one city, another) coloring our sense of who instinct calls good and bad.

Thus, as you read the rest of these fifteen lives, remember I'm still Ada Palmer, specialist in Florence, Rome, and Italy, who came to the Renaissance to watch ideas and events shape each other. Sometimes we'll reverse perspectives, adversaries suddenly becoming kinsmen as we switch points of view, but for every life I show you here there's definitely another someone else could share which would reverse this perspective, triumphs becoming disasters from the other faction's side, or Battle Popes becoming great renewers. As you read, please think of these lives as photographs of sculptures: I've captured one angle, and the details that you see from here are absolutely real, but sculptures are so rich because we can walk all the way around them, and the same smile that seems sweet from one angle seems callous from another. Like sculpture, history does not have one right view, and never should.

34

Ippolita Maria Visconti Sforza: The Princess and the Peace

Ippolita Maria Visconti Sforza (1445–88) was the eldest daughter of Milan's conquering Power Couple: Francesco Sforza, and of his bride Bianca Maria Visconti.[43] At the ducal court of Milan, Princess Ippolita Maria received an extraordinary education, personally tutored by Constantine Lascaris, a Byzantine-born Greek expert who had fled to Italy when the Ottomans took Constantinople in 1453.[44] She also had access to Francesco Filelfo, who tutored her younger siblings including little Ascanio Visconti Sforza (to whom she gave the bunny, too young for the parrot yet)—a family portrait including all her siblings appears as one of the illuminations in one of Filelfo's works.[45] Many accounts describe Ippolita Maria's extraordinary erudition: she delivered a Latin address before the pope at age fourteen, and composed poetry and many learned letters.

Ippolita Maria was betrothed at age ten, then married at age twenty, to Crown Prince Alfonso of Naples, heir to King Ferrante of Naples and grandson of the high-paying King Alfonso the Magnanimous. (King Ferrante's name was actually Ferdinand, but there are far too many Ferdinands, so historians are *very grateful* for his nickname Ferrante.) Her dowry—fit for a future queen—was 200,000 florins ($200 million), much of it in trousseau, jewels, fourteen illuminated manuscripts, and other treasures.[46] The marriage was intended to reinforce the treaties of the Peace of Lodi between Milan, Naples, and Florence, and was so important that young Lorenzo de Medici (not yet twenty) traveled to Milan to

attend the ceremony, there becoming Ippolita Maria's lifelong friend. The princess traveled south with a thousand attendants, her wedding journey punctuated by such typical Renaissance incidents as horseraces in Siena, fireworks in Florence, running out of food in Aquapendente, a bout of plague in Rome, the murder of a kinsman in Naples (that's three Horsemen of the Apocalypse in attendance: famine, pestilence, and death), and wedding celebrations including a mock joust between a man and a woman symbolizing the couple's first night.[47]

Alas, Ippolita Maria did not find the same rapport with her husband Prince Alfonso that she had with Lorenzo. The prince was two years her junior and likely intimidated by her intelligence and learning—he and his father Ferrante, alas, had not gotten along with their *umanisti* tutors. Accounts of the period say Prince Alfonso treated Ippolita Maria with scorn and abuse, insulting her father's (admittedly sketchy) noble pedigree, and humiliating her by parading publicly with his mistress Trogia Gazzella (c.1460-1511). More positive were Ippolita Maria's relations with her husband's younger siblings, one of whom, Princess Beatrice, was a girl of seven when nineteen-year-old Ippolita Maria arrived in Naples, and would grow up to marry Matthias Corvinus the Raven King and be twice Queen of Hungary.

Eleven years into Ippolita Maria's marriage, her tyrannical elder brother Duke Galeazzo Maria was assassinated, passing Milan to his ten-year-old son Gian Galeazzo (1469–94). This hit Ippolita Maria hard—while many hated her elder brother, she and he had long been very close. The power vacuum of a child duke triggered a power struggle between Ippolita Maria's ambitious younger brothers and the boy's mother Bona of Savoy (1449–1503), sister-in-law of the French King Louis XI (the same Bona who almost married Edward IV of England, but was spurned in favor of Elizabeth Woodville; thus, improbably, both Bona's possible marriages would have led to her brother-in-law locking her princely son in a tower). As that dragged on, with Ippolita Maria helping by letter, the Pazzi Conspiracy erupted. In its aftermath, wrathful Pope Sixtus excommunicated Lorenzo de Medici, using the Archbishop of Pisa's death as the excuse, and ordered Milan to attack Florence. Instead, Bona and the Visconti Sforza, despite

their ongoing family feud, sent a small force to Lorenzo's aid; even Sixtus could not shake the multi-generation friendship between Sforza and Medici, especially when another Medici defender rose in outrage, one just as fearsome as a wrathful pope: France.

Lorenzo's father Piero the Gouty had known it was worth investing a few millions to get the French fleur-de-lis for the Medici balls. Now the payoff came. "The Universal Spider," the cunning and fearsome King Louis XI of France (1423–83), sent an angry letter to Pope Sixtus making it *very* clear that Europe's greatest power, newly strengthened now that the Hundred Years' War had ended, *will not tolerate* this desecration of the Florentine cathedral *where we our royal self have stood!*, and that France would protect "our cousin" Lorenzo—the king used "cousin" in the letter, despite the Medici having no marriage ties with him or noble blood, to indicate how personally he took this attack on the family that had so long served his own.[48]

The Battle Pope did not back down, and to counter wrathful France and defiant Milan, Sixtus sent his nephew Girolamo Riario with the papal armies and Federico da Montefeltro's hired force into Tuscany, attacking Florentine-held Montepulciano and Perugia, while Milan and Florence's long-time Guelph ally Bologna sent troops to help the defenders in what quickly became the Pazzi War. Wrathful Sixtus intended a *large* war, and wrote to King Ferrante of Naples—Ippolita Maria's father-in-law—commanding the king to use his royal armies to attack Florence to capture the fugitive Lorenzo. All knew King Ferrante was unlikely to risk making the pope his enemy, but a full-scale Neapolitan attack on Florence would break the treaties of the Peace of Lodi, dooming Italy to a return of large-scale wars between its big powers, and would certainly have dragged in Milan's still-feuding Visconti Sforza split across both sides. King Ferrante mobilized reluctantly, his troops advancing north, fighting few battles but burning crops and despoiling the Tuscan countryside as, by November, they advanced to Colle Val d'Else, only fifty kilometers from Florence.[49]

November was the end of 1479's war season, Italy's professional troops pausing, as customary, for winter's frosts and holidays, giving some breathing space to the crisis in which Florence and

the Medici were firmly winning the war of public opinion, producing multiple histories of the conspiracy in prose and verse, disseminating Montesecco's confession, and making the most of King Louis's threats, but wars of words can only go so far in wars of troops. The pope's command to King Ferrante had been to capture Lorenzo *himself*, not his city, so that December, in a daring move, Lorenzo sailed to Naples, and surrendered himself directly to the king, declaring that he repented of his sin (of not being murdered?) and formally begging Ferrante to reconcile him—a poor repentant excommunicate—with the pope, which is exactly what excommunicated people are supposed to do to seek pardon.

How did Lorenzo dare take such a risk, walking alone into the palace of the king who had been commanded to subdue him? He had planned carefully through correspondence with his friends in Naples, foremost Crown Princess Ippolita Maria. Lorenzo was an almost-kinsman too, his Roman wife Clarice Orsini a cousin of King Ferrante's first wife Isabella of Clermont, so Ferrante's heir Crown Prince Alfonso and Lorenzo's heir Piero shared Orsini blood, and a strong interest in sustaining, not shattering, the Orsini and Guelph patronage network which tied Naples to Florence, Bologna, and many smaller powers. And Florence had another major voice in Naples: the royal banker Filippo Strozzi, son of Alessandra Strozzi, who had become a major financial power in Naples during his years of exile, but whose banishment had been rescinded in 1466, so he was eager to protect his city and stay on the now-friendly Medici's good side. Strozzi's efforts, joining Princess Ippolita Maria's and Lorenzo's, worked to help her royal father-in-law shape a deal to avoid, or at least slow down, the unwelcome war, and keep his precious peace pacts with Milan and Florence.

Sixtus did not let Ferrante back down easily. Negotiations remained tense for months, with Lorenzo in Naples, half guest half prisoner, and Ippolita Maria at the heart of the process, until the Ottoman invasion of 1480 turned all Italy's thoughts to defense. The sultan's troops landing in Otranto, on the heel of Italy, fired the peninsula with terror that Rome might follow the fate of Constantinople, which the Ottomans had taken only twenty-eight years before, so all forces dropped what they were

doing to rush together as allies: Naples, papal troops, Florentine troops, Florentine funds, Matthias Corvinus of Hungary, everyone (except Venice which made a separate peace with the Ottomans, angering many).

The campaign in Otranto was in some ways successful, the small Ottoman fleet countered by a hastily mustered papal navy commanded by the implausible Archbishop of Genoa, twice ex-doge, ex-pirate Paolo Campofregoso (1430–98), a churchman with serious sea battle experience from his years leading a pirate fleet raiding his homeland's shipping out of spite at being deposed as doge (yes, he was still archbishop at the time), whom Sixtus rewarded with a cardinalship.* But we cannot call Otranto a victory for Italy (unless we have a clever historian like Bruni to declare it one), since the land devastation was enormous, and the invasion ended by luck not strength, since Ottoman Sultan Mehmet died in May 1481, and his armies left Italy to rush home for the civil war between his rival heirs Bayezid (1447–1512) and Cem (1459–95). With the crisis past, and much of Rome's strength and budget spent, all forces returned home. The tattered Peace of Lodi endured, with Princess Ippolita Maria—the living link between Milan and Naples—as one of its lynchpins.

This was far from the end of the threats to peace, since the Ottoman invasion weakened southern Italy, leaving Naples vulnerable. In 1484, upon the death of Sixtus, his faction was not *quite* able to secure the election of his main successor-nephew Giuliano della Rovere (Battle Pope 2: Coming Soon to a Christendom Near You...), but they leveraged the neutral cardinals' fears that the remnant allies of Pope Paul II (the reclusive Venetian pope) might elect another Venetian, or that allies of Spain and Naples might elect Rodrigo Borgia (a non-Italian!). Exploiting these fears, Sixtus's faction managed to land a semi-ally on the throne as a compromise candidate, Giovanni Battista Cybo of Genoa (Genoa being a sea rival and foe of Venice, and an ally of the della Rovere), who became Pope Innocent VIII (1432–92).

* Campofregoso wasn't the first pirate cardinal; during the schism Cosimo de Medici's ex-pirate friend Baldassare Cossa (1370–1419) became a cardinal and then Antipope John XXIII, and is buried in Florence's baptistery with the proud inscription *Iohannes Quodam Papa*, John the Sometimes Pope.

We can perhaps compare Pope Innocent VIII to King Log of Aesop's fable, since a log floating inertly in the frog pond, ignoring strife and problems as he soaks up wealth and power, is not a *good* pope, but feels like a good one if the popes before and after are frog-devouring predators. Pope Innocent let the rising factions grow unchecked, especially Sixtus's della Rovere faction (we demand more Battle Pope!) since they had enabled his election. Indeed, Innocent was seen so much as della Rovere tool that his election triggered my nominee for The Most Passive Aggressive Letter in Earth History, when Lorenzo de Medici sent his young son Piero to give Florence's obedience oath to the new pope, instructing Piero to tell the pope on his behalf, "I am aware it was my duty to prostrate myself in person at the feet of His Holiness, as I did at those of his Predecessor of saintly memory; but that I trust in his goodness to forgive me because at that time *I had my brother* who was well able to fill my duties," [i.e. running Florence while Lorenzo went to Rome] the Predecessor of saintly memory being Sixtus, and the brother his victim, the murdered Giuliano.[50]

Innocent facilitated della Rovere expansionism in many ways, especially via a new war known (confusingly) as the Conspiracy of the Barons (1485–6). This was an attempt to continue Sixtus's project of expanding the Papal States, by riling up certain southern Italian barons to overthrow Princess Ippolita Maria's father-in-law King Ferrante of Naples, and expand papal power in southern Italy. This attempt, like that in Florence, failed, thanks primarily to Naples securing the help of Florence and Milan, enabled by Princess Ippolita Maria who secured the support of her Visconti Sforza kinsmen, and her friend Lorenzo de Medici.

The Conspiracy of the Barons poured fuel on an old fire: the feud between two great Roman houses both alike in dignity, the Ghibelline Colonna and their arch-rivals, the Guelph Orsini. Both families were supremely powerful in and near Rome, able to command and stir up the Roman people enough to make any pope's life a misery, and with many sons who were successful mercenary generals, and pedigrees tracing their lineage to medieval nobles and senatorial families of ancient Rome. The Ghibelline Colonna were marriage allies of many other prominent mercenary families, and of Pope Sixtus's family, while the Guelph Orsini's

marriage allies included Lorenzo de Medici via his controversial marriage to Clarice Orsini, and the royal house of Naples through King Ferrante's Orsini first wife.

This volatile division of Italian powers largely mapped onto the slumbering Guelph-Ghibelline feud (continuing in Italy's Three Hundred Years' War), and filled Rome anew with bitter *Romeo and Juliet*-type street fights, as when Sixtus's grand-nephew Cardinal Raffaele Riario lost the love of his life, his beloved Lorenzo Oddone Colonna (d. 1484), who was accused of killing an Orsini in a street brawl, kidnapped and tortured for a brutal month, then executed.* Like Pope Sixtus, the Riario branch of the della Rovere family—sprung from Sixtus's sister Bianca—is often credited with rising from poverty, as is Sixtus's main heir Giuliano della Rovere (Battle Pope 2: From Rags to War!), but the Riario were nobles with a castle, etc., and Giuliano della Rovere's Greek émigré mother Teodora Manirola was probably refugee Byzantine nobility, so it's another case of nineteenth-century biographers reading rags-to-riches into the insults thrown at wealth and power's top 1 percent by wealth and power's top 0.1 percent.

The mess over the abortive Conspiracy of the Barons helped set the stage for the later French invasion, since Pope Innocent, to spite King Ferrante, reversed an earlier papal decree which had named Ferrante—an *illegitimate* son of King Alfonso the Magnanimous—heir to Naples; illegitimate princes needed papal confirmation to inherit, so this greatly weakened Ferrante's claim. At the peak of his anger, in 1489, Innocent VIII also excommunicated King Ferrante and *actively invited France to invade Italy*, to oust Ferrante's Spanish dynasty and restore the old French claimants to Naples, whom Ferrante's Aragonese father Alfonso the Magnanimous had displaced. This was 1489, and King Louis

* The Orsini's strong position in the war let them pressure Pope Sixtus into executing Oddone; that a member of a princely house actually faced execution for a murder he committed was shocking: Romeo is supposed to be *banished* not *executed* for killing Tybalt. The grieving Raffaele Riario never forgave the Orsini, entrenching enmity between the della Rovere faction and the great Guelph Roman house whose marriage allies included the Borgias, Naples, and the Medici. Meanwhile, della Rovere marriages tended Ghibelline, linking to the Sforza, Montefeltro, and Sanseverino families, the old feud re-mapping itself on another generation.

XI had died six years before, leaving the throne to his young son Charles VIII (1470–98), and real power to Charles's cunning elder sister Princess Regent Anne of Beaujeu (1461–1522). The two were then busy planning the annexation of Brittany, so they did not take up the invitation to invade Italy right then, but a papal invitation has no expiration date.

Princess Ippolita Maria died during the wars of the Conspiracy of the Barons, in 1488, aged forty-two. Relations between Naples and the Visconti Sforza worsened after her death. During the last months of her life, she was finalizing the long-planned marriage (a marriage of first cousins) of her daughter Isabella to her nephew, the crowned-as-a-child Duke Gian Galeazzo of Milan, which would renew the ties between Naples and Milan. The marriage did go through, and the couple went on to have four children, but—jumping briefly forward beyond Ippolita Maria's lifetime—the princess's ambitious younger brother Ludovico Visconti Sforza (1452–1508), who had been regent for the young duke, refused to give up power when Gian Galeazzo came of age, and had him imprisoned.* This turned the alliance between Milan and Naples into an enmity, since Ippolita Maria's widower did not want to see his son-in-law and grandson stripped of ducal honors, and the resulting wars resulted in the overthrow of *both* ruling families, the Visconti Sforza losing Milan and Ippolita Maria's husband and son losing Naples.

It could be easy to feel that our brilliant, peacemaking princess's life and efforts came to naught, since she herself suffered so much, and both the families she was supposed to link were overthrown not long after her death. But we get another sense when we zoom in. Years of peace—even *one year* of peace—is a precious thing within a lifetime. Ippolita Maria spent twenty-three years in Naples, a substantial diplomatic career, and during that time she was vital to the negotiations which shaped the Pazzi War, to the alliance that defended against the Ottoman

* Still true to the old Visconti vow, all these Sforza names actually have Maria in them, i.e. Ludovico *Maria* Visconti Sforza, Galeazzo *Maria* Visconti Sforza, Gian Galeazzo *Maria* Visconti Sforza, etc., but including the Maria every time makes the names even harder to keep straight, so most historians omit them.

invasion, and to keeping the friendship of Florence and Milan which saved her royal father-in-law from being overthrown by the Conspiracy of the Barons in 1486, extending her family's reign by eight precious years. Through this and her Pazzi Conspiracy interventions, she helped extend the treaties of the Peace of Lodi by a full decade, and while thousands died in Italy's wars during her lifetime, it could have been thousands more. The world does not stay saved, but to save it three times is no small achievement, and Ippolita Maria's ten-year prolongation of semi-peace was no less precious to her generation than the peace between the First and Second World Wars. And Fortune's Wheel repeats its ups as well as its downs: in 1518, one of Ippolita Maria's granddaughters, Bona Maria Visconti Sforza, married King Sigismund of Poland, impressing a new kingdom with her mastery of Latin, Greek, history, law, science, and mathematics, and working with the next generation of Medici and other allies to try to restore her family to Milan.

35

Josquin des Prez: The International Renaissance

Josquin des Prez (*c.*1450/55–1521) was the most renowned composer of the decades around 1500, and remains one of the most frequently performed Renaissance composers to this day.[51]

I said before that these lives were like pictures of sculptures, each capturing one angle of its subject, but the friends we're meeting are like sculptures in another way: they're products of great wealth. Alessandra Strozzi with her million-dollar dowry, Amanatini working for the king, Filelfo with his ducal salary, Montesecco with his family castle, royal-born Ippolita Maria Visconti Sforza; all of these are high elites, in the top 1 percent of wealth and power[*] in an era filled with poor farmhands and hard-toiling weavers.[52] The fact that Amanatini and Filelfo had far less wealth and power than a Strozzi widow or the daughter of a duke can make them feel like they represent average, ordinary men, but getting into a guild apprenticeship or a classroom of the *studia humanitatis* was not possible for many, and much of the trauma Amanatini faced in Brunelleschi's prank was being told he was no rich guild member but a simple laborer with a tenth the income and no way to rise. As we read Baron or Machiavelli celebrating civic participation in the Florentine Republic, we must remember that the merchant rulers whose names were in the bag were a few elite hundreds amid the city's disenfranchised hundred thousand, and that the early training in the *studia humanitatis* which made Filelfo ready to achieve fame and travel east to Greece was something an upper-middle-class family had to work hard to pay for; even Machiavelli's family, when their farms outside the city were trampled by armies in the Pazzi mess, had to move Young Nick to a cheaper school.[53]

[*] The History Lab often struggles to access to the lives of the humblest, but for a selection of histories that do so in in ingenious ways, see notes.

I chose these fifteen friends because their lives all intersect (people of like classes do mix), and also because I study ideas, and if we want to investigate the Renaissance's much-vaunted innovations in thought, individualism, radicalism, political theory, etc., and how those intersected with power, war, and the patronage system that let artists and writers thrive, the room where it happened is a million-dollar room, with 100,000-dollar books stacked on its 50,000-dollar table. The cultural tools of legitimacy—art, architecture, Filelfo's Greek—opened the door to becoming a courtier, with favored access to a princely ear, but while this was a ladder to wealth and power, it mainly let those already rich enough to be a shop owner or attend a university to move from the top 5 percent of wealth and power to the 1 percent.

Music is an exception, one rare field in which a boy of genuine peasant roots blessed with the right combo of voice and ear could catch the notice of a choir director and be recruited, trained, display his talents before local lords, then larger lords, and make it all the way to royal courts and pay. Thus, while Josquin spent most of his life in the million-dollar room where it happens, earning elite salaries as Filelfo and Amanatini did, he and our still distant fourteenth friend (the sibyl Julia) are the only two in our fifteen of genuinely humble origins, extreme exceptions whose rare abilities—music, prophecy; one could also rise through genius skills at language, art, or memory, religious visions, or much-sought-after dwarfism—met the fancies of the super-rich, triggering rare moments when Fortune's Wheel truly turned all the way, bottom to top.*

* Examples of rising through mysticism include Joan of Arc (1412–31), through dwarfism Jeffery Hudson (1619–82) and Nano Morgante, aka Braccio di Bartolo (active 1550s), and through language Jorge da Costa of Portugal (1406–1508), a muleteer's son who was first a swineherd, then a servant in a university town, taught himself Latin, became a Latin tutor, entered the Church, and gained renown enough to be selected as the king's confessor, since a confessor without any other patronage ties is easier for a king to trust. That earned da Costa a cardinalship and lifelong wealth, but also banishment under a later king, and old age in exile in Rome. Such cases are very rare, while most famous rags-to-riches figures of the period turn out to be not quite so rag-born as they seem, such as the visionary Catherine of Siena (1347–80) whose father was a reasonably prosperous cloth-dyer and her mother the daughter of an educated poet, or Leonardo da Vinci (1452–1519) who had humbler origins than most of his artist peers, but was still the son of an educated notary.

Nothing certain is known of Josquin's early life, except that he was the son of a policeman (not *quite* the bottom of Fortune's wheel). Josquin was likely a choir boy when young, attached to a large church or cathedral, which gave him a chance to learn the increasingly popular art of polyphony, music with complex harmony in which separate lines move independently, instead of just paralleling each other. Polyphony in Europe had been on the rise in the 1300s, enough for Pope John XXII (pope 1316–34) to ban it from Church music, accusing it of being frivolous and interfering with understanding the lyrics of sacred music, but it had been re-legalized and endorsed by Pope Clement VI (pope 1342–52, i.e. during the Black Death) who encouraged and invested in innovative music, another example of the constant contradictions of the ever-changing papacy. By Josquin's time, polyphony was well established but still new, and growing rapidly in popularity and complexity, so he became one of its most influential shapers. His works included both sacred music and playful secular music, such as *El Grillo* (*The Cricket*) which imitates insect sounds, and *Faulte d'Argent* (*The Problem with Money*)—it was not uncommon for composers to write teasing songs about money when their pay was late.

If Josquin was a choir boy, was he a castrato?

No, but it's a good question. Castrati singers are documented in the Byzantine empire until the sack of Constantinople in 1204, but we don't have records of them in Europe between then and the mid-1500s, so Josquin was a bit too early for it to have been considered. We do have records of castrati around the end of Josquin's life, especially in the documents of the House d'Este of Ferrara and their Gonzaga neighbors (the children and grandchildren of Alfonso and Isabella d'Este), and the popularity of castrati increased toward the 1600s along with the vogue for complex vocal music. But Europe was uncomfortable with castration, associating it with the East in negative ways, and medieval theologians had debated whether eunuchs could be full participants in the Church.

Josquin's nationality is hotly disputed. He was born in the Duchy of Burgundy (an area straddling modern-day France, Belgium, and the Netherlands), which was then a sovereign independent state ruled by Duke Charles the Bold (1433–77), but

Charles had only a female heir, Mary, so every king in Europe scrambled to marry her and thereby annex some of the richest lands in Europe.[54] In 1477, Duke Charles of Burgundy died suddenly in battle. Josquin was in his mid-twenties at the time, living in southern France singing for René of Anjou (1409–80), the overthrown King of Naples who lost the city to Alfonso the Magnanimous. Duchess Mary—likely hoping to resist France's attempts to annex Burgundy—married Archduke Maximilian Habsburg, heir to the Empire, since subsections of the Empire retained more independence than French territories. France, unwilling to lose Burgundy, invaded it, burning many villages in the area where Josquin thus grew up. Thus Josquin found Burgundy, France, and the Empire all claiming his allegiance.

Soon thereafter, in the 1480s, Josquin moved south to Italy, taking the Sforza in Milan as his new patron-employers. His primary patron was Cardinal Ascanio Maria Visconti Sforza (Ippolita Maria's little brother, the one with the bunny and the parrot), for whom he composed both sacred and secular music. His patron was also able to secure him a high-paying job in the Church which normally required one to be a priest, but the cardinal waived that requirement for his faithful client—patronage at work.

In Milan, one frequent presence in Josquin's audience was Leonardo da Vinci (1452–1519), who had been sent there by Lorenzo de Medici as something between an ambassador and a gift for his Sforza allies. Josquin was probably surprised by how much Leonardo's paintings, with their crisp plants and detailed naturalistic backgrounds, resembled paintings from his Burgundian homeland—he had seen nothing like them in his time in France. The key to the mystery was, once again, Florentine banking: a few years earlier (in 1475) the Portinari family (the family that produced Dante's heavenly patron Beatrice) had been running the Medici bank branch in Bruges, and commissioned a big altarpiece, the *Portinari Triptych*, from Flemish painter Hugo van der Goes, who gave it all the long bodies, distinct facial expressions, and crisp, natural details that both we and Josquin recognize as Northern Renaissance art. When the family brought the triptych down to Florence, *boom!* local artists started painting

backgrounds like that, an influence extremely visible in the works of Leonardo and Michelangelo.

Alas, Milan was not a place of peace. In 1480 Ludovico Visconti Sforza had driven out young Duke Gian Galeazzo's mother, Dowager Duchess Bona of Savoy, and seized power, exiling her and imprisoning the eleven-year-old duke in the Visconti Park, a "garden of delights" where ample supplies of leisure, luxuries, and ladies were designed to keep the youth completely distracted from the affairs of politics, and from education which might make him take an interest in them.* Ludovico was now master (if not yet duke) of Milan, and while he and his brother Cardinal Ascanio become political partners later on, at this point there was a rift between them as different Sforzas took different sides of the family feud. Cardinal Ascanio almost certainly took Josquin with him when he left Milan to seek safety in Ferrara at the court of Duke Ercole d'Este (1421–1505). There Josquin would have met the duke's young children, including little Isabella d'Este (not yet writing her own shopping lists), and little Ippolito (the future cardinal who had not yet gouged anyone's eyes out, or failed to thank Ariosto for *Orlando Furioso*).

Ferrara was uniquely stable for an Italian city-state, ruled by just about the only genuinely blue-blooded old noble family in Italy (relatives of the House of Welf and the Hanoverians), and positioned as a kind of buffer zone between Venice's land empire and the Papal States. A stable regime in Ferrara prevented border friction between papal Rome and aloof, Byzantine-aligned Venice,

* It is likely that Gian Galeazzo Visconti Sforza's lack of political self-determination was related to an intellectual disability or mental illness, as in the case of England's Henry VI. One of the boy's uncles Filippo Maria Sforza (1449–92) had such a disability, which is why he was skipped over for succession despite being Francesco Sforza's second-oldest son; he lived in princely comfort in Milan throughout these tumults, hunting and beloved by the court, but left in peace while his five brothers struggled for power. Sigismondo d'Este (1480–1524), younger brother of Alfonso and Ippolito d'Este of Ferrara, is a similar example, transitioning to a non-competitive, hospitality-focused role in the family's political affairs after a serious case of syphilis affected him at age sixteen. Accounts suggestive of mental illness in the d'Este family go back as far as Ugo Aldobrandino (1405–25) and his famous tragic affair with his stepmother Parisina Malatesta (1404–25).

and since war between them could throw all Italy into danger (and invite Ottoman invasion), many worked hard to keep Ferrara stable. In fact, the official history of the city says that one day, in 1264, the people of the town spontaneously gathered in the city square and unanimously elected the House d'Este to rule them forever, and, by an implausible coincidence, representatives from Venice and the pope and the Emperor all happened to be there (with soldiers) to confirm it! What a super legitimate government![55]

The stability of Ferrara was so famous that Machiavelli used it in *The Prince* as his example of princes who don't need to work hard to maintain power.[56] You can understand why no one batted an eye when little Ippolito d'Este was made an abbot aged three and a cardinal aged fourteen. Between its noble blood, strong allies, and serious investments in the best artillery works in Europe, members of the House d'Este were not just the most eligible bachelors and bachelorettes in Italy, but able to spend lavishly on luxuries like art and music. In Ferrara, Josquin would have encountered much of the best and most innovative in music, but d'Este stability also meant less need to treat their clients well (no need for street riots without rivals), so he would also have witnessed how the d'Este siblings often didn't bother to pay salaries, sometimes kidnapped each other's courtiers when they wouldn't share, and gave artists a tour of their dungeons if they felt the work was going too slowly.[57] Such behavior would have been extra alarming to Josquin, who had a reputation for composing only when the inspiration struck him, rather than on demand, as testified by a letter from a client to Isabella d'Este's husband Francesco Gonzaga advising the marquis to hire rival composer Heinrich Isaac instead of Josquin, since Isaac worked when ordered, and was cheaper.[58]

After his time with Cardinal Ascanio Visconti Sforza in Ferrara, and thanks to his patron's strong connections in Rome, in 1489 Josquin secured the grandest musical gig in Europe: directing the papal choir, a position which let him earn a huge salary, compose many of his grandest masses, and graffiti his name in the Sistine Chapel's choir balcony, to posterity's delight. The Vatican was a prestigious but tumultuous place to work, since Josquin's first papal patron was Pope Sixtus (Battle Pope!), so the musician had watched

first-hand Sixtus's glorious efforts to restore Rome's urban grandeur, but also his violent efforts to restore her empire. After that, Josquin served Pope Innocent VIII (King Log), under whom Sixtus's faction entrenched its power and made that attempt to overthrow Ferrante of Naples in the Conspiracy of the Barons. And Josquin served on, past 1492, when Innocent died and France and Sixtus's faction tried to secure the papal throne for Sixtus's nephew Giuliano della Rovere (Battle Pope 2), but were thwarted by the many enemies they had made by now, plus influence of Spain and Naples, which secured the election of Rodrigo Borgia, Pope Alexander VI (1431–1503).

Ah, the Borgia papacy…

Once, when I was in the Borgia Apartments in the Vatican, admiring the newly restored golden Borgia bulls which decorate the ceiling, I saw a Korean tour group rushing through, one of whom paused to ask the guide, "What's this room?" The guide, flustered and clearly hurried, froze a moment, then answered, "These are the rooms of Alexander VI, he was a very, very, very, very, very, very, very bad pope." Not bad for ten seconds.

Ceiling of the Borgia Apartments, Vatican Palace.

Whence the infamy? Pope Alexander was a brilliant and veteran bureaucrat, administrator, and scholar of canon law, whose decades of Vatican experience meant he could play the Church administration with as much virtuosity as Josquin directing his choir. The new pope used legal cunning to secure an unprecedented number of new cardinalships for his cronies, seeking to guarantee that the Borgia family would control the next papal election, and the next, a permanent power to end Rome's ever-shifting power games. Next, to the eternal dismay of those who thought defeating the della Rovere faction would win peaceful days, Pope Alexander unrolled his own war plans, aiming to turn the section of central Italy that Sixtus had destabilized into a permanent Borgia kingdom—not an extension of the Papal States that would continue to be passed from hand to hand by the ever-changing wheel of popes, but a permanent kingdom, split off from the Papal States and given to Alexander's descendants to rule as kings. While the early stages of Alexander's papacy were not too dire, as ambitions and enmities mounted, Josquin saw Rome slide into a state of terror, with frequent poisonings, night-time assassinations, murdered cardinals, street violence, the destruction of great families and confiscation of their goods, shock on shock as Alexander—who knew well how quickly tides turn with changes of popes—tried any and every means to plant his family's power in Italy firmly enough to last beyond his death.

At the same time, things worsened greatly in Josquin's former home, Milan. By 1494, Duke Gian Galeazzo was a grown man with children of his own, but still held prisoner in that garden of delights by his ambitious uncle Ludovico, while Gian Galeazzo's mother Dowager Duchess Bona of Savoy, and his wife Isabella of Naples (daughter of Princess Ippolita Maria), kept trying to muster help to overthrow Ludovico. King Ferrante of Naples started threatening to attack Milan, hoping to restore his grandson-in-law Gian Galeazzo to real power, so Ludovico wrote to King Charles VIII of France encouraging him to act on Pope Innocent's five-year-old invitation to invade Italy and claim the Neapolitan throne. The invitation was also a tool to get Ludovico on Charles's good side, since Charles had two close kin eager to see Ludovico fall: Charles's aunt Bona of Savoy, who wanted her son

Gian Galeazzo (Charles's matrilineal first cousin) to rule Milan, and Charles's closest *patrilineal* cousin Louis of Orléans, who had *legitimate* Visconti blood via his father's mother Valentina Visconti and thus believed *he* should rule Milan.

Ludovico did not intend Charles to *actually* take Naples. The invitation was supposed to be a deterrent to make King Ferrante back down, but two other Italian forces also egged on the invasion. One was Pope Alexander himself, who was quarreling with the Orsini over some land, and the Orsini were aided by their kinsman King Ferrante, so Alexander too wrote to Charles, hoping to play the French threat as a deterrent against Ferrante. The third main advocate of the invasion was the only one who truly wanted it to happen: Cardinal Giuliano della Rovere, who had lost to Borgia in the election but still hoped to someday be Battle Pope 2. Della Rovere encouraged King Charles to enter Rome on the way to Naples, depose Alexander, and make him pope, securing a friendly papacy for France and returning to days like the Avignon papacy when France did not have to fear rival crowns controlling Saint Peter's Throne.

King Charles was now twenty-two years old, strong and unchallenged on his throne despite his skeletal malformations and related disabilities, and held Brittany and half of Burgundy (secured by his sister Anne during her regency), so Charles leaped at this chance to make his name as a conqueror king. In 1494 he entered Milan, welcomed by Ludovico, and while Charles was there the imprisoned Gian Galeazzo Sforza died in suspicious circumstances—soon afterward, Ludovico bribed Emperor Maximilian to crown him duke, disinheriting Gian Galeazzo's son and three daughters, and further estranging Milan from Naples.

Duke Ludovico had intended Charles to move through Milan but to be quickly stopped, either along the eastern route down through Italy guarded by the alliance of Urbino, Venice, Rimini, Bologna, etc., or on the path west of the mountains down through Tuscany guarded by Florence. Charles chose the western path, but frightened Florence didn't stop him and instead allied with him, so Charles continued south, slicing a trail of carnage through the smaller towns, and soon the same French armies which had burned Josquin's homeland bore down on his new home in the

Eternal City. Rome—already ravaged by plague that year—now braced for sack or conquest, but Pope Alexander, to the astonishment of all, won King Charles over by offering to crown him King of Naples, so the French betrayed Giuliano della Rovere, left Pope Alexander in place, and marched on, ousting King Ferrante from Naples, only to have city and army both devastated by a bout of plague. After this hollow victory, the young French king left Italy, and Pope Alexander mustered forces to take advantage of the devastation to create his Borgia kingdom.

All this was too much for Josquin. As Pope Alexander's reign grew bloodier, Josquin left Rome, returning to Sforza service in Milan in 1498, now under Duke Ludovico and his brother Cardinal Ascanio, who had helped Pope Alexander win his election, which made Milan comparatively safe from Borgia ambition, though not from other griefs. While Ludovico had allowed Charles through Milan, he never expected the king to *actually* overthrow his kin in Naples, so once the French passed Florence and it seemed like Naples might actually fall, Ludovico had turned on Charles and joined the Italian league opposing him. Charles had therefore allowed a separate invasion of Milanese lands by Louis of Orléans, his cousin with *legitimate* Visconti blood, ravaging the region and again testing Ludovico's martial skill.

Josquin's return also found Duke Ludovico recently widowed and disconsolate. His duchess Beatrice d'Este (1475–97), whom Ludovico had worked hard to court as a *legitimizing* link to Italy's noblest ducal house, had been a great asset while she lived, even leading defenses against Louis of Orléans while Ludovico was incapacitated by something like a stroke late in 1494 to early 1495, but, alas, Duchess Beatrice died in childbirth in 1497.[59] Remaining to the duke were her two young sons Massimiliano and Francesco, the duke's earlier illegitimate daughter Bianca, and his most trusted friend and long-time lover Galeazzo Sanseverino (*c.*1460–1525), whom period sources paint as the sexiest thing in pants in Italy. Sanseverino was so charming that even Duchess Beatrice had adored her husband's *male* lover (while hating his *female* mistresses), and he was so trusted as Ludovico's proxy that the court openly called him "the second duke", and Ludovico married Sanseverino to his illegitimate daughter Bianca to make the tie

more solid. Ludovico's beloved also came from a major mercenary family with land near Naples, Sforza ancestry, and marriage ties to many powerful houses including the Montefeltro Dukes of Urbino, the Malatesta Lords of Rimini, the Campofregoso Doges of Genoa, and the still strong della Rovere, while one of his elder brothers was a general in King Charles's armies and another Emperor Maximilian's favorite jousting champion. The Sanseverino family's many ties made the lovers' long partnership an important alliance, and a source of armies for Milan.

This strong network plus two young sons with d'Este blood might have been enough to sustain Ludovico's Milan, but Fortune remained fickle. King Charles of France died suddenly after banging his head on a doorframe (history, unlike fiction, doesn't have to be plausible), and since Charles left no heirs, Visconti-blooded Louis of Orléans was crowned King Louis XII of France, and swiftly pursued his claims to Milan as well as Naples. France invaded *again* and captured Milan in 1499, imprisoning Ludovico in the same iron cages he had invented to display his own war prisoners. Both irresistible Sanseverino and invaluable Josquin served the conquering King Louis for a time, but Josquin soon managed to head east to the safety of Ferrara, where the d'Este had remained secure through the chaos by marrying their scion Alfonso d'Este (Isabella and Ippolito's big brother) to Alexander VI's daughter, that most celebrated of femmes fatales Lucrezia Borgia. Josquin's Ferrara was thus the eerily peaceful eye of the hurricane in the first years after 1500, until in summer and fall 1503 plague emptied Ferrara (neither noble blood nor Roman arches impress *Yersinia pestis*), and soon thereafter Pope Alexander died and Sixtus's nephew Giuliano della Rovere finally secured the papal throne, becoming Pope Julius II (Battle Pope 2: More Art! More War!).

It was again too much for the great composer. Despite the riches of Italian patrons, Josquin returned to his (still recovering) Burgundian homeland. There, Duke Philip the Handsome (1478–1506), heir to Duchess Mary and her husband Emperor Maximilian, had revoked the Great Privilege of 1477, which had granted some autonomy and self-governance to key parts of Burgundy, and was ruling a newly centralized and top-down

Burgundy firmly under the control of the Empire. But it was less chaotic than Italy. Returning to Condé-sur-l'Escaut, near his birth region, Josquin spent his final decades printing his music with the newfangled printing press. His work became so popular that, for decades after his death, other composers, to sell more copies of their work, would falsely put Josquin's name on it, leading to the joke that Josquin wrote more music when dead than alive. On his deathbed, Josquin left money asking that his *Pater Noster* be sung by processions in the town whenever they passed his home, and asked to be listed as a foreigner for tax purposes, leaving us uncertain which, if any, of these tumultuous lands our brilliant musician living between the French, Northern, and Italian Renaissances viewed as home.

I promised that these lives would intersect in Italy, yet Josquin is not the first foreigner to cross our paths. We've found Italy full of Greeks, Romans, Frenchmen, Spaniards, and Burgundians, while Florentine merchants, craftsmen, and exiles are working as far afield as London, Bruges, and Székesfehérvár, plus only 20 percent of the population of Rome are Romans, and Petrarch, who wrote so powerfully of Florence, spent less time in the city than I have. The Muslim world is also ever-present, a source of manuscripts, of Greek tutors, of pigments for the frescoes Josquin stands under as he sings, and of the alum used to dye his clothes. We think of the Renaissance as European, but if we turn for a moment to another Renaissance celebrity, Leon Battista Alberti (1404–72), philosopher, artist, architect, and poster child Renaissance Man™, he described his family in 1432 as "great merchants" known all over Italy but also in Spain, "the West," Syria, Greece, and "all ports," by which he means North Africa, the Middle East, and the Black Sea.[60] To be a Renaissance Man was to be international, or at minimum internationally known.

And yet we have these phrases: Italian Renaissance, Northern Renaissance, English Renaissance. The idea of separate Renaissances is not fully false; certain innovations did have certain epicenters (music in France and the Netherlands, for example)—but work in the History Lab has increasingly shown that all these achievements were fundamentally international, shaped by contact, not isolation. Many of the most celebrated works of the

northern composers were written in Italy, Italian political innovators studied and served foreign kings, Shakespeare borrowed from Spanish popular tales and Italian and Roman theater, early German printers teamed up with Venetians, and Christopher Columbus who sailed from Iberia was born in Genoa. Objects like the *Portinari Altarpiece*, brought from Bruges to Florence and influencing Leonardo's *Last Supper* in Milan, show how, the more we zoom in on real lives, the more the lines between our separate Renaissances vanish.

Why then do we tend to talk about these Renaissances separately? Partly because of how the discipline of history developed, and partly because of one big (understandable!) error.

On the disciplinary side, remember how Renaissance studies blossomed amid nineteenth-century nationalism? Cue every nation's historians constructing *their* Renaissance, focusing on anything they could call a national achievement, and minimizing co-authorship or migration. There's also a practicality factor: you need languages to study history, and most people who train to study Florence don't have Hungarian, Breton, Catalan, Arabic, etc. We have a lot more scholars capable of studying the Renaissance of one place than we do scholars who can follow Manetto Amanatini the woodcarver from Italy to Hungary. Border-crossing histories take big teams, or excruciating patience, like when my friend Stuart McManus, interested in those Ciceronian orations written by Aztec-descended nobles, realized mid-dissertation: *Well, time to take two years to learn Portuguese and Konkani before I can write Chapter 4;* he's now followed his sources on to China.[61] History is written by people who can actually finish their histories, and that's a lot easier when your story only needs three languages. Projects which cross boundaries are a priority in today's History Lab, but we have a lot of work to do.

As for the error, remember our Greenland archaeology that found no fish bones in the middens? This is similar. We had these great studies showing that pre-modern Europeans moved very little, that travel was dangerous, and that most people married someone born less than a mile from their birthplace. But those early studies were mainly of the British Isles, and later, when we looked at other places, we realized people in the British Isles

were *super way more stationary* than most Europeans. Continental DNA mixed all over the place throughout the Middle Ages, so it's only in Britain that you can dig up a 3,000-year-old bog body and compare its DNA to the person who lives nearest to the bog and it'll tag them as first or second cousins.[62] The British Isles even have villages so isolated that their populations never developed Black Death resistance, they didn't have enough people go in and out, so while London got slammed every few years, corners of Wales or Scotland still have some DNA with minimal influence from *Y. pestis*. When we believed travel was rare, separate Renaissances made sense, and we're still fixing that mistake. It's all connected, but we have a lot to do, which is why it took so long for us to come to our current theory about the Greenland's Norse settlers: that they too were victims of the Black Death.

Really? They got the plague?

No. *Yersinia pestis* didn't make it it to Greenland, but the backbone of their economy was the export of luxury walrus ivory, and walrus hide (used to make water-resistant rope), the only goods that kept the mainland's boats coming. In the decades after the Black Death, Europe's luxury market went haywire and the bottom fell out of the walrus trade (think how COVID made the board game industry boom but formalwear bust), so the ships stopped coming. The 1348 plague killed Petrarch's friends, pool ball struck pool ball, and by the 1430s the Greenland settlement could no longer endure such isolation, so everyone who could leave emigrated, and the rest faded away.[63] Even more recent studies have found signs that the Norse may have also overhunted walrus, exhausting the resource which had meant ships and import goods for Greenland, and for the rest of Europe luxurious ivory statuettes, fans, combs, swords, backgammon sets, and instruments as far away as Constantinople.[64] We had assumed the cause of the settlement's end must be local—climate, erosion, farming practices—until we realized how connected everything was. Josquin and other celebrity travelers helped us realize this, their migrations turning our attentions to the international Renaissance, but undoing the segregated Renaissances projected backward by the nineteenth century still has a long way to go.

36

Angelo Poliziano: Patronage Repays

Angelo Poliziano (1454–94) is celebrated now, as in his lifetime, as one of the most elegant voices of the Renaissance, a master of Greek, Latin, Italian, poetry, and prose, who gained renown for translating Homer into beautiful Latin verse that finally captured both the sense and poetry.[65] He was also, originally, nobody.

Named Agnolo di Benedetto Ambrogiani before he followed the fashion common among *umanisti* of picking a classical nickname, Poliziano was born in Montepulciano, a hill town near Siena and Arezzo. Montepulciano had gone through the usual 1300s Montague–Capulet-type internal faction fighting, resulting in the dominance of the Del Pecora family, and then the usual Guelph-Ghibelline checkerboard fighting which made the city Guelph (since its neighbors Siena and Arezzo were Ghibelline). This made it first an ally, then a protectorate of the mightiest Guelph city, Florence. In 1464, Poliziano's father, a minor jurist but in the Medici patronage network, was killed by enemies of the Medici, so his mother—knowing how patronage works—packed the ten-year-old boy off to Florence to live with relatives, and seek the support of the Medici family who would, of course, take care of any child who spoke the words, "My father died for you."

Young Poliziano had a gift for languages, and with Medici funding studied with master scholars including Latinist Cristoforo Landino (1424–98), Greek expert John Argyropoulos (*c.*1416–87), and Platonist Marsilio Ficino. He gained fame by circulating learned Latin letters starting at age thirteen, then his Homer translations at sixteen, and quickly became one of the star scholars

of Florence. Lorenzo de Medici invited the teenaged Poliziano to live in his home, and made him tutor to his then young children, much as Ficino had tutored Lorenzo. Thus, Poliziano taught Latin, philosophy, and formative ethics to boys who would grow up to lead the city and, in one case, become pope, and to girls who would marry scions of great families and become lynchpins of the family's network in and beyond Florence. Poliziano also had an innovative interest in studying antiquity *in order to learn about antiquity*, not just as a tool for the present. He took great interest in correcting texts and spotting Medievalisms. For example, he was the first to realize Virgil was originally spelled *Vergil*, and why it changed. This made Poliziano exceptionally important as a *scholar*, not just as an author and courtier, one of the great progenitors of the modern discipline of classics.

All this fame and favor was, of course, a result of *grace*—Poliziano's family had been part of Cosimo's network, so Cosimo took care of him, but patrons were not universally generous, and when an *enemy* of the Medici network left a little boy behind, the same great man *full of political influence* who gave Poliziano trust and Greek would instead work Florence's courts to deny widows' petitions and exploit the tax system to confiscate inheritance, as he did to Alessandra Strozzi and her sons, and to their many clients too; *grace* only helped one's faithful.

It's worth setting Poliziano himself aside for a couple paragraphs to make clear how difficult it was getting Greek back to the level that allowed him to produce his gorgeous Latin Homer.[66] Petrarch (over a hundred years earlier!) had owned Homer manuscripts, and wrote of what it felt like knowing he had the greatest masterpiece of poetry *there in his own hands* but couldn't read it, and feared no one ever would again. When Petrarch was thirty-five (1339) he managed to learn a few Greek basics from Bernardo Barlaamo (1290–1348, lost in the Black Death), who came from Calabria (the toe of Italy) which was Byzantine enough to still speak Greek. Boccaccio later helped get Petrarch a Latin translation of the *Iliad* and *Odyssey* by another Calabrian, Leonitus Polatus, but it was a clumsy word-for-word translation; the spoken Greek of 1350 had undergone two millennia of change post-Homer, so think of early Google translate,

or a kid in the second year of foreign language study too anxious about correctness to produce anything but the stilted prose teachers affectionately call "translationese."

Things changed in the next generation—the lifetime of those who were young at Petrarch's death. In 1390, a contingent of ambassadors came from Constantinople to Venice to negotiate for military aid, one of whom was the scholar Manuel Chrysoloras (1355–1415). On discovering that he had masterful *classical* Greek, Italian scholars begged him to stay, so he taught Greek in Florence, then Bologna, Venice, and Rome. But even with a master scholar, lessons remained challenging, since Chrysoloras and similar scholars had only ever taught ancient Greek to native speakers of modern Greek. Teaching Italian-speaking Latinists required an adaptation as daunting as spending your career teaching Old English to modern English speakers, then being asked to teach it to Portuguese speakers. It took decades of trial and error to create effective textbooks for Romance-language speakers, and while Chrysoloras did translate some Homer, his was a technical and literal translation, far from beautiful enough to *feel* like the greatest poetry of all time.

Chrysoloras died in 1415, when Alessandra Strozzi was a little girl, and Poggio was about to take his famed book-hunting trek across the Alps. Another of Poggio's generation, Giovanni Aurispa (1376–1459) brought back 238 Greek manuscripts from a trip East in 1423, and our friend Francesco Filelfo made his journey soon after. Then came the Council of Florence in 1438–9. This was a Church council intended to reconcile the Roman and Byzantine Churches—Ferrara was supposed to host, but had a bout of plague (it never stopped), so wealthy Florence offered to both host and foot the bill, a canny investment which let the city show its wealth to envoys from all over. ("Welcome, ambassador, please take a seat under our new ENORMOUS DOME!!!!") The council brought to Florence the Greek scholars Gemistus Plethon (*c*.1355–*c*.1454) and John Argyropoulos (*c*.1415–87), who lingered to teach in the city desperate for Greek, Plato, and all things ancient. (They trained Constantine Lascaris, who would in turn tutor Princess Ippolita Maria Visconti Sforza.)

All this was perfect timing for Cosimo de Medici, who, in the

1430s, was just moving from phase 2 to phase 3 of the *Siena* board game, turning money into power, and was eager to fund Greek study for youths in his network like young Marsilio Ficino (five years old when the Council of Florence started), one of the first Italians to *grow up* with teachers used to teaching Greek to Italians, a subtle but important turning point. The Council of Florence was still winding down when Cosimo commissioned his famous naked bronze *David* statue from Brunelleschi's friend and lover Donatello (c.1386–1466), which so distracted our hypothetical envoy, and whose innovative and shocking nudity was partly justified by ideas of Platonic love, which Donatello signaled by decorating Goliath's helmet with the cart of Venus. The quest for Greek had passed its centennial when Poliziano was born in 1454, into a world where he could access good Greek while he was young enough to learn to translate and compose with fluency. Today Renaissance Penguin Classics all sit side by side, but it took teamwork, decades, and generations to get those texts, each step as different as the generations of our century.

What was Poliziano's life like, as a tutor in Lorenzo's palazzo? Unusual.

Courts and grand houses in the period usually served communal meals at long tables, with strict seating by rank. Family members sat at the head of the table along with powerful guests, such as visiting nobles, diplomats, and ambassadors, with lower seats for favored clients such as business managers, secretaries, or the family doctor, and seats at the far end open to lower figures like craftsmen, some of whom might live in the house, others nearby but dining often at the patron's cost in return for good service. Some faces would be at nearly every meal, others invited only occasionally. Like clothing on a bride, seating charts were a tool to track status and advancement; one could see a courtier's rise or fall by watching their seat migrate up and down the room, and to be seated closer to the patron than his sons was a great honor. That was the normal way, but guests at Lorenzo's homes—both Palazzo Medici in the city and at the country villas the family used to escape the summer heat—were baffled to discover that the unofficial master of Florence ignored rank entirely at mealtimes. Lorenzo had everyone sit in whatever order they showed

up, and young Michelangelo (who lived in the Medici house for a time) wrote of ambassadors and mighty bankers being shocked to find themselves seated next to a mere apprentice sculptor (a man who labored with his hands!).[67] At that long table, Poliziano, Ficino, and their Medici hosts and pupils chatted about Plato with political leaders, artists including Botticelli and Ghirlandaio, and other unusual characters like organist Antonio Squarcialupi (1416–80), and book-dealer Vespasiano da Bisticci. It was with such a mixture of companions that Poliziano, with Lorenzo and his brother Giuliano de Medici, went to mass on April 25, 1478, when Pope Sixtus's Pazzi Conspirators made their attack, and Poliziano—a physically tiny man but not too tiny to help—jumped between Lorenzo and the assassins' blades. Patronage did its work, the multi-generation cycle: my father died for you, you gave me everything, home, education, *grace*, and in return I'll give my life for you if need be—just as Milan's people did *not* do for tyrannical Galeazzo Maria Visconti Sforza when his assassins came. Poliziano survived, now his patron's savior.

While the family was sheltering outside Florence after the Pazzi bloodbath, Poliziano's best-known quarrel came to a head. Like most *umanisti*, Poliziano sometimes partook in literary quarrels, though more often his letters are aglow with praise for everyone he mentions.* This quarrel was not with a scholar, but with Lorenzo's Roman wife, Clarice Orsini de Medici. She, sources say, did not like her children reading mainly Greek and Latin pagans, pushing for more religious education. Planning for her three-year-old Giovanni (whose childhood nickname "Leo" reminds us that he will someday be Pope Leo X), Clarice wanted the boy to read the Psalms in Latin (in *bad medieval Latin* in Poliziano's opinion) rather than reading Ovid as Poliziano planned. This is historically important because Leo

* To demonstrate Poliziano's warmth, I shall now flip his letters open at random: my finger finds Letter III.22, Poliziano writing to his friend Jacopo Antiquari (*c.*1444–1512) in Milan, saying Antiquari is much too modest about his work, and that his excellence is tempting Poliziano and his friends in Florence to have a contest over which of them love him most (Poliziano, Letters, 2006). But, like any passionate *umanista*, he could also be vicious in scholarly quarrels, specially in his *Miscellenea*.

will be pope when Luther releases the Ninety-Five Theses, so many Reformation histories will cast him as the villain. The most recent English-language biography of Pope Leo X, written in 1908, states *as fact* that if Clarice had won the argument and three-year-old Leo had read the Psalms instead of Ovid, the Reformation wouldn't have happened.[68] Petrarch did warn us that, if we possess countless books, we'll possess countless errors, and need to spend lifetimes fixing them.

Soon after the Pazzi aftermath enters the man whom Poliziano's letters often call the light of his life, or light of the whole world: Giovanni Pico della Mirandola, Count of Concordia (1463–94), author of the famous (not) *Oration* (not) *on the Dignity of Man*.[69] For a long time, Pico was the first example in Wikipedia's page on *genius*. From the ruling family of Mirandola, near Modena, young Pico had a gift for languages, and studied not only Latin and Greek but Arabic and Hebrew. He turned his back on politics to dive into the secrets of the soul, studying every philosophy and religion he could access. Pico first turned up in Florence in November 1484 on the astrologically favorable day Ficino had chosen to publish the Plato translations he had begun for Cosimo thirty years before.

The charming young count immediately became an intimate of Lorenzo, Ficino, and especially Poliziano. Documents make it hard to tell whether the two were lovers or just had one of the most enthusiastic Platonic friendships in literary history, but whether or not there was sex, there is a playful passion in the letters where Poliziano calls Pico "Prince of Muses," saying "no mortal is more beautiful or preeminent in all kinds of learning!" while Pico says of Poliziano, "Who wouldn't want to die on the receiving end of your sword?" meaning, in context, the sword of Poliziano's brilliant literary criticism.[70] Pico was also *actually a count*, ruler of a dinky city (Concordia, between Mantua and Ferrara) but a city nonetheless, and he had kinsmen with larger dominions, armies, and was even a marriage ally of the dukes d'Este. This—in Florence's republic where even the powerful *ottimati* had to deny all noble status—meant that Pico was the highest-ranked man in the city, unless another major noble was visiting, a political reality which made enthusiastic young super-scholar Pico rather like a

hyperactive puppy that has not yet realized it's grown big enough to knock things over.

Pico's philosophical work is some of the densest and most ambitious of these centuries. We'll come back to it, and to Ficino's work too, in Part IV when we dive deep into Renaissance humanism, but for now in extreme brief: Ficino believed that the ideas of Plato and other ancient philosophers, especially about virtue and the soul, were divinely inspired, a second revelation parallel to the Hebrew Old Testament, and equally important for understanding the New Testament. Ficino believed that integrating Platonism into Christianity would complete God's message, rehabilitate and renew the Church, reveal the true path to a golden age, and perhaps bring world peace by creating a religion in which God's Truth would be so clear that everyone would instantly convert. This was a form of *syncretism*, an attempt to amalgamate different religions and philosophies into one. Pico loved Ficino, and became an even more expansive syncretist, attempting to achieve the true, perfect religion by integrating, not only Plato and Greek authorities, but Zoroastrianism, Hermes Trismegistus, Kabbalah, even the Koran.

Alas, the Prince of Concord was not as prudent as he was brilliant. In 1487 (aged twenty-three) he completed his *Nine Hundred Theses* (not 90—900!) proposing to unify all world religions. He genuinely believed they would make all Jews, Christians, Muslims, and others realize their faiths were fundamentally the same, and join as one. He sent copies to everyone who was anyone, and announced that he would defend it publicly in front of the pope at the Vatican, proposing a debate like those Peter Abelard's charisma had made must-see events centuries before. Then (because this was not reckless enough), on the way to Rome, Pico stopped in Arezzo and attempted to run away with Margherita, wife of Giuliano Mariotto de Medici, a cousin of Lorenzo. Pico was wounded in the subsequent swordfight, arrested, then freed, stopped off in Perugia to hang out with Jewish magic teachers, and then arrived in Rome where he was probably the only person surprised to hear that Pope Innocent VIII (King Log) had banned, both his public event and his project.

It was a gentle ban at first, condemning only thirteen of the 900 theses (98.5 percent approval!) and inviting Pico to revise

them—most modern people would expect a severe ban for something so extreme, but this was a celebrity scholar and nobleman with powerful friends, and even popes are part of the web of patronage, and in this phase cared more about war than they did about theology. Pico, alas, was certain truth would vanquish ignorance, so published a defense instead of a retraction. In response, in 1488, all 900 theses were condemned, the very first printed book banned by the Church, and the order went out for Pico's arrest. A flight to France could not save him, but Lorenzo de Medici's purse and *grace* could (who has royal fleur-de-lis on his balls?). Lorenzo arranged for Pico to return to Florence (to fretful Poliziano's loving arms!), and got permission for the count to live with him in a kind of city-wide house arrest, with Lorenzo vouching for his good behavior. *(He's living practically like a monk, just studying the Psalms, I promise!)*

Four years after this crisis, in 1492, Lorenzo de Medici, age forty-three, weakened and died, an effect of his chronic illness, and (alas) of the doctors' ill-advised efforts to treat it. (Ground-up sapphires are not good for you.) Poliziano sat at Lorenzo's bedside to the end, Ficino too, Plato in hand, reading it out just as he had done for Cosimo.

The next day, Lorenzo's twenty-year-old son Piero (not Piero the Gouty, that's Lorenzo's father), took charge of the city and the household, and *immediately* gave the order that, from now on, all who dined in Palazzo Medici would sit by rank.[71] As news spread, fast as horseback, that the famed peacemaker Lorenzo* had died so young, Pope Innocent VIII (King Log) wrote that the peace of Italy was at an end, while Jacopo Antiquari (writing for the anxious Visconti Sforza in Milan) said God must be incensed against Italy, since Lorenzo's death would—like snow

* Lorenzo's reputation as peacemaker was carefully crafted. In addition to his showy actions opposing Sixtus, he often made interventions in neighbors' politics which carefully placed him in the role of peacemaker, as in 1488 when his intervention saved (and propped up) Florentine ally Giovanni Bentivoglio, First Citizen of Bologna (the vital Guelph ally which guarded Florence's back across the main pass through the Appenines), when Bentivoglio had been captured in a popular rebellion in Faenza after his daughter Francesca Bentivoglio poisoned her husband, the town's ruler Lord Galeotto Manfredi.

melting on a mountaintop—pour down destruction on the land. King Ferrante of Naples (Ippolita Maria's father-in-law) called Lorenzo's life "too short for Italy," and wrote of his prayers beseeching God not to let *that* be attempted which was not dared while Lorenzo lived, meaning the war plans of Sixtus's faction and others primed to benefit from war.[72]

That summer, Pope Innocent died, and the election of Rodrigo Borgia as Alexander VI began the era which would come to be called the *Calamità d'Italia*, the disastrous decades around 1500 when Italy lost so much so quickly that Machiavelli's friend feared posterity could never believe it, or forgive it.

Within two years (1494), with Borgia's kingdom-building starting and the French armies slouching their way toward Tuscany, Poliziano—aged forty—died. His dear Pico—only thirty-one—followed weeks later.

It was murder.

We confirmed it was murder in 2007. But before we talk about the murder, I want you to read this chunk of Poliziano's English Wikipedia entry, extracted April 30, 2020. It gives four contradictory causes for Poliziano's death: three old legends, the last forensic fact. Why are the outdated ones still there? You know the many Renaissances we've imagined since Burckhardt, and how subtle the evidence has been for each, a villainous Lorenzo and a heroic Lorenzo one detail apart. Each outdated cause of death on Poliziano's Wiki page is a piece of evidence for *somebody*'s Renaissance. Once someone has been persuaded by *that* Renaissance, entranced by a book, a tour, a documentary, the details which support *that* Renaissance feel true, and get repeated—like the Greenland Vikings dying out from climate change—even if new facts contradict it. Hence this:

> It is likely that Poliziano was homosexual, or at least had male lovers, and he never married. Evidence includes denunciations of sodomy made to the Florentine authorities, poems and letters of contemporaries, allusions within his work (most notably the *Orfeo*) and the circumstances of his death. The last suggests he was killed by a fever (possibly resulting from syphilis) which was exacerbated by standing under the windowsill of a boy he

was infatuated with despite being ill. He may also have been a lover of Pico della Mirandola. But it is just as likely that his death was precipitated by the loss of his friend and patron Lorenzo de' Medici in April 1492, Poliziano himself dying on 24 September 1494, just before the foreign invasion gathering in France swept over Italy. In 2007, the bodies of Poliziano and Pico della Mirandola were exhumed from the Church of San Marco in Florence to establish the causes of their deaths. Forensic tests showed that both Poliziano and Pico likely died of arsenic poisoning, possibly on the order of Lorenzo's successor, Piero de' Medici.[73]

There are four Renaissances in this paragraph. Villari's nationalist revolutionary Renaissance with degenerate Lorenzo and his syphilitic cronies; the romantic Renaissance of poets crooning under balconies; Burckhardt's Renaissance with true philosopher Lorenzo so beloved that kindred spirits follow him in death; and last the forensic Renaissance of plunging life expectancies and murder without consequences if the patronage network is on your side. New facts struggle to dispel old portraits. Doubtless several facts in the book you're reading right now will be proved wrong soon, or have been already, in sources I don't know. Our countless books have countless errors; the best solution is to write *more* books.

But young Piero de Medici the murderer? Lorenzo's heir? Poliziano's pupil and—after Lorenzo's death—his patron too? How? Why? Poliziano saved his father's life from Pazzi blades! What about Cicero and moral maxims? What about a student's debt to teachers, which made Francesco Filelfo spend his *grace* to reach from Milan to Constantinople to help his teacher's widow? What about dynastic trust? The trust that saved Cosimo in 1433, that saved Lorenzo in 1478, that, when broken, *did not save* Galeazzo Maria Visconti Sforza, who paid a fatal price? Why would we think Piero would shatter all that? Or is this just slander, the Renaissance of *romance* making us seek for treason's grim glitter?

Not all historians think Piero did it—there are several suspects whom I'll go through shortly—and most think Pico rather than Poliziano was the main target, since they dined together

constantly and died similarly, Poliziano sooner since he was a very petite man and Pico tall, and arsenic ravages small bodies faster. But the fact that Piero is on history's suspect list is itself a very damning comment on how history has viewed the famed Lorenzo's heir.[74] Why do people suspect Piero, enough for him to still be named as the culprit on a Wiki page 500 years later?

Because there was another power on the rise in 1492. Some might call him a specter haunting Florence. Others a new dawn. They call him bigot, tyrant, savior, rebel leader, a last gasp of medieval zealotry, or a first breeze of the Reformation coming like a cleansing storm. He is controversy, a hero/villain more extreme in histories than our Lorenzo. And we don't know who poisoned Pico and Poliziano, but many people at the time, and many since, suspected that young Piero—barely twenty and stepping into some of the biggest shoes in human history—feared anyone who called this rising power *friend*...

37

Savonarola: Saint or Demon?

Girolamo Savonarola (1452–98), born in peaceful Ferrara to an unsuccessful merchant who tried to get his clever son to go to med school; burned at the stake aged forty-five, not for heresy—the world is more complex than that—but for his political activities during the four years he helmed Florence as a theocratic republic, from the French invasion of 1494 to 1498.[75]

Who was this charismatic friar who rose so high and fell so far? His written works run the full gamut, from hellfire and brimstone sermons to astute, progressive criticisms of social inequality. Skim his corpus and you can find quotes that make him sound like an enemy or an ally of almost any movement: he criticized study of the classics, praised study of the classics, studied the classics himself, followed Catholic dogma with iron strictness, and called for reforms more radical than Luther's. As for period accounts, those too run the full gamut, from those who pushed for his death, to those who treasured splinters of his pyre as holy relics of a forbidden saint. Machiavelli, not quite thirty, described Savonarola as a man who "acts in accordance with the times and colors his lies accordingly."[76] After the friar's execution, Ficino testified to the Inquisition that he believed Savonarola had been a demon who didn't know he was a demon, believing his own false prophecies as his demonic nature spread discord in accordance with Providence's strange plan. Nearly fifty years after Savonarola's death, artist-biographer Giorgio Vasari asked Michelangelo: *You were in Florence then, what was he like?* Michelangelo answered: *Sometimes I still hear his voice.*

What facts are clear? Savonarola's father sent him to a good school, likely the *studia humanitatis*, then on to university, hoping the boy might become a renowned physician, like his grandfather (with up-to-date methods like taking patients' horoscopes at the time that they peed). In April 1475, twenty-two-year-old Savonarola walked twenty-five miles to Bologna—a Dominican headquarters and beyond his family's reach—and joined a Dominican monastery. Why? Period sources range: he heard a moving sermon, he was wrestling with temptations of the flesh, he had been spurned in love, he was disgusted by the rich d'Este dukes his father wanted him to serve (though eye-gouging little Ippolito wouldn't be born for two years yet).

All sources confirm Savonarola was an outstandingly rigorous friar,* causing friction by pushing his superiors to be stricter. With the Dominicans, he studied scholasticism and Aquinas, taught, and wrote works on logic, ethics, statecraft, and devotion. The theme of renewing the corrupted Church appears as early as his Lenten sermons of 1485 (aged thirty-two).

Preaching for Lent was a *big deal*, an oratory marathon composing and delivering a new multi-hour sermon every day for six weeks. Towns competed to hire star performers, crowd-drawing celebrities like Bernardino of Siena (1380–1444), whose arrivals were anticipated like a major touring rock band, and whose listeners would travel many miles from surrounding villages to camp out at dawn for a chance to hear a thrilling three-plus-hour sermon. In 1490, Lorenzo de Medici invited Savonarola to give Florence's Lenten sermons (the big leagues!), probably at the request of Pico della Mirandola, who had heard Savonarola

* While we think of him as a monk, technically Savonarola was a *friar* not a *monk*, since monk means a member of a more traditional monastic order like the Benedictines, whose members' vows include a *vow of stability* tying them for life to a specific monastery in a specific place, while the Dominicans (as well as the Franciscans, Augustinians, and Carmelites) are *mendicant* i.e. itinerant orders, whose friars take vows of *poverty, chastity* and *obedience* (to the hierarchy of their order) but circulate from monastery to monastery within the order as they travel to preach, teach, beg on the street to experience poverty, etc. This is how Savonarola and similar preachers could (when their superiors approved) be relocated easily from city to city to bring innovative ideas and organize new communities.

speak, and, still struggling intellectually and emotionally with his condemnation for heresy, wanted to meet this exciting theologian.

Savonarola remained in Florence after his epic six weeks of Lenten preaching, joining San Marco (the monastery Cosimo had built, with his personal cell). Savonarola pushed the local Dominicans to be stricter *(rugs on stone floors in winter? luxury!)*, and within the year zealous new recruits were flooding San Marco, while some of the original brothers fled to Florence's other Dominican monastery, Santa Maria Novella, and wrote in alarm to higher Dominican authorities about Savonarola's growing power. (To this day Santa Maria Novella's tourist brochure says of this period that we were always perfectly sensible Dominicans over here and had nothing to do with *that man!!*)

Savonarola's sermons drew (alarmingly) large crowds, as he preached against many things: corruption, bribery, adultery, sodomy, gambling, and feuding. He had an entrancing style in the pulpit, making prophecies, and sometimes having spontaneous live dialogs with God. He also preached against displays of wealth, like when donors put their coats of arms on church art, or had themselves included *in the painting* standing beside the saints in their Florentine finery, turning a holy space into an advertisement, like Alessandra Strozzi's daughter's $400,000 wedding outfit. Many things Savonarola criticized are things the Medici did, making it easy to read his sermons as anti-Medici, but they can equally be read as anti-elite in general, since the same was done by many powerful families in Florence, Bologna, Savonarola's native Ferrara, and in Rome, where even the Dominican headquarters church of Santa Maria sopra Minerva sports one of my favorite frescoes: Filippino Lippi's Saint Thomas Aquinas Interrupts the Annunciation to Introduce the Virgin Mary to Cardinal Carafa who paid for the painting, while patient Archangel Gabriel just has to wait.

As churches became increasingly a space for elites to advertise their wealth, you can understand the mix of horror and delight at incidents like when Savonarola was in Bologna for a time in 1493, when Ginevra Sforza, wife of the city's ruler Giovanni Bentivoglio (and mother, by her first husband Sante Bentivoglio, of Machiavelli's letter-writing friend Ercole) kept

Filippino Lippi's *Annunciation* in the Carafa Chapel, with interrupting St Thomas presenting kneeling Carafa on the right (1488–93, Santa Maria sopra Minerva, Rome).

walking late into Savonarola's sermons in her bejeweled finery, and Savonarola—a nobody!—did the unthinkable and shouted at her—a Sforza!—right there in the church in front of everyone! The sky was falling, but whether for good or ill depended on your point of view.

Savonarola did not go to pay his respects to Lorenzo when he arrived in Florence, nor did he ever visit Palazzo Medici. He did not get along with Ficino, criticizing his use of astrology and magic. He did hit it off with Pico and Poliziano, who definitely

(sources leave no doubt) became his close friends, spending more and more hours with him in San Marco debating, and even writing together. Pico was still excited by theology, perhaps more than ever after his condemnation, but we don't know what they really talked about together in San Marco, how pro- or anti- the Petrarchan/classicizing/humanist movement they were, since our Savonarola sources are incomplete and suspect, and our Pico sources were actively censored by his family after his death. Savonarola definitely urged Pico and Poliziano to distance themselves from magic and astrology, and to become Dominicans, though how he urged it and how they felt about his urging (hostile pressure? casual invitation? soul-searching debate?) we don't know. Pico and Poliziano remained close with Lorenzo and Ficino, though we can't know how the hours spent at San Marco changed those spent in Medici spaces.

In 1492, when Lorenzo lay dying with Ficino, Poliziano, and Pico at his bedside, Savonarola finally visited the unofficial lord of Florence for the first time. He did not give Lorenzo his last rites. Anti-Lorenzo histories read this as Savonarola's condemnation of the tyrant. Anti-Savonarola accounts depict it as bigoted Savonarola vindictively spurning this philosopher king. In fact, Lorenzo had already had his last rites, and you're not supposed to do them twice, so Savonarola not doing it tells us nothing, but, like the tale of Poliziano wistful under a balcony, the idea of Savonarola refusing Lorenzo his last rites is useful to many portraits of the Renaissance, so it keeps getting told, and told, and told.

Upon Lorenzo's death, young Piero de Medici assumed power, established seating by rank in Palazzo Medici, and started running Florence, but without his father's acumen he quickly made mistakes. Things felt precarious. Remember, the Medici weren't *legally* rulers of this city, they just advised, got their people on committees, wielded "temporary" emergency powers, and had such *grace* that the Duke of Milan and King of France wrote to them rather than to the Nine Dudes in the Tower. Medici power came in part from the ways they'd altered Florence's system to keep their network in control, but it was still a patronage network, and *grace* is only valuable if the figure at the top can get things done. Lorenzo had been an extraordinarily skillful player of patronage's thousand-stringed

harp, with a meticulously performed persona mixing humility with the kinds of nobility acceptable in the city, and a carefully cultivated reputation as a peacemaker and solver of great crises. Young Piero in contrast often rubbed people the wrong way, and made the kinds of entitled mistakes a kid raised to expect power makes, like shutting down a major street to make a sports space for his friends to play *calcio* (the period's extremely violent football).

As young Piero made mistakes, both personal and political, the value of the Medici network and the loyalty of Medici clients rapidly weakened. And a popular preacher drawing crowds is equally capable of telling Nine Dudes in a Tower what to do. We think Piero feared Savonarola as a rival influence, especially as the prophecies Savonarola sometimes made from the pulpit started to come true. In 1492 Savonarola prophesied, "the sword of the Lord from the north and soon," and in 1494 this materialized as the French invasion. Savonarola's followers had cohered into a group, called the *piagnoni* or "wailers," which included many from powerful families, and began more and more to feel like a political faction. Day by day, as war approached, more Florentines turned to the city's prophet, not its Medicean not-a-prince. In this volatile moment, poet superstar Poliziano, and Pico too (who—don't forget—was Count of Concordia, real nobility whose brothers had armies), both spent time with Savonarola every day, lending him credibility, influence, and power—our enthusiastic scholar-puppy not realizing how big he is, how much his *legitimizing* presence might knock over as he left Palazzo Medici to play at San Marco.

So, the arsenic?*

That's what many thought in 1494, and still today.[77] But we don't know. We have other suspects. A spy reported to the Doge of Venice that Pico's servants Cristoforo and Martina da Casalmaggiore were the direct poisoners, on someone's orders but not whose. An account by Giovanni Veronesi said the culprit was an unrelated Florentine whom Pico had loaned money to, who was desperate to escape

* The exhumation confirmed arsenic present in Pico and Poliziano's remains at 5x the level expected in bodies from their time and region. The exhumation was led by anthropology Professor Giorgio Gruppioni of the University of Bologna, but also shaped by the hope for publicity via a TV documentary, etc., a profit motive which led some academics to view the results incredulously.

paying it back. Others suspected Pico's brother Anton Maria Pico and his wife Bianca Maria d'Este did it, as part of family squabbles over who would inherit Pico's property if he did renounce it to become a Dominican, though Pico's swift death meant the property *did not* go to them, making that theory less convincing. These and Piero were the suspects when it happened, but in the fragile state of power so soon after strong Lorenzo's death, many in Florence had reason to be frightened of politically outsized Count Pico knocking things about in fragile Florence.

All these theories see Poliziano as collateral damage, since with Poliziano only Piero had a motive, the motive of an angry barely-more-than-kid whose childhood tutor was still there trying to tell him what to do, while that tutor and his genius lover praised this foreign preacher who railed from the pulpit against wealth and tyranny in ways Piero must have taken personally. But we don't know. Arsenic we can excavate, not motives, jealousy, or fear. We do know that the suspicions around their deaths forever joined other criticisms of Piero in painting him as failure or worse, in contrast with the larger-than-life magnificence of his father. Savonarola buried Pico and Poliziano together in San Marco, their bodies dressed in the Dominican robes they had been considering adopting in life. At their funeral, Savonarola praised their scholarly work, and assured everyone, with his prophetic authority, that Pico's soul (despite his excommunication) was on its way to Heaven. That Poliziano—so long a Medici man—was not buried by the Medici despite dying three months *before* Piero's expulsion was itself a sign of troubled times.

But King Charles and his armies were still coming. Worse, since it had been unclear whether the French would ride down the west or east side of the Italian peninsula, most of the defensive coalition (papal forces, the King of Naples's forces) had gone east, leaving Florence to face France *alone*. Piero rode out to negotiate. This is what the Medici were for: *Your family funded the French kings' wars for three generations! You have King Charles's ear! His fleur-de-lis is on your family balls! Now go out there, young Medici, and call those favors in!* He flubbed. He promised the French vast payments, even giving them the invaluable port city of Pisa (which Florence had fought many wars to take!), but got no clear promises of safety

from Charles in return. The city rumbled, angry at this failure, and as King Charles with his city-razing cannons rumbled close, on November 9, 1494, Florence expelled Piero and the Medici network from the city. Piero, with his closest allies, fled to Venice (just as his great-grandfather Cosimo had when pushed from power sixty years before), leaving Florence alone. This and surrounding disasters earned Lorenzo's heir the epithet Piero the Unfortunate, which always makes me imagine his grandfather Piero the Gouty ranting: *I'm the unfortunate one being dismissed by history books despite my achievements because I was nicknamed for the family medical condition! You're Piero the Incompetent!* But facing down the greatest armies in his world is a lot to ask of a kid of twenty.

Take a deep breath, fragile, friendless Florence—one last chance. The Florentine ambassadors went out to see King Charles, taking Savonarola with them. The firebrand preacher persuaded the king to spare the city, and Florence was saved. A miracle? Many hailed it as one. Other Florentines helped too: diplomats like former ambassador to France Piero Capponi (1447–96), and artists who raced to paint gold-and-blue French fleur-de-lis all over the Palazzo Vecchio reception room so Charles, entering, would feel like Florence was already his (the French noticed the wet paint smell).

Savonarola told the king he was God's instrument, that he would succeed in taking Naples, and other things we don't know. The French entered Florence in peace, the soldiers billeted in homes throughout the city, though things still got tense as the king and nine *priori* met in the Palazzo Vecchio. Bold Capponi ripped up the French ultimatum when they pressed too much, and when Charles threatened, "We could blow our trumpets," i.e. muster the soldiers, Capponi threatened back, "Then we'll ring our bells," the instant signal to the populace to rise and fight.[78] Even town-crushing France did not want a street fight *inside* the hornet's nest that is Florence. Many minds helped save the day, Savonarola most charismatically and unexpectedly, so, as the French moved on to wreck the rest of Italy, Florence, miraculously safe, effectively became a theocratic republic, still with its nine *priori* in the tower, but listening to Savonarola and his *piagnoni* instead of to the Medici.

Palazzo Vecchio room of the *priori*, decorated in 1494 with hasty wartime French-style fleur-de-lis. On the right, Donatello's *Judith and Holofernes* was made for Cosimo de Medici in *c.*1457, but moved to the Palazzo Vecchio in 1495 to celebrate the expulsion of his great-grandson Piero the Unfortunate.

This new regime—influenced but not solely shaped by Savonarola—put many *piagnoni* in power, and instituted many innovations designed to pluralize power and prevent another single-family takeover. In addition to replacing Medici clients in key offices, they created a Great Council of 500 *popolani* drawn from a bag to meet, debate, and vote on legislation, the largest participatory council, not just in Florence's history, but Italy's. And, subtle but almost more important, those elected to the council were thereafter eligible for all Florence's offices for life, *without* having to re-undergo the periodic process of scrutiny and having the *Accoppiatori* decide if you go in the bag or not. This transformed a system where full enfranchisement had always been temporary and provisional, so it could be lost at any time if you went deep into debt or got on the wrong side

of powerful men, into one where, once a participant, you were forever a participant.

So enthusiastic was the city about this expansion of participation that the *Hall of the Five Hundred* that was added to the Palazzo Vecchio to hold this huge council is the only public works project in the city's history that was finished early and under-budget.[79] At the time, Florentine day laborers earned enough to live on working three days in a week, so usually took off the other four to look at art or listen to people recite Dante (really!), but they were excited to put in full weeks building the new room *even though day laborers were plebs and not eligible for the council,* since the *idea* of the city having vastly more political participation than any other polity in their world was a point of pride and excitement even to the disenfranchised. (Sure sounds like civic humanism!)

If you know only one thing about Savonarola it's the Bonfire of the Vanities, the Renaissance's darkest hour (nope), a mass book burning (nope) and art burning (nope), invented by Savonarola (nope) to exert the stifling force of Church and Faith against the broadening of art, science, and thought that he hated (still nope). The scholar I know who's worked most on Savonarola thinks that it was more like Burning Man.

It was Carnival, normally the time for festivals, music, parades with people dressed as Bacchus, Caesar, or Ages of History, riding on huge painted parade floats designed by artists like Leonardo or Michelangelo, which were often burned in triumph at the end. (Fire is fun!) Other popular Florentine carnival activities included betting on hounds as they devoured tame lions, making stallions fight to the death over mares in heat, and gangs of youths mugging and assaulting women in back streets with legal immunity. In 1497 Savonarola suggested, instead of blood sports, assaults, and a costly parade, holding a Bonfire of the Vanities, a genre of religious display which had been popular for decades, especially with Tuscan local boy Saint Bernardino of Siena (1380–1444). For weeks, Florentines put stuff onto a big wooden ziggurat-shaped structure, then set it on fire, dancing around in a final celebration. Some of the stuff was definitely put on unwillingly—the youths who usually mugged women this time seized their wigs and fancy accessories—but most of the stuff, it's clear from accounts, was

put on the pyre willingly through the enthusiasm/excitement/zealotry/piety/indoctrination/pressure/mania (different words can make it feel so different) of the owners.

What was burned? Definitely makeup, wigs, fancy clothes, and other adornments. A 1470 painting of a Franciscan leading such a bonfire shows fancy hats, false hair, dice, playing cards, a backgammon board, high-heeled shoes, and *no art*. The diary of apothecary Luca Landucci (1436–1516), who saw Savonarola's version, describes pornography on the pyre, some printed books (none unique) including Boccaccio's *Decameron*, works by Poliziano and another Medici-sponsored poet, Luigi Pulci (1432–84), plus "lascivious statues."[80] Historians think there were some drawings or paintings, likely nudes, possibly by Botticelli since the artist was a great enthusiast of Savonarola, and likely put them on the pyre himself, but we don't have details (How many? How big?). In 1860, Burckhardt's field-founding *Civilization of the Renaissance in Italy* included a detailed description of what was on every level of the pyre, describing the top three tiers as entirely filled with art, and while recent historians have realized that Burckhardt made this up from pure imagination, that doesn't stop HistoryOfPainters.com from stating, last time I checked it, that "thousands of the greatest masterpieces ever created by some of the giants of renaissance art" were burned in the "Taliban style regime" which Savonarola "ruled with an iron hand."[81]

What did the real Bonfire of the Vanities feel like? Again we need our telepathic time traveler. Was it fun like Burning Man or Carnival? Scary like a fascist rally? If Botticelli did put an old nude on the fire, did he feel religious exultation or regret watching it burn? If he felt one way, did the person standing next to him feel the opposite? Fun for *piagnoni* but frightening to less enthusiastic outsiders? Savonarola famously had bands of youths go around the city dressed as angels urging people to give up their vanities; did their knock at the door feel like cookie-peddling Girl Scouts, or tedious Jehovah's Witnesses, or maniacal Hitler Youth? If we add the fact that many of those youths had been child prostitutes, whom Savonarola gave another means of life, how different does their devotion to him feel? We do know that it wasn't a mass book burning, or a mass art burning, or an effort to

plunge Europe back into the (mythical) Dark Ages. The bonfire aimed at virtue and renewal, as Petrarch said Florence needed, as Dante said Florence needed, as Pico and Ficino said Florence needed, but the bonfire sought to achieve it in a different way, one that feels more alien to us moderns, layered with the more recent burnings of the Reformation, and colonialism, and witch burnings, and the twentieth century's most shameful hours, all of which were not there yet to be part of what Savonarola and those of his era thought a bonfire meant. It was frightening to his enemies, that's clear, but it didn't feel to them as it would feel to us, it was another era's fear, which takes hard work for us to understand.

How did this improbable quasi-theocracy come to an end? It was a mixture. Savonarola had many enemies in Florence, as well as friends. Some were frightened by his extreme words, his prophecy of Florence surviving like the Ark as God destroyed all Europe. Some were oligarchic elites angered by his populist reforms, since Savonarola expanded the franchise from a few hundred guild leaders truly participating in the republic to several thousand. Some were other Church forces, Franciscans, or traditional Dominicans longing for the old order before *that man!!* Some were Medici loyalists, patient and careful, planning for the family's return, like Lorenzo's brilliant eldest child Lucrezia de Medici (1470–1553), who had married a Salviati (with a $2 million dowry) and (like Alessandra Strozzi) was still in Florence working toward her family's return.[82] There were also many who merely felt themselves outsiders to the *piagnoni*, hoping for the fall of the new faction in power. Savonarola had railed against the corrupt papacy, denouncing Alexander VI's efforts to make a permanent Borgia kingdom out of central Italy. Rome waited until tensions in Florence deepened, and the lottery to pick the nine *priori* (Dudes in the Tower) chose several who were *against* Savonarola, then Pope Alexander pronounced his condemnation.

Savonarola probably expected Florence to defy the pope and stand by him, as they had when Sixtus IV excommunicated Lorenzo, but instead the threat from Rome put pressure on the cracks. A Franciscan challenged Savonarola to prove that God was on his side through a trial by walking through fire, and one of

Savonarola's eager followers agreed too quickly to back out. April 7, 1498, the trial by fire (not a common thing! The first in many years!) was prepared before the Palazzo Vecchio, but hours of argument over the exact process gave way to rain which broke things up, and left onlookers—including many disillusioned *piagnoni*—feeling that Savonarola had failed to prove his divine mandate. Not long after, mobs organized by his political opponents rushed San Marco, arresting him and his associates. Radical as he was, Savonarola's theology was extremely orthodox; they couldn't get him for heresy, but condemned him for causing political disorder, which he was tortured into confessing to. As he awaited execution he wrote—with his shoulders dislocated—reflections on the Psalms, and on how torture shouldn't be used in justice, since it can get anyone to say anything (arguments which would not gain momentum until the 1700s with Beccaria and Voltaire).

Along with two close followers, Savonarola was burned at the stake, in the same square where the trial by fire had been planned. His last recorded words were correcting the priest who made an error in the execution ceremony, saying that the condemned were being expelled from the Church Militant (Earthly) and Church Triumphant (Heavenly), but Savonarola reminded him that the ceremony is only supposed to name the Church Militant, since no Earthly power can expel one from the Heavenly Church. The priest accepted the correction. The executioners tried to throw all Savonarola's ashes in the river to avoid a cult collecting relics, but wood chunks, garments, his rosary, and other relics remain in San Marco to this day, poised to be confirmed as holy whenever the petition for his canonization finally succeeds—the most recent major push was Cardinal Silvano Piovanelli's in 1999.

However variable Lorenzo de Medici may be in our histories, Savonarolas vary more. He's a hero voicing Italy's nationalist dream of freedom in Villari's *The History of Girolamo Savonarola and of His Times* (1859). He's a proto-Protestant saint in *Savonarola, the Florentine Martyr: A Reformer Before the Reformation* (1880) and again in William H. Crawford's *Girolamo Savonarola: A Prophet of Righteousness* (2006; which quotes George Eliot's novel *Romola* as if it were a factual source). He's the opposite, an exemplary Catholic and anti-Protestant proto-Counter-Reformation

saint, in J. L. O'Neil's *Jerome Savonarola: A Sketch* (1898), and in *Savonarola: A Tragedy*, a play in Shakespearian verse by conservative Catholic poet laureate Alfred Austin (1891).

Modern scholarship has better data, but even in the History Lab Savonarola remains polarizing. He's a hero sweeping away corruption in Lauro Martines's *Fire in the City* (2007), and a hero always almost preternaturally right in Strathern's *Death in Florence* (2011). Meanwhile he's a villain in Hollingsworth's *The Family Medici* (2017), in my friend Lawrence Rothfield's *The Measure of Man* (2021), in many Machiavelli books, and in many art histories, general histories, and blog posts that use Savonarola-the-antagonist to represent how the Church, or Faith, or zealotry, or "Medievalism" (wince) has always been an enemy of Reason, or art, or innovation, or freethought, or whatever X-Factor one wants to claim the Renaissance was about. Donald Weinstein's *Savonarola: Rise and Fall of a Renaissance Prophet* (2007) and Stefano Dall'Aglio's *Savonarola and Savonarolism* (2010) come closest to the herculean labor of neutrality. More cautious histories just leave Savonarola out, no mention of this aberration which so complicates Florence, our so-called cradle of the Renaissance. Even here in 2025, I've had serious scholars tell me in private they're nervous admitting that they like Savonarola, afraid fellow Renaissance scholars will dislike them for it.

Savonarola was only in power for four years, but the memory of Savonarola, the fact that such a thing could happen, has been a power for five centuries. For those who lived through it—Josquin des Prez, Ficino, young Machiavelli—it changed the palette of the possible, how radically a nation could suddenly change, and never quite change back. In the next generations, Savonarola was appropriated by the Reformation, and by many Christian movements since. The monuments to him in Florence and elsewhere are mainly nineteenth- or twentieth-century, the footprints of moments when an idea of Savonarola struck a chord. The statue of him which now stands in Piazza Savonarola was conceived in 1861 during an anti-papal movement (Savonarola the anti-corruption reformer!) and was originally installed in the Palazzo Vecchio in 1882, but, in the nationalist surge after the First World War, Florence found a new way to express itself via Savonarola by

dragging the statue off to a minor square and giving its place of honor to Michelangelo's *Genius of Victory*. Another nineteenth-century statue of Savonarola was placed in San Marco in front of the double tomb of Pico and Poliziano, sternly blocking the inscription many *romantic* lovers of the Renaissance come to visit.

In 2018, a friend of mine attended Florence's 520th anniversary ceremony for Savonarola's death, which included a mass, a parade, strewing flowers on the pyre site, and the clearly uncomfortable mayor giving a speech about how this wasn't really about Savonarola, it was about Florence's inclusive tradition of piety and religiosity, while a whole wall of nuns and fierce old ladies *glared* at him—it's about Savonarola. May 23 will always be about Savonarola in Florence, but whether seeing a crowd gather for him is welcome or frightening (whether learning *that he existed* is welcome or frightening) is different for each person, just as it was at the bonfire of 1497, and at the very different fire that took his life in 1498. Today San Marco is still an active monastery, attracting men who choose, of all monasteries on Earth, the one defined by *that man!!* It's also an active church, attracting worshippers who choose this one church among all Florence's magnificent options. And it's a museum, drawing tourists, or we might say pilgrims: art pilgrims there for Fra Angelico's frescoes, humanism pilgrims there for Pico and Poliziano, Medici pilgrims there for Cosimo's cell, local Catholic pilgrims there for the tomb of Saint Antoninus (who built it), monasticism pilgrims there for the authentic space, and Savonarola pilgrims drawn by a variety of Savonarolas. Camp out beside his cell for an hour and listen as visitors ask their friends or guides, "Who was Savonarola?" and you'll meet dozens of Savonarolas, Lorenzos, Florences, Renaissances, even Christianities.

Michelangelo's answer remains the clearest: we still hear his voice.

38

Alessandra Scala: The Girl of Our Dreams

Alessandra Scala (1475–1506) debuts in our documents in 1493 in the role of Elektra, bringing the passionate heroine of Sophocles' tragedy spectacularly to life as she recites every line in flawless classical Greek.[83] This performance, staged in Florence in her father's grand classical villa, was described by Poliziano in two epigrams in ancient Greek composed in Alessandra's praise, and in a letter he wrote to another great learned lady of his acquaintance, the Venetian Latinist Cassandra Fedele (*c.*1465–1558).[84] Poliziano's letter describes eighteen-year-old Alessandra studying Greek and Latin day and night, and her stage performance mixing modesty and propriety with naturalistic gestures and virginal innocence to rivet the eyes and minds of an audience of many learned men. The first of his poems describes how Alessandra's fluent performance stunned spectators, and made Poliziano burn with jealousy when he saw her embrace her brother Giuliano, who was playing Elektra's brother Orestes. His second poem declares, "I've found her!" calling Alessandra the ideal maiden through whom Love has finally fulfilled his dreams, though she, he laments, will not glance in his direction.

Alessandra Scala* is one of the most discussed female scholars of the Renaissance, and the only confirmed Renaissance woman who wrote works in ancient Greek, yet her surviving corpus is miniscule: a single Greek poem responding to Poliziano's, and a brief

* Those who, like me, struggle with names can keep our two Alessandra S-es straight by thinking of the "zz" in Strozzi as $$ or εε or ££ or ¥¥, and thinking of the "sc" in Scala as scholar.

two-sentence letter to Cassandra Fedele, congratulating the Venetian lady—ten years Alessandra's senior and a natural role model—for giving a luster, both to their sex, and to their era.[85] Everything else we know about Alessandra Scala depends on texts written *about* her or *to* her, so any effort to understand her is dominated by the challenge of navigating the ways female scholars were written about, both in the Renaissance and since (see Lisa Jardine's beautiful 1985 article on the myth of the learned lady in the Renaissance).

What facts do we have? Alessandra Scala's mother was Maddalena de' Benci (born c.1450), a daughter of the wealthy Florentine Benci family; her kinswoman Ginevra de' Benci (born c.1458) is the subject of a sonnet by Lorenzo de Medici and a portrait by Leonardo da Vinci.[86] In 1468, with a dowry of 1,000 florins plus 200 in wedding gifts ($1.2 million), Maddalena married Renaissance success story Bartolomeo Scala (1430–97). Son of a miller born in the tiny town of Colle Val d'Elsa between Florence and Siena, Bartolomeo had gone to law school in Florence. (One of his law school classmates, Bernardo Machiavelli, would soon have a son named Nick.) After law school, Scala worked in Milan for a year forming useful connections with the Visconti Sforza, and thereafter worked in Florence as a secretary for the Medici, then in state positions, receiving Florentine citizenship and membership in the elite enfranchised *popolo* in 1457, rising rapidly to the Chancellorship of Florence, then a papal knighthood, then to Florence's highest office, Standard-Bearer of Justice, in 1486.[87] Bartolomeo Scala was also a skilled Latinist, publishing letters and dialogues, including *Whether a Wise Man Should Marry*, and an unfinished history of Florence.

I've seen historians celebrate Bartolomeo Scala as proof that Florence's tradition of innovative scholar-statesmen lasted the full century, and others call him a bureaucratic yes-man whose shallow works prove that the Medici stranglehold stamped out political innovation. Whatever version of the Renaissance you want to use Bartolomeo Scala to reinforce, he and his wife Maddalena were an in-period success, and their Palazzo della Gherardesca is one of Florence's grandest examples of classicizing architecture (transformed today into a posh hotel). The couple had five daughters and one son, Giuliano, who became a merchant and office-holder. The

two eldest daughters—Giovanna and Battista Scala—married into rich, Medici-allied families, while the third—Francesca—married a lawyer who turned out to be a deadbeat, but the family helped them out. As for Alessandra, a flurry of classicizing love poems written in her honor from 1491 to 1494 have forever entangled her story with Cupid's arrows and their baggage.

Alessandra likely started classical study with private tutors, and we know she and her brother Giuliano studied Greek *c.*1490–1 (when she was fifteen) with Greek émigré Janus Lascaris (1445–1535), their studies possibly ending in 1491 when Lascaris sailed east to look for manuscripts. Alessandra also studied Latin with Poliziano from 1491 to at least 1493. She is said to have studied Persian, and translated the poetry of Avicenna. Her 1493 *Elektra* performance came in the midst of her studies, so she had been studying with Poliziano for two years before he wrote his "I've found her!" poem. Poliziano also gave her flowers and a carved bone comb, writing poems about the gifts, and her Greek tutor Lascaris wrote a romantic poem about the comb, comparing Alessandra to famous female figures of antiquity.

Alessandra was also celebrated in poems, possibly as early as 1491, by the man who would be her eventual husband: soldier-scholar-crusader-poet Michele Tarcaniota Marullo (*c.*1453/4–1500), a self-described son of Greek nobility, conceived (he claimed) in Constantinople just before its fall, and raised in exile like Petrarch, first in the Republic of Ragusa (modern Dubrovnik), then in northern Italy. He describes himself as dedicated to twin passions: scholarship, and the dream of liberating his conquered homeland. The latter led him to join a mercenary band in his youth, with which he fought for Vlad the Impaler against the Ottomans.[88] Marullo's poems hailed Alessandra as the Tenth Muse of Rome, as Sappho had been the Tenth Muse of Greece, though he adds that Alessandra is better than Sappho because she is so chaste (sigh). A poem of Marullo criticizing Pico for admiring the golden hair and bosom of "my girl" has been interpreted as evidence that Pico too wooed Alessandra Scala, though reading Marullo's phrase "my girl" as Alessandra is dubious, since she and Marullo would not wed until years after Pico's death.[89] Finally, we have a letter to Alessandra from

Cassandra Fedele in Venice, dated January 18, 1492—*before* the *Elektra* performance—apparently replying to a now-lost letter of Alessandra's in which she had asked the older woman for advice on whether to dedicate herself to the Muses or to a husband, i.e. whether or not to marry.

Clearly marriage was on sixteen-year-old Alessandra Scala's mind in early 1492, but was this truly a romantic perfect storm of four scholar-suitors vying for the ideal Renaissance bride? Until recently, most discussions have treated it as that. G. Pesenti's 1925 article, still the most informative work on Alessandra available, describes her as a Juliet caught between suitors and languages, the Latin Romeo Poliziano against the Greek Paris Marullo, and Pesenti spends nearly half the article describing her suitors and speculating about Alessandra's feelings about each.[90]

But if we look at the poems about Alessandra with the keen tools of the modern History Lab, they are all clearly formulaic, modeled on Ovid, Sappho, and Catullus, the kind of thing all Renaissance poets produced to display their skill. Marullo's and Poliziano's collected poems include pieces just as romantic dedicated to a variety of subjects: unnamed women, different women, Muses, boys, etc. The two Poliziano poems about the *Elektra* are separated in his collection by a four-line erotic poem addressed to an unnamed youth whose glances shoot fireworks into his heart. Alessandra's reply poem is also formulaic, saying that such a wise man's praise has brought her glory, but that Poliziano overestimates her, for he is as famous as Hercules, while she is still "learning my ABCs," her voice tiny before his greatness like a cat before an elephant; she ends by urging him to remain true to Athena.

Composing poetry like this was a common scholarly exercise, not courtship poetry but the well-established genre of laudatory love poetry, in which poets praise and celebrate a woman-as-Muse, as Catullus with Lesbia, Dante with Beatrice, and Petrarch with Laura, with no expectation of sex and even less of marriage.[91] Unlike in the nineteenth century when Tennyson and Elizabeth Barrett Browning published courtship poems, such as the iconic "How do I love thee, let me count the ways..." the Renaissance *did not* associate love poetry with marriage or courtship: marriages were business matters negotiated like contracts, while love

poetry was appropriate to distant Platonic admiration, or chivalric adulterous romance like Lancelot and Guinevere. A woman gained fame from being the subject of such poems, as Alessandra's maternal cousin Ginevra de' Benci gained from Lorenzo's poem—the only unusual element in Alessandra's case was that this time the Muse wrote back. This is not to say that being the subject of such poems would have had no emotional impact on a teenaged girl, and the letter from Cassandra Fedele shows Alessandra was thinking about marriage in 1492, but it is unlikely anyone considered Poliziano a serious suitor when Lorenzo was preparing to advance him toward a cardinalship, which precluded marriage. Nor do the few poems Poliziano addressed to Alessandra, which repeatedly stress chastity and untouchable purity, come near the passion with which he wrote of Pico daily.

These poems, like the *Elektra*, were part of Alessandra Scala's public debut, a hybrid debut as both an admired beauty and a serious scholar, since circulating learned poems or letters (which were meant to be circulated, not private) marked one's entrance into the community of *umanisti*. Alessandra's Venetian role model Cassandra Fedele had made her own debut by performing not a Greek play, but a Latin oration of her own composition in Padua in 1487, and had thereafter entered the community of scholars by exchanging Latin letters with Poliziano in 1491.[92]

In these same years, Poliziano and Marullo were amplifying one other's fame by quarreling in verse, as professional *umanisti* often did, and as Poliziano did again in 1494 with Alessandra's father Bartolomeo Scala, Poliziano criticizing Bartolomeo for his political ambition ("teetering on the summit"), and—more shockingly—claiming that he made a gender mistake in the ending he put on the word for mosquito in one of his Latin poems (unforgiveable!!!!).[93] Historians who interpret the poems about Alessandra as courtship poems often read Poliziano's quarrels with Marullo as evidence of romantic jealousy, but we have no evidence Marullo was courting Alessandra yet, and many a multi-decade scholarly feud stretched on with no such secondary cause. Participating in public exchanges, whether argumentative or friendly, was a major way Renaissance scholars earned fame, often leading to invitations to court, employment,

and teaching positions. What is distinctive in Alessandra's case is not that an exchange of poems happened, but that, because of her sex, she was cast in the role of admired Muse, rather than coequal interlocutor. As a result, the historical record amply describes her modest gestures and blonde tresses, but can't tell us which ancient authors she was reading. Alessandra writes back, in ways Dante's Beatrice or Petrarch's Laura do not, but she remains Muse in the interaction, not peer or scholar.

The question of Alessandra-as-Muse must be interrupted, as all things were interrupted, in 1494 with the French invasion and Savonarola's swelling power. Poliziano was right to say that Bartolomeo Scala was teetering on a summit, and when Piero the Unfortunate fell from power, many Medici partisans like Bartolomeo were arrested, fined, banished, tortured, and at least one hanged. Bartolomeo was one of the lucky ones; he appears to have absented himself from the Palazzo Vecchio right away (his handwriting disappears from documents) but he was not formally dismissed as chancellor until nearly two months into the regime change (it took some time to remove Medici people from power since the *Accoppiatori* in charge of putting names in the bag to draw were still the Medici-appointed ones, so the turnover took many steps).

Three days after being fired, Bartolomeo was hired back, but with a colleague closer to the new regime sharing the office, and with his salary reduced from 432 to 200 florins a year. In fact, most of the administrative staff, despite having risen through Medici favor, were hired back, likely because experience was indispensable in the tower whose leaders turned over every couple months. Bartolomeo was also still protected by patronage: do you remember those two estranged Medici cousins who sued Lorenzo over their inheritance? Bartolomeo's first job with the Medici had been as secretary to the elder one, Lorenzo di Pierfrancesco de Medici (who commissioned Botticelli's iconic *Venus*). Because these two Medici cousins had been banished by Piero and were clearly *not* his friends, they were allowed home in Savonarola's years, renouncing the Medici surname and adopting the name *il Popolano* (declaring themselves men of the *popolo*, not *ottimati!*), but retaining wealth and influence enough that

Bartolomeo wrote to them in his days of need, and their *grace* likely lubricated his transition.

Bartolomeo Scala may (we can't know) have liked some of Savonarola's changes, since he had always supported reform, and he quoted with approval Cosimo de Medici's criticisms of the more extreme Carnival festivities, but his writings about Savonarola are professional, not candid. Back in 1478, in the aftermath of the Pazzi Conspiracy, it had been Bartolomeo Scala whom the city called on to write the *Excusatio Florentinorum*, the city's official account of the failed coup, which integrated Montesecco's confession into a work designed to circulate, justifying the city's actions and requesting aid from friends. Eighteen years later in 1496, Bartolomeo was again called on to defend Florence's strangeness, writing his *Apologia contra vituperatores civitatis Florentiae* (*Defense Against the Critics of Florence*), which countered rumors that Florence or Savonarola were conspiring with the French (rumors were natural after Charles left the city in peace). The *Apologia* attempted to present the new regime as a restored republic, minimizing the role played by the troubling friar and his prophecies. It was as her father sat writing this work—with his salary and power both reduced—that twenty-one-year-old Alessandra married Marullo, five years after she had written to Cassandra Fedele for advice as she felt torn between the Muses and marriage.

Did having a poet for a husband let Alessandra enjoy both loves? Perhaps, but we're already being dragged into the romantic mystique if we associate love with the marriage at all; while the couple's shared literary interests must have helped the match, the decision to marry was shaped by the declining fortunes and health of Alessandra's father, who died within the year and must have worried about her financial future. The marriage was another result of patronage, since Marullo was, like Alessandra and her father, a client of those two estranged Medici cousins, Lorenzo and Giovanni di Pierfrancesco de Medici *i Popolani*, so the tie strengthened an established network.

As for what Alessandra's married life was like, remember what we learned from Alessandra Strozzi: being a wife was like managing a business, i.e. directing servants, looking after clients, negotiating with merchants, and organizing bulk supplies for year-round storage.

A letter by Isabella d'Este, anxious that the six pigs they have ready for slaughter are not enough to supply the household with prosciutto, salami, and lard through winter (plus two pigs already made into mortadella) and trying to decide the most economical solution, is typical of the kind of task which ate a married woman's time.[94] Alessandra Scala never published after her marriage, and we have no record of further scholarship. Much the same is true of Cassandra Fedele, who in 1499, after struggling financially, married physician Gianmaria Mappelli. *Wait, why was she struggling financially? Isn't the classicizing erudition of* umanisti *a ladder to wealth and power? Look at Poliziano! Look at Alessandra's dad! Couldn't Cassandra Fedele find work as a diplomat?* (no) *elite tutor?* (no) *university professor?* (no) *in a grammar school?* (no). *Does this lack of opportunities have to do with gender?* (hmm… could be). So, with failing finances, and health problems which make Fedele an exciting disability history study, she married, and we have no more writings until she was widowed. Choosing the Muses required maintaining one's fame through skilled letters, poems, and participation in learned gatherings, not a path compatible with managing a home/business.

Alessandra and Marullo had little time together in their married years. These were the days of loss and terror recorded by Machiavelli, and Marullo was a soldier as well as a poet. Alexander VI's efforts to create a Borgia kingdom re-endangered the towns and cities destabilized by Sixtus, so Marullo took up service with Giovanni di Pierfrancesco *il Popolano* and (when Giovanni died in 1498) with Giovanni's widow Caterina Sforza, the "Tigress of Forlì."[95]

Warrior-matron Caterina Sforza is even more of a legend than scholar-maiden Alessandra Scala—an illegitimate daughter of the (now long dead) tyrannical Duke Galeazzo Maria Visconti Sforza of Milan, and widow of Pope Sixtus's incompetent nephew Girolamo Riario (the Pazzi conspirator under whom Montesecco served). Caterina—for whom they coined the word *virago*, a warrior woman or Amazon—is perhaps best known for her actions upon Sixtus's death. She had been his Vatican hostess (managing the papal household required a woman to do the things wives did), and was super popular with the Roman people and papal troops, but she knew that, if the next pope wasn't a kinsman, he would appoint one of his own relatives to replace her husband

as commander of the papal armies. So Caterina, seven months pregnant at the time, took over the fortress of Castel Sant'Angelo (she just walked in and the men obeyed!) and aimed its cannons at the Sistine Chapel, threatening to blow up the cardinals inside unless they promised to secure her husband's position.

La virago Caterina had many more adventures, including the famous moment when enemy troops threatened her children and she bared her genitals up on her fortress walls, declaring: *Go ahead and kill them, I have the mold to make more!* Alessandra's husband Marullo was with Caterina serving in Forlì in 1499 when, resisting to the end, they were both captured by Cesare "Valentino" Borgia. We have no details about Marullo's release, but soon thereafter—1500, the sixth year of his marriage to Alessandra—he drowned attempting to cross a river in heavy rains in his rush to defend the town of Piombino from another Borgia assault. Widowed Alessandra Scala—still only twenty-five—entered the Benedictine nunnery of San Pier Maggiore in the eastern quarter of Florence, where she died in 1506.

Accounts will tell you that Alessandra entered the convent out of heartbreak at the death of her beloved, or because of the influence of Savonarola, and they always skip from there directly to her death, as if the cloister were a direct road to the grave. They do *not* remind you that retiring to a nunnery was a common path for widows, especially those who had no children to assist into careers and marriages. They do not remind you that Alessandra spent more years with the nuns than she did with Poliziano or Marullo, or that nunneries were rich centers of female intellectual life, discussing books, debating philosophy, even writing and performing plays. They do not point out that convents varied, and that this was an extraordinarily prestigious one, founded soon after 1000 CE, boasting masterpieces by Botticelli and Perugino, and open only to the most elite Florentine women, a seat of power for Florence's female oligarchs, and a ladder by which Alessandra could aid her brother and sisters' fortunes in the city. They do not mention San Pier Maggiore's signature ritual, that every new bishop of Florence had to ceremonially marry its abbess, and that negotiating this ceremony involved the abbess setting conditions, establishing the line between her (local) authority and the (usually foreign, papal-appointed) bishop's, and even a wedding

feast held by the abbess-bride's relatives which helped establish the relations between Florence's old families and the churchman suddenly entrusted with 1/5 of the power in the city. Alessandra Scala could have lived sixty years in San Pier Maggiore, studying with her sisters, corresponding with fellow *umanisti*, and exerting power in politics—the fact that she lived only six years there is not why her monastic life gets half a sentence in accounts and the three-year poetry exchange from 1491 to 1493 gets page on page on page.

People don't want to imagine Alessandra Scala as a nun.

Alessandra Scala is what we've been looking for, the Renaissance Woman of our dreams, of every era's dreams from Poliziano's to today's. She's brilliant, articulate, powerful, embodying ideals of scholarship and self-fashioning, and she's nearly a blank slate. We have the flowing golden tresses of romantic poems and Hollywood costume dramas, we have exciting heroes near her, poets, crusaders, and we have no record of her thoughts except one perfect aloof poem telling Poliziano to stay true to Athena, and the letter proving that this paragon was torn between scholarship and the marriage path, which imagination quickly labels *love*. She can be anything. In 1491 she can be Sappho; in 1925 she can be Juliet; in 1985 she can be a proto-feminist proving the brilliance of womankind.

That's why we have to be so careful with her. As Lisa Jardine points out, Alessandra Scala was not a major author; she merits only a brief entry in an encyclopedia of Renaissance humanists, but that isn't where discussions of her appear. They appear with those of Princess Ippolita Maria Visconti Sforza, Vittoria Colonna, and Caterina Sforza, with legends who supply the great Renaissance Woman to partner the great Renaissance Man. The nunnery has to be glossed over because (like Savonarola) our modernizing Renaissance can't take Alessandra Scala's years of Greek and Latin being overshadowed by years of so medieval-feeling a setting as a nunnery. The possibility of Alessandra Scala *enjoying* the convent grates against our X-Factors: self-fashioning, nationalism, secularization. We can't know if she enjoyed it. She may have fled to the convent devastated by true love cut short, or she may have felt liberated by this all-female intellectual life free from intruding suitors—both versions are imagination, and my interest in Alessandra's life inside San Pier Maggiore is just as influenced by feminist scholarship on nunneries[96]

as G. Pesenti in 1925 was influenced by rising nationalism when he characterized local hero Poliziano as Romeo and foreigner Marullo as Paris, whom Juliet could never really love. You know from meeting many Lorenzos and Savonarolas how much accounts can pick and choose, but with women the problem is amplified by how often we study them *because they're women*, focusing our inquiries on gendered issues—relationships, feelings, families, gowns, gems, combs—while the sources tell us more about Alessandra's hair than about her reading list, or her ideas.

Another asset that helps Alessandra Scala fit our dreams: we don't have any portraits so we can always imagine her ideal beauty. Why does that help? To this day there's very little scholarship in English about Beatrice of Naples Twice Queen of Hungary, and as recently as 2015 her Wikipedia page stated that Beatrice was so shrewish and obnoxious that she annoyed her mother-in-law Elizabeth Szilágyi (*c.*1410–83) to death, and when I traced the source it was a nineteenth-century art historian saying Beatrice *looks kind of chubby in her portrait bust* so she must have been annoying, an assumption stated as fact in print even though Beatrice was savvy and popular enough to get the people of Hungary to literally let her pick the king because they loved having her as queen so much![97] But Alessandra Scala, with no portrait, will always look perfect in the imagination's eye, pure glitter without a single flaw.

Alessandra Scala is the ideal Renaissance Woman for another, sadder reason too: her death at thirty-one doesn't make us face how much she couldn't do. She proves a woman could be a scholar in the Renaissance, then exits like a proper heroine, still young and glorious. Cassandra Fedele lived into her nineties, longer than Francesco Filelfo, but there was no professional path for a female *umanista*. Before her marriage she had been invited to the court of Isabella and Ferdinand of Spain, but politics (war) prevented the journey. In 1521, widowed, with her reputation stale and property lost in a shipwreck, she tried again to find work *(Diplomat? Tutor? Professor? Courtier?)* but couldn't find anything *(damnit gender!)* and eventually wrote to Pope Leo X (Medici pope), who didn't reply because he dropped dead, then to the next pope Paul III (Alessandro Farnese, 1468–1549) who offered her a job *(As a secretary? To write an epic? Tutor to the papal nieces?)* running an orphanage, a respectable

occupation for a widow, but not for a famous scholar. Maybe she enjoyed it, taught the little orphan girls Latin, we don't know, though we do know that grammar and rhetoric were the core of the *studia humanitatis*, and we have Bruni's advice that women should study "divinity and moral philosophy" but should be actively "ripped away" from trying to master geometry, arithmetic, astrology, or (sigh) rhetoric, which Bruni says is useless to a woman "who will never see the forum... so far is that from being the concern of a woman that, if she should gesture energetically with her arms as she spoke, and shout with violent emphasis, she would probably be thought mad and put under restraint. The contests of the forum, like those of warfare and battle, are the sphere of men."[98] Bruni was in his grave well before these women's births, but remember Poliziano praising Alessandra's careful, modest gestures on stage as Elektra, even when playing a woman whose public display of passion makes the play one long mad scene?

Cassandra Fedele did stand in Venice's forum one more time, in 1556, after her ninetieth birthday, when the woman, who in her twenties had been invited to address the Venetian Senate about education for women, was invited again to speak in public, to welcome visiting Queen Bona Maria Visconti Sforza of Poland (our Ippolita Maria's granddaughter). Doubtless the Most Serene Republic of Venice did not reveal to the famously scholarly queen how little they had supported their own Renaissance Woman when they rolled her out to prove they had one—we too often do the same.

Portraits of Queen Beatrice and King Matthias Corvinus, made in 1476 by Benedetto da Maiano, who also designed Palazzo Strozzi.

39

Raffaello Maffei il Volterrano:
A Scholar Fears for His Soul Too

Raffaello Maffei (1451–1522), called Volterrano, was a prolific scholar, translator, biographer, and author of a staggeringly ambitious and popular Latin encyclopedia of everything,[99] who worked at the Vatican through the wild papacies of Paul II (reclusive Venetian), Sixtus IV (Battle Pope!), Innocent VIII (King Log), Alexander VI (the very, very, very…), and Julius II (Battle Pope 2: the Wars Get Weirder!). He was a close friend of Marullo and of his wife Alessandra Scala. He was a witness to the fiercest persecution of scholars in his century, to the Pazzi Conspiracy, to the French army's entrance into Rome, to the 1503 looting of the papal palace, and went down in history as a minor figure nobody cares about or studies very much.[100]

We learn much about the myth of the Renaissance by visiting figures like Poliziano and Alessandra Scala who get magnified because they fit that myth, but we also learn from the other half, figures like Francesco Filelfo and Raffaello Maffei who don't make it into the canon, or the textbook, or the walking tour, because they aren't what people want to see when we moderns look back seeking the birthplace of modernity.

Why did Raffaello Maffei drift into obscurity? I think there are four reasons, and the range is telling in itself:

1. He was extremely super pious. Not in a dramatic, firebrand reformer way like Savonarola, but in a quiet, traditional, good Catholic way that's just no fun.
2. He criticized Pomponio Leto, and we like Pomponio Leto.

3. He was criticized by Erasmus, and we *love* Erasmus.
4. The formats and apparent topics of his works are actively off-putting to anyone looking for the innovations of a Renaissance golden age.

These are posthumous issues of Maffei's legacy, and as we review our obscure scholar and his interesting times, you know enough about Renaissances by now to spot the little details which will make the difference between being celebrated like Poliziano, or neglected.

And now: *Working at the Vatican c.1500, aka Raffaello Maffei's terrible, horrible, no good, very bad four and a half decades.*

The Maffei family came from Volterra, a small Tuscan town near Florence, so Raffaello is also known by the classicizing name il Volterrano (the dude from Volterra), like the place-based nicknames Aretino (dude from Arezzo), Poliziano (dude from *Mons Politianus*, i.e. Montepulciano), and indeed Cesare Borgia's nickname Valentino (since he was Archbishop of Valencia). Raffaello's father Gherardo Maffei (1408–66) was born in the same year as Alessandra Strozzi, married a good Volterran girl, Lucia di Giovanni Seghieri, and moved to Rome by the 1430s to pursue a career as a Vatican bureaucrat. Gherardo rose steadily under a string of colorful popes, earlier ones we haven't talked about yet: Eugene IV (who struggled with the aftermath of the schism, and the Visconti Viper of Milan), Nicholas V (who started rebuilding Rome and founded the Vatican Library), Callixtus III (the first Borgia pope), then Pius II (awesome *umanista*, scholar, and pornographer who left an epic tell-all papal memoir) who made Gherardo a law professor and papal secretary. For a small town like Volterra, having a native son gain the ear of popes and cardinals was a great asset, so Gherardo was a prominent figure in Volterra, advancing the city's interests as he traveled between his birthplace and the papal seat. It was in the reign of Paul II (the reclusive Venetian anti-Latin pope who preceded Sixtus) that Gherardo died.

Gherardo's four sons were likely born in Rome but identified as Volterran (just as Petrarch identified as Florentine and Marullo as Greek). This made the family part of the 80 percent of Rome's

population which was not Roman. One brother died young, but the others, Antonio, Raffaello, and Mario, followed their father into papal service. The youngest, Mario, became a priest (ideal for advancing at the Vatican), while the eldest, Antonio, married to continue the family, and Raffaello in the middle kept both options open at first; you never know which a family will need more of, grandkids or fat clerical paychecks.

Mario and Raffaello (and probably Antonio but we know less about Antonio for *reasons*) loved scholarship, and Raffaello mastered Greek enough to exchange letters in ancient Greek with Poliziano. As a teenager, he attended at least one of the classicizing celebrations of the festival of Romulus—the legendary founder of Rome—held by the Roman Academy, a circle of *umanisti* led by the brilliant philologist Pomponio Leto (1428–98). Leto (the one whose sentences I send to Latin teacher friends to punish troublemakers) was the star student of one of the most renowned master linguists the *studia humanitatis* ever produced, Lorenzo Valla (1407-57),[101] and like his teacher applied himself intensely to the project of reconstructing classical Latin and grammar.* Leto's Roman Academy produced corrected texts, commentaries, print editions, and was also Renaissance neoclassicism at its most revivalist: staging plays, celebrating ancient (pagan) holidays, reenacting Roman (pagan) ceremonies, and giving each other Greek and Latin (pagan) names, while Pomponio Leto, as leader, was addressed as *Pontifex Maximus*, the title of ancient Rome's high priest.[102] In 1466 Leto, while in Venice on his way east to study Greek, was arrested and prosecuted for sodomy

* Leto's teacher Lorenzo Valla is best known today proving that the *Donation of Constantine* (the document on which the papacy based its claims to Earthly power) was a fake, making him popular with later Protestants, but this student of history-slicing Bruni and Constantinople-visiting Aurispa was famous well before that, for his work on Aristotle, his shocking claim that Quintilian wrote better Latin than Cicero, his long scholarly feud with book-hunting Poggio, and for using linguistic mastery to refine the darts Petrarch had slung at the scholastics into a veritable nuclear missile. He was also famously quarrelsome; just as one can flip Poliziano's letters open and put one's finger down at random to—nine times out of ten—find effulgent praise, flip Valla's open and just as consistently you'll find him Oscar the Grouching at someone.

and seducing his students, and in Rome in 1468 the antisocial and anti-scholarly Pope Paul II (the reclusive Venetian) rounded up key members of Leto's academy, charged them with heresy and conspiring to murder him, and had them tortured. Leto was extradited from Venice to the papal prison. Raffaello—barely seventeen—was *not* arrested, but the mass prosecution of the more pro-pagan members of his scholarly world had a lingering impact, and his later comments on Leto and the incident would come to dominate his posthumous legacy.

Next came 1472, the sack of Volterra. This was the incident with the alum mine, when Lorenzo de Medici hired his mercenary godfather Federico de Montefeltro to intimidate the town, and intimidation turned to pillage. The Maffei brothers were in Rome, but certainly lost friends, allies, probably property, and saw the sovereignty of their homeland shattered; Volterra henceforth was a Florentine dominion. Gherardo was dead at this point, and young Mario likely still living with his mom and granddad, while Raffaello lived with Antonio in a house near the Pantheon in Rome, which contained a printing press where they printed books for use by papal secretaries.

Antonio Maffei is often misidentified as a priest because he held Church offices, but he had married Caterina Cortesi, a daughter of another family prominent in the Vatican bureaucracy. Her family had ties to one of the most powerful patronage networks in Rome: the della Rovere and Riario network, newly empowered by the election of Sixtus IV (the Battle Pope rises). The della Rovere faction recruited Antonio to join the Pazzi Conspiracy, tapping into his resentment over the sack of Volterra. Thus in 1478 when Raffaello was twenty-seven, Antonio was one of the men who pulled out a dagger during communion, landed a non-lethal blow on Lorenzo de Medici's throat, and was prevented from finishing off his victim by Poliziano leaping in between. Antonio managed to hide out for a few days but was captured, maimed, and hanged, leaving his widow Caterina with two young children and a third on the way; if our descriptions are complete, Antonio was not considered important enough for his corpse to appear in Botticelli's gruesome fresco of the executed conspirators (which is one piece of art we know Savonarola *did* destroy).

In the aftermath of the attack, Florence's vengeance extended beyond the assassins to their families and associates in and beyond Florence—one of the fleeing conspirators made it as far as Constantinople, but was caught and sent back by the Ottoman Sultan, such was the reach of Medici power. Yet Raffaello, despite his brother's direct involvement, was not only spared but received a letter of consolation from Lorenzo about his brother's death. The letter was so elegant that, Raffaello later wrote, he at first mistook it for Poliziano. This comment, made years later in Raffaello's account of the Pazzi mess in his encyclopedia entry on Florence, confirms that, by the year of the conspiracy, he was already a correspondent of Poliziano and other Florentine *umanisti*, and important enough in Rome for Lorenzo to write to him during the crisis, though whether Lorenzo valued Raffaello's scholarship and friendship or his influence at the Vatican depends on which Lorenzo you believe in. (Did Raffaello really mistake Lorenzo's letter for Poliziano or was the comment flattery? This depends on which Raffaello you believe in.)

Over the next few years, 1478–80, as Lorenzo made his dramatic trip to Naples while the post-Pazzi tensions threatened the Peace of Lodi, Raffaello made his only voyage outside Italy, taking service with Cardinal Giovanni d'Aragona of Naples (1456–85), a younger brother of Princess Ippolita Maria's husband Crown Prince Alfonso of Naples. Raffaello accompanied his new patron to Hungary to visit the cardinal's no-longer-little little sister Queen Beatrice and her husband Matthias Corvinus the Raven King. Raffaello's visit would certainly have been welcome to the king and queen with their strong interests in scholarship and library-building, but things were likely tense, since five years of marriage had produced no heirs, and Matthias had just begun to promote his illegitimate son by a mistress, not a good step for the Naples-Hungary alliance. During this visit, Raffaello also experienced the fears and pressures of the Ottoman expansionist threat to Hungary, which he would later discuss in his encyclopedia. And while there, he certainly saw buildings and objects in a familiar Tuscan style, created by our woodworker friend Manetto Amanatini or his apprentices—Amanatini had died there roughly twenty-five years before.

Returning to Italy in 1480, Raffaello rejoined his younger brother Mario working at the Vatican during the last years of Sixtus's reign, then under Innocent VIII (King Log). In 1485, Pope Innocent and the della Rovere launched the Conspiracy of the Barons against Naples, and the same year Raffaello's patron Cardinal Giovanni of Naples died (part of a fever epidemic in Rome). Even with the cardinal's death, Raffaello was now in the difficult position of having ties to two opposed patronage networks: Pope Innocent and the della Rovere one side of the war and Naples and Tuscany on the other (united by the fact that both the Medici and the heirs of Naples had Orsini blood). In this dangerous period, Raffaello began donating money to rebuild a community of Poor Clares in Volterra (the nun branch paralleling the Franciscans), and considered becoming a Franciscan, but decided against it, a moment which previews the spiritual focus of his later life and writings. Even monastic life could not be a fully apolitical decision at the time, since the della Rovere faction was deeply tied to the Franciscans (both Battle Popes were Franciscans), and Naples had strong ties to the Spanish-supported Dominicans (Cardinal Carafa of Naples, leader of the Dominicans, was a blood relative of Saint Thomas Aquinas, hence commissioning that fresco of Saint Thomas interrupting the Annunciation to introduce him to the Virgin Mary).[103]

Instead of joining the Franciscans, Raffaello married Tita di Bartolomeo Minucci, a Volterran woman of good family (a choice very unlike his brother's marriage to a Vatican curial family in the della Rovere network). She remained permanently in Volterra, raising their daughter Lucilla (there was also a short-lived son) as Raffaello continued to work in Rome, but he increasingly spent time in Volterra, especially after the death of his sometimes-patron Cardinal Giovanni of Naples. Raffaello's decision to marry is usually attributed to a sense of duty to continue the Maffei line after his elder brother's death, and he never lived with his wife for any length of time—in fact Antonio had left three children, but Raffaello's daughter Lucilla and her husband Paolo del Bava Riccobaldi (another Vatican bureaucrat) became the Maffei family's eventual inheritors. Raffaello continued to exchange learned letters in Latin and Greek with prominent *umanisti*, demonstrating a rare ability to maintain friendships even when

rivalries erupted between friends, as happened with Poliziano and Marullo.

What more adventures had our scholar still to face? First 1492: the death of Lorenzo, and the election of Alexander VI. The Borgia pope rapidly transformed the Vatican and Rome, replacing della Rovere loyalists with his own allies, and working to break the strength of the city's great families, the Colonna and (despite an earlier marriage alliance) the Orsini too. Before his election, Rodrigo Borgia had long been Vice-Chancellor of the Church, an administrative position which made him a familiar figure to functionaries like the Maffei brothers, whose careers were thus secure under his rule, but Raffaello later described Borgia's papacy as an even worse stage of the degeneration which, in his account, began with Paul II (the reclusive, anti-Latin Venetian) who had opened the gates to decay by caring less about the faith than he did about palaces, art collecting, and his diamond-covered hat.

Pope Alexander immediately made twelve of his cronies new cardinals—*twelve!*—and quickly promoted his illegitimate children. Papal bastards were nothing new—for functionaries like the Maffei brothers and their colleague Choir Director Josquin des Prez, Pope Innocent's son Franceschetto Cybo (*c*.1450–1519) had been a constant presence (and annoyance), a vain, useless, entitled prince who, at one point, tried to rob his father's papal treasury to pay his gambling debts (he once lost 40,000 ducats in a single night! $40 million!). Innocent had nonetheless made his son Count of the Lateran Palace, and the youth married Lorenzo's second daughter Maddalena de Medici (1473–1528), with a dowry of 4,000 ($4 million), Lorenzo's bribe to Innocent in exchange for making his son young Giovanni "Leo" de Medici a cardinal.

But Pope Alexander's children were different from selfish and irresponsible Cybo. Juan/Giovanni (made a duke and a commander of the papal armies), Cèsar/Cesare (made a cardinal), and Lucrezia (married to powerful husbands) were all ambitious, active political minds in themselves, partners of Alexander's plans as Sixtus's nephews had been to his.

Alexander also brought another partner with him to the Vatican: his new mistress, the brilliant, legendary beauty Giulia

"*la bella*" Farnese (1474–1524) who, like a wife, openly joined in administering the Vatican and Borgia patronage network. She even bore Alexander a daughter—Laura—*during his papacy!* Giulia's ties to the powerful Roman Farnese family strengthened the Borgias' position in the city. (I'm sorry I don't have a more dignified simile, but if Rome's great rival houses, the Orsini and Colonna, are Coke vs. Pepsi, we can compare the Farnese at this time to Snapple, not in their league but a behemoth in its way.)

Two apocalyptic horsemen came in 1494, first plague in Rome, then war on a scale unmatched in recent memory: the French Invasion. In Rome, these were days of terror, as news rushed in day by day telling Raffaello of French victories in Genoa, of the death of Poliziano, of the sack and massacre of the fortress town Mordano, of the death of Pico, of the Medici expulsion from Florence, and of Savonarola's intervention with King Charles which, while a joyous day for Florence, meant the mighty city would not slow the French approach to Rome. King Charles brought, not only troops and cannons to the holy city, but his ally Giuliano della Rovere, whom rumors said Charles planned to place on Saint Peter's Throne by force, so Raffaello and Mario must have spent harrowing nights wondering what the overthrow of a pope would mean for his staff, especially given their mixed ties to Naples, Florence, and the della Rovere via Antonio's participation in the Pazzi Conspiracy. Pope Alexander's willingness to hand Naples to Charles saved Rome from the French, but the wars in Italy and state of fear in Rome continued, as the Borgia faction worked to battle and suppress those who opposed them, in and beyond Rome.

Now, June 14, 1497: The pope's beloved son and heir Juan Borgia (I'm using his Spanish name because there are *too many Giovannis!*) was found dead, floating in the Tiber, with his throat slit, nine stab wounds, and plenty of gold in his purse. One of history's most thrilling murder mysteries (top suspects include the Orsini, Colonna, Visconti Sforza, many angry Romans, and both of Juan's brothers), this crisis triggered a new phase of Borgia expansion efforts as Alexander's other son Cesare "Valentino" Borgia became the family's war leader at last. Cesare renounced his cardinalship (the first ever to do so), married a French

princess, received the title Duke of Valentinois (chosen by the French king half humorously, since it made the ex-Archbishop of Valencia doubly "Valentino"), and, now with French armies at his back, continued carving out a Borgia kingdom, seizing city after city. The day in 1496 when an (accidental?) explosion in the papal fortress of Castel Sant'Angelo thundered through the Maffei brothers' offices likely still felt like a slow news day.

More personally uncomfortable for Raffaello in the same period must have been Borgia's promotion of one of his few scholarly enemies, Annius of Viterbo (1437–1502). Annius is a fascinating figure, a Dominican scholar and *umanista* who forged ancient documents and faked archaeological sites, invented an Etruscan language, and used it all to advance a false history of the ancient world, in which his hometown of Viterbo was the true center instead of Rome. When Annius published this in his *Antiquities* in 1498, Raffaello immediately denounced it as a forgery, but many were deceived, and it was this charlatan whom Borgia chose as Master of the Sacred Palace—the pope's theologian and most influential theological authority in the Church. Raffaello—now answering to a charlatan!—started spending more time in Volterra, away from Rome, and his home there became a frequent stop for *umanisti*. Thus, it was in Volterra in April 1500 that Raffaello tried but failed to persuade his soldier-poet friend Marullo *not* to ride out in heavy rains to battle Cesare Borgia, just before Marullo's tragic drowning which widowed Alessandra Scala.

August 12, 1503: Pope Alexander and Cesare Borgia both fell ill, and Alexander died six days later, while Duke Valentino faced a slow recovery. The Roman mob traditionally celebrated the turnover of popes with rioting and looting, especially emptying the former residence of the newly elected pope who would no longer need his earthly goods, but this time was different. The whole Vatican Palace was ransacked, the papal treasures carried off by Borgia forces, palace staff, and general riot. So thorough was the sack that Pope Alexander's corpse was later found wrapped in a carpet, without a stick of furniture remaining, since Borgia servants, terrified of grim days coming, had grabbed everything of value they could lift. Raffaello's later history of the popes vividly

described Alexander's blackened, swollen corpse as it was laid out on the steps, clearly interpreting the body's state as evidence of wickedness, the opposite of the incorruptibility and odor of sanctity which was supposed to mark the bodies of dead saints.

Raffaello also describes a universal sense of hope when he, Mario, and all in Rome heard that, with Cesare Borgia still greatly weakened from sharing the meal that killed his father, and the Borgia and della Rovere factions in stalemate, the College of Cardinals had elected a compromise pope, Francesco Todeschini Piccolomini, now Pius III (1439–1503). This was a nephew of the brilliant and learned Scholar-Pope Pius II, who had promoted the Maffeis' father Gherardo, and whom Raffaello later celebrated in his lives of the popes as the last of the golden age before Rome's degeneration (also the pope who was greeted by a plagiarized version of one of his own obedience orations). But Cesare Borgia recovered, remaining strong enough to force Pope Pius to reconfirm him as commander of the papal armies, and Raffaello describes Duke Valentino rampaging through the Vatican Palace slaughtering Orsini allies who attempted to take revenge for the Borgia tyranny.

After less than a month, Scholar-Pope 2 died, "to the grief of all good men," says Raffaello.

The *second* papal election of 1503. Again the two surviving Maffei brothers held their breaths. Again the stalemate, Borgia vs. della Rovere. When the white smoke rose, Giuliano della Rovere didn't even change his name, so after conquering Alexander and our brief breath of pious Pius came another emperor, Pope Julius II (Battle Pope 2: It's Time). The news broke before the details behind it: the factions had allied, Julius promising Cesare Valentino Borgia that he could keep his offices, his conquered kingdom, his command of the papal armies, and that the two together would make both Rome's lands and the Borgia Kingdom mighty states to stand for generations. Within days, Julius broke his word, stripped Valentino of his titles, and over the next months chased him from his lands, dissolved the Borgia conquests, brought a breath of precious peace... and immediately set about reconquering the lot of it, inviting all the powers of Europe to join him in subduing his old enemies in this new war.

Like his uncle Sixtus IV, Julius II feels one way if we study Rome first, seeing all his splendid art (the Sistine Chapel ceiling, Raphael's *School of Athens*), but feels very different if we read Raffaello's later account.[104] Julius spent lavishly on construction, antiquities, and hired many *umanisti*, but when Michelangelo asked what book His Holiness wanted to be holding in his portrait statue, Julius answered, "Give me a sword, I'm no scholar." Julius also famously said he had no Latin, which—from a man trained in Latin-based scholastic classrooms, who spent hours at mass reciting Latin texts—doesn't actually mean no Latin, it means I'll pay the bills, and you should keep starting your books with dedications about how wonderful I am, but *don't expect me to actually read the damned book! And no, I don't want to discuss participles with you, go away!*

In 1506—three years into Julius's reign—Raffaello made him the dedicatee of his masterwork, the encyclopedic *Commentaria Urbana*, a massively ambitious compilation of histories, biographies, even science, which would be reprinted for a full century, and excerpted and reused far beyond that. The encyclopedia's dedicatory address to Pope Julius expresses Raffaello's hopes that the new pope chosen by Providence might bring healing to Rome, and that, by enumerating not only good things but also wicked ones, the encyclopedia's examples could demonstrate the moral dangers a ruler should avoid as well as virtues to follow. Within the year, Raffaello left Rome, moving permanently to Volterra with a bitterness encapsulated by his later comment that Julius II was a man who did not even bother to read the titles of books dedicated to him.

Raffaello's writings during his final fifteen years in Volterra show that Julius's ingratitude on receiving the *Commentaria Urbana* was merely the last straw that broke a weary camel's back. Raffaello had grown terrified for his soul in the sea of corruption around the Vatican. His entries on popes in the *Commentaria Urbana* already show his disgust, but while in Vatican service he had written cautiously—now he could write more freely of the papacy's degeneration and the need for the restoration of the Church. In Volterra, Raffaello continued to host visiting *umanisti*, established a school where he taught the *studia humanitatis* to

local youths, helped with the refurbishment of the city cathedral, and paid for the reconstruction of a grand church for the community of nuns he had been supporting for twenty years. Papal service paid well, and giving so much to a holy order was certainly a mix of charity and stinging conscience after years of profitable complicity with Vatican corruption. Raffaello also separated from his wife Tita (it looks like mutual consent) to live as a Servite monk (one of the orders *least* entangled with high politics at the time), devoting himself to scholarship while Tita administered the family.

In these years, Raffaello translated Homer, Xenophon, Procopius, Saint John of Damascus, and Saint Andrew of Crete, wrote a theological treatise *De Institutione Christiana*, and edited and published a major edition of the works of Saint Basil the Great, pursuing classical and religious scholarship as one united undertaking centered on virtue and the soul. He also wrote of his feelings of guilt living in tranquility as his surviving brother Mario remained at the soul-snaring Vatican, earning money for the family. Nor should we forget that, during these years, Julius II's chaotic wars to expand the Papal States were raging across Italy. The Medici had remained in exile since Savonarola's rise, leaving Florence a republic, but now they aided Pope Julius (old enemies united by the chance of wartime gain) in return for papal troops, which in 1512 seized Florence, restoring Medici rule over the city and her dominions, including Volterra.

In 1513, Raffaello, like many scholars, was cheered by the death of Julius II and the election of Lorenzo de Medici's second son Giovanni "Leo" de Medici as Pope Leo X (1475–1521). This new pope loved Latin and Greek, was raised by Poliziano, and was shaped by a father who had promoted scholarship, peace, and written in sympathy to Raffaello about Antonio's death even when Lorenzo's neck was still bandaged from Antonio's knife (though whether out of sincere sympathy or calculated strategy depends on which Lorenzo you believe in). Leo X was the dedicatee of some of Raffaello's last and most hopeful theological works, and Raffaello wrote biographies of Julius and Leo, criticizing Julius for ignoring piety and scholarship in favor of politics and war, while praising Leo's generosity and clemency, though criticizing

(carefully—this pope was still alive) his spending, and his wars. Leo, like every pope since Sixtus, attempted *yet again* to use the instabilities of central Italy to expand the Papal States and secure noble titles for his relatives.

In 1517, crisis came anew, in two ways. The local crisis was a plot to assassinate Pope Leo, led by della Rovere faction members and other familiar suspects. The more distant crisis was a certain Martin Luther up in Germany. Between 1517 and 1520, as Luther's criticisms of the Church disseminated, Raffaello composed *Nasi Romani in Martinum Lutherum Apologeticus*, a peculiar work in which, speaking as the Nose of Rome, he defends against what he sees as Luther's dual attack on the inseparable classical and Christian traditions. Raffaello is reported to have died with the odor of sanctity that marks the deaths of saints, and his brother Mario built him a splendid tomb, and led a campaign to have him canonized.

Raffaello Maffei lived through and chronicled all these exciting crises, yet the first time I mentioned to someone in the History Lab that I was thinking of working on Maffei, I got the answer, "Isn't that the guy who picked on Pomponio Leto?" So let's look again at the four things I think made Raffaello unpopular:

1. He was super pious, in a quiet, traditional, no fun kind of way.
2. He criticized Pomponio Leto.
3. He was criticized by Erasmus.
4. The formats and apparent topics of his works are off-putting to anyone looking for a golden age.

The pious part you've seen: Raffaello's monastic inclination, his theological works, his mix of Church Fathers with pagan authors. Raffaello's writings echo many of those (less fun) patches of Petrarch, in which he fears it might be sinful loving Cicero too much, and imitate religious works like Petrarch's *Secretum* on Augustine and Boethius. For those who want the Renaissance to be the cradle of secularization, piety marks Raffaello as an outlier or adversary, just as Filelfo's ducal service excludes him from proto-democratic Renaissances, even though both piety and serving monarchy are anything but outlier activities if we tally up what

portion of Renaissance scholars did them. Nor could Raffaello's piety make him popular in the Reformation, as Savonarola's did, because he lived late enough to attack Luther and (mildly and carefully) defend tradition and Rome, nor could the Counter-Reformation make much use of someone who criticized the popes so much. One bad biography of Raffaello was published in 1722, a propagandistic work by Bishop Benedetto Falconcini, who was from Volterra and lobbying for the canonization of his hometown hero in a way which exaggerated all the pious characteristics later historians were *not* interested in, muddying the waters more.

As for "Isn't he the guy who picked on Pomponio Leto?" Raffaello did criticize Leto: his encyclopedia includes short entries on contemporary scholars as well as popes and ancients, and almost all the scholarly entries are positive, but in Leto's entry Maffei stressed that Leto was "ignorant of Greek" (Raffaello doesn't stress this weakness in anyone *else*, just Leto), that he reveled in ostentatiously showing off whatever archaic or bizarre Latin he ran across, and that his ceremony for the birthday of Romulus was "the beginning of abolishing the Christian faith."

Now, the arrest of Leto and his academy was the showiest persecution of classical study in the period, with the oppression of homosexuality and religious freethought mixed in, so history's sympathies are justly with Leto. This makes Raffaello's criticisms come across as an endorsement of oppression. In fact, Raffaello didn't praise Leto's arrest, and he criticized Pope Paul far more fiercely than he criticized Leto, calling Paul the root of the whole era's degeneration. He was also correct that Leto's religious attitudes were radically heterodox, and this is the Leto whose monster sentences are cruel enough to punish Latin students with.[105] Yet, however accurate Raffaello's criticisms of Leto, our Volterran was not on the radical, fun, classical reenactment side of the split among Rome's *umanisti*, a fact which has not endeared him to posterity.

Erasmus did not come up in my account of Raffaello Maffei's life, so why is he involved? Because Erasmus (1466–1536) wrote a life of Saint Jerome in which he criticized the entry on Jerome in Maffei's *Commentaria Urbana*, and he also corrected some errors in Maffei's translation of Basil the Great. *Yes, but weren't*

umanisti *constantly criticizing each other like that? Poliziano criticizing Bartolomeo Scala's mistake with the gender of mosquito was a reputation-making quarrel, and both Poliziano and Scala are still celebrated.* That's all true, but there's a difference between a quibble about one ending and an accusation of multiple mistranslations, and being criticized by Poliziano is a very different thing from being criticized by Erasmus "Prince of Humanists," the one scholar in all history so universally loved that the European Union could agree to name its scholarship fund after him (not Plato, Cicero, Galileo, Kant, Hume, or Voltaire—Erasmus).[106]

Excluding Machiavelli for the moment (his case is special), Erasmus's influence is an order of magnitude above other Renaissance figures: a staggeringly prolific author, editor, and stylist, loved for his wit, his piety, his humaneness, his handbooks of eloquence, his encyclopedic knowledge of the classics, whose publications in the later 1500s comprised as much as 30 percent of all books being printed! Even when Erasmus's efforts to reconcile Luther with the papacy made both sides feel obliged to formally condemn him, both sides still loved this frenemy, and the Inquisition still let Catholics teach and read his works, all you had to do was ritually cross out his name on the title page. His scholarship is masterful, his corpus vast, but the experience that helped me really understand why Erasmus's impact was so special happened a few years ago, during an exhausting afternoon at my desk, slogging through a pile of *extremely repetitive* publishers' prefaces from sixteenth-century classroom editions of Epictetus. I was tired, feeling my ability to parse the Latin fading minute by minute, when suddenly one of the prefaces was clear, smooth, easy to read, neither simple nor ornate, just lovely, elegant, and inviting, like stepping out into a breezy courtyard after a stuffy room. I cried aloud, "This is gorgeous! Who... oh, it's Erasmus." So when this Prince of Humanists said that Raffaello Maffei made mistakes in his scholarship, that criticism had an order of magnitude more reach than Maffei's works ever did, and for centuries people were far more likely to know Raffaello Maffei as *that man who made Greek mistakes* than they were to ever lay eyes on his work.

Finally, Raffaello's works are hard to fit into any Renaissance. It's not just that they don't feel modern, individualistic, secular,

democratic, etc., it's that, on the surface, they don't even look like part of Petrarch's call to heal the world. An encyclopedia is just a list of information, not a moral project, and by its very nature it quickly grows out of date. Most libraries don't keep old copies of *Encyclopedia Britannica*. The very structure of the *Commentaria Urbana* disguises the fact that there's more to it than a list of facts about 1506. We do not expect a section called "geography" (yawn) to contain micro-histories of the tumults of the Italian Wars, the entries on ancient philosophers to lay out a case for the importance of neglected female philosophers of antiquity (is he thinking of Alessandra Scala?), or the entries on popes to outline a moral history commenting on Bruni's, subdividing history again into a good antiquity, bad Middle Ages, good early Renaissance, and then a new degeneration starting with Paul II in 1464. Raffaello Maffei's *Commentaria Urbana* is, like Machiavelli's *Decennale*, part of an amazing moment just after 1500 when our long Renaissance reflected on itself, no longer asking whether it could make a golden age but evaluating whether that golden age had ended, and asking what factors had made Italy (as Ercole Bentivoglio said to Machiavelli) lose so much so quickly. Buried in an encyclopedia, these innovations are nearly invisible.

Raffaello Maffei and other *umanisti* weren't writing for our Penguin paperbacks, and many of their most sophisticated arguments don't come in clear treatises that lay out what they think. There is no treatise where Petrarch lays out his project. A huge portion of the innovative work of *umanisti* happened in formats we today find difficult or alien: in funeral orations, exchanges of letters, Socratic dialogs, aphorism collections, classroom works composed for princes and princesses, encyclopedias, and especially in commentaries on classics, which claim on the front page that they're just elaborating Vergil yet hide radical new ideas within. We look to treatises, not commentaries, for innovation, yet the most radical psychological theories of the 1400s were in Ficino's Plato commentaries, Machiavelli's utilitarian ethics disseminated via footnotes in Spanish editions of Seneca, debates over Aristotle vs. Galileo raged in the marginal notes of Lucretius editions, and (I'm not kidding) the roots of deism and atheism spread in those tedious editors' prefaces to Epictetus that I was slogging through.[107]

This age cared more about ancients than moderns, so a scholar got more attention pointing out something in Vergil than saying something new—this is why Machiavelli's book of republican government is *Discourses on Livy*, why so much of Erasmus's work was editing classics, and even why Annius of Viterbo expressed his innovative history by forging fake ancient works.

We look to the Renaissance for geniuses, originality, and in art it's visible, but Renaissance authors bent over backwards to pretend their innovations weren't new, so when, centuries later, historians opened a book which says "this is just a commentary on Seneca"[108] or "this is an encyclopedia of geography drawn from ancient texts," it's perfectly natural to be duped into thinking we won't find innovation there.[109] The *Commentaria Urbana* doesn't *look* like a place you'd find innovative political theory, or a narrative of the Renaissance's rise and fall, and it doesn't make an easy paperback. In the centuries after 1700, the works by Renaissance *umanisti* that *do* resemble treatises, things like *The Prince*, or Pico's (not) *Oration* (not) *on the Dignity of Man*, came to dominate efforts to understand the Renaissance, but these were wildly atypical of Renaissance writing. Even if you're looking for something that hasn't been studied as much, you're much more likely to pick up Manetti's slim and alluring *On Human Worth and Excellence* or Pietro Bembo's two-volume *History of Venice* than Maffei's unwieldy *Commentaria*, with its misleading sections "Geography" (secretly history), "Philology" (secretly science and Aristotle) and "Anthropology" (everything else).

It's taken several generations of the History Lab for scholars like, in Raffaello Maffei's case, John D'Amico and Alison Frazier to start reading oddball works like his as we strive to repopulate a Renaissance we didn't realize had been thinned down to *atypical* works—thinned both by how X-Factor hunting shaped inclusions and exclusions, and by the fact that *umanisti actively lie about what their books are about!* As for our friend Raffaello, it's easy to understand why he spent so long on historians' *don't bother* list, but the fact that someone so fascinating was waiting unexamined in the wings shows how much small things, like a quarrel between scholars 400 years ago, could be the butterfly flapping its wings that makes, not rain or shine, but prominence or obscurity, which in turn shaped our constructed Renaissances.

40

Lucrezia Borgia: Princess of Nowhere

Thus far the Borgias have been an enemy, a shadow, danger, a sudden rising mire of war, murder, and sin that made even Battle Popes feel like a lesser evil. Time for the other side.

*

You are **Lucrezia Borgia (1480–1519).** You had the best of educations: the *studia humanitatis*, Latin, Greek, music; you're fluent in Italian, Spanish, Catalan/Valencian, and French. You can compose poetry in multiple languages, and by age twelve you knew the histories, leaders, and dynastic tangles of all European and Mediterranean powers inside out. You were born near Rome, raised in Rome, and will know no home but Rome and Italy, yet you are forever a foreigner, your family immigrants from distant Aragon which you will never see, and if you did the people there would call you foreign too. You are a Princess of Nowhere. You will die before your fortieth birthday, yet live long enough to see your brothers fall, their deeds unravel, and your family crest effaced from every surface Roman mobs can reach. Centuries from now actresses will sing your griefs in art forms not yet invented, and historians who peel back the façade of femme fatale will conclude that, in fact, you did very well.[110]

Your family comes from Valencia, high nobles of Aragon, the Eastern half of still-uniting Spain. Your great-uncle, churchman-diplomat Alfons de Borja (1378–1458), came to Italy to work with and for King Alfonso the Magnanimous when Alfonso, already King of Aragon, seized Naples too. He tutored King Alfonso's heir Ferrante, and was made a cardinal in 1444 as a reward for

reconciling King Alfonso with Pope Eugene IV. In 1455 he was himself elected Pope Callixtus III, on the merit that he was bedridden and likely to die soon, and Rome's factions were in a deadlock, so wanted a compromise candidate to buy time without favoring any faction.

Your great-uncle Callixtus spent his papacy failing to organize a crusade to retake Constantinople, and promoting his young relatives, including his sister's son, your father Rodrigo Borgia, whom Callixtus made a cardinal and Vice-Chancellor of the Church, overseer of papal finances. Your father proved such a skilled administrator that he was kept in that tedious but important office by Pius II (Scholar-Pope), Paul II (reclusive Venetian), Sixtus IV (Battle Pope!), and Innocent VIII (King Log), even though at Innocent's election your father, with Spain's backing, had been a serious rival for the papal throne. You were barely four years old at Pope Innocent's election—if you remember anything it would be a rush of bodies, crates, and furniture, the first of many times you saw the Borgia treasures packed away in case of looting, Rome's strange custom to celebrate the turnover of popes.

Your mother was Vanozza dei Cattanei (1442–1518), probably the daughter of an obscure artist from Brescia who came to Rome to work during the boom of cardinals and ambassadors building new palaces. Savvy and entrepreneurial Vanozza used the wealth she gained from lovers and her first husband (dead before your birth) to purchase several profitable inns. But you did not live with your mother even as a tiny child; in your era no self-respecting father would leave his children with the kind of woman who'd have children out of wedlock! (The fact that Julius II let his mistress Lucrezia Normanni actually raise their daughter Felice was widely criticized as proof of a neglectful father.)

At the time of Pope Innocent's election, you (aged four) and your brothers Cèsar (i.e. Cesare, five years older) and Juan (either four or six years older, documents unclear) were living with your father's trusted cousin Adriana de Mila (c.1434–1502), the widow of Ludovico Orsini. Adriana's marriage had been important, linking the newly arrived Borgias with one of Rome's oldest families (with ties to Naples and the Medici), and had produced Adriana's son your second cousin and foster-brother Orsino

Orsini (four years older than you). You had several older half-siblings by other mistresses of your father, including your elder half-sisters Girolama and Isabel, and the family's scion Pedro Luis (twelve years older than you). And there was little Jofré (also called Gioffre or Gioffredo, two years younger) born after your mother's second marriage, which your father arranged to give her economic stability; little Jofré lived with your mother, not with you and Adriana, and whether he is considered your father's son or Vanozza's new husband's son will flip-flop many times over his rocky life. You were six years old, eagerly studying Latin and Greek, when you heard the fuss about the wild heretic Count Pico of Mirandola and his effort to merge all world religions.

How hostile was Rome to you and your siblings in your childhood? Did the youths of Rome's great houses, the Colonna or Farnese, treat you as a peer to flirt with? Or spit at you in the streets and call you bastard bull calves and other slurs based on your family crest, the Borgia bull? We don't know. It's an active research question how regional identities worked in the Renaissance, what *Italian* or *Spanish* meant to people then, or how foreign a Valencian Borgia felt compared to a Florentine Medici in a Rome which was only 20 percent Roman. We have long believed the Borgia family's fate was shaped by anti-Spanish feeling, but the nineteenth- and twentieth-century historians who claimed that lived during nationalist surges, and projected modern identities back onto periods that, we now realize, they don't fit.[111] Certainly your father worked hard to make links with Roman society, marrying your half-sisters Girolama and Isabel to grooms from middlingly important but old Roman families, Isabel to Pier Giovanni Matuzzi and Girolama to Giovanni Andrea Cesarini, and while unlucky Girolama died within a year, Isabel survived and had a son, your first nephew, Aurelio Matuzzi, a precious, real blood link between the Borgias and Rome.

As for your and your siblings' illegitimacy, while some cultures considered all children born out of wedlock equally undesirable, Renaissance Italy distinguished strongly between two different kinds of illegitimate child: a *natural child* whose parents weren't married *to anyone*, vs. a *spurious child* where there was adultery, one or both parents being married to another partner. You are

a *natural* child, born to an unmarried priest and an unmarried woman, easily legitimated, and Italy commonly recognized such children as heirs, with little shame attached. Cèsar was born before your mother's first husband died, so he is *spurious*, and had to be legitimized by Pope Innocent. Little Jofré, born after your mother remarried, is also *spurious*, even if he is your father's son. You, born between her marriages, are a *natural* child. The failure to recognize Italy's natural/spurious distinction, and the assumption that all *natural* children were looked down upon, is again the fault of nineteenth-century historians, especially in England where illegitimacy carried much more stigma—indeed, the same bad 1908 book that blames the Reformation on Poliziano having little Leo de Medici read Ovid instead of the Psalms blames the Wars of Religion and 1527 sack of Rome on Clement VII being the illegitimate (natural) son of Lorenzo's unmarried brother Giuliano (the one killed in the Pazzi Conspiracy).[112]

Innocent's reign, from your family's point of view, was a time of patient preparation. You and your brothers studied for political careers as your father toiled in the Vatican, making allies, learning about other great families through paperwork and tax receipts, and doing favors for your royal patron King Ferdinand of Aragon (overlord of the Borgia lands in Spain), and for Ferdinand's cousin King Ferrante of Naples. Your father had long been Aragon's best friend in Rome, arranging things like the papal dispensation needed for King Ferdinand's marriage to Queen Isabella (they were cousins)—popes tended to make royals pay through the nose for things like this, but when the pope in power refused to allow the match, your father had *arranged* for a dispensation signed by Pius II to conveniently turn up, years after Pius's death but with just the right signature and seals. In return for such assistance, in the second year of Innocent's reign, King Ferdinand made your elder half-brother Pedro Luis (aged ~17) Duke of Gandia, an area south of Valencia near the Borgia ancestral home (your father helped buy the land; the king supplied the title).

Under Innocent, the Conspiracy of the Barons increased the tensions between the Innocent/Sixtus faction allied with the Colonna on the one hand versus Naples/Spain and your family allied with the Orsini on the other, but your father knew how to

tread carefully in a burning building, and we might describe this period of his life with the advice Shakespeare has Richard Duke of York give himself as he bides his time before making his bid for England's throne: "Be still a while, till time do serve: / Watch thou, and wake, when others be asleep, / To pry into the secrets of the state."[113]

Your half-brother Pedro Luis died in 1488 (or possibly 1491), leaving his ducal title to your brother Juan and 10,000 ducats ($10 million) for your dowry. A dowry fit for a princess was essential to secure a marriage alliance that would advance the family's fortunes, as Adriana had with the Orsini; your half-sister Girolama had had only 4,000 ($4 million) in dowry at her marriage, which was why your father had only managed to secure a groom from a minor noble family like the Cesarini. In 1491, when you turned eleven, your father contracted a marriage for you with a Valencian lord, then broke that off for a Neapolitan count, since ties in Italy were more valuable than ties with Spain, which you already had.

Then came 1492, the death of Innocent. Time again to empty the Borgia houses and brace for the mob. It was a close election. Sixtus's warlike nephew Giuliano della Rovere came to the conclave with 200,000 gold ducats for bribes supplied by Charles of France and another 100,000 from Genoa ($300 million, likely the most ever spent on a papal election). Your father reached out to the many who feared della Rovere and his French allies, to the Genoa-hating Venetian bloc (still strong from when reclusive Pope Paul II packed the conclave with Venetians), and used his own bribes too, of course. He worked especially hard to recruit another top candidate, Milan's Ascanio Maria Visconti Sforza (Princess Ippolita Maria's little brother, who did have his parrot by now, and good reason to trust a pope friendly to Naples). It was enough—the della Rovere and France, for all their gold, had made too many enemies, with memories of Sixtus fresh in Italy. At last, it was your (empty) palaces the mob ransacked as your proud father came home to you as Pope Alexander VI.

Victory made many enemies—foremost Giuliano della Rovere and his faction—so it was essential to protect and solidify your power quickly. Every pope since Paul II had appointed a few new cardinals, but your father went much farther, using his

brilliant knowledge of canon law (he had been a star pupil at the University of Bologna) to invoke an obscure emergency power the pope has to appoint extra cardinals in times of crisis (such as war or surges of heresy). With that he made *twelve* new cardinals, allies to protect against the della Rovere cronies, and to ensure the next pope would be a friend.

This meant cardinalships for your brother Cèsar, who also became Archbishop of Valencia, and another cardinalship for young Alessandro Farnese, the brother of your father's cunning new Roman mistress Giulia Farnese. You already knew Giulia well, the wife of your foster-brother Orsino Orsini, but as your father moved her to a residence near the papal palace, she transitioned from being simply a member of your extended family to a pillar of it, especially with the birth later that year of her daughter, your little half-sister Laura. Why a new mistress and not your mother? Giulia was younger, and it was normal (indeed *expected*) in your era for powerful men to move on to younger mistresses as old loves aged, hence your father arranging a marriage for your mother to give her respectability and stability. Your mother remained a friend and ally of the family, but Giulia was a much more powerful one, bringing Roman respectability through her old blood and local *grace*.

You had a part to play too in solidifying power. As a pope's *natural* daughter—acknowledged by the Holy Father—you were a powerful yet unstable marriage prospect, since marriage with a pope's family has great short-term benefits but might wither to nothing long-term if a pope failed to entrench his power. Your first marriage took place in 1493, to twenty-seven-year-old Count Giovanni Sforza d'Aragona, Lord of Pesaro and Gradara, a mercenary captain and *natural* son of a minor Sforza branch, with ties to Naples. The match secured the friendship of the Visconti Sforza, an essential swing bloc that had secured your father's papacy, and it gained allies in Naples, Ferrara, and the Medici. Your dowry was 31,000 ducats plus 10,000 ducats in jewels and trousseau ($41 million), much of it supplied by the kings and queen of Aragon, Castile, and Naples, who were eager to strengthen *their* pope. You were no longer Princess of Nowhere, you were Countess of Pesaro—a tiny place but real. You did not go with Giovanni to

Pesaro, you remained in Rome working with your brothers and father, and much ink will be spilled over whether the marriage was ever consummated. That same year, Juan married an excellent Spanish bride (whom Pedro Luis would have married if he'd lived), Maria Enriquez de Luna, a first cousin of King Ferdinand, and worthy of the rising Borgia scion.

But lofty-sounding titles to tiny plots of land were a step, not an end. The end was something safe that would outlast your father's papacy: a Borgia home, not tiny Pesaro or Juan's little duchy in distant Aragon. Sixtus and Innocent had left central and southern Italy weakened by war, most of its towns ruled by new-risen minor families, ex-mercenaries, tyrants like the Bentivoglios who dominated Bologna without title or legal right, or papal governors appointed by Sixtus or Innocent, and easily replaced. Sixtus had used his authority to hand out titles and annex towns, even removing the Duchy of Sora from the papal states to give it permanently to his nephew Giovanni della Rovere (brother of the future Julius). With this precedent, your father could make your brothers lords of territories in the Papal States, or beyond the Papal States, since, as heir to the Caesars, a pope could claim all Italy, and both Sixtus and Innocent had stressed this right.

Still 1493—it's strange how small things escalate. Franceschetto Cybo, Pope Innocent's foolish son, had been given lordship over some papal castles near Rome which your father wanted to transfer to Juan, but Cybo suddenly sold them to the Orsini family. The Orsini were semi-allies via Adriana and Orsino Orsini, but your father wanted to see Orsini power shrink, since their strength and audacity had increased under Sixtus and Innocent, and their vendetta with the Colonna sparked frequent violence which popes often failed to quell (as Shakespeare's Prince of Verona fails to stop the Montagues and Capulets). And worse, the Orsini got the money to buy the castles from their ally-by-marriage King Ferrante of Naples, a sign that Ferrante, despite his Aragonese ancestry, was trying to slow Borgia power. In the end, Ferrante had fallen in line with his stronger cousin King Ferdinand in supporting you, but at first Ferrante had bitterly opposed your father's election—he wanted a cardinal from Naples whom he could control—and he was likely afraid your family might use

your alliance with King Ferdinand to ask the greater king to force the lesser to yield lands to you.

Your father declared Cybo's sale of the castles to the Orsini treason against the papacy (they were part of the Papal States after all), cracked down on the Orsini (and on their Colonna rivals too), and, as a further warning to King Ferrante, had a letter sent to Charles VIII of France suggesting (though not promising) papal approval if Charles crossed the Alps to press his claim to Naples. The plan came from your husband's kinsmen: Duke Ludovico Visconti Sforza, his irresistibly delightful lover Galeazzo Sanseverino, and his brother Cardinal Ascanio Visconti Sforza (your father's new vice-chancellor); strong and experienced Ludovico had seized Milan from his nephew Gian Galeazzo, angering Gian Galeazzo's Neapolitan wife, so Naples was threatening to attack Milan. The threat of the pope endorsing a French claim to Naples was the perfect stick to get obstreperous King Ferrante to leave Ludovico and Milan in peace, and to make him stop resisting Borgia power. In one sense it worked perfectly: King Ferrante reconciled with your father immediately, and agreed to a marriage between your *spurious* little brother Jofré and Ferrante's *spurious* granddaughter Sancha of Aragon (a daughter of Ippolita Maria's husband Prince Alfonso and his mistress Trogia Gazzella), giving Jofré the titles Prince of Squillace and Duke of Alvito.

But King Charles actually came.

No one in Italy—not the Visconti Sforza or your father—had intended the French invasion to be anything but a threat, but this King of France was young and eager for war after his successes in Brittany and Burgundy, and was deadly serious about his claim to Naples. There was more than Charles's ambition behind it: your father's greatest enemy, Giuliano della Rovere, had fled to France after losing the election, and was with Charles, weaving his plans like a spider and spewing his poison in the king's ear. Della Rovere warned the king how dangerous a Spanish pope might be to France, and promised Charles everything he wanted if he deposed your father on the way to Naples, installing della Rovere as a France-friendly pope.

1494—Plague flared in Rome, so you moved for safety to your

husband's dominion of Pesaro, taking Adriana and Giulia with you, though your husband was away leading troops against the French. You helped as you could, writing to your father with the information your position as a Sforza wife let you gather about this volatile family, which was still split over Ludovico's overthrow of Gian Galeazzo. Even though you were only fourteen, your letters read like Machiavelli's political dispatches: meticulous, succinct summaries of the characters and likely actions of different leaders, firm advice on which allies are important and which disposable, even military assessments of where to reinforce, or prepare troops.

Ludovico Visconti Sforza let Charles through Milan—you aren't sure whether to call Ludovico a coward, a traitor, or simply realistic, since he couldn't have stopped the French alone, but he could at least have slowed them down while Italy's forces organized a resistance. The precious time Milan failed to buy was granted by King Charles contracting a brief case of smallpox (God defending his Earthly vicar?). The best hope now was that, during the respite, mighty Florence might stock itself for siege, and stand strong enough to slow the French through November and December, when surely the armies must stop for winter. Instead, strange news: first that the Medici were out, then that Florence and the French had made peace, and the armies plunged on, despite oncoming winter, straight toward Rome! No Italian mercenary would keep fighting as the frosts approached, but these were not the professionals of Italy's small wars, these were French peasants pressed to service by their king, who would not pause to spend a comfortable winter, but march on and on until the task was done, no matter how imprudent and deadly winter warfare was. Poor Adriana and Giulia had set off for Rome to rejoin your father, were captured by the French en route, and had to be ransomed. By Christmas, Rome was ringed by French troops, the Orsini and Colonna joining della Rovere in urging Charles to overthrow your father, and even Ascanio Visconti Sforza—traitor!—joined Charles, since his brother Ludovico had capitulated.

You waited breathless through the dark of the new year, but then—miraculous!—your brilliant father won Charles over, meeting the king dressed in a friar's humble habit which surprised

and impressed Charles after the terrible lies he'd heard about your family, and offering him Naples and his blessing. The French marched on in peace, leaving spiteful Giuliano della Rovere with nothing! Charles took Naples early in 1495, but (partly because of plague) quickly turned around to return north, and a league of Italian defenders drove them out, with help from Ferdinand of Aragon (who did *not* want France snatching Naples), and Ludovico Visconti Sforza, who changed sides again when he saw a chance to free Milan from French domination. Help quickly returned plague-weakened Naples to Ferrante's heirs (Ippolita Maria's son Alfonso, in fact), and the French threat ended, leaving Italy scarred and full of weakness. It was the perfect moment for your father and brothers to use the papal armies and hired mercenaries to further crush your Orsini enemies (some of whom died in battle, others in prison, others possibly by poison) and to seize their lands for Juan.

When you returned to Rome, your father's unfaithful Vice-Chancellor Ascanio Visconti Sforza was trying to regain his influence, but nothing would make your family trust a traitor (not the scholarly eloquence Ascanio had learned from his *umanista* Francesco Filelfo, nor the brilliant choir director Josquin des Prez he brought to Rome, nor even his Latin-speaking parrot, charming as it was). It was time to leave Sforza ties behind. Your father pushed to dissolve your marriage to Giovanni Sforza, claiming the union was unconsummated and Giovanni impotent (one of few justifications for annulment accepted by the Church). Giovanni did *not* cooperate, despite the offer that he could keep your lavish dowry, and insisted that the marriage *was* consummated even though you'd been apart so much, a controversy that would spark debate for centuries. Giovanni also accused you of incest with your father, and rumors of incest with your brothers abounded too. Such slanders were common in the period, and there was never any evidence, but legends that add *romance* (even the sinister kind) never die. And things got worse from there.

On Good Friday 1497, your husband Giovanni suddenly left Rome—some say for fear of murder, others that it was outrage over your conduct. As wicked rumors worsened, you fled to the old and extremely respectable Dominican convent of San Sisto (where you

had studied as a girl) to await the result of the annulment proceedings in tranquility—in fact, you refused to leave even when your father sent guards to get you. Ten days later, your brother Juan's corpse was found floating in the Tiber. Did you ever learn who did it? History never did, there were so many suspects: the Orsini, the Colonna, many Roman husbands or fathers offended by Juan's frequent affairs, Ascanio Visconti Sforza who had quarreled with Juan recently; rumor even accused your brothers, some saying Jofré did it because Juan had been sleeping with his wife, others that Cèsar did it to make himself the family's heir. Your father was devastated—some say "mad with grief"—and shut himself up in Castel Sant'Angelo. When he recovered, planning began for Cèsar to renounce his cardinalship and take the stage as the new Borgia prince. Why not transfer the dynastic part to Jofré? Personality? Cèsar's ambition? Your father's insecurity about whether Jofré was truly his son? Certainly Cèsar had a taste for politics and conquest which, as Machiavelli would soon observe, made him an outstanding warlord, even in this age of warlords.

Your annulment went through in December 1497. No longer Countess of Pesaro, you were a Princess of the Borgia Nowhere once again. In February 1498, your father's chamberlain Perotto Calderón (who had tended on you in the convent), was found dead floating in the Tiber, along with a maid called Pantasilea. Soon thereafter, a son was born in the Borgia household, little Giovanni Borgia, known as the *Infans Romanus*. Rumors spread that you had given birth, impregnated by your father, or your brother, or by murdered Perotto, while other rumors suggested the baby was the pope's son by yet another mistress. Later your father would declare the boy to be Cèsar's, but in another declaration he would claim the boy as his own; in letters you called the child your half-brother. These events made you as infamous as your courtly graces had made you famous, and these years birthed such vicious rumors as the legend that you wore a hollow ring with poison inside, to use on enemies.

More strange news from Florence. After the Medici fled, a wild Dominican friar called Savonarola started dominating the city, claiming to be a prophet. His hellfire sermons attacked your father in all but name, saying the Antichrist was seated on Saint

Peter's throne! Such rants could be ignored, they were uttered by only one man, but he was having his sermons printed as pamphlets, trickling out of Florence, magnifying your family's infamy. Your father tried to shut him up by summoning him to Rome, even tried to bribe him with a cardinalship, but the strange friar stubbornly refused. His sermons got more ferocious, denouncing Rome, the papacy, the world, and declaring Florence a new Ark like Noah's which would survive an apocalypse as God swept all else (especially your family) away. Florence is a lynchpin of Italy, and this strange regime, which reports painted vividly as an apocalyptic theocracy helmed by a mad monk, could not be left in place to destabilize the whole peninsula, so your father finally put Florence under interdict to make clear he was serious. The more sensible Florentines realized that being on your father's good side was more important than one lunatic friar, so they rebelled against Savonarola's zealot followers, and burned him at the stake, in May 1498. One problem solved.

In April the same year, King Charles VIII of France hit his head on a doorframe and died, and was succeeded by his cousin Louis XII. Louis (conveniently) *desperately* needed an annulment—something only popes can grant. While Charles lived, his cousin Louis had been a political rival, so to prevent this royal branch line from continuing Louis had been forced to marry Charles's sister Joan, who was incapable of bearing children, due to a more severe form of the hereditary skeletal condition that also affected Charles. Now that Louis was king, he needed a wife who could produce heirs, and specifically he needed to marry Charles's widow Anne of Brittany, since if Anne left she would take Brittany with her (the bit of France that sticks out at the top left, toward England). Louis also had a claim to Milan via a Visconti ancestress, which he wanted your father to endorse. Cèsar went to France to negotiate, requesting a ducal title, a high-ranked bride, and further French military support.

One of the potential brides your brother attempted to secure was Princess Charlotte of Naples (King Ferrante's heir's heir's eldest child), who was being raised in France (to control her). Defiant Naples (or possibly Charlotte herself?) refused, but Naples tried to make up for it by letting *you* marry Alfonso, Prince

of Salerno, another *spurious* child of Ippolita Maria's husband Prince Alfonso and his mistress Trogia Gazzella. Alfonso came secretly to Rome and married you in July 1498, and your new dowry as Princess of Salerno was 40,000 ducats plus trousseau (likely $50 million). Accounts describe your second husband as the handsomest man ever seen in Rome, though such descriptions must be taken with a grain of salt, since other accounts say the same of Cèsar, and of your father in his younger days, and that you and Giulia were the two most beautiful women in Rome, or Italy, or Europe, or all of history. Even if Alfonso was not quite the handsomest man in Rome, he was much admired, and you left many signs to history—with words and actions—that this husband you *truly loved*.

In 1499, Cèsar became duke of Valentinois (making him doubly "Valentino"), married a French princess, Charlotte of Albret, and was ready to return to Italy and carve out a Borgia kingdom in earnest. Your ally Louis of France was eager to invade to claim Milan and Naples, and happy to let you take anything in between. Cèsar rode in triumph with Louis into Milan as you ousted that turncoat Ludovico Visconti Sforza. Your father formally deposed most of the rulers of towns and cities of the Papal States in central Italy, declaring the land Cèsar's, and Cèsar set out with papal and French armies to conquer those which resisted. Your father, trusting your political acumen, appointed *you* governor of two towns—Spoleto and Foligno—not your husband, *you*. Cèsar quickly captured Imola (which Florence and Sixtus had squabbled over), Forlì (where Cèsar captured Caterina Sforza and Marullo), Pesaro (ousting your former husband Giovanni Sforza), and set his sights on Rimini and Faenza, planning, once central Italy was subdued, to ride south with Louis to besiege Naples and crush the resistance of Ferrante's heirs and the remaining Colonna.

One of Ferrante's heirs, alas, was your husband Alfonso, who had just given you a healthy son—your sweet little Rodrigo. July 15, 1500, hired assassins attacked your husband on the steps of Saint Peter's, and wounded him gravely before his guards put them to flight. He survived, and you nursed his wounds, along with his sister Sancha (Jofré's wife), but on August 19 a group led by your brother Cèsar's long-time friend (and personal assassin)

Micheletto Corella (d. 1508) broke in and strangled your poor husband in your arms. Cèsar later claimed Alfonso had tried to kill him first, and some suggested the Orsini were behind the murder, angered at Alfonso's connections with the Colonna. In the grief and chaos, you hardly had the energy to mourn the death of your foster-brother Orsino Orsini. His widow Giulia Farnese also left that year, ending her affair with your father and going to govern Carbognano, a town outside Rome where your father had given her and Orsino a castle.

In 1501, with Naples and the Colonna subdued, Cèsar was crowned duke of the newly created Duchy of Romagna (i.e. central Italy), and set out to conquer the few remaining powers (Urbino, Camerino, Bologna) and to solidify his new-made duchy. You—a princess of Romagna now—were a potential bride once more, and a potential solution to one of the few remaining challenges: Ferrara, north-east of Cèsar's conquests, seat of the powerful House d'Este, the most secure and respected noble family in Italy. The old buffer zone between Venice's territories and the Papal States had long benefited from a general understanding—supported by popes and emperors—that, whatever small wars went on in Italy, one must not destabilize Ferrara. Sixtus had violated this, fomenting the brief Salt War in 1482–4, but the d'Este remained a far more *legitimate* and intimidating power than the rest of central Italy. The current duke, Ercole d'Este, had even married Princess Eleanor of Naples, one of the daughters of King Ferrante, so the new generation had the blood of kings, and the love and support of their royal aunt Queen Beatrice of Hungary.

Ferrara's heir, Prince Alfonso d'Este was Italy's most eligible bachelor, having just lost his first wife in childbirth (the fascinating Anna Visconti Sforza (1476–97), who had dressed in men's clothes and openly preferred female lovers).[114] Your father proposed a match between Prince Alfonso and yourself, which would guarantee peace between your family and one of the few neighbors Cèsar still had cause to fear. Reluctant but fearful of facing Cèsar in battle, Duke Ercole agreed.

The negotiations took some time, but in January 1502 you were forced to leave your little son Rodrigo behind in Rome, and, with Adriana as escort, you made the journey to Ferrara. Your new

sister-in-law, Isabella d'Este dressed for the wedding far too lavishly for a mere sister-in-law, and was clearly trying to upstage you with her jewels, but *you* shocked Italy by wearing something so unprecedented that nothing could upstage it: the same black mourning gown you had worn since the murder of your previous husband—a shocking act of public protest, which also popularized black in European fashion.[115] King Louis XII of France sent as a wedding gift a gold shield with Mary Magdalene enameled on it, with the comment that her life (a reformed prostitute) resembled yours—a *very personal* insult from Europe's strongest king, who joined the chorus of those who considered an infamous Princess of Nowhere an unworthy match for Italy's noblest house. There was nothing you could do but gracefully pretend not to understand.

Your dowry as future Duchess of Ferrara? Now that your family were masters of half of Italy, and your groom one of Europe's noblest princes? A full 100,000 ducats plus castles and lands which would yield 3,000 per year ($100 million + $3 million a year), a stunning amount compared to Alessandra Strozzi's $1.6 million, and not shabby even when compared to Alessandra's cousin-in-law Palla Strozzi's $250 million banking fortune. (Some exiled Strozzi had settled in Ferrara, by the way, so their descendants were among your subjects in your new domain.) Your trousseau at this wedding included 200 gowns each worth 100+ ducats ($100,000), a single dress worth 20,000 ($20 million) by itself, and a hat worth 10,000 ($10 million). Your father-in-law the duke wrote to your sister-in-law Isabella that he heard more gold was used preparing your clothing within a few weeks than the tailors of Rome and Naples usually used in years.

Your dowry was a show of strength, for both your family and Ferrara, as well as the price of turning one of your strongest possible adversaries from foe into friend. In contrast, your showy sister-in-law Isabella d'Este's dowry when she married Francesco Gonzaga, Marquis of Mantua, had been only 44,000 ($44 million), similar to your first wedding, including 25,000 in cash, 9,000 in clothing and ornaments, 8,000 in jewels, and a 2,000-ducat silver dinner set.[116] But much of the value Gonzaga got from marrying Isabella d'Este was the stability of her noble

house—it took a lot more cash to balance the political gamble of wedding you. Your increasing dowries mark both the scale of your family's power, and the scale of risk, which made old powers like the d'Este reluctant to tie themselves to a house that could fall as quickly as it rose, without the guarantee of cash which would outlast the life and fortunes of one aging pope.

Your half-sister Girolama's dowry back in 1482	4,000 ducats	$4 million
Funds left for your dowry by Pedro Luis in 1488 or 1491	10,000	$10 million
Dowry marrying Giovanni Sforza d'Aragona in 1493	31,000 + 10,000 trousseau	$41 million including trousseau
Dowry marrying Alfonso d'Aragona of Salerno in 1498	40,000 + similar ~$10,000 trousseau	$51 million including trousseau
Dowry marrying Alfonso d'Este of Ferrara in 1502	100,000 + 3,000/year annual income + far larger trousseau	$100 million + $3 million annual income + at least $15 million trousseau
Giuliano della Rovere's election bribe budget to defeat your father in 1492 (he still failed)	200,000 from France, 100,000 from Genoa	$300 million

What were the end goals of your family's ambition? For Cèsar to be made a king, not merely a duke, creating a new kingdom that would unite the middle of Italy, everything between the Kingdom of Naples to the south and the territories of Milan and Venice to the north, including that messy old bite out of the Papal States: Florence-dominated Tuscany. But Rome is the Eternal Problem City, and Sixtus and Innocent had proved no power stood secure in central Italy while the volatile papacy constantly changed hands. *Regulatory capture* was likely the real goal, not to overthrow

the papacy but to permanently control it. Cèsar and his heirs, ruling the lands surrounding Rome, would control the selection of cardinals and popes, as France had done back in Petrarch's day by dragging the papacy to Avignon. History has other examples of regulatory capture: the closest comparison (though you have never heard of it) being the Tokugawa Shogunate's control over the Emperors of Japan, in which imperial dignity and theological authority remained with the emperors, but decision-making and military power rested with the shoguns. Your victory could have permanently ended the chaotic turnover of popes which (Machiavelli agrees) made the Italian peninsula impossible to stabilize.

In 1502, when Cèsar's conquests were advancing daily and you were expecting a child who would be heir to Ferrara, all seemed well, except for the coldness of your new husband Alfonso d'Este, and his increasingly irksome sister-in-law Isabella, who had tried so hard to upstage you at your wedding.[117] Many admire Isabella d'Este (some will call her "the First Lady of the Renaissance"),[118] but she is not a person *you* can call a friend, not while she takes every opportunity to remind the world you are not good enough for *her* family. Isabella constantly overspent on art, often simply not paying her artists or other courtiers, or begging her father and Alfonso to send her more money to spend on artists, antiquities, fashion, $10,000-a-yard fabric, exotic slaves, all to maintain her air of superiority. Apparently she's always been competitive like that: back in 1491, when *wonderful* Ariosto started sharing the first chapters of *Orlando Furioso* (you love that poem so much! How could ungrateful Ippolito not be overjoyed to be its dedicatee?!). Isabella and her sister Beatrice had quarreled so fiercely about which of their favorite characters was best (Isabella championing Rinaldo and Beatrice the titular Orlando) that Isabella tried to bully poor Pietro Bembo—such a dear man and brilliant scholar—into fighting a duel against Beatrice's champion (her husband Ludovico's lover Galeazzo Sanseverino) for the honor of *her favorite character in a book! In a book!* The joke duel never happened, but Isabella's so-called jokes often have that vicious streak.

Isabella showed herself at her pettiest in June that year, with

the sack of Urbino. The city was one of the major powers in the Papal States, home to Isabella's sister-in-law Elisabetta Gonzaga and her husband Duke Guidobaldo da Montefeltro (1472–1508). Duke Guidobaldo was a remarkable man, sole son of the famed mercenary Federico da Montefeltro (remember the little boy in the portrait where Federico was sitting around reading in full plate armor?) and his beloved wife Battista Sforza (1446–72; no Visconti blood in this one, a daughter of Francesco Sforza's brother Alessandro, who took Pesaro and Parma when his brother took Milan).[119] Taking after such parents, the learned and dashing Guidobaldo was one of Italy's star mercenary generals, taking his first command at the age of *eleven*, when he inherited his father's commission leading an alliance of papal armies.* Duke Guidobaldo was a hub of Italy's military world, since, in addition to his Sforza blood and Gonzaga wife, his five elder sisters and several *natural* half-siblings (Federico waited a *long time* for an heir) had made many major marriages: to the Roman Colonna, the mercenary Sanseverinos, the Campofregosos who so often held the dogeship of Genoa, both feuding branches of the Malatesta of Rimini, and to Giovanni della Rovere Duke of Sora (1457–1501), nephew of Pope Sixtus and brother of the hateful Julius. Duke Guidobaldo was also famous for his love of art, scholarship, the classics, and antiquities, and so stunningly confident in himself and his power that when, after years without children, he was pressured to divorce Elisabetta Gonzaga (barrenness is a legitimate reason!), he shocked the world by publicly declaring that it wasn't her fault, he himself was impotent, braving anyone who dared to make something of it. For a ruler and a soldier to make such a weakness public was, frankly, incredible, and when friends pressured Elisabetta to leave Guidobaldo, she wouldn't hear of it, preferring life in Urbino's Platonic-in-both-senses court.†

* Young Guidobaldo was aided in this and many campaigns by his much older *natural* half-brother Antonio (1445–1508), who had tried in vain to get his father to give him the throne instead of passing it to the child Guidobaldo, but Federico was devoted to his wife and the young son she left him.
† Guidobaldo and Elisabetta's famous court at Urbino is immortalized in Castiglione's *Book of the Courtier*.

Cèsar had been careful to hire the powerful Guidobaldo early in his wars, and the duke fought for him faithfully until 1502, when Cèsar—knowing he needed to add Urbino to his conquests (it's smack in the middle of what he aimed to rule)—betrayed the duke, seizing Urbino in a sudden strike which the duke escaped with nothing but the shirt on his back. Here's the Isabella d'Este moment—the very day Isabella heard that Cèsar had looted the ducal palace of Urbino, she had her brother Cardinal Ippolito write to Cèsar to say she always liked a particular pair of antique statues in that palace, a Venus and a Cupid, asking if he would send them to her.[120] Cèsar did so (the Borgia-d'Este alliance was important), but for Isabella to profit so callously from the sacking of her husband's sister's home! Duke Guidobaldo fled via Rimini and Mantua to Venice (it's where you flee…) and your father offered him a cardinalship if he would yield his claim to Urbino (an impotent man's marriage isn't valid, so wasn't an impediment), but the proud and powerful soldier refused, biding his time, and Venice gifted him a palace and a pension, eager to befriend a man who might soon be a weapon against you and Rome.

December of that same year, you heard of a terrible conspiracy against Cèsar, an attempted coup where a group of his supposed allies tried to murder him. To your relief, Cèsar cleverly turned the tables and killed them instead, just when they were least expecting it, in a place called Senigallia (or Sinigaglia). The relief was enormous, especially when he visited you soon after, safe and sound. When Isabella d'Este learned of Cèsar's clever maneuvers, she sent him a gift of a hundred masks in many colors representing his many deceptions[121]—not quite as biting a gift as King Louis's Mary Magdalene shield, but hardly sisterly.

Tragedy came next: you bore a stillborn son. Naturally, Isabella d'Este wrote letters blaming you. You retreated to a convent for a few weeks to recover. When you came out, your husband Alfonso was away, but you stayed in Ferrara with your father-in-law Duke Ercole, enjoying the splendors of his brilliant court. There were frequent dances (*everyone* admired your dancing), poetry performances, and plays, many with musical interludes (which, right there in Ferrara, will evolve into something future eras will name

opera). There were musicians, artists like Mantegna (who frescoed your rooms), and wonderful poets! Dear Ariosto periodically released a new canto of his entrancing *Orlando Furioso*, the brilliant banished Florentine poet Ercole Strozzi (1473–1508) became a dear friend, and the Venetian scholar Pietro Bembo (1470–1547) became... *more* than a friend.

Dear Pietro Bembo was a backbone of that generation of *umanisti*.[122] He was just old enough to have known Poliziano, Pico, and Lorenzo de Medici in his youth when he traveled to master Greek and Latin. Now he was working with the Venetian printer Aldus Manutius (1448–1515) to print the first complete set of Greek and Latin classics edited by scholars: clean, affordable editions which raced around the world, revolutionizing printing, scholarship, even punctuation.[123] Bembo had the innovative idea that the different marks we use to break up written words should have specific meanings, that . should be used exclusively for the *end* of a sentence while; should combine two complete clauses and, should mark a minor pause. So great was the influence of these Aldine editions that this practice spread across Europe, making Bembo the father of modern punctuation. Bembo was also witty, charming, kind, all you could want. The flirtatious letters you exchanged, peppered with poetry, will be celebrated for centuries (a poet named Lord Byron will call them "the prettiest love letters in the world"), and historians will long debate whether you and Bembo had a physical affair or merely enjoyed the learned poetic performances of love (as with the poems about Alessandra Scala).

August 1503 everything changed. Plague emptied Ferrara that summer, as if to herald your misfortunes, so you were hiding in a country villa when your brother-in-law Cardinal Ippolito broke the news: your father was dead. You later wrote that you felt as if you yourself were dying. Worse, Cèsar was also at death's door from the same sickness (food poisoning?), your faction leaderless and in disarray, and all your enemies—the Orsini, the Colonna, the ever-scheming della Rovere—were back in Rome. You were inconsolable, not even Bembo could cheer you—he wrote a letter about how helpless he felt. It was more than family grief. It was fear. Your husband, cold, unromantic Alfonso d'Este, clearly did not feel anything like love for you, and you had not yet produced

a living heir. Your value as a wife plummeted with the end of your father's papacy, so you feared he might try to get rid of you. The King of France himself wrote urging Alfonso to divorce you (presumably to marry a French bride), but fortunately your father-in-law Duke Ercole liked you, and defended you. Maybe he just wanted to keep your dowry, but his words and letters in that dreadful hour were so kind. You determined to work as hard as you could to win over the rest of the court and city of Ferrara, since one resource no enemy could seize was your princely education.

That fall, as more and more of your household sickened with plague, the second blow came: your compromise pope, Pius III (Scholar-Pope 2) a compliant man who had long since bowed to Borgia rule, had died too soon, with Cèsar still unprepared. Another election—you felt so helpless, stuck so far from Rome. Then word came that Cèsar had made his choice: Giuliano della Rovere promised to recognize the Borgia lands, affirm Cèsar's titles and maintain him in command of his armies, if in return Giuliano could have his time as pope—he was an old man now, Cèsar would have more chances. Cèsar and della Rovere drew up formal promises, and Cèsar ordered his cardinals to vote for della Rovere. Then the betrayal: so quickly that you only heard when it was all over, Cèsar was stripped of his offices, armies, titles, and conquests, his followers arrested, and his treasures snatched away.

Cèsar fled south to the Kingdom of Naples, but was betrayed and captured—his alliance with France had angered Ferdinand of Aragon, who in 1504 drove the French from Naples once again, not restoring the descendants of Ferrante this time but keeping the crown for himself, merging Naples with Aragon. Victorious Ferdinand had not forgotten Cèsar's role helping King Louis XII take Naples, nor your father's earlier betrayal when he gave the crown to invading Charles VIII, so Ferdinand moved your brother to a prison in Spain, beyond the reach of friends—true Juan's young son was still there, Duke of Gandia, and your father's sisters and their kin had *some* influence, but it was little enough against a strong king's wrath. King Ferdinand also seized most of your little brother Jofré's lands, leaving him only the tiny territory of Squillace. Julius II imposed *damnatio memoriae* upon

your family, commanding that your crest be effaced everywhere in the city, the Borgia name crossed out of documents, paintings you commissioned blacked out, your father's tomb opened and desecrated, and his reign never spoken of on pain of excommunication. This *damnatio memoriae* had not been imposed on other controversial popes—Paul II, Sixtus IV, even Boniface VIII whom many blamed for the Avignon papacy—but it was for your father. And Julius immediately started seizing all Cèsar had conquered, giving it to his kinsmen and cronies.

Defaced papal crest, Rome, Castel Sant'Angelo.

With Cèsar's fall, your court in Ferrara became the haven for what remained of Borgia hopes in Italy. Apart from Jofré's tiny town of Squillace in the south, your dowry and other personal property were most of what remained of your family's days of greatness. Juan and Cèsar's distant duchies remained, Juan's in Spain and Cèsar's in France, which both passed to their heirs, but lands and heirs alike were in the power of kings who no longer had reason to care about a family that had lost its strength in Rome and Italy. It would be a labor of years securing your inheritance,

and helping your nephews, nieces, and young sons secure theirs, since many took advantage of your sudden weakness to seize your property, or renege on debts. You dedicated yourself to using your position in Ferrara to advance the family, and to work toward Cèsar's liberation. Unfortunately, the d'Este had married you to buy peace, so it was no easy task persuading them to aid your family if the price was war. Even your kind father-in-law offered nothing more than sympathy and prayers for Cèsar's safety.

In 1504 war threatened anew. Pope Julius, with his imperial ambitions and ties to Genoa, still hated Genoa's rival defiant Venice, and when Venice laid claim to some towns your brother had conquered, Julius declared them papal territories and used the excuse to invite the armies of France and the Empire to cross the Alps yet again to help him attack Venice's land empire. The invasion was nipped in the bud by the death of Queen Isabella of Castile, which triggered succession complications (Aragon and Castile had different inheritance laws, both entangled via marriage with the Empire), but it was clear that Pope Julius, who would rather hold a sword than a book, had set his sights on Venice, and on the buffer zone of Ferrara. In April, fearful of the coming strife, your father-in-law the duke sent your husband Alfonso off to renew Ferrara's friendship with the royal courts of France, the Empire, and England, leaving you in Ferrara with your in-laws.

It was in this period that you started to understand the dysfunctionality which flourished in the House d'Este, whose firm, *legitimate* hold on power meant family members had little need to support each other (so different from your family). Their sheer security in office is hard to express, the one semi-solid rock in Italy's sea of troubles, but amid the many overthrows of Visconti, Sforzas, Medici, and Bentivoglios, one detail may epitomize the difference: after your death when the Medici take Florence for the final time, subduing the republic and installing themselves permanently as dukes, they will build the Vasari Corridor, a kilometer-long elevated hallway running along the city's roofs, with tiny, assassin-proof windows designed to let the duke walk from his palace to the seat of government without risk of attack from his turbulent people. In contrast, in 1494 your husband Alfonso

as crown prince had boldly walked around Ferrara buck naked, holding a sword in one hand and his penis in the other, reveling in the confidence that no one in his city would dare raise a hand against a d'Este.[124] No one, you would soon learn, except a fellow d'Este.

The first quarrel was between the second d'Este brother, Cardinal Ippolito, and your father-in-law Duke Ercole. The imperious new Pope Julius had made some demands of Ippolito, and, instead of placating the bellicose pontiff, Ippolito had provoked Julius with angry letters, which made Julius angry at Ferrara. Your father-in-law and Ippolito quarreled so bitterly over this that they called in an outside peacemaker, your brother-in-law Francesco Gonzaga, Marquis of Mantua (1466–1519), the husband of your haughty sister-in-law Isabella d'Este. Francesco got the feuding father and son to shake hands, but everyone had the feeling that the quarrel would shed blood another day. Nor had you long to wait. Your husband had other brothers beyond Ippolito, including Ferrante d'Este (1477–1540, who had been raised in Naples with their mother's family and foster-fathered by his grandfather and namesake King Ferrante) and a *spurious* half-brother, Giulio (1478–1561). Late in 1504, as their father began to sicken, Cardinal Ippolito demanded and (when refused) abducted a musician courtier of Giulio's (Don Rainaldo da Sassuolo). The quarrel dragged on through January of 1505 when Duke Ercole d'Este—your kind father-in-law and best ally in Ferrara—died. It was May by the time Ferrante and Giulio found and freed the kidnapped courtier. Your husband, now *Duke* Alfonso, took Ippolito's side in the quarrel, and banished both Giulio and Ferrante, while you, Francesco Gonzaga, and even Isabella (agreeing with you for once) tried to calm things down.

Repeated peacemaking visits from Francesco Gonzaga—a great military commander and ally of Pope Julius—were a precious chance to renew your efforts to secure aid for Cèsar. You had met Gonzaga briefly years ago in Rome, and had been exchanging letters since 1502, asking patronage favors for clients, as was natural with a brother-in-law-in-law (your husband's sister's husband). Now you pleaded with him to help poor Cèsar. Private meetings about your brother's needs soon turned into more *personal*

meetings. Francesco Gonzaga was a very passionate man, fond of pornography and lovers of both sexes, so, between your husband's coldness and the feeling that Gonzaga aid might be Cèsar's only hope, your meetings soon blossomed into an affair. The letters you exchanged were far more raunchy than the poetic pieces you traded with scholarly Bembo. Naturally Gonzaga's wife Isabella *hated* this, but that bridge was burned anyway, and as for your husband... it bothered him, he tried to keep you apart, but it's not as if he was faithful to you either. It's not that you had a rival in his affections (that would have felt more normal), rather Alfonso was so *un*affectionate he didn't take a mistress as one would expect, or exchange letters with courtly ladies, he just hired prostitutes, professional, disposable, using women's bodies for plain sex without flirtation or romance, much as he used your body as a tool for making heirs, and continued to hold your miscarriage against you.

Summer 1505 felt a little better. Your formal coronation as duchess had taken place, and on August 19 you gave Alfonso the heir he needed, little Alessandro. Your marriage was secure now—you would never again be a Princess of Nowhere; even if you outlived Alfonso you would always be Lucrezia d'Este, Duchess of Ferrara, with your title, dowry, an heir to care for you in your old age, and a home, if not the home your family had tried to build.

How quickly things can fall apart. Little Alessandro died in October—only two months of life!—and in November the feud flared again between your husband's brothers Ippolito and Giulio. Several relatives had joined you in Ferrara for safety, including your little "brother" Giovanni (the *Infans Romanus*) and your lovely cousin Angela Borgia (1486–c.1522). Both Ippolito and Giulio fell for Angela, but she preferred Giulio, and told Ippolito she cared more for a glance from Giulio's eyes than the cardinal's whole person. So Ippolito had Giulio's eyes gouged out. Horrible. Ferrante sided with Giulio, demanding that your husband, as duke, punish Ippolito, but Alfonso and Ippolito were close (having grown up together while Ferrante grew up in Naples) so Alfonso refused. So Ferrante and Giulio tried to assassinate Alfonso, Ferrante hoping he would get the throne. With much pressure and negotiation by yourself, Francesco Gonzaga, and Isabella, your husband forgave his brothers, but they tried again.

And again. Even your one *nice* brother-in-law Sigismondo d'Este (the sweet, disabled one) couldn't calm things down.

In the end, Alfonso sentenced his two murderous brothers to death, but pardoned them at the last moment—he couldn't spill d'Este blood (or didn't want to be seen doing so) and instead permanently imprisoned them in the castle dungeon. They're still down there, beneath the stones where you daily live and walk, such a strange thought. So different from your family, who, even after the grief and distrust around Juan's death and your second husband's murder, had still depended on each other so much in a hostile world. There was also another bout of plague in Ferrara, another surreal moment of an empty city and a world turned upside down.

In 1506 Cèsar escaped from his prison in Spain, and joined the allies of his French wife in Navarre. Freedom! A chance! You did everything you could, wrote to everyone, pulled in every favor, but you had already pulled in every favor long ago. Cèsar was killed in battle the next year, and buried without ceremony in unconsecrated ground, the last hope of a Borgia kingdom with him.

That same year, 1507, Julius invited Emperor Maximilian to visit Rome for his long-sought formal coronation, and so he could attack Venice's land holdings on the way, but Venice repelled the attack, thwarting the pope's plans to bring the Venetian lion to heel. So in 1508, Julius tried again, this time inviting France, the Empire, and Spain to form a league (the League of Cambrai) and invade Italy together, dividing up Venice's territory, each keeping small pieces while the rest would join the Papal States. Your husband—recognizing overwhelming force—joined the league.

The league's huge forces quickly overran Venice's mainland territories, seizing even Padua, but on reaching the edge of the lagoon the armies found the island city impossible to reach, and could do no more than stand on the shore and fire cannonballs into the lake. Armies from rival foreign kingdoms with little to do in wealthy Italy soon began looting, and fighting each other. By 1510, Venice formally surrendered to the pope (though the impregnable city had no intention of keeping its unenforceable promise to submit to papal authority thereafter). Meanwhile, Pope Julius began to regret what he had unleashed, realizing

that Louis of France especially intended to snatch up every inch of Italy his unchecked troops could reach. Julius also quarreled with your husband Duke Alfonso, who stood ferociously by his rights and refused to let even the tiniest part of his dominion be annexed by the Papal States, so Julius excommunicated him as a traitor, and sent the papal armies to attack Ferrara.

For a strange period in 1510–11, the war which had begun with Julius calling France, Ferrara, and other powers to attack Venice turned into Venice, now reconciled with Rome, defending the pope from France and Ferrara. Frightened Julius called for what became the Holy League, assembled to drive the French from Italy, asking for help from Spain, the Empire, England (always eager to fight France), Venice (eager to retake its lands), and Swiss mercenaries. France called in its allies Scotland and Florence (the republic was still grateful for Charles's mercy in 1494, and angry at Julius's part in the Pazzi Conspiracy), and Ferrara joined them, since the pope had betrayed you. This mess is how we got Englishmen fighting Scotsmen in the hills of Italy, a war in which every single participant changed sides, some several times.

What did you do through this maddest of wars? Like your husband, you did all you could to keep Ferrara one step ahead of ruin, even pawning jewelry from your dowry. Personally, 1508 was the turning point for you, for good and ill. In April 1508 you finally gave Alfonso a healthy son, little Ercole, who grew into a lovely young man, a successor to keep Ferrara safe. And you became pregnant again, bearing a second son, Ippolito, the next year—one boy for the throne, a second for the Church (marked for a cardinal's hat like his namesake-uncle), just what a noble house needed.

It should have been the happiest of years, but instead…June 6, 1508, your beloved friend the poet Ercole Strozzi was found dead in the street near your castle, with twenty-two stab wounds. The absence of blood showed the body had been moved, and clearly many hands had done the deed—but at whose order? So many suspicions. Ercole Strozzi (yes, descended from the exiled Strozzi) had held a tax collecting office, and many people hate tax collectors. Strozzi's widow Barbara Torelli said she thought the murder was retribution for the couple's efforts to recover her dowry from

her first marriage (she had been the wife of Ercole Bentivoglio, who wrote that letter to Machiavelli, and the Bentivoglio were ruthless). But you feared a different cause. Ercole Strozzi had been your go-between delivering letters, between you and Bembo, and between you and Francesco Gonzaga, so your husband… your husband knew and… and maybe vicious Isabella knew too, Francesco's jealous wife, did she… did both of them… was it your fault? You did what you could for the widow, and arranged for poor Strozzi's poetry to be printed in Venice by Bembo's friend Aldus—a poet's paper immortality—but nothing could repair the loss, or the loss of trust thereafter each time you met your husband in the halls.

Meanwhile, the wars stretched on. By 1512, as the French retreated from Italy, leaving their Florentine allies and French-controlled Milan to face Pope Julius's wrath. So from the wings came two displaced dynasties: the deposed Visconti Sforza of Milan, and the exiled Medici of Florence. Both were full of promises of friendship and obedience to Julius if he would restore them to power. Thus the Republic of Florence was forced to accept the return and rule of the surviving sons of Lorenzo de Medici, Cardinal Giovanni "Leo" de Medici and his younger brother Giuliano (1479–1516), while Milan accepted the coronation of Massimiliano Visconti Sforza (1493–1530), the son of Ludovico Visconti Sforza (who had died in a French prison) and your husband's late sister Beatrice d'Este. Things might have ended to Pope Julius's advantage, but he remained too greedy and too bitter. As the conquerors (him, Spain, the Empire, Venice) sat down to divide up their conquests, he decided to completely exclude Venice, restoring none of its land empire even though Venice had fought for him. Wrathful and still impregnable Venice quickly switched sides again to join Ferrara and France, which sent new armies to retake Milan. That same year another personal tragedy touched you—little Rodrigo, your son by your dear second husband, had been living with his aunt Isabella (Princess Ippolita Maria Visconti Sforza's daughter, whose husband Gian Galeazzo was imprisoned by Ludovico), but the dear boy died of illness in 1512, aged twelve, far from his mother's loving arms.

In February 1513, Julius II, the enemy who had haunted your

family since your earliest memories, finally died. When you heard the news you celebrated, rushing from altar to altar through the chapels of Ferrara for everyone to see as you publicly thanked God and all the saints for freeing the world from this tyrant, whom you compared to the biblical Holofernes. Pope Julius had likely intended to pass the Throne of Saint Peter to his nephew Cardinal Raffaele Riario (the only surviving in-person participant in the Pazzi Conspiracy), but, joyously, the enemies of the della Rovere faction proved stronger than their cronies, and Riario was defeated by Giovanni "Leo" de Medici, who now became Pope Leo X.

Pope Leo was extraordinarily young, only thirty-seven, so his election promised several decades without papal turnover, while his fondness for art and the classics (a student of Poliziano!) made the *umanisti* at your court hail his election as the birth of a golden age. Your dear Bembo agreed, and went to work for Leo, where he rose rapidly in the ranks, and in the young pope's trust. But a golden age for *umanisti* is not necessarily a golden age for peace. The wars lingered on—Julius's Holy League war had spread beyond the Alps, Spain and England using Julius's invitation as a pretext to invade France and Navarre, and Scotland to invade England, but Leo did not share Julius's imperial ambitions, and the northern Italian Wars settled down by 1516, with the exception of the Duchy of Urbino.

Urbino—at whose splendid court dear Bembo often stayed; some called this a new war, but to you it felt like proof that the more things change the more they stay the same. Duke Guidobaldo had been Pope Julius's brother-in-law so Julius had given Urbino back to Guidobaldo, or really to childless Guidobaldo and Elisabetta's adopted heir, Julius's own nephew Francesco Maria da Montefeltro della Rovere (1490–1538). Though still in his thirties, Guidobaldo died of illness in 1508, leaving Elisabetta Gonzaga regent for the young della Rovere duke, and now with Julius gone, Pope Leo decided to exercise papal privilege over Urbino as a city in the Papal States and oust the young duke (still a grudge, perhaps, from the Pazzi mess?) and give the ducal crown of Urbino to *his own* nephew, young Lorenzo di Piero de Medici (1492–1519), son of the late Piero the

Unfortunate. Pope Leo succeeded in taking Urbino, but the war was costly, destabilizing the area again, just as Cèsar's conquests had. Some said Pope Leo intended to imitate your father, and to turn Urbino and other towns into a Medici kingdom, others that he was just following the precedents of Sixtus and Julius reshaping the Papal States at will. All so depressingly familiar.

As for yourself, the years after Julius's death in 1513 were stable for Ferrara, freeing you to focus on three things: (1) your children, who must have a princely education like your own, (2) religion, both personal and through the patronage of nunneries and other pious projects, and (3) on wealth—not joint wealth held by your husband, *your* wealth. You were still working to recover pieces of your Borgia inheritance, but you were after more than that. You used your dowry and personal treasures cunningly (as the brilliant historian Diane Yvonne Ghirardo will show), working out an innovative way to amass agricultural wealth *without* selling your jewels or even buying land outright.[125] Ferrara was surrounded by swamps, and whenever you heard of a village or local lord disrupted by the wars and struggling to pay taxes, you would offer to pay the tax debt in return for a permanent lease on the useless swamp land next door. You would then drain the swamp to create new farmland, paying for the ambitious engineering by pawning jewels from your dowry, which you could then buy back with the profits of the farms. The same jewels you had once pawned to finance wars against abominable Julius could be pawned again year after year, one year to drain a marsh, another to buy calves and lambs which quickly multiplied to pay back the investment. Many of your enterprises were win-win, turning a marsh into rich farmland in return for keeping half while the original owner kept the other half, now more valuable than the whole had been. Thus, as Isabella d'Este down in Mantua kept overspending on art and courtiers (future generations will love the fruits of that, but not so much the people Isabella never paid for their services), your personal investments in 1518 alone turned a profit in excess of 10,000 ducats ($10 million). Was that a typical year for you? Probably, though, alas, many of your letters and records will be lost in 1945, due to a war far larger than your father's or Julius's, hard as that may be to imagine.

How did you spend this wealth? Most you reinvested—you

know the value of building a stable patrimony. But some you spent on churches or nunneries, on courtiers, on your household of more than 150 servants, and on your children: their tutors, *umanisti*, princely clothes. You bore Alfonso more children in these years: Alessandro, Eleonora, Francesco, then more miscarriages. You were in your thirties now—an age at which many wives in political marriages find their husbands' attentions moving to younger concubines—but from 1513 on Alfonso started keeping you continually pregnant, even though you already had healthy sons, almost as if...

Almost as if he wants you to die in childbirth?

Of course there can't be direct evidence. It was certainly unusual in the period for Alfonso to keep you pregnant so much, despite not liking you very much, but why? Was he trying to kill you? Was he just that lustful? Were *you* just that lustful? Insatiable? Implausibly fertile? This is exactly the kind of moralistic speculation historians will make about both you and everyone around you for centuries to come, tipping your portrait back and forth between villainous femme fatale and tragic heroine.

In 1516/17 (records are incomplete), word came that your last brother, little Jofré, had died, leaving the tiny territory of Squillace to his only son. Soon thereafter you had some consolation, seeing your old enemy Cardinal Raffaele Riario (Julius's main successor) stripped of his wealth and banished for his alleged entanglement with the plot to murder Pope Leo (and an act of strange ingratitude if true, since Leo's father Lorenzo had personally saved Riario's life during the Pazzi Conspiracy, but Leo's election so young had ended Riario's hopes for the papacy, and Leo had his mother's Orsini blood; perhaps Riario never did forgive the Orsini for what they did to his beloved Lorenzo Oddone Colonna—you wouldn't have). *Orlando Furioso* was finally complete and printed, that was a joy. And around that time you started hearing of a friar in Wittenberg called Martin Luther, whose list of the corruptions of the Church also sounded depressingly familiar—you'd seen such calls for reform so many times before, voiced by Petrarch, Bembo's *umanista* friends, even Savonarola.

In 1518, your mother Vanozza died in Rome, buried with great honors in a ceremony which Pope Leo attended and ordered all

the cardinals to attend as well, a remarkable honor for the mistress of a dead and widely hated pope, and an intriguing window on how this still-young Medici (whose family had endured more than a decade of exile due to the French invasion that your father partly caused) felt about your family. The honors pleased you, but could not ease the solitude. Far off in Spain Juan had a grandson, and Cèsar's daughter in France had married, but such distant kin were merely names on letters. They were all gone now, the companions of your youth: Juan, your father, Cèsar, Jofré, Adriana, Orsino Orsini who grew up with you, your mother too, all gone.

So here you are in 1519, aged thirty-nine, recovering from the birth of your newest daughter Isabella Maria. How many times in childbed is it now? Ten? More? Stillbirths leave so few marks on history. But this childbed is different. This is the childbed you will not rise from, where Lucrezia Borgia the woman dies, and Lucrezia Borgia the legend begins.

Stately mourning will come first, burial with honor in the castle in Ferrara, a more peaceful path from death to tomb than any of your siblings had. Little Isabella Maria will not live long, but other children you bore to Duke Alfonso will thrive, Ercole becoming duke, Ippolito a cardinal as planned. Popes will deny Cardinal Ippolito II permission to build himself a palace in Rome (lingering anti-Borgia sentiment?) but he will rent the palace on Monte Giordano where you and your brothers spent those early years with Adriana learning Greek and Latin. There, your Ippolito will host the next generation's great poets, including Torquato Tasso, whose poems, alongside Ariosto's, will be celebrated as this century's masterpieces of Italian literature. And with his wealth—partly the fruits of your investments—your son Ippolito will erect a palace far grander than any Rome could fit, with sprawling gardens and 3,000 fountains, built in Tivoli near the ruins of the Emperor Hadrian's villa, which dear Bembo so loves to visit. Bembo will do well, advancing scholarship, becoming a cardinal himself, buried with honor in the end, at the feet of his friend and patron Leo X in the Dominican headquarters church of Santa Maria sopra Minerva. Juan's grandson Francis Borgia (1510–72) will reject a cardinalship, preferring to lead the Jesuits, and will be made a saint. And dear Francesco Gonzaga

and petty Isabella d'Este will have many children, who will marry into all the best families in Europe, as will some of your own.

For many years, while Bembo's crest, and Medici crests, and Farnese crests, and della Rovere crests immortalize their marks upon Saint Peter's city, your family will be seen only in scandal tales, and scarred stone where your enemies have chiseled off the Borgia bull. Hateful Julius sealed away the beautiful Vatican apartments your father decorated (with a portrait of you among the frescoes), but they will be restored again in 1889, the same year that your poor father will finally rest in a proper tomb; Cèsar will have to wait a full 500 years, until 2007, to rest at last in consecrated ground. Through four of those five centuries, your family will be remembered as the worst papal warmongers of this chaotic age. Whether your house deserved to be called very, very, very, very, very, very, very much worse than your rivals, or whether you simply had the most vindictive enemies (aided by later anti-Spanish sentiment), will begin to be debated, mainly in the later 1900s, much as historians will debate whether your Medici neighbors were citizens or tyrants.

You yourself? Legends of your life will make you a heroine and villainess of print and stage. As early as 1875, scholars will begin to exonerate you, using letters and documents to write new portraits which will change repeatedly over the decades, as ideas of female power, female sexuality, and appropriate female action change.[126] With the rise of feminism in the later 1900s, Lucrezia the poisoner will diminish in scholarship, as a series of studies—many by women—attempt to replace the Lucrezia of opera with the Lucrezia who was stunningly intelligent and politically astute. Yet as books defend you, the entrancing sinister Lucrezia will still be repeated, in those histories which don't take time to consider you in depth, and in fiction where mystery writers will use a resemblance to Lucrezia Borgia as flag for femmes fatales. Meanwhile, Isabella d'Este will be celebrated as another great heroine and art patron of the Renaissance, and you will often be made to play the bad sister-in-law in her story, as she plays the bad sister-in-law in yours. In 2011, even as your operas continue to be performed, two different television series will depict different Lucrezias, one anachronistically shocked at

the prospect of an arranged marriage at age fourteen, the other stormingly fearful that she'll become an old maid as her father hesitates about her early betrothals[127]—the latter attitude is more likely for the period, but equally a fruit of imagination, as are the sentiments and feelings in this account. We can assemble facts, work out which rumors have a basis in real evidence, but we still hunger for the interior Lucrezia, your actions and reactions.

One type of art, which many great museums own but are embarrassed to display, is their fake Botticellis and similar fake Renaissance masterpieces, many made in the twentieth century to scam rich buyers. Such fakes fooled the best when new, but become obvious as years pass, because the women's faces resemble popular actresses of the decades they were made; artists trying to make a *beautiful* woman *not quite* copied from a real Botticelli unconsciously integrated the tastes of their moment, that year's fad-sense of the ideal woman, 1940s fakes sporting 1940s faces. Just so, the best Lucrezias of the 2010s and 2020s—including this one—will doubtless, in a few decades, feel as false and flawed as the first efforts to rehabilitate her will feel to later readers, like Ferdinand Gregorovius's well-researched 1875 defense *Lucrezia Borgia According to Original Documents and Correspondence of Her Day*. Gregorovius sums up his Lucrezia as an "amiable, gentle, thoughtless, and unfortunate woman" "ethically crippled" by being raised in papal Rome where crime and sin were ubiquitous. His infantilizing attitude and anti-Catholic bias leap out like Judy Garland's face from a fake Botticelli, because no reconstructed Lucrezia can avoid being shaped by the author's preconceptions of human nature, and of a woman's nature. Even which painting of Lucrezia we put on book covers—the sultry blonde nude by Bartolomeo Veneto, the regal, saintly Saint Catherine fresco by Pinturicchio, the grave-faced Dosso Dossi portrait of her in men's clothes—cycles with what we (authors, publishers, book-buyers) want Lucrezia to be.

These biases don't mean our Lucrezias aren't getting better. As with the Norse Greenlanders, we wouldn't know so much about Lucrezia today without wrong-and-biased Gregorovius there in 1875 beginning the dig. The televised Lucrezias of 2011 are not just different but closer, more useful windows on real history, than

earlier Lucrezias of stage and screen. Yet Gregorovius's reflection in 1875 on what it's like to write about Lucrezia Borgia still captures best the challenge of approaching her, and all of our Renaissance friends:

> Men of past ages are merely problems which we endeavor to solve. If we err in our conception of our contemporaries, how much more likely are we to be wrong when we endeavor to analyze men whose very forms are shadowy. All the circumstances of their personal life, of their nature, the times, and their environment—of which they were the product—all the secrets of their being exist only as disconnected fragments from which we are forced to frame our conception of their characters. History is merely a world-judgment based upon the law of causality. Many of the characters of history would regard their portraits in books as wholly distorted, and would smile at the opinion formed of them.

41

Camilla Bartolini Rucellai:
Spirit of the Last Republic

Camilla Bartolini Rucellai (1465–1520) would *not* smile at the opinion formed of *her*. We turn to her now because we can learn much from examining a figure everybody hates—not in her own day, *now*. Some historians treat her with criticism or contempt, others with silence, minimizing how much they mention her, even in narrating events she shaped. Why? Camilla rubs against every X-Factor, everything we moderns want the Renaissance to be, and especially of what we want the Renaissance *woman* to be. And yet she remains irksomely real.

Camilla was born in 1465 to the wealthy Florentine Bartolini-Davanzi family.[128] On the day of Camilla's birth, Piero the Gouty was still ruling Florence, Alessandra Strozzi was a grandmother, our woodcarver Manetto Amanatini was dead and buried, Francesco Filelfo was nearly seventy up in Milan, our assassin Montesecco was about ready to begin his military career, Princess Ippolita Maria Visconti Sforza had been married for less than a week, Josquin des Prez was just past his voice dropping with adolescence, little Poliziano had recently come to town after his father's death, Savonarola and Raffaello Maffei were young boys, and the lovely Vanozza dei Cattanei had not yet caught the eye of ambitious Rodrigo Borgia.

Camilla married Ridolfo (or Rodolfo) Rucellai. The Rucellai were a major Florentine family, originally made rich by a monopoly on a purple dye made out of a kind of lichenized fungus (*oricella*, hence the name Rucellai), but by Rodolfo's generation they were bankers like other top Florentine families. Model Renaissance

Man™ Leon Battista Alberti (who would have made another fabulous friend if we had space for more than fifteen) designed Palazzo Rucellai, still considered one of the architectural wonders of Florence, and the family decorated the church of San Pancrazio and commissioned one of the most splendid chapels in Santa Maria Novella—in sum, they were skilled players of the stage of the game where you compete to put your coat of arms on the most art, though not so strong in Cosimo's game of turning money into power. No documents confirm Camilla's wedding date or dowry, though she likely married around age nineteen, and since Rodolfo was a second son, not scion, of the Rucellai, we can estimate a dowry of 3,000 to 10,000 florins. So far, so Alessandra Strozzi-like.

The Rucellai intermarried densely with other major banking families, including the Strozzi, Soderini, Capponi, and, yes, the Medici. In this stage of their rise (1470s), the Medici were "master of the shop" as Lorenzo once put it, but their ability to leverage power rested on close ties with other office-holding families, and marriage ties were vital. One of Lorenzo the Magnificent's big sisters, Nannina, took a Rucellai husband, Bernardo Rucellai; indeed, the Medici were careful to marry most of Lorenzo's sisters and daughters to Florentine husbands, an effort to counter the accusations of ambition sparked by Lorenzo's Orsini marriage, despite its quasi-republican glamor (SPQR; SPQF). The Pazzi Conspiracy, partly sparked by fears of that ambition, rocked the city when our Camilla was twelve years old.

In 1492, at a service in the church of Santa Maria Novella, Camilla—now in her mid-twenties—saw Giovanni Pico della Mirandola enter the church, and she suddenly shouted out to everyone that she had had a vision, in which she saw Pico either become a Dominican or die in "the time of the lilies"—which she said, Dominican or death, differs in the many accounts of this very public moment. She also made more prophecies in private. Savonarola was then on the rise, and Camilla was a fervent supporter and likely a regular attendee at his women's sermons. Back in 1490 Savonarola had begun a special series of Italian-language sermons for female audiences, a reaction against the policy of some churches—including many Dominican ones—of excluding women from sermons, which Savonarola felt was disgraceful for

an order which called itself "the Order of Preachers," especially when their Franciscan rivals welcomed anyone, including women, following the tradition of Saint Francis preaching even to insects and forest animals. Just as Savonarola's prophecy "the sword of the Lord from the north" gained credibility with the French invasion, so did Camilla's when Pico did indeed die, and was buried in Dominican robes, in the "time of lilies" when the gold-on-blue lily of France and red-on-white lily of Florence met in the field.

In March 1495, soon after the French passed by, when the expulsion of the Medici had birthed the new Savonarolan republic, Camilla (aged twenty-nine) and her husband Rodolfo had their still-childless marriage dissolved in a ceremony in San Marco, so they could both take religious vows. Rodolfo entered San Marco as a novice Dominican, while Camilla—taking the religious name Sister Lucia—founded, funded, and joined a small new convent of Dominican nuns in a house she owned in the Via dei Cocomero, which was likely part of her dowry. In Savonarola's Florence, San Marco saw a flood of new recruits, but within a few months, Rodolfo Rucellai grew tired of rigorous monastery life, and left the order (easy when one is still a novice). He asked Camilla to leave too, and resume their marriage. She refused, and, resisting pressure, managed to remain a nun.

Later that same year, Camilla made her second very public prophecy, shouting out in the cathedral in front of everyone that she saw a white bull trampling flowers, and that the bull would trample all Italy under his heels. This was three years into Rodrigo Borgia's papacy, so the meaning of a trampling bull was clear, but many in the coming years would talk of how Camilla predicted the then-still-veiled Borgia ambition to carve up Italy. The prophecy caused such a stir that Savonarola himself asked Camilla to make her prophecies more privately in future. She obeyed, but Savonarola visited her often and listened to her prophetic visions, and others made by her fellow nuns. Gianfrancesco Pico della Mirandola—nephew of our Pico—witnessed some of Camilla's prophecies, and wrote later that she had divine foreknowledge of Savonarola's sermons and their messages, and that she predicted Savonarola would be martyred, and when. In Savonarola's confession, made between his torture and execution in 1498, he named Camilla as

one of several women whose prophecies he had incorporated into his sermons alongside his own. Of the other named prophetesses, Vaggia Bisdomini and Bartolomea Gianfigliazzi, we know next to nothing, but they came from lower guild families whose women tend to leave few footprints in the documentary record.

These female mystics had a complex relationship with Savonarola and his *piagnoni*.[129] Female mystics were *extremely* influential at the time, drawing enormous crowds and wealth to cities, often called "living saints" (*sante vive*).[130] For example, at this same moment, the Dominican mystic Columba Guadagnoli of Rieti (1467–1501) was so celebrated that multiple cities in her home region of Umbria squabbled over her, each wanting her to come be *their* living saint.[131] The *piagnoni* were well aware that a charismatic prophetess could add momentum to their movement, but also that such momentum might be uncontrollable. And since powerful visionary women were often objects of fear and conflict with the established Church, visionaries like Camilla were the aspect of Florence's religious turn most likely to trigger a crackdown, or to be used as an excuse for it. Male leaders feared such women. Living proof of this was Sister Madalena of Santa Maria a Casignano, a charismatic and visionary nun of exactly the type to appeal to Savonarola's followers, but who *opposed* his reforms, and traveled to Florence specifically to speak against him.[132] Savonarola consistently encouraged Florence's female Dominican communities to live cloistered lives with minimal outside contact, even with relatives, priests, and friars—something practiced by some female orders of the day but not standard for Dominican tertiary* women, who modeled their lives on the celebrated tertiary Saint Catherine of Siena who had led a very public life.[133] Savonarola also encouraged female visionaries

* In monastic life, the *first order* means monks (or friars), and the *second order* nuns, both living in closed monastic institutions separate from the secular world. Mendicant friars of the first order might leave their monastery daily to work or preach out in the city, but still lived in a monk-only space. The *third order* (i.e. *tertiaries*) means lay brothers and sisters, who take less strict vows and lead more public lives, dwelling either in group communities open to secular visitors, or in secular homes (think of versions of Robin Hood where Friar Tuck starts out as a tutor living in Maid Marian's castle). Tertiaries were technically lower status, and wore different habits, but were particularly important in the new Franciscan and Dominican orders, with their focus on preaching and public outreach.

to report their visions only privately, to their priests or confessors (or him), and in public sermons talked about how often the devil deceives women with false prophecies, suggesting that he believed male prophets were more reliable. Historians debate the motives behind these statements. Did Savonarola genuinely believe God spoke mainly through men, the devil through women? Was this a political move, Savonarola joining the male *piagnoni* in seeking to maintain control? Or was this a defensive and caring choice, Savonarola fearing that the incautious public enthusiasm of women like Camilla might bring the wrath of Rome and other authorities down on Florence and themselves? Savonarola's final confession document—extracted through torture—is one of the main places where he says he acted on the prophecies of Camilla and similar women. Was this an addition demanded by his captors, who saw the opportunity to undermine female religious authority? An effort to protect male *piagnoni* from danger and expulsion, since nuns had more social protections than men? Or his own truthful acknowledgment of fellow visionaries?

Savonarola's death did not stop us from hearing Savonarola's voice, and it certainly did not stop Camilla. Her small nunnery remained a center of Savonarolan memory, protecting his relics and studying his sermons. She and others continued to make and record prophecies. Nor was hers a quiet house of isolated zealots hidden away—by 1500, two years after Savonarola's execution, well-connected Camilla and her enthusiastic sisters raised enough money to secure a valuable property just catty-corner to San Marco and build a grand new convent for Dominican nuns, Santa Caterina, named for Saint Catherine of Siena. Camilla became under-prioress and second-in-command, a position she held for the rest of her life. The nuns of Santa Caterina were major custodians of the legacy of Savonarola, even more so than San Marco, since the mainstream Dominican leadership worked hard to control and scatter the Savonarolan brothers, but did less to restrain the nuns. The nuns of Santa Caterina lived by illuminating manuscripts, painting (nearly a third of known female painters of the 1500s were Dominican nuns), and by printing books with their own printing press.

Camilla's Santa Caterina was only one of many places which nurtured Savonarola's legacy.[134] Right after his execution, powers in

the city had banished many of his *piagnoni* supporters and ejected others from office, but *piagnoni* from *ottimati* families remained powerful, and many Savonarolan brothers and sisters fled to establish new communities elsewhere. Even the friar's brother Maurelio Savonarola, a fellow Dominican friar then at San Marco, was banished but survived.[135] Many fled to Mirandola seeking the protection of our Pico's nephew, others to Savonarola's hometown of Ferrara, others to the well-established Dominican hub of Viterbo. In the next decade, Savonarolan ideas (often cautiously without his name attached) appeared in pamphlets and sermons in Florence and far beyond. A stream of self-proclaimed successors appeared across Italy, charismatic preachers, prophets, and visionaries claiming to continue the friar's message, to the dismay of authorities and, often, of surviving *piagnoni* who often disapproved of various would-be successors. Some such successors were suppressed by either Florentine, papal, or other authorities, but the movement continued. Meanwhile, in Florence, the *piagnoni* remained a political force, strengthened by its many *ottimati* members, and had such factional coherence independent of any theological ideas that in 1509 they were strategic in the city's reconquest of Pisa, and rewarded by the city with the return of the *Piagnona*, San Marco's peculiar-sounding "wailing" bell, which at Savonarola's fall had been arrested, flogged, and sentenced to fifty years of exile, the bell symbolizing the whole political party both in its banishment and return.[136]

Many Savonarolan successors were visionary women, like Camilla. One famous example, gorgeously examined in Tamar Herzig's magnificent study of Savonarolan women, was Lucia Brocadelli (1476–1544) a Dominican visionary and stigmatic from a wealthy family in Narni, north of Rome not far from Viterbo.[137] Her family married her to a count, who (desiring her large dowry and family contacts) agreed at first to respect her pious desire to remain a virgin after marriage hoping she would change her mind with time, but eventually became so frustrated by her conduct that he tried to imprison her, and, when she ran off and became a nun, he vented his anger by burning down the monastery of the prior who accepted her. After gaining visionary fame, she was sent to Viterbo to establish a new convent (the kind of movement

mendicant orders existed to facilitate), where she received visions and stigmata from 1496, and from 1497–9 Viterbo fought bitterly against Duke Ercole d'Este's efforts to recruit the living saint to bring her fame (and legitimacy) to Ferrara.[138] The duke triumphed, and the convent of Santa Caterina that Brocadelli came and founded in Ferrara was a model for the one Camilla soon founded in Florence.

But Brocadelli, like Savonarola and most mystics, proved ungovernable. By 1500, less than a year after coming to Ferrara, she reported a visitation by Savonarola's spirit; the famous Columba Guadagnoli of Rieti reported similar visitations around the same time, linking the dangerous charisma of the two women. Brocadelli proclaimed her Savonarolan enthusiasm even more clearly by recruiting the infamous friar's niece Veronica Savonarola to join her community in Ferrara, persuading her to take the name Sister Girolama in direct imitation of her (in)famous uncle.[139] In time, friction between Brocadelli, her fellow nuns, and the formerly-enthusiastic d'Este family led to her suppression and imprisonment within her convent, especially with the arrival in 1501 of the new duchess-to-be Lucrezia Borgia, who was excited at first about having a visionary nun in the city (Rome's Dominican convent of San Sisto had always been Lucrezia's haven in trying times), but *very displeased* to find Lucia echoing Savonarola's denunciations of Pope Alexander.[140] Lucia even reported a vision in which the soul of her dead aunt Concordia supposedly described Pope Alexander lusting after her and threatening to behead Concordia's father if he didn't bring her to satisfy the cruel pontiff's desires, a story clearly based on classical ones about the lechery of Emperor Tiberius, and the kind of thing which Borgia enemies—especially Julius—often used when fashioning the posthumous myth of Alexander's extreme evil.

Both for local authorities like the Duke and Duchess of Ferrara, and for centralized Dominican authorities, women like Brocadelli were dangerously powerful, a danger increased by the legal protections nunneries enjoyed, which required complex tactics. Lucia Brocadelli, for example, could not be directly arrested despite the anger of new duchess and duke, who could only get at her via internal convent politics, moving other nuns into the community who took their side against the mystic and imprisoned her via the

authority the heads of nunneries have over disobedient sisters. Silencing such women required finesse, but could be done with the right *grace,* so by 1505 most prominent Dominican Savonarolan visionary women had been effectively silenced from within by the anti-Savonarolan authorities who remained dominant within the Dominican order (still controlled by Cardinal Carafa, whose interrupted Annunciation surrounded by his coat of arms was *exactly* the kind of self-advertising art Savonarola railed against). But the Dominican crackdown could only control Dominicans, so Savonarola's ineradicable popularity simply spread to other orders, and other corners of religious practice.[141]

Camilla had been under-prioress of radical Santa Caterina for twelve years when the Medici returned. Lorenzo's heir Piero the Unfortunate had drowned fleeing a battle (unfortunate indeed), but Piero's sisters and especially his brother Cardinal Giovanni "Leo" de Medici still labored to reclaim the city. In 1512, the chaotic wars of bellicose Pope Julius (Battle Pope 2: None Shall Escape the Battle Pope!) were in their late stages, and the Medici cardinal lent his strength and clout to Julius and got what he wanted in return: a few of Julius's armies to threaten Florence with siege, unless they allowed the Medici to return.

The Medici who returned in 1512 were very different from those who had intermarried with the Rucellai decades before. Lorenzo's youngest son Giuliano (fourteen when he fled in 1492, now thirty-two) was not accustomed to the intricate web of Florence's families, or to shaking hands with fellow merchants in the streets. He was installed as lord of the city, since a secular city needed a secular lord, but the new regime was really controlled by his older brother the cardinal, who on Julius's death in 1513 became Pope Leo X (Medici Pope: Read Ovid Not the Psalms). The younger brother Giuliano, meanwhile, set off to France to advance the family's *noble* fortunes, securing from the king a French noble bride and ducal title (just as Cesare Borgia had done): Giuliano de Medici, *Duke* of Nemours and *Lord* of Florence, though not *Duke* of Florence, since Florence was still-ish a republic-ish, and the nine *priori* still existed, names drawn from a bag, serving their months up in the tower enacting the orders of the strong Medici pope. Leo X did persecute the Medici's adversaries in the city (both the anti-Medicean republicans and

the *piagnoni*) mainly through redistributing offices and some banishments. Some accounts describe him firming up his power but exercising less brutality than many feared, thus earning goodwill much as Francesco Sforza and Bianca Maria Visconti had earned goodwill by persecuting Milan's Guelphs less than expected.[142] Zooming in, though, much of his widely-discussed clemency was toward Florence's stronger families, whom he also made agents of his regime, a strategy which made the city's more powerful citizens complicit with and dependent on Medici power. Certainly the male *piagnoni*, especially those who reported visions of or otherwise mentioned Savonarola, suffered consistent and prompt arrests.

When Duke Giuliano de Medici died in 1516, control of the city passed to his nephew, young Lorenzo di Piero de Medici (1492–1519), son of the late Piero the Unfortunate, the eldest son of the eldest son of Lorenzo il Magnifico. Young Lorenzo di Piero had been two years old when his family carried him from Florence, but returned at twenty-two dressed like a nobleman in courtly style, with a French bride, and the title Duke of Urbino, which his uncle Pope Leo spilled much blood to take away from Francesco Maria da Montefeltro della Rovere (1490–1538, the adopted heir of Guidobaldo da Montefeltro and Elisabetta Gonzaga). This scion of Lorenzo the Magnificent had been shaped by royal courts, Rome, France, the Empire, east-facing Venice, and was more acquainted with the customs of distant monarchies than merchant guilds. In 1519, when Lorenzo Duke of Urbino died young with no legitimate son, Pope Leo's strength was enough to secure the succession of Lorenzo's *natural* son Alessandro de Medici (1510–37) whose mother was likely Simonetta da Collevecchio, a servant or enslaved woman of African descent.*

Through all these shifts, Camilla's nunnery of Santa Caterina thrived, still living by Savonarola's rules and treasuring his relics, printing, painting, and recording prophecies made by many sisters over the changing years, though keeping them semi-private, much as Savonarola himself had urged them to do (for their safety or his

* Some sources claim Alessandro de Medici was instead the *natural* son of Cardinal Giulio de Medici (later Pope Clement VII), but he was acknowledged by Lorenzo Duke of Urbino.

empowerment?) years before. As usual, the status of nunneries as separate spaces untouchable by secular (and male) power secured more protections for such women than for their male counterparts. In the same period that the male visionary Fra Spirito, from the Augustinian monastery of Santo Spirito (a few blocks west of Machiavelli's house) was repeatedly arrested for preaching that Savonarola's spirit had told him Florence gravely needed populist reforms,[143] the Medici treated the influential and well-connected nunnery of Santa Caterina as a friend, so much so that Lorenzo Duke of Urbino's only legitimate child, his little daughter Catherine de Medici (1519–89, the future Queen of France) spent time in Santa Caterina as a child being educated by the sisters, as young Lucrezia Borgia had at San Sisto. By that time, Camilla—still technically under-prioress—had moved even deeper into mysticism, delivering numerous ecstatic visions, usually discussed as "illness" in the few modern accounts which mention her, but they were enthusiastically recorded by her sisters, and Florentines outside the convent were eager to hear them as well.

Camilla died in 1520, only a month before the death of Leo X, but this was not the end of her political influence. Locals immediately began treating her as a saint, and spread accounts of her miracles, both prophecies which had come true, and posthumous visitations. One of the prophecies she had once shared with Savonarola was that Rome would fall, and this came true in 1527 with the sack of Rome by troops of Emperor Charles.[144] After Pope Leo's death, and the brief papacy of Adrian VI (more on him later), Leo's cousin and foster-brother Cardinal Giulio de Medici (whose father Giuliano was killed in the Pazzi Conspiracy) secured the papacy as Clement VII, continuing Medici power but in a reduced way, since Clement now had to be in Rome, leaving a less powerful head of Medici affairs in Florence itself. Clement angered many in Florence, both through his and his subordinates' handling of internal strife and policy (including arrests of *piagnoni*), and through his external policy, especially his choice to ally with Spain and the Empire against Florence's preferred long-term ally France (all those gold-on-blue fleur-de-lis aren't still in the Palazzo Vecchio for nothing). Historian Lorenzo Polizzotto paints a vivid portrait of the day-by-day

erosion of support for the Medici over the course of 1526–7: small errors in domestic policy enraging people, radical preachers or others speaking out in squares sparking sudden chants of anti-Medici slogans, and frightening news making the people doubt whether the Medici could protect them as French and imperial armies prepared to fight each other inside Italy yet again.[145] For the *piagnoni*, the hope for transformation was strengthened by fresh Savonarolan visions, and the increasing sense that the early deaths of Giuliano Duke of Nemours, Lorenzo di Piero, and Pope Leo were Providence showing Heaven's displeasure with the Medici. News of religious reform gaining momentum across the Alps also felt to many *piagnoni* like confirmation, especially as Luther and other reformers embraced Savonarola as a predecessor, Luther himself in 1523 editing and printing *The Pious and Erudite Meditation of Girolamo Savonarola, burned by the Pope, on the Psalms "Miserere mei" and "In te Domine speravi,"* a selection of Savonarola's commentaries with an introduction by Luther arguing that Savonarola's interpretations strengthened his idea of *sola fide* (salvation by faith alone).[146] Finally, strife arose between French-allied Pope Clement and Emperor Charles, the grandson of Emperor Maximilian Habsburg and of Ferdinand and Isabella of Spain, so ruler of Spain and Germany. Pope Clement switched back to France's side, a reversal ensuring neither of the great transalpine powers really liked or trusted him. As once again great armies camped near Florence, the city felt under-protected by a Florentine but unreliable pope, and made one attempt to expel the Medici early in 1527, even before the Empire's now-Protestant soldiers marched on to do the once-unthinkable and sack Rome itself. The sack—substantially the Medici pope's fault—shattered Medici power in Italy for a time, just as the fulfillment of Camilla and Savonarola's prophecy of Rome's fall rekindled enthusiasm for Florence's unofficial saints. The Medici rulers of the city, teen-aged Alessandro and his aide Cardinal Passerini (who wasn't even Florentine), fled the city, triggering the strangest chapter yet in Florence's long history: the Last Republic.

You will not find chapters on the Last Republic in most overviews of Florence or the Renaissance. It is a blip, a little tremor in the needle, doomed from its inception, with a Medici still on

Saint Peter's throne. It only lasted four years, after all, 1527 to 1530. *But isn't that the same length as Savonarola's republic which is the subject of book after book?* It is, while this one gets attention in Eric Cochrane's *Florence in the Forgotten Centuries* and Nicholas Scott Baker's *The Fruit of Liberty*, brief chapters in some overviews like my friend Larry Rothfield's *The Measure of Man*, and John N. Stephens' incredibly hard to find *The Fall of the Florentine Republic, 1512–1530*, plus Stefano Dall'Aglio's and Francesco Polizzotto's books on Savonarolan successors, but in most histories of Florence it is invisible.[147]

What was the Last Republic? Not what we moderns want to see. We want a resurgence of proto-democracy, a defiant final anti-monarchal resistance, a foreglimpse perhaps of how Renaissance ideas will blossom into the Enlightenment once tyranny is overthrown. It was some of those things. It welcomed home many people the Medici had exiled, and restored power to many guildsmen blocked from office for opposing Medici power. It tried to ban citizens from holding noble titles (like Duke of Nemours or Duke of Urbino). It reinstituted the legal appeals process Savonarola had tried to implement. It set up a new Great Council based on Savonarola's council of 500, greatly expanding participation in the government. A moderate standard-bearer of Justice, Niccolò Capponi (a kinsman of the Capponi who threatened that if the French blew their trumpets, Florence would ring her bells) tried to secure the republic by placating Pope Clement at a distance, but was expelled for doing so and replaced by a more radically Savonarolan one.[148] And, for the first time, Florence's ruling body solicited, discussed, and frequently followed proposals made by women... specifically by the nuns of Santa Caterina, who were still relating visions, especially visions of Savonarola returning to reveal to them how Florence should be run.

That's what's so off-putting. The Florentine Republic, birthplace of Bruni's history, of Machiavelli's *Prince*, was free again to rule itself, and chose to become *more* Savonarolan than when Savonarola was alive, basing real policy decisions on ecstatic women having visions of a now *dead* monk and his *dead* nun friend, as well as embracing male visionaries, especially one Pieruccio *dei poveri* (of the poor) who advanced Savonarolism even in the

anti-Savonarolan rival monastery of Santa Maria Novella (the one whose modern brochure says they had *nothing to do with that man!*) via a confraternity it housed.[149] The austerity returned, the crowds at sermons, the restrictions on prostitution and gambling, the heady talk of destiny. Florence was chosen once again, an Ark of faithful coasting through the European storm, trusting its governance to God more literally than ever, since, inspired by a vision of one of the nuns, on February 9, 1528 the new Great Council held a formal vote electing Jesus Christ to be King of Florence in perpetuity, with only twenty votes against.[150]

One must wonder about those twenty votes (anti-theocratic republicans? Medici partisans? curmudgeons? not-so-closet atheists?), but while there were dissenters in the city, the fact remains that liberated Florence—cradle of the Renaissance, of republican democracy, individualism, capitalism, secularization, of all the thrilling X-Factors—chose to welcome elements of mystical theocracy. *Again.* Savonarola's years weren't a lone blip; Florence

Inscription over the Palazzo Vecchio entrance declaring Christ King of Florence "Rex Regum et Dominus Dominantium", added during the Last Republic, 1528. Note the Guelph/French gold fleur-de-lis on blue, and in the center the Coat of Arms of Christ designed by Franciscan Bernardino of Siena (later adopted as a Jesuit symbol), positioned to prevent any specific family's crest from ever hanging there.

chose it *again*. Prophecies, visions, mystics guiding the choices of those in power, instinct wants to call these things medieval, backward, everything the Renaissance should leave behind. If *other* cities competed to lure charismatic living saints like Camilla or Lucia Brocadelli, one can still try to claim the Renaissance's new rational turn hadn't penetrated *those* places yet; not so when Florence does it, our celebrated epicenter. The progress narratives which claim that modernizing changes (expanded the franchise, legal reform, anti-corruption, female empowerment) should come hand in hand with secularization fall apart.

Florence's Last Republic, 1527–30, is uncomfortable the same way Camilla Bartolini Rucellai is uncomfortable. We want Renaissance women to be powerful. We celebrate when we find them heading families, delivering orations, planning engineering projects, or helming states. As a key influence on Savonarola, and as founder of Santa Caterina and the prophetic role model of the Savonarolan sisterhood that semi-helmed the theocratic Last Republic, Camilla had more political power (more *grace* with the Florentine state) than Alessandra Strozzi, more perhaps than any Florentine woman who wasn't born or married to the surname Medici. But it's not a kind of power we find comfortable. Camilla's power was not wealth and savvy investment (proto-capitalism), or the classicism of the *umanisti* (the learned Renaissance woman), nor was she breaking into male-dominated spheres like our *virago* Caterina Sforza, or even excelling in the female-dominated spheres of motherhood and charity that both eras (past and present) respect. Camilla turned her back on all those paths, and wielded spirituality at its most mystical. That makes us—in our new millennium as we look to the Renaissance to find the roots of our modernity—uncomfortable.

It made the nineteenth century uncomfortable. To early historians like Villari, and to George Eliot writing her influential Renaissance Florence novel *Romola* (1863), Camilla's ecstatic visions seemed like what medicine then called hysteria. Their depictions (fiction and nonfiction both) shaped the next round of histories, which often leave Camilla out entirely, focusing on more charming figures like Pico when treating Savonarola's

influences. Even in today's History Lab, when histories touch on Camilla they tend to call her visions illness or madness, and present her as a delusional fanatic who bullied her reluctant husband into joining the Savonarolan wave.[151] Savonarola works as hero or villain, depending on your Renaissance, but Camilla, like the Last Republic, just—to modern eyes—chose wrong.

We sometimes respect the kind of choice Camilla made. We respect it in medieval mystics. We respect it in Saint Catherine of Siena (1347–80), the namesake of Camilla's monastery, a woman whose life overlapped with Petrarch's, and whose visions were so popular that the Dominicans assigned men to follow her around and write down her sayings, since she did not learn to read and write herself until her last two years of life. But we respect Saint Catherine, other mystics, even Joan of Arc, largely because (A) they *were* medieval, doing what we're told medieval people should, and (B) visions and devotion were a path to female power open, not just to queens and wealthy matrons, but to the powerless, to poor, illiterate girls. It makes us hopeful, knowing, even back then, there was one ladder female excellence could climb. It feels very different with rich, elite Camilla Rucellai, who *had* power, who *had* her banking empire like Alessandra Strozzi, and education, access to the *umanisti*, Greek and Latin, yet turned her back on it. Camilla Rucellai is the opposite of glitter and romance. She rejected what our galleries and novels celebrate about the Renaissance to walk the (medieval) mystic path our progress narratives told us should fade away. She didn't fade away. She ran a printing house, but published mystic pamphlets where we hoped for Sapphic odes. And Florence listened to her. In the very years that Venice was ignoring Cassandra Fedele, leaving her in poverty until her nineties, Florence valued Camilla and her visionary nuns, and valued them *more*, not less, as decades passed.

In Petrarch's day there were (precise numbers are hard) around thirty nunneries in Florence, a few big, most small. By 1520, when Camilla died, there were at least a hundred, some grand like Camilla's Santa Caterina and Alessandra Scala's San Pier Maggiore, but many tiny, with just a couple sisters in a house, like the first one Camilla founded in that building which was likely part of her dowry. The surge of new ones was in many ways

an arms race: when plagues intensify, and wars of Battle Popes grow worse, you appeal as hard as you can to the celestial patrons who have *gratias* in the Court of Heaven, where the outcomes of battles are decided. Nothing gets the attention of a saint like prayers from nuns. In maps of Florence, you can see that the nunneries cluster around the city's gateways, as if to reinforce the fortifications with prayer, and cleanse arrivals of plague while showering blessings on the brave who venture forth. An increase from thirty to a hundred nunneries is not the investment of a society that's becoming more secular.

I am not saying the Renaissance was growing *more* religious than the Middle Ages. This too is Ever-So-Much-More-So: Florence of 1520 had more money, and more problems, and more widows, so more nuns. Nor am I saying there was no secular thought happening: as Camilla was working to found Santa Caterina, Machiavelli was giving readings from his radical *Discourses* in the gardens of Camilla's cousin-in-law Bernardo Rucellai. These things were happening in the same place, at the same time, among the same families, a weirder and more plural Renaissance than we were promised, which will never let us end the sentence "Renaissance people believed X" with any single X. That should not surprise us. Our modern age is just as plural: secular, religious, many secularisms, many religiosities, all thriving and competing, all at once. It was the nineteenth-century idea that each age had one defining spirit which made the Renaissance feel simpler than the present. We were told of one great movement growing toward its mature form (modernity), reducing other modes of thought to remnants, as an oak seedling reduces lesser trees to spindly undergrowth, surpassing all in reaching toward the light. Instead we have a tangled grove. Alessandra Scala in her rich, old Benedictine nunnery, and Camilla Rucellai in her radical new Dominican one, were as different from each other as the old-fashioned Dominicans of Santa Maria Novella from *that man!*, and all of them different from patriotic Machiavelli, and poetic Poliziano, and phoenix-brief Pico, and pious Raffaello Maffei, and proudly tresticular Francesco Filelfo.

What ended the Last Republic?

You know what must end it: power, wealth, a Medici pope still on Saint Peter's throne who wants *his* city back. Clement switched sides again, making friends with the imperial army that had sacked Rome, and Emperor Charles lent those forces to besiege Florence. Nine months of resistance, October 1529 to August 1530, and the city surrendered. There were some executions of resistance leaders (not the nuns, of course), but no sack, since the conquering Medici wanted Florence intact. But it was a conquest this time, with Emperor Charles's intimidating mercenaries quartered in the city to strangle resistance. There would be no balance anymore, no playing citizen, no drawing names from bags to pick the Nine Dudes for the Tower as they had since 1250 through plague, and war, and many, many Medici. In 1532, Pope Clement and Emperor Charles made young Alessandro de Medici duke, not Duke of Elsewhere like his father and other past Medici, but the first Duke of Florence. The last nine *priori* chosen by lot were kicked out of the Palazzo Vecchio, which became the ducal palace. Male *piagnoni* were removed from office or worse, male mystics silenced, but even still, the conquerors didn't dare hurt nuns. The sisterhood of Santa Caterina continued writing, printing, painting, but kept their Savonarolan visions quieter, mostly among themselves, as Savonarola had advised decades earlier. Art and literature continued to be made, but for dukes now, not competing merchant families, art with a very different character, expressing power, conquest, and force. A republic no more.

We knew it had to end. With the Medici so strong, it had to end, just as Alessandra Scala had to die someday inside her nunnery, we knew that when she joined it, she knew that. Yet, if we don't fast forward, if we zoom in, we find a messier, more plural Renaissance, with strange new people in it like Camilla Rucellai and the many Florentines who heeded her in life and death—a Renaissance which defies efforts to claim there was one spirit, one anything, which defined this time and place, or any time and place.

42

Michelangelo: The Great and Terrible

If Michelangelo had a bumper sticker, it would read: *I'd Rather Be Sculpting.*[152]

Michelangelo Buonarroti (1475–1564) is an intimidating figure for me to treat, since so much has been written about the platinum mega-stars of Renaissance painting.[153] I considered many other possible friends for our list, people more in my comfort zone (Cassandra Fedele, Lucrezia de Medici Salviati, Beatrice Twice Queen of Hungary, Renaissance Man™ Leon Battista Alberti, Aldus Manutius the printer, Camilla Pisana the courtesan, John Argentine the necromancer and doctor to dead princes, Pius II the pornographer pope, imprisoned Sultan Cem, long-lived Cardinal da Costa, dear Pietro Bembo, many more). But since artists dominate most modern people's first encounters with the Renaissance, I want you to see how an artist's life, which we usually glimpse as fragments on museum labels, braids among the rest. This will not be an art-focused account of Michelangelo, but event-focused, his path through the webs of power that also held our princesses, scholars, monks, nuns, and assassins. Just as books that cost as much as a house only existed where wealth supported them, a statue required a patron rich enough to support that sculptor's workshop, and all such patrons—be it a duke, abbey, or wealthy banker—were high elites, thus part of the bloodstained web of power that no sculptor could escape. Michelangelo never escaped; his life was such a constant battle with coercive patrons dragging him from home that his last wish was to be buried in Florence, so he could at least see the great dome one last time when he rose on Judgment Day.

Michelangelo's father, Ludovico di Leonardo Buonarroti Simoni, was (like Savonarola's father) an unsuccessful merchant banker, but with lofty ideas about the family being descended from the noble Counts of Canossa. Michelangelo's mother Francesca di Neri del Miniato di Siena was a distant Rucellai cousin, but so poor that the only dowry her father could offer was his house, which the couple inherited after his death and rented out for the cash. Both parents were Florentine, and Michelangelo grew up in Florence, but he was born while his father was briefly working in the town of Caprese, which has since been renamed Caprese Michelangelo to encourage tourists. There were eleven kids in the Buonarroti house in Florence, which Michelangelo's father shared with his married brother (double Buonarrotis), and the family was just low enough on the (still middle-class) economic ladder for our records to make it hard to sort siblings from cousins (paper trails cost $$ just like books).

Michelangelo was sent to start a merchant education, but preferred sketching and hanging out with artists, so—with many sons to employ—his father grudgingly apprenticed him in 1488 (at age thirteen) to master painter Domenico Ghirlandaio (1448–94). Ghirlandaio was a splendid artist, brilliant at complex multi-figure fresco scenes and warm, human facial expressions. His fame caused Pope Sixtus IV to call him to Rome for a time to help decorate his new Vatican chapel, soon to be known as the Sistine Chapel. In Florence, Ghirlandaio frescoed the Sassetti Chapel in Santa Trinita, and the Tornabuoni Chapel in Santa Maria Novella (whose Dominicans would soon have nothing to do with *that man!*). Both chapels were made for Medici allies, so they include many portraits of Medici family and friends including Ficino, Poliziano, and Lorenzo's sons Piero the Unfortunate and Ovid-reading Giovanni "Leo."* Ghirlandaio's studio was thus a natural place for Lorenzo to turn when he needed artists.

* The many portraits of rich families in these frescoes in Santa Maria Novella and Santa Trinita, which advertise power, lavish garments, and patronage networks, make even clearer how atypical are the starkly religious and apolitical frescoes painted by Fra Angelico in San Marco, a place already atypical among Florentine monasteries in its rejection of worldly representations and merchant life, well before Savonarola came to Florence.

Even at age thirteen, Michelangelo would rather be sculpting. The Medici owned a garden near San Marco, filled with ancient statues which artists (including, earlier, young Leonardo) gathered to study. Young Michelangelo practically lived in that garden, neglecting Ghirlandaio's studio. One frequent sight as he worked was Savonarola, since the friar moved into San Marco the same year Michelangelo started hanging out in the gardens right outside the front door (1490), so our young sculptor watched the growing crowds and influential friends stream in and out.

The most famous story about these days in front of San Marco first appeared in 1553, when Ascanio Condivi (1525–74) wrote a biography of Michelangelo (then in his eighties). Condivi says that, back in 1489, Michelangelo (then thirteen or fourteen) was there carving a stone copy of an ancient satyr's head, embellishing the original closed-mouthed design by sculpting an open mouth full of teeth. Lorenzo de Medici, strolling by, teased the boy for giving an old, wrinkled satyr a mouth full of perfect, youthful teeth; Michelangelo quickly carved one of the teeth away, and this so impressed Lorenzo that he invited Michelangelo to join his household. This dubious anecdote does not appear in Michelangelo's own account of his life, or in Vasari's 1550 first edition of his *Lives of the Artists*, but Vasari added it to the 1569 revision (after Michelangelo's death) with the (invented) detail that this was the first time Michelangelo had ever carved marble, true proof of "the Divine" Michelangelo's prodigy status.

Whether we accept this delicious origin myth or no, Michelangelo did live with Lorenzo from 1490 to 1492, and Lorenzo even gave Michelangelo's impoverished father a job (thanks, patronage!). The Medici household was full of kids around Michelangelo's age: he was younger than Lorenzo's eldest children Lucrezia, Maddalena, Piero, and their cousins Giovanni and Lorenzo di Pierfrancesco (who had earlier sued Lorenzo over their inheritance), but just the same age as young Giovanni "Leo" (already on track to become a cardinal), and a bit older than Luisa, Giuliano, and their cousin and foster-brother Giulio (the posthumous son of Lorenzo's murdered brother). Young Michelangelo likely shared some of the Medici kids' lessons, and, on days when he arrived for dinner on the early side, he would have sat closer to Lorenzo at that chaotic self-seating

table than the Medici kids. There, the teenaged craftsman sat between ambassadors, philosophers, book-dealers, musicians, merchant princes, and Medici clients, including certainly Bartolomeo Scala, whose daughter Alessandra was exactly Michelangelo's age, and starting to study Latin with Poliziano and Greek with Janus Lascaris, another frequent Medici dinner guest.

Many have puzzled how Michelangelo's paintings can contain such sophisticated Neoplatonic philosophical themes when he could not read Latin, but how could he *not* pick up Neoplatonism hearing Ficino and Poliziano chat meal after meal with guest scholars, their Medici pupils, and even Pico frequently at meals?[154] The kind of mixing that happened at Lorenzo's table, and in the sculpture garden outside San Marco, was core to the classical revival: whether in rich men's homes, or while exploring ruins or planning projects, artisans with practical training mixed with educated scholars and poets, exchanging observations, theories, sketches, and objects (excavated artifacts, coins, sketches, transcriptions). Such encounters often triggered invaluable epiphanies: "I read this neat description in Pliny this morning." "Whoa, I saw exactly that while digging a basement!" Remember that long phase in Norse studies when the archaeology and literature departments didn't talk to each other, and the burst of progress when the barrier broke? Just so, the barrier between the carvers and diggers who used their *hands,* and the learned men who read *books,* broke down when projects or patronage gathered such men together in what the brilliant historian of science and ideas Pamela Long has called a "trading zone."[155] The painter, architect, scholar, poet, and often the patron too had equal interest in examining a recently-unearthed statuette, sketching and measuring the lines of an ancient foundation, visiting Hadrian's villa, or climbing down into the Golden House of Nero when it was discovered. When we see Michelangelo or his contemporaries use ancient pigments not used in the Middle Ages but described *in Latin* by Pliny or Vitruvius, we see the direct fruits of the precious "trading zone." Raphael used them, for example, in his Cupid & Psyche frescoes in the Palazzo Farnesina, and Raphael also went on picnics to Roman ruins with scholars including Castiglione and Pietro Bembo.

Nor did this commerce of ideas, objects, and application always result in derivative imitations of ancient things. Just as *umanisti* combined Latin irregular constructions Cicero would never have squeezed together, Renaissance artists often produced hybrids antiquity would have found quite alien, such as using the profiles on coins as models for large-scale relief busts in profile (like the one that made Beatrice Twice Queen of Hungary look chubby). Hilary Barker, a brilliant young art historian and student of mine and Niall Atkinson's, is working on a project on how, since ancient sites contained chunks of buildings built centuries apart all jumbled together, Renaissance people using these as models when designing a tomb, palace, etc. mixed elements of many eras of ancient architecture together, in a way that looked ancient to Renaissance people, but to an ancient Roman would look as improbable as a glassy skyscraper with art nouveau trim sitting on a Victorian red brick base—improbable but beautiful.[156] Renaissance monuments are the fruits of this antiquarianism shared among learned and artisan cultures, personified by hungry young Michelangelo listening at lunch as Poliziano and Lorenzo discuss the meaning of a motto on a newly-found coin with travelers fresh from Aragon, Sardinia, and the Balkans.

In 1492 Lorenzo de Medici died, and his heir Piero *immediately* evicted the young art prodigy his father had so favored.[157] Michelangelo returned to his father's home, studied anatomy by dissecting corpses in the hospital of Santo Spirito (paying in kind by carving them a crucifix), and bought a block of stone with his own money to try his first large statue, a Hercules, later purchased by the Strozzi family for the still-under-construction Palazzo Strozzi that Alessandra Strozzi's son Filippo started building after his return from exile. In January 1494 there was heavy snow, and Piero de Medici commissioned Michelangelo to sculpt a colossal snow figure, Michelangelo's first paid commission, after which Piero invited him back to his old room in the Medici house.

Fourteen ninety-four was not a good year to join the household of Piero de Medici. Things were falling apart: Savonarola rising, the French approaching, Poliziano and Pico suspiciously ill after a meal with Piero, and, after hearing a particularly apocalyptic Savonarola sermon, Michelangelo left the threatened republic

and fled to Venice (all the cool kids flee to Venice), then moved to Bologna where he worked on sculptures for the tomb of Saint Dominic. Michelangelo later claimed that his flight from Florence was triggered when a musician in the Medici house had a dream, in which Lorenzo's ghost appeared in rags, warning that his son would soon be expelled—Piero de Medici had laughed when the musician related the dream, Michelangelo said, but he took it seriously. This could be an invention to excuse Michelangelo's rather cowardly flight from the city in her time of need, though someone in Palazzo Medici having such an anxiety dream as the French approached is wholly plausible.

Late in 1495, Michelangelo (twenty years old) returned to a now-Savonarolan Florence, working for those Medici cousins Giovanni and Lorenzo di Pierfrancesco *i Popolani*. The latter commissioned a classically styled sleeping cupid, and had Michelangelo give it fake damage to pass it off as a rediscovered antique, which would fetch a far better price than any new statue. In that guise it was sold to young Cardinal Raffaele Riario (the nephew of not yet Battle Pope 2 Giuliano della Rovere, whom Lorenzo had rescued after the Pazzi Conspiracy). Cardinal Riario saw through the deception, but was charmed enough to invite Michelangelo to Rome, where the architectural ambitions of competing cardinals offered far more employment than Savonarola's Florence. There, in 1497–8, Michelangelo established a reputation as the greatest sculptor of his day by completing his *Pietà* (now in Saint Peter's), commissioned by Jean Bilhères de Lagraulas, an agent of King Charles and the main liaison between the king and Pope Alexander VI during the invasion. That Michelangelo carved his name prominently on the Virgin's girdle was unusual (some said arrogant) in a period when few sculptures were signed, though even more unusual was the contract for the commission, in which Michelangelo promised that the work would be the best sculpture ever seen in Rome—the client did *not* demand his money back.

After the execution of Savonarola in 1498, Michelangelo returned to the new republic led by Piero Soderini. Florence's mighty cathedral, which Michelangelo adored, was now starting on its façade, and the committee commissioned Michelangelo to

make a colossal statue of King David, one of many giant-sized statues intended to be positioned far up on the cathedral face (where the hands and facial features would have to be extra deep and exaggerated to be visible at such a distance). David had long been a favorite subject of Florentine art (undertaken by Donatello, Verrocchio, and others), since the little republic surrounded by gigantic kingdoms liked to compare itself to little David against looming Goliath. You know these decades well enough by now to understand how powerful this image was when Michelangelo began work in July 1501: The Borgia conquests and the second French invasion had begun. France's new King Louis XII had captured Florence's neighbors Milan and Genoa, imprisoning Duke Ludovico Visconti Sforza, and France was now preparing to march through Tuscany toward Naples. Pope Alexander had just crowned Cesare Valentino Borgia Duke of Romagna, after a string of conquests including Bologna (ousting the Bentivoglios), Imola and Forlì (capturing Marullo and ferocious Caterina Sforza), and Pesaro (ousting Lucrezia's first husband Giovanni Sforza). Meanwhile, exiled Piero de Medici, eager to retake *his* city, was gaining strength through friendship with King Louis, and his brother Cardinal Giovanni "Leo" de Medici was back in Rome exerting influence. All this left Tuscany a bite-shaped hole in the side of the growing Borgia kingdom, and directly in the path of France between Milan and Naples. As Michelangelo and his assistants shaped the marble *David* month by month, news streamed in of sieges, rebellions, reconquests, sacks, and ever-shifting sides, while Florence's government raced to court the friendship or deflect the attentions of giant powers they could not face head-on.

By the time the statue was complete, the Borgias had fallen, Lorenzo's heir Piero had drowned, and the fleeting papacy of Pius III had given way to Julius II. It was in January 1504, early in Julius's reign, as the city waited to learn just how warlike this second Battle Pope would prove, that Michelangelo's innovative *David* was unveiled, depicting the young king, not in the tranquility of victory with Goliath's severed head at his feet, but *before* the battle, his tense expression inviting the viewer to imagine his thoughts as he planned for the crisis to come. The image resonated with the city, and all agreed it was too excellent to put way

David in its original position by the Palazzo Vecchio.

up on the cathedral largely out of sight. One of the most epic committees in Earth history—including Botticelli, Leonardo da Vinci, Perugino, Filipino Lippi, Ghirlandaio's surviving brother Davide, and Giovanni Cellini (father of the implausibly interesting Benvenuto Cellini)—was tasked with choosing a fitting spot for the statue. They chose the most prominent place possible: right in front of the gates of the Palazzo Vecchio, as a permanent avatar of Florence.

Michelangelo had also been commissioned to carve twelve marble apostles for the cathedral, and the delighted city now offered him the incomparably prestigious commission (acclaim! honor!) of frescoing one wall (*painting?* ugh...) of the *Hall of the Five Hundred* that the Savonarolan republic had added to the Palazzo Vecchio to hold its new huge council.[158] Leonardo da Vinci was tasked with the other wall, and if they had both finished their tasks, that room would now be the most thronging tourist destination on Earth, but Leonardo tried an experiment with wax which made his fresco melt off, and Michelangelo left

for another commission: to spend five years designing and carving (*no paint! just sculpting!*) forty (*count them, forty!*) marble statues for the staggeringly ambitious tomb Pope Julius was planning for himself (Battle Pope 2: Posterity Will Gaze in Awe Upon the Resting Place of Battle Pope!). And the tomb would have the greatest possible venue: Saint Peter's Basilica, not the thousand-year-old basilica Constantine built, but the new replacement which Nicholas V (the first Renaissance pope to attempt big changes to rebuild Rome's glory) had proposed as far back as 1450, and which imperial Julius now planned to make the supreme church of Christendom, outshining even Florence's great dome. This began what Michelangelo called "the tragedy of the tomb" which would dominate his life for forty years (and leaves us with a count of two unfinished projects so far, the cathedral apostles and the Palazzo Vecchio room; let's watch that grow).

All descriptions of Giuliano della Rovere confirm that *Il Papa Terribile* ("terrible" in the sense of Ivan the Terrible, awe-inspiring, overmastering, conquering) was as possessive and controlling toward artists and courtiers as toward cities and provinces. In Michelangelo's case, Julius's obsession is hard to describe with any word but *stalker*. Michelangelo signed the tomb contract in 1505, and went to Carrara for eight months to get the marble. The 1,000 ducats ($1 million) Julius gave him for the costs proved insufficient, so he paid extra out of pocket, trusting he would be reimbursed. When he returned to Rome, the pope refused to pay him back. The quarrel intensified, Michelangelo venting those passions which made friends and rivals alike call him *terribile* just like the warrior pope, and Julius retaliated by refusing to even let Michelangelo see him. So, Michelangelo sold his house in Rome and crept out of the city in secret, riding breakneck until he reached Florentine territory, then resting at a hostel. His caution was wise: that night armed men sent by the angry pope burst into the inn, threatening him and demanding his return, and only the presence of witnesses and the threat of Florentine law protecting a native son saved Michelangelo from being dragged to Rome by force.

Michelangelo took refuge in Florence, but over the next months wrathful Julius sent increasingly ferocious demands for his return,

and—as Michelangelo described in letters—by summer 1506, Soderini, leader of the republic, told the artist he was not willing to go to war and risk the nation for a single man. Michelangelo considered evading the pope by accepting a commission to go to Constantinople to design a bridge for Sultan Bayezid II, but he was persuaded to surrender by Julius's long-time stooge and secretary, the infamous Cardinal Francesco Alidosi (1455–1511, whose dramatic murder will be a plot point in a few pages).

By autumn 1506, Julius had conquered long-defiant Bologna (again ousting the Bentivoglios who had returned since the Borgias' fall), and Michelangelo (with solemn promises of clemency) went to Bologna to formally beg the pope's forgiveness on his knees. (Yes, this is a technically *free citizen* of a *different country* begging forgiveness for the crime of *going home*.) Michelangelo's account of his surrender describes a monsignor at the audience attempting to protect him from the pope's wrath by saying that artists are all ignorant (mere craftsmen), and that Julius was so angry at the man for insulting *his* Michelangelo that he had the monsignor violently beaten and driven out of the audience chamber. Julius pardoned Michelangelo, but ordered him to stay in Bologna and create a giant bronze statue of the conquering pope (in which Julius asked to hold a sword, not a book). The statue was finished in 1508, but (jumping ahead a bit) in 1511, when the Bentivoglios took the city back from Julius again, they melted the statue and made the bronze into a cannon, named "la Julia," a good example of how the political nature of Renaissance art often led to its destruction.

After finishing the giant bronze Julius in 1508, Michelangelo managed a few months' respite in his dear Florence, but the pope commanded him to come to Rome to work on the tomb. When he arrived, *Il Papa Terribile* instead ordered him to postpone the tomb, and to fresco (*painting! nooo!*) the enormous barrel-vaulted ceiling of the chapel Julius's uncle Sixtus had added to the papal palace. Some claim that forcing the sculptor to paint was suggested by other artists he was feuding with—especially Bramante—who wanted to frustrate Michelangelo by keeping him from doing what he was best at, but, whatever the cause, one could not say no to Julius II, especially not in 1508 as the warrior pope was forming all the crowns of Europe into the League of Cambrai to invade Italy and

attack defiant Venice. At one point, when Julius and Michelangelo quarreled over the sketches which the willful artist refused to show even to his patron, the pope physically beat him with a staff.

Let's pause for a few minutes in the Sistine Chapel of our minds' eyes, since it's impossible to pause in the real one with its ceaseless stream of tour groups (don't get me started on how doomed you are if what you're there to study is the Sistine Chapel floor). Like most Italian churches (and unlike gothic cathedrals, for example), the Sistine was designed largely blank, not ornamented by the architect, but a canvas designed to be filled in by later generations. Sixtus IV built it (Battle Pope 1), and had the mid-level walls (above head height) frescoed with the lives of Christ and Moses. The lower walls he had speedily painted with fake drapery, a quick placeholder for later real tapestries, which would provide winter insulation. The wall frescoes were done in the 1480s by Botticelli, Perugino, Cosimo Roselli, and Michelangelo's teacher Ghirlandaio—these Florentine artists with Medici connections working for Sixtus so soon after the Pazzi Conspiracy was certainly arranged by Lorenzo de Medici, part of his effort to un-burn bridges between Florence and Sixtus's faction. The chapel's mosaic floor—like many in the Vatican—has spiraling patterns in colored stone, including costly purple imperial porphyry and green porphyry (lapis Lacedaemonius) looted from ancient Roman sites, since these rare stones came from distant mines inaccessible in the Renaissance. The original ceiling was painted lapis lazuli blue with stars, like those we see today in the Basilica of Saint Francis in Assisi and the Sainte Chapelle in Paris, but Julius determined to further glorify his uncle's chapel, so had Raphael design the long-planned tapestries for the lower sections (these were looted and scattered in 1527), and ordered Michelangelo to do a more ambitious ceiling.

If you've spent time looking at the Sistine ceiling as a whole (not just the famous bits), you may have noticed some odd things.

One is that, around the edges, the images of Old Testament prophets alternate with Greek pagan prophetesses: the Persian, Erythraean, Delphic, Cumaean, and Libyan sibyls. Why are priestesses of Apollo in this extremely Christian space? The short answer is Ficino: those lunches in Lorenzo's house, plus Julius's

enthusiasm for Roman antiquity. Ficino had that theory, sometimes confusingly called the "secular revelation," that ancient philosophers and prophets were another channel of divine truth, a second revelation parallel to the Hebrew Old Testament. (Remember Saint Augustine saying Vergil was a "Gentile prophet?") This idea was popular with figures like Julius, who wanted to claim the glories of both Christian and pagan imperial Rome. In the 1480s similar sibyls, as well as Socrates and Hermes Trismegistus, had been included among Old Testament kings in the floor decorations of Siena's cathedral, and in the 1490s Filippino Lippi had painted a version in Rome (clearly an influence on Michelangelo's) on the ceiling of the Carafa Chapel in Santa Maria sopra Minerva (above the interrupted *Annunciation*). In Michelangelo's version, the distribution of sibyls matches Ficino's idea that each region of antiquity had a different oracle to convey the divine message, and the stages of creation in the center of the ceiling are even slightly out of order (the creation of the planets and the separation of earth from sea are reversed) in a way which matches Ficino's efforts to reconcile Genesis with the version of creation described in Hesiod's *Theogony* (*c.*700 BCE). In today's Vatican, this celebration of pagan sibyls is only a few chambers away from a slightly later room whose ceiling depicts a statue of Hermes shattered on the floor and a cross taking its place, an amazing glimpse of how the Catholic Church's stance on paganism flip-flopped with the temperaments of popes.

Another odd thing about the Sistine Chapel ceiling is that the creation story skips straight from the expulsion of Adam and Eve from Eden to Noah and the flood, skipping Cain and Abel and other well-known stories, and culminating with the episode (rather obscure today but considered important in the Renaissance) of the Drunkenness of Noah. In this story, old Noah got drunk and fell asleep, and his sons pulled the blanket off him and laughed at his naked aging body. Why is this here? Likely because of Julius. A period interpretation of the Drunkenness of Noah considered it the last stage of creation: the creation of law and government. Before that—the theory went—human society had been direct patriarchy, ruled by the natural filial respect of offspring for father. Noah's sons' laughter shattered that respect, requiring Noah to

create law and government to bind human behavior. Julius liked this reading, which made the birth of legal authority (of which the pope was supreme head) a moment as important as the creation of the planets. The presence of this scene shows the ways patron and artist were co-authors of a work, the patron requesting specific saints or stories, and the artist choosing the framing, visual focus, exact moment (before Noah awakes? before David strikes?), and other nuances.

There are enough odd things about the Sistine Chapel ceiling to fill many books, so I'll content myself with just one more: the fact that each of the nine biblical scenes showing creation is surrounded by four naked men, each sitting on a pillar supported by two smaller naked men painted in white to look like marble, separated by a pediment flanked by two shiny gold naked men, with a large round medallion painted in between cleverly made to look like a relief scene cast in bronze depicting yet more naked men, for an average ratio of twenty naked men to each bible scene (most of which also contain naked men).

Michelangelo's iconic *The Creation of Adam*, with its usually-omitted frame of nudes and pagan sibyls.

Part of the reason for this is that Michelangelo would rather be sculpting, so, condemned to paint, he filled the surface with imagined sculptures: some marble, some bronze, some in the round, some in relief, all in poses ideal for the limitations of each medium (stone, metal); Michelangelo's wistfully imagined forty sculptures that will never be.

The other reason is Michelangelo's deep, passionate love of naked men.

Michelangelo loved naked men. He loved arms, muscles, joints, abs, biceps, calves, every detail he studied in those dissections back in Santo Spirito. If you have the internet right now, pull up a picture of the Doni Tondo, his only surviving complete panel painting (the details we need don't come through well in black and white). It's in the standard genre of round Florentine paintings of the Virgin and Child, the kind you commission for a bride (this one, in fact, was for a Strozzi bride), but you'll notice that in Michelangelo's version, behind the foreground figures, there's a crowd of splendidly buff naked men lounging around for no apparent reason. One entertaining way to spend an afternoon in Florence is to stand next to the Doni Tondo in the Uffizi and listen to the stream of tour guides failing to cope with all the naked men. Usually half of them just pretend the naked men aren't there, commenting on the foreground figures then moving on. The other half provide an endless variety of contradictory explanations of what perfectly wholesome scriptural or theological thing these splendidly gratuitous hot naked men symbolize. They're naked men. All Michelangelo's works are full of naked men. He loved, loved, loved depicting naked men. (Even most of his women are naked men with lumps attached.)

Back in the History Lab, my dear friend Michael Rocke (author of the fabulous *Forbidden Friendships*, the go-to work on Italian Renaissance sodomy) is even now finishing up his study of Michelangelo's sexuality, but to give my brief, incomplete best: Michelangelo has been celebrated as a gay icon, and is a wonderful antidote to the distorted histories which give schoolchildren the impression that homosexuality didn't exist between Socrates and Oscar Wilde. But *gay* is a word-concept deeply embedded in the modern era, invoking modern fashions, affects, and political

experiences. To call Michelangelo *gay* is like calling a Renaissance market a "shopping mall"—the facts are right, but the valences (suburbia, teenagers, consumerism) all wrong. Renaissance ideas about homosexuality were articulated differently, and taboos enforced differently and disobeyed differently, from today.

Was Michelangelo having sex with men? Art historians are—justifiably—very prickly about this question, because for a long time people argued *Yes!* for badly researched reasons. This often took the form of observing things about Michelangelo's art or writing which felt gay by nineteenth-century or early twentieth-century standards, without bothering to check what they meant in the period. People would argue, *His figures are so homoerotic!*—to which the answer is that tons of Renaissance art looks homoerotic by Victorian standards. People would argue, *He's using only male models for his nudes!*—to which the answer is that *everyone* used only male models for their nudes, or the occasional cadaver. People would argue, *His letters to male friends use the word love!*—to which the answer is that *with love*, *my beloved*, etc. were common phrases in letters between men in the period, even if there was no sexual relationship. People would argue, *His women all look like men!*—without remembering that Donatello's women really look like women and Donatello ♥ Brunelleschi were one of the most adorable gay couples in the history of Italy. All this is *bad* evidence, and art historians are right to be prickly about it, just as historians of the Medici are right to be prickly when accounts say Lorenzo was a villain because of his gout, instead of pointing at good evidence like his iron grip on the institutions of power.

Happily, we now have *good* evidence that, *yes! Michelangelo was super having sex with men!* The important part was proving it using our evidence-based research on homosexuality in the period, *not* projecting backward the aesthetics of the age of Oscar Wilde. We now know what the letters of Renaissance male lovers usually read like, the language people used. We now know customs and expectations. Several of Michelangelo's proposed lovers were his students or apprentices, and we can compare his dynamic with them to other cases of apprenticeship, both those provably with and those provably without sexual components. With this

evidence in hand, we can firmly identify some of his beloveds, with corroborating documents, etc. We don't have such specifics for his early life—like many people who rise to prominence, the majority of our documentation is about Michelangelo's late years. We have the love poems and letters of a man nearing sixty, passion performed with eloquence, far beyond the standard expressions of love used among non-lovers in the period and clearly similar to the language used by confirmed lovers, but we don't have as many documents about him as an unfamous youth, or as the medium-famous figure painting those nudes in the Sistine.

Was Michelangelo having sex with Pope Julius? Many have asked, since the *terrible* pope's obsession with the *terrible* artist had the passion of a stalker, but documents suggest Julius preferred female lovers (good work, team History Lab!), and my best answer, after much reading, is that, if there was lust as well as power in this clash of storms, it was 90 percent about power.

Whether or not Michelangelo was actively having sex with men in 1510, his art is important to the history of homoeroticism.[159] Here in the twenty-first century (in the West at least) the most widely expected non-heterosexual orientation is the homosexual man (attracted to men *but not to women*) echoed by the corresponding lesbian woman (attracted to women *but not to men*). Currently, bisexuality is far less represented, and bisexual erasure is a major problem. Sources from Renaissance courts, like those Michelangelo frequented, reveal a different set of expectations about sexuality, where the most expected type is what I call (avoiding modern terms and their baggage) *male dual attraction*, i.e. a man attracted to both men and women.

Renaissance men often visited both male and female prostitutes, and/or took both male and female lovers, often while also marrying. Letters and documents show such dual attraction was not *licit*, but it was *common* among men (though far, far more taboo for women). Machiavelli as a youth wrote erotic love poems to Giuliano de Medici (Lorenzo's youngest son), and later, as a married man, wrote in his personal letters quite casually about extramarital romance and visiting a female prostitute, and more circumspectly about visiting a male prostitute. Machiavelli also happily gave sex advice to a friend attracted to

both sexes, who was dealing with two other friends, one of whom preferred women, the other men.[160] Dante gives us useful data too: in *Inferno* (the eternal Hell for souls that pointed downward at the instant of death) the *physical* act of sodomy is punished as a more severe sin than heterosexual adultery, situated deeper in the pit, but in *Purgatorio* (for souls that pointed upward but are still having their sins purged en route to Heaven) homosexual and heterosexual *lust* are treated as equivalent, purged on the same step of Mount Purgatory, showing that even strict Dante thought that feeling attraction to both sexes (without acting on it) was common and normal among the virtuous.[161] Governments expected male dual attraction too, as we see in anti-sodomy campaigns which often offered legal privileges to female prostitutes to help them lure customers away from male competitors. Venice paid female prostitutes to stand topless in a line across the *Ponte delle Tette* (Bridge of Tits) in order to kindle heterosexual lust in passing men, a policy which presumes abundant dual attraction.[162]

Whether those in the period excused such attraction or condemned it, they *expected* male dual attraction. When a man in the period was *exclusively* attracted to men, letters and friends tend to comment on it as odd, and we have multiple cases of men who reveled in self-identifying as perverted because of their *exclusive* interest in men. The fascinating Floriano Dolfo (or Dolfi, c.1445–1506) was such a man, a renowned jurist and theologian, who for most of his life never left his office at the University of Bologna due to a mobility disability, but wielded legal and diplomatic influence via his teaching and correspondence, and wrote numerous erotic letters to Francesco Gonzaga, in which Dolfo declared that he despised women but loved sodomy with men, and described elaborate pornographic literary hellscapes of swollen penises and insatiable imaginary orgies.[163] (History: the deeper you dig the weirder it gets!)

In this dual-attraction culture, men were expected to be attracted to men in the same spirit as to women, that is to *younger, more feminine men*. So entrenched was this expectation that Michael Rocke found Florentine courts even levied heavier sodomy fines on homosexual couples who violated the norm by

having the elder partner be the penetrated partner in the sex act.[164] And indeed, Michelangelo's actual sexual partners were also young, but in his *art* it's striking to contrast Michelangelo's large, muscular *David* with the boyish, feminized physiques of Donatello's and Verrocchio's *Davids*.[165] Image search for some period Ganymedes or Saint Sebastians, and you'll see how much feminized, youthful bodies outnumber mature-looking ones (and many mature ones trace their influence to Michelangelo). Michelangelo's celebration of the large, muscular, unfeminine male nude challenged the supremacy of the feminized bodies associated with the dual-attraction model. When you go through a museum today, many people attracted to *mature* men, after room after room of boyish androgyne, see a Michelangelo and experience catharsis: *That feels like what I desire!* In parallel, many men who are made uncomfortable by the feminized eroticism of Donatello's *David* see a Michelangelo and think: *That feels like the way I want to be desired!*

In sum, gender and sexuality in the Renaissance were just as complicated, plural, and unstable as today, and Michelangelo made, and still makes, ripples in that never-placid pond.

Wasn't it dangerous for Michelangelo to create such homoerotic work?

Not when we remember the unreasonably interesting Benvenuto Cellini boasting about how his patrons helped him get away with *literal murder*. Remember that letter from Machiavelli's clerk, describing poet friends in Rome appealing to cardinals to guard them from an anti-sodomy campaign? The *grace* of powerful patrons kept clients safe. Michelangelo's contemporary Giovanni Antonio Bazzi (who was around the corner frescoing another room while Michelangelo was in the Sistine), was such an infamous sodomite he happily adopted *Il Sodoma* (the Sodomite) as his name (as our Angelo adopted Poliziano). Nor did literally answering to "Sodomite" stop him from getting plenty of Church commissions, like his enormous cycle of the *Life of Saint Benedict* for the monastery of Monte Oliveto Maggiore, as well as secular commissions, like the one in the Villa Farnesina in Rome that I call the Bisexual Visibility Fresco, showing Alexander the Great poised between his sexy bride Roxana and his even sexier male lover Hephaestion.

The Bisexual Visibility Fresco, better known as Sodoma's *c*.1517 *Wedding of Alexander the Great* in the Villa Farnesina.

This is how Renaissance homoeroticism was often *illicit yet not covert*. Ludovico Sforza could live openly with his lover Galeazzo Sanseverino, since, even if distant churchmen grumbled about depravity no one could touch a duke, while his duchess Beatrice d'Este had hated his female mistresses, but adored Sanseverino, giving him free access to her quarters and playing croquet and other games with him daily.[166] *Everyone* loved Galeazzo Sanseverino, even impossible-to-please Isabella d'Este, with the exception of Isabella's husband Francesco Gonzaga, and we learn much from the letter when Sanseverino had challenged Gonzaga to a duel, and Gonzaga replied beginning, "Prù—this is a fart sound I make with my mouth with the addition of a fuck-you gesture and a fig sign," continuing to say that he was a ruler of a great city and successful general while Sanseverino was a military loser known only for "ass favors," and that when Gonzaga himself has gay sex "I do it at the door of others (i.e. penetrating) while you do it at your own" (i.e. receiving).[167] Gonzaga also sealed letters with a personal seal depicting a couple having anal sex, based on an ancient Roman brothel sign (though he did not use it for letters to his wife).[168] Such high elites had nothing

to fear from such openness about their sexuality, but lesser men needed to be careful, and shelter under greater. Those of the status of Michelangelo or Machiavelli did live in fear, but less fear of the law than of patrons' anger, which could throw them to the legal wolves. That fear was one more chain which locked such men into patronage networks, and made abusive patrons like the d'Estes or Pope Julius more inescapable.

It took Michelangelo four frustrating years, 1508–12, to finish Julius's ceiling. During these years, the warrior pope tried and failed to take Ferrara from Duke Alfonso d'Este (and his duchess Lucrezia Borgia), and the armies of the League of Cambrai steamrolled Venice's land empire but discovered *La Serenissima* herself was still impregnable, and turned on each other. King Louis then turned his armies south to Naples, so the retreating Battle Pope called yet more foreign armies into Italy to form his Holy League against the French. Through all these wars, the cardinals complained of Michelangelo's construction raining plaster dust on them during Vatican ceremonies, and Julius told Their Eminences to *get bent*—no one could pick on *his* Michelangelo but him. In these same years, Julius's secretary Cardinal Francesco Alidosi (who had persuaded Michelangelo to surrender to Julius instead of running off to Constantinople) had lost Julius's confidence, largely because of the Bentivoglios retaking Bologna (and melting Michelangelo's big bronze Julius), and in the end Alidosi was brutally murdered in broad daylight by Julius's nephew Francesco Maria della Rovere (adopted heir to Urbino), and mourned by no one (but the murder will still be a plot point in a few pages).

The political change that most affected Michelangelo came in the last months before the ceiling was finished: Lorenzo de Medici's heir Piero the Unfortunate had died in 1503, so the exiled Medici were led by Lorenzo's second son, Cardinal Giovanni "Leo," who was just a few months Michelangelo's junior and, from ages fifteen to seventeen, had dined with him daily at that strange, rankless table where Ficino and Poliziano babbled of Plato and a golden age. Despite the old bad blood between the Medici and della Rovere, the Cardinal de Medici had spent Julius's papacy earning the trust of the warrior pope, who, in

return, lent him armies to threaten Florence until the republic accepted the Medici's return. Florence capitulated on August 29, 1512, remaining a republic on paper but yielding command to Cardinal Giovanni "Leo" and to the youngest brother Giuliano de Medici, who went off to France to secure the family's *grace* with the royal patron whose fleur-de-lis still decked the Medici balls.

The grand reveal of the Sistine Chapel ceiling and its glorious naked men took place on October 1, 1512. Ten days later, Julius—the warrior pope whose dreams of empire had filled Rome with grandeur and Italy with blood—fell ill. Within two months, he died. The first papal election watched over by Michelangelo's sibyls and prophets selected Pope Leo X, whose elevation at the stunningly young age of thirty-seven promised a long pause in the turnover of popes, and decades of golden age for *umanisti* and artists, whom a Medici raised by Poliziano was sure to hire.

But Julius's death did not end his hold on Michelangelo. The sculptor was bound by contract to complete the impossibly ambitious tomb, or at least part of it, and Julius's nephew Duke Francesco Maria della Rovere (who had now inherited Urbino from his impotent uncle Guidobaldo da Montefeltro), insisted the work continue. Thus, Michelangelo found himself compelled to keep toiling away at his now-famous *Slaves*, also called *Prisoners*, a set of captives in life-sized stone which the imperious pope had wanted bound forever in submission around his tomb. At first, Pope Leo tried to keep on good terms with the surviving della Rovere, so encouraged Michelangelo to continue the tomb (which in 1513 was re-contracted to be a more modest wall tomb rather than Julius's unprecedented 50-statue mega-tomb), but in 1516 Pope Leo's little brother Giuliano—still in France—died unexpectedly, and the family's new heir was the now-teenaged Lorenzo di Piero left behind by Leo's big brother Piero the Unfortunate. Young Lorenzo di Piero was hungry for a ducal title, and Urbino was a lovely duchy, had already changed hands a lot, and was held by a weakening della Rovere whom these Medici had courted while they needed troops to retake Florence, but (with memories of the Pazzi mess still in their hearts?) had little reason to keep calling friend.

In 1515, King Louis XII of France died, and as the new king

Francis I visited Bologna with his armies (don't ask what France's new king was doing near Bologna, it was still the War of the League of Cambrai, nothing makes sense), Pope Leo asked the king if he could borrow the French troops to seize Urbino from the della Rovere. King Francis refused, so, just like the string of popes before him, Leo tried to gift this papal city to his nephew by fiat, justifying the expulsion of Duke Francesco Maria della Rovere by (wait for it...) saying he was unworthy to be duke since he had murdered Julius's old secretary Cardinal Francesco nobody-cared-about-my-murder-back-in-1511-but-now-it's-a-plot-point Alidosi. How does all this matter to our sculptor? New strife between Medici and della Rovere meant Leo pulled Michelangelo off the Julius tomb (unfinished project #3), and directed him to instead design a grand façade for the Medici church of San Lorenzo in Florence, which had been built by Leo's great-grandfather Cosimo, but with a blank exterior left (like parts of the Sistine) for later generations to embellish.

The relationship between Leo and Michelangelo is another question of interiority, for which we need our time traveling telepath. The two had lived and dined together for three years as youths, and the pope continually employed Michelangelo, but letters from the days just after Leo's election suggest that Michelangelo might have voiced some anti-Medici sentiments during the republican period, and feared retribution. The now-papal Medici almost-brother Michelangelo had grown up with kept the sculptor continuously employed, but Michelangelo complained that Leo gave young Raphael higher-paid commissions. A letter of Sebastiano del Piombo is often quoted—one of few artists of the time who got along well with the jealous and competitive Michelangelo—in which he writes to Michelangelo on October 27, 1520, that the pope "spoke of you as of a brother, with tears in his eyes. He told me you were raised together, and shows that he knows and loves you, but you frighten everyone, even popes."[169] On the basis of this letter, many say the fun-loving young pope found *terribile* Michelangelo hard to get along with compared to Raphael, whom everyone (except Michelangelo) describes as so sweet, warm, and affable that it often sounds like the actual guardian archangel Raphael came down from Heaven

to gift humanity some frescoes.[170]

Before we read too deeply into the Michelangelo-Raphael-Leo dynamic, we should remember that Pope Leo—an enthusiastic singer and lute and harpsichord player—did not pay either artist (or any artist) as much as he spent on his favorite lute-player Gian Maria Giudeo, his thirty-plus other court musicians, or his beloved pet white elephant Hanno (a gift from the King of Portugal). Leo kept his elephant in the Vatican's big courtyard (where the giant pinecone is now), and, after the animal's death in 1516, had Raphael memorialize it with a fresco (now lost, but we have the sketch), while the pope himself poured the erudition he had learned from Poliziano into composing a poetic epitaph for this most favored papal pachyderm.[171] Michelangelo and Raphael are superstars of our modern postcards and itineraries, and Vasari's 1550 *Lives of the Artists* (the first text to call the era a *rinascita*) gave epic weight to both men and their rivalry, but artists had many competitors for fame and cash in their own day: musicians, poets, jousting masters, superstar preachers, astrologers, saintly visionaries, strangers from exotic places; all these often exceeded artists in both fame and funds, and few in 1517 would have bet money that, in 500 years, Raphael and Michelangelo would be household names and master lute-player Gian Maria Giudeo an obscure footnote. Even fewer would have put their money on a little German monk called Martin Luther, whose *Ninety-Five Theses* denouncing Church corruption read a lot like Savonarola. Rome had little attention for Luther at first, since 1517 saw that plot to murder Leo X, which resulted in the banishment of Cardinal Raffaele Riario, the last surviving Pazzi conspirator, who eighteen years before had bought the fake antique cupid which first made Rome aware of young Michelangelo.

In 1519—as Lucrezia Borgia breathed her last, and papal legates were still hoping to settle the kerfuffle with this Luther guy calmly—Pope Leo's nephew and heir, Lorenzo di Piero de Medici, died. He left behind his infant daughter, Catherine de Medici (partly educated at Camilla's Santa Caterina), plus his *natural* son (the one likely mothered by the African-descended Simonetta da Collevecchio) named Alessandro de Medici who became lord of Florence.

Pope Leo ordered Michelangelo to drop work on San Lorenzo's

façade (unfinished project #4), and design the Medici tombs. San Lorenzo already contained the tombs of Leo's great-grandfather, Cosimo the Elder, who had turned money into power, of Cosimo's parents, and of Cosimo's sons Giovanni and Piero the Gouty. Now a new section on the other side would be the resting place of the next generations: for Leo's father Lorenzo the Magnificent and his murdered brother Giuliano, Leo's younger brother Giuliano Duke of Nemours, and Leo's nephew Lorenzo di Piero, sometime Duke of Urbino. Because Michelangelo actually mostly completed them, the tombs of the two young dukes are now far more famous than the dukes themselves, portraits of the dead Medici flanked by naked men (and some women, but again they look like men).* The grander tomb planned for Lorenzo the Magnificent and poor Giuliano dragged on and never fully came to be, cut short like many things in 1521, when Pope Leo's sudden death from pneumonia at the age of forty-six ended the papacy everyone had expected to last another twenty years.

In a pattern painfully familiar by now, the 1521–2 papal election was a slow deadlock dominated by distant thrones. The French and many cardinals appointed by Leo X supported Leo's cousin and foster-brother Giulio de Medici (who grew up with Leo and Michelangelo), while England's new and ambitious King Henry VIII pushed for Cardinal Wolsey (1473–1530), and those wary of a pope too tied to foreign kings favored Alessandro Farnese (the brother of Pope Alexander's mistress Giulia *la bella*, nepotism but the *local* nepotism of a good Roman family). A compromise, pleasing the Spain-and-Naples faction, was Cardinal Adriaan Florensz Boeyens (1459–1523), a Dutch theology professor and the personal tutor and Grand Inquisitor to Emperor Charles V (inheritor of the Empire and united Spain).

Arriving in Rome to an austere reception (the city was emptied by plague again), Pope Adrian liked theology, orthodoxy,

* The hypothesis proposed by doctors that the strange breasts of Michelangelo's *Night* on one of the tombs might represent breast cancer has prompted discussions of the role of doctors in the History Lab, see Jonathan Nelson's "Cancer in Michelangelo's Night. An Analytical Framework for Retrospective Diagnoses," in *Representing Infirmity: Diseased Bodies in Renaissance Italy* (Abingdon, Oxon: Routledge, 2021).

institutional reform, and papal independence, and disliked art, corruption, nepotism, courtly extravagance, and this weird new classicizing stuff (scholasticism is just fine!). Adrian VI (the No-Fun) plunged into an anti-corruption campaign, refused to do any favors for Emperor Charles, and launched a fierce theological and diplomatic pushback against what was by now the Lutheran revolt. In his book *Quaestiones in quartum Sententiarum* he also argued *against* papal infallibility, using many theological and epistemological arguments, though it's easy to read the subtext: *Have you seen my predecessors?!* He also considered destroying that most beloved center of Roman street life, Pasquino, a broken old statue set up in a square in 1501 by Cardinal Carafa; on holidays *umanisti* would dress Pasquino up as various gods in whimsical procession, while year-round poets posted verses on its base satirizing the pope and other notables,[172] and still do to this day.*

Pope Adrian the No-Fun died within two years, but if he hadn't his papacy might have been a mini golden age for washing the Church's dirty linens, and a mini dark age for artists and scholars. Romans always celebrated the deaths of popes, but when Pope Adrian died, revelers carved a note on the door of the physician who failed to save him hailing the doctor and his staff as saviors of the city: "*Liberatori patriae* SPQR."[173]

Michelangelo created no art during Adrian's brief, twenty-month papacy, not just because Adrian didn't want any. Our sculptor spent the whole two years being sued by Francesco Maria della Rovere, who had taken Urbino back at Leo's death, and was determined to have Michelangelo finish his uncle Julius's tomb (we need a worthy resting place for Battle Pope!). Meanwhile, from the other side, Cardinal Giulio de Medici was pressuring Michelangelo to finish the tombs in San Lorenzo (but not paying him for it), and suddenly requested that he also design a grand addition for the library attached to the church, where many of Cosimo and Lorenzo's rare manuscripts remain today. Michelangelo later wrote that the pressures, interruptions, and

* Returning to Rome after the COVID lockdowns, I was reassured to see Pasquino in 2022 was again covered in fresh notes and verses in five languages including Latin, satirizing many Italian and international figures, including Donald Trump.

anxiety made it impossible to focus on anything creative during these two years (that he "couldn't even pick up a chisel"), so the next time you catch yourself feeling guilty or ashamed of stress slowing you down, just remind yourself that this *terrible* and legendary genius also lost many days (whole years!) to stress; we're in good company.

At Pope Adrian's death in 1523, Leo X's foster-brother Giulio de Medici succeeded in becoming Pope Clement VII (Medici Pope 2: Ovid vs. Psalms Rematch! Ovid Wins Again!). Thus, as Michelangelo approached his fiftieth birthday, direct orders from the new pope overrode the della Rovere lawsuits and packed him off to Florence to work full time on San Lorenzo, where the tombs had interrupted the façade, and were interrupted in turn by the ambitious library. The Laurenziana library entrance is one of few portions of this design which came close to completion, and whenever I step inside, and see the strange dark stone, the blinded windows with their broken pediments, the functionless columns bulging half-way from the walls, and the unprecedented stairway which oozes toward you like a lava flow, it feels like Michelangelo's *terrible* frustrations are still vibrating within. He worked away in Florence until 1527, when strife between Emperor Charles and Pope Clement triggered the Sack of Rome (a good time for our sculptor to be far from the Vatican). This caused the expulsion of the Medici from Florence for the brief, embattled Last Republic whose leaders (like Michelangelo) were still hearing Savonarola's voice. As Florence's most celebrated architect, Michelangelo was tasked with building fortifications to prepare the city for siege. One of the defensive structures he built is now Piazzale Michelangelo, the famous square above the city where visitors enjoy panoramic views of Florence's skyline—even that is a desperate remnant of our desperate Renaissance.

In September 1529, with armies closing in, fearful Michelangelo for the second time abandoned Florence in its time of need, fleeing to impregnable Venice (it's where you flee…), but he regretted the decision and returned within a month, joining his homeland just as the siege grew tight around her walls. He knew what must come next as much as we do: all Florence's arts, her statecraft, citizens, Michelangelo's engineering, the prayers of hundreds of

hardworking nuns, were not enough. In August 1530, Florence surrendered to the conquering Medici, and the republic was no more. The governor placed in command by Pope Clement ordered that Michelangelo be executed for his offenses against the Medici, but the artist and his goods were saved by patronage again, in this case by one Giovan Battista Figiovanni (1466–1544), the churchman in charge of the finances of San Lorenzo (i.e. of Michelangelo's construction costs). Figiovanni had served the Medici family since Leo, Clement, and Michelangelo were boys, so had enough *gratias* to intervene on the sculptor's behalf. Pope Clement ordered that Michelangelo be spared so he could keep working, and the sculptor spent the next years traveling between Florence and Rome, alternately not finishing the tomb of Julius and not finishing the San Lorenzo façade, library, and tombs (unfinished projects #4, #5, and #6, not counting other smaller tasks along the way).

On a happier note, in 1532, when Michelangelo was fifty-seven years old, he met "the light of our century" Tommaso dei Cavalieri (1509–87), a twenty-three-year-old with Roman patrician ancestry on his father's side and Florentine merchant blood on his mother's, whose long friendship with the sculptor gives us our best record of Michelangelo in love.[174] The artist wrote thirty sonnets and other poems to Tommaso (fully a third of all his poetry), tutored him in drawing and architecture, and gifted him a set of mythological drawings including an extremely erotic version of Renaissance Europe's most prominent homosexual narrative: Zeus abducting Ganymede. In Michelangelo and Tommaso—whom some historians call "lovers," others "friends"—and especially in the Ganymede drawing, we see the period's age hierarchy continuing but also changing.

Yes, Michelangelo was decades older, but Tommaso was no delicate teenager, and in the thick, muscular limbs of the Ganymede drawing we see Michelangelo's delight in a mature body, not a feminized, youthful one. We have some documents of Michelangelo's other loves: male models Gherardo Perini and Febo di Poggio, who took advantage of the artist's affections to wring money from him, and a younger apprentice Cecchino dei Bracci who died after knowing Michelangelo only a year, for whom the artist wrote a set of funeral epigrams. But the artist's

deep and clearly positive intimacy with Tommaso lasted the rest of his life, and included collaborations in which Tommaso's figure sketches made it into some of Michelangelo's finished works.

Jumping forward a moment, after Michelangelo's death, Tommaso was largely erased from the historical record. His drawings were misidentified as Michelangelo's—same style, subjects, and everyone would rather own a Michelangelo than work by a mere student—and when Michelangelo's grand-nephew published the artist's poetry in 1623, he changed the male pronouns in the Tommaso poems to female, to erase the homoerotic content, a calculated act shaped by the moral tightening of the Counter-Reformation, similar to how Giovanni Pico della Mirandola's nephew Gianfrancesco, in publishing his famous uncle's works, changed invocations of plural gods to God singular, among other adjustments.[175] Only in 1893 did English poet-scholar and homosexual activist John Addington Symonds (1840–93) restore Tommaso's presence by retranslating Michelangelo's original poems. Interpretations of Tommaso's relationship with Michelangelo (hot sex! just friends! platonic contemplation! true love!) vary to this day, but our hard work with evidence back in the History Lab now strongly supports the love and sex.

September 1534, two years into the Tommaso relationship, Pope Clement VII—the second of the two Medici popes Michelangelo had grown up with—lay dying from fever. As one of his last commands, he ordered Michelangelo to return to the Sistine Chapel and fresco (*he would still rather be sculpting*), the long-postponed *Last Judgment* which would complete the altar wall. Like the ceiling, the complexity of Michelangelo's *Last Judgment* merits volumes of analysis, but for our purposes its uncommonly wrathful Christ and stern-faced saints certainly reflect Michelangelo's frustrations at the years that dragged him from his home, from peace, and from sculpting. Serving powerful patrons was not slavery, but it was not freedom either, a complex unfreedom visible in letters and accounts, in so many aborted projects, and in Michelangelo's chilling self-portrait in the Judgment scene, where he depicts himself as the empty, stretched, flayed skin carried by Saint Bartholomew. Several sketches by Tommaso appear in Michelangelo's final design (notably Saints Lawrence

and Andrew), as does Michelangelo's love of nudity. The mass of naked saints surrounding a naked, beardless Christ so shocked Rome that the papacy was pressured to destroy the fresco, and in the 1560s as the Counter-Reformation Church grew sterner, a long project of censorship and alteration began which lasted centuries, loincloths painted in and other interventions made over the years as the Church changed pope by pope. Clement's death also meant the end of Michelangelo's attempts to finish the Medici tombs in San Lorenzo, since henceforth other popes and patrons would forever give him their more pressing tasks.

The *Last Judgment* was ordered by dying Pope Clement, but it was the next pope who made Michelangelo complete it: Paul III, Alessandro Farnese's turn at last to hold the papal throne. Giulia *la bella*'s brother, the Borgia-appointed "petticoat cardinal," had spent many years building his power base, and for this election he lined up the support of France, Rome (which always loves Roman popes), and the remaining Medici partisans, who still had a cardinal, young Ippolito de Medici (a *natural* child of Lorenzo's youngest son Giuliano). It was the smoothest papal election of Michelangelo's long lifetime, with no other major candidate rising to challenge this well-established Roman who had his political ducks well in a row, and it is no coincidence that the fifteen years of the Farnese papacy (1534–49) saw a higher rate of Michelangelo *actually finishing things* than usual. The last of Lorenzo de Medici's sons was dead, their successors too weak to override this pope, while the della Rovere faction was fading and the interminable lawsuit with it. Tumults still shook Florence, and the Reformation kindled war in the north, but in Rome herself one patron had the power to commission work, and no one had the power to interrupt.

The key year to avoid Florence in this patch was 1537, when the stern and unpopular Alessandro de Medici was assassinated by his distant cousin Lorenzino (-ino = little Lorenzo), also known as Lorenzaccio (-accio = bad Lorenzo). Remember those boys who sued Lorenzo for their inheritance sixty years ago, and later gave up the Medici name for *i Popolani*? Lorenzino is the grandson of the one who *didn't* marry the tigress Caterina Sforza. After murdering Alessandro, Lorenzaccio fled to Venice (like you do…), where many exiled enemies of the Medici had gathered, led by

(among others) several Strozzi, still carrying the Medici-Strozzi tensions that had exiled Alessandra Strozzi's sons a century before. These exiles raised an army, hoping to oust the Medici upon the tyrant's death, but Lorenzaccio had acted out of grudge, not in coordination with this exiled resistance, so they had little time to plan.[176] Meanwhile, many both inside and outside Florence stood to profit by keeping the dynasty in power, and were already searching for an heir.

Murdered Alessandro de Medici had left behind a *natural* son, little Giulio, but the boy was only four, not a promising age to lead troops or rule cities. The pro-Medici faction found a more martial and promising heir in seventeen-year-old Cosimo de Medici (1519–74), named for his celebrated ancestor. Though not descended from the most recent Medici rulers of the city, this young Cosimo was full of Medici blood. His mother Maria Salviati was the daughter of Lorenzo il Magnifico's brilliant firstborn daughter Lucrezia (who had stayed in Florence working toward the family's return), while his father had been the celebrated mercenary general Giovanni delle Bande Nere (1498–1526, Giovanni "of the black stripes" for the mourning bands he added to his insignia at the death of Leo X), who was the son of Giovanni *il Popolano* (the one of the boys who sued Lorenzo for their inheritance who *did* marry the ferocious Caterina Sforza (the one who, for a time, employed Marullo). Thus this young Cosimo was, through his mother, the famous Lorenzo's great-grandson, and had the Medici surname through his father as patrilineal great-great-grandson (son of the son of the son of the son) of the original Cosimo's younger brother (unhelpfully also named Lorenzo).

With a patrilineal claim, his mercenary father's military glories upon him, the blood of the Tigress of Forlì in his veins, and just the right degree of youth to look imposing on a horse while tricking important men in Florence into thinking he was manipulable enough that they could rule through him, young Cosimo's candidacy was perfected by the convenient fact that he was *actually physically there* in Tuscany (unlike the rival heiress Catherine de Medici, who had gone to France as the bride of a prince, and would spend her life insisting that *her* sons—descended from Lorenzo's heir Piero—should rule Florence, not the *cadet* branch,

but her sons ended up Kings of France instead; win some, lose some). Defenders of the republic raised an army, but Cosimo's troops defeated them, and by summer the last of the resistance had been slaughtered and their severed heads set up on the Bargello (where Montesecco's sat after the Pazzi Conspiracy), and around the square in front of the Palazzo Vecchio (around Michelangelo's *David* and the spot where Savonarola had been burned).

The young conqueror was crowned Duke Cosimo I of Florence, but spent years trying to get someone to crown him King of Tuscany (as Pope Alexander VI had wanted for his sons in Romagna) and eventually Europe compromised by inventing the title "Grand Duke of Florence," which sounds fancier than Duke of Milan or Duke of Ferrara, but didn't make Cosimo a peer of any king.*

The finality with which Cosimo I's victories ended the Florentine Republic is nicely captured in the life and works of one of Michelangelo's great admirers, the then-young Florentine sculptor-goldsmith-necromancer-assassin Benvenuto Cellini (1500–71), who boasts in his implausibly interesting autobiography about the time in Rome when he impressed and delighted the elder artist by dressing a handsome boy as a girl and introducing them at a party (Michelangelo thoroughly approved).[177] Cellini includes many sketchy episodes in his autobiography—his murders, his maimings, his dabbling in necromancy, the time he almost crushed not-yet-pope Alessandro Farnese to death with falling masonry, the time he got sodomy charges dismissed by demanding that the accuser clearly describe what they were accusing him of, and they were too prudish to name the body parts—but Cellini is *absolutely dead silent* about the change-overs of power in Florence in 1512–37. At the start of the memoir, Cellini

* The fact that Cosimo *the First* comes at the *end* of the sequence confuses many, and is part of why we desperately need their traditional epithets, since a succession which goes Cosimo, Piero, Lorenzo, Piero, Giovanni & Giuliano, Lorenzo, Alessandro, Cosimo (with a variety of younger brothers mostly named Giovanni, Giuliano, or Giulio) becomes much more navigable with epithets: Cosimo (the Elder), Piero (the Gouty), Lorenzo (the Magnificent), Piero (the Unfortunate), Giuliano (Duke of Nemours) & Giovanni ("Leo" cardinal then pope), Lorenzo (di Piero), Alessandro (il Moro), Cosimo (the First). It could be worse; I know scholars who work on a phase in seventeenth-century Iceland when 40 percent of all men were named Jón Jónson.

is a boy growing up in a proud republic, entertaining himself by climbing over Florence's rooftops and throwing rocks at people's heads (I love that any choose-your-own-adventure book set in Florence can have "killed by young Cellini on the roof throwing rocks at people" as an ending option). Cellini becomes an apprentice, then an artist, has adventures in Rome and France, comes back, and suddenly, without mention of any strife or transition, Florence has a duke, glorious and noble, whom Cellini is oh-so-proud to work for, and oh-so-loyal to.

It was Duke Cosimo who commissioned Cellini's bronze *Perseus* holding the severed head of Medusa, which stands catty-corner to Michelangelo's *David* in front of the Palazzo Vecchio.

Benvenuto Cellini's bronze *Perseus with the Head of Medusa*, 1545–54.

The *Perseus* is so cunningly positioned, just under the eaves, that when it rains (and the wind is right) the naked hero remains dry, while the water drips like blood from the gore that streams from Medusa's head, from the neck of the headless body at the hero's feet, and from his sword. Just as *David*, the boy who bested giants, had a very particular meaning when placed in the city's heart in 1504 as the republic braced for the rise of Julius II, Cellini's *Perseus*—whose severe face resembles portraits of Duke Cosimo—had a very particular message when unveiled in 1554 to an audience who had seen the real severed heads of the republican resistance rotting in that spot not long before. The *Perseus* too was a project of legitimacy: classicizing bronze, the son of Jupiter in heroic armor, with a frieze at its base depicting Perseus (Cosimo) rescuing Andromeda (Florence) from a dragon, with armed horsemen in the background, unrelated to the Perseus story but making clear the rescue isn't just from any dragon, it's the dragon of rebellion—the crushing of resistance reframed as a providential rescue. However Cellini, Michelangelo, or others may have felt about Duke Cosimo in their hearts, the Medici dukes were patrons no Florentine could anger, a fact driven home by the fate of Lorenzino de Medici (the one who had assassinated Duke Cosimo's predecessor Alessandro), who fled first to Venice, thence to Constantinople, thence to France in search of aid, then back to Venice to try to raise a new resistance, where in 1548—more than eleven years after the deed—assassins caught him at last, proving the reach and patience of Medici vengeance. Duke Cosimo also transformed the Palazzo Vecchio's *Hall of Five Hundred*, built to house that big council the Savonarolan republic had been so excited by, into a gallery of the city's grandeur and his own, replacing the podium where Savonarola and other republican leaders once addressed the Council of 500 with a looming statue of his grandmother's brother Pope Leo X.

Michelangelo, through this, stayed safe in Rome. Alessandro Farnese, Paul III (who was not crushed to death by Cellini's falling masonry), had always had lavish and ambitious tastes in art. As a cardinal he'd had portraits painted by Raphael and Titian; now he secured another by Titian, and added a new chapel to the Vatican, the Cappella Paolina, for which he coaxed two more frescoes out of Michelangelo (interrupting the *Last Judgment* for a time). Pope

Paul also had Michelangelo work on his expansion of Palazzo Farnese (formerly Palazzo Borgia, but all bulls had been long since stripped away), a project so sprawling and protracted that its construction woes were the subject of a satirical play, Annibale Caro's 1543 *Gli Straccioni*.

This Roman pope wanted to glorify ancient Rome as well as papal Rome, so, for the decade of 1536 to 1546, he had Michelangelo—with his beloved Tommaso managing the construction—design and erect a grand square and palaces to hold Rome's civic government, up on the largely bare Capitoline Hill. The Capitoline was where *umanisti* knew Rome's oldest and most precious temples had stood, and where in 1341 (200 years before), Petrarch had himself crowned poet laureate, a mythmaking moment which had become the symbolic beginning of antiquity's rebirth. Thus Michelangelo's Capitoline—which today graces Italy's 50 cent coin—commemorates both Rome's ancient glory and the ambition to revive it. This project transformed a run-down hilltop into the administrative heart of Rome's city government, a new symbolic heart of the *idea* of Rome, hence the same hill being chosen for the grand Victor Emmanuel II National Monument commemorating Italian unification (constructed 1885–1935), and by Mussolini for many a grand event.

Pope Paul also inherited the project of rebuilding Saint Peter's Basilica, which had proceeded on and off ever since Julius II planned it as the site for his impossibly ambitious tomb. The project outlived many chief architects, and in 1546 it was Michelangelo's turn to be tasked with creating a dome larger than Brunelleschi's in Florence. His design was a success, but Michelangelo always insisted: *Her sister in Florence is prettier.* Ambivalent as Michelangelo was about Saint Peter's, it was a matchlessly important commission, and when Duke Cosimo de Medici asked Florence's stray genius to come home and work for him, Michelangelo always wrote back that he was too frail to travel, and that it would be a terrible sin for him to abandon Saint Peter's—popes and saints still outrank dukes in the patronage networks of Earth and Heaven.

Pope Paul III lived long enough to see the *Last Judgment* completed in 1541, and to call the Council of Trent, which tried to

organize a response to the Reformation, including grudging steps to address *some* of the corruption on Luther's grievance list. Paul's papacy also saw the death of Vittoria Colonna (1492–1547), a brilliant poetess and *umanista* with complex Protestant leanings, who for ten years was Michelangelo's dear friend and spiritual adviser, and whose life offers another window—like those of Alessandra Scala and Cassandra Fedele—on what facets of scholarship were and were not open to women. That same year Pope Paul's eldest son Pier Luigi Farnese (who had, of course, been furnished with a dukedom and a richly dowered Orsini bride) was brutally stabbed to death in a conspiracy led by Ferrante Gonzaga (son of Isabella d'Este and Federico Gonzaga) and motivated by the usual palette of a pope's entitled son being an ambitious and tyrannical jerk. The assassination would have felt familiar to anyone who was in Rome in 1497 when Juan Borgia's corpse was pulled from the Tiber, but as Michelangelo and others in the papal city braced for brutal backlash, the aftermath was strangely different. Paul pursued comparatively little revenge for Pier Luigi *even though the killers were known*, a remarkable difference. The lack of revenge certainly reflects differences between how Alexander VI felt about Juan and how Paul III felt about Pier Luigi, but (my student Katya Kukucka did brilliant work on this) also show how the papacy's general political strength (necessary to go after assassins from such great families) was weakening, both due to the Reformation, and the excessively long sequence of papal wars and regime changes, which had seen so many families rise and fall so quickly in the Papal States that popes' strength was now being taken less seriously than those few enduring powers—d'Este, Gonzaga, Malatesta—that had proven themselves by lasting many storms.[178]

Revenge (or its absence) is one way to evaluate a man's power after death, but tombs are another, since a tomb project can easily be dropped as the priorities of the living move on from the agendas of the dead. Men like Rodrigo and Cesare Borgia whose power shatters at their deaths may end up, as we've seen, in a ditch or under a plain slab, and with Terrible Julius not only was only a fraction of his tomb completed but he isn't even in it; his body with his uncle Sixtus's is still under the floor in Saint Peter's a bit

to the right of the main altar in what was intended as a *temporary* resting place until their tombs were finished. The Reformation was certainly weakening the pan-European power of the papacy by the 1540s, but Roman Local Boy Makes Good Alessandro Farnese is the only pope in this sequence who genuinely got the super grand imposing tomb popes hope for, with short-lived and much-loved Pius III as runner-up, and the bronze medal shared by the Medici foster-brothers Leo and Clement, who face each other in twin tombs in the Dominican headquarters church of Santa Maria sopra Minerva (with Pietro Bembo buried at Leo's feet). Pope Innocent (King Log) gets honorable mention for the tomb completed (and shared) by his gambling addict son Franceschetto Cybo with money from the hefty dowry he got marrying Maddalena de Medici as Innocent's price for Leo's cardinalship.

Tombs are records of the *next* generation, not one's own. Visitors to Florence are often confused why the two grand Michelangelo tombs in Florence are of two of the least important Medici—Giuliano Duke of Nemours and Lorenzo di Piero Duke of Urbino—followed in impressiveness by the tomb of Piero the Gouty and his brother Giovanni, while the famous Lorenzo's tomb looks like it was hastily thrown together in five minutes. The answer is simple: Lorenzo was powerful enough to make a grand tomb for his father, as were Leo and Clement for the brother and nephew that died during their papacies, while Lorenzo's tomb practically *was* slapped together in five minutes, since nothing could be made under Piero the Unfortunate, Savonarola, or Soderini, while under Leo and Clement it kept being postponed since it was supposed to be the grandest so most difficult. Construction was abandoned during the Last Republic, and the final version of Lorenzo's tomb was hastily slapped together during Clement's papacy, a plain box with an unfinished Michelangelo Madonna flanked by a Cosmas and Damian made by his students, and an unsuccessful fresco on the wall above which was painted over by order of Vasari to get things over with, so he and other artists could concentrate on new projects to project ducal power, like Cellini's *Perseus*.[179]

At Pope Paul's death in 1549, the next election was dominated, as you can guess, by a French faction, an Empire-plus-Spain

faction, and the faction of relatives and cronies of the previous pope, Farnese in this case, but by now Reformation concerns were complicating everything: the Empire was splintering, England had broken with the Church, and the papacy had great power to strengthen or weaken Catholic sides in the escalating Wars of Religion. After a two-month stalemate, the factions compromised on a neutral and theologically minded Italian diplomat: Giovanni Maria Ciocchi del Monte, who became Pope Julius III (1487–1555). This new Julius did little to advance the reforms he proposed, and his papacy was dominated by the scandal of the pope adopting a handsome but illiterate teenage male prostitute from Parma and making him a cardinal to keep him nearby as a lover. During these years Michelangelo—now in his seventies—was making something for himself, intended for his own tomb, a *Deposition*, depicting old Nicodemus (a self-portrait), Mary, and Mary Magdalene holding the body of Christ. Many and fascinating are historians' attempts to understand why in 1555, Michelangelo suddenly attacked and mutilated the statue, which—mangled and unfinished—remains one of the treasures of Florence where it now resides.

Pope Julius III gave way to Pope Marcellus II (1501–5), a crony of Farnese's faction, who died in less than a month. Michelangelo continued to work away under the next pope, Paul IV, Gian Pietro Carafa (1476–1559, successor to Cardinal Oliviero Carafa of the interrupted *Annunciation*). Paul IV is best known for advancing the Inquisition and persecuting the Jews (not a happy time in Rome). At his death, the same factions flared as usual, and elected Pius IV, Giovanni Angelo Medici (1499–1565). To add to our confusion, this was not a Florentine Medici but a member of a Milanese family called Medici, so distantly related that we have no evidence of a connection whatsoever (lots of families are called Fisher or Smith), but the Medici dukes acknowledged him (no one says "no" to a pope in the family), and, like his many predecessors, he continued to redirect Michelangelo to his own projects: the Basilica of Santa Maria degli Angelo including the pope's tomb, and his grand palace the Villa Pia.

Pius IV was Michelangelo's last pope. The artist had seen thirteen popes, from Sixtus who began the string of wars clear to the

Counter-Reformation. He kept sculpting until just days before his death in 1564, less than a week before what would have been his eighty-ninth birthday.

How much did he leave unfinished? The Palazzo Vecchio frescoes, the apostles for the Duomo, the San Lorenzo tombs, façade, and library, the *Prisoners* for Julius II's half-realized tomb, Saint Peter's which outlived so many architects, dozens of papal projects interrupted by yet other papal projects, and small projects, from Michelangelo's *Deposition* with Nicodemus which he smashed with his own hands, to an unfinished bust of Brutus commissioned by Donato Giannotti, one of the exiled leaders of the fleeting Last Republic, who probably intended it to honor Lorenzino de Medici, the cousin who had assassinated Alessandro de Medici and given Florence's republican exiles a last, brief gasp of hope.

If the list of finished Michelangelos feels short among so many incomplete, even shorter is the list of projects we can say he took on fully willingly. The drawings for Tommaso, the Nicodemus *Deposition*, that first big Hercules made from the marble block he bought himself, the *David* or at least the innovations he brought to it, these we can call the artist's free expression, but almost all the rest were dominated by the web of power politics. The artist nuns painting away in Camilla's Santa Caterina nunnery were unfree in some ways, bound to their cloister by strict vows and social norms, but nobody could drag them off to Rome, or force them to make a portrait of an Earthly conqueror instead of the heavenly conquerors whose *gratias* could not be overruled. Paintings were cheap too, just pigment on panel, something many a merchant family could afford, but for a man who wanted to be sculpting, the complex unfreedom of life at court was as inescapable as the straps of stone which were to bind the *Prisoners* to Julius's tomb.

But they weren't bound to the tomb in the end. Popes didn't get the art they wanted either, all these projects of grand restoration interrupted by the turnover and wars, leaving our Eternal Problem City a patchwork of half-finished palaces and boulevards leading to empty squares, where ambition's imagined monuments were never raised, or if raised were torn down again. If artists weren't fully free, popes and dukes weren't either; the secure-in-power

dukes d'Este in Ferrara were perhaps, but not conqueror Cosimo I de Medici who, the year after Michelangelo's death, commissioned the tunnel-like Vasari Corridor to let him walk across Florence safe from the people of the ex-republic whom he did not dare face in the streets. Michelangelo never made a Perseus or Hercules or other conquest symbol for Duke Cosimo, but the duke threw a grand funeral celebration for him, reinforcing with pomp and ceremony his hereditary claim to the artist: once a Medici client, *always* a Medici client. Like his *Prisoners*, our sculptor could not escape being used to glorify conquerors, in life and death.

But, also like his *Prisoners*, who were scattered so they never had to glorify the tomb of gloating Julius, Michelangelo got one wish: his tomb glorifies, not Rome, but Florence. It stands in Santa Croce, a resting place he shares with (among others) Poggio who trekked across the Alps, Bruni who sliced up history, Ghiberti whose *Gates of Paradise* Michelangelo admired, and Leon Battista Alberti whose *On Painting* he detested, an illustrious company soon to be joined by one Galileo Galilei, born the very year of Michelangelo's death, 1564, a good reminder that—exhausted as we are after this marathon—we have a lot of Renaissance to go. Would Michelangelo like his tomb? He'd criticize it certainly; the sculptor *terribile* was hard to please, and even the Nicodemus he made for himself failed to satisfy. He'd also chuckle to learn that *he* got a grandly decorated tomb, while terrible Julius remains under the flooring and magnificent Lorenzo in a hasty plain white box. But in this story where almost no one gets the tomb they wanted, Michelangelo may be the only one who got the thing he wanted most: given the position of the windows, if he rises as he planned on Judgment Day, he will have to take about four paces to the left to see the Duomo one last time.[180]

INTERLUDE

Let's Ground Ourselves in Time

One hundred and fifty years passed between Petrarch's *Italia Mia* and Lorenzo il Magnifico inviting young Michelangelo to Palazzo Medici, as great a jump as from the first steam locomotives to the atom bomb, and we still have two centuries of Renaissance to go.

One thing that makes the pace of history hard to understand is that the eras we moderns use to slice up history get shorter closer to the present. Eras are invented, lines drawn as in Bruni's day, but, once the chunks get names (Gilded Age, Great War, Cold War), each chunk tends to get one slot in our general imagination. Everyone knows the Roman Empire was longer than the Roaring Twenties, but they can *feel* oddly the same in size: each is a setting, with signature fashions, architecture, hairstyles. They get equal consideration when we're planning Halloween costumes, or fancy dress, or Barbie is releasing a new doll. If you pitch a TV show to a producer, say about the Emperor Tiberius, the producer might say "We're doing Constantine this year, we don't want two Roman things," even though Constantine is 250 years later. But if you pitch a series about the Second World War, the producer won't reject it just because they have a show set in the Roaring Twenties, even though those two are far closer in time. They're different *settings*. Cleopatra was closer in time to us than to the founding of her monarchy, but ancient Egypt remains one imagination slot.

So let's try an experiment. We still have two more friends to meet, but we'll understand them better if we take a moment to solidify our grasp on the events we've just seen from so many

sides. We know modern history decade by decade, which events our parents can remember, which our grandparents, so let's map them, borrow the fact that we have a *feel* for how far the First World War was from the Second World War, in a way we don't for Battle Popes 1 and 2.

Our starting point: 1348 = 1848.

They're very different but both turning points, the waves of the Black Death vs. the waves of revolution, but both shook the old order. So let's imagine ourselves as Michelangelo in the 1520s or 1530s, straining under the stress of della Rovere lawsuits and unfinished Medici projects, thinking back, and make him equivalent to us in the 2020s or 2030s looking back an equal distance at our past. For Michelangelo, Dante's *Commedia* is as old as *Pride and Prejudice* or *Frankenstein*, and he looks back on the Black Death and Petrarch as remotely as we do on 1848, when top hats were at their height. Dante and his contemporary Giotto are as far for Michelangelo as Napoleon for us, the Avignon papacy 1309 = 1809 like the Napoleonic Wars. It was the grandchildren of Dante and Giotto's generation which the Black Death hit, so the accounts of Petrarch and Boccaccio are as old to Michelangelo as the accounts by Tocqueville and Victor Hugo of the 1800s revolutions, while Petrarch's calls to revive antiquity are as distant as the political movements spearheaded by Edmund Burke and Thomas Paine, while the negotiations which returned the papacy to Rome parallel the US Civil War, and the unifications of Italy and Germany, 1370s = 1870s.

I don't want you to memorize these dates. In fact, as a history professor, I hereby give you official permission to never memorize another date ever! You can just look them up! If you learn *some* dates, remember 1348 Black Death, 1450 printing press, and 1517 Reformation, plus optionally 1492, for Europe's contact with the Americas, Lorenzo's death, and Borgia's election. The point is not the dates, it's to get a sense of *lived time*, how many years it took for Petrarch's friends to assemble their libraries, and get Michelangelo's Delphic sibyl on the Sistine Chapel ceiling.

The scholar friends who knew Petrarch tutored and employed history-slicing Bruni, book-hunting Poggio, and our Florentine woodworker Manetto Amanatini. Poggio was around twenty and

Bruni thirty when the Viper of Milan dropped dead, events as distant for Michelangelo as when we read of the Opium Wars and Harriet Tubman's Underground Railroad. The wedding of Henry V and Poggio's journey to hunt for books are as distant as the First World War, and Poggio's was the generation of Stalin, Mussolini, Roosevelt, Ataturk, Einstein, Helen Keller, Picasso, and Virginia Woolf. Art champions Brunelleschi and Ghiberti competed in 1401 = 1901 for the commission to make the baptistery doors, then for the cathedral roof in 1418 = 1918, so the great dome Michelangelo so loved was as old for him as the grand train stations and mansions erected in the Gilded Age, while the *beginning* of Florence's cathedral project was all the way back in 1296 = 1796, as distant for Michelangelo as when George Washington declined to run for a third presidential term.

In the 1420s (our Roaring Twenties), Poggio came home, Alessandra Strozzi married, and young tresticular Francesco Filelfo went to Constantinople. In the 1430s = 1930s (Great Depression, Hitler on the rise), Cosimo de Medici lost then recovered power, banishing the Strozzi men and Filelfo from Florence, and the main structure of Brunelleschi's dome was complete by 1436 = 1936 (parallel to when Jesse Owens triumphed at the Nazi Germany-hosted Olympic Games). The Ottoman conquest of Constantinople and Greece, climaxing in 1453, was, for Michelangelo, a world-changing event parallel to the liberation of India in 1947. In the 1450s = 1950s the power couple Bianca Maria Visconti and Francesco Sforza had just seized Milan, the Wars of the Roses were brewing, Nicholas V proposed rebuilding Saint Peter's, and *Time Magazine*'s "Man of the Millennium" Johannes Gutenberg debuted his press. If there was a Baby Boom equivalent, births in the 1440s and 1450s (1940s and 1950s) included Lorenzo and Giuliano de Medici, our assassin Montesecco, pious Raffaello Maffei Volterrano, Savonarola, Poliziano, Cardinal Ascanio Visconti Sforza with his bunny and his parrot, Queen Isabella of Castile, and Beatrice of Naples Twice Queen of Hungary.

The 1460s = 1960s (Vietnam War, Space Race, the Beatles, China's Cultural Revolution) saw ten-year-old Poliziano come to Florence, and Pope Paul II (reclusive Venetian) arrest and

torture Pomponio Leto and his *umanisti*, while in 1466 = 1966 our fifty-eight-year-old widow Alessandra Strozzi finally welcomed her exiled sons back to Florence, a year that marked the death of Donatello and the birth of Erasmus. Pope Paul's death in 1471 = 1971 saw the rise of Sixtus IV (Battle Pope!), so the political turmoil around the Pazzi Conspiracy corresponds to Watergate, the rise of Margaret Thatcher, and the Soviet invasion of Afghanistan. Young Savonarola donned his Dominican habit in 1475 = 1975, when Botticelli and Leonardo were apprentices working away. Michelangelo would have been around thirteen when he heard of the death of Princess Ippolita Maria Visconti Sforza in Naples in 1488 = 1988, and if Lorenzo de Medici really did see young Michelangelo carving a faun's head, it aligned with the fall of the Berlin Wall (1489 = 1989). Michelangelo certainly remembers Savonarola's arrival in Florence in 1490 = 1990, and his days dining at Lorenzo's rankless table align with the first Iraq War, and the first webpage. The Borgia chaos and French invasion of 1494 = 1994 are for Michelangelo like the Gulf War, Dolly the cloned sheep, and the launch of the Hubble Space Telescope. In 1498 = 1998, as we may remember the EU forming the Euro, and a handy new tool called Google debuting, Michelangelo remembers finishing his *Pietà*, hearing dispatches from Florence about Savonarola's fall, Raffaello Maffei denouncing the fake *Antiquities* of Annius of Viterbo, and Rome abuzz about Lucrezia Borgia's illegitimate *Infans Romanus*, much as US newspapers were with Bill Clinton's Monica Lewinsky scandal.

As the new century comes, Michelangelo remembers finishing the giant sword-wielding statue of Julius and starting the Sistine ceiling in 1508 = 2008 (Global Financial Crisis). By 1513 = 2013, friends of Machiavelli got to see drafts of his little book on princes, around when 2013 gave us moderns Disney's *Frozen*. In 1516 = 2016 (Brexit vote, Trump's election, authoritarian surge) the Italian Wars were finally over except for the mess in Urbino, Ippolito d'Este did not thank Ariosto properly for *Orlando Furioso*, and Michelangelo may remember starting to hear the name Martin Luther. By the 1520s, Michelangelo hears of Luther every day, and may hear soon of someone called Cortéz conquering Mexico. The reign of Pope Adrian the No-Fun corresponds

INTERLUDE

to 2022–3, Florence's strange Last Republic will fall in 2030, *The Prince* will be printed in 2032, Michelangelo will discard his unfinished *Deposition* in 2055, and Cassandra Fedele, who debuted 1487 = 1987, will deliver her old-age speech to Queen Bona Sforza of Poland in 2056. England's Queen Elizabeth I will take the throne in 2058, the Saint Bartholomew's Day massacre will come in 2072, the Spanish Armada will sink in 2088, *Hamlet* will premiere in 2100, the King James Bible will come out in 2111, Shakespeare will die in 2116, and Galileo will finally be condemned by the Catholic Church in 2133. Today the long Renaissance is one imagination slot, Bruni's history shelved next to Machiavelli's, Giottos hung next to Titians, but when we zoom in each generation's experience was as different as Neil Armstrong's from Napoleon's.

43

Julia the Sibyl: A Prophetess in an Age of Science

Our wings of thought must bear us far to find our fourteenth friend, to the year 2189, i.e. 1689, where enters a woman known to us today only as Julia (born ~1665?). She served as a lady-in-waiting, clairvoyant, and sibyl to King Kristina of Sweden, the most celebrated learned lady of her century. This Julia's origins are low like Josquin's, so I have only wisps of information about her, no birth record, no death date, just glimpses in biographies of her royal employer, a fleeting blip on the historical record—though at any moment some enterprising grad student could decide to track her down and give us more.[181]

To meet Julia, we have jumped more than a century beyond the death of Michelangelo, and 1689 brings us to the farthest limit of the label "Renaissance," so far into the foothills of the Enlightenment that Montesquieu is in diapers, and a little toddler girl up in Paris, Marie Arouet, will soon welcome her baby brother Voltaire. If we search for late-Renaissance hero Galileo—whose musician father Vincenzo Galilei was a newborn back in 2020 = 1520 as we imagined Michelangelo gazing back—we will find that astronomy's champion has already lain proud in his grave for forty years, as ongoing attempts to refute or vindicate his theories amplify his fame. The tail end of the seventeenth century finds us deep in what has been called the Scientific Revolution, when the old systems of Aristotle, Galen, and Ptolemy were challenged, and new models of nature grew through the collaboration of hundreds of now-forgotten scholars, punctuated by the big names: Copernicus (*De Revolutionibus*, 1543), Galileo (*Starry Messenger*,

1610), Kepler (*Epitome*, 1617–21), Francis Bacon (*Novum Organum*, 1620), Harvey (*On the Motion of the Heart*, 1628), Descartes (*Meditations*, 1641), and Newton (*Principia*, 1687). Leviathan the Great—as some contemporaries called the much-feared Thomas Hobbes—has risen and fallen, turning statecraft on its head, which John Locke will restore again this very year with his *Two Treatises of Government*, 1689–90. Experiments measuring density, temperature, and refraction have joined (not replaced!) Ovid, opera, hunting, and classicizing comedies as fashionable activities for the elite, so gentlemen calling upon Julia's royal patron Kristina in her chemical laboratory are as likely to have a barometer built into their canes as a sword. Yet in this Age of Reason our next stage direction is: *Enter Sibyl.*

Our main source about this latest of our three Renaissance prophets is the epitome of unreliability, the anonymous *History of the Intrigues & Gallantries of Queen Christina of Sweden and Her Court Whilst She Was at Rome*, for many years mistakenly attributed to its German translator Christian Gottfried Franckenstein (1661–1717, about a century too early to be the imaginary Victor's uncle). Historians have now confirmed the oldest version of the text is French, published in 1697 in (censorship-free) Amsterdam. Its nameless author uses the oh-so-period trick of claiming the book is a translation, in this case of an Italian document brought from Rome by an unnamed abbot. Julia appears in only one scene, in which she flatters her royal mistress, prophesies Kristina's death, two other prominent deaths, and her own wretched persecution, and faces wrath and criticism from five different men before her speedy exit. And behold! (our extremely sketchy source proclaims) this sibyl's predictions all come true.

Who was Kristina of Sweden, to be the subject of such a strange and untrustworthy book?[182] A portrait hangs in the hallways of the Uffizi Gallery in Rome, which I've pointed out to many friends, students, and passers-by over the years, to a mixture of oohs and aahs, and scowls and sneers, and comments which reveal anew how variable impressions can be when textbooks boil historical figures down to one defining fact: "Ooh, Kristina the lesbian!" "Ugh, the convert." "Ah, the scientist!" "You mean the trans king? Neat!" or "Isn't that the one who killed Descartes?"

Portrait of Kristina of Sweden by Jakob Voet, c.1670, Uffizi Gallery portrait collection, Florence.

Kristina (1626–89) ascended the Swedish throne aged five, and while period documents use feminine language for her, and sometimes "Queen" (*regina*), her coronation title was "*King* of Sweden" (use of *queen* for a female monarch, as opposed to a king's wife, was new at the time, appearing only toward the end of the reign of England's *Prince* Elizabeth I; when Machiavelli wrote *The Prince* the term included women). King Kristina spent her earliest years in the care of her father's sister, then, after her father's death, spent nineteen months with her mother (more on that anon), after which her education was taken over by the council of Seven Wise Men who ruled Sweden in her minority (and had largely ruled it for her father while he was busy failing to conquer Poland). Her education was very unusual for a woman, including fencing, hunting, and riding in the male style. Many accounts describe Kristina's wild unkempt hair and "masculine" comportment, that her shoulders were different heights (she wrote that she believed she was dropped as a baby), and that she swore like

a soldier. Kristina usually wore partial or complete male dress (as the Uffizi portrait shows), except during her residence in Rome when the pope commanded her to dress as a woman.

Even detractors acknowledge Kristina as one of the most learned women of the 1600s, versed in the latest works of Kepler, Copernicus, Tycho Brahe, Pascal, and Francis Bacon's new efforts toward systematic science. She patronized arts as well as sciences, and was said to study ten hours a day and to sleep only a few hours at night, usually sharing her bed in those hours with—in her early years—her lady-in-waiting Countess Ebba Sparre, in what was, depending on which biography you read, either the hottest lesbian relationship of the century, or a wholly asexual and perfectly normal bed-sharing practice in the days before efficient heating, as we see when it's considered perfectly normal that Hero and Beatrice shared a bed for a year in Shakespeare's *Much Ado About Nothing*.*

In 1649 Kristina persuaded Descartes to come to Sweden to create a new scientific academy and join her studies. He moved there in winter, at her request joined her for several 5 a.m. tutoring sessions, quarreled with her, contracted pneumonia, and died on February 11, earning Kristina the title "the one who killed Descartes." Soon after this (1651–3), Kristina had some sort of medical crisis, which gaps in period sources and medical understanding make impossible for us to fully understand. Efforts to diagnose Kristina (diabetes, nervous breakdown, high blood pressure) loom large in her biographies, contemporary and modern, and the fact that so much more ink has been spilled over her presumed maladies than over the better-attested illnesses of Lorenzo and his fellow Medici (or, for that matter, Diderot and Voltaire, who were both chronically ill,[183] ditto John Calvin for a time, and Heidegger), is very much a product of Western culture's tendency to pathologize (A) women and (B) gender non-conformity.

Next, and inextricable, come King Kristina's abdication and conversion. She had spent lavishly on art, science, theater, and favorites, causing Sweden a financial crisis and much discontent.

* IV.i, "No, truly not; although, until last night, / I have this twelvemonth been her bedfellow."

She also read and discussed, not only science, but radical religious views, and by 1644 was supporting radical variants of Sweden's official state Lutheranism. After years of pressure to marry her nearest male cousin Charles Gustav, she declared in 1649 (soon after her twenty-third birthday) that she had a distaste for marriage and "all things females discussed and did," admiring monastic celibacy and the model of England's Virgin Prince Elizabeth I. Kristina declared she would therefore remain unmarried, and abdicate, giving the throne to her fiancé-cousin. The abdication and new coronation took some time, during which she corresponded in secret with many Catholic figures, then packed up her books, art, and laboratory, and left Sweden in 1654. Traveling through Denmark and the Netherlands in men's clothing with the pseudonym "Count Dohna," she converted secretly to Catholicism in a friend's palace near Brussels before the year's end, then traveled, with her entourage of more than 200 attendants, through the Germanies toward Italy where she planned to make her conversion public.

The convert queen was a publicity coup for the Vatican, and her procession through Italy an epic spectacle, its last stage decorated by the artist Bernini, who became Kristina's lifelong friend. But when the victory party ended, Rome discovered that a headstrong and ungovernable gender-bending king, practicing her own idiosyncratic radical Catholicism, was as disruptive in Rome as she had been in Sweden. Wild parties and alleged affairs with opera singers and cardinals ensued, and Kristina befriended and defended heretics of all sorts, even issuing edicts like that of 1686 declaring all Rome's Jews to be under her protection as "La Regna" (The Queen of... Nowhere?) In fact, Kristina almost became Queen of Naples, an arrangement proposed by young Louis XIV and his mom when Kristina visited them in France, but a bout of plague (yes, still!) interfered, and Kristina lost their (and lots of people's) respect in the Monaldeschi affair of 1657 when she chose to exercise her royal right to summarily execute one of her servants if they betrayed her, which was totally legal but *just not done!*

So, in 1689, it is back in Rome that we find crownless King Kristina (now in her sixties), and our final Renaissance prophet, Julia. Far as we have strayed in time, the elegant mirrored

chamber where Julia is about to make her entrance is familiar, the sun-kissed marble palace known today as Palazzo Corsini, but originally built by Cardinal Raffaele Riario, the nephew of Julius II (Battle Pope 2: It Was Your Job To Be #3, Riario!), the same Riario whom Lorenzo saved from the Pazzi Conspiracy, who bought Michelangelo's fake antique sleeping cupid, whose beloved Lorenzo Oddone Colonna was cruelly executed for a murder he actually committed, and who was finally banished in the plot to murder Leo X. And now, in the raw 1697 English translation by Phillip Hollingsworth, I present to you the entirety of our period testimony about Julia.[184] I urge you to remember that this source is extremely unreliable, and yet so peculiar in some of its specifics, so different from what a generic scandal-monger would make up, that it must have some root in some rumor at least, and—more important—it was *considered plausible* by our scandal-monger and his readers. The claims here are in line with 1689's expectations of the strange doings and strange companions of this strangest monarch. And keep a special eye out for what our scandal-monger thinks of the science of chemistry:

> The Queen had some Pre-sentiments of her Death, which made her apprehensive, she should not live long. Six Months before her Sickness, or thereabout, she made her Habit [i.e. gown] of Sattin, white Ground, stitch'd with Flowers, and other works of Gold, garnish'd with Lace, and buttons set in Gold, and Fringe of the same below. This Habit was Invented by her self, and serv'd for a *Manteau* and Body together. It was close before, without a Tail, and round at the bottom, and the Queen tried it on upon Christmas Eve, and took many turns in her Closet, without speaking a Word: She look'd upon her self often, both before and behind, in a couple of Looking-glasses, which were set opposite one to another, and then walked again, in profound Silence. Her Taylor, who thought he had done better than ordinary, rejoic'd within himself; And there was none but him, the Marquis *Caponi*, and two Maids there, when *Sybil* entered. This *Sybil* was a Woman well skill'd in Chymical Operations, and had served the Queen for some time. Cardinal *Azzolini* brought her in to counter-check *Bandiere* [i.e. another favorite]. Her name was *Julia*, and she was Daughter to

an Apothecary, a good Simpler [i.e. user of medicinal herbs], who taught her his Trade, which she improv'd, by the Invention of a certain number of fine Secrets. She had something Marvelous in her Person, and her Birth was Extraordinary. For when her Mother Lay in of her, which was upon the *3d.* of *November,* 1665, she was seven Hours in Travel, with great Pains, and was not deliver'd, but by an horrible Clap of Thunder: The Lightning that accompanied it, made her Chamber seem all on Fire; and the Fright made such an Impression upon her, that it threw out the Child.

Her Sex was doubtful at first, and though time made it appear she was a Girl, yet she always had the inclinations of Men, flying Girls Company, and seeking after Boys; She would throw Stones as they did, and fight with her Fists, and shewed a Masculine Spirit in all things. She learn'd Latin, and made a great Progress not only in Pharmacy, but in Chymistry; besides this, she touch'd Instruments well. But she had yet a Quality beyond these, which pleas'd the Queen better than all, which was that of the foretelling of things to come, and for this reason, the Queen gave her the name of *Sybil.* I have been inform'd she had once an Husband a Distiller, but he died after he had been Married about six Months.

The Queen, who was foolish in the belief of all vain and curious Sciences, as *Chymistry, Astrology,* the *Divining-Rod,* and loved those who pretended to possess them, believ'd all that Astrologers said, and particularly the Abbot *Massoni,* who us'd to flatter her with the promise of living Fourscore Years, and by these deceitful hopes, he drew a good deal of Money from this credulous Princess, and afterwards Laugh'd at her.

I could tell you a great many Stories of this nature, if this Book were not too big already.

Sibyl coming to congratulate the Queen upon her fine Garment, exaggerated the fineness of the Stuff, its Beauty and Fashion, which very well suited her Majesty's Person.

Well, *Sybil,* (says the Queen) does this Habit please you?

Yes, Madam, (replied she) it is perfectly well made.

Upon this the Marquiss *Caponi* took up the Discourse, and said, you are come very luckily, for we are here acting the Comedy of the Mutes.

It is true, says the Queen, that no body has said any thing, nor

I my self, but this Habit which you see, makes me think of some things of great Consequence, and I believe it will serve me in a little time, in one of the greatest functions that can be; but *Sybil*, thou art not able to Divine what Function this should be.

Pardon me, Madam, (answer'd she) looking attentively on the Queen, your Majesty thinks this Habit will serve; Shall I speak it, Madam?

Yes, saith the Queen.

The thought afflicts me, saith *Sybil*, Your Majesty thinks, you shall be Buried in this Habit in a little time.

And I, saith the Marquiss, interrupting hastily, believe the Queen thinks it will serve her to wish the Pope an happy New Year in.

Sybil has spoke the Truth, replied the Queen, that was it I thought on, but we must put all into the Hand of God, for we are all Mortal, and I as well as another.

The Taylor, to divert this sorrowful Discourse, addressing himself to the Queen said,

Will your Majesty have a Cover made for this Habit?

Why a Cover, great Beast, says the queen?

To keep it twenty Years, and above, saith the Taylor; For if it be design'd for the use your Majesty speaks, you must take care the Worms do not eat it.

She fell a Laughing, and was well pleas'd with the Repartee. After some Discourse of this nature, they separated, and the Marquis grumbled at *Sybil*, for her ill Augury.

You mistake, quoth *Sybil*, I have not foretold the Queen's Death, I only found out her Thought.

This odd Apprehension did so possess the Queen's Mind, that the Taylor Congratulating her upon the recovery of her Health, as others did, said,

Madam, the Habit is the Cover, and may, if it please god, be so for a long time.

God grant it, says the Queen, but I am of Opinion it will serve me ere long for the use I believe 'tis design'd.

This thought made too strong an Impression upon her Spirits, to believe the *Sybil* Divin'd it merely by chance.

It is strange, says the Marquiss *Caponi*, your Majesty should

think so much upon the words of a Fool; and will your Majesty always be abus'd?

Cardinal *Azzolini* coming in, he desir'd him to assist, to take off the ill Impressions the Queen had receiv'd; which he endeavouring to do, the Queen seem'd to believe, only for this reason, that he might no farther trouble her Head about it.

The Cardinal meeting the *Sybil* afterwards, gave her a smart Reprimand, for entertaining the Queen with Melancholy Visions. But she excus'd her self, That she had done nothing with an ill intent; That she wish'd not the Queen's death, for her own sake; for, said she, there will be no body lose more than my self, for I foresee the Crosses and Persecutions that will happen to me. God preserve us, for your Eminence will not be long after the Queen, when God call her.

Azzolini, who heard the first words of the *Sybil*, without Emotion, was troubled at the last, and turn'd his Back all in Confusion.

She repented that she had said so much, for her Predictions were but too true, whether it were that she was effectually Inspir'd from Heaven, or Chance and Conjecture, that made her to advance things, I know not, but the Event confirm'd them.

She had also told the Queen that the Pope would die the same Year, in the Canicular days, and he Deceas'd the 13$^{\text{th}}$ of *August* next following.

He [the Pope] was inform'd of these Predictions of the *Sibyl*, and was so displeas'd, that as soon as ever the Queen's eyes were clos'd, he caus'd [Julia] to be taken up and Imprisoned in the Castle of St. *Angelo*, where she remain'd till her dying day.

She said something also of *Alexander* VIII, but he changed her Prison into a Conservatory, where she consum'd and pin'd away for grief.

Exit the Sibyl, Julia.

What can we conclude from this unreliable scandal rag? First, that the description of a dress so curiously specific probably had some real, specific source, and that—like *Vogue* and Nancy Drew novels—readers of 1689 wanted all the details of celebrity fashion. That the complexly gendered queen was expected to have (or truly

had) a complexly gendered companion. That the queen is presented as preyed-upon by (mostly male) scammers, while Julia is presented as more genuine, both in her chemical abilities, and her prophecies. That our author (and presumably his audience) wondered whether such powers were "Inspir'd from Heaven, or Chance and Conjecture." That the reader is expected to believe that popes and cardinals would crack down cruelly on unwelcome prophecies. And that, while writing for the same audiences who are lapping up Locke, Leibniz, Newton, and Dryden, our scandal-monger expects readers to have no problem with his statement that the queen "was foolish in the belief of all vain and curious Sciences, as *Chymistry*, *Astrology*, the *Divining-Rod*…"

♫♪ One of these things is not like the others ♫♪—not to *us*, at least, but when we pair names like "Scientific Revolution" or "Age of Reason" with a list of famous figures who discovered scientific truths, our cherry-picking of successes disguises the hundreds of other figures who thought that the character of one's soul was mystically present in one's facial features (Thomas Browne), that magnetism was made of tiny flying screws (Descartes! Descartes thought that!), or that gold could be condensed out of sunlight (looking at you Newton), while it was not uncommon at the time for step eight of a *chemistry* experiment to involve evaporating the solution and feeding the resulting powder to a bird, then doing augury with its entrails. Chemistry in 1689 was *not* more credible than astrology, not yet.

Rather than Age of Reason, I like to call the seventeenth century *the Try Everything Age*, because they were trying *everything*, not just things that we moderns respect. The vogue of dropping things off leaning towers was *also* a vogue of diagnosing ailments by one's horoscope, and conjuring demons from ancient stones. Historian of science and information Brendan Dooley has a brilliant book on one Orazio Morandi (1570–1630), a scientist, astronomer, alchemist, abbot, friend of Galileo, and, for a while, a courtier to a *natural* son of Duke Cosimo I, who was imprisoned and likely assassinated only one year before Galileo's own trial, not because of any of his scientific findings, but for prophesying the death of Pope Urban VIII, just as our unfortunate Julia did.[185] In figures like Julia and Morandi, we see how intellectually

omnivorous experimenters of the Try Everything Age could be, while in the predatory charlatans depicted as preying on King Kristina with their *Chymistry*, *Astrology*, and the *Divining-Rod*, we see that Sturgeon's Law that "90 percent of everything is crap" was as true then as it is now, but that it is often hard to know which 10 percent is not. Luther had condemned the divining rod 150 years earlier, Savonarola and Machiavelli had condemned astrology, and many a monarch condemned the costly (al)chemists who kept failing to deliver the philosopher's stone, but people kept on trying things, and science got better *because* people kept trying things, even things they'd thought were bunk for centuries like (*shudder!*) doctors actually touching patients' bodies to diagnose their ailments! When we discuss the science of mixing substances in beakers, we use the words chemistry and alchemy as a kind of binary to distinguish experiments we respect from those we think were bunk, and we use astronomy and astrology much the same, but those are retroactive separations.[186] The alchemists were the chemists, and modern chemistry grew out of the great strides they made, even as they made great mistakes in other projects tried at the same time.[187] Similarly, most pre-modern astronomy was done by astrologers, and while there were always some stargazers who said prophecy was bunk, in many decades the majority who did believe the stars could show the future made as many, if not more, great strides in serious astronomy than the incredulous minority. As for the divining rod, while it is bunk, it's such weirdly convincing bunk when you actually try it that scholars would still be publishing in *Nature* in 1986 trying to figure out how it works, so we have no right to mock those who found it worth examining.[188] An age of discovery required people to keep testing things, even when hundreds of similar things had turned out to be bunk. Julia the Sibyl is not the kind of figure textbooks admit existed in the Age of Reason, but her powers, prophetic and chemical, are presented by this source as *real* powers in a sea of charlatans. In this we see the seventeenth century's characteristic open-mindedness—"sometimes it's real"—an open-mindedness which kept the door open *both* for great advances in chemistry and astronomy, *and* for continued belief in prophets.

But is this still the Renaissance?

We'll circle back for a fuller answer in the final section, as we look at how the Try Everything Age grew from our desperate times. For the moment, let's return to King Kristina's first year on the throne, 1632, the year that Milton published his verse epitaph of Shakespeare, that Galileo completed his *Dialogo* comparing the cosmologies of Copernicus and Ptolemy, that Shah Jahan began building the Taj Mahal, and that the ghost of Cesare Borgia, still restless in unconsecrated ground, witnessed the birth of his great-great-great-great-granddaughter Marie Charlotte de La Trémoïlle. At this point, five-year-old King Kristina lived, not yet with Seven Wise Men, but with her mother, freshly widowed Maria Eleonora of Brandenburg. After her royal husband's death, Maria Eleonora had his heart removed from his body and put into an elaborate golden reliquary, which she permanently suspended above the bed where she and little Kristina slept at night. She also refused to let the remainder of the late king's body be buried for nineteen months, keeping it in a silver coffin near her as she mourned week after week, keeping Kristina ever at her side. In this strange year, accounts tell us, the widowed queen and child king received no entertainment except for dark, candle-lit visits from the royal court's collection of dwarfs and hunchbacks. We understand now why the ruling council took the child away. This macabre pageantry does not feel like the Age of Reason—indeed, Hollywood would use such a scene to make a costume drama feel medieval, shadows and candles perfect for a Dark Age, but hiring court dwarfs actually boomed in the 1500s and 1600s, part of curious Europe's appetite to understand nature, the body, medicine, and more.[189] Tycho Brahe, one of our big names in astronomy, hired dwarfs too. Curiosity, discovery, obsession with the strange and unexplained, these made people *more* excited about dwarfs and sibyls, *increasing*, not replacing, practices we're taught to think of as medieval. Sure feels like Ever-So-Much-More-So.

But the seventeenth century does have a new character—the Try Everything Age of telescopes and beakers is not quite the same as Petrarch pleading for the library of Cicero to bring us peace. To get from Petrarch's plea to Frankenstein's great-uncle translating this tale of Julia in her laboratory prophesying deaths of cardinals and popes, we must circle back almost two centuries,

and visit once again the days when this Roman palace was still being built for Cardinal Riario, and when our final, patient friend received a letter urging him to finish up his history, or future generations will never believe so much was lost so quickly.

Seventeenth-century spiral thermometer, hand blown glass (Museo Galileo, Florence). The black dots marked degrees as the liquid inside expanded or contracted. Used for experiments similar to those Julia and King Kristina enjoyed, this one was made for Florence's Accademia del Cimento, founded 1657 by students of Galileo and funded by the Medici dukes.

44

Our Friend Machiavelli

My PhD adviser said you should choose your dissertation topic based on the cuisine of the region you must visit for research. More seriously, I am profoundly fortunate that my interests in events and ideas takes me so often to Florence, where hauling my bags across the cobbles now feels like coming home. After so long in the city, life feels strange without church bells to inform me when it's noon, or 7 a.m., or 6 p.m., or 6.12 a.m. (why?), without squash blossoms and arugula as pizza toppings, without transcendent gelato, the constant soreness of "museum feet," and suspense each time I enter a new bathroom about which ways *this* plumbing will be bizarre. I crave my daily glimpses of Cellini's *Perseus*, Verrocchio's *Doubting of Saint Thomas*, and the gobsmackingly enormous dome. And, more than anything, I crave the long sunsets sitting by the Palazzo Vecchio, watching evening mature through every shade of blue, each one filling the sky around the gold stone battlements, and reflecting off the palace's grand windows, and the little windows of the offices where Machiavelli worked.

Why is Machiavelli such a big deal?[190]

After ten years of syllabus revisions I feel I'm finally good at getting this across in the classroom, but the first place I had to do it was the streets of Florence, where I often rescue befuddled tourists and study abroad students from such threats as bad pizza, bad gelato, the elusiveness of restrooms and water fountains, or the old "Help, this is the right street number but my hostel doesn't exist?!!" (Answer: Florence has two sets of street numbers, the red numbers (*rossi*) sometimes written in black, and the black numbers (*neri*) often written in blue—this is not *reasonable* but

it is *hilarious*, and based on which doors were commercial and which residential 300 years ago.)

Rescued tourists, on learning I'm a scholar, would ask me questions: "What's this building?" "What's this statue about?" "Why did they make all this art?" "Does the Vatican Library really look like in Dan Brown?" (No, the Vatican does not have that much money, but it does have a ceiling painted with exhausted-looking cherubs weighed down by carrying huge stacks of books, and a big statue of Thomas Aquinas glaring at you if you goof off while working. Also, the librarians often wear white lab coats, so one time I was working away and a thunderclap and downpour burst out of a clear blue sky, and then a bunch of people in lab coats and priest robes rushed through the room, and five minutes later the clouds opened up and a perfect golden sunbeam slanted down with rainbows like a Hallmark illustration of the rains parting for Noah's Ark. Surreal old place, the Vatican.) Among such tourist questions (generally smart questions, tourists are great!) I often get variants on "What's really up with Machiavelli?"

The answer is complex, not least because there are at least four Machiavellis, all important:

1. Machiavelli, statesman and patriot—I introduced him at the start (SPQF)
2. Machiavelli, founder of the modern disciplines of political science and history.
3. Machiavelli, pioneer of utilitarianism/consequentialist ethics.
4. "The murderous Machiavel," Arch-Heretic, Anti-Pope, "Old Nick" a synonym for the devil, the evil councilor who looms in that most misleading adjective *Machiavellian*.

And since you now know Pope Alexander, Julius, Savonarola, all the details of the wild wars he describes, we can dive in:

Machiavelli Part 2: The Three Branches of Ethics

Machiavelli, Part the Second: in which terms are defined, moral codes tested, teachers betrayed, a hypothetical man executed,

Batman and Sherlock Holmes placed before the Reader's judgment, and Old Nick never actually appears.

Ethics, or moral philosophy, is the branch of philosophy which deals with good and evil, right and wrong, and decision-making, how we separate correct from incorrect action, and make choices in our daily lives. A moral philosophy, or ethical system, is the set of criteria by which an individual judges whether an action should or should not be taken. All ethical systems can be separated into three fundamental categories, whose names are confusing, to the eternal grief of philosophy students. (Footnote: I have encountered modern philosophy specialists using slightly different names, or using these names differently, but all the alternative terms are *strictly more confusing* when we're trying to include pre-modern philosophy, so this is the best I've got.) The three are:

- **Virtue Ethics**—confusing because it does not necessarily involve *virtue*.

- **Deontology**—confusing because it sounds like it's related to *ontology*, but it comes from Greek δέον, obligation or duty, and has no relation to *ontology*, from ὄντος, being.

- **Consequentialism/Utilitarianism**—confusing because many will say utilitarianism started with Jeremy Bentham in the eighteenth century, and that's true of utilitarianism as a school of philosophy, but the core concepts are earlier, and while it would be lovely if *consequentialism* was the name for the general version, and *utilitarianism* of the Bentham-era version, no one actually uses the words in such a clear-cut way, alas.

First, I shall give away my ending by saying that Machiavelli is the founder of consequentialism/utilitarianism as we know it (with some precursors, notably Mohism in fifth-century BCE China), and that few changes in the history of thought have had such *consequences* (tee hee) for humanity. But we must start in a pre-modern world *without* consequentialism, for it is in such a world that Petrarch, Savonarola, and the young Machiavelli find

themselves trying to judge good and bad action using two tools: *virtue ethics* and *deontology*.

Virtue ethics is any ethical system which judges action based on the *interior motives, character, feelings, or intentions of the actor.* Did the person *will* a good deed when they took that action? If so, it was good. Did the person will a wicked deed? If so, it was bad. The focus is the character of the doer: is this a good person or a bad person *in the moment of this choice*?

Virtue ethics manifests in such legal concepts as a self-defense plea, heat of passion, and manslaughter. Yes, this person killed a fellow human, but they do not have *the character of a murderer*, because it was self-defense, (or) they were out of their mind due to shock, (or) it was an accident. Virtue ethics is often less about absolute right and wrong than the fine grain, as we see in homicide trials: *Manslaughter:* they did it, but never *intended* a fellow human's death, they do not have the soul/mind/character of a murderer; *second-degree murder:* they did it, willed it, but suddenly, they only had the soul/mind/character of a murderer for a moment; *first-degree murder:* they planned it, made the choice, sustained that choice, had many chances to turn back, and had the soul/mind/character of a murderer throughout.

In Europe, the oldest articulation we have of virtue ethics (as of many things) is Plato. In *The Republic* he attempts to define Justice. Is Justice, as one speaker proposes, *Law*? Is it *The will of the stronger* who uses state violence to define what is or is not permitted? Compressing a long seminar debate into one line, Plato defines Justice as *a harmony of the soul*, i.e. an *interior* quality independent from action. For Plato, while saving a drowning child, or sacrificing oneself for one's country, are virtuous *actions*, a *person* is equally virtuous while sitting in solitary meditation, if the person's *inner state* remains just. Plato also concludes that this inner harmony of the soul is what makes people happy, rather than wealth or fame or power, which bring stress, risk, and, often, the opposite of happiness. (For extended discussions see Aristotle, Marcus Aurelius, Petrarch, Ficino, most philosophers really.)

Deontology, in contrast, is any ethical system which judges action based on *a set of laws or rules external to the doer*. They can be *any* rules, with *any* source. A citizen who judges actions based

on whether they are lawful or unlawful by the country's laws exercises deontology. A religious person who judges actions based on a holy book exercises deontology. A warrior who judges actions based on a code of honor exercises deontology. A rationalist deist philosopher who judges actions based on a set of "Natural Laws" derived from observations of Nature and human behavior (like Hobbes and Locke) exercises deontology. The uniting characteristic is the existence of external rules by which the act is judged. If homicide, or theft, or disrespecting your parents, or painting an offensive slogan, are judged to be wrong because they're illegal (government), or against the Ten Commandments (religion), or disgraceful (honor), or unnatural (the laws of Nature), those judgments are deontology—if they are judged to be wrong because doing them makes someone a bad person on the *inside* then they are wrong by virtue ethics. Europe's oldest discussions of deontology are also in Plato, so either we can call Plato in the West and Confucius in the East twin fathers of both virtue ethics *and* deontology, or we can say these concepts are as old as philosophy, present in all the oldest surviving discussions of ethics, and presumably in their lost predecessors too.

This is a good moment to pull the car over at a rest stop and get ourselves some Aristotle for the road—we'll be glad later. Aristotle broke violently (by philosophical standards) with his master Plato, and strode off, either boldly to new truths, or foolishly back into the Cave, depending whose side you take. But Aristotle too discussed deontology and virtue ethics. For Aristotle, virtues are a mean between two vices, i.e. bravery is the mean between cowardice and foolhardiness; generosity the mean between miserliness and prodigality; sageness the mean between giving terrible advice and talking someone's ear off with more good advice than they can possibly remember. For Aristotle these are, as in Plato, *internal* qualities. A man can be a brave man even if he never has the opportunity to show bravery, a good man even if he never rescues a drowning child, and a just man even if he is never called upon to arbitrate justice. Yet Aristotle discusses *habits of virtue*. Someone who does not have the correct virtuous balance, he says, can attain it through practice. One who is not naturally generous can practice generosity, for example, by making a rule

that he will give every time he sees a beggar or donation cup, and eventually, through practice, the man can acquire a *habit* of giving, and become internally generous. A coward who takes up a martial art, might, by habit, become brave. The pre-modern practice of beating a disobedient schoolchild to teach obedience had the same logic, in an age when obedience was considered a virtue. The idea of acquiring virtues through repetitive practice underlies a lot of medieval Christian practices, especially the monastic life in which you try to attain virtues through repetitive daily routines, following rules. It lies even more distantly behind our modern practice of assigning public service hours as punishments for minor crimes. *Habits of virtue* <= we'll need this concept later.

Back to deontology vs. virtue ethics: Dante is a fabulous window on how most ethical systems are *hybrids* of the two. In Dante, judgment is dictated by Divine Law, but Divine Law cares *both* about the soul's character and the soul's deeds. Hell has three large sections, corresponding to (A) sins of *minor moral weakness* like lust, gluttony, greed, laziness (the best word is *incontinence*); (B) sins of the *violent passions*, so anger, pride, ambition, the heat of blood that makes one have a bar brawl or commit second-degree murder; (C) sins of the *intellect*, the premeditated, calculated, complex sins like seduction, forgery, deceit, or giving evil counsel. Sins of the intellect are the worst, for Dante, because they take the noblest facet of the human creature—Reason—and apply it to base ends. This system clearly centers virtue ethics, differentiating between a sudden crime of passion and a premeditated crime, *but* the whole of Dante's Hell is organized by *deeds* more than *thoughts*, sodomy and adultery two different types of sin, punished in different sections. The thoughts-based area—where heterosexual and homosexual lust are treated as the same—is Purgatory, which has one section for each of the Seven Deadly Sins, where upward-pointing souls en route to Heaven spend time cleansing sin's weight from their helium balloons. In other words, Hell is organized by which act was done and which rule broken (deontology), while Purgatory is organized around interiority (virtue ethics). It's also (an oversimplification) generally true from the Reformation on that Catholicism is more concerned with repenting for *deeds*, and many Protestantisms (especially Calvinism and Puritanism)

with the purity of one's *thoughts*. This is all to say that practically no ethical system is 100 percent deontological or 100 percent virtue ethics; rather we dwell in a world of layered hybrids.

Some practical examples:

> *EXAMPLE 1: Tortoise kills Hare (to borrow some traditional denizens of The Kingdom of Thought-Experiment).*

A virtue ethicist cannot yet say whether Tortoise has done right or wrong. Most deontologists couldn't either. If a deontologist follows a strict form of Buddhism, which says that taking a life is *always* wrong regardless of the circumstances, such a deontologist could say Tortoise has done wrong. But for all others we need some detail:

> *EXAMPLE 2: Tortoise is a professional executioner. He executes Hare, carrying out a sentence ordered by their lawful government, for a capital crime which Hare did indeed commit.*

Now many deontologists can give us an answer. In a deontological system in which the lawful government has a right to lethal force, Tortoise has done no evil. But a deontologist who believes the death penalty is *wrong*, that governments are subordinate to a higher law of God or Nature which forbids taking a life, can say that Tortoise has done evil. Others may want to know what Hare's crime was (murder? adultery? atheism? public urination? insulting the king? arguing that the Holy Spirit emanates from the Father alone instead of coequally from Father and Son?) to determine whether or not it is appropriate for the law to punish such a crime with death, or whether some *higher* law of ethics makes that law an *unjust* law. The deontologist must also answer whether, if a government has commanded an inappropriate execution, the correct course on the executioner's part is to protest in those ways the law allows but nonetheless carry out the order, or to refuse the order even if that means breaking a law. All these fine-grain options are still 100 percent deontology.

Our virtue ethicist still has no way to judge Tortoise, because we need to know what's in Tortoise's mind. Did Tortoise become an executioner because Tortoise looooooves killing people, and jumped

at a state-sanctioned way to vent that murderous appetite? If so, a virtue ethicist might say it's a wise way to vent the appetite, but that enjoying killing people is bad. (Maybe Aristotle can help Tortoise get over it through practice?) Alternately, did Tortoise become an executioner because he witnessed a botched execution as a child, and decided to do it himself in order to strive to be as humane and respectful as possible to those about to face the undiscovered country? If so, we might call his choice a very kind, humane, and good one. Did Tortoise kill Hare because Tortoise was drafted into the army of a genocidal dictator and is just following orders? Did Tortoise question the orders? Was Tortoise brainwashed? Does Tortoise hate this task and feel anguish every night, or does he do it unhesitatingly? All these details the virtue ethicist must have before answering where Tortoise's actions fall amid the many shades of gray from good to evil. Even a Tortoise whose enthusiasm for killing is his own vs. a Tortoise whose enthusiasm is a result of indoctrination fall in subtly different places. And for virtue ethics it does not matter whether or not Hare is *actually* guilty, what matters is whether Tortoise *thinks* Hare is guilty. We are interested in Tortoise's internal character, whether or not Tortoise would execute an innocent. If Tortoise assumed Hare was guilty, Tortoise might be guilty of failing to investigate, but not of willing the death of an innocent, a different shade of gray. How we rank those shades of gray varies culture by culture, or person by person. Winston Smith working for Orwell's Ministry of Truth in *Nineteen Eighty-Four* spends his workday falsifying documents, and hating every minute of it, but he does it anyway—do we respect Winston's regretful complicity more or less than we respect his colleagues who believe, deep in their propaganda-twisted hearts, that the work is good? You see now how, even with only these two macro-categories—*virtue ethics* and *deontology*—there are layers enough to occupy philosophers for centuries.

"*What about me?*" objects voluntarism in a high, squeaky voice.

Yes, I was just getting to you.

Voluntarism is an ethical system which says an act is only good if (drumroll please…) it is good by *both* virtue ethics *and* deontology! That is, that an act must be good by external rules, *and* the doer must have good motives while doing it.

The quintessential example, for which we may thank William

of Ockham (1287–1347) and his newfangled *via moderna* (kids these days), is a thought experiment where someone goes to church. *You may think this is a good act*, Ockham warns his presumed-Catholic medieval reader, *but what if the person goes to church, not for the Lord's sake, but in order to show off her Sunday finery, and make political connections to advance her earthly greed? And what if she also comes in late and interrupts the sermon every week!* (Ockham and Savonarola are looking at *you*, Ginevra Sforza! Bet your little boy Ercole still remembered *that* particular Sunday when he wrote to Machiavelli about how bad things are!) In sum, voluntarism posits that true moral virtue includes only those good *actions* which are taken for good *reasons*.

To give a less formal example, but one which has the distinction of being perhaps the first documented manifestation of voluntarism in Western philosophy, Heloise (1101–64) spent her days in the nunnery praying, fasting, looking after the sick, mortifying her flesh, and everyone told her she was a very good nun leading a virtuous life, but, as she wrote in letters: *Even while praying, I spend all day thinking about how much I want to be having sex with Peter Abelard. How is this good?*, asks Heloise. *How is going through these pious motions supposed to make me good without thought behind them?* (Remember Shakespeare's Claudius in *Hamlet*: "My words fly up, my thoughts remain below; Words without thoughts never to Heaven go." III.iii) This is Heloise's critique of Aristotle's habits of virtue, the first recorded instance of voluntarist ethics in Europe's history, which Abelard answered by telling his former lover to just keep nunning harder (sigh). The question hits close to home—very close for partisans of Petrarch's plan of flooding Italy with virtue. Did Cosimo de Medici have Ficino translate Plato only for the good publicity? Or was it truly for the health of his soul? Was it for his grandsons Lorenzo and Giuliano? If for them, was it for their souls' sakes, or for their political advantage? Again we need our time-traveling telepath before we can judge any action *good* by voluntarism, except our own.

An eager hand goes up: "What if Cosimo did it for family advancement, but wanted to advance his family to safeguard Florence?" But this hand is our Young Nick, and he must wait his turn.

So, we have *deontology*, *virtue ethics*, and their child *voluntarism*. (Deontology: "A child conceived within the strictures of formally permissible union!" Virtue ethics: "And with love!")

Party game time! Now you're ready to spend a fun evening with your friends picking out interesting characters from fiction and discussing whether they acted on deontology or virtue ethics. This game brings endless delight, especially if you enjoy slotting people in alignment grids. You will also notice a pair of patterns, at least in recent popular fiction: (1) good guys tend to act more on virtue ethics, bad guys on other motives, especially deontology, (2) the writer tends to assume the reader/viewer will judge the characters based primarily on virtue ethics. *(Cue Darth Vader saying: Luke, search your feelings: you know you're guided primarily by virtue ethics.)*

Test cases:

Batman: Depends on the version, but when Batman is absolutely committed to never killing, even to stop the Joker, we must ask: Is his commitment to not killing because he thinks it would be bad for his moral character, giving him the soul/character/mind of a killer? (Virtue ethics.) Or does he do it because he has a rigid code which he refuses to break? (Deontology.) When the Joker puts Batman in situations where he could save 100 people by killing one, the Joker is enjoying how consequentialism can poke at both.

Spiderman: Uncle Ben died because of Peter Parker's selfish impulse to let a thug get away with robbing a jerk. Why, then, does Peter dedicate himself to fighting crime? Is it because he learns that *with great power comes great responsibility*, i.e. he feels there's a rule that the strong must use their power? That feels like deontology. If it's because Peter hopes to redeem the flaw in his character, that's very Aristotelian habit-of-virtue virtue ethics, practicing good deeds in hopes of gaining the corresponding virtue.

Average Disney hero(ine): battles villain, villain conveniently falls off cliff. The virtue ethicist can cheer that the hero(ine) never willed a death. Hooray, we've dodged moral complexity!

Caliban in *The Tempest*: Prospero enslaves and torments Caliban as punishment for his assault on Miranda. Virtue ethics

says Caliban willed a bad thing in attacking Miranda, so punishment is appropriate, but modern audiences often sympathize with Caliban, feeling the punishment is too extreme, and recognizing the factors of race and colonialism in the background of his oppression. Virtue ethics needs to know what Caliban is like inside, which usually comes from the individual performer's non-verbal choices rather than the script: does this Caliban leer and grab at Miranda on stage, making us feel he is wicked inside? Or is his body language benign, dignified, childlike, alien, or otherwise non-threatening? Deontology's answer, meanwhile, depends on which of several laws one considers. Shakespeare's era believed in right of conquest, and of patriarchs, and considered Prospero to be Caliban's patron and teacher, with the right to punish. If instead we have modern ideas about indigenous self-sovereignty, Prospero is a cruel colonizer. Or is the severity of Caliban's attempted crime more important than anything? As always, the deontologist must choose among specific codes for ranking evils.

Darth Vader: (Spoiler warning, I guess?) He betrays his emperor to save his son; the film presents this as redemptive, and his spirit moves on to the vague special-effects glowy-person Force afterlife. Virtue ethics supports this, since the morally good Light Side of his character won out. As for the deontologist, if we believe the emperor was a legitimate ruler, then this is treason (hello, Thomas Hobbes). If we believe the emperor is a mass-murdering tyrant, tyrannicide is good (hello, John Locke). If we believe that a parent's drive to protect his child overrides law, then killing to save one's son is good. If we believe an apprentice's fealty to his master should equate to a son's to his father (hello, Hippocratic Oath), then this is parricide, which many cultures consider worse than filicide. What if the Sith code says the apprentice *should* kill his master? Then Darth Vader is a slacker, and should've done it ages ago. This is one of many occasions in which Hollywood presents a narrative which is simple under virtue ethics, but much more complex if deontology rears its head, reopening such old debates as the *right to rebel* (Hobbes vs. Locke), or whether family or law comes foremost (before we cheer for Vader's choice to overthrow his head of state to save his son, remember how much Petrarch

admired the republican Brutus for valuing the good of Rome over the lives of his sons).

Sherlock Holmes: He helps justice, but sometimes he lets criminals escape when he thinks the crime should not be punished. Feels like virtue ethics—or is it? In "The Adventure of the Blue Carbuncle," (2392, I mean 1892), Holmes lets the thief go, saying "I suppose that I am committing a felony, but it is just possible that I am saving a soul. This fellow will not go wrong again; he is too terribly frightened. Send him to jail now, and you make him a jail-bird for life. Besides, it is the season of forgiveness." Is this religious deontology overriding secular deontology? The religious mandate to exercise mercy overriding earthly law? In "The Abbey Grange" (1904), Holmes appoints Watson as jury in the unofficial trial of a self-defense killing, and, on receiving Watson's "Not guilty," Holmes quotes the old, "*Vox populi, vox Dei*"—the voice of the people is the voice of God. When Holmes burgles the master blackmailer Charles Augustus Milverton (1904), he justifies his law-breaking by invoking the honor-based (deontological) duty of a gentleman to aid a lady in distress. Our perfect analytical reasoner walks a subtle line which often feels like virtue ethics, but it is hard to catch him overstepping rules of right and wrong. And yet it feels anew like virtue ethics when Holmes phrases it, "Once or twice in my career I feel that I have done more real harm by my discovery of the criminal than ever he had done by his crime. I have learned caution now, and I had rather play tricks with the law of England than with my own conscience. Let us know a little more before we act."[191]

Niccolò: "Wait! Wait! Is Holmes talking about… *consequences?*"

Yes, Nick, murky waters lie before us as ethics' third branch stirs in the depths.

Consequentialism (or *utilitarianism*) is any form of ethics which judges an action based on the consequences of the action, rather than the action itself or the motive of the doer.

Tortoise killed Hare before Hare could push the nuclear destructor button and kill a million people—consequentialism says it doesn't matter what law says about homicide, or what Tortoise was thinking, saving a million lives is *good*. Period. Okay. What if Tortoise killed Hare before Hare could exterminate a bus full of nuns and

orphans? *Good*. If Tortoise killed Hare before Hare could kill ten nuns and orphans? We feel the trolley problem drawing near. How many must be saved by Hare's death for it to be good: three nuns and an orphan? Two nuns? One but she's a super-duper great nun? One nun but she's thinking about having sex with Peter Abelard?

Tortoise killing Hare to save thousands of lives is a scenario early deontologists and virtue ethicists had thought of too (for them it was the figure of the tyrant, rather than the bomb). The deontologist must check the rules for killing to defend life, while the virtue ethicist must explore Tortoise's motive. If Tortoise killed Hare the Tyrant that may feel good, but before we call it good, we must check whether the assassin Lorenzino de Medici *ahem* Tortoise assassinated Alessandro de Medici *ahem* Hare in order to free the republic, or because he personally hated the dude, and didn't even bother to contact the exiled resistance in advance to give them a chance to organize a competent rebellion. Or, back in our scenario where Hare had the nuclear destructor button, what if Tortoise didn't care about the nuclear destructor button, and killed Hare just because Tortoise loves killing people? Or in order to steal Hare's avocado toast? What if Tortoise is a government sniper hired to kill Hare to save innocent lives, but became a government sniper in order to have license to kill because Tortoise just loves, loves, loves killing? When Tortoise's character is different, the virtue ethicist must judge differently, even if all these Tortoises keep Hare from pressing the big red button. Meanwhile, most deontological systems would still prioritize the act itself. The consequentialist, different from both, is concerned with the outcome, and doesn't need to ask what Tortoise was thinking when a million lives were saved, or what the legal system says—the act was good.

Consequentialism posits that external rules and internal character are not important when *consequences* matter so much. When the going gets tough, when the Joker has set it up so Batman *can't* save the innocents without killing, it's virtue ethics which says *don't kill, not even the Joker!*, it's consequentialism which says *kill him, it will save lives!*, and it's deontology which wants to know what Police Commissioner Gordon would say first. Consequentialism would still say it's *better* if Batman can avoid killing, but not worth risking many lives. If you've ever watched a *Star Trek* captain put

the whole crew in extended danger for the slim hope of rescuing one person, the voice inside that agreed with the captain was virtue ethics cheering on this act of hope, while the voice inside that called it reckless endangerment was consequentialism—deontology was busy flipping through Federation regulations to see what captains are supposed to do.

Consequentialism joining us as a third branch of ethics does more than make it more fun discussing Batman with your friends. It causes big changes.

One is that consequentialism's rise in the eighteenth century led to the first arguments for *deterrence-based justice*, advanced by figures like Voltaire (1694–1778), and Cesare Beccaria (1738–94), a Milanese Enlightenment figure much admired and publicized by Voltaire, and hailed today as the father of our modern systems of deterrence-based justice.[192] In contrast with *retributive* justice, *rehabilitative* justice, or *restorative* justice, deterrence-based justice aims to minimize human suffering by inflicting *the lightest possible sentence that still effectively deters the crime,* so the sum total of the pain experienced by victims *and* criminals together is the lowest possible. Punitive suffering, Beccaria argues in his groundbreaking *On Crimes and Punishments* (1754), is only justified if the suffering caused by the punishment is less than the suffering prevented by its deterrent effect, otherwise it just increases the sum total of human suffering. Thus, for Beccaria, doubling the punishment for something (double the fine, double the jail time) is only justified if the extra deterrent prevents so many people from doing the crime that the combined pain savings of the potential victims is greater than the increased suffering of those who experience the doubled penalty. This applies to punishments large and small: How much human pain is caused by doubling the fine for speeding vs. the pain prevented by that deterrent reducing traffic accidents (if it does so)? How much human pain is caused by increasing the sentence for drug trafficking from two years to twenty vs. the real deterrent effect that change has on the pain the drug in question causes within society (if any)?

Beccaria also argues that, if someone is prepared to do a deed despite the threat of death, the threat of a protracted, torturous death will not be a more effective deterrent—a vital turning

point in Europe's move away from torture and "cruel and unusual punishment." While individual voices in Europe had spoken against torture for some time before Beccaria (Savonarola among them), consequentialism joining discourse triggered a new wave of formal arguments against torture, which finally made major inroads, persuading lawmakers that justice should focus on preventing crime, rather than the enforcement-for-its-own-sake of some (deontological) code, or a (virtue ethics) sense that justice is when bad people are punished and good people rewarded. If you've ever had a debate over an issue like marijuana, prostitution, or abortion, with the structure: "X should be banned!" "But banning X means it can't have safety regulations, so studies show more people suffer if it's banned." "It's about principle, not consequences; X is wrong!"—you have encountered the modern legal borderlands of consequentialist justice. Current debates such as whether trying juveniles as adults actually deters juvenile crime, or whether any potential crime is deterred by sentences like life without the possibility of parole that wouldn't be deterred by a normal life sentence, are direct continuations of Beccaria.

Getting torture out of legal systems sounds good, so consequentialism is good, right?

Yes and no, as Peter Abelard would say, since the Pandora's Box which releases Voltaire and Beccaria to campaign against torture has other contents too, including that deadliest inhabitant of thought-experiment land, the trolley problem.

Questions multiply as we consider how many lives Tortoise must save before killing Hare is justified. If killing to save lives is good, what about a smaller evil for a smaller good? Is stealing to feed a beggar good? (Catholicism says yes: Saint Zita, popular in Italy, was a servant girl who stole from her employers to feed the poor, and when she was about to be caught the stolen food miraculously turned into flowers, protecting her.) Is lying to advance your nation's interests good? What about second order consequences? What if Tortoise stops Hare from pushing the button, but Hare was trying to nuke the zombie apocalypse contamination epicenter, so by sparing those million people Tortoise has condemned billions? What if the nuke would kill a million people, but Hare, if he'd lived, would have cured heart disease and saved 250,000 lives a year,

making up for it within five years? What if we change the scenario: Hare is a drowning baby and Tortoise saves him—good!—but Hare grows up to become a tyrant, slaughtering thousands—does saving baby Hare become retroactively evil? If, with our finite perspectives, we can't know the infinite consequences of any butterfly wingbeat, can we never know if an act is good or bad?

Ancient Stoics like Seneca and Marcus Aurelius warned us about this very problem, less in terms of right and wrong than in terms of happiness, warning us not to seek our happiness in fame, honor, or even earthly deeds, since what if our names are cursed or forgotten after death? What if Rome and her empire someday become corrupt and vile? Dwindle and fall? What if Rome's symbols are someday borrowed by some abhorrent future regime *cough* fascists *cough*? Or future generations rethink colonialism and empire and consider Rome's conquests immoral? The stoic solution is (A) to trust Providence, that the cosmos which made Nature work so well, giving each animal the tools it needs to live, has put us on good paths, but also (B) that one should seek happiness, not in external goods (wealth, glory), but in those internal things we can fully control: contemplation, friendship, love of beauty, love of truth. Plato agrees with this advice, since it turns the mind toward the Good. Aristotle agrees since it leads to cultivating a balanced soul (virtue!), and participating in humanity's habitat, the city-state, as ants participate in their colonies. Thomas Aquinas and Dante agree because Truth, Beauty, and Platonic Love are True, Eternal Goods which lead the soul to God (soul-eye points up toward everlasting joy!), while to invest in this fleeting ball of mud we call Earth is folly, since it will fade back into nothingness when God's Plan for it is done (Richard III and his kingdom will both be dust and ashes someday, horse or no).*

* Why so many capitalized words? Good, Truth, Beauty, Love, Plan, Maker, Will? Technical discussions of Plato, Aquinas, and others who believe that eternal unchanging things exist in a higher realm than Earthly ones, often use capitalization to differentiate eternal from finite, for example distinguishing eternal Truths, such as "Justice is a Virtue" or the Pythagorean Theorem, from finite truths such as "that cherry tree is in bloom," which will not be true next week, or "Rome is a great city," which will not be true when the perishable mudball that is the Earth sinks back into nothingness at the end of days.

Petrarch also agrees with this advice because the virtues—love of Beauty, love of Truth—teach the soul to... wait... to save that little mudball from the ravages of war? Petrarch's plea—*Pace, pace, pace*—was not for contemplative inner peace, it was for peace for Italy, for Florence, a plea to produce good souls, but for Earth's sake as well as (more than?) Heaven's. Petrarch wants Cosimo to invest in Ficino translating Plato because that will help Florence. The project articulated by Petrarch aimed at something fundamentally different from Dante's, Aquinas's, Seneca's, and Plato's—something we might almost call social engineering?

This returns us to the historical question: if deontology and virtue ethics are as old as philosophy, why did it take 1,800 years for the third (to us equally obvious) branch of ethics to enter the formal conversation?

Because, my friends, before we can have consequentialism, we must have Borgias.

Machiavelli Part 3: Enter the Prince

Once upon a time (*c.*1475) the whimsical Will that scripts the Great Scroll of the Cosmos woke up in the morning and decided: Someday centuries from now, when humankind has outgrown the dastardly moustaches of melodrama and moved on to a phase of complex antiheroes, sympathetic villains, and moral ambiguity, I want history teachers to be able to stand at the front of the classroom and say, "Yes, he really did go around dressed all in black wearing a mask and killing people for fun." Thus Cesare Borgia was conceived.

Sometimes my father, discussing a fictitious villain—Darth Vader, or the Joker—comments on how ridiculous it is that people are willing to work for a boss who randomly kills his own minions for minor failures, or for fun. Joining such a group is ludicrously dangerous. If he's stalking you, or you have some sort of debt to him, then joining might be the safest option, but getting involved *on purpose* is like deciding to play Russian roulette. I cite this example because its appeal to human reason (Evil is dangerous! You don't want to be around it!) is just the sort of argument which

lay at the heart of the mirror for princes genre before Machiavelli got his hands on it.

The Prince (completed by 1513) was far from the first mirror for princes. It came from a long tradition of such advice manuals and collections of heroic maxims; the first use of the title *Speculum regum* (mirror of the princes) was 1183, but there are examples far earlier.[193] Many mirrors for princes were written for a specific prince; King Ferrante of Naples, for example, commissioned Pontano to write one for his heir Prince Alfonso (Ippolita Maria's husband), and Diomede Carafa to write another for his daughter Princess Eleonora when she married Duke Ercole d'Este of Ferrara (we know Eleonora as the mother of Lucrezia Borgia's last husband Alfonso d'Este and his colorful siblings).[194] Such handbooks were intended to be read by more than the addressee: associates and allies read them, fellow scholars, and some were published to advertise the excellence of the ruler raised so virtuously, and the court where the manual was written. Others were not published, but come down to us only in single copies, preserved among the private papers of one sovereign house.

What was in a mirror for princes? Mostly examples of virtues, great deeds of men and women who exemplified particular virtues: courage, forgiveness, prudence, etc. Some also had examples of terrible men whose crimes exemplified vices to be avoided: wrath, greed, pride, etc. Post-Petrarch, the ratio of classical examples in such collections increased, but examples from antiquity had always been popular, alongside biblical, saintly, and chivalric examples, and local heroes from wherever a particular manual was written, especially ancestors of the dedicatee. Handbooks might be organized by virtue, by the arena in which a virtue was needed (battlefield, courtroom, throne room), or by other structures. In *On Human Worth and Excellence*, Giannozzo Manetti (1396–1459) organized it by body part, going through the parts of the human being one by one, praising how God made each one perfect for its tasks, resulting in the unforgettable declaration, "The rounded-up flesh of the butt, how apt for the duty of sitting!"[195]

The Nine Worthies are a good example of the medley of examples such works included: a list of celebrated figures popular since the early 1300s, who embodied the virtues of chivalry. Who

was on the list? Hector of Troy, Alexander the Great, Julius Caesar, King David, Joshua (Moses isn't conquery enough), Judas Maccabeus, King Arthur, Charlemagne, and last (Place your bets now! Who'll be number nine?!) First Crusade leader Godfrey of Bouillon (No one ever wins that bet). For centuries, the Nine Worthies were a popular subject for manuals, pageant plays, and decoration (frescoes, tapestries, candlesticks), stale enough by the 1590s for Shakespeare to parody them in the last act of *Love's Labour's Lost.* The Nine Worthies were sometimes joined by much more variable lists of nine virtuous women: Penthesilea Queen of the Amazons, the biblical Queen Esther, Roman heroines like Lucrezia and Portia, clever Penelope who waited so chastely for Odysseus, Queen Tomyris who defeated Cyrus, even Petrarch's Laura makes some lists.

Nine Worthies lists and similar works stripped subjects of historical context, discussing personality and actions, not the cultural practices of different times and places, or how geography or circumstance affected events. We see this in the long tradition of wildly ahistorical Troy narratives, featuring anachronisms such as Hector and the Greeks fighting chivalric duels around the walls of Troy[196] in works like Chaucer's *Troilus and Criseyde* (*c.*1390). This gorgeous nonsense remained so popular that even the return of the *Iliad* had no power to stop the surreal experience of Shakespeare's Chaucer-based *Troilus and Cressida* (1602), or the mind-bending Troy/Arthuriana crossovers in *Orlando Furioso*, which feature the haunted tomb of Saint Merlin (really!), and—a truly epic work of flattery—a flashback scene where we see that Hector's tent when camping around Troy was decorated with tapestries depicting prophecies of the *future* chivalric feats of the (not yet born) ancestors of the author's patrons, the d'Este Ferrara.[197]

Whatever a mirror for princes' organizing scheme (worthies, places, body parts), moral analysis usually alternated with examples, a text-and-commentary structure similar to the medieval commentaries which used the margins of an *Aeneid* or the Psalms to elaborate enormously original ideas reflecting on the text (much as Machiavelli used the text of Livy in his *Discourses*). And while each treatise had unique ideas, there were patterns. One primary thesis was that the virtuous prince will

not just be happier and better but *more politically successful* than the bad prince. Why? First, people will love and respect him, and therefore obey him. If he acts like Caligula or Nero, reason and self-preservation will drive followers away. Tyrants will fall to tyrannicide, while beneficent monarchs will attract loyal followers, who will keep a good ruler in power. In foreign affairs too, virtue will increase success, since people will be more eager to ally with someone respected for his faithfulness, generosity, and honor. A virtuous man will have few enemies, at home and abroad, and will live with a clear conscience, free from the Sword of Damocles. Lying and betraying to protect your kingdom would not work long-term, since, once it was exposed, no one would trust you, and if it was not exposed the sin would worm away in your heart, making you more likely to do other reckless crimes, leading to your undoing. (All this we shall revisit in Part IV, under the invaluable label *virtue politics*.)

Providence was part of this equation, the expectation that the true assigners of success and failure are God and patron saints. Saint Lucy, the Virgin Mary, even "Sweet King Henry" VI, were at the heavenly court, advocating for the virtuous. *But bad things happen to good people too!* we object. *What about Job? What about Hector dying at Troy? What about virtuous nuns who caught the plague tending to people who had the plague?* True, the Renaissance answers, sometimes God tests the virtuous, but by persevering through such trials one earns greater rewards. If God sometimes calls great kings to Heaven—like Saint Louis (King Louis IX, 1214–70) who died on crusade, or Saint Louis of Toulouse (1274–97), a royal prince from the line of French Kings of Naples who renounced the throne to become a Franciscan and died tending the sick—in Heaven they become more powerful patrons, ensuring their people's posthumous prosperity. Who does more good for France, a king who tells a lie and thus prevents one war, or a king who goes to the Court of Heaven and intercedes with the King of Kings *every time* France faces war thereafter? The Renaissance knows its answer.

Mirrors of princes by *umanisti* had many innovations, especially in the range of newly available classics they could quote. *Umanisti* also took more interest than earlier writers in the

differences between time periods, so rather than projecting courtly culture back on antiquity, they addressed ways antiquity differed from the present, advocating the restoration and imitation of the lost mores and practices they judged most valuable. And there was innovation related to the new goal of stabilizing Europe. The handbooks written in Naples by Pontano and Diomede Carafa show that Machiavelli's *Prince* did not spring from nothing. These *umanisti* discuss the idea that one function of a ruler cultivating virtue is *didactic*, a teaching function. When a populace witnesses its leaders exercising courage, generosity, piety, truthfulness, honor, etc., said the *umanisti*, the people will learn and emulate those virtues (think of celebrities endorsing vaccination or recycling). Many of what we would call trappings of power, *umanisti* argued, were part of this teaching process: the Latin mottoes, parades, allegorical figures, and tapestries of great deeds were supposed to teach a kind of trickle-down virtue, absorbed by the populace through witnessing the ruler and their royal stuff. Even gold and jewels had a teaching function, reflecting the light of Heaven and drawing eyes to observe this exemplar of virtue, an argument echoing Plato's ideas of beauty being a mirror of the Good. Female *umanista* Nicolosa Castellani Sanuti (*fl.*1453) employed a similar argument in a long letter protesting sumptuary laws that restricted women's dress, saying that one function of expensive clothes and jewelry was to draw people's attention to a virtuous woman so that (like Dante's Beatrice and Petrarch's Laura) her example could inspire virtue in others, showing them that virtues are a great treasure to be honored with gold and gems, like a holy relic in a golden reliquary.[198]

Thus, while the *studia humanitatis* focused on educating elites, the whole populace was expected to become virtuous by observing or hearing about a prince who was raised on Cicero, even if most of them never read more than a motto-length snippet of Latin. Seeing the prince's virtue would make the people more law-abiding, honest, brave, successful in their dealings, and would win approval from the all-controlling patrons in the court of Heaven. The people seeing the prince's virtues was vital, not just to make the prince popular, but to make the whole country more prosperous, more stable, more secure in war. Which leads Pontano to a

radical suggestion: if the prince does not *have* a certain virtue, he or she should *seem* to have it, so it can still teach the people. One could make a *performance* of generosity, or stand between allegorical statues of temperance and courage, *even if* the human being inside the princely costume is not actually generous, temperate, or brave. Additionally, by going through the motions, feigning generosity or courage, the prince may gradually learn that virtue, like a good Aristotelian-guided nun. The Aristotle part sounds familiar, but, framed another way, Pontano advises that, if a prince lacks an important princely virtue, (s)he should *lie*, and pretend to have it.[199] Lying and deceiving for a good purpose sure sounds like something our friend Tortoise might do to our friend Hare. It also sounds more than a little Machiavellian.

So stands the mirror for princes genre, teetering on the Aristotle-buffered edge of consequentialism, when, in 1498, a young patriot named Niccolò Machiavelli—about ten years younger than the Neapolitan prince for whom Pontano wrote his manual—takes up his post in the Palazzo Vecchio to safeguard fragile Florence. And, down in the Eternal Problem City, a suite in the Vatican is being repainted with gilded bulls, where someday tour guides will point and say, "He was a very, very, very, very, very, very, very bad pope."

We've seen these events through the eyes of other friends, but if we visit again with Machiavelli the patriot, feeling the weight of fragile Florence on his shoulders, we'll notice something changing.

Young Nick (SPQF!) came from a medium-affluent Florentine guild family, comparable to our prank-scarred woodcarver Manetto Amanatini, but higher in status since his father was a (sometimes unemployed) lawyer, and lawyers don't work with their hands. Nick's sister Primavera had a dowry of 503 florins from the dowry fund, plus 50 in cloth and clothes (so, $553,000), and her wedding dress was paid for by trading barrels of wine from the family farms instead of cash.[200] This branch of the Machiavelli was on the periphery of the Medici family network, close enough to it for Young Nick to write homoerotic poetry addressed to Lorenzo's youngest son Giuliano.[201] Nick's extended family was part of the enfranchised *popolo*, but he and his father Bernardo

(the one who went to law school with Alessandra Scala's dad) also lived their lives in debt, inherited from Nick's grandfather and great-uncles, and since debts make people easy to bribe or extort, the Florentine system barred men too deep in debt from having one's name in the bag to serve in the *signoria* and other offices—Machiavelli the Patriot toiled so hard for a republic in which he was not even a fully participating citizen.

By age twenty, Young Nick had already faced several apocalyptic horsemen: in his boyhood his family faced sudden poverty when mercenary armies in the post-Pazzi Conspiracy mess trampled their farms, he nearly lost his father to a resurgence of plague, and while we know he later loved to enter the halls of the ancients and commerce with the classics, his years studying the *studia humanitatis* had been soured from ages fourteen to eighteen by sexual abuse by his teacher, suffered by both him and his classmate and lifelong friend Francesco Vettori (1474–1539), the same friend with whom he would exchange letters on politics and the writing of *The Prince*.[202] Machiavelli the triumphant sexual assault survivor, as well as Machiavelli the patriot, and queer/bisexual Machiavelli, is another role model our present can benefit from.

Young Nick was still in his early twenties when Florence heard Lorenzo's young son Giovanni "Leo" de Medici would become Rome's new youngest cardinal. Soon came the deaths of both Lorenzo and Pope Innocent VIII (King Log), triggering the 1492 papal election. Nick had been barely fifteen when Innocent succeeded Sixtus, so 1492 was the first papal election of his adult life, his first experience reading up on different cardinals and trying to anticipate the actions of big power brokers—practice for those dire months in exile wondering what war would hatch out from councils at Cambrai. (Everybody joins up to go after Venice? Why?!)

The year 1492 was a brilliant political playground for our Young Nick. Some structures are the usual: only a few power players actually wanted to be pope. Other cardinals wanted to sell their votes at the best price, ride coattails, or play kingmaker. Some wanted wealth, others had wealth and wanted to cash it in for power. Some were young and on the rise, others old seeking positions for their heirs. Some had particular needs: Cardinal de Medici was sixteen and seeking to make friends and turn money

into stability; the Patriarch of Venice was nearly ninety, dying, and mostly wanted to go home to lovely, impregnable Venice and eat candy. Ten cardinals were nephews of dead popes, eager to keep the nepotism flowing. Eight were what we call Crown Cardinals, relatives or pawns of kings there to ensure a pope friendly enough to grant their royal masters' wishes, in case, for example, special papal dispensations were needed for the marriages of Charles VIII of France and already-married Anne of Brittany, or of close cousins Ferdinand and Isabella of Spain, or of bigamous Vladislaus I of Hungary (yes, annulments were often the rub, just like Henry VIII with Anne Boleyn, but in 1492 that Henry was still in diapers).

Who were the frontrunners in Machiavelli's first election experience?* The Battle Pope faction was well-prepared to throw their weight behind imperious Giuliano della Rovere, but he had opponents. Cardinal Michiel of Venice wanted the papacy so he could break the string of Genoese control and reassert Venice's

* Now, there is a different story to tell about the formation of Machiavelli as a political thinker, one which looks less at what he observed and lived through the wide world, and more at the intimate, local world of Florentines discussing politics. Well we recall Petrarch and his buddies discussing Cicero, and that vibrant conversation had continued steadily, the meaty side of Baron's civic humanism. Young Nick spent days and nights reading political works ancient and recent, debating in gardens and over dinner the best ways to run a city council, and studying the papers and libraries of relatives and allies near him in Florentine patronage networks, like the legacy of Leon Battista Alberti Renaissance Man™ who had close ties to Nick's branch of the Machiavelli family. Fellow Florentine historians like Bruni and Nick's dear friend Francesco Guicciardini (1483–1540) had a great impact. But this is the Ada Palmer who came to study history excited by how the First World War influenced Freud's death instinct, so rather than tell again the Florence-centered tale, I want to focus on the larger Renaissance crossroads that Machiavelli shared with our fourteen friends. For the intimate Florentine story, check the bibliography for admirable studies by Gene Brucker, Delio Cantimori, Felix Gilbert, Peter Godman, Mark Jurdjevic, Hanna Fenichel Pitkin, Erica Benner, my own dear friend John McCormick, my mentor James Hankins, and John Nejamy, editor of the admirable *Cambridge Companion to Machiavelli* (Cambridge: Cambridge University Press, 2010) which is available online, and collects a great range of scholars and approaches to our many-faceted fifteenth friend, including (rare in studies of so political a figure) analysis by women. See also *Feminist Interpretations of Niccolò Machiavelli*, ed. Maria Falco (University Park: Pennsylvania State University Press, 2004).

sea supremacy. Cardinal Carafa of Naples wanted the papacy to guard Naples from two main threats: (A) Charles VIII of France who is threatening to invade and take Naples from King Ferrante, and (B) King skipped-his-Latin-homework Ferrante himself. Cardinal Ascanio Visconti Sforza of Milan (whose parrot at least did not skip Latin class) wanted the papacy because Milan was, as usual, a nightmare whirlwind of Sforza backstabbing. Genuinely rags-to-riches Cardinal da Costa of Portugal also made a bid, hoping to use the papacy as leverage against King João of Portugal who exiled him, and since Portugal's sole cardinal was in his late eighties he seemed a promising compromise candidate, likely to die soon and give others another chance. (Surprise! Da Costa will live to 102!) And there was Vice-Chancellor Borgia, who had spent decades amassing contacts, favors, and secrets to deploy at what (given his age) would likely be his last chance to secure a long and solid papacy. Any of these as pope would tip the balance among powers, so observing the election, even at a distance through letters and rumors (Orsini was the kingmaker? Sforza a crucial bloc?) was perfect for our Young Nick to learn to read the web of power. And, as we know, the bells ring Borgia.

Rodrigo Borgia's ambition was greater than anyone realized, and Machiavelli would write later, with awe, about how quickly this master bureaucrat enacted plans grander than Sixtus's. Pope Alexander made smart, strategic marriages, and used his canon law expertise to turn an unprecedented number of Borgia clients into cardinals. He knew how to work Rome too, weakening both the Colonna and the Orsini (despite his marriage ties to the latter), and thereby shattering the structures of Rome's resistance (SPQR), something Machiavelli would call one of Alexander's wisest moves.[203] Even Pope Alexander's spending on palaces, and his Roman mistress Giulia "*la bella*" Farnese, strengthened the Borgia network. As accusations of corruption dogged the Borgias, Machiavelli observed that even deaths which weren't actually the Borgias' doing were thought to be, so made people more desperate to stay on their good side. Thus even the sinister glitter strengthened Alexander, until he overstepped the often-forgotten second half of Machiavelli's famous takeaway: *It is better to be feared than loved, but you must at all costs avoid being hated.*[204]

When fear crosses to hate, that's when enemies no longer care if they go down in flames, so long as you burn with them. And now, a Brief Review of the Events of/after 1494:

> *Giuliano della Rovere:* "Hey, King of France! This Borgia pope is evil!"
>
> *France:* "What's wrong with him?"
>
> *Giuliano della Rovere:* "He's better at bribing people than I am! He bought the election I was trying to buy! I hate him! I hate him!! I hate him!!!"
>
> *France:* "Is that so? What a marvelous world we live in."
>
> *Giuliano della Rovere:* "Your Majesty should invade Italy, overthrow the wicked Borgia pope, and save Rome from corruption that isn't mine!"
>
> *France:* "Tempting… Say, the Kingdom of Naples is in Italy, right? That incredibly valuable giant Mediterranean trading port with tons of juicy land attached? I seem to remember having a claim to it."
>
> *Giuliano della Rovere:* "Indeed, Your Majesty, and the current king of Naples, Ferrante, is ruthless, unpopular, illegitimate, and didn't do his Latin homework."
>
> *Pontano:* *Cries quietly in his copy of Cicero*
>
> *Giuliano della Rovere:* "Plus Ferrante is a puppet of Ferdinand of Aragon."
>
> *France:* "Ferdinand of Aragon! I hate that guy!"
>
> *Ludovico Visconti Sforza:* "Your Majesty should totally announce that you're going to invade Italy, to press your claim to Naples."
>
> *France:* "Sforza? Aren't you the Duke of Milan?"
>
> *Ludovico Visconti Sforza:* "No, my useless imprisoned nephew is Duke of Milan, and his annoying wife keeps trying to get her relatives in Naples to oust me. Please threaten to invade to shut them up?"
>
> *France:* "I get to Naples by going *through Milan*, right? You're asking me to invade *your city?*"
>
> *Ludovico Visconti Sforza:* "No, I'm asking you to *threaten* to invade my city."
>
> *Giuliano della Rovere:* "Please invade Italy!"

France: "You Italians are very strange people…"

Alexander VI: "What?! The King of Naples is helping the f*** Orsini take my stuff! Hey, Maffei, take a letter: Dear King of France, please invade Italy and press your claim to Naples…"

Raffaello Maffei: *Cries quietly in his copy of Basil the Great*

France: *reads letter* "Srsly? Even the evil pope wants me to invade?"

Giuliano della Rovere: "Do it! Make me pope! I'll be your buddy and do whatever you want!"

France: "You Italians have very strange priorities. Okay, I suddenly care deeply about this evil Spain-favoring pope. I will oust him and take Naples!"

Alexander VI: "Wait, I didn't mean you should actually…"

France: "CRUSH THINGS!"

Italy: "Waaaaaaaaaaaaaah!"

Della Rovere: "Don't crush too much! I want to tyrannize this stuff later."

France: "CRUSH MILAN!"

Sforza: "Thank you!"

Other Sforza: "You jerk!!"

France: "CRUSH FLORENCE!"

Eerie Savonarola voice: "You are the Sword of the Lord!"

France: "I am?"

Savonarola's sensible friends: "Definitely, Your Majesty. Also, have you considered *not* crushing this lovely city, with your coat of arms painted all over it?"

France: "Oh, I thought you Italians liked being crushed. My mistake." *gentle condescending head pat*

Machiavelli: "That worked?! How did that work?!?!"

France: "Now, where is this evil Borgia pope?"

Alexander VI: "Hello, Your Majesty. I'm the evil Borgia pope. Would you like me to make you King of Naples?"

France: "Did you read my character goals or something? Naples, yes, that's what I want."

Alexander VI: "I hereby crown you King of Naples. Now you can crush the southern half of Italy as much as you please, it's all yours. I shall crush the middle, and Sforza can have the top."

France: "That was unexpectedly easy. I AM THE KING OF NAPLES! CRUSH THINGS!!!!"

Della Rovere: "But, the evil Borgia pope!"

France: BANG! CRASH!! SMASH!!! "Sorry, busy conquering Naples."

Della Rovere: "Borgia bad! You said you'd oust Borgia!"

France: "I can see how Borgia out-bribed you at the election. He's way better at this evil pope stuff than you. Also, did you hear I'm the Sword of the Lord?" *SMASH!!!!*

Naples: "Someone please rescue us from the horrors of war!"

The Plague: "HELLO! You called?"

France: "Plague? Yikes! Bye!"

Horsemen of the Apocalypse: *high-five*

Naples: "That isn't what we meant!"

Alexander VI: "France is gone? Juan, Cèsar, your turn."

Baby Borgias: "CONQUER THINGS!" *BANG! CRASH!*

Della Rovere: "Hey, that was *my* plan!"

Italy: *is on fire*

Alexander VI: "Della Rovere did it!"

Della Rovere: "Borgia did it!"

Sforzas: "The other Sforzas did it!"

Savonarola: "THIS POPE IS THE ANTICHRIST!"

Italy: "He has a point…"

Alexander VI: "No he doesn't! Florence, kill that dude!"

Florence: "Kill Savonarola?"

Alexander VI: "Yeah."

Florence: *internal strife* *internal strife* *internal strife* "Okay, we killed him, but not because *you* wanted us to! We did it for our own incomprehensible-to-outsiders merchant republic reasons!"

Alexander VI: "Whatever. Can Juan be king now?"

Juan Borgia: …

Alexander VI: "Juan?"

Juan Borgia: …

Alexander VI: "Juan!!!!!"

In 1497, one of the bodies floating in the Tiber was their own. Whoever the true perpetrator (did anyone in Rome *not* have a

motive?), the key consequence of Juan Borgia's death was that Cesare Borgia finally took center stage. Duke Valentino, as we shall here call Cesare, since that's what Machiavelli and his peers use (given names like Cesare were only used by intimates) then shocked the world by renouncing his cardinalship as the Borgia plan to turn central Italy into a permanent Borgia holding became overt, and the toppling of city-states began in earnest. The Borgias would be kings, entrenched like Anjou, Valois, Habsburg, Trastámara, and (perhaps most similar) England's new-risen Tudors, planted in the ruins of the Plantagenets. This new agenda was especially terrifying to those on its borders who faced a clear choice: aid and abet this conquest, or face the sword. Even aloof Ferrara chose marriage with Lucrezia to avoid the fate of Urbino, Bologna, and Forlì. Soon one city, full of bankers' gold, sat temptingly at the edge of the region where Valentino was playing king-unmaker.

> *Good morning, Mr Machiavelli.* Your mission, should you choose to accept it, is to keep Duke Cesare "Valentino" Borgia from conquering Florence. You will serve as our ambassador to him. You will send back reports about his character and tactics, and develop plans to keep him from adding Tuscany to his expanding kingdom. While traveling with him, you will need to maintain yourself and your team with grandeur sufficient to make him take Florence seriously, but we can't send you any money, since the area is so unstable that bandits are robbing all the couriers. As always, should you or any member of your team be caught or killed, the *signoria* will disavow all knowledge. This message will self-destruct in a few weeks when your office is inevitably looted and burned, but if you throw it in the fire that will speed things up.

Thus began our Machiavelli's very special education in the conduct of a very special prince.

Valentino was both feared and loved. The *loved* part may seem strange given his infamy, but many of the papal-appointed rulers he overthrew were hated themselves, recent conquerors or corrupt appointees of Sixtus or Innocent, with few roots in the lands they

held, and no *legitimacy*. Valentino offered something better. Better how? Better at the fundamental goal of government, from the perspective of your everyday butcher, baker, or neoclassical-satyr-shaped-candlestick maker: keeping the peace and preventing killing and looting. Valentino did that *very well*. How? Severity. The orders he gave his occupation governors were to maximize the violence of the law: if someone was caught looting, the perpetrator was horrifically executed and his corpse strung up in public. Consequence: peace. Also: justice.

How justice? The role of patronage and *gratias* in the judicial system meant that most people who worked for rulers could get away with murder, and people accepted this in the case of trusted, *legitimate* rulers (we don't particularly want to see Hamlet executed for killing Polonius) but it really rankled when the offenders were new and illegitimate (Macbeth), which applied to all the newly appointed Battle Pope-crony rulers in the Papal States. The Borgia conquest sweeping away *illegitimate* rulers meant a lot of past popes' cronies finally got some comeuppance, and a lot of wronged locals, who had given up on justice, got to see their oppressors suffer at last. That was popular. Duke Valentino's newly planted governors didn't have any ties to local people, so they were short-term more equitable in their enforcement of justice than those who had been in town long enough to have local favorites. It is sometimes said of modern democracies that every politician enters office at their most popular and least competent, and leaves it at their most competent and least popular—this was somewhat similar. City-states that had changed hands two or three times in living memory had no love and much hate for the tyrant-we-know, leaving people open-minded toward the tyrant-we-don't. (Pontano will remind us that princes should display virtue to win the love of their people, and Machiavelli will note that, once one regime change has undermined legitimacy, it often leads to a rapid string of further regime changes.)

Two examples of Valentino's actions are particularly vivid in Machiavelli's little book on princes.

The first is the case of Remirro de Orco (aka Ramiro de Lorqua, c.1450–1502), a man likely from Murcia, in Aragon, who came to

Italy and served the Borgias, accompanying Valentino on his trip to France in 1498, and with much the same starting job description as our reluctant assassin Montesecco. After Valentino's return from France, he put Remirro in charge of governing a chunk of his conquests, including the city of Cesena, while Valentino himself rode south to help his French allies besiege Naples (again). He left Remirro with the order to bring peace to the area using *maximum severity*. Remirro carried out many executions, accepting few excuses (and few patronly interventions), and speedily crushed the region under the iron heel of peace. No one looted. No one dared. Sometime later, overlord Valentino visited, and confirmed the area was indeed stable, but found the people full of bitterness and rage *toward Remirro* (not toward Valentino). Valentino had Remirro arrested, and after three nights of speculation by the people of Cesena as to what toothless punishment this loyal stooge would receive, dawn rose on December 26 to find the duke and his entourage gone, and Remirro de Orco's body in the town square, sliced in half, with his entrails strewn across the pavement and the bloody knife which did it at his side (an unforgettable second day of Christmas). The event was shocking, but the aftermath more so: to Machiavelli's astonishment, this unthinkable betrayal brought lasting peace, and even loyalty. The people were grateful that Valentino had taken revenge on the oppressor, delighted to find a patron who *didn't* let his vassals get away with murder, and the new, gentler vassal Valentino left in place was readily obeyed. Remirro took the blame, Valentino reaped the love; it worked.

Remember my father commenting that people shouldn't work for Darth Vader or the Joker? Every mirror for princes said the success of the prince depends on his ability to inspire loyalty and love in vassals. If the Medici don't adopt little Poliziano after his father's death, who will leap between Lorenzo and the assassins when the Pazzi strike? The vassal betraying the benefactor is *the worst thing* in Dante's *Inferno*, right at the center of Hell where Satan and Judas are; Dante didn't even *have* a section for benefactors who betray their vassals, it wasn't in his mind that anyone would *do* that. But it did occur to Valentino, who, by this time, had been disfigured by syphilis and started wearing a mask most of the time.

But wait, there's more! December 1502 is the political science gift that keeps on giving!

Events earlier that year, like Valentino's sudden invasion of Urbino betraying his ally Guidobaldo da Montefeltro, meant that, several allies/vassals who had supported the Borgias in return for power, protection, or help crushing their enemies were becoming afraid for their lives and lands, especially as the full scale of Valentino's ambitions (*a permanent kingdom?!*) became clear. They plotted against him. This was rational. In October (while Remirro was loyally brutalizing Cesena) these conspirators heard rumors that Valentino knew about their plot. The traitors (or should we say *resistance?*) had some troops, and were in a decent position, since Valentino's French allies had been lured away, but the Borgia duke still had *some* allies (Florence stayed with him, on Machiavelli's advice), and every day his reinforcements grew closer. Now or never.

Cunning Valentino cornered and defeated a small group of the conspirators' troops—giving the main force a scare—then sent a messenger to them, to offer friendship, reconciliation, and forgiveness, since they hadn't *yet* directly opposed him. They decided to abandon the plot (it's useful to be feared...) and accept his offer, renewing their vows of fidelity to the Borgia cause. He expressed his love and gratitude. They rejoiced. He sent his reinforcements away. They breathed a sigh of relief. He turned down their offer to help him conquer Tuscany and Florence (our Machiavelli hard at work!) and instead ordered them to take the town of Senigallia, one of the holdout forts in the lands of recently-betrayed Urbino. After their vitory, Valentino then headed to Senigallia to congratulate them (stopping by Cesena on the way to have Remirro de Orco sawed in half and smeared across the town square). The duke joined the ex-traitors in Senigallia on December 31 for a celebratory feast... and had them all seized and executed—Happy New Year. High on Olympus Hestia sighed, the Furies gnashed their teeth as the Laws of Hospitality lay wounded, the ghost of Dante reviewed his notes about his subdivisions of the treachery section of Hell, and Valentino's vassals never plotted against him again. His own men went a little wild sacking Senigallia, but he executed some of them to shut that down, and the populace didn't

blame him—it was his looting troops they *hated*, him they simply *feared*.

Soon after this, on January 9, 1503, Machiavelli received a letter from his friend Biagio Buonaccorsi expressing shocked relief that Machiavelli was still alive after the massacre at which so many of Valentino's entourage had breathed their last.[205] The letter is a relic of those terrible waits, invisible in history books, since *we* know Machiavelli wasn't killed at Senigallia, but, with the roads in chaos, rumors of massacre far outpaced details like who survived. Throughout these terrifying months, Machiavelli's dear ones were braced to hear any day that he had been killed, either with Valentino or by Valentino, but Florence needed someone at the Borgia prince's side, ever repeating to the rising king that Florence was more valuable as a friend than as a conquest. Florence still didn't manage to send Machiavelli his salary; once they tried giving it to Michelangelo to carry to him en route to Rome, but even *terrible* Michelangelo turned back for fear of bandits.[206]

What about our Mirrors of Princes? Machiavelli the theorist as well as Machiavelli the patriot is at Valentino's side, with a voracious knowledge of political wisdom ancient and recent. Won't such betrayals make the rest of Duke Valentino's vassals turn on him? Won't people rise up hearing of such brutality? Don't dozens of handbooks tell us every move Valentino is making should fail? Then why does every step make him stronger? Battle Pope Sixtus failed to carve out something new in central Italy, thwarted largely by the goodwill he lost in the Pazzi mess, but being *even more cruel* is working? How? One part was that Sixtus broke things *first*. Sixtus had begun this pattern of destabilizing central Italy, overthrowing *legitimate* regimes. He was criticized for it, but here, twenty years later, these towns had already changed hands two or more times in recent memory, so their people had no loyalty to one papal crony over another. One of those killed at Senigallia was Oliverotto da Fermo, who had himself seized rule of his home city by betraying and overthrowing the foster-father who'd adopted him when he was an orphan; Valentino, the prince who killed that jerk, felt like a step up.

Now, Valentino's successes did not completely undermine the advice in traditional mirrors of princes. Many historical examples

showed that Providence had exalted tyrants before, part of the Great Plan teaching its divine lessons about good and evil power. Valentino might still fall at the hands of some noble defender of Italy, and the Borgia story join our collections of moral examples of hubris and cruelty, while one of his foes (brave Guidobaldo da Montefeltro perhaps?) becomes the hero. But as 1502 turns to 1503, Guidobaldo is hiding out in Venice with nothing but the shirt on his back, while hubris and cruelty seem to be winning.

Machiavelli's hasty letters from these months include reflections on these larger questions, but mostly they contain urgent military intelligence and political advice combined with panic panic panic aaaaaugh! In later writings, especially the last part of *The Prince*, Machiavelli says he believed at the time that Valentino was going to unite all Italy, even that he *seemed destined by Providence* to do so—a religious comment rare in Machiavelli, attributed by most to the fact that it's from the final chapter where he's sycophantically sucking up to the book's addressee, but it still makes very clear that Nick thought something rare and extreme was happening as he watched these days unfold. As for inventing political science, writing up his analysis of what he lived through, that must await the leisure days of exile. For now, every second is for Florence, which is safe in the eye of the storm taking the tyrant's side, but no safer than Remirro de Orco and Urbino had been.

Side note: despite Remirro's execution occurring *in the middle of* the Senigallia affair, they almost always get discussed as separate incidents. This is largely because Machiavelli discusses them separately, Remirro in Chapter VII of *The Prince*, Senigallia mainly in a separate little text, the *Description of the Methods Used by the Duke Valentino when Killing Vitellozzo Vitelli, Oliverotto da Fermo, the Signor Pagolo, and the Duke di Gravina Orsini*. I learned about the two separately, and took a decade to realize they were the same week, and to start thinking about what that means. Things like this happen a lot, two details get separated and never discussed together (like Lorenzo's inheritance lawsuit and the fact that such lawsuits were normal), which is why major discoveries often come from someone studying a *different* topic asking new questions. Insights about Machiavelli often spark

when someone looking at the same information asks questions about a building he visited, a hat he wore, a job title he held, or a poem he read (my dissertation is the latter, and I had no idea when I started that Machiavelli would end up being big in it—so learning goes). Like our Norse scholars realizing those loom weights might be fishing weights, old questions are sometimes answered by investigating unrelated questions—this is intellectual *diversity*.

Now, where were we? Or rather, where is our Niccolò in spring 1503, as he looks forward to his thirty-third birthday, facing some rather darker and thornier woods than Dante's? Ah, yes, he stands on the threshold of something *terrible*...

Machiavelli Part 4: Julius II the Warrior Pope

Long has he waited, Sixtus's successor, the new prince who, in 1503, rises in Alexander's wake to forge his empire. Giuliano della Rovere is cunning, experienced, persuasive, well connected, versed in using the ancients as a language of power, and fluent in the subtleties of Church, politics, and war. In 1492 he was within a few votes of the papal throne, only to see Borgia snatch his victory away. This time he is more than power-hungry, he is power-starved, beaten at two elections—Innocent's and Alexander's—but in the interim he has done much more than lick his wounds and wait. Innocent was his ally and semi-crony, and let Sixtus's heir undertake his war with Naples, the Conspiracy of the Barons. When in 1492 the white smoke rose for Borgia, della Rovere scented blood in the wind before most others did, and wisely fled to France, where he won the ear of King Charles, *primus inter pares* of Europe's thrones. In 1494, he rode with the armies across the Alps to carve a deeper wound through Italy than Petrarch ever saw. Charles betrayed him in Rome, seduced by Borgia's honeyed tongue, but as the Borgia Kingdom project prolonged the fractal wars, della Rovere forged a coalition out of Borgia's enemies. He was not strong enough to battle Valentino while the Borgia prince had papal power behind him, and strong allies—Florence, Ferrara, bribe-won France. But della Rovere is

like the oak upon his crest, his roots slow-growing, constant, deep, and strong.

August 6, 1503, food poisoning (a human hand? or God's?) strikes Alexander and Valentino both. Alexander soon dies. Valentino recovers slowly, weeks of suffering—one account says his skin peeled off, likely due to botched attempts to treat the illness with toxins like mercury. The tipping point has come at last, and suddenly. The Vatican is sacked, the swollen corpse displayed, and Valentino lies at death's door, too weak to act as our Eternal Problem City must change hands once more. Three nearby armies threaten this election: France and its allies, Naples and its allies, and Valentino's. Borgia has eleven solid votes in the College of Cardinals, but with its prince dying the faction is uncertain whether there will *be* a Borgia faction when the Sistine doors open.

France—helmed by Louis since the death-by-doorframe of King Charles—wants a French pope, backing Louis's faithful crony Cardinal Georges d'Amboise (1460–1510), who rode at Louis's side the second time France invaded, in 1499. King Louis promises Valentino he can keep his conquered lands if Valentino supports Louis, and the Borgia votes plus the French-controlled votes are *almost* enough. To make up that almost, King Louis turns to France's old Italian friend Giuliano della Rovere, and to Cardinal Ascanio Visconti Sforza, captured in Milan's fall, whom France releases on condition of his pledge to support d'Amboise and urge his allies to do likewise. So close, yet such a house of cards. Della Rovere (with his several kinsmen) refuses to vote for d'Amboise—if France wants an ally on the throne, it will be him or no one. He sets about persuading the French bloc that he can win: he is Italian, French-allied but less hated than a Frenchman, and an enemy of the Borgias, so all Borgia foes will flock to him. Sforza, meanwhile, keeps the *letter* of his promise by *personally* voting for d'Amboise, but wields his clout and firebrand rhetoric (Filelfo's training in action!) to urge his fellow Italians to oppose France at any cost.

And team Borgia? With Valentino near death, the clients of so tenuous a patron fear they may need new protectors, and Spain and Naples are their main alternative, who do *not* want the papacy in France's hands. So, despite Valentino's alliance with

King Louis, the Borgia cardinals turn. The French, triply betrayed, refuse to cave to della Rovere, and will forever after blame him for d'Amboise's defeat (the closest France has ever come to having a French pope post-Avignon).

Deadlock. Time for the old solution: a compromise candidate, someone old, ill, and inert, likely to do little and die soon, giving all sides time to regroup and advance their voting tallies toward majority. Francesco Todeschini Piccolomini, Pope Pius III (Scholar-Pope 2), hails from comparatively neutral Siena, and has spent the Borgia years sufficiently subservient to Valentino for the Borgia faction to be confident that, if their ailing prince returns from death's door, he will not be too displeased. Pius III quickly confirms Valentino as commander of the papal armies, postponing war and letting Borgia power lie. But despite having long-ago bowed to being part of the Borgia power network, this nephew of Scholar-Pope Pius II is still sufficiently disgusted by their ambitions that one of his first acts as pope is to announce that Alexander VI was too wicked for the honors usually given to a dead pope, and will not rest in the papal crypt beneath Saint Peter's.

September 22, 1503, Pius III crowned.

October 18, 1503, Pius III dies. New election.

All Italy braces for impact, especially Machiavelli.

In the brief weeks of Pius's papacy, Valentino has recovered and secured his armies, but his force is weak, and his position fragile. He still has ten votes (–1 for Pius) but all else is teetering. France has not forgiven della Rovere, but Sixtus's heir has worked hard to convince France that, in stubborn, volatile Italy, he is the most France-friendly man likely to get the throne. Now della Rovere courts Valentino, promising to let him keep his armies, titles, funds, and lands, and to merge their factions, taking Valentino as his political partner. Just as, at Sixtus's death in 1484, still-young Giuliano della Rovere had partnered with the older Pope Innocent (King Log), so young Valentino and older della Rovere could become allies. The two of them will share Italy, della Rovere taking his turn as pope, then Valentino will choose the next pope after him, and by that time the Borgia Kingdom will be complete. It is a risk—Valentino wants a puppet on the throne,

not someone with his own vast power base and fierce agenda. But these are desperate times.

Valentino accepts, and a few promises to Ascanio Visconti Sforza secure the unanimous election of Pope Julius II.

This moment was special for Machiavelli, in a way more *personal* than we can usually trace. Unlike the passion and humanity of his letters (*I have no decent shirts!*) in formal writing Machiavelli describes events he witnessed with the same clinical distance he uses for the deeds of Hadrian. Even the massacre at Senigallia (when loved ones waited breathlessly to learn if poor Nick lived), he describes with no hint that *he was there and could have died*. But for this moment, he breaks the pattern.

The Borgia prince was no fool, he tells us. Valentino had planned for his father's death; he knew well how quickly popes' sons fall if they don't have a plan. As Machiavelli describes it in Chapter VII of *The Prince*, Valentino had now held his conquering sword in hand five years, and had pursued four strategies to keep himself secure upon his father's death, all sound: (A) killing as many of the former rulers of his conquests as possible, leaving no rival claimants, (B) wooing Rome's great families (especially winning back the Orsini), whose influence was so important in an election, (C) controlling many cardinals, both those appointed by his father, and others made his by threats or bribes, and fourthly, (D) military force, making more conquests including (next on his list) Florence and Tuscany. Machiavelli states plainly that Florence would have fallen next (on his watch! it was his job to guard it!) had Pope Alexander lived another year. But Alexander's death had been so sudden that part (D) of the plan (conquest) was not complete, and hostile armies still roamed Italy. The foundations of the Borgia Kingdom were sound, Machiavelli says, and Valentino had such boldness, cunning, and ability, and was so expert in winning men and manipulating enemies, that, even as he lay on his sickbed, conquered Romagna stayed loyal, and his troops held Rome. But, of Valentino, Machiavelli writes:

> On the day of Julius's election, *he told me* [first person! *"lui mi disse"* = *he* told *me!*] that he had considered all that could happen when his father died, and found a remedy for everything, except

he never thought that, at his father's death, he would be dying himself. When all the duke's actions are recalled, I don't know how to criticize him; rather it seems to me, as I have said, that all those raised to rule by fortune or the arms of others should imitate his example. Because he had a great spirit and lofty aims, could not have governed his affairs differently, and only Alexander's short life and his illness thwarted his designs.[207]

Valentino did not fall *because* of his cruel and fearsome deeds, says Machiavelli, they were *the best possible plan*. The Borgia fall is *not* a moral lesson that good princes rise and evil princes fall, it is the *opposite*: all Italy's traditionally virtuous princes fell like wheat before the scythe (even war-savvy Duke Guidobaldo of Urbino, for all his ancient statues and his Cicero). Nothing thwarted Valentino's tactics except Fortune. His sole mistake, Machiavelli adds, was that, when at Pius III's death he was still too weak to make one of his cronies pope, he trusted Giuliano della Rovere.

November 1, 1503, Julius takes the throne.

Julius has Valentino arrested, thrown in prison, stripped of his land and titles, ultimately deported to Spain, and—after some intervening chaos and the brief escape which filled Lucrezia with hope—Valentino is ambushed and killed in March 1507.

This shock was more shocking than it sounds, at least for Machiavelli. The Roman pontiff, Christendom's highest prince, had betrayed and destroyed a sovereign duke to whom he had pledged himself as a bosom ally, and to whom he owed his throne. We have seen a lot of broken promises, but this was, for Machiavelli, utterly different. When enemies clash in battle, violence is honorable. When enemies poison each other, that is dishonorable but business as usual. When Valentino sawed Remirro de Orco in half, that was new, shocking, beyond the possible. This was the same on an unimaginably larger scale. The innermost circle of Dante's *Inferno* was for traitors against their benefactors. This inversion—the patron betraying a supporter he has promised to defend and hold as closely as a son—will need one of those special custom punishments that pepper Dante's Hell.

There is also no place for this in mirrors for princes.

Rome's new master Julius—who already made so many enemies

in past wars and his stubbornness with France—has betrayed and murdered his strongest supporter. No one can trust him now. Any pledge he makes is unreliable. Anyone near him is in danger. *Grace* with such a man means nothing when the sword he wields cuts down both friend and foe. The rational man has only one conclusion: do not serve such a master. Leave him. Run. His vassals should abandon him at once, declare the tyrant what he is, and fight or flee. Machiavelli is a good student of politics, he knows this must happen, waits breathlessly for the next week's post horse to bring word that the all-betraying Battle Pope has woken to an empty throne room, while the banners of his former allies mass against him.

The post arrives: the day after Valentino's fall, everyone turned up and to kiss the pope's feet as usual, no one even whispering the name *Borgia*. Everyone serves the traitor-pope just as before.

This is *the moment that should not be*, as Machiavelli explains in *The Prince* and further in his letters. The virtuous ruler was supposed to be successful because his servants and clients trust him, and because good policies have beneficial outcomes—both are false. Why is the latter false? Look at what has just happened and what could have happened:

Outcome if Julius II had played by the book:

Julius seals his pact with Valentino. After mounting the throne, Julius keeps Valentino as a close ally, and lets him solidify his conquests. Tens of thousands die in combat, more from bandits and disease, as Valentino secures Romagna, finally turns on Florence, takes Tuscany, annexes Modena and Ferrara, takes what he can of the Venetian land empire, and tries to get the Emperor to crown him king. He and Julius collaborate on shared goals, like weakening Naples and Venice, but iron-willed Julius pours his imperial ambitions into strengthening what remains of the Papal States near Rome, and neither his plans nor Valentino's can be complete since both require taking many of the same squares on Italy's board (Bologna, Urbino, Forlì). The strength of *Il Papa Terribile* means the Borgia Kingdom cannot fully control the papacy in Rome as France controlled it in Avignon, so when Julius goes the way of all popes, the Eternal Problem City's quicksilver politics casts all back into Fortuna's hands once more, and Mars's too…

Outcome when Julius II commits his unthinkable betrayal:
Valentino is removed. The wars in central Italy cease. The shock makes everyone fear that this ruthless pope will crush them too if they cause trouble. Peace is immediate. The Borgia Kingdom vanishes from maps like some false continent drawn based on mariners' reports of what turned out to be mere clouds. Florence and Ferrara are safe. The surviving rulers driven out by Valentino, like exiled Guidobaldo da Montefeltro, awake to find the storm has passed without a single drop of rain. Death toll: Valentino Borgia a few of his soldiers, plus a few guards and associates, no more. Pope Julius is free to advance his agenda, without trouble from the faction that held Europe in its iron grip mere days before.

Conclusion: a virtuous prince would not have been better for Italy. Nor more successful at advancing his own plans.

More is being undermined here than the mirror for princes genre. Ethics is reeling, the philosophical tradition back to Plato. A pope who kept his word to Valentino would have doomed thousands to death and Italy to years more chaos and conquest, and would have also surrendered hope of achieving his personal project of stabilizing Italy under a strengthened Rome. The ethicists of Machiavelli's past condemn Pope Julius as a traitor, but is it really a *bad act*—our Nick asks—betraying one man and his followers to end so terrible a war? Is that a meaningful use of *good* and *evil*?

Thus utilitarian ethics is born. For us it feels familiar, but in 1503 it was radically new. What if the categories *good* and *evil* depend, neither on external rules nor what someone intended deep inside, but on the results? If Julius had done the good/right/lawful/virtuous thing, and kept his word to Valentino, letting the violence stretch on, should we call that *good*? And what of virtue ethics? Julius, our would-be Caesar, certainly had selfish motives when he backstabbed Valentino (resurrect the empire by fire and blood!) yet it saved lives. Doesn't that matter? Doesn't the *consequence* of an act, its *utility*, matter? *I think*—our stunned young Florentine writes to his friends—*it does.*

All this is core to the advice Machiavelli will send the Medici, when the forced retirement of exile gives him time to write a new mirror for princes for his desperate time. Florence's conquerors have the most power to protect fragile, irreplaceable

Florence. Machiavelli does not teach the addressee of *The Prince* on how to keep power for abstract power's sake, but because the survival of so fragile a people in so tumultuous a world depends above all on stability. With invasions across the Alps becoming frequent, and popes showing little sign of setting down the sword of war, one more Florentine civil war could be the end. The sentiment surfaces throughout his work: in order to exercise virtue, the people must first be *alive*. In such a desperate time, we should, as older mirrors of princes said, study Caesar and Augustus as examples of the utility of love, and Caligula and Nero as examples of the dangers of hate, but we should also study Valentino and Julius, who—with their treatment of Remirro de Orco and of each other—showed that fear and cunning are even more potent in crisis than virtue and love. Nick put this into action in 1505, helping to free from Julius's prisons "Valentino's Executioner" Micheletto Corella (the one who led the killing of Lucrezia's second husband) and hiring him to lead Florence's police, since a man so *feared* will mean laws are *obeyed*. Liars and traitors had been in mirrors of princes only with the moral "Don't be like this man!" (as Rafaello Maffei said in his lives of bad popes) but Nick disagrees: If the deeds of terrifying princes worked, imitate them. If fear will discourage conspiracy, use fear. If the betrayal of one dangerous family will stabilize the nation, use betrayal. If breaking a treaty will give Florence the ally she needs to survive, rip up that scrap of paper. To make the art, the poetry, the Latin, and the genius inventions, our people must be *alive*.

As much as his letters show Machiavelli loved the classics and his library, this is a major break with the classical education of his day. The ancients should not, he says, be taught as rote, osmotic memorization of grammar and virtues as in the classrooms of the *studia humanitatis*—they should be taught as case studies, examples to help us work out the results most likely to keep people *alive. Even the deeds of wicked men* should be imitated if they worked, the deeds of good men avoided if that particular deed was a disaster. Boccaccio had written, in defending his *Decameron*, that reading about lewd and wicked tricksters in his humorous tales would have a good moral impact, not bad,

because laughing at such villains would make one want to be unlike them, yet another kind of words that sting and bite.[208] The Murderous Machiavel's conclusion is utterly and (at the time) unbearably different: study *and imitate* those who succeed, even if they lie, betray, or worse.

One detail worth stressing: the ethics Machiavelli is discussing is not one of a good consequence *making up for* an evil act—his argument that *the act itself is not evil, because of its good consequence*. Saving a hundred thousand lives, or saving Florence, is good—the means, therefore, *are also good*, even if the means include murder. This isn't only in *The Prince*, but in the *Discourses* too, which has such pithy maxims as, "The man who uses violence to ruin things, not one who uses it to heal them, deserves blame," and that you should always hide when you mean to do evil, since "When asking someone for a weapon there is no need to say 'I plan to kill you with it,' rather you can satisfy your desire with the weapon in hand."[209]

In all this, the old oversimplification, *the end justifies the means*, is in this sense *a smaller shift* than what Machiavelli is suggesting: he wants us to *judge the means by its end*. What Julius II did was *bring peace*. Bringing peace is *good*. Sometimes it sounds like Nick is saying that the prince takes on sin for the people's sake, a sovereign's duty to shoulder the burden of bad acts to buy that ounce of peace which lets the citizens survive and live virtuously. But more often it feels like Nick is assuming there is no scale of good and evil beyond Earthly consequences, nothing bad or burdensome about the prince needing to betray or kill, any more than there is to the prince needing to reward or have a parade. *(No sin or Hell, eh, Nick? Do we smell atheism?)* Machiavelli never explicitly discusses the religious implications of consequentialism, but he very conspicuously *does not* talk about the theological side; there is no section of *The Prince* to parallel the final part of Hobbes's *Leviathan*, "On the Kingdome of Darknesse" about how theology trumps politics. The reader cannot avoid noticing how *absent* God, sin, Heaven, and Hell are from this strangest mirror for princes *(where is our praise of God the maker of the butt so perfect for the act of sitting?)* so we—like Nick's contemporaries—must wonder how deep that lack of interest in God goes.

Okay, we have consequentialism. That can of worms turns out

to be a can of trolleys bearing down rapidly upon hypothetical victims, and on us all. But we have also opened another can of worms: the papacy of Julius II.

Giuliano della Rovere brings peace, ending the Borgia crisis, saving thousands, then launches his own new wars. This is *Il Papa Terribile*, the pope who takes the papal name of Julius last used in 352 CE, to make *extremely* clear that Sixtus's imperial agenda is alive and well. France, Naples, Spain, and the so-called Emperor are all stirred up, England eager for conquests, Portugal and the Ottomans expanding, Egypt strengthened by recent peace. Julius's wars lead to the council at Cambrai, and Machiavelli rushes frantic letters to his friends attempting to predict the sides, failing so utterly to guess the answer: Everyone against Venice.

Meanwhile, Julius also plunges into renewing the glory of his capital. He effaces Borgia crests all over Rome *(not normal practice for new popes)* and bricks off the splendid new apartments Alexander decorated, summoning Raphael and others to fresco a new suite for him, the *Stanze*, which will include the iconic *School of Athens*. He also brings more *umanisti* to the Vatican, stocking its libraries, and has Michelangelo mix pagan sibyls among Hebrew prophets in his Sistine, welcoming the ancient philosophers into his Christianity. But, as Raffaello Maffei Volterrano laments, Julius does not bother to read the essays on virtue dedicated to him by *umanisti*. Julius's name is terror in his life, but his investments in culture will make him beloved of art historians in centuries to come, while his propaganda, and the effective *damnatio memoriae* imposed upon the Borgias, will set up the tour guide's answer that Alexander VI was "a very, very, very, very, very, very, very bad pope." And Julius enables one more thing.

February 19, 1513 (2013), in the ninth year of Julius's warlike reign, the victorious Medici, masters of Florence once again, give the order to arrest one Niccolò Machiavelli on suspicion of participating in a conspiracy against them. The forced retirement of exile gives him time to write the texts which transform how we understand politics, ethics, and history, including his analysis of the Borgias and Julius, how their acts of terror and betrayal were *good strategies*, and how we need to rethink all mirrors of princes. In 2013, the city of Florence commemorated the 500th

anniversary of this quiet but so important turning point with a procession, in which the city crier proclaimed Machiavelli's arrest in every quarter of the city. It may seem a grim day to celebrate, the imprisonment and torture of one of Florence's favorite sons, but it is in many ways the birthday of political science, the one day which, if disrupted by some time traveler, could deprive us of the produce of that vital exile. Machiavelli could have been forgiven, hired by the Medici he tried so desperately to work for. He could have been executed, or died in prison of infection or hemorrhage. Instead we got utilitarian ethics, a vein of thought so influential that today we struggle to understand the world without it.

Before we leave things feeling like the *studia humanitatis* approach that shaped Machiavelli had no role in this but to fail disastrously and make him realize it was time to try something new, it's important to remember that Machiavelli's practical, outcome-focused, Earthly turn shared much with the whole classical revival project's transition from scholasticism's unworldly *let's study Aristotle so we can prove things about how to get to Heaven with a greater safety net*, to the much more worldly project of the *umanisti*: *let's study Plato in order to save Florence/Italy/Europe from war and destruction*. One amazing scholar, whose work I've been saving for this moment, is the masterful Riccardo Fubini.[210] He has meticulously examined the writings of many star practitioners of the *studia humanitatis*—figures like book-hunting Poggio, and the partner of his scholarly quarrels Lorenzo Valla—and demonstrated that their philosophical and speculative writing thinks a lot about worldly issues, politics, ethics of action, the best ways to live and act in *this world*, not just in preparation for the next. In sum, even when pious and quite Christian (and when still thinking via deontology and virtue ethics) the interests of these *umanisti* had a worldly turn, especially in their deep interest in analyzing and describing politics and civil life (Baron's observation of civic humanism astute once again). Fubini connects this with secularization, pointing out that an important foundation for people to *stop* thinking mostly about Heaven is to *start* thinking about Earth, even if they're still doing so piously. We'll return to secularization shortly, but for now Fubini's observation is a precious reminder that Machiavelli's classics-loving peers and

predecessors didn't simply assemble the libraries which let him realize that the project *wasn't* working, they did a *lot* of innovation which got him most of the way there. Putting that first footprint on the Moon makes one famous forever, but it genuinely was a small step for a man from the Apollo Lunar Module to the lunar surface—just so, all those book-hunters, and library-builders, and philologists assembled and launched the lunar lander which got Nick to the spot where he could take his great, small step.

When scholars argue about "Who was the first modern philosopher?" those who argue for Machiavelli point out that he was the first person to combine all three forms of ethics, and the first to use history, not as a set of moral maxims, but as case studies to be analyzed, making history an *empirical*, not a philosophical or literary exercise: a social science, looking for *the hidden causes of things*, which is precisely how Francis Bacon will define the scope of scientific inquiry when empirical science booms a few chapters from now.

Like many turning-point thinkers, Machiavelli's most important contributions are invisible to us today, because we don't realize they weren't always there. When we think of Freud, we think first of the parts we find absurd, the sex obsessions and the Oedipus complex, forgetting that Freud's major contribution was to argue that the human being is not a 100 percent rational calculating machine, that we can have things like trauma, irrational behavior, unconscious bias, and that mental illness can be treated in better ways than with electroshock or hysterectomies—we don't doubt any of that today, so when we read Freud it's hard to realize it was new. Marx can be similar: the name invokes communist movements and regimes, but his big innovation was to say that social classes and economic tensions shape historical events *at all*, so every time we look at things like GDP or wealth gaps, we are using Marx. There are many figures like this. Plato advanced the radical idea that it would be better if kids took jobs they were well suited for instead of automatically doing what their parents did, but we mainly remember the weird stuff, the Cave, the "noble lie." Aristotle said maybe nature has patterns we can understand (science!), but we remember all those tedious syllogisms. Just so, with Machiavelli, we take away *the ends justify the means* and *better to be feared than loved*, not realizing that his more important, now-ubiquitous innovations were ever new:

that ethics should consider consequences, and that studying history can help us understand the causes of past tragedies and triumphs, birthing my department's motto:[211]

> "Don't make me repeat myself!"—History

Coda: Many Machiavellis

Now you know him, our little Florentine historian, the last and most elusive of our fifteen friends. In a decade plus of teaching, there are many texts I've taught same way over many years: Plato, Dante, Voltaire... *not* Machiavelli. I kept changing my approach, trying new things: which texts, what combinations, expanding how many class sessions he got (two, four, six, more...). My current method involves three weeks of lecture, then a three-week simulation of the papal election of 1492 which turns my life upside down for a month and involves sixty students playing different historical figures each with 20+ pages of unique character material, twenty class chroniclers, and a support team of over seventy friends and former students who remember the event so vividly they volunteer to help in future years. After that herculextravaganza, and a week of post-simulation analysis, and reading a fat pile of Machiavelli's letters, *then* I let my students read *The Prince*.

It works.

It means they have the context, every detail at their fingertips. They learn the names and families and alliances, they have to, to protect their characters' homelands and defeat their enemies. The big problem with *The Prince* is that Machiavelli doesn't unpack his contemporary examples, he assumes that you lived through it and know, so sometimes he just says things like: *Some princes don't have to work to maintain their power, like the Duke of Ferrara*, period end of chapter.[212] He doesn't explain, so modern readers can't get it, except my students who say, "Oh, Alfonso and Ippolito d'Este of Ferrara! Those jerks! They milked me for all I had while my homeland was on the verge of annihilation, while they were always cozy and secure!" I'll talk about the simulation more later

on, but having my students do it, live it, defend their fragile city-states while our King of France invades and makes them *actually* fight the War of the League of Cambrai, that experience lets them finally understand the half of *The Prince* which makes no sense because Nick doesn't explain his examples. It lets them feel when they have to break with the candidate they respect and *love* to support a different candidate they *fear*, because otherwise their home (Florence, Siena, Naples, Rome, Forlì) will burn. It lets them feel when someone goes too far, when *fear* tips into *hate*, and someone goes down in flames. It works.

But once—just once—I found a method that was even better.

It was the magical year my papal election class was in the same time slot as my wonderful colleague John McCormick's course on Machiavelli's political thought, so we had a *crossover*. We brought both classes together, so each could hear how the other's approach (history vs. political science) felt different.

As an example, I asked both classes, "What would Machiavelli say if you asked him what would happen if Milan suddenly changed from a monarchal duchy to a republic?" The poli sci students went first: He'd say that it would be very unstable, because the people don't have a republican tradition, so lots of ambitious families would be tempted to try to take over, so you'd have to get rid of those ambitious families, like the example Livy gives of killing the sons of Brutus in the Roman Republic, and you would have to work hard to get the people passionately invested in the new republican institutions, or they wouldn't stand by them when the going gets tough or conquerors threaten. It was a great answer. Then my students replied: He'd say it would all depend on whether Cardinal Ascanio Visconti Sforza is or isn't in the inner circle of the current pope, how badly the Orsini-Colonna feud is raging, whether politics in Florence is stable enough for the Medici to aid Milan's defenses, and whether Emperor Maximilian is free to defend Milan or too busy dealing with Vladislaus of Hungary. "And I think I'd have something to say about it!" added my fearsome Caterina Sforza; "And me," added my ominously smiling King Charles. In fact, my class had given a silent answer before anyone spoke, since the instant they heard the phrase, "if Milan became a republic," all my students had turned as a body

to stare at our King Charles with trepidation, with a couple of glances for our Ascanio Visconti Sforza. It was a completely different answer from the other class's, but the thing that made the moment magical is that *both were right*.

My class and John McCormick's met two different Machiavellis: his the polished, impersonal, analytic Machiavelli of the *Discourses* and *Florentine Histories*; mine the overwhelmed, up-past-midnight-fretting Machiavelli of his personal letters, of the *Deccenale* which Ercole Bentivoglio hoped would prove to future generations just how bad it was, of Nick's family waiting to hear whether he'd died at Senigallia, and of that all-important little moment in *The Prince* where his description of Valentino lets the first-person break through the mask of the historian: *he told me*. They're both real Machiavellis, the Machiavelli who helps political scientists predict and explain outcomes, and the Machiavelli who helps historians make fact-based portraits of what it was like to live in another time. The students realizing they had completely different *yet equally valuable* understandings was the best synthesis I've ever seen of how different academic disciplines *really are different*, and studying *The Prince* in the History Department, or in poli sci, or comp lit, or Romance languages, or philosophy, all get at equally valuable understandings of a complex source.

As the Ada Palmer who started studying the Renaissance because she realized the First World War sparked Freud's *death instinct*, I love the Machiavelli I meet in his letters, the human, erring, desperate Machiavelli. It's so common for history to seem like a sequence of marble busts on pedestals who handed us great works, and I love exploding that illusion with personal letters (Machiavelli's, Petrarch's, Voltaire's, Cicero's) that instead reveal people who messed up, who ran out of money, who ran out of clean shirts, who worried about their friends, who lost their tempers, who felt lonely, who failed at things, who whined, and who got persistent letters from their mothers worrying they weren't eating enough capers and fennel (i.e. vitamins). Even Machiavelli ran out of clean shirts, and got motherly and wifely letters about eating his vegetables, and there's a great letter from Lorenzo (when he's already a head of state!) where he writes home to Mom that he forgot his favorite purple bathrobe.[213] We need that part of

history. We need that antidote to the illusion that the world is shaped only by geniuses, by special people, history's protagonists, who never fretted about rent or laundry as we powerlessly ordinary people do. It turns out history was actually shaped by people who messed up, and did laundry, and had chronic illnesses, and definitely worried about their salaries—people, in short, like us. We need to show that more.

Especially with Machiavelli.

Because Machiavelli did *not* think the ends justified the means *in general*. He thought that Florence, in order to be what it was—the great crossroads where Manetto Amanatini learned the skills he took to Hungary, where he helped build the palace that would house Twice Queen Beatrice of Naples, whose dear sister-in-law Princess Ippolita Maria Visconti Sforza helped save Lorenzo after Montesecco refused to murder him where God was watching under Brunelleschi's dome—for all that to happen Florence must be *alive*.

There was one more Florentine Republic, by the way. Machiavelli said a nation invested in having a republic never stops, it's still a rash Florence comes out in, so in 1861, when the unification of Italy kicked out the Habsburg rulers, and Florence suddenly had to decide whether to be part of the new Italian Republic, they gathered the descendants of the families that had been the last set of Dudes in the Tower, gathered them anew in the Palazzo Vecchio, and had them vote on it—the old oligarchic republic ready to reconvene even after three centuries. For all that to happen, Florence had to survive.

Petrarch would agree.

But did you notice the difference Petrarch would be surprised by? Nick's strange, radical break with what the Renaissance's founding generations tried and knew? The break which is the reason, when I was a PhD student, my big qualifying exam began with the question: "Was Machiavelli a humanist?"

Wasn't it supposed to be virtue that saved the world?

To answer that, we need to face the question which looms over Renaissance historians as inescapable, spectacular, and many-makered in its ever-incomplete construction as the sky-defying dome: *What was Renaissance humanism?*

PART IV

What Was Renaissance Humanism?

If you can seriously discuss what *Renaissance humanism* means for half an hour, you can have an MA in Renaissance history. I mean it, that was my oral exam.

Why does it matter? Because when we invoke the Renaissance golden age, whether to legitimize our capital buildings or just to understand our past, we tend to imagine the core of that golden age to be its people, its minds, the spirit of the age. We in modernity know that historic greats and terribles involve economies, technology, class, climate, many factors; scholars study these as Machiavelli's peers studied the planets and astrologers' predictions, governments investing in the newest high-precision armillary sphere. But Machiavelli thought astrology was bunk— he studied people. Petrarch said we should study people too, Roman education more than Roman roads. Medieval authors agreed, saying kings' and nations' virtues or vices earned the boons or blights of Providence. The nineteenth century studied geniuses of place and peoples. Even Vergil said that Rome was fortunate, not because of her great wealth or empire, but her great people. Whether we call it a work ethic, or values, or a worldview, or a national genius, or a spirit of the age, we moderns have inherited a long tradition of believing eras are defined by the characteristics of their people, like the strengths and flaws of epic heroes. When museum goers marvel at Renaissance masterpieces, wondering how an age produced such wonders, instinct feels the answer should be in people's heads. As long as people seek the answer

to *Why Renaissance?* within the human mind—a light, a spark, a dream—that answer must address the term *humanism*, the label most frequently used, both for the Renaissance's key intellectual movement, and for the modern strains of thought which (truly or falsely) most claim Renaissance descent. In sum: a careful answer to *what is Renaissance humanism?* gets us at the many things that these chameleons, *Renaissance* and *humanism*, have meant to those who have invoked them in the centuries from Petrarch's to our own. Thus we return to:

> *Umanista* **(noun):** a teacher of the *studia humanitatis*
> *Humanism* **(noun):** a nineteenth-century ideology centering the human

We know they aren't the same, just as we know the T-rex and the seagull are not the same, but finding archaeopteryx helped us understand the path from T-rex to seagull, and we moderns crave that for the evolution of the word *humanism* too. We want *Renaissance humanism* to be a thing, something with an intellectual core, not just an educational method. Impulse says this should be what lay behind the curtain, that a Renaissance humanist should be a category, people who believe something innovative and connected with the celebration of the human. But any quest to define such an ideology quickly becomes a claim about the new, defining spirit of the Renaissance, i.e. about an X-Factor.

And this is where our tale of the great and terrible Renaissance is dragged into the high-stakes, knock-down, drag-out battlefield of... arguing over which of two book series at the same academic publisher a monograph should be published in! (Battle Pope 3: Publishing is War!)

45

What Was Behind the Curtain?
Garin vs. Kristeller

Once upon a time, the talented young concert-pianist-in-training Paul Oskar Kristeller (1905–99) decided he would rather study philosophy. Being German, he wanted to study the super rigorous treatise-focused institutional philosophy favored in German philosophy departments. And being Jewish with German nationalism on the rise, he had trouble finding support at the University of Freiburg, where his top-choice adviser refused to take him, saying he already had one Jewish student and wouldn't take another (people express prejudice in many strange ways). So Kristeller ended up studying with his second-choice adviser, Martin Heidegger (1889–1976), and often played piano at Heidegger's afternoon soirees. In 1933, with the Nazi party on the rise, Heidegger, wanting to keep his student safe, sent Kristeller off to Italy to study the philosophy of the then fashionable Renaissance. Kristeller worked at the *Scuola Normale Superiore* in Pisa for Giovanni Gentile (1875–1944), a neo-Hegelian philosopher and fascist strongly influenced by Marx and Nietzsche, who was one of the premier scholars in Italy at the time, and a ghost-writer for Mussolini of part of *The Doctrine of Fascism* (1932). Gentile was also influenced—in his thought and his fascism—by politician and philosopher Benedetto Croce (1866–1952) who was a great advocate of seeking the Spirit of an Age, and believed historians should look through history noting what was important, valuable, and defining about each era, and that such things contributed to a constantly evolving and human force transcending religion, well described by the term (if we dare) *human<u>ism</u>.*[1]

Kristeller spent five years studying in Italy before Mussolini's 1938 racial laws drove him to flee to the US, an escape which his

scholarly advisers' friends in high places made possible.* During those five years, despite the growing barriers facing Jews in fascist Italy, young Kristeller wielded substantial power in the Italian scholarly world through Gentile's influence (patronage is powerful) and worked as supervising editor for two series of academic books published by the *Scuola Normale*, one for studies treating *philosophy*, the other for *literature*. Editing both meant young Kristeller had the task of *judging what made a work philosophy vs. literature*. When the up-and-coming Italian scholar Eugenio Garin (1909–2004) submitted his study *Giovanni Pico della Mirandola, vita e dottrina* for publication in the *philosophy* series, Kristeller insisted that Pico's work was not philosophy but literature, and belonged in the other series.[2] Thus a field-defining amicable feud was born, which would be played out over decades between Kristeller and Garin, their wives (who were good friends), their students, and their students' students (including me), on to today.

Fundamentally the question was: *What is philosophy?*

For Kristeller, coming from the universities of Freiburg and Berlin, philosophy was formal and narrow, the kinds of highly technical work that Heidegger and Wittgenstein were doing, with treatises, definitions, and proofs. Garin, meanwhile, was thinking of Jean-Paul Sartre (1905–80) and other existentialists, who wrote novels, short stories, plays, and meditations advancing philosophy through many literary forms. For Garin, Pico's work was philosophy, but Kristeller insisted that Pico and similar Renaissance

* That Heidegger and Gentile, despite their Nazi and fascist ties, protected Kristeller this way is a textbook case of the widespread phenomenon in which advocates and enablers of discrimination and persecution make individual exceptions for personal contacts, arguing that *this* Jew, *this* Black person, *this* homosexual, *this* transgender person, *this* woman needing an abortion, etc., isn't like the rest and should be exempted—a phenomenon important to our understanding of how discriminatory movements recruit support even among those with intimates in the targeted group. Once safe himself, Kristeller strove unsuccessfully to use his German and Italian scholarly connections to save his parents, who died at Auschwitz and Thierenstadt; on that story see John Monfasani's masterful and chilling article, "From the Liner Vulcania to the Martin Memorial Lectures: Paul Oskar Kristeller's First Fifteen Years in America," *Mediterranea*, 5 (2020) pp. 373–92, which reprints letters confirming Kristeller's efforts and their deaths.

figures were a *literary* movement, concerned with aesthetics, rhetoric, and style, *not* the rigorous ideas expected of philosophy. Kristeller was studying Marsilio Ficino, whose treatise-like analyses of Plato *did count* as philosophy by his standards, *unlike most works by umanisti*, and Kristeller was fond of reminding us that Ficino had scholastic training, formal and rigorous, not just the form-over-substance *studia humanitatis*. You may object: *But weren't Ficino and Pico doing basically the same thing? While eating at the same table?* Indeed, but so was Michelangelo, so where do we draw the line? Garin published his Pico book with the University of Florence in 1937, but the argument between the two continued: was Renaissance humanism a *philosophy?* Was there an ideological core behind that curtain of Ciceronian subjunctives? Or was it really about methods of education and literary style?

For Italian scholars like Garin, humanism's status as a philosophy had a personal and national side, since humanism as an *–ism* was Italy's biggest claim to be a contributor to the history of thought after antiquity. I mentioned before how histories of philosophy tend to skip from antiquity (Confucius and the Greeks) straight to Hobbes, Locke, Leibniz, Kant, Hume, Rousseau, etc. I once did statistical analysis of this: in fifty intro philosophy courses offered at English-speaking universities from 2010–15, a whopping 1 percent of assigned readings were Renaissance (basically just Machiavelli), contrasted with 14 percent ancient, 6 percent medieval, 13 percent from our seventeenth-century Try Everything Age, and 66 percent (two-thirds) eighteenth-century or later. Statistical analysis of the topics treated by scholarly philosophy books published in 2014 yielded extremely similar results, with 16 percent ancient, 3 percent medieval, 2 percent treating the 1300s–1600s, 12 percent the Try Everything Age, and 67 percent the eighteenth century or later.[3] And, except for that teensy taste of Machiavelli and a little Pico, no post-antiquity Italians—in fact, usually no Mediterranean figures after Augustine. Part of this relates to the merits of individual authors, and which debates are *live* in philosophy, but another big part of it is the result of the nationalist self-fashioning of European countries. In the nineteenth century (the true recurring villain of our story) England, Scotland, France, the Dutch empire, and uniting Germany did

a lot of work to paint themselves as the true shapers and inheritors of Western thought, claiming straight lines of descent from the *golden age* of ancient philosophy to their own intellectual golden ages: the French Enlightenment, English scientific revolution, Scottish Enlightenment, modern German science and *geisteswissenschaft* (moral sciences, humanities, literally spirit-of-a-people-studies), etc. Such efforts to claim the ancient golden age worked better if one could exclude Italy's Renaissance one, resulting in claims that, while the Renaissance was an *artistic and cultural* golden age, the more serious *intellectual* golden age waited for [insert nation here]. This was part of a larger project of casting Mediterranean nations—especially Spain and Italy—in a negative light, magnifying the evils of Catholicism (there were real evils, but they could still be magnified), claiming the Inquisition's censorship strangled freethought and made true intellectual innovation impossible (even though Protestant powers had their own censorship), and even claiming that only Iberian empires did the *bad* colonialism with atrocities, while the English and French empires did beneficent *good* colonialism (look up the Black Legend if you aren't familiar). All this meant lining up arguments for Italy as an intellectual backwater, and Italy in turn lining up scholars determined to defend Italy's contributions to the global world of ideas, a project still big and ongoing in Italian scholarship today. The absence of the Renaissance, and of post-classical Mediterranean thinkers, from the courses my statistics come from is in a big way a product of this *successful* smear campaign—successful in the English-speaking world, while if you took a philosophy overview course at an Italian or Spanish university, there would be plenty of Renaissance.

While it is completely true that this propagandistic exclusion of the Renaissance from histories of thought is harmful, it's equally true that sometimes those trying to defend the philosophical legitimacy of *humanism* did so with bad, anachronistic arguments. Just as Nazi contamination of Norse studies virtually shut it down for the decade after the Second World War, so Mussolini and Hitler's celebration of Renaissance art and culture, and the fascist activities of prominent scholars like Benedetto Croce, Giovanni Gentile, and Ernesto Grassi (1902–91), poisoned Renaissance

studies for a time, especially in Germany and Italy, requiring new approaches and a fresh start.

Garin's well-researched and historical arguments that Renaissance humanism is philosophy gained sudden strength in 1946 when Jean-Paul Sartre published an address he had given the previous year at the Club Maintenant in Paris called *Existentialism is a Humanism* (take that, Kristeller!). It then suffered a setback later that same year when Heidegger published his response, *No It Isn't, Sartre, Get Stuffed*, or as it's officially titled Heidegger's *Letter on Humanism*. This high-profile and exciting debate muddied the waters, so interpretations based in actual period sources was further drowned under mid-twentieth-century what's-hot-today concerns.

Another muddling arose in the US, where, by now, Kristeller was teaching in the Philosophy Department at Columbia, then a major center of American humanism in the modern *secular humanism* sense, whose philosophy department, and the students attracted to it, were strongly shaped by the recently retired John Dewey (1859–1952), a prominent atheist and secular humanist and one of the signatories of the 1933 *Humanist Manifesto*.* Dewey's successor in the department was John Herman Randall (1899–1980, author of *The Making of the Modern Mind*, 1926), and the department had another *Humanist Manifesto* signatory actively lecturing, Corliss Lamont (1902–95), a socialist, ACLU director, and one of the targets of McCarthy's persecutions. These presences drew a lot of students to the philosophy major, so when Kristeller offered his first course on (how does the dictionary say we translate *umanisti?*) Renaissance humanists, he and his students were equally dismayed by the mismatch between their expectations (atheism! modernity! The Church of Humanity!) and his syllabus.

A hundred classroom rants explaining, "No, Petrarch *doesn't* think what Comte and Dewey think!" lie behind Kristeller's insistence that Renaissance humanism was *an educational movement, NOT an ideology*. For him, *umanisti* were also philosophers, like Ficino or Pomponazzi, just as others were ambassadors, statesmen, historians, soldiers, monks, or priests, but to be an *umanista*

* Not the Dewey of Decimal System fame, that's Melvil Dewey (1851–1931).

was not to hold a shared philosophy. In 1956, Kristeller, along with Randall and Ernst Cassirer (another major German-trained Jewish philosopher-in-exile) co-edited one of the most fascinating scholarly compromises in the history of histories (and a publication saga scholars still rant about in all caps in private), *The Renaissance Philosophy of Man: Petrarca, Valla, Ficino, Pico, Pomponazzi, Vives*, a classroom paperback still in print today, showcasing several *umanisti* Kristeller considered genuine philosophers, but also Petrarch and Pico who were favorites of the modern humanism crowd.[4]

Kristeller's influence encouraged many to study the Renaissance *without* assuming *umanista* = ideological humanist in the modern sense. But the truly generative part was the debate itself, which made decades of scholars ask: Was there a unified philosophy in what we call Renaissance humanism? If so, what? Can defining an ideological core help us give meaningful answers about edge cases? A fully professional definition of Renaissance humanist, where only those employed as *umanisti* count, feels too exclusive. Does Cassandra Fedele, despite her Latin oration to the Venetian Senate, only count as a Renaissance humanist if, in those years running the orphanage, she taught the *studia humanitatis*? Does Alessandra Scala only count if we discover she taught Greek and Latin to her fellow nuns? Our hearts cry, "No!" but in avoiding that Scylla we must not fall into the Charybdis of projecting modern ideas back on sources that never read Dewey or Comte.

What, then, is a Renaissance humanist?

46

Who Gets to Count as a Renaissance Humanist?

Let's start in the center of our diagram, with those even the narrowest definition will include: professional *umanisti* who made a living using classicizing Latin and/or Greek, including teachers and those like Leonardo Bruni who put his *umanista* skills in service of his republic. Does Renaissance humanist then include everyone who wrote in the new style? Everyone who studied the *studia humanitatis*? Everyone who hung out with *umanisti*? All these, if held strictly, force us to include some who feel wrong, or exclude some who feel right.

If a Renaissance humanist is someone who wrote in the new style, then Alessandra Scala and Cassandra Fedele are in (good!), but we've excluded the celebrated Niccolò Niccoli, Poggio's book-collecting partner, who hosted famous literary gatherings in his library which surpassed the University of Paris, but wrote nothing because—his friends attest—he had severe anxiety about making Latin mistakes and getting pounced on about it, so he could never force himself to write. Many of us can identify with this glimpse of pre-modern impostor syndrome (I certainly can), but no Renaissance *umanista* would embrace a definition of their movement which excluded one of its dearest founders.

What if a Renaissance humanist is someone educated in the *studia humanitatis, whether or not* they write Latin? Niccolò Niccoli is in, but we've still excluded Cosimo de Medici, who loved and supported *umanisti* but had a merchant education, so could only give the *studia humanitatis* to his grandkids, not himself. Being

excluded because one was born on the generational cusp and came to it in adulthood feels wrong—surely if this is an *ideology* one can love and embrace it whatever one's childhood education. And do we really want to include *everyone* who had a humanist tutor? (♫♪ I'm Henry the Eighth, I am, I am; ♪ had an *umanista* tutor named Thomas More; ♪ I chopped off his head I did, I did, ♪ I'm Henry the Eighth, I am. ♪♫)

If we expand Renaissance humanist to include *participants in and supporters of the classicizing movement*, Niccolò Niccoli and Cosimo are in, but so is Julius II (Battle Pope 2: More Pet Scholars For the Battle Pope!), who had a Franciscan scholastic education, plunged straight from the monastery to high politics when Uncle Sixtus became pope, spent lavishly on antiquities, hired many *umanisti*, but preferred to be sculpted holding a sword not a book, didn't bother to read the title of the masterpiece Raffaello Maffei dedicated to him, and does *not* want to talk about Latin grammar, go away! Julius is very far from Petrarch's *Pace, pace, pace!*

Julius gives us an idea: what if a Renaissance humanist is someone who *socializes* with *umanisti* discussing the classics and philosophy? Then Niccolò Niccoli, Cosimo, Alessandra, and Cassandra are all in, while Julius and Valentino are likely out, since they discussed war and politics with *umanisti*, but we don't have evidence of them sitting down to discuss whether Livy or Pollio is the best Roman historian. This feels better, but if intellectual socializing is the qualifier then Savonarola is also in, and a humanism that includes the firebrand of Florence's quasi-theocracy while he was denouncing Ficino from the pulpit feels awfully far from anything that would be recognized by those students drawn to Kristeller's classroom by Randall's modern secular humanism. If we exclude Savonarola for his orthodox piety, what about pious Raffaello Maffei, who taught the *studia humanitatis* to Volterran boys, while supporting a nunnery for Volterran girls, and was nearly a saint?

Do we want to narrow *humanist* to only include people who debated intellectual questions with *umanisti* and *also agreed with them*, taking a positive (not hostile) interest in their innovative works? This includes Raffaello while keeping Savonarola on the edge (which feels right), but then we face the tricky case of Pope

WHO GETS TO COUNT AS A RENAISSANCE HUMANIST?

Nicholas V (Tommaso Parentucelli, 1397–1455), who worked as an *umanista* as a young man, then toured Europe book-hunting like Poggio, and, as pope, founded the Vatican Library (a hero of humanism!) but—as John Monfasani observed from the manuscripts that Nicholas acquired for the library[5]—Pope Nicholas collected classics, theology, and scholasticism, but *didn't* have his new library acquire new works by contemporary *umanisti* like Poggio or Bruni; the only works by Renaissance *umanisti* in Pope Nicholas's collections are gift copies from scholars who dedicated things to him (much like Julius II). Pope Nicholas feels like a perfect Renaissance humanist, until we ask whether he thought the *new* ideas of his contemporaries were valuable. If someone believed that the *studia humanitatis* was important, but *didn't* think that the new works by Renaissance *umanisti* were important, then Nicholas's case doesn't feel like Garin's argument that Renaissance humanism had an ideological core.

Often the most useful figures for testing the limits of our definitions are the odd cases like Savonarola, Cosimo, or Julius II, figures who *should* fit strangely on the edge, so any definition which makes them an easy *yes* or easy *no* should give us pause. Thus we turn again to Cesare Valentino Borgia, who showed Machiavelli how much more effective it is to be feared than loved for one's virtue (Petrarch: **whimper**); Valentino had a fine humanist education, employed *umanisti*, spent time discussing politics with Machiavelli, but gut instinct doesn't want to call him a humanist. Yet what about Lucrezia Borgia, who shared her brother's classroom, read Latin and Greek, aided the Borgia project to carve a kingdom out of central Italy, wrote elegant poetry *in vernaculars* (not Latin) and didn't merely hire *umanisti* but loved them (in Bembo's case *a lot!*). Lucrezia feels close to Alessandra Scala, but if Valentino had lived long enough to settle down as a duke or king, he certainly would have filled his court with *umanisti*, as Guidobaldo da Montefeltro did. Is the difference between Valentino and Lucrezia that he advanced the Borgia conquests by the sword, she by the pen? Or would we want to know what's in their hearts, whether a mature Valentino would have enjoyed discussing Livy with his courtiers, or just collected them like Julius? Could the qualifier really be whether

Cesare Borgia enjoyed his Latin lessons? Can something so slippery be a useful line?

We could exclude both Valentino and Lucrezia by saying humanist literature must be written *in Latin*, and a lot of Renaissance figures might agree, but then we'll find ourselves excluding masterpieces like *Orlando Furioso*, and Bembo's analysis of the Italian language. (Plus it feels strange saying Lucrezia Borgia was less of a humanist than Cardinal Ascanio Visconti Sforza's Latin-reciting parrot.)

The Young Cicero Reading, commissioned by Cosimo for the Medici bank branch in Milan, an idealized portrait of classical education, complete with anachronistic contemporary Renaissance clothes and tomes just as his sons, as well as young Valentino Borgia, Guidobaldo da Montefeltro, Ascanio Sforza, and Ippolito d'Este, would have worn and used in their days studying the studia humanitatis. But did they enjoy their lessons? Can we find a way to do without the answer? (Vincenzo Foppa, *c.*1464, now in the Wallace Collection.)

47

Back to Our X-Factors

If we check ever-changing Wikipedia, with what you now know, you can feel different past claims about the Renaissance wrestling even within the 150 words that begin the page called *Humanism*:

> Humanism is a philosophical stance that emphasizes the value and agency of human beings, individually and collectively. The meaning of the term humanism has fluctuated according to the successive intellectual movements which have identified with it. The term was coined by theologian Friedrich Niethammer at the beginning of the 19th century to refer to a system of education based on the study of classical literature ("classical humanism"). Generally, however, humanism refers to a perspective that affirms some notion of human freedom and progress. It views humans as solely responsible for the promotion and development of individuals and emphasizes a concern for man in relation to the world. In modern times, humanist movements are typically non-religious movements aligned with secularism, and today humanism may refer to a nontheistic life stance centered on human agency and looking to science rather than revelation from a supernatural source to understand the world.[6]

Did you feel them? Kristeller's humanism as an educational movement wrestling with Burckhardt's spirit of individualism, both with Baron's political engagement, and all with notions of Renaissance proto-democracy, proto-liberalism, and the great specter: secularization? If we turn to Wikipedia's page on *Renaissance humanism,* we find:

> Humanists sought to create a citizenry able to speak and write with eloquence and clarity and thus capable of engaging in the civic life of their communities and persuading others to virtuous and prudent actions...[7]

By now the phrase *engaging in civic life* raises a flag—we recognize you, Hans Baron! Does the Baron definition work?

Yes and no, as Peter Abelard would say. Baron's civic humanism—often mythologized beyond what Baron actually claimed—remains appealing, proposing a spirit of the age founded in political participation. Co-helming the state created a sense of pride and duty which pushed citizens to strive to become their best selves (Plato would approve), the better to steer the ship of state through Fate's rough seas. This feels modernizing: humanity rejecting the classical idea that the philosopher-sage must retreat from the city to live the life of the mind in hermetic solitude, and the medieval model which confined inquiry to the cloister and the rote scholastic classroom. Bruni's history, and Machiavelli's too, are fruits of humanity remembering that the human is a political animal (as Aristotle said), whose potential is best actualized within the polity, where human nature can be study's object. And even if Machiavelli's *popolo* was exclusive, 10 percent civic participation was still far broader than most.

The problems with this are, first that classical Stoicism recommended political participation almost two millennia earlier (which is what made Stoicism so popular in Rome, compared to contemplative sects like Platonists and Epicureans), and second that, if we use this definition and then ask who is or is not a Renaissance humanist, Bruni, Machiavelli, and Poggio remain, as do Venetian humanists, but those who served kings in Naples or popes in Rome move to the margins. All those humanists King Alfonso the Magnanimous gathered in Naples, Filelfo when he chose to work for the Dukes of Milan, are they not humanists, if humanism = civic humanism? Must we call them failed humanists, or bad-faith humanists? Their peers did not.

Additionally, by demanding *both* republics *and* political participation, the Baron model has basically excluded women. Alessandra Scala was not eligible for republican office-holding, so can't be part

of civic thought if it flourished only in people who *participated* in the running of the state. Our female friends who participated directly in politics did so in monarchies: Ippolita Maria Visconti Sforza, Isabella d'Este, Lucrezia Borgia, Beatrice of Naples Twice Queen of Hungary. Our Florentine women who did strongly affect the government are Camilla Rucellai and Lorenzo's firstborn Lucrezia de Medici during her brothers' banishment, both of whom Baron would say were *undermining* the republic. You can see why the political science classes down the hall delight in Baron's examination of civic engagement, but also why my history PhD students responded with dismay to hearing civic humanism accepted as *the* Renaissance X-Factor without its grain of salt.

What if we go back to Burckhardt's idea of the Renaissance as the birth of individualism and self-fashioning? Recalling the philosophical commandment *Know thyself*, the Renaissance realized humanity's millennium-long error in seeking to know ourselves through the distant Heavens, and turned at last to history, society, art, verse, birthing the humanities which would launch us from medieval stagnation through the Enlightenment to brave modernity! My formulation here is more hyperbolic than Burckhardt, but versions of it, ornamented and mythologized, are often invoked by modern-day humanist movements.

How does such a definition fit our edge cases? Bruni and Machiavelli certainly self-fashioned, Petrarch too, and our bookhunter Poggio Bracciolini who turned his quarrel with Lorenzo Valla into an epic feud waged in letters which secured fame for both. Many non-*umanisti* also fit: Michelangelo, Leonardo, Benvenuto Cellini the goldsmith-sculptor-assassin-jailbreaker-necromancer with his implausibly exciting autobiography, Lorenzo de Medici self-fashioning every minute, while we would have to place more marginally Raffaello Maffei Volterrano who, after the cold reception his encyclopedia got from Julius II (Battle Pope 2: More Swords, Less Books!) retired to Volterra to teach youths and finance nuns. He did all the *umanista* things, yet every choice he made feels backwards (medieval?) if Renaissance = modernizing self-fashioning. It's also hard to think of Renaissance figures who put more effort into their self-fashioning than Valentino Borgia and Julius II; do they feel like steps toward modernity? Perhaps,

but not in ways that make us happy? Or, as Burckhardt might point out, is their grandeur so enormous and awesome that we don't judge them quite as human beings anymore, but as powers—each a self-fashioned human state which is a work of art? Here the brilliant historian of selfhood John Jeffries Martin challenges us with his beautifully-evidenced argument that the period did not have a singular understanding of the self but plural selves, with the *sincere self* imagined as very separate from the *performative self* and the *socially-constructed self* (who you are *inside* is different from the self you perform in public without that difference being bad or hypocritical, and both are different from your social role defined by networks of power and obligation). In other words, there was much more separation between the fashioning of a public or performed identity and the cultivation of the soul or true self in the Renaissance than there is for us today.[8] When we look at Cardinal Ascanio Sforza's parrot, or Julius not bothering to read the titles of books dedicated to him, are we detecting hypocrisy or a different understanding of the self, which allows a great separation of such acts from the true self which might see its pursuit of virtue as wholly aloof from the activities of the public self?

Finally, self-fashioning as a focus gives us a source base bias. Think of Poggio's impostor-syndrome-riddled friend Niccolò Niccoli—no one points to him as a paragon of self-fashioning, not because he didn't do it, but because the ways he did it don't survive: he did it aloud, in person, not in ink. Speech, live discourse, the words spoken in the rooms where it happened, these vanish in the historical record, while the written word looms large. Historians work hard to reconstruct live speech, and there's wonderful recent work on Renaissance noise and shouting,[9] but it's difficult, and new, so those who entered the canon as Burckhardt's examples of self-fashioning were exclusively those who did it in print or art, and are not necessarily those that the Renaissance man on the street would have said were the most outstanding figures of his day.

The self-fashioning focus can have a gender problem too, well represented by that letter/treatise against sumptuary laws regulating women's attire published in 1454 by Nicolosa Castellani Sanuti.[10] Writing to Bologna's then-governor the celebrated Greek scholar Cardinal Bessarion (1403–72), Castellani Sanuti unleashes a torrent

of Greek and Latin authorities that would stagger any *umanista*, but one of our learned lady's complaints is that she has been compelled by the injustice of the law to speak so publicly, that she would rather not publish, instead displaying her virtues through the ornamentation of her body and face-to-face interaction, as is a woman's right and province. Ornament, she argues, is how a woman teaches virtue, wearing gold an ancestral honor commemorating the great deeds of women of the past, like Flavia who sheltered Marius, or the women who saved Rome from Coriolanus. Such examples, brought to the gazer's mind by seeing a grandly dressed woman, revive the fame of great deeds and edify the living. Again, John Jeffries Martin calls on us to remember that the construction of public personae and the inner self were very separate, and the choice for one's philosophical work to have a public side perhaps a more uncomfortable leap.[11]

Castellani Sanuti's professed aversion to asserting herself through words in public is not mere rhetorical modesty: despite her erudition, she never published anything beyond this letter, writing poetry only for private exchange with her lover Sante Bentivoglio (the ex-blacksmith's-apprentice brought to govern Bologna, whose son will urge Machiavelli to finish his history). Castellani Sanuti's learnedness is mentioned once in a letter by fellow female scholar (humanist?) Laura Cereta, who compares Castellani Sanuti to Cassandra Fedele, but Castellani Sanuti's learning left no record beyond this letter, *and that was her preference*. Not all women felt as she did—many Renaissance women did publish and craft personae of the kind Burckhardt celebrates, and Laura Cereta, who praised Castellani Sanuti, also wrote a letter about how pointless she thought fancy clothes and jewelry are.[12] But Castellani Sanuti was certainly not alone in preferring to express her excellence, not through writing, but through dress and private conversation, media which—like the learned gatherings of Niccolò Niccoli—leave few records. A definition of the Renaissance and humanism as self-fashioning that inflates those who self-fashioned via text and surviving artifacts, and virtually erases those who used more perishable arts, can't help us understand the whole Renaissance, just a sliver of it.

Where do we turn if our X-Factors fail?

48

Once Upon a Time at Vergil's House...

A few years ago, I spent some delightful History Lab days at a mini-conference at the Vergil Villa outside Naples. Our focus was the idea that *transformation* is a better term than *reception* for discussing what later eras do with things from the past, i.e. the *transformation* of Homer in the Renaissance vs. *reception* of Homer in the Renaissance, since we don't passively receive objects in a timeless state, and the Homer translated by Poliziano was transformed in meaning and impact by its (Petrarchan, Florentine, Medicean) context, just as the meaning and impact of an ancient obelisk is transformed by being re-erected on top of a fancy fountain with a pope's name on it and a cross on top. The whole mini-conference was delightful, but at one point we got to jokingly proposing definitions of humanism that *feel* right, but are too oddball or informal to use in scholarship. Two I will never forget.

Johannes Helmrath—a brilliant proof that Renaissance studies still thrive in Germany—proposed: "*A humanist is someone with the ability to activate antiquity.*"[13]

It works.

The antiquities were always there, always in use, the Vergil quotes, the Roman coins, those ruins in the backyard of your father's castle; the Middle Ages had them *and used them* for legitimacy and other things, but those who used the *studia humanitatis* could activate antiquity in a new way, deploy it as the new language of power it was becoming, a tool for education, for identity, for signaling participation in innovation. And they could activate the perceived connection between the classics and *virtue's power to change the state of politics*.

Medieval powers had used the classics in many ways, but the Renaissance had a new set of promises, new things antiquities coded for: virtue of a very particular type, displayed in a particular set of ways, advertising a particular kind of political stability, acumen, and potency—invoking a golden age. Passionate Petrarch, history-slicing Bruni, scholar-popes Nicholas V and Pius II, such humanists could activate antiquity, and with it the promise that antiquity's libraries would draw a new line between present and past, as potent as the line between the *Pax Romana* and its end. Alessandra Scala as *Elektra* on the stage invoked the same. Cardinal Ascanio "My-Parrot-Speaks-Latin-For-Me" Visconti Sforza, and Julius II (Battle Pope 2: Don't Talk to Me About Participles!) hired others to activate antiquity for them. Lucrezia Borgia, as Duchess of Ferrara, could activate antiquity herself with her erudition *in addition to* hiring *umanisti* to do it for her. Valentino also had the right education to activate antiquity, while Julius II didn't, but both had other tools at hand (terror and cunning) which were at odds with *antiquity-defined-as-virtue*. They could use antiquity via their ancient names—Caesar, Julius—and they could use classical trappings legible beyond the virtue-oriented project, but when Machiavelli wanted to describe their actions in *The Prince*, he couldn't frame them via classical virtue the way Naples's humanists had framed Alfonso the Magnanimous's.

Humanism as the ability to activate antiquity *with antiquity understood as a tool for healing Europe through virtue*, this describes something coherent, and satisfies Garin's desire to argue there's a *there* there in humanism, without fully breaking with Kristeller reminding us how much it focused on rhetoric and performance. Our definite yes-es all feel like yes-es (Niccolò Niccoli, Filelfo, Maffei, Alessandra Scala), our edge cases like edge cases (Cosimo de Medici, Savonarola, Lucrezia Borgia, Henry VIII), our extremes (Julius, Valentino) like extremes.

This suggestion of Johannes Helmrath's comes from the exciting world of German studies of the Renaissance, still advancing the Kristeller-Garin debate and, often, very interested in the compromise position advanced by Ernesto Grassi of presenting humanism as a *rhetorical philosophy*, categorically distinct from the *rational philosophy* of the Enlightenment and the *analytic philosophy*

of figures like Bertrand Russell (1872–1970) and Wittgenstein (1889–1951).[14] The research group Helmrath then helmed, which my American group was collaborating with, focused on *the transformation of antiquity*, the different ways Renaissance people changed, relocated, reused, and reinterpreted ancient texts, objects, and ideas changing their meaning (i.e. quoting Homer didn't mean the same thing in 1450 that it did in 300 BCE, 1915, or 2015).

This project reflects how funding structures shape research. The way Germany funds scholarship these days encourages big, collaborative, grant-funded research groups, required to write very detailed explanations of their methodologies when asking for funding, which has caused Germany to produce lush detailed studies of the methodologies and collaboration of Renaissance scholars too. The way Italy funds scholarship these days gives lots of support to philology and art history, encouraging translations, critical editions, and lushly-researched group-authored exhibit catalogs. A similar set of funding structures encourage Dutch scholarship to do meticulous teamwork and philological analysis, resulting in deep readings of Renaissance texts from scholars like Karl Enenkel, Susanna de Beer, and Lodi Nauta.[15] In America, meanwhile, neither collaboration, nor exhibit catalogs, nor translations, critical editions, or deep philological analysis will get a historian tenure, so we mostly produce single-authored topical monographs like my *Reading Lucretius in the Renaissance,* that sweep more shallowly over many texts, bringing them together into big conclusions. Scholarship still follows the money, no less with universities and grants than upstart dukes and Florentine bankers.

At that same brainstorming session in the Vergil house, Christopher Celenza—whose single-authored topical monograph *The Italian Renaissance and the Origins of the Modern Humanities* does a more beautiful job than any book I know portraying just how the *studia humanitatis* and the modern *humanities* are connected[16]—proposed another definition:

"*A humanist is someone who receives a letter from Erasmus.*"

It also works.

Receive a letter from Erasmus doesn't mean only Erasmus, it's shorthand for a letter from a master scholar: Petrarch, Bruni,

Pontano, Poliziano, one of the recognized shapers of that generation of the learned world.[17] Letters were core to *umanisti*, not the quick personal notes asking family to send fresh laundry, but literary works, polished, elaborate, modeled on Pliny or Cicero, often expounding on some virtue (patience, peace), or on some passage (a line from Propertius, or a newly discovered inscription). Such letters were intended to be shared, copied, sent all around the learned world, so even in minor hill towns, the city clerk (a professional *umanista*) might rush to his friend who tutors the count's son (another *umanista*), crying, "Look! My cousin in Arezzo sent me a copy of a new letter Poliziano sent to Pontano about the proper way to console a grieving prince!" Quickly all *umanisti* in the town gather to discuss the letter, and make copies for friends in other towns. Such letters were also meant to be collected and published, so to be the addressee was to have your name preserved forever in a great scholar's *opera*. To receive such a letter was to be acknowledged as a node in the learned web, and to have your name spread far and wide, in life and for posterity. And, like any social medium, this world of letters had its share of nastiness, as recorded in a Ficino letter to Bernardo Rucellai advising him not to respond to ~~internet trolls~~ detractors, saying such a dog will keep barking until it dies, unless it joins Cerberus in barking even after death.[18]

In such a world, a young scholar hoping to enter the humanist world often made his debut (or tried to) by writing a learned letter to some famous figure, discussing a passage in the figure's work or lines from a classic that the figure edited, quoting as many sources as possible to display erudition. It was your debut humanist gymnastics routine. If the famous man *replied*, if you got a letter *back* from Erasmus, Pontano, Poliziano, etc., if he thought *your ideas* were worth discussing, you were *in*. Others would write to you, scholars who passed your town would stop to visit, you could ask them for letters of recommendation, career paths opened, you were *somebody*. This wasn't just academic fame; *umanisti* were celebrities, and a whole town would hear the news (and often the read-aloud letter) if someone local got a letter from a major scholar, or even if someone carrying such a letter came through town.[19] Petrarch used to complain that people were so eager for his letters that they were copied numerous times en route, and

read by many before they reached the addressee.[20] Such letters could also have complexly plural authors, as one classics lover served as amanuensis to another, hence Raffaello Maffei plausibly mistaking a Lorenzo letter for Poliziano, since Lorenzo's correspondence was usually dictated to one of his *umanisti*, not in his own infamously illegible hand (likely a consequence of his disability); even when Venice circulated a mock letter supposedly from Jesus Christ, criticizing Pope Julius for the War of the League of Cambrai, they included a scribe's note, expected on any letter from a royal court including Heaven's, stating that the letter was transcribed by John the Baptist from Jesus's dictation.[21]

Letters had secured scholars fame for centuries, from Pliny and Cicero to Abelard and Heloise, but this was Ever-So-Much-More the case in densely populated, scholar-packed Renaissance Italy, whose ever-improving trade networks and courier systems carried letters so thick and fast that even Erasmus felt he must visit Italy to be fully part of its world of letters. Centering our definition of *umanisti* on letters communicates the interconnected, diasporic, multi-city, multi-national nature of Renaissance scholarship, built of friendships, friend circles, schools, and also rivalries, whose battles in letters made combatants famous. (You gotta read this! Valla just insulted Poggio's understanding of the ablative! Again!!) And it communicates how exclusive the humanist world could be, how failing to be acknowledged, failing to get a letter back, could lock you out, no matter your efforts.

It also yields the best answer I've found to the question: *could a woman be a humanist in the period?*

A woman could have the Greek and Latin, she could have an expert tutor, she could join scholarly gatherings, write poetry and commentaries, publish, but when Cassandra Fedele wrote to Poliziano—sweet Poliziano, warm Poliziano, our Poliziano who finally made Homer into poetry again!—Poliziano did write back to her, but the reply was basically: *O learned maiden, how astounding that such a learned letter could come from a woman! A girl! Let me compare you to Sappho! And Corinna! And I bet you're really beautiful! And I'll just keep abstractly praising your beauty for the whole letter without ever actually answering your questions or engaging with the ideas you expressed in the original letter!* Sigh.

Such a letter made other people write *to Poliziano*, but not to Cassandra. Similarly, with Alessandra Scala, the poetic exchange was all about her-as-woman, not her-as-scholar. A woman could study the *studia humanitatis*, she could read, deliver orations, master the ability to activate antiquity, but the core exclusion wasn't just that she couldn't get hired as a tutor or secretary, it was that she didn't get the kind of letter back that men got. When a woman activated antiquity, people responded to her as a *woman*, not as a *scholar*.

Thus, we can define a Renaissance humanist as someone who receives a *reciprocal letter* from a figure like Erasmus, a letter that invites the addressee to join discussions of the classics. Humanists wrote letters to many people. Lorenzo Valla wrote to Pope Eugene IV asking for a job; Marsilio Ficino wrote to young Cardinal Raffaele Riario urging him to repent and save his soul; Pontano wrote a lovely letter to his former-pupil-now-King Ferrante of Naples reading (paraphrase): "Dear King Ferrante, today is my birthday, so since it's traditional on your birthday to do whatever you want all day, I took a long, lovely stroll along the beach, and now I'm going to write you a long letter about all the ways you're a terrible king, and a disappointment to me and your late father…" (Pontano was taking a risk criticizing Ferrante so, but counting on his super-fame and the fact that a weak monarch wouldn't want the bad publicity of murdering a major celebrity.)[22] Such letters did not expect reciprocal replies, but copies circulated, so Valla or Ficino or Pontano would receive scholarly *comments* on their erudition in such letters, from *umanisti* who were not the addressee.

To receive a learned reply to a learned letter, especially from a major figure like Valla, Poggio, Filelfo, or Erasmus, was to join the in-group, and we see the limits of that in-group when Cassandra Fedele's letter received a *different kind* of answer, and when Nicolosa Castellani Sanuti received no reply to her gorgeously learned sumptuary law protest letter to scholar-Cardinal Bessarion. (There is, by the way, a giant 5 lb. reference book of the late Renaissance, created in the 1980s, which is literally a dictionary of everyone mentioned in the letters of Erasmus. Its entry on Raffaello Maffei Volterrano reminds us that Erasmus criticized his translations.[23])

These two definitions together—activating antiquity and receiving a reciprocal letter from a major *umanista*—give us a Venn diagram with professional *umanisti* in the middle, then a circle for people like Cassandra Fedele who wrote learned letters but didn't get reciprocal replies, a circle for interlocutors like Savonarola who participated in discussions but didn't do the *studia humanitatis*, and a circle of patrons, *some of whom* wrote learned letters, but some of whom collected humanists like they collected parrots. And we have a circle of people who supported the project but couldn't grow up with the *studia humanitatis*, like Cosimo, and Petrarch himself. Petrarch grew up too early, and tried to classicize but could never write the gymnastics-routine Latin of the later *umanisti*, who praised him as an ancestor but just couldn't (you can tell) respect his Latin. They knew he tried his best, but to their tastes, Petrarch's Latin was too medieval, the Latin of the age of ash and shadow, not yet the Latin of what felt, as learned letters raced across the map, like a golden age.

Now, do you remember that weird little conference room with a dozen people discussing Ficino next to the room with a hundred people discussing Renaissance hats? There were barely over a dozen of us at the Vergil villa working to define humanism, a niche corner of the History Lab, much smaller than where our colleagues gather making their evidence-based portraits of Renaissance life. Debates over the meaning of epochs, *what is Renaissance humanism?*, these questions were center stage for historians in the nineteenth century, but if you walk into the History Lab today, most of my Anglophone peers would say they spend little to no time on these questions, and that we're wiser to avoid looking for the spirit of an age at all. Other friends would not—the German half of our little gathering at Vergil's house came from an educational system still shaped by Herder and Hegel's *geisteswissenschaft* (the moral sciences, study of the spirit of a people, *volksgeist*) and where *geistesgeschichte* (spirit-of-a-people history) grapples with *kulturgeschichte* (cultural history), so such questions are central in that scholarly world. And those Italians who joined us were shaped by their universities' desire to prove that humanism was post-antique Italy's contribution to the history of Great Ideas, and its bid to be on philosophy reading lists.

Yet even within the English-speaking world, the reason these debates remain important—and that our little cadre met at Vergil's house to mix with Germans and Italians over such questions—is that the idea of humanism is still a huge part of what English-speaking people *outside* the academic parts of the History Lab invoke when *they*—journalists, popular writers, novelists, talking heads, the *Assassin's Creed* videogame series, even scholars from other fields like literary studies, philosophy, or religious studies—make claims that touch the Renaissance. If you buy ten recent Renaissance books by PhD historians, the issue of humanism may not appear in them at all, but you'll find it in the Renaissance sections of books on atheism, on progress, on banking, on art, on Shakespeare, on Leonardo, in travel guidebooks to Italy and, yes, in the *Assassin's Creed* framing story, in which you help Machiavelli and his secret society strive to protect the rationalist seeds of modernity from the evil Church, and even get to beat up Montesecco and Alessandro Maffei. That's why this discussion, native to a tiny corner of the History Lab, is worth having at length if we want to navigate the wider world of claims about the Renaissance.

49

Follow the Money!

Another question looms in our quest to find a core ideology within Renaissance humanism: what if it was just about getting a job?

Sometimes it absolutely was about getting a job, as my dear friend Barry Torch recently demonstrated in his brilliantly-titled study, "Do I Have a Book for You!" which shows how, on the death of Pope Innocent and election of Sixtus, Greek scholar Theodore Gaza gifted his translation of Plutarch's *Moralia* to his friend, papal librarian Giovanni Andrea Bussi, in return for Bussi helping Gaza snag a Vatican job in the great employment shuffle that accompanied the death of every pontiff in the Eternal Problem City.[24] Susanna de Beer, a brilliant Dutch historian and stunning Latinist, has shown much the same in the self-advancing motives of Renaissance Latin poets.[25] The invaluable gadfly scholar Robert Black has similarly confronted those who celebrate humanist classrooms as centers of freethought by looking at the actual classroom practices of humanist schools, which reveal a distinctly unexciting, *un*-glittery focus on rote memorization, regurgitation, moralizing Christian readings of Vergil, and the same dose of physical violence normal in classrooms when the allegorical representation of music had a lyre, the allegorical representation of mathematics a compass, and the allegorical representation of grammar a grumpy expression and a bundle of cane to beat kids with—not endearing as a birthplace of modernity.[26] The *studia humanitatis* was one of few ladders by which sons of no-name families could advance to court and have the ears of potentates. Indeed, if Lorenzo's brother Giuliano had lived to become a cardinal, he would have

given Poliziano profitable Church benefices, as Giovanni "Leo" de Medici later did for Pietro Bembo, and Ascanio Visconti Sforza for Josquin des Prez. While we know several prominent *umanisti* who were refugees from law school or med school and defied their parents to study Cicero instead, as *studia humanitatis* success stories like Bruni and Poliziano gained fame, many middle-class parents sent their boys to the *studia humanitatis* just as they did to law school, medical school, or seminary, easy paths to steady jobs, like today's computer programming majors.

How profitable was humanism? We know patrons got a return in legitimacy for the cash they spent on *umanisti*, but what was an *umanista*'s income compared to other avenues open to those of similar backgrounds? University salaries have the advantage of being easy to compare. The astute Paul Grendler has great numbers on university salaries which (as today) varied enormously, by subject, the wealth of the institution, and the acclaim of the teacher.[27] The lowest were 40 to 80 florins per year ($40,000–$80,000), while 100–200 was average ($100,000–$200,000), with superstar professors in the big bucks fields of medicine and law earning salaries of 800 to 1,000 per year ($800,000–$1 million). And salary wasn't a professor's full income, since city universities paid professors a salary to be resident, bringing prestige and rich students to town, but, on top of salary, professors were also paid at the door by each student for each lecture (your grad student would stand by the entrance collecting coins in their graduate hood), so the larger your class the higher your pay (you can understand the hard cash reason rivals hated superstar Peter Abelard, whose high attendance numbers rerouted literal coins from colleagues' pockets). But salary still tells us how *valued* different subjects were.

Renaissance universities were still dominated by scholasticism, training students in logic, theology, medicine, and law. At first, the *studia humanitatis* thrived in newer smaller schools, mainly founded by *umanisti*. But when it became clear that *umanisti* could attract students (and cash), universities began to hire them, creating chairs in Greek and Latin style, rhetoric, moral philosophy, and sometimes in specific authors, like a chair in Seneca. This took off mainly after 1425, and the first few *umanisti* to teach at universities included Giovanni Aurispa

(fresh from Constantinople with exciting Greek!), and trescticular Francesco Filelfo, who earned ~66 florins a year (100 Bolognese lire, $66,000) teaching at the University of Bologna in 1427. In the later 1430s with a much bigger reputation, Filelfo earned 350 at the University of Siena ($350,000), but preferred the offer of 700 a year ($700,000) for tutoring the children of the Duke of Milan. Lorenzo Valla, as a novice professor in Pavia in 1431, received 50 a year ($50,000) while three more-established *umanisti* earned ~170 each ($170,000), and in wealthier Milan some university *umanisti* earned ~300 each ($300,000) almost law professor range, while Galileo teaching math in 1590 (a low-paid subject) earned 60 ($60,000). On such salaries, a scholar was expected to support, not just his family, but a household containing a variable number of servants (maid, valet, cook, stable keeper), at least one scribe or secretary, and, for more celebrated scholars, several students living and working in one's home as assistants.

Filelfo's massive salary in Milan, and King Alfonso the Magnanimous in Naples paying his *umanisti* 300 florin-sized gold ducats per year ($300,000), shows that work in a princely court paid much more than universities, but courtier pay was high in general. Francesco Filelfo's 700-a-year was what kings of France paid Leonardo da Vinci and Benvenuto Cellini, around the highest pay artists could make, but much less than a star law professor. Pope Leo X paid his choir singers and musicians 100/year ($100,000), while mid-level ambassadors like the Aragonese ambassador to Venice might earn 300 a year ($300,000) on top of whatever they had from their own noble estates, and a court dwarf might take home a thousand a year ($1 million) or more.[28]

Annual salary was only a small part of a courtier's income. One might earn as much or more in gifts of gold or jewels, given for a completed poem or painting, or an exceptional performance. By custom, a patron also bought each courtier a new set of clothes each year, whose cost could come to more than the salary (remember luxury fabric = luxury car). This let the patron communicate preferences, costly furs and velvets announcing at a glance who at court was most in favor this year, who slightly less

(no brocade, somebody's slipping!...), while a displeased patron could withhold new clothes entirely and sentence a courtier to months in last year's fashions.[29] Details of dress = status were very legible to urban populations in the period, so if you offended your patron you wore your humiliation, not on your sleeve, but *as* your sleeve. The next time you're looking at Renaissance art, pay attention to how often the Virgin Mary is sitting on very detailed drapes and curtains—a clothing historian can translate those painted details to $$, and it's pretty common for Mary to be sitting on a $300,000 cushion, or in front of a million-dollar ermine drape, a proof of the gifts the King of Kings gives to the universe's highest courtier. Housing was also included in patronage. A patron might house a courtier in the palace, or provide a villa nearby, a rent-free loan, or a permanent gift of property, and there might be additional gifts of a summer home outside the city, or farms yielding income. Patrons in the Church could also reward courtiers with benefices, Church offices usually without real work but with annual income, such as the rents from Church-owned land, making a courtier a deacon or honorary abbot of somewhere they never actually went, incentivizing many—like Raphael, Titian, and indeed Lorenzo's brother Giuliano—to live with long-time partners without marrying, to remain eligible for clerical appointments.

If one year a courtier got an ermine coat, a benefice, a villa, and a princely tip, that might come to many times his salary, while if the patron dynamic turned sour he might get his salary alone. And a courtier with the ear of the patron might earn more than all the rest in bribes and thank-you gifts, in return for recommending someone for a job, or getting a letter or petition into the right hand. Composer and long-time papal choir presence Johannes Puyllois (d. 1478) accumulated benefices which yielded an annual revenue of 400 a year ($400,000) on top of his ~80 a year salary, all in return for lubricating various petitions through papal approval.

So, what does it mean for humanists at the court of King Alfonso the Magnanimous to take home 300 a year plus housing, clothes, and tips? Let's count the florins again, this time comparing the cost of a scholar, not to the cost of a shirt or Piero's $12,000 dog bed, but to the salaries and incomes of other kinds of people:

	Florins	Dollars
Florentine day laborer's average annual income	35	$35,000
Florentine worker able to support a wife and kids	70	$70,000
Total at-home property owned by average Florentine master woodworker (his shop's contents and household goods)	200	200
Total value of all non-luxury goods in Palazzo Medici	15,000	$15 million
What the artist Mantegna paid for a nice new house, and had to pay in three installments	340	$340,000
Grammar teacher's salary at ordinary school	25+	$25,000
Average, un-famous *umanista* annual salary	45+	$45,000+
Filelfo's university salary early in his career	66	$66,000
Filelfo's university salary when more famous	350	$350,000
Francesco Filelfo's pay from the Duke of Milan	700	$700,000
Bartolomeo Scala's salary as Chancellor of Florence before his Medici patrons lost power	432	$432,000
Bartolomeo Scala's salary as Chancellor of Florence after his Medici patrons lost power	200	$200,000
What the French king paid Leonardo per year	700	$700,000
Annual salary of one of Pope Leo X's choir singers	100	$100,000
Annual salary of the Aragonese ambassador to Venice	300	$300,000
Annual salary of top profs. of law or medicine	900	$900,000
"Spending money" sent by Isabella d'Este to her son Ercole, when a student at the university of Bologna (aiming to be a cardinal); her letter indicates that she will send more soon[30]	90	$90,000
Isabella d'Este's shopping spree, including a fur muff, silver statuette, a portrait, a Bellini painting, and an antique bronze	280	$280,000
Isabella d'Este's annual allowance from which she paid her own expenses and (according to a letter) those of a hundred servants, including several ladies-in-waiting, and two gentlemen-in-waiting, who got higher salaries[31]	6,000 (60 per person at her court)	$6 million ($60,000 per person at her court)

Clearly, training as an *umanista* was a path to a career which could out-earn manual labor, and secure an upper-middle-class income, even if one lacked the starting capital to own a business. It occasionally meant great wealth, mainly if one was close to a prince, but it was not as sure an earner as law, medicine, or the Church. It was higher status than being an artist, since it didn't involve manual labor (writing didn't count), but the rewards were similar. By the mid-1400s when universities started hiring *umanisti*, it's a sure bet that plenty of youths were as bored in humanist classrooms as in scholastic ones, and classroom practices involved more rote regurgitation than the stimulating Socratic seminars we associate with the liberal arts—Socratic debates were held outside classrooms: in the Rucellai gardens where Machiavelli discussed Livy, in the Medici villas where Ficino, Poliziano, and Pico debated the nature of evil, in the Roman gardens where Pomponio Leto and his ill-fated students reenacted Roman rites, or at archaeological sites like Hadrian's villa in Tivoli, where Pietro Bembo, Raphael, and *umanista* friends used to picnic. Robert Black's work reminding us that classrooms were not idylls, nor so different from scholastic classrooms, is invaluable, yet, to jump to our own era, every modern high school Latin class is full of students whose parents pushed them there because Latin boosts SAT scores, and some of those students hate it while others fall in love with it.

This confirms how much Renaissance Latin study was much like a computer science degree today, a default option for students and families concerned to secure a good-paying job. That the *studia humanitatis* was a good career path reminds us to take ideological claims of humanism with a grain of salt. And we owe to historian Jerrold Seigel (one of Kristeller's allies arguing against Baron) the observation that *umanisti* were very willing to write puff pieces celebrating vicious tyrants and overt murderers so long as those murderers paid well—not the kind of hypocrisy we expect from a philosophical movement with a deep and aspirational ideological core.[32] Book-hunting Poggio happily worked for Cardinal Beaufort, and while the real Beaufort was not the scene-chewing villain Shakespeare makes of him, plenty of *umanisti* served tyrants whose deathbeds their

subjects would have imagined much as Shakespeare scripts Beaufort's end, with the audience gleefully looking for confirmation whether the soul is pointed up or down: "*King:* Lord Card'nal, if thou think'st on Heaven's bliss, / Hold up thy hand, make signal of thy hope./ He dies, and makes no sign: O god forgive him! / *Warwick:* So bad a death argues a monstrous life." (*Henry VI 2*, III.iii)

While Seigel is 100 percent right that some *umanisti* extolled the virtues of terrible people, we should also be wary of being too influenced by the (largely nineteenth-century) idea that money automatically contaminates philosophy and art. Contemporary ideas of *selling out*, and the romantic archetypes of the starving artist and hermit philosopher, contribute to the common modern expectation that an intellectual movement cannot be both profitable and sincere. We even have *umanisti* themselves saying they sometimes wrote word-portraits of their patrons that made them seem better than they actually were, not only because the populace would be inspired to virtue by hearing of a good leader, but in hopes that the patrons would read these descriptions of the great men they *could* be and want to live up to them. Words could sting and bite even while flattering by forcing patrons to compare themselves to their best possible selves. Such statements from *umanisti* could be excuses, or sincere hopes, or both.

A good historian always questions a source's motives, and *umanisti* had many reasons to make the *studia humanitatis* sound idealistic, but a good historian also remembers that Shakespeare making a living as a playwright didn't stop him from writing good plays. Our best course lies in the golden mean between believing all the lofty claims of *umanisti* and dismissing all of them. Humanism paid, but there were more reliable ways to make a living (art, music, priesthood, banking, medical school, mercenary service, scholasticism). Historian Kenneth Gouwens supplies a reading of humanism helpful here, seeing it as a learned and practiced set of behaviors adopted by intellectuals with many aims and taught by them to others; that those who chose to adopt such behaviors applied them to many ends including selfish ones does not negate the idealistic ones

being equally real.³³ And there can be no doubt that *umanisti* embarked on many projects which were far more radical than the kinds of undertakings that appealed to parents seeking good jobs for their sons. Especially in one place in particular...

50

It's Getting Weird in Florence

A hundred books name Florence as the epicenter of Renaissance humanism, and Petrarch, Bruni, Poggio, Filelfo for a time, Marsilio Ficino, Poliziano, Alessandra Scala, Salutati, Machiavelli, all are tied to Florence. Our bookshelves have a Florence bias, from the self-fulfilling source base, from romance, from those who went on the Grand Tour and fell in love. *I get it*, you say, *we need to look at Rome, Milan, Naples, the monarchies, Hungary, Spain.* That's not the problem this time. *What then?* We must never, not for a fleeting instant, make the mistake of thinking that what was going on in Florence was *normal*.

I promised I'd return to Marsilio Ficino's theory of the *secular revelation*. Ficino styled himself a *doctor of the soul*, as his father had been a doctor of the body, and he believed, perhaps more literally than anyone, that the libraries of the ancients truly held the secrets to healing Europe through improvement of the soul.[34] Ficino's lush Latin painted ancient philosophers and sibyls as part of Christianity as vividly as Michelangelo painted them in the Sistine. Seeing how much Christian theology matched classical Platonism, and latching onto the suggestions from Saint Augustine that Vergil was one of many "Gentile prophets" and from Saint Ambrose that Pythagoras might have had a Jewish father, Ficino believed (brace yourself) that a perfect, true primordial religion inherited from Adam, and refreshed as God spoke to the ancient prophets, was passed down via direct word of mouth through a string of teachers, from Moses to the legendary philosopher-mage Hermes Trismegistus, thence to Orpheus (of the Orphic mysteries), thence to the obscure Aglaophamus,

whom tenuous ancient sources say initiated Pythagoras into the Orphic mysteries, then through Pythagoras to his student Philolaus, to Plato, to Plotinus, to the Church Fathers. Platonism was thus a missing piece of the true ancient religion revealed by God to Adam and Eve and Moses, which could heal Europe by revealing the true path to soul-healing divine blessings, and repair the rifts with other faiths whose leaders would immediately recognize the truth of the new Platonic Christianity once it was made clear. Hence Ficino's *Platonic Theology* and commentaries on Plato, efforts to bring about world peace (Petrarch said the classics could do it!) through reconstructing what he believed had been antiquity's universal religion, which all humanity had followed until religions splintered, like languages after Babel.

This both was and was not the same experiment that Petrarch's generation had begun. Ficino still aimed to save the world through classical virtue, though not by getting ruling elites to imbibe the qualities that shaped Cicero, but by instead revealing an ancient, fractured world religion which would unite humanity. Followers of Ficino even wrote to the Ottoman Sultan explaining how sufficient application of Plato shows that Islam and Christianity are really one, genuinely expecting the sultan to instantly announce that it was time for the Muslim world to merge with Christian Europe. And in a world of one true religion, they imagined, no one would ever have cause for war again—hopes for a golden age on a truly Biblical scale.

Ficino also thought the works of Plato were an elaborate coded message. You know how, in the Allegory of the Cave, the prisoners are chained in place looking at the shadows cast by objects instead of at the real objects? Except the actual allegory is several steps more complicated than that: instead of shadows cast by *sunlight*, they are looking at shadows cast by firelight (what is the fire?) from the far side of a wall (why a wall?), and there are people moving the objects around (who are those dudes?) and then there's a tunnel to a *separate* place with *separate* objects and a *separate* light source that's the sun. Why all the extra levels when it would have made sense with just the sun, the objects, and the shadows?

Ficino, imitating late antique figures like Plotinus and Porphyry, who had in turn been influenced by what they saw

Jewish scholars do with Kabbalah, believed the extra elements in the Allegory of the Cave and other parts of Plato were a *super special magical secret code*, designed to allow only those with the greatest degrees of learning to understand Plato's most powerful insights, for example that there are not two layers of reality (material vs. immaterial) but *five layers of reality!*: God (the sun), eternal unchanging forms (the stuff casting the shadows), dynamic-but-eternal souls/gods/angels (the people), physical structures (the shadows), and structureless matter (darkness). Hesiod's genealogy of the gods must also be coded secret wisdom, so Ficino, Pico and their friends started spending their days trying to work out what secret message was coded in the statement that Apollo (light/inspiration) is descended via Zeus from Nyx (night/darkness?), whether this was about *Let There Be Light*, or a code to doing alchemy (gold/light out of lead/darkness?), or more likely a guide to theurgy, the good old ancient Mediterranean art of doing magic by projecting your soul out of your body to do things like cast love spells, perform miraculous healing, suspend your body agelessly outside of time, and spy on things.[35] (Remember when I ducked out to the water fountain at a conference and heard two scholars saying: "That's the Ficino room; it's *weird* in there.")

Ficino did not get all this from nowhere. Lots of very serious people did theurgy in antiquity, the Middle Ages too, and when Petrarch said to look at ancient books, that's part of what the next generations found. Remember too that our ancient sources for classical philosophers are pretty sketchy, that even Diogenes Laertius's *Lives of the Philosophers*, after giving us invaluable information about figures like Epicurus, tells us that Pythagoras could fly in a chariot of solar fire and shoot down enemies with philosophical laser beams created by reflecting the light of Heaven off of his perfected soul; why shouldn't Ficino and Pico expect to do the same?[36] There is no difference between a philosopher and a wizard in these sources, hence the guards in *Hamlet* fetching Horatio to help them deal with the ghost, with the directive, "You're a scholar, speak to it!" (I.i).

We see this too in the medieval popularity of what is either the best or worst board game ever invented, *rithmomachia*, "The

Philosophers' Game," an asymmetric chess-like game except that each side's pieces have a unique set of numbers on them (so one side has 2, 4, 6, 8, 36, 64, 153, 289, etc. while the other has 3, 5, 7, 9, 18, 49, 120, 361, etc.) and the goal is to get the combination of your numbers and your opponent's numbers into an arrangement so the ratios between the numbers and the distances between them harmonize with the proportions of the celestial spheres. (Once, when I brought a rithmomachia set to a party with sixteen gamer nerds, four of whom had advanced math degrees, while playing *cooperatively*, we managed, in about two hours, to reach *a win condition* of this ridiculous game.) The point of rithmomachia is that getting your soul in harmony with the secret numbers that govern the cosmos is healing and empowering, both emotionally and magically, so playing it was supposed to train monks and philosophers to get their souls into that state of self-mastery which ancient sources said resembled the eternal and ever-happy gods.

Thus, the young Ficino who sight-translated Plato at Cosimo's bedside grew up to teach his students how to get high chewing laurel leaves while playing the lyre and projecting their souls out of their bodies. Ficino also refused to write down his most powerful work (especially on the *Chaldean Oracles*) for fear that those whose souls were not prepared might accidentally summon demons (that's why Plato put his stuff in code!). Ficino became a priest in 1473 (priest = wizard too), while writing very seriously about believing in reincarnation (though, when the Inquisition came knocking, he told them it was just an allegory, and they went away). Ficino even wrote, in what is definitely the best job recommendation letter in the history of time, that a young scholar he was recommending for employment to Matthias Corvinus the Raven King was probably the reincarnation of Thomas Aquinas.[37] Meanwhile, in the next room, Giovanni Pico della Mirandola was writing a manual on how to turn your soul into an angel, and publishing 900 theses on how Islam, Judaism, Zoroastrianism and Christianity are the same if you just read enough Plato and Kabbalah. Many in their circle debated whether Ficino or Pico was the reincarnation of Plato since they couldn't *both be*. Pico also started advocating the (heretical) position of *apocatastasis* of

the ancient theologian Origen, the idea that even Hell was not eternal but remedial, and that all souls there would eventually be purified and brought into Heaven, either after additional reincarnations, or directly after enough character development (yes, just like in *Sandman*).

Meanwhile, elsewhere in Italy, *umanisti* are writing to each other: *Do you know what's going on in Florence? It's getting weird up there! I'm just trying to stage a Plautus play, describe good qualities of kingship, and finish this index of irregular participles, but His Majesty King Ferrante just called me to his study because he got a long Latin letter from Ficino saying the ghost of his late father King Alfonso scooped Ficino's soul out of his body, and lifted him up to the Heavens to deliver a lecture on how the soul is an immaterial sphere of infinite radius, which ghostly Alfonso commanded Ficino to translate for Ferrante out of the language of the angels.*[38]

It was getting *weird* in Florence. Not *everyone* was hanging out with Ficino, but a lot of those who weren't were hanging out with Savonarola, which is not *less* weird, and the ones on the outs with both may choose instead to hang out in the radical gardens where soon young Nick Machiavelli will be discoursing on Livy, and in time become a household word across Europe, but not in a *normal* way. I mention all this because we really, really need to remember that Florence was an outlier. We have so much material from Florence *because* it was an outlier, in everything: art, wealth, politics, law, literacy rate, sodomy rate, soul projection rate, you name an attribute a Renaissance city could have and Florence is at an extreme end. Yes, all these things happened elsewhere too, but we must be careful basing any impression of the defining *spirit of the age* on such an outlier.

Faith reassures Lorenzo that there is no conflict between Platonism and Christianity, from the same fresco cycle which showed him welcoming the refugee Muses (Palazzo Pitti, 1635).

On the adjoining wall, Lorenzo hosts Muses, Virtues, and scholars at his villa; Ficino is prominent to the left of the imaginary statue of Plato; Pico and Poliziano appear on the far right.

51

Scraps of Philosophia

The term for what Ficino and Pico were doing is *syncretism*, the effort to attain a more complete or true religion by combining many. It may seem a strange ingredient in Christianity, with its history of persecutions and heresy trials, but it was a not uncommon impulse in the European tradition, shaped especially by three things: (A) Renaissance people being totally wrong about dates, (B) the childhood wildness of Saint Augustine, and (C) the image of the tattered gown of Lady Philosophy.

The Lady first: our counts of surviving manuscripts reveal that one book remained the most widely read in Europe consistently for the full millennium from late antiquity to the Renaissance. It was not the Bible (only priests could read that) nor can we count prayer books or Books of Hours as one book, since there were patterns to them, but enormous variations. The single introductory text read and reproduced most in medieval Europe was Boethius's *Consolation of Philosophy*, a philosophical dialog written in the last days before the great scholar-statesman's execution in 524 CE.

Boethius (*c*.477–524) came from a Roman senatorial family, but was born just *after* the last Roman Emperor was deposed, so Boethius was a senator, consul, and bureaucrat under the Ostrogothic King Theodoric, whom he served until he was accused of conspiring with the Byzantine Emperor in a dispute which was the hairline crack that, much later, would lead to the East-West Christian schism. Boethius's works on mathematics, music, and the soul were also the inspiration for that strangest of board games, rithmomachia.

Few people shaped European thought as much as Boethius. He lived in the moment that knowledge of classical literature

(especially Greek) was fading in the West, the old papyri literally crumbling, and between his political tasks he devoted himself to scholarship, and to translating into Latin what he considered the most valuable parts of Greek thought, including Aristotle's logical method, creating the *Organon*. He also wrote Christian theological works, including refutations of the Nestorian heresy, and works on what the Father and Son are made of. Early Christianity involved many fierce disputes over fussy-sounding questions like whether the Father, Son, and Holy Spirit are made of the *same* substance, *similar* substances, or *different* substances, and whether or not Christ was wholly divine and wholly human (i.e. material) at the same time. These questions sound less fussy, and the concern over them more reasonable, when we remember they are *physics* questions, efforts to figure out what substances the universe, souls, and matter are made of, and how they connect together, the Hard Problem as modern researchers call it, a question for which Christ and the Holy Spirit were considered major data points, much like magnets, lenses, seizures, and optical illusions. Boethius weighed in on these questions as a theologian, a scientist, and a logician in an era when the three were inextricable.

The *Consolation of Philosophy* is different from Boethius's other works, a deeply personal dialog in which Lady Philosophy descends into the prison to help the philosopher prepare to face his coming death. It has a special poignancy, amid so many philosophical thought experiments about the Sword of Damocles, since Boethius *really did* write it in prison while under a death sentence, after which he *really was tortured to death*. Much of the early section focuses on getting his mind off of earthly concerns (grudges, fears, grievances) and focusing on eternal things (the soul, Truth, cosmic Beauty) which no executioner can take away. It then turns to the troubling problem of Providence, and Boethius's struggle (*everybody's* struggle) understanding how free will can exist if the universe has a cosmic Plan. Lady Philosophy leads Boethius via Socratic dialog to understand that Providence is planned from *outside of time*, but that the beings who are part of it still make their choices *within* time (think of the author of a novel, whose characters make choices on the page, doing what is in-character for them to do). This solution is not completely

satisfying, and will be debated for the thousand-plus years of the text's ubiquity, but it is notable that Boethius's solution *does not involve the Trinity, Christ, Scripture, or anything explicitly Christian.*

One of the most striking things about the *Consolation of Philosophy* is that, in contrast with Boethius's writings on the Trinity, the *Consolation* is both extremely religious and extremely vague. He speaks of a Creator, Providence, Fate, freewill, divine or angelic beings of which Lady Philosophia (very angel-like but very Athene-like as well) is one, but everything he mentions is equally present in early Christianity and in the hybrid Stoic-Platonic-Aristotelian philosophical-religious system which was early Christianity's main rival. If you give the *Consolation* to a college class and tell them, "This is early Christian theology," they believe you, but if you tell the class next door, "This is Platonic pagan mysticism," they believe you. In this extreme moment of Boethius's life, the difference between Christians and non-Christians fades into the broad strokes of a providential but unspecific philosophical religion, compatible with *both* the Church Fathers *and* the pagan authors who shared shelves in Renaissance libraries.

And there is Boethius's description of Lady Philosophy herself. She is queenly, commanding, supernatural, and wears a long gown with its skirt tattered and missing many pieces. Over the years, she explains, many have tried to grasp her, and many philosophers or sects have torn a piece from her gown and carried it off, clutching it dearly and believing that they possess the whole of her, not realizing it's just a tiny scrap.

It's a powerful image, but notice what it means: all those philosophers and sects, the different wisdom-seekers of the world, *do* have a piece of truth. They *are* a little right. The Stoics, Skeptics, Platonists, Aristotelians, Zoroastrians, Chaldean cults, they all had scraps of truth. Doesn't it sound like it would be a good idea to stitch that tattered fabric back together? Especially when the ideas Philosophia voices are so compatible with those of pagans *and* Christians, and indeed with other neighbors too?

Much of the compatibility of Boethius's ideas with both pagan and Christian thought comes from the fact that Saint Augustine was a very, very, very, very, very, very, very troublesome

child, and his mother Monica was a very, very, very, very, very, very, very patient mom. (Monica is, in fact, the patron saint of patience, a fact I successfully guessed *before looking it up*, just from knowing about her kid.)

Little Augustine, who lived a bit over a century before Boethius, was a really smart kid—the kind of smart kid who asks grownups lots of questions, and loses patience when they don't have answers. Monica was a poorly educated, deeply pious recent convert to Christianity, whose practices she struggled to adapt to, often falling into old habits, such as turning up at the church wanting to sacrifice a chicken, worried that gods are usually angry if they don't get sacrifices, and needing to be told repeatedly by the priest that Christ did the sacrifice, no more sacrifices are needed, that's the point. But it's hard transitioning from one set of religious habits to another.

Little Augustine mocked this, asking Monica and others the kinds of poking questions that smart kids will: Can God make a rock He can't lift? What do people in Heaven stand on if it's in the sky? What's God made of? What is the soul made of? How is it connected to the body? Does it have parts? If God is good, why did He make mosquitoes? If penises are bad, why did God make penises? Augustine's autobiography doesn't record his specific childhood questions, but we're all familiar with them, and a lot were the Hard Problem: consciousness, the soul, what it is, how it works. Monica did not have satisfying answers. Neither did the local priest, because this was *early* Christianity before it had doctrines or councils or decisions on these things, they mostly just had the Bible, and you may have noticed the Bible doesn't say what souls are made of or if they have parts.

Young Augustine decided that Christianity was a stupid religion for stupid people like his stupid mom, and meanwhile his dad was paying for an expensive education so he could be a lawyer or an orator, so he hung out with lots of smart types in the cool parts of downtown, who were into sex and drugs, and another hip new trend the up-and-coming smart people were into. Is it fruitarianism? Is it pyramid schemes? Is it *Star Wars*? All of the above! It's Manichaeism! Good old Manichaeism, the belief that the cosmos is ruled, not by one Maker, but by two great forces in constant

conflict, a Good/Light force and an Evil/Bad force (so, *Star Wars*), and *you too can be part of this epic battle if you give the leaders of this movement lots of money!* Manichaeism was a mystery cult, like Mithraism or the Orphic Mysteries, with exclusive membership, tantalizing recruitment, dazzling rituals, months or years of initiation before you learned their real beliefs, and constant demands for cash. Adherents could help the light force defeat the dark by finding *seeds of light* trapped in base matter and liberating them, and many seeds were trapped in expensive foods like delicious fruits and desserts, and could be liberated by buying those foods for the cult leaders whose spiritually trained digestive systems were capable of liberating seeds of yummy yummy light. And throughout his Manichaean period, Augustine was also having lots of fun, wine, and sex, and constantly dissing and ditching his still supportive mother, wandering off without leaving her any way to trace him in the vast, pre-cellphone Roman world. (They lived in North Africa, and one time he ditched her *on a trip to Italy*, and buggered off to *the other side of the Mediterranean* without a word!)

In time, Augustine realized the scam was a scam, and moved on to the more intellectually satisfying and less pyramid-schemey pastures of Platonism, or rather late antique Platonism, which *they* called Platonism but we call Neoplatonism, because if you'd shown it to Plato he would've been very puzzled and blamed Aristotle. By Augustine's day, Platonism had done that thing where they thought the Allegory of the Cave was an elaborate coded message, and in the decoding process they incorporated a lot of elements from *other* classical philosophies, creating what was actually a hybrid of Platonism, Stoicism, and Aristotelianism, mixing Platonic soul theory and epistemology with Stoic ethics and providentialism, and Aristotelian terminological rigor. Augustine studied this, and it had very satisfying answers to what the soul is made of, how many parts it has, how Heaven exists relative to Earth, and why it's absurd to ask if the Demiurge lifts rocks. After mastering it all—and other experiences, such as his encounter with Ambrose of Milan (*c.*339–397 CE), the first Christian figure Augustine met who was skilled enough in both philosophy and oratory for our smart-kid-now-grown-up to find

him seriously persuasive—Augustine then reread the Bible and went, *Holy shit! This religion isn't stupid, it makes perfect sense, it just needs coherent metaphysics!* He then sat down and wrote so many books explicating Christianity that they outnumber the entire surviving corpus of classical Latin. Using Neoplatonic-Stoic-Aristotelian-hybrid metaphysics (and a dash of Kabbalistic practice), he created the first Christian answers to many questions the Bible doesn't answer, and everyone embraced him as the prince of theologians, who rescued Christianity from the annoying questions of smart kids like he had been. Augustine's work was Christian canon when Boethius was educated, so it makes perfect sense that, when Boethius read Christian authorities, and also Plato, Aristotle, and Stoics, they felt to him like scraps of one coherent whole.

Europe then kept rereading Augustine and Boethius for centuries, during which every young scholar met that image of Lady Philosophy, and contemplated the message of her tattered gown. By the time we got to late medieval scholasticism, most of the original Platonic, Stoic, and Aristotelian sources that influenced Augustine and Boethius were missing, so the Neoplatonic content in Augustine seemed, to figures like Abelard and Aquinas, to originate with Augustine and thus to be 100 percent Christian. Thus Thomas Aquinas absorbed tons of Neoplatonic details, including his Christianized version of those five layers of reality deduced from the Allegory of the Cave (Good = God; eternal beings = angels; dynamic beings = human souls; structured matter = beasts; raw matter = devils) without Aquinas and his century realizing it came in part from Plato.

This is where chronology kicks Europe in the gut. Remember that time Peter Abelard ticked off his abbot by proving their abbey's founding saint didn't exist? That was Saint Denys, i.e. Pseudo-Dionysius the Areopagyte, a book more than a person, since the author was imagined backward from the book. The book is a work of late antique mystical theology written in Greek around the fifth or sixth century CE (later than Augustine, contemporary with Boethius) and full of the period's typical Neoplatonic/Christian hybrid stuff about the soul and abstract Maker. But the work was mistakenly attributed to Dionysius

the Athenian lawyer described in the Acts of the Apostles, who was converted to Christianity by Saint Paul and became the first Bishop of Athens, so the book *seemed* 500 years older than it really was. When in 827 the Byzantine Emperor gave a copy of this book to the Carolingian co-Emperor Louis the Pious, Louis gave it to the illustrious Parisian monastery of Saint Denys, which eagerly decided it was the work of their legendary founder (and were *not* happy 300 years later when Abelard showed this wasn't true). The monks of Saint Denys sent copies of the book all over, and it was considered by figures like Thomas Aquinas to be *the direct writings of a personal apprentice of Saint Paul*, i.e. perhaps the oldest and most authoritative of all Christian texts after the Bible.

Fast forward to Petrarch urging everyone to hunt down lost books, with Pseudo-Dionysius's 500 CE Neoplatonism still thought to be from 100 CE, *before* Augustine, and this totally scrambled Europe's chronology of how the cross-pollination between Christianity and Platonism worked. We think Christianity got a big dose of Platonism in 400 CE with Augustine, and another with Boethius a century later, but Renaissance people thought that *earlier* Christianity, exemplified by Pseudo-Dionysius, was *more* Platonic than Augustine, concluding that Christian and ancient Greek theology had become *less* similar over time, splitting from one archaic whole instead of merging two things into one. Factor in other errors from works like the fake medieval letters between Seneca and Saint Paul that were hot reading in the Renaissance (more popular than *real* Seneca[39]), and everyone forever reading Boethius's I-Can't-Believe-It's-Not-Plato™ *Consolation of Philosophy*, and you can understand why sweet Ficino thought there was an ancient theology known to the Hebrew prophets and Pythagoras, but that over time it got divided up and garbled, split into incomplete pieces as different sects each clung to their own scraps of Lady Philosophy's gown.

Platonic sense theory (epistemology) strengthened this belief, with its concept of Universal Forms. Plato says that the imperfect things we experience in daily life (shadows) derive from perfect Eternal Forms (stuff casting shadows), which wise people perceive with the mind's eye. We all glimpse different shadows cast by the same distant ideal Tree, the same distant ideal Circle, the

same distant ideal Justice. As every circle we draw attempts to approach a perfect circle, so every tree that grows tries to actualize as many potentials of a tree as possible (thanks for the technical vocabulary, Aristotle!) without any specific tree ever achieving 100 percent of what a tree *could* be. Just so, every justice system we create aims at but falls short of perfect Justice. And, just as all mathematicians, when striving to describe a perfect circle, are describing the same object, so all lovers of wisdom (philo-sophers) are striving to describe the *same* philosophical truths.

In this theory, many philosophers attempting to describe ideal Justice or ideal Virtue are like many artists sitting around the same set of objects, sketching many different, imperfect versions of the same still life, or like many people who watched the same movie producing different, imperfect summaries. The philosopher kings who take turns ruling Plato's hypothetical republic are expected to agree 100 percent, because their souls are trying to craft laws that are sketches of the same perfect justice, and slight disagreements will be corrected as easily as two people discussing a movie correct each other's imperfect memories of it. If this is how you think cognition works—which not just Ficino but most Renaissance people did—then all wise people *in all cultures throughout history* were imperfectly describing the same dimly glimpsed universal truths, sketching different portraits of the same model.

This means that comparing different philosophies *including non-Christian ones* is valuable, because the points on which they agree will be the truest points, as when many versions of a still life show the same pattern on a vase, or the same odd double cherry in a bowl, you know that detail must be real if it's repeated. Available primary sources seemed to support this: as *umanisti* read Plotinus and Porphyry for the first time in centuries, they recognized ideas shockingly similar to Thomas Aquinas. How did Aquinas agree so much with *texts his century did not have access to?* Clearly these separate philosophers were approaching the same divinely inspired truth! (We now say Aquinas got it from intermediate sources, which the *umanisti* either did not have, or did not read because they were in yucky, ugly medieval Latin.)

Returning to the image of assembling the scraps of Lady Philosophy's torn gown, we see why Ficino was so excited seeing

bits of pseudo-Dionysius that resembled both Pythagoras and Augustine. We see why Pico went farther, seeking truths in Zoroastrian, Jewish, and Muslim authors, since where the scraps connected up, where the portraits or movie summaries aligned, there lay glimpses of perfect Justice, perfect Virtue, and perfect Order. Once these were identified, humans and our governments could strive to reproduce them as perfectly as possible in this imperfect world, as architects raise domes with circles not-quite-perfect, yet perfect enough to stand a thousand years. The *Pax Romana* had been such an almost perfect circle, and the new age of peace that Petrarch had prayed for seemed within reach through the ancient sources whose geometry taught Florence how to raise a dome to match Rome's Pantheon, and could as plausibly teach them how to match Rome's peace.

What about the moments when ancient sources contradicted each other? Or said things incompatible with Christianity? Well, every artist sketching was imperfect, so there were bound to be a few stray lines that were plain wrong, but these were few, and most could be resolved through an art Ficino and Pico learned by reading scholastics as well as ancients: *just Abelard harder!* Scholasticism was a master class in how to make two contradictory authorities agree. Aquinas managed to squeeze the square peg of Revelations into the round hole of Aristotle; you can totally add the Koran and Epicurus and the Orphic Mysteries, if you just Abelard hard enough!

So Pico sat down to Abelard as no one had Abelarded before, learning Hebrew and Arabic. And, at his side, Ficino sat down to write a giant treatise on how to heal Christianity using Plato. And Poliziano sat down to… advance linguistic criticism and develop methods of distinguishing different eras of Latin style in a way which had zilch to do with syncretism. Because *even in Florence where things were weird*, the *umanisti* still cared deeply about grammar and style, and while Poliziano loved hearing Pico ramble about angels, he also had that multi-year feud with Alessandra Scala's dad about the Latin word for mosquito. No matter how weird it got in Florence, the new educational movement (hello, Kristeller) and its obsession with Latin style remained.

One can call this obsession with style *form over substance*, but it was not quite that: *form was substance*. In period (Platonic) epistemology, beauty was a tool God made to draw the soul toward noble things, so a beautiful face or body, beautiful light, the glint of gold like the sun, the star-like purity of gems, these all existed to draw the soul to think about celestial things and turn upward, away from earthly matter. Beauty of language, poetry, these were teaching tools, the greatest writers divinely inspired by the Muses/Apollo/angels/God. To ornament truth with gorgeous language was to add gold and diamonds to a reliquary, or to ornament the body of a virtuous woman like sumptuary-law-protesting Nicolosa Castellani Sanuti, who preferred to advance the golden age by being seen embodying virtue instead of publishing about it. For *umanisti*, focusing on beauty was normal, using the classics was normal, expecting Plato to be compatible with Christianity was normal—but the ambition to convert all Europe to a massive synthesis of all religions which would reconstruct the ur-faith handed down from Adam, that was several steps beyond those rote-memorization classrooms Robert Black has reconstructed for us so vividly. *Was radical syncretism happening?* Yes. *Was it normal?* No. *Was it humanism?* That depends on who you ask.

"Ficino wasn't a humanist," a friend once challenged at a debate on humanism.

"Then what was he?"

"A guru."

With his laurel leaves and lyre he was definitely that, but is being a guru a disqualifier for being a humanist? It is, but only if—here's the rub—we still expect humanism to involve *secularization*.

52

Was There Renaissance Secular Humanism?

You have made the mistake of asking a scholar about her dissertation topic. Don't worry—it's the best kind of mistake.
Were there atheists in the Renaissance?
In Machiavelli's day? Yes, definitely, absolutely, 100 percent, no doubt, we found them, we have proof.
Great! How many?
Two.
Two is not very many.
Well, there were likely more than two, probably lots more, but when you ask for 100 percent certain proof that's actually very difficult.[40]
Is one of the two Machiavelli?
No, actually. For him we don't have proof. Machiavelli was definitely a radical who mocked the established Church, but we can't *prove* atheism, and the fact that it's so hard to prove is worth zooming in on. Of the two where I *do* have proof, one is Raphael Franchi, who in 1504 published a set of simplified Latin paraphrases of Lucretius, and whose friend Giovambattista Pelotti joked, after Franchi's death, that he was sure to be welcomed to Hell by Epicurus and Lucretius, which would surprise him a lot because he didn't believe in it.[41] The other is an illiterate workman in Venice named Guido Donà, identified by the invaluable Inquisition archive-diver Nicholas Davidson.[42] Donà was in his seventies when, in 1512, the Venetian Inquisition put him on trial for denying the afterlife and that God created the universe. Now, if we were to jump forward three generations to the 1570s, I could name a dozen more, but for the generations we've

focused on—those of Ficino, Poliziano, Lorenzo, Machiavelli, and Michelangelo—I only have the two. Genuine atheists are very hard to pin down in the Renaissance, and not for the reasons you may expect.

Isn't it because they were all hiding from the Inquisition?

Yes and no, as Peter Abelard would say—*yes* people feared persecution and were careful voicing radical beliefs, but also *no* it's only partly that. The other part is that, in the period, strict atheism is very hard for us to differentiate from other radical beliefs.

By *strict atheism* I mean what most moderns would mean, i.e. (1) denial of the existence of any divinity, and usually (2) denial of the immortality of the soul. But when we look at Inquisition trials where the charge is listed as *atheism*, the details of the charges include a huge range of things which had nothing to do with modern atheism: denying the real presence of Christ's body in the communion wafer (transubstantiation), denying the existence of witchcraft and devils, believing that miracles are natural phenomena planned by God rather than a suspension of the laws of Nature, believing that life originates from meat or soil through a process like fermentation or the way worms appeared in cheese,[43] believing that only good people have immortal souls while bad people's souls dissolve at death, believing Aristotle's logical proof that the world is eternal, believing the pope is the leader of the Church, *not* believing the pope is the leader of the Church, having too much sex, having gay sex, eating pork on a Friday, writing satiric poetry, living (this from a sixteenth-century trial of some corrupt friars in Verona) "as sons of iniquity, as Epicureans and Lutherans," and, my personal favorite atheism accusation, running around outside with no pants on and saying you care not a fig what God in Heaven thinks of it.[44] Plenty of atheists would deny miracles, transubstantiation, or devils, but so would Deists, Lutherans, nice Catholic followers of Descartes who argued that there is no force at a distance and therefore no witchcraft, and all sorts of other people (drunk streakers among them), many of whom still believe in some sort of divinity and/or immortal soul. *Atheism* in the period was a catch-all term for beliefs that strayed from tradition, and even for actions that challenged it.

Lists of "famous atheists" from the 1600s and 1700s—a kind of sensational literature like our books about serial killers—included

not only figures like Epicurus, Lucretius, Machiavelli, and Galileo, but also Martin Luther, John Calvin, Mohammed, Erasmus, Peter Abelard (yes our Abelard, who worked so hard reconciling saints but also *had sex with Heloise!*), a variety of other famous radical theologians, also Aristotle, Ovid, Thales, and people like Pope Alexander VI and the Roman Emperor Caligula, who are on there for generic wickedness, on the assumption that they must not have feared God or they wouldn't have been so bad (setting aside the fact that Caligula *believed himself to be a god*, which is a bit outside most modern people's definition of atheism). This same logic, that sinful living proves atheism, surfaces in a moment documented in 1471 when Princess Ippolita Maria Visconti Sforza asked a priest in Naples to pray for the soul of her murdered brother Galeazzo Maria, and the priest was shocked at being asked to pray for a man "who fears God as much as that wall does."[45] In perhaps the most splendid example, John Milton in *Paradise Lost* calls Lucifer and the rebel angels "that atheist crew" even though they're angels, so what the **bleep** does *atheist* mean if Lucifer can be one when he was talking to God on the previous page!

The answer is that atheism in the period often meant *turning your back on God*, as Lucifer did. This drew on a logic chain which would not pass the rigorous standards of the *Organon*: (1) Fear of Hell drives men to good behavior. (2) These men do bad things. (3) These men do not fear Hell. (4) These men must not believe in God. A huge portion of atheism accusations in the period were leveled against what scholars now call *practical atheism*, i.e. people who lived scandalous or libertine lives, having lots of sex or behaving wildly, so that, in the eyes of their peers, they *acted as if there were no God*. Sixteenth- and seventeenth-century discussions of atheism say this is the most common kind, and that such people deep down inside do believe in God but *wish there were no God*. The brilliant historian of anti-atheism Kenneth Sheppard quotes a hilarious mid-1600s pamphlet lamenting that "millions of atheists" are flooding the streets of London (whose population at the time was not more than 400,000), a phenomenon the pamphlet blamed on dancing, cafés, theater, drinks stronger than beer, and all the traditional things that corrupt kids these days.[46]

Another form of atheism believed in at the time might be termed *foolish atheism*, which in modernity we would understand as mental illness or intellectual disability: drawing on the Bible verse "the fool said in his heart 'there is no God'," people thought that simply observing the patterns in Nature made the existence of an Intelligent Designer obvious (forest animals have forest camouflage), but that intellectual disability could result in a specific individual failing to have the capacity to reach that conclusion.

A third form of atheist described at the time we might term *malicious atheists*: wicked men who advanced arguments that undermined the faith intentionally, out of malice or diabolical inspiration, which is how *atheist* was applied to Luther denying transubstantiation, or experimental scientists denying witchcraft, since denying transubstantiation might weaken people's confidence in sacraments and thus in God's presence, and teaching there is no witchcraft might make people doubt the existence of devils, then doubting angels, then doubting God.

Finally, and very, very rarely in the period, one finds the occasional suggestion that, uncommon among the hordes of practical atheists or foolish atheists, there were some bookish unfortunates who read so many arcane tomes that their understandings became muddled, or, more likely, like Doctor Faustus they came upon too many earthly and diabolical temptations, and became lost in their own magical/scientific/arcane powers, turning the soul away from God. In fact, in Marlowe's *Doctor Faustus* it is directly books that lure him into his demonic contract: "Divinity, adieu! / These metaphysics of magicians, / And necromantic books are heavenly; / Lines, circles, scenes, letters, and characters; / Ay, these are those that Faustus most desires." (I.i) as Mephistopheles offers him more books, while his Good Angel urges, "O, Faustus, lay that damned book aside, / And gaze not on it, lest it tempt thy soul / And heap God's heavy wrath upon thy head!" But, alas, Faustus's soul is so turned downward by his love of books he cannot pray. This supposedly rarest category, atheism caused by having too many books, is the only type a modern person would call a true atheist.

In a period whose perplexing definitions make both Martin

Luther and the vast majority of modern Christians qualify as atheists, we can't use the word *atheist* in any text as an indicator of atheism in our sense. And note that all my examples in the preceding paragraphs are from the 1600s and 1700s, a few from the very late 1500s—in the 1400s through the early 1500s (the days of Bruni through Michelangelo) we have far fewer uses of the word at all. What changed? Mainly, one Martin Luther nailed ninety-five theses to a door in 1517, so by the 1560s Europe was a giant mess of competing Christianities, all paranoid about being invaded by their rivals. Suddenly many doctrinal positions were characterized as "atheism" by their opponents. Catholics called Lutheran or Calvinist positions atheism, because they undermined particular doctrines, while Protestants and Anglicans frequently characterized support for the papacy as atheism, arguing that supporting such a corrupt version of Christianity undermined its credibility.

Thus, from 1550 on, a firestorm of accusations of atheism awaited anyone who offered a powerful alternate answer to some question whose traditional answer *depended on* God. This firestorm fell *even if* the author in question never denied divinity or the soul, which, generally, they didn't. Luther saying we didn't need anointed priests—atheism. Lucretius saying the cosmos could have formed through the physical principles of atoms—atheism. Deists saying Reason alone is enough to teach people ethics without Revelation—atheism. In the 1600s, Thomas Hobbes sparked one such firestorm when his *Leviathan* suggested that pre-civilized humanity, living in a war of all against all, might through Reason and self-interest come together and develop society. Until Hobbes, Europe had no explanation for how government came to be other than that God instituted it, and no explanation for what glue should hold men together other than fear of divine punishment. Hobbes does not say *There is no God*, but he says, *Government arose without God's participation*, denying the divine creation of law—the *Drunkenness of Noah* panel on the Sistine Chapel ceiling, which Battle Pope-era Christianity considered as essential to Creation as *Let there be light*, or the expulsion from Eden. Hobbes's was a political theory an atheist might use, giving atheism an answer, and thereby so terrifying England that the

government strengthened its censorship specifically to target "Leviathan the Great," as Hobbes was called by a broadside of 1679 celebrating his death, "Leviathan the Great is faln! But see / The small Beemoths of his Progenie, / Survive to duel all Divinitie / Here lies Tom Hobbes, the Bug-bear of the Nation / Whose death has frighted Atheism out of fashion,"[47]—this for the same Hobbes who devoted an entire book of *Leviathan* to defending the Church of England against Catholicism.

And amid all this muddle, yes, atheism and related beliefs were illegal in many places, and you could get put on trial for them, censored, fined, imprisoned, executed, so there were pressures to keep silent.

How, in such a mess of paranoia and silence, do we hunt for real-by-the-modern-definition atheists? This was my question when, as an eager PhD student, I packed off to the archives looking for atheists, following the model of my beloved undergraduate mentor Alan C. Kors.[48]

I found (and still find) pre-modern atheism fascinating, and I treasure every hint I find. Pre-modern atheism is very different from modern atheism. Why? Because it didn't have science on its side. Modern atheism has a perfectly coherent system, with good explanations for basically everything, so a modern atheist can put the burden of proof on theism to establish the existence of a divinity. Not so before modernity.

Medieval and Renaissance Europe had perfectly respectable answers to most scientific and social questions, they just all depended on God. Take gravity, for example. Celestial bodies are moved by angels. As for why some earthly objects fall and others rise, morally inferior objects fall down toward Satan (in Hell, at Earth's core) and morally superior ones rise up toward God in Heaven, sorting themselves out into natural layers like oil and water. Stones sink in water because water is superior to earth, hot air rises because fire is superior to air, and virtuous men go to Heaven because good souls are light and wicked souls are heavy with sins which make them fall to the circle of Hell corresponding to the weight of their sins, nine circles separated out in layers like a blood sample put through a centrifuge. God also established the first societies, handed down the first laws, created the first

languages, enabled the mind-body interface (thanks Aquinas), and caused the rise and fall of empires, all to communicate His Will. If one wanted to be an atheist in the Middle Ages one had to throw away 90 percent of all science and social theory, and when asked "Why do rocks sink?" or "How do planets move?" or "Where did the world come from?" or "How does the mind connect to the body?" one had to answer, "I have no idea."

Turning one's back on answers is very difficult, and is part of why the study of atheism is so closely tied to the study of philosophical skepticism, i.e. philosophies which say we *cannot* understand the fundamentals of existence. Only very recently have atheists had the leisure of both denying God and still having a clear, technical model of the universe. Early atheists had to accept life without answers. In that sense, atheism in the 1400s or 1500s was in the position of Creationism today; it required saying you believed one thing *so much* that you were willing to turn your back on the understandings of the world shared by almost everyone, even though you *didn't* have a coherent alternative. There is a fragile courage to pre-modern atheism, when we read someone like Diderot (1713–84), who was among the first atheists who wrote directly about his atheism, as well as my first historical love, my first-contact pre-modern atheist who made me want to give years of my life to learning more about people like him.[49] Diderot feels that the burden of proof is on him, and freely admits that he can't meet it, that without Intelligent Design he doesn't have a good explanation for how stars started to move, and how forest animals have forest camouflage, he just looks around and the world he sees, with its random encounters and entangled lives, doesn't feel like it's scripted by any Providence or Maker. Diderot's atheism is not the self-confident atheism of a modern armed with scientific answers, but a timid, tender atheism sprouting like a crocus through the snow, with little more than instinct to back up its radical position. Embracing such an atheism was very hard. Collecting ideas which could fill in the gaps left by removing God from science—theories which could explain how stars moved, or how animals fit their environments—could make it easier.

Naturalist theories, models of Nature as self-governing rather

than divinely governed, had existed since antiquity, things like the atomism of Democritus and Epicurus which said that substances were chance conglomerations whose properties arose from tiny invisible atoms. But such models were not *systems*, not yet. The ancient atomists could not supply diagrams of the cosmos, or rules of physical properties which explained multiple phenomena, they only offered guesses: *Maybe lightning is the clouds rubbing together making static electricity?* with no proposed physical laws to connect the theory about lightning with the theories about erosion or evaporation. They had nothing detailed enough to let you make calculations or test theories as Newton would, nor any systematic biological principles to explain patterns in Nature as Darwin would.

Lucretius's *De rerum natura*, our most complete classical source on atomism, posits that, in the beginning, there were atoms randomly bouncing around in the void, but offers no explanation of where they came from, how they gained motion, or the source of the famous *swerve* which Lucretius says makes their motion chaotic and keeps the universe from being deterministic pool balls on a table. Lucretius also relates that Epicurus thought many atoms have little hooks on them which is what made them clump together into worlds, that there are many worlds like ours, and that the animals we see are all suited to their environments because only animals suited to their environments survived, but he also says that no new species come into existence anymore because Earth has undergone menopause and no longer grows giant placentas out of the ground, which is where new species used to come from (so close and yet so far…). Classical atomism had lots of suggestions but no *system*, nothing like how Newton's laws would make many things click together. When discussing questions like why the lengths of day and night vary, Lucretius doesn't say "It's X," instead he gives three to five different explanations, "It could be X, or Y, or Z, or something else!" This is enough to convince you that it *might* be atoms instead of a god/angel, but the divine solutions were the only ones that had been expanded enough to have charts and rules, and form a coherent whole. Atomism was not fully satisfying, not yet. But it was *partly* satisfying, so…

So we can use it as bait!

This was my dissertation plan. My precious pre-modern atheists were hiding, camouflaged, but, like dear Diderot, they craved a science that could explain the order they observed in the world without a divine plan. Thus, they should crowd around Lucretius's atomism like deer drawn out of cover by a salt lick. If I looked at the people who owned, read, edited, discussed, quoted, or printed Lucretius, if I hunted through the notes in the margins of their copies, I would see how Renaissance atheists—the predecessors of my dear Diderot—were engaging with a science which, while unsystematic, offered them the best tools available at the time for understanding the world without divinity.

I got this bait approach, tracking a text an atheist might like, from reading historians I admired—Alan C. Kors, Nicholas Davidson, Michael Hunter, David Wootton—who wrote eloquently about how most of our histories of atheism are really, really bad. No historical question is truly neutral, but the study of atheism (and its cousins skepticism, deism, radical heterodoxy, and freethought) is particularly charged because it is so impossible to be detached. The existence or not of a divinity—the stakes are high, and personal for all of us, which makes it hard for historians to discuss it calmly. Serious attempts to write histories of atheism, rather than just thrillers about Caligula and murderous Machiavels, began in the later nineteenth century, but didn't try to hide their biases, offering totally contradictory analyses of the same process: some gave grim accounts of how the evils of the modern era were caused by secularization, others triumphant accounts of how its great achievements were caused by secularization, others hybrid accounts in which secularization was evil and bad but caused by the corruption of [either Catholicism or Protestantism] and happily being battled by [the other]. Twentieth-century histories try to be more objective, and I'd say we are 90 percent more objective than our 1800s predecessors, but even in our century one tends to find very strong claims, either, *All the most important Renaissance figures were atheists!* or, alternately, *There was absolutely no atheism in the Renaissance at all, it was a golden age of orthodoxy, and all atheism is the fault of the [Reformation/Counter-Reformation/Enlightenment, etc.].*[50]

WAS THERE RENAISSANCE SECULAR HUMANISM?

Even when we strive to avoid such biases, all historians of atheism, whether pro or con, have one inescapable bias: we're looking for atheism. We're excited if we find it, so we're prone to take any hint as a *yes*, as whale watchers may mistake any dark shape for that elusive humped back. Knowing that an atheist won't fess up in documents, it's natural to try to read between the lines, seeing hints of heterodoxy in the subtext of a treatise, or taking a mild expression of interest—such as people reading Lucretius—as proof of hidden atheism. Careful reading is indeed the only place we can expect to find such radical ideas expressed in ink, but it risks false positives. Yes, there was censorship, but absence of evidence isn't evidence of atheism, or of rationalism, or modernity. As the invaluable Lucien Febvre put it in *The Problem of Unbelief in the Sixteenth Century*, we moderns are bound to see that rare beast the atheist around every dark corner.[51] We see him because we want to.

It was reading Febvre that birthed my dissertation, since he proposed that, instead of reading between the lines, we should confine ourselves to searching for a habitat capable of supporting the hidden atheist, as Febvre puts it, only then can we safely say that we have found him, not his shadow.[52] By *habitat*, Febvre meant the other ideas related to atheism which make atheism easier and more tenable—ideas like atomism. The habitat is right for atheists if it has access to new scientific theories: atomism, vacuum, heliocentrism, anything which makes Nature more self-sufficient and less dependent on divine action. The habitat is right for atheists if it's rich with theological challenges: attacks on the immortality of the soul, on miracles, on Providence, on angelology, anything which diminishes how often God is the answer to some basic question. The habitat is right for atheists if it's rich with ancient texts which offer alternatives to Christianity: Epicurus, Lucretius, Plato, Pythagorean remnants, Cicero's skeptical dialogs, the books innocent Petrarch told his friends to find to heal the Christian faith but turned out to contain dozens of incompatible alternatives. Where we find these things in high concentrations—the bookshelves of our *umanisti!*—here may prosper atheists. Lucretius, with his atomism, was the best of salt licks.

So I proposed to spend my grad school years combing through copies of Lucretius, from the two medieval copies, to the fifty-ish Renaissance manuscripts surviving from after Poggio found it in 1417, through the thirty print editions produced by 1600. I vividly remember when I'd just picked my project, and attended a small party at my adviser's house where I met Brian Copenhaver. I was so starstruck (his name was all over my MA exam reading list!) that my heart was pounding, and I felt like I was babbling like a fool (hello, impostor syndrome), but when I mentioned there were thirty editions of Lucretius by 1600 *Brian Copenhaver thought that was really exciting!* It was the first thing that made me realize my research might actually be *important*. And he was right, thirty editions before 1600 meant (print sizes ranging from 300 to 1,500) likely 30,000 copies of Lucretius around in Europe before 1600! Thirty thousand likely atheists!

But you only found two?

Yes. And no.

What I found were patterns, and a moment of change, *not* when I had expected it, not in 1400s Florence in those humanistic circles around Poggio, Bruni, Salutati, Pico, and Poliziano, nor even in the crises of the Italian Wars. I found it in the 1570s, forty years *after* Machiavelli's death, when Galileo, Shakespeare, and Francis Bacon were boys. It's still the Renaissance, so it may not seem like a big difference, 1417 vs. 1570, but if some future historian wrote excitedly about how same-sex marriage was legalized in the 1860s and claimed the same-sex marriage movement defined the nineteenth century, that historian would be, to use the technical term, *wrong*. The 1800s had important shifts in attitudes toward sex and gender which helped shape the path toward marriage equality, but that's not the same as same-sex marriage being the defining spirit of the 1800s. Just so, what I had expected to find in 1420 I found in 1570, and when I came home from the archives and compared my findings to the work of others focusing on atheism, it matched up.

What were the patterns and the change?

The patterns were what kinds of annotations readers made in the margins of Lucretius, and what sections of the text they tended to mark. The *De rerum natura* is a long poem with a lot

of different content, not just atomism and denial of the soul, but names of plants, depictions of pagan rites, poetic descriptions of gods and nymphs, a sex scene, cute Greek nicknames to call your girlfriend, discussions of disease, plague, drunkenness, epilepsy, astronomy, reflections on virtuous life, friendship, the development of human civilization from a primitive pastoral golden age toward luxury goods and wars fought over them, and some poetic lines copied (stolen) by Vergil. The sections my beloved atheists should mark are the technical science sections, atomist discussions of how night, day, evaporation, sight, etc. function, and the description in Book II of atoms clumping in the void, and of the *swerve*.

To my surprise, out of 300 copies, only a couple seriously annotated those passages, and most of those wrote things next to them like "*opinio non Christiana*" (unchristian opinion) and "*absurditas in sententia*" (absurd to consider).[53] The annotations I did find clustered at the start (our ancestors also didn't finish all their reading), and around the vivid poetic descriptions, the discussions of good Roman morals, the lines Vergil copied, the rare vocabulary, the random facts about antiquity like the rituals of Cybele, the plague (relevant at the time), and above all the sex scene (relevant always). Among hundreds of anonymous annotators, even the copies marked by famous hands—Poggio! Panormita!—showed no sign of interest in the atomist bits. Pomponio Leto (a persecuted radical imprisoned by the pope!) annotated the whole text very thoroughly, focusing on... language: participles, deponent verbs, archaic forms, rare nouns, contractions, it was all philology, an effort to work out a technical vocabulary which would let *umanisti* someday chat science without resorting to the bad medieval Latin terms the scholastics used for such discussion, but underlining elegantly classical words for *chick*, and *white*, and *continuingly* while ignoring the atoms was disappointing.[54] There's also a manuscript in Padua (that exuberant nest of heresy!) with dots next to a bunch of lines, and after days trying to figure out why the author picked out those lines I realized they were all lines where the scribe made a mistake so the poetic scansion had the wrong number of beats. These were not the traces of radicals drawn to Lucretius's atomist salt lick, these were Latin teachers excited by good Roman morals, Latin vocab, and *the words that sting and bite*.

The change I found was the 1570s. Suddenly there they were, lots of annotations which focused on the medical details, evaporation, astronomy, even the atoms, while the notes on grammar and Roman morals dwindled away. These weren't copies printed in Italy; print's center had moved by the 1550s to Paris and to Amsterdam, to serve big universities, and trade networks which carried books out by ship, river, and wagon through Europe's spreading empires. Here were my inquiring scientific minds, not focusing on atoms, but at least marking the medical and scientific things. And when I reviewed other historians' work, sure enough there in Nick Davidson's studies of the Inquisition archives he had dozens of examples from the 1570s to 1590s of atheists who clearly voiced denial of God, but back in Machiavelli's lifetime only stubborn, illiterate Guido Donà.

What caused the change then, not before or after? Many things, some famous (the Reformation, New World discoveries, the microscope) some more obscure (changes in print culture, in botany, in touch), and some caused by our *umanisti* (flooding Europe with thousands of copies of unchristian Classics did a lot!), but since those mark the end stages of what we call the Renaissance, before we turn to them we must zoom in on two niggles.

One niggle is a question, possibly already in your mind, which I've been asked dozens of times, from the very first time I stood up in the History Lab (with my stomach full of butterflies) to present at my first conference: *What if these Lucretius readers were interested in the atomism, but avoided marking those passages out of fear of the Inquisition?*

The second niggle, which we'll turn to once I give my ten-years-in-the-making answer to the first, is that there is one early copy of Lucretius (1490s) whose annotations stand out from the rest, whose reader didn't mark the grammar or Vergilian lines, but concentrated on the sections in Book III with the technical fundamentals of atomism, and, in the margin by the explanation of the famous random swerve of matter, which others marked "*absurd to consider,*" this scholar wrote instead, much as a modern would, "*that motion is variable, and from this we have free will.*" And that copy is Machiavelli's.

53

How (Not) to Dodge the Renaissance Inquisition

What if Renaissance Lucretius readers avoided annotating the atomism to dodge the Inquisition?

My answer: If you were afraid of being prosecuted for possessing illegal drugs, would you meticulously hide your tiny stash of smuggled Canadian painkillers, but leave a giant bag of cocaine on your kitchen table? No? Then, if you were afraid of the Inquisition, would you carefully avoid putting a dot in the margin next to Lucretius's atheistic passages, but publish a treatise publicly espousing something the Inquisition thought was way worse than atheism?

The Renaissance Inquisition had priorities. Atheism ranked low among them, worth prosecuting but nowhere near as high-priority as a lot of other heterodoxies, from denying the immaculate conception of the Virgin, to reading the Bible in unauthorized translations, to so-called "Judaizing," i.e. mixing Jewish practices into Christianity. Lutheranism and Calvinism, once they came about, made any atheist a slow news day. Roman Inquisition specialist Christopher Black has great numbers: looking at Inquisition records from Venice and Friuli from 1547 to 1585, he found 717 cases of people indicted for Lutheranism plus 37 for Anabaptism, 12 for Calvinism, and 68 for espousing various banned theological ideas, for a total of over 800 people brought to trial for banned variants on Christianity.[55] Meanwhile, 59 were prosecuted for practicing magic, 34 for "Judaizing," 10 for "Mohammedanism" i.e. Muslim influence, 15 for apostasy (converting then lapsing), 21 for vague irreligiosity, and *only one* for atheism (0.001 percent). From 1591 to 1620, Naples had 489

accusations of magic, 86 of heretical theology propositions, 73 of bigamy, 67 of Mohammedanism, 43 of lying under oath, 32 of blasphemy, 18 of Protestantism, eight of atheism, and nine of possessing banned books.[56] Atheism *was* a target for the Inquisition, but it was way down on the list. In the *literal* list, the Inquisition's infamous *Index* of banned and prohibited authors, Lucretius wasn't even listed in the 1500s. Atheism wasn't high-profile. The mid-1500s versions of the *Index* put the names of really dangerous authors in all caps, and they're all theologians: Luther, Calvin, Zwingli, lots of now-obscure Protestant preachers; even Old Nick doesn't get all caps!

Now, Inquisition interest in prosecuting particular things went in waves, based on whatever authorities were anxious about at any given time. When Ferdinand and Isabella of Spain and other particularly anxious rulers were in charge, they would drown the Inquisition with cash and send it out to hunt down what they feared, causing an atrocious surge in persecuting one particular thing, like "Judaizing." Next decade, new king, new target. Black's numbers make this visible. The Inquisition in Spanish-dominated Sicily led 2,080 indictments for "Judaizing" between 1501 and 1550, but these suddenly dropped from thousands to dozens in 1550 when fears and prosecutions started focusing on Muslims instead.[57] After 1600, Muslims weren't the target anymore, but witchcraft was. If we jump further back, there were medieval moments when the (then-new) Inquisition did a burst of persecuting particular groups like the Waldensians, other moments when it banned Aristotle, and other moments when it loved Aristotle but banned other things. This continued into modernity, when the Church and Inquisition had patches of targeting Marxism, or Darwinism.

Within this pattern, Inquisition indictments related to science and philosophy, like those of Bruno, Galileo, and Campanella, were also a wave, all clustered within a decade of 1600, and *there were only about a dozen trials total*, throughout the whole history of the Inquisition, which actually focused on science and materialism, contrasted with tens of thousands for Lutheranism, witchcraft, "Judaizing", etc.[58] Galileo's and Bruno's trials were an aberration, not the norm they're often painted as, part of a cluster around

1600, and even then there were a lot of things you could say that would get you on the Inquisition's bad side a lot faster than mentioning atheism or Lucretius. As Nicholas Davidson pointed out, Giordano Bruno's interrogation before his condemnation focused on his radical views on Aristotle, not his interest in atomism or multiple worlds, and the only time Lucretius is mentioned in his trial records was when Bruno himself brought up Lucretius to disagree with him—the Inquisition never brought up Lucretius, atomism, or atheism *at all*.[59]

We also have to understand that the Renaissance Inquisition *was not* an all-powerful, all-seeing Orwellian thought police; it *aspired* to be that, *claimed* to be that, but its inner workings show it constantly felt understaffed and underfunded, stretching its resources thin to hold back what it saw as an avalanche of threats. Inquisitors had to negotiate with local authorities for resources, for police man hours and prison cells; they had to negotiate with Rome or bishops for permissions, staff, and salaries; they had to compete with local religious authorities about who had final say; it was a mess. When a government or ruler was enthusiastic about wielding the Inquisition as an instrument against its perceived enemies (think Ferdinand and Isabella) then the Inquisition had lots of resources and could persecute as many people as the crown could fund, but when the state was indifferent, or a local bishop was obstreperous, or a patron wanted to protect a client, the Inquisition could be quite impotent. Just as Ludovico Sforza and Francesco Gonzaga could have open sodomy at their courts without consequences, if you were close enough to a powerful patron like Lorenzo de Medici you could even (hello Pico) publish 900 theses unifying all world religions and still get bailed out and protected. When the Inquisition started sniffing after Ficino, it was largely the Archbishop of Florence who made them back down—Archbishop Rinaldo Orsini, whose grace in Rome guarded Medici clients thanks to Lorenzo's marriage: good old patronage. Bishops and other local Church officers could usually override Inquisition judgments, so if an Inquisition censor denied you permission to publish, you could go ask the bishop, like a kid getting a "No" from mom who then asks dad. Even when the Inquisition was at its fiercest, arresting and killing thousands,

internal documents always show inquisitors feeling they don't have enough authority, let alone time or resources. The Inquisition was terribly destructive, responsible for hundreds of thousands of deaths and periodic true reigns of terror, but it wasn't infinite; it chose its battles, prioritizing the threats it considered most important. It did *not* choose atheism.

Why wasn't the Inquisition worried about atheism? Largely because it was *so* radical they thought no sensible person would take it seriously. Atheism couldn't even explain how the planets move, or how cognition works, or why animals are all adapted to their environments. Even if Lucretian atomism had suggestions for things like weather and evaporation, it didn't have *evidence* for its suggestions, and Lucretius had nothing for the big questions of intelligent design. Returning to *the fool said in his heart there is no God*, they thought only a fool would consider the notion that there really is no God. The lack of answers of early atheism meant it wasn't seen as a real competitor. The only people who would be tempted by it, in the period's view, would be a fool, or someone fundamentally wicked who *hopes* there is no God because they're afraid of being punished—both those categories are people the Church didn't care about. The Renaissance Church thought the vast majority of people would go to Hell; its job was to take care of the good minority who had a realistic shot at Heaven. Anyone who would be tempted by atheism was already a lost cause—whether through foolishness or natural wickedness. The *dangerous* positions, the ones the Inquisition fretted about, were ones likely to be tempting to the *pious*. The devil quoting scripture, tempting and misleading monks and nuns, the pious "errors" of Luther, Calvin and their followers, *those* were the threats that could confuse and harm the flock the Church believed it could protect. Atheism could only mislead people who were already on the wide and easy road to Hellfire.

Additionally, I learned on digging deep, *even if* the Inquisition was going to go through your books to look for signs of atheism, your Lucretius isn't where they would have looked. In 1516 (a century after Lucretius's return) Pietro Pomponazzi—a professor in Padua, under Venice's protection—was condemned by the Inquisition for his work *De immortalitate animi* (*On the*

Immortality of the Soul), which argued that the soul's immortality cannot be proved, based on heterodox readings of Aristotle, and on Ibn Rushd, the medieval Muslim commentator on Aristotle known in Europe as Averroes, or as *The Commentator*, unrivaled in impact, as Aristotle was *The Philosopher*. Giordano Bruno's trial interrogation too focused on his radical use of Aristotle. In contrast, in 1557 Michele Ghislieri (not-yet-Pope Pius V), one of the architects of the book-policing phase of the Inquisition, wrote a letter about how books like Lucretius, *Orlando Furioso*, and the *Decameron* are harmless, because everyone knows to read them as "mere fables," to be enjoyed for their beauty, but no one was expected to take atoms more seriously than *Orlando Furioso*'s hippogriff and the ghost of Saint Merlin.[60]

Armed with these details about the Inquisition's attitudes, I then looked at the lives of all Renaissance people we know of who (A) got into trouble *and* (B) read Lucretius. I found that they *always* got into trouble for things which *weren't* reading Lucretius, but were much higher on the Inquisition's Most Wanted list than atheism. Hence, when people ask "Didn't they avoid marking the margins out of fear of the Inquisition?" I turn to my simile of hiding Canadian painkillers while leaving cocaine out on the table.

Marsilio Ficino read Lucretius, and got in trouble with the Inquisition... for publishing a book of magic on how to summon and control angelic spirits, which described belief in reincarnation—much higher on the Inquisition's worry list. Pico got in trouble with the Inquisition... for hybridizing all world religions—very very high on the Inquisition's worry list (remember how we saw a hundred trials for "Judaizing" for every atheism trial?). In 1575 Sperone Speroni—a student of Pomponazzi—was denounced to the Inquisition for his *Dialogo d'amore*, which includes Lucretian content... specifically a sex scene. It was the porn, not the atoms, that sparked the trouble. Bartolomeo Scala—our Alessandra Scala's awesome dad—read Lucretius and got in trouble... for being entangled with the Medici, nothing to do with his Lucretian radical ideas.[61] Pomponio Leto was a major reader of Lucretius; he reenacted pagan religious ceremonies, had students call him *pontifex maximus*, and hung out with

anti-papal figures like Bartolomeo Platina, 1421–81 (whose antipope protest vigil nearly triggered a Church council); when Leto was arrested in 1466 the charges were sodomy, pagan worship, and conspiring against the pope—would a man who openly walked around Rome dressed as a pagan priest of Apollo carefully suppress all hints of covert atheism in his marginal notes in a book the Inquisition considered a "mere fable"? Scipione Capece, who published a digest of Lucretius with the title *De principiis rerum*, publicly endorsed several positions of Martin Luther (incompatible with atheism), and was forced to flee from his home for his support of Protestantism—are those the actions of a closet atheist? Another major Lucretius commentator, Aonio Paleario, was burned at the stake in 1570 for criticizing Catholicism and defending Luther's doctrine of *sola fide*, i.e. that souls are saved by faith alone, not faith and good works. No closet atheist would go to the stake for *sola fide!* He would tell the Inquisition he didn't care, and the Inquisition would sentence him to sit through some tedious lectures, then send him home.

The real-life actions of these people simply aren't compatible with them being closet atheists. No one would meticulously avoid even underlining the atomist arguments in Lucretius, then loudly publish about a position the Inquisition is literally a thousand times more determined to persecute. Also a lot of them *did* underline the sex scene, which the Inquisition *did* prosecute someone for. Yes, atheism was a capital offense, but remember patronage: the justice system in which the sentence on the books actually being carried out is the aberration, not the norm—that aberration was saved for the heresies the Inquisition thought might tempt the virtuous, like Lutheranism, "Judaizing," and demonic magic (*good* magic was *fine*). Atheism, like Sodoma's sodomy, or Cellini's murders, was a minor issue, easily handled via a patron's *grace*.

All this shows why, even though there *was* an Inquisition forcing people to self-censor, we cannot assume that what they self-censored must have been atheism. Sometimes it was atheism, as with Raphael Franchi, my sole Lucretius-reading 100 percent confirmed his-friends-said-he-was-one atheist. But many Lucretius readers were other kinds of freethinking radicals, dissatisfied with the standard answers of the Church and interested

in new approaches. While a few turned to atheism, Ficino, Pico, Franchi, and even Giordano Bruno turned in other directions: to Luther, to Aristotle, to Zoroaster, to astrology, to new mystic visionaries and old rediscovered texts, to all sorts of things. Atheism was an option, but it was not the default direction for a freethinking Renaissance radical.

This makes sense. Pre-Darwin atheism wasn't nearly as satisfying as modern atheism, since it lacked most fundamental answers. Even Lucretius's suggestions of how atoms and vacuum could make the cosmos lacked any physical studies to back them up; they were theories arrived at by observing motes in a sunbeam, much less detailed than the well-fleshed-out Aristotelian and Galenian sciences with which they competed. Without satisfying answers to how mindless matter could create the ordered systems of nature, atheism was not yet a very satisfying worldview for an inquiring mind.

Despite the efforts of modern secular humanist movements to claim the Renaissance, the documents I've seen show us a Renaissance in which questioning or rejecting orthodoxy *was indeed common* (as it had been in the Middle Ages too!), but the directions thinkers moved after rejecting orthodoxy were all over the place, not a homogenous step toward a secularizing future. Instead, they dabbled in all kinds of radicalisms, from Pico's omnivorous syncretism to Cellini's necromancy, with a world of other strangeness in between. Comfortable as it would be to imagine that the self-censorship of our Renaissance heroes concealed attitudes that resembled modern ones, we do these brave Renaissance freethinkers a disservice when we dismiss their vast diversity of innovative projects as mere veneers over a familiarly modern secularism. The Renaissance was full of radicals, and they challenged established religion all over the place, but it *wasn't* a unified underground of secret proto-moderns working to dismantle the Church and erect a distant secular future—it was a wild kaleidoscope of ambitious worldview experiments, which tried to make hundreds of different futures, some atheist, some Platonic, some Savonarolan, some stranger than we will likely ever know. And very few of these experiments would feel at all familiar to someone looking for the spirit of our modern age.

The meta-lesson here is that one of the victims of censorship is our ability to interpret the historical record. When we know people are self-censoring, we inevitably try to deduce their secret thoughts, but such efforts are very vulnerable to the subjective bias of we who do it. I have seen the same texts interpreted by one scholar as absolute proof the author (Leto, for example) was a secret atheist, and the *same* text interpreted by another scholar as absolute proof of the opposite. This is why I don't claim to know which of my many readers of Lucretius were or were not atheists. My two 100 percent certain atheists were atheists; my Lucretius readers who faced persecution for publicly avowing theisms much more dangerous than atheism were not. For the rest, presumably some were atheists (my beloved early atheists!) some not, but we need to acknowledge the fact that we can't tell, and that the things these figures thought in secret varied wildly; we cannot assume they all converged on a proto-modern secular worldview which was not yet (without Newton and Darwin) scientifically satisfying. Later we find more familiar minds—I'll come back in our last section to those new more scientific annotations left in Lucretius copies in the 1570s—but when I'm looking at the half of Renaissance before 1550, every time I think I *feel* an atheist, I remind myself how different are the Lorenzos and Savonarolas others have *felt*, and make myself give Socrates' answer: we don't know.

And yet we can't stop asking…

54

Why We Care Whether Machiavelli Was an Atheist

First why we care, then why it's so hard to accept that *we don't know*, then why we must.

We care because he feels so likely. But even more, because he feels like us.

Why does he feel so likely?

Partly because he was the archetype of atheism for so long: Arch-Heretic, Anti-Pope, Destroyer of Italy, Shakespeare's Murderous Machiavel—in an age when atheists were silent and invisible, Machiavelli's godless ethics made him one of the most (in)famous *presumed* atheists. Dante readers know where the author of *The Prince* goes: straight to circle 8 section 10, for those who advise others to do evil. The beard-stroking villainy invoked by "Machiavellian" (though real Nick had no beard) reconjures the pre-modern logic chain: (1) Fear of Hell drives men to good behavior, (2) Machiavelli advocates sinful acts like lies and rule by terror, (3) Machiavelli does not fear Hell, (4) Machiavelli was an atheist. *In order for people to be virtuous they must first be alive—* False! replies most of the Renaissance: the saints and blessed exercise virtue *in Heaven!* The man who says that sometimes one must kill and lie to protect the state sure sounds like he doesn't think the afterlife is more important than the living world, and the man who will serve even the Medici who tortured him in order to guard Earthly Florence's sky-braving dome sure seems to have what Shakespeare called "a base ignoble mind that mounts no higher than a bird can soar."[62] For Dante, the mark of souls in Hell is that they care about Earth and politics, souls pointed

downward and forever asking, *How's my city? How's my family?*, while the upward-looking souls in Purgatory don't care a fig how our fleeting mudball Earth is doing, they never ask—almost as if Baron's civic participation, that deep investment in SPQF, is the reason Dante thinks Florence would be a city famous throughout Hell.[63] Atheist or no, if Machiavelli had dying thoughts they were likely of Florence—in this, dying Richard III still shouting of his kingdom and his horse does indeed match the Murderous Machiavel.

Beyond all this, Machiavelli *feels* modern. He feels like us. He advocates evaluating right and wrong based on secular criteria, *as if there were no God watching*, compatible with separation of Church and state. Having spotted someone who thinks about history as we do, about ethics as we do, about law as we do, about the consequences of our actions as we do, he feels *ahead of his time* (dangerous words). My own research supports this: Nick even annotated his Lucretius as we do, focusing on the atomism, unlike all the other annotators in his lifetime—this is fresh, solid, real, quantitative proof that he was more like us than his peers! Proving that Machiavelli was exceptional for his day was the least surprising conclusion my Renaissance dissertation could come to, yet still precious, and those unique annotations feel like one more sign of the *modern man* who we feel in our gut must be behind *The Prince*.

Let's return to the lunar lander metaphor a moment, before zooming in on Old Nick's inner thoughts. Remember historian Riccardo Fubini, who did that meticulous reading of works by *umanisti* that helped us see how they built the intellectual lunar lander of Petrarchan social engineering, that got our Nick to where he could take his one small step? Fubini is one of the finest fruits of the invaluable Italian project of fighting to defend *huma<u>nism</u>* as a worthy presence in philosophy intro courses, and provocatively titled his book *Humanism and Secularization: From Petrarch to Valla*. That turn he noticed in our *umanisti*, spilling more ink about worldly things, politics, civic participation, the social engineering project of making their world more stable through the classics, that did involve thinking less about the immaterial world of celestial laws and winged souls, and more about the dynamics of peoples, the actions of princes, and the consequences of

policies. Doesn't that feel like a big part of what makes Nick feel like us?

As Fubini's research helps us see, a secular turn doesn't require anyone to be a card-carrying, God-denying, soul-denying atheist, it can take the form of simply caring more about secular things, even if the soul and divine still come up in an *umanista*'s every book, or even every paragraph. A secular turn *simply in the sense of caring more about secular things than earlier thinkers* started as a trickle around 1400, entered libraries and courts, then universities started offering more courses on rhetoric (how to convince Earthly people of Earthly matters) and hired their first chairs in ethics (how to behave on Earth). One world-changing effect of our *umanisti*—one which clearly *does* merit association with *secular humanism*—was simply increasing how much people thought this world was a meaty topic. Major contributions to the history of thought don't have to be systemic theories or advancing a specific answer, they can instead be *broadening the range of questions*. Many of the most important eras in the history of thought can be better characterized by their questions than their answers. Antiquity: How do we know things with certainty? Medieval: How do we know things about the eternal and permanent? Scientific revolution: How do we know things about Nature? Analytic philosophy: How do we know what we mean when we express things? Renaissance: What can we know about the human world, social dynamics, and how to make them better? In that sense, the word *humanism* really does fit, and there is a philosophical shift, not to questions no one ever asked before, but to questions which were always little side shows, but at last took center stage. Sometimes Ever-So-Much-More-So is a big step in itself. We can even call Fubini's idea a new X-Factor: not secular humanism in the modern sense, but increased interest in worldly questions, humans and our world receiving a greater share of human inquiry, even among pious Christians, shaping the world we will in time call *modern*.

In this way, even as pious Raffaello Maffei helped set the stage for secular thought, simply by giving his encyclopedia of everything such big sections on places, people, and our history. None of these figures had to be atheists themselves for *humanism* to

include a world-changing secular turn. Remember my editors of Epictetus, their slippery slope from claiming in the early 1400s that Epictetus was almost as good at teaching ethics as a Christian, to claiming in the early 1500s that he was *as good as* Saint Paul, to claiming around 1600 that Epictetus was *better than Saint Paul* at teaching ethics and good living *without the help of Revelation?* That last argument is an inch from deism, and opens space for imagining an ethics for atheism. The stage set by Petrarch, Poliziano, Ficino, and Maffei helped ready Europe for the entrance of the Enlightenment's great atheists: Rochester, Diderot, La Mettrie, and the Marquis de Sade. All without anyone needing to be an atheist.

But Machiavelli still feels like an atheist!

Yes. Yes, he does. So, let's zoom in.

What do we know of Machiavelli's personal beliefs from his personal life, separate from his political writings?

We know he was a soldier, fought, killed, and led troops, and was what I call "averagely promiscuous" for a Renaissance man, married but with intermittent lovers male and female, and comfortable giving sex advice (both queer and straight) to friends.[64] We know he was involved in simony, paying bribes to get his brother a job in the Church—ubiquitous at the time. We know he owned and loved many pagan classics, and that in his comedy *The Mandrake* the twist at the end is that the trickery *isn't* exposed, and everyone carries on committing deception and adultery and living happily ever after, including those being deceived. *(Thinking about consequences are we, Nick?)* We also know he was not religiously orthodox. His friends in letters joked about how he never went to church. He himself wrote about clerical corruption without a jot of religiosity, analyzing the strategic (Machiavellian) actions of popes, cardinals, even Savonarola, just as he analyzed King Charles and Duke Valentino.

From his formal writings, we know he wrote about religion and the Church very... *distinctively*. His *Discourses* devote several chapters to demonstrating that ancient Roman religion made ancient Rome stronger than Christian nations are.[65] How? First, because the Roman cult of honor and ancestor worship meant Romans believed their posthumous wellbeing depended on being

remembered on Earth, a state best achieved through doing deeds of valor, glory, and renown, so that to fight and die for one's country was encouraged by religion, *unlike* Christianity which glorifies a humble and contemplative life and otherworldliness, which are useless to the welfare of the state. Second, he adds, ancient Rome's religion was taken very seriously, its temples and priests honorable and uncorrupted, so people followed its rules with exactitude, feared divine punishments sincerely, and were more afraid to break oaths than to die—for the modern contrast, he says, have a look at the sewer of corruption that is Rome, and ask how Christians can be expected to fear breaking oaths when every prince of the Church does so. The only comment he makes on Christianity's veracity comes in a passage where he says the reason modern people love liberty less than the ancients did is the difference between current and ancient education, since "our religion, having taught us the truth and true life, makes us place less value on worldly honor; while the Gentiles, esteeming it highly, and having placed their highest good in it, were more ferocious in their deeds."[66] That fleeting *having taught us the truth and true life* is the *only* thing Nick has to say about Christianity's claim to truth as a religion, amid many pages on how *useful* Roman religion was to people and politics, and the corruption and hypocrisy of papal Rome.

There is also a delightful letter he sent to fellow historian Guicciardini, written when Machiavelli was hired by the wool guild to recruit a preacher for Lent, in which he said that those who hired him wanted a preacher who would show them the way to Heaven, but he preferred one who was mad, hypocritical, "wilier than Savonarola" and whose corrupt behavior would show people the way to go to the devil, so they would learn from that horrible example to do the opposite.[67] Machiavelli also played a prank on the monks, in which Guicciardini sent him frequent letters fattened up with irrelevant papers, and told the messenger to jog the final stretch to the monastery so he'd arrive breathless and sweaty, and the monks would think Machiavelli was involved in some important political business, and give him better food. The last letter we have from Old Nick in that sequence says he suspects the friars were starting to catch on.

You now have pretty much all our evidence about Machiavelli's personal beliefs. Smells like an atheist, doesn't he? His modern-feeling attitudes and his playful anticlericalism tempt us into feeling that the Lucretian bait has lured out a true specimen of that rare beast we seek. But Boccaccio also said bad examples taught people to do the opposite. Without a time-traveling telepath we must remain wary. Was Machiavelli religiously unorthodox? Absolutely, but there were many kinds of heterodoxy thriving in his day.

Thinking just of radicalisms abroad in Machiavelli's lifetime, there was Pomponazzi and that nest of Averroist radicals up in Padua, who were challenging the immortality of the soul and divine creation-in-time *without* challenging Intelligent Design. There were the radical readings of Aristotle which got Giordano Bruno into trouble, which argued for a Prime Mover but a self-regulating cosmos and no individual immortality. There was reconstructed classical Stoicism, which argues there is no personal afterlife or *separate* God, but that all things in existence are parts of one divine whole, within which our actions advance an unknowable but perfect Plan (this will be echoed by Spinoza). There was Lucretius himself, whose Epicureanism denies the afterlife *but still says gods exist*, dwelling in eternal bliss far off in space, not hearing prayers or interfering in human life, but giving us concepts like Mars and Venus which help us understand the organs of Nature. Machiavelli's Europe was also approaching the Enlightenment, in which the blossoming of atheist authors (La Mettrie, de Sade, dear Diderot) came alongside the blossoming of deism (Voltaire, Rousseau, Thomas Paine) with its Clockmaker God. Deism denies divine intervention in Nature and politics, often has no posthumous judgment, and lessens theology's role in ethics (much like Machiavelli), all *without* denying divinity. Deism is just as compatible with Machiavelli's work and life as atheism, so why do we constantly ask whether he was an atheist but not whether he might have been a deist?

Machiavelli was 100 percent definitely radical for his day, but nothing he said was *more* in alignment with modern atheism than with a wide variety of theist radicalisms available during his life. It's getting weird in Florence, and if Ficino and Pico's definition of

"Platonism" is quasi-Pythagorean, Kabbalah-incorporating, theurgic soul-projecting magical Christianity-plus-reincarnation wacky space alien Platonism, why should we assume Machiavelli's secret beliefs were somehow the familiar modern atheism we're most comfortable with? (Machiavelli thought Pico and Ficino's system was totally bonkers, but so did noted non-atheist Savonarola.) Lucretius's scientific model of a Nature which can function without divine maintenance was of interest to a wide variety of early modern radicalisms. If Machiavelli (like Lucretius) thought organized religion can be destructive, and that many monks were corrupt and hypocritical, so did Voltaire, Rousseau, and Martin Luther, without being atheists. Radicals yes, atheists no.

So, Machiavelli may not have been an atheist; so what? Doesn't he still take a step toward it? And isn't he still a good forefather for modern atheists to claim?

Yes, but this is when I remember, not only our many Lorenzos and Savonarolas, but the tragic life and death of Charles Blount (1654–93).

A generation younger than King Kristina of Sweden, Blount was a modest English gentleman, raised by a freethinking and open-minded father, and one of the few people in his day who could be called an admirer and follower of Thomas Hobbes, instead of an adversary, since Leviathan the Great was an even more fearsome intellectual monster in his own day than Machiavelli. Publishing under a variety of pseudonyms, Blount's political works defended liberty and voiced Whig positions opposing Catholicism (part of the momentum leading to the Glorious Revolution, which happened when Blount was thirty-four). His *A Just Vindication of Learning* (1679) echoed Milton's *Areopagitica* (1644) arguing for the importance of a free, uncensored press. His *Anima Mundi* (1679) reviews pagan theories about the afterlife, and ambiguously both defends and undermines the idea of an immortal soul—it and several other of Blount's works were condemned and burned, and he admiringly sent a copy of it to Thomas Hobbes, to whom he also wrote many letters. Blount's *Miracles, No Violations of the Laws of Nature* (1683) advanced Hobbes's materialist idea that miracles do not violate scientific law, but are simply rare physical phenomena not yet understood by human beings which *seem*

impossible, but were, in fact, planned for by the Clockmaker when He first made the Clock. (Anyone familiar with the modern study of the real ridge under the Red Sea which, if the wind was juuuust right, could have actually parted it for Moses, has in that a good model of the idea that God could have designed Nature to enable His planned miracles.)

Blount's deist works are his most moving. His 1680 *Great Diana of the Ephesians* and *The Two First Books of Philostratus Concerning the Life of Apollonius of Tyre* take the form of a traditional *umanista*'s commentary on ancient classics, but their notes attack Revelation, the Eucharist, Church practices, and accuse organized religion in general of erasing rational religion. His last work, *The Oracles of Reason* (1693), collects essays questioning the possibility of Revelation, and considers the probability of life on other worlds (hello, Lucretius and Giordano Bruno). Blount was also an interlocutor of John Wilmot, 2nd Earl of Rochester, the most infamous libertine and skeptic/atheist of the seventeenth century, and the two men's struggles to find beliefs consistent with their readings of Nature influenced each other's doubts and radicalisms.[68]

While Blount's writing is often satirical, mocking ideas he finds foolish, it is also passionate. Take this example from the preface to his *The Oracles of Reason* (1689 edition) in which he echoes Francis Bacon's arguments about Reason being a gift given by God to enable humanity to meet its needs and desires:

> Nature, or that Sacred and Supreme CAUSE of all Things, which we term GOD, has furnished his Creatures with such guides as may best conduct them to the several Ends of their Beings. To the Birds, Beasts and other Animals, which we generally hold inferior to Mankind, he gave INSTINCT, as sufficient to direct them… But in Man we (at least) discover a farther and nobler End. Nature therefore must have given him another and more sufficient Guide; for the Mind of Man (the Chief Ingredient of his Composition) is not bounded by present objects in which Instinct alone would serve. Futurity has always a share in its Thoughts, and its Faculties will be employed with a Care of those Things that are to come, from which it may derive not only

Advantage, Interest, Ease for the Body, but also Improvement, Happiness, and Tranquility for itself...

Brief interruption here to point out how the classical ideal of using philosophy to achieve tranquility of the soul, celebrated by our classicizing *umanisti*, is an ingredient in this seventeenth-century celebration of Reason and empiricism which helped advance the scientific method. Blount continues:

But the *Omnipotent CAUSE*, that had so well furnished Brutes, left not the Mind of Man without its Director in this Maze and Lottery of Things; He gave it *Reason*, as its sovereign Rule and Touchstone, to examine them by, and to fit our Choice to our double Advantage of Body and Mind. Reason is the Light, that brings Day to those Things, that will contribute to, or oppose, our Happiness; without which we should vain grope in the Dark.

It's lovely. It's a sentiment we recognize as the Age of Reason. It's also straight out of Francis Bacon (whom we shall meet more directly as our Renaissance journey nears its end). Bacon argued that a benevolent Creator would not send humankind out into Nature naked and without the means to meet our desires, thus that Reason—with which the Creator equipped humans, as birds their wings and wolves their fangs—must be capable of meeting all humanity's desires if only we use it systematically, i.e. that science can improve the human condition! Blount's and Bacon's are profoundly *theist* celebrations of Reason, and amid Blount's evident doubts about such details as whether the soul has individual immortality (which Aristotle and Pomponazzi also questioned), Blount is passionate in his love of the order of Nature and its Maker. And, unlike confident Bacon, Blount—who saw how Hobbes was treated, and watched his own books burned by the London hangmen—voices a lot of pain. This is the beginning of his introduction to his 1679 *Anima Mundi* on the soul:

Methinks I already behold some haughty Pedant, strutting and looking down from himself as from the Devils Mountain upon the Universe, where amongst several other inferior Objects, he

happens at last to cast his eye upon this Treatise; when after a quibble or two upon the Title, he falls foul upon the Book itself, damning it by the name of an *Atheistical, Heretical Phamphlet:* And to glorifie his own Zeal, under the pretense of being a Champion for Truth, summons Ignorance and Malace for his Seconds; But such a person understands not wherein the Nature of Atheism consists, how conversant forever he may otherwise be in the Practice of it. It were Atheism to say, there is no God; and so it were (tho' less directly) to deny his Providence, or restraint it to some particulars, and exclude it in reference to others. Such are Atheists, who maintain such Opinions as these; And so are those Hereticks, who erre in Fundamentals, and continue obstinately in such errors. But the ignorant Vulgar People (whose Superstition is grounded upon the assimulating God with themselves) are apt to think that every one they Hate, are God Almighty's Enemies; and that whosoever differs from them in Opinion, (tho' in never so trivial a matter) are Atheists, or Hereticks at least; Not rightly considering the words of St. *Peter*, That in every Nation, he who feareth the Lord and worketh righteousness, is accepted with him. And *Minucius Felix* says well to the same purpose, He is the best Christian who makes the Honestest Man.

Here we see sweet, wounded Charles Blount, a man who endured blow after blow from a world where *atheist* was a term of abuse applied equally to libertines, Epicureans, Stoics, Calvinists, Catholics, radical Aristotelians, and magic-working Platonists, to Shakespeare's Machiavel, to Milton's Lucifer, to Spinoza (aptly described by the nineteenth-century Romantic poet Novalis as *drunk with joy at the idea of God*), and to that dude who ran around outside with no pants on. And it was applied to Blount, who strived so hard to argue that deism and atheism are profoundly different; that while deism may reject Scripture, Genesis, and Church authority, the difference between deism and atheism remains the largest possible difference: the existence or not of an infinite omnipotent Creator and a Plan.

Charles Blount took his own life in 1693, aged thirty-nine, a year before the birth of Voltaire, and two centuries after young Machiavelli watched Savonarola gain momentum in Florence.

Contemporaries attributed his suicide to love—a widower, he had petitioned to marry his late wife's sister, which in the period required special permission, which was denied. But we know so complex a thing as suicide never has just one cause, and when we see Blount write of his pain at the constant attacks of "haughty pedants," and read how hard he tried to no avail to argue that his deism *was not* atheism—that pain certainly shaped his death as well. In the short defense of Blount written for a posthumous edition of his works, their anonymous defender addresses the charge that Blount cannot have been a true philosopher if he succumbed to such a thing as love, since a philosopher is supposed to master the Passions, and be ruled by Reason (tranquility of the soul). Blount's defender argues that Nature is "a wise Author of all her Works, that does nothing in vain… the Passions therefore were given to be us'd," and that once Reason has judged things to be good or evil "it has done its office, and leaves the Passions to exert their force, sets 'em no bounds, for a *Good* cannot be lov'd too much, nor an *Evil* hated more than it deserves… Such a Lover may be a Philosopher, that is a Lover of Wisdom, and obedient to her Laws; and such a Lover was Mr. *Blount*."

So, when I run across modern people saying deism is *just a ladder to* atheism, or that it doesn't matter whether Machiavelli was an atheist or followed another radicalism which is *basically* the same, I think of our fragile Lover of Wisdom Charles Blount, and say: it does matter. Charles Blount was a deist. Raphael Franchi was an atheist. With Machiavelli *we don't know*, and Blount would weep anew each time somebody says the difference doesn't matter.

And yet, a few years ago in the History Lab, I was at a conference where one speaker suggested that Machiavelli's idea of an emperor or other conqueror (Valentino) coming into Italy and uniting it by force was influenced by Machiavelli growing up surrounded by Christian messiah narratives, and in response to this the Q&A lit up with the most ferocious indignation I've ever seen at a conference as attendees raged that the presenter *dared* suggest that Machiavelli *might ever possibly have been influenced in any way* by the Christian narratives he grew up hearing every day. Even so slight a challenge to Machiavelli the

pure and perfect atheist turned the History Lab's civil debate uncivil. I understand it. Losing a role model is traumatic. I still find people listing Pico as an atheist, and I can't blame them, he was celebrated as an icon of atheism for so long—if someone discovered a lost end-of-life treatise by Galileo in which he wrote that the Church was right and he shouldn't have opposed them, and that we should subordinate the findings of empiricism to Revelation, we who grew up admiring Galileo would have trouble accepting that too.

But Machiavelli feels so modern! So secular!

Yes! Secular is a better word to use than atheism.

Modernity is still dominantly theist, after all—searching our present populations for atheism in the sense Blount would have used the word, we find that atheists remain a small minority. When we say the modern world is *secular*, the real difference is that today (A) atheism is consistently *present* in our world, so we know its positions, the cosmologies it uses, can buy its books, are used to atheists existing in everyone's lives, and (B) many of our *social* institutions are secular, operating Machiavellianly, i.e. without considering external divine Law. Our legal systems do not strive to be Earthly portraits of God's Mercy, our laws consider consequentialist questions of social impact and deterrence, our claims of political legitimacy use history, culture, reason, rights, nature, liberty, or dignity more often than divine mandates, and while voters and politicians discuss religious *values* frequently, when they push for *theocracy* that push is notable, sparking comment, not the default. The vast majority of theists today agree that religious tolerance, and the presence of atheism as an option in daily discourse, is part of what makes our society different from our predecessors. *Even those who think atheism is bad* still recognize its ubiquity as a characteristic of the modern world. That part of our world is one that Machiavelli's secret radicalism—*whether theist or atheist*—did resemble, and shape.

If humanity's study of history is more than mere delight in stories of past exploits, it is an attempt to understand our origins. When we comb through the past and spot something characteristically modern—be it science, hygiene, feminism, or atheism—we are excited to find an early trace of home. Of us. That *us* excites

us, when we recognize an argument we'd make, a thumbprint on a page, a portrait face on an ancient Roman wall that looks like someone we went to school with. Was Machiavelli an atheist? We can't know, but by looking at why we want him to be, and why so much ink is spilled over this unanswerable question, we see our own anxieties about the origins of secular thought, and our narrative of how we got to this modern situation in which theism must stand constantly prepared to debate its rival.

In the small talk phase of a party—a wedding dinner or holiday reception—I often answer "What do you do?" with "I study the history of atheism." Sometimes simple chat ensues, but often I get one of three reactions, all three telling. Two are inverses: either an enthusiastic gushing version of *I'm an atheist and, since I presume you'll agree with me, I now want to vent at you about how much I hate organized religion and my evangelical parents!* Or I get the opposite, an awkward *I'm a theist, but I pride myself on being sensible about it, and I'm scared that if I tell you I'm a believer you'll think I'm the kind of zealot who gives theism a bad name.* I sympathize with the anxieties behind both these reactions. Both are symptoms of debate done badly: an atheist shaped more by pain and harassment than by free examination, a theist shamed and harmed by the bad actors at the fringes of their faith. In both cases I invite discussion, hoping a positive experience can help the wound scab over just a bit.

But sometimes I get a third reaction: one particular new acquaintance in the crowd will get *really excited!!!* and start asking lots of questions about my research, the Inquisition, quickly zooming in on one figure, on Pico, Galileo, Machiavelli, or Leonardo da Vinci—"Isn't it true that [X] was an atheist?" Over many iterations of this conversation, I've realized the subtext, both of this conversation, and of the whole hunt for Renaissance secret atheists. As I give answers about the real biography and real writings of the figure my new acquaintance asks about, their questions zoom in on the real one: *But [X Renaissance Person] was really smart, my role model, someone who feels like me, and I'm an atheist so wasn't [X] also an atheist? Isn't atheism intuitive? Something all smart, freethinking people like me always arrive at? Throughout history, didn't all smart people like me*

see through, by Reason's light, and find the truth? If I'd been born in a different century, shaped by different social mores, wouldn't I still be an atheist? Wouldn't I still be me?

It's about identity. It's a hunger for the reassurance that one's beliefs aren't culturally contingent, that logic is logic and that true is true. That's what many modern atheists see in atheist Machiavelli, atheist Leonardo, atheist Pico, proof that, if one were born in another age, one's core would be the same. It's a hard question to answer, because anything that chips away at our confidence that we are who we are, is very distressing—I've handled the conversation clumsily sometimes, and made people upset. I'm better at it now, and give a two-part answer.

Part one is that this appetite—the hunger to find evidence that your beliefs would still be yours if you'd been born in another time—is very common. Petrarch really, really wanted to find evidence that Cicero's wisdom basically arrived at Christianity. Later *umanisti*, and medieval figures too, actually *did* argue that Epictetus and Seneca were so wise they must have been secret Christians.[69] Ficino and Pico filled in gaps in fragmentary ancient oracles with bits of Plato and Saint Augustine because they were so sure that all wise people over time converge on the same truth. Lots of people crave the authenticity and security of feeling one's beliefs are bigger than just chance of birth—it's a natural impulse, and very understandable.

Part two is to say that there's a difference between arriving at *questions* and arriving at *answers*. Curious, inquisitive, open-minded people in all periods questioned their dominant religion and scientific models. They criticized institutions, spotted flaws in logic, debated whether holy books make sense as sources, challenged the historicity of factual claims, and explored what can be known from observing Nature. Machiavelli, Leonardo, Pico, Kristina of Sweden, Peter Abelard, Charles Blount, and my new acquaintance at this party, all arrived at *doubt*, at similar *questions*. But the answers such freethinkers experimented with *in response to* that doubt varied, because the tools, texts, methods, and experiential data they had in hand varied. Petrarch, growing up with questions, had Cicero. Ficino, growing up with questions, had some new Plato and Aristotle, plus Petrarch and Cicero. Pico had

the same plus Pythagoras and Kabbalah. Machiavelli also had Lucretius, Pontano, plus other new handbooks of princes written by experimental *umanisti*, plus his observations of Pope Julius and Duke Valentino. Jumping back in time, Peter Abelard had new ways to use Aristotle, and that was enough to let him doubt the authenticity of Saint Denys. Jumping forward, Kristina of Sweden will have her "vain and curious Sciences, as *Chymistry, Astrology,* the *Divining-Rod.*" A generation beyond Kristina, Charles Blount will have Hobbes, and barometers and lenses, and an academy of scientists to share their observations of Nature. Same questions, different inputs, different outputs. And (I usually mention as a consolation to my scientific friend) we have these twin studies which suggest that genetics have a role in faith and doubt, since separated twins often wind up with the same *degree* of religiosity (both devout, both agnostic, both intermittently practicing, etc.) even if raised in different religions.[70]

So—I say to my new friend—if you had been born in 1450, you absolutely would be a radical freethinker, and you would be tracking down banned books, debating forbidden authors, meeting up with other radicals, and hiding your true thoughts from the Inquisition, but I don't think you'd arrive at *modern* atheism because you wouldn't have Hobbes, Newton, Locke, Marx, Darwin, genetics, or telescopes to guide your answers, instead you'd have Aristotle, Abelard, Averroes, Lucretius, Plato, Petrarch, and the astrolabe. The modern scientific answers core to modern atheism aren't transparent when you don't have telescopes or DNA. It's natural for different data to yield different answers. You would be a radical freethinker, you'd ask the same brilliant, all-touching questions, but, like Lucretius's many Renaissance readers, you might be drawn to any of a wide variety of new, exciting radicalisms which prospered in 1450's wide Renaissance world. And if the 1450 version of you did arrive at atheism, it wouldn't be today's atheism, just as, if Machiavelli was an atheist, his wasn't today's atheism, it was his own gorgeous, unique Renaissance atheism, as alien to modernity's as Ficino's Platonism to our Platonism, or Pico's Christianity-plus-plus to the wildest syncretisms of our present. No one can ask big questions of a different world and come to our world's answers.

It's not a comfortable answer. It's a challenging answer. It's challenging partly because it requires admitting that, since the past version of us would be *wrong* from the point of view of our present, the present version of us is probably also wrong judged by an imagined us fortunate enough to be born in the future when the Big Bang Theory has been replaced by the Better-Than-The-Big-Bang-Theory, and the Hubble and Webb space telescopes seem as limited as looking through Galileo's. I've looked through one of Galileo's telescopes, it's in Florence, and realizing it's less powerful than the plastic Hamburglar binoculars I once got in a McDonald's Happy Meal filled me with new awe that a cunning mind armed with the right questions can get a long, long way with simple tools.

The most challenging thing about this answer is that it requires surrendering the idea that our present was shaped by people who agreed with us. So often we say "a man ahead of his time," or that someone's work "anticipated" a future innovation, or that a persecuted figure "looked ahead" and predicted the coming of our wiser era when humanity would realize Galileo, Bruno, Machiavelli, Hobbes, etc. were right. We're comfortable imagining a Renaissance with an underground of secret proto-moderns working to create our world—it implies that the work *we're* doing will likewise create a future that resembles us. It doesn't only make us feel like we have friends in the past, it makes us feel more in control of our future. Remember how people find conspiracy theories appealing because having *some* structure underlying events feels more satisfying than believing it's random, even if that structure is a sinister conspiracy? Our fiction that touches on the medieval and Renaissance loves to posit a secret underground—works from Neal Stephenson's *Baroque Cycle* (2003–4), to the film *Quest of the Delta Knights* (1993), to Rebecca Meluch's *Tour of the Merrimack* books (2005–15), to the *Assassin's Creed* videogames (2007+), to Umberto Eco's *The Name of the Rose* (1980), all posit secret movements preserving or manipulating the progress of science toward our distant modern day.

It is comfortable believing that people who would agree with us if they popped up in our living rooms intentionally dismantled the old world to create ours. It is less comfortable to admit that our era

was equally born from Pico's mysticism, Ficino's magic, Pomponio Leto's reckless toga parties, Savonarola's sermons, Giordano Bruno's Aristotelianism, Camilla Rucellai's prophecies, Julia the Sibyl's prophecies, Charles Blount's passionate deism, and lots and lots of other threads shooting in all directions, not just one.

We keep asking if Machiavelli was an atheist because we want to believe that big historical changes are caused by people who *intend* to cause those changes, that the hero who shaped us must have been like us. It's harder to admit that the real consequence of Petrarch calling for peace and humanistic education was Roman pediments on African capital buildings, and nineteenth-century nationalists competing to bowdlerize their local paganisms. The possibility that Machiavelli *could* have been some different kind of radical, instead of a familiar proto-modern, challenges us to rethink *agency*, to rethink how *intentional* history's changes are. Giving up on believing in a Renaissance underground in which *most* Renaissance heroes (Lucretius readers, Leonardo) were secret proto-moderns means questioning how much the visionary future-makers of our day—the kind who get featured on tech magazine covers with headlines like "Will This Man Be the First to Live Forever?"—know about what their actions will actually do to our future. It makes sense that we tend to exaggerate the historical influence of those who look like us. It's uncomfortable admitting that we owe our world to people who wouldn't agree with us, and that those who *did* agree with us did not shape us more than their unappealing contemporaries. Savonarola shaped us as much as Machiavelli, and Hobbes's opponents shaped us as much as Hobbes. If we accept such plural, multivalent agency, that the unintended consequences of many contradictory projects shape our present more than anybody's master plan, then how do we understand our own efforts to shape the future?

I will return to this question in the last section, and try to zoom out to a portrait of historical change that is at once authentic and actionable, honest about the uncomfortable messages in our sources, but optimistic too.

But first we have an MA exam to pass.

55

Was Machiavelli a Humanist? Part 1

It was Dante who set the precedent of suddenly putting the reader through an MA exam in the middle of a book: he does it in *Paradiso*, where it turns out that advancing to the higher spheres of Heaven requires passing an oral exam in theology administered by the sanctified soul of Thomas Aquinas. "Was Machiavelli a humanist?" is what I was asked on my MA exam, and it's a brilliant invitation to review and test our definitions.

Was Machiavelli a Burckhardtian self-fashioned individual? He did the self-fashioning things, writing and circulating histories, poems, productions of his plays, caring about his reputation and appearance at court, though Machiavelli's choice to stay in obscure exile and turn down politically prominent advancement outside Florence suggests that he cared about at least one masterpiece more than himself—Florence, his state which was so much *a work of art*.

Was Machiavelli a part of romantic dramas in grand palazzos? Absolutely, those desperate letters from loved ones overjoyed that he survived the massacre at Senigallia record it perfectly.

Was Machiavelli a civic humanist as Baron would recognize? Certainly, nothing could have been more important to him than political participation, *even though* he was barred from core offices—in every way he could he participated in, described, helped, theorized about, fought for, and influenced his republic... though *The Prince* shows his willingness to support monarchy too, when the regime had changed.

Was Machiavelli part of the *studia humanitatis* as Kristeller wants? Certainly he studied it, and that letter about putting on

his court finery to step into his library expresses Petrarch better than Petrarch. He did not teach, was no Latin teacher, but he did annotate and correct his manuscripts of Lucretius and Terence, comment on Livy, mine many classics for examples, and his diplomatic career was a path common to those we call *umanisti*.

Was Machaivelli someone who, as Riccardo Fubini catches *umanisti* doing, devoted more time and thought to worldly questions than his scholastic predecessors? Absolutely.

Was Machiavelli someone who gets a letter from figures like Erasmus? Yes, he wrote and received learned Latin letters, though most of Machiavelli's correspondence was, like his works, vernacular (Italian), and his letters are mostly either fun but personal, or detailed analyses of the immediate political situation, focused more on living dukes than on the syntax of Catullus or the word use variants in Seneca. We don't have a fat collection of Latin Machiavelli letters, just a few; we mostly have a statesman's letters, not the kind one exchanged with Erasmus. That he delivered commentaries on Livy to friends in the Rucellai gardens in Florence tells us of his activities in learned spheres, but in letters at least he was more statesman than philologist.

Was Machiavelli someone who could activate antiquity? Here we must, with Abelard, say yes *and* no. His works are saturated with antiquity: ancient examples, ancient anecdotes. He styled his *Discourses* as a commentary, his *Mandrake* as a Plautine comedy, composed his *Decennale* in *terza rima* like Dante, and constantly referred to the ancients, *but*...

... did he use antiquity *the way the* umanisti *did?*

We know he didn't.

Machiavelli's candidacy for the position of "first modern philosopher?" rests in part on his innovative use of history (including antiquity), *not* as a source of moral models to be absorbed, but as case studies to be analyzed, searching the past to understand *the hidden causes of things*. That is not the same activation of antiquity.

And now I must reveal that, all this time, I've been secretly agreeing with my PhD dissertation adviser. (I did warn you not to believe me.)

56

Virtue Politics

All this time, I have been talking about the Renaissance's classicizing project as one, not just of idealism and liberal arts values, but with concrete political aims: to bring peace and heal wounded Italy and Europe by raising its leaders on the library that shaped young Cicero—a library whose *words that sting and bite* would spur rulers toward *virtue*. Virtuous rulers would rule more successfully, more prudently, more generously, and displays of virtue in art, architecture, pageants, and orations would produce virtuous citizens, who (unlike the feuding Montagues and Capulets and Guelphs and Ghibellines) would put the good of homeland above honor and ambition.

This is a hybrid understanding of Renaissance humanism, between Kristeller's idea of humanism as a purely educational movement and Garin's idea of humanism as having a defining ideological core. In fact, it hybridizes most of our ideas of humanism. Like Baron it posits a political focus, though not one limited to republics or office-holders. Like Burckhardt, it posits a focus on the cultivation of the self, the virtuous individual a newly important goal. And, like our less formal definitions, it depends on activating antiquity, on the webs of learned letters about virtue, prudence, and good rule exchanged among participants, and on the romantic palazzos where those educated in the *studia humanitatis* lived and wielded *grace*.

This way of understanding the Renaissance has a name now: **virtue politics**, the Renaissance project to use the study of the classics to cultivate virtue in Europe's ruling elites, using a *particular* method and aiming to advance a *particular* stability-seeking

political agenda.[71] That the method and political agenda are particular is key, because medieval elites were *also* raised on the classics, and medieval education *also* centered virtue, but Renaissance *umanisti* and their patrons and students did so in different ways (for example, exaggerating their classicism), and for different reasons (for example, the hope for European peace). The project was to heal Italian and European politics through cultivating personal virtue, a union of soulcraft and statecraft.

The virtue politics model fits our edge cases. It has room for the patrons who liked and supported it even if they weren't themselves raised by *umanisti*. It has room for the diplomats, secretaries, and churchmen who studied the *studia humanitatis* but didn't teach it. It has room for the women who studied, read, wrote, and even ruled, but didn't receive jobs or *reciprocal* letters from male humanists. Niccolò Niccoli is in, Cosimo de Medici is in, Raffaello Maffei Volterrano is in, Pope Nicholas V (library founder) is in, learned virtue-advertising kings like Alfonso the Magnanimous of Naples are in, and Alessandra Scala, Cassandra Fedele, and Lucrezia Borgia (who worked so hard to impress people when she was a duchess) are all in, while Valentino, Julius II, Henry VIII, Cardinal Ascanio Visconti Sforza, and his Latin-speaking parrot are all figures who interacted with the movement, and made self-fashioning political use of it, but did not embrace it, *not even* by publicly feigning Roman virtues, as Pontano and others advised leaders to do. Whether one reads Lorenzo de Medici as a hero or a villain, even the most hostile interpretation identifies, in his letters and patronage, a good follower of the advice: *if you don't got it, fake it*. Whether Lorenzo had it or faked it, he engaged in virtue politics in a way Valentino didn't, and in a way Savonarola didn't—the virtue Savonarola preached, and the political reforms he attempted, were not classicizing ones, but different, though shaped by his dialog with *umanisti* and the shared feeling that the world needed reform.

Virtue politics redefined nobility, the culmination of Bruni's new definition of knighthood and Donatello's Caesar-like *Saint George*. By claiming *true* nobility lay in the exercise of virtue, it advanced a merit-based or action-based model of nobility, relocating political legitimacy from blood and chivalry to moral

education, character, and deeds. Legitimate power equaled power virtuously exercised. This was appealing in an Italy full of new powers, where traditional legitimacy was virtually absent, so newborn republics, mercenary tyrants, and the subjects of both all needed an understanding of nobility which could exist in, explain, and shape their political reality. It also appealed in a Europe with a bad case of Musical Thrones, in which virtually every monarch had to fear rivals with better blood claims; if virtue equaled legitimacy, then a triumphal procession, and giving the pope a particularly showy obedience oration before the eyes of Europe could make up for an embarrassing genealogy.

This is a bigger change than it may seem. Italy suddenly redefined nobility, putting Roman antiquity at the center. Europe's other powers largely consented, racing to fill their courts with antiques and Italian arts, excited to have this new, non-military axis on which to compete; like the Space Race, the classical culture race could let powers compete while keeping wars cold, and even the costliest *umanisti*, sculptors, and busts of Caesar cost orders of magnitude less than fielding armies. There were benefits to any power getting into the classicism race, but it meant that, for more than a century, Europe invested in a power game in which—despite Italy being a fractious political disaster pit—Italian powers had a huge advantage, since the Italian peninsula would always have the most Roman stuff and the most Italian arts.

The propaganda coup of Virtue Politics failed to defend Italy from plagues, feuds, and invasions, but it did establish the importance of Italy's culture in a way which prevented the cultural assimilation Petrarch had feared. Foreign swords in Italy, he feared, meant Italians wearing Spanish fashions and singing German pub songs. Instead, Petrarchan sonnets and classical themes entered pub songs and plays in a dozen countries, and Italian arts and culture were so treasured by Europe that conquerors and invaders protected, nourished, and diffused them. In the centuries after 1500, different parts of Italy were conquered several times, but *Italy has never to this day been conquered by a nation that did not respect its culture*, so its treatment in its years as a colony was very different from that of most conquered places. Italy's languages, texts, and art treasures were consistently protected:

looted, yes, but valued, almost never intentionally destroyed, thanks to the same defense mechanism we saw Cosimo deploy against our imaginary envoy so many years before: you don't want to *burn* this, you want to *have* it. Italy defined itself as the win condition of the culture game, and soon, not only did we have Hungarian warlords using laurel wreaths to impress the heirs of Vlad the Impaler, but Lucretius also reached Voltaire's bookshelf, and Epicurean materialism entered Hobbes's thought, thanks to the same momentum that spread equestrian statues and Greek tutors. The virtue politics project protected and disseminated even Epicureanism, a system fundamentally at odds with many of the hybrid classical-Christian virtues humanism celebrated, a fact which demonstrates how the educational movement ultimately spread much farther than the project's virtue politics core.

This virtue politics attempt to remake Europe, like many great ambitions, had many consequences, great and terrible. The great? There was the rise in library-building and demand for manuscripts, which triggered the print revolution and many related innovations. There was the birth of liberal arts education.[72] There was the preservation of antiquities—poor Raphael living in 1519 Rome watched wheelbarrows full of Roman marbles going by daily outside his window on their way to being destroyed to make mortar for the Eternal City's building boom, but Castiglione helped him phrase a protest in beautiful classicizing Latin, and together they convinced Leo X to ban the practice, the first regulation protecting antiquities.[73] There was the idea that rulers should be judged by their virtues and deeds, which contributed greatly to ideas of political accountability, of governments having a responsibility to their people, of constitutional monarchy, and ultimately Locke's concept the right to rebel. There was the role of the humanities in fostering discussion of humane values, including the duty of those in power to advance such socially constructive virtues as truth, justice, charity, temperance, and access to learning. There was the pacifist, anti-faction, anti-feuding, anti-civil war message which never ceased to be important to those who held Petrarch's old plea dear. And there was the idea that education makes nobility, and that a child of gold like Poliziano may be born to parents even of the lowest rank—that now-familiar hairline crack which gradually

widened toward the radical idea that all humans might be created equal. As for the terrible consequences, these we shall visit in our final section, but you know our humanists preferred imperial Vergil to anti-war Homer, and that the age of European empires spread more violent things than classical pediments around the globe. And, finally, there was a component that some call great and others terrible: the greater quantity of study devoted to worldly issues, government, cities, social dynamics, people, social sciences, a shift in the *proportion* of focus given to different issues, which yielded new worlds of pious, virtuous political and ethical thought, but paved the way for secular and atheist thought too.

The term virtue politics helps us understand this intellectual movement as simultaneously self-interested and sincere. Its enthusiasts hoped and expected that youths steeped in classical virtue, and rulers surrounded by virtuous courtiers, would rule more justly and successfully. For an ambitious bank clerk or minor land-owner, getting one's son an education in the *studia humanitatis* was a ladder to a good career, but also meant participating in this aspirational effort to obtain a new form of nobility and create a golden age; a medical or law degree, which often offered larger salaries, did not feel like they made one part of changing the world (not until the early Enlightenment would make law and medicine feel more like new frontiers). For a rich Renaissance ruler, many other, non-humanistic tools of political legitimacy were likewise available: jousting, church-building, crusading, other architectural styles, exotic animals and objects, fireworks displays, showy pardons or showy executions; many of these tools were connected to older ideas of virtue such as chivalric virtue, or Christian virtue.

To add virtue politics projects to one's royal budget, to arrange to be seen in public standing between two Greek scholars as Shakespeare's Richard III arranged to be seen between two priests, was to embrace the addition of a new model of nobility in which rulers invited others to judge them by these new, learned virtues which were not (unlike chivalric virtue) associated with blood nobility, they were virtues *any social class* could have, and to display them was to prove one was good *above and beyond* one's blood—in effect to enter into competition with the whole of humanity, not just those one might invite to a joust. That was

a significant choice. As princes and cities decorated their libraries as proudly as their armories, they could have (some still did) just concentrated on their armories. If some were sincerely touched and shaped by classical values and chose to plunge into this new and larger competition of *human* virtue rather than *hereditary* virtue, others saw humanist courtiers as mere court furniture, yet even a halfhearted patron like Pope Julius might sustain sincere intellectuals like Raffaello Maffei Volterrano, advancing this change in the role of virtue in politics, and enabling the diffusion of knowledge in a world where a single manuscript cost several years' wages for a humble scholar.

Virtue politics didn't have a name when young Ada Palmer, excited by how the First World War influenced Freud, started my PhD at Harvard, studying with James Hankins. In those years it was still something he struggled to name, something I learned to feel as I read more texts and tested out the definitions of humanism available at the time. It took a long time for him to name it, and I had to wait even longer for the arrival of Jim's whopper of a book—*Virtue Politics: Soulcraft and Statecraft in Renaissance Italy*—which, at last, gave me something more concrete to cite in footnotes than, "Lunch with James Hankins, John Harvard Tavern, February 2006." (In fact, despite starting to work with Jim in 2001, I finally heard the term virtue politics for the first time in 2013, at that little meet-up at the Vergil Villa where we traded our unpublishable definitions of a humanist as someone who can activate activity, or gets a letter from Erasmus.) Jim's virtue politics thesis is new to the field of Renaissance studies, the latest big theory alongside Baron and Kristeller, with 700 pages of well-footnoted small print to back it up, but which the world of scholarship must chew on, test, apply, revise, improve, and will, no doubt, in time surpass and replace, just as we will someday have the Better-Than-The-Big-Bang-Theory.

My articulation of virtue politics is not identical to my adviser's—naturally, we've studied different things. My version focuses more on the Renaissance turning antiquity into a language of power, on how the classical revival operated as a defense mechanism, on how the *studia humanitatis* affected science, on censorship and forbidden things (magic, atheism, sodomy), on

female intellectuals, and on the hypocrites and exploiters of the system—Battle Pope Julius, eye-gouging Ippolito d'Este, Ascanio Visconti Sforza and his parrot—who took advantage of the *ideals* of Virtue Politics, and funded its practitioners, while remaining pretty awful human beings. My articulation focuses more on the later 1400s and the disasters of the Italian Wars, while Jim's book mostly looks earlier, at Bruni and his peers. My articulation focuses on tracing Renaissance virtue politics' relationships to later European movements—to the Enlightenment, deism, Diderot, and Hobbes—while his compares it to other world movements, especially Confucianism. And my articulation is both more open to and more excited by the link between the worldly project of our pious *umanisti* and my beloved Enlightenment atheists. Meanwhile, my first PhD student John-Paul Heil's articulation of virtue politics focuses more on social networks, on the patronage and marriage ties between Naples, Ferrara, Hungary, and Milan, and my second student Brendan Small's focuses on Rome, and the tricky balance between republican city and monarchal papacy.

I say all this to show you what the first steps are of testing a new thesis in the History Lab, what the steps were that Hans Baron's students went through, and Garin's, and Kristeller's, of whom Jim Hankins is one. We develop a portrait of what we find, test and explore it, publish, invite other scholars to try applying it to different times and places (early, late, north, south) applying it to different people (pamphleteers, hypocrites, Muslims, popes, nuns, Caterina Sforza) until we find its edges, tweak, improve, and in time advance from the virtue politics theory to the Better-Than-Virtue-Politics-Theory, just as we advanced from Baron's civic humanism to virtue politics, and from Greenland's Norsemen dying out from climate change to our current theory with the walrus ivory and the Black Death. Each step, each new discovery, each dissertation helps, each good name for a core idea too—*virtue politics* useful like *civic humanism* or *the state as a work of art*. And this is why we need to *keep* writing new histories, even of places like Renaissance Florence that already have hundreds of histories.

Now, back to our MA exam.

57

Was Machiavelli a Humanist? Part 2

If we accept virtue politics as our best attempt so far to articulate an ideological heart of the Renaissance, then Machiavelli was doing something different. He had the education, read the texts, but he was seeking the hidden causes of events, treating the classics as a casebook of examples to analyze so one can take more prudent actions on the battlefield—not the same thing as trying to achieve political stability by teaching leaders patience, generosity, and prudence. Machiavelli was not just a product of the *studia humanitatis*, he was a fourth-generation product, reading Livy with tutors of Ippolita Maria Visconti Sforza's generation, who were raised by tutors of Francesco Filelfo's generation, who studied books gathered by Poggio Bracciolini's generation, whose parents knew Petrarch. The virtue politics project had been underway long enough that even Europe's oldest rulers had tasted it as toddlers, and yet the wars were getting worse. *Must invent political science.* Machiavelli was a passionate lover of the *studia humanitatis*, a product of virtue politics, but he saw the project to save Europe by instilling virtue in its rulers as a failure. If the *studia humanitatis* did produce some philosopher princes like Ippolita Maria Visconti Sforza and Alfonso the Magnanimous, it just as often produced their next generation kinsman, entitled Ippolito d'Este. The wars got worse. After a century of putting Petrarch into practice, Machiavelli looked around still-wounded Italy and said: *It isn't working; saving Europe requires something new.*

Even Machiavelli's use of the term *virtù* (over which more ink has been spilled than over some entire nations) is different from the classical virtues of virtue politics, including bold attacks

and canny betrayals. *Umanisti* before Machiavelli said rulers should *seem* to have those virtues they lacked, but the positive outcome of displaying false virtue was supposed to be that citizens would absorb and imitate it, making the people better, plus the Aristotelian habit-of-virtue hope that you might pick it up yourself. Machiavelli's *if you do X, the people will trust/obey/fear/follow* is wholly different—the people don't *imitate* or *learn* the ruler's virtues; the outcome is manipulative, not didactic.

Let's look again at *Discourses* II.2 where Machiavelli says that Christianity taught humanity the truth but made people love liberty less, valuing deeds of contemplation over deeds of valor, a problem he frames as "the difference between our education and that of antiquity." If Petrarch had written those words, he would have meant that scholastic classrooms and pedantic tutors lacked the lost books that had raised young Cicero, but Machiavelli is writing well over a century later, this education he is criticizing *has* those books, recovered by the generations in between, but it fails anyway. In the preface to Book II, Machiavelli discusses how people tend to think antiquity was better than the present, *and that they're wrong*, that people think this because, in the present, we see every failure and feel the sting of every disaster, while when we read about antiquity from afar, the bad moments don't hurt us and thus seem small. He adds that many peoples have been conquered recently and a conquered people—whether Greeks under the Ottomans or Italians under their various dominators—have many reasons to criticize their abject present, but that some parts of the world are just as excellent as any ancient polity. He then gives a mini-history of where the world's "virtue" (*virtù*) has been centered: first Assyria, Media, Persia, then Rome, then after Rome in the Kingdom of the Franks, the Saracens, the Turks, and at present in the Ottoman Sultan, war-ready Switzerland, and the Germanies. Machiavelli didn't even agree with Petrarch and Bruni that there was a bad Middle Ages, just that success and skillful politics migrated from one polity to another over time, and that one should imitate the best, Rome when Rome was prudent and successful, others equally whenever history opens its pages to reveal tools of success. But if, *c.*1500, Italy had lost

so much so quickly, the *studia humanitatis*, blended as it was with Christianity and Heaven-seeking otherworldly virtues that would teach the soul's eye to point up not down, this was a cause of the present disasters, not their solution.

The virtue politics lens lets us see that Machiavelli was, in one critical way, closer to Savonarola than to Ficino or Poliziano. Both the apocalyptic preacher and the Murderous Machiavel were products of a world long saturated by *umanisti*, generations into the project of virtue politics, and both concluded that virtue politics was not giving the world the transformation it so badly needed. They proposed incredibly different solutions, but they both perceived the same problem. And another innovative perceiver of that problem lay on the horizon, shaped by the fourth generation of the *studia humanitatis* and observing the continued tumults of this desperate a century: Martin Luther. Luther—like Machiavelli and Savonarola—grew up with Vergil and Ovid, the old educational starter set which had been used in medieval classrooms for centuries, but which were now *transformed*, layered with new ideas. A full look at Luther's relationship with the *studia humanitatis* and its practitioners would be a book in itself (Erasmus's involvement in the triangle another),[74] but we can glimpse one connecting thread in his last words—a written note found in his room, in Latin, with the last sentence in his native German, records how much the study of the classics as a tool of good government had touched even a man we think of as so very different from the (secularizing?) currents of our humanists:

> No one can understand Vergil's *Bucolics* unless he has been a shepherd for five years. No one can understand Vergil's *Georgics*, unless he has been a farmer for five years. No one can understand Cicero's Letters (or so I teach), unless he has busied himself in the affairs of some prominent state for twenty years. Know that no one can have indulged in the Holy Writers sufficiently, unless he has governed churches for a hundred years with the prophets, such as Elijah and Elisha, John the Baptist, Christ and the apostles. Do not assail this divine *Aeneid*; nay, rather prostrate revere the ground that it treads. *We are beggars; this is true.*

Even Luther called theology's sources a divine *Aeneid*, after the text that so many generations (since long before Petrarch) had turned to seeking virtue, and whose labyrinth was far from mapped over a thousand years of study. There was not an impenetrable wall, even in Luther's mind, between the educational projects and methods of improving the soul through pagan authors and Christian. His idea that the solution to Europe's crisis lay in returning to Christianity's ancient sources echoed the return-to-sources project of the *umanisti*. While Luther developed new methods for reading the Bible very different from anything practiced in the *studia humanitatis*, his project of retranslating and correcting Scripture used new translation methods, and new tools for understanding Greek, developed when Ficino had translated Plato, Poliziano Homer, Valla Aristotle and so on. The meticulous philology of the *umanisti*, and their multi-generational teamwork assembling Greek and Latin lexicons, helped Luther to expose centuries-old confusions caused by the distorting word-for-word translation methods the ancients had applied to Christian and pagan texts alike. The Reformation was a new and different intellectual world, several new worlds in fact, but Luther and the movements which followed were not only sparked by the increasing corruption of the Eternal Problem City, but by many other factors, among them the availability of new scholarly methods, new libraries, and the observation Luther shared with Machiavelli and Savonarola, that the century-old effort to heal Europe via the *studia humanitatis* had not (yet?) succeeded.

Was Machiavelli a humanist? In every social sense yes, in every educational sense yes, in his heart which thrilled at access to a manuscript of Terence absolutely yes; but he was also a critic of the core project of virtue politics, and a rejector of its myth of a golden antiquity, and of worthless Middle Age of ash and shadow. His Lucretius marginalia—so radically different from the interests of his peers—signal a man *different from* his teachers, aiming to convince his peers to try to reshape their still bleeding world in a new way. And he was not alone.

PART V

The Try Everything Age

We now have a nice mosaic of some traits which define Renaissance: the classical revival, virtue politics, banking and commerce, self-fashioning, romantic drama in palazzos, the *studia humanitatis*, new political ideas (some born in republics), learned letters buzzing over Europe, library-building and the printing press, the expert activation of antiquity, and the Middle Ages' escalating Ever-So-Much-More-So. But if the Renaissance began vaguely amid the Black Death's aftermath, when did it end, or change? And why? Machiavelli critique can't be the end or turning point, his ideas weren't famous in his lifetime or the decades after, and we still have a century of Renaissance to go. What changed?

Was it the Reformation?

Yes and no.

Martin Luther's firebrand days were not the end of the long Renaissance, since Shakespeare's parents hadn't yet been born when Luther's 1517 pamphlet took Europe by storm. Remember how my colleagues in the Italian department debate whether Machiavelli is too modern to be called Renaissance, while the English department across the green considers Machiavelli's English contemporaries still almost medieval. The Reformation did change Europe's world enormously, and by now you understand the reasons half of Europe finally determined to break free of the ever-more-corrupt and warlike papacy and its ongoing prisoner's dilemma, even if it cost a lot in blood, and in *legitimacy*.[1]

You also know how Luther's feeling that Europe needed radical change had the same cause as Machiavelli's critique, Pico's syncretism, Petrarch's lament, Savonarola's sermons, Poggio's willingness to trek across the Alps to look for manuscripts, even Boccaccio's incisive jests—all desperate responses to a desperate time. But if Luther's had a different impact, it was all still Ever-So-Much-More-So, and even as wars of religion set fire to the continent, our X-Factors (banking, self-fashioning, political engagement, the *studia humanitatis*, virtue politics, letters from dear Erasmus) were still Renaissancing along.

The quest for legitimacy also continued, on grand scale and small, as dukes and queens collected ancient gems, scholars, frescoes, holy relics, illuminated books, $10,000-a-yard velvets, exotic animals, and statues of themselves in Roman dress, while bank clerks' sons at universities collected the same on their small scale: Roman coins, woodcut prints of famous artworks, saving up for a stripe of velvet trim, a crusader's finger bone, a parrot-feather plume, a new book, one of the Papillon puppies Titian famously bred,[2] or perhaps even a portrait holding one. These collecting appetites fed the Age of Empires, creating the same glory-by-conquest (or legitimacy-by-glory) impulse which made Florence crave to conquer Pisa and France to conquer Naples turn outward beyond Europe, as the imperial ambition which made the 1400s prefer Vergil to Homer partnered with monarchs recently risen to precarious thrones, who often acted on the advice Shakespeare has Henry IV give young Henry V: "Be it thy course to busy giddy minds / With foreign quarrels; that action, hence borne out, / May waste the memory of the former days." (IV.iv). And as all this kept unfolding, so did one of the most world-changing types of Ever-So-Much-More-So of them all: *an information revolution.*

58

An Exponential Information Revolution

Something changed between the Renaissance and the Enlightenment to make us feel they merit different names. We glimpsed it when I told you Machiavelli's annotations in his copy of Lucretius were unique for 1500, but that by the 1570s the majority of annotators marked science and medicine instead of the Vergilian poetry. What happened?

One major accelerant of Europe's Ever-So-Much-More-So, in addition to the wealth and new resources streaming in from its new empires, was an information revolution: not new technology (we're on the Gutenberg-type press until the nineteenth century) but a *distribution network* revolution. Let's jump back a moment to see the change in action.

1450: Demand for manuscripts is sky-high thanks to the vogue for library-building (hello, Petrarch) and the exciting new career path *umanista*. Johannes Gutenberg creates a brilliant device which can produce 300 copies of a book for the cost of one manuscript (and will in the year 2000 make him *Time Magazine*'s Man of the Millennium)! He prints the most high-demand books he can think of: a grammar textbook and a bible. There are maybe twenty school-bound youths in his landlocked German village who actually need a grammar textbook, and only clergy are legally allowed to read Scripture, so at most three people want to spend thousands of dollars on a bible right now. Congratulations, Mr Gutenberg, you have 280 unsold grammar textbooks and 297 unsold bibles, what are you going to do next?

The answer was *go bankrupt*, which he did. His creditors took his shop, tried to go into printing, they went bankrupt.

Apprentices who learned the method from him tried printing Cicero and Seneca, but they went bankrupt too; there were 300 people in *Europe* who wanted Cicero at that moment, but they were scattered over 80 towns. In a world of artisanal production, with few mass-produced commodities beyond coins and still newfangled woodblock-printed playing cards, this costly mass-produced commodity did not have a way to reach the rich but far-flung buyers who were building libraries.[3] Ficino could afford to print his Plato because Lorenzo de Medici was happy to pay for printing 300 copies of a work which so glorified his family and city, but printers living on book sales required distribution methods. Think of e-books; technically the first e-book existed the first time someone typed a book on a computer, but the e-book *market* did not exist until the release of the first e-reader, which made a distribution system, a way to buy and sell this newborn thing. Some of Gutenberg's apprentices fled their debts as far as Venice (it's where you flee), married Venetian women, and started print shops there in the Mediterranean's biggest port where (think of airport hubs, Heathrow, O'Hare) if you had 300 copies of Cicero, you could sell three each to a hundred different ship captains bound to different cities where they could find buyers. Landlocked Germany took a bit longer to develop its system: book fairs like the famous Frankfurt Book Fair, first firmly documented in 1462 but mostly thriving after 1500, in which once a year hundreds of printers got together, each bringing 1,000 copies of the three books they'd printed that year, and leaving with 10 copies each of 300 different books to sell at home (or with a wagon full of gouda, having sold all their books to other buyers).

The printing press also spread exponentially, so—like anything exponential—growth was slow at first.[4] Gutenberg had *one* press; his apprentices had four or five, their apprentices had ten or twenty. Much like the puzzle where you put one penny on the first square on the chess board, two on the second, four on the third, doubling each time until you have trillions, you still need to get to the third row before you have a *lot* of cash—just so, each printing press had to be built by someone who'd learned to make one from another printer, so the innovation spread *exponentially*,

AN EXPONENTIAL INFORMATION REVOLUTION

reaching large cities first, then medium, taking generations to reach smaller towns and saturation point.

In parallel to the books-on-boats and books-for-cheese economies of Venice and Germany, the period also saw the growth of a *news* economy.[5] News, like always, moved at horse speed, and there had long been semi-professional news riders, people who traveled back and forth between cities, arriving in each with news of the other, delivering it to patrons and associates in return for pay and hospitality, and gathering new news to carry back. Such riders carried written documents as well: copies of letters, speeches, sermons, edicts, new laws, or trial outcomes. With printing came not only books, but broadsides (a single-sided sheet printed in one day), and pamphlets (a thin bundle of pages printed in a couple days) which could make hundreds of copies of a piece of news, and send it out *much faster* than a professional gossip could spread his news around a town and court. This transformed already extant news-rider networks into pamphlet networks: a rider sent from Milan across the Alps to Geneva carried a couple copies of every pamphlet he had found available in Milan, which would include some brought there from Venice, Florence, Naples, and Rome. The instant he reached Geneva, printers would pay him for the pamphlets and print their own versions, ready in three days to flood Geneva with exciting news, and to enter the bags of riders heading west to Lyon, north to Strasbourg, north-west toward Paris via Dijon, each city large enough to have a printer multiplying the pamphlet 500-fold.

This is how Luther's words were in print in London *seventeen days* after they went public in Germany.[6] Not all pamphlets were serious—many were tales of a flying mermaid, the visions of an unrecognized weird saint, a totally invented account of a crusader siege, vacuous speeches delivered at a ducal wedding, a satire on the Bishop of Paris set to the tune of a well-known harvest chanty, or a classic scandal rag, like *A Cruel and Moving Case in the City of Padua of a Gentleman who Killed a Manservant with the Connivance of His Maid, Poisoned His Wife, Cut Out the Heart of the Maid, and At Last Set Himself on Fire*.[7] But pamphlets meant that in the 1510s new ideas could reach thousands in the time it took to reach dozens in the decades when there were printing presses but not yet networks.

Like some strange Goldilocks and the Three Bears, Savonarola's radical ideas caught fire too soon, Machiavelli's—gaining fame only later when the censorship of print was more advanced—too late, but Luther's call for change was timed just right, when the printing press and pamphlet distribution networks were just swift enough (and censorship just underdeveloped enough) for his 1517 *Ninety-Five Theses* to saturate Europe within a month, unlike Savonarola's pamphlets which—though printed only two decades before—did not have networks to get them much past Tuscany, and the authorities were fast enough to stomp out such a fire. Ficino too had shared Machiavelli's feeling that the Italian Wars showed a failure of virtue politics, and turned from writing long learned tracts to drafting his 1493 *De sole*, a short, fast, easy-to-read guidebook to how to make souls good *right now!*[8] Ficino dedicated his last years to sending copies of his *De sole* to absolutely everybody everywhere in Europe he could reach, but at Ficino's death in 1499 even a famous scholar had to work hard over months and years to touch all Europe's great courts—by 1517 Luther could reach 1,000 times as many people with a fraction of the effort.

Ever-So-Much-More-So accelerates in information revolutions—we feel that today living in the digital revolution, when every few years a new disruptor changes how information moves: cassette tapes shaping the Iranian revolution, cellphones the Arab Spring, social media the 2016 authoritarian surge, etc.). As 1500 became 1560, and ever smaller towns made it onto the printed news network, the Renaissance's Ever-So-Much-More-So gained momentum, new ideas reaching millions instead of thousands.

Was the transition out of Renaissance just Ever-So-Much-More-So clear up to the present? In some ways yes, but in some vital ways no. Our X-Factors were all continuing, the number of banks, and classical façades, and self-fashioning literary dialogs, and *studia humanitatis* classrooms multiplying even as scholastic classrooms kept on multiplying too, in Europe and its empires from Mexico to India. But I want to zoom in on one particular thing which did, around 1600, undergo a major transformation: the answer to *how do we make a golden age?*

59

We Can't Just Abelard Harder Anymore

The camel whose back broke at last was as much a medieval camel as Renaissance. In 1123, Peter Abelard attracted Woodstock-sized crowds using *The Philosopher* (Aristotle) to make two seemingly contradictory authorities agree. In the 1260s *The Theologian* Thomas Aquinas demonstrated this wedding of authorities even more potently, and all supporting Christianity. In 1345, the circle of scholar-friends of whom the Black Death spared few but Petrarch read Cicero's so-Christian-seeming moral works, and spread the dream of tracking down more missing scraps of Lady Philosophy's torn gown. It would all fit together, they were sure, as one saw from how much Plato, Aristotle, and (pseudo-)Dionysius agreed with Augustine. Cue book-hunting Poggio, Filelfo, and Aurispa trekking out. Cue re-translation, as master philologists like Lorenzo Valla, Pomponio Leto, and Poliziano give us a larger and stranger classical canon (we were so wrong about what Aristotle said!). Cue our charismatic genius Pico Abelarding harder than any man dared Abelard before, merging Kabbalah, Zoroaster, and the Koran, held together with Platonic baling wire. They *must* agree, they're *wise*, and Plato and Aquinas both say all *wise* people are trying to paint word-portraits of the same truth glimpsed from slightly different angles.

Ada Palmer, the bright-eyed bushy-tailed grad student, found my Renaissance buddies Abelarding hard like this as I trekked through the archives seeking what they said about Lucretius. Some claimed Lucretius doesn't *really* deny the immortal soul, offering other interpretations of those lines, or saying he wrote those sections while ill and temporarily insane, or that a wholesome

Roman like Lucretius (friends with Cicero!) never believed such things but was repeating things Epicurus had said, who was farther from Christianity so more confused. But Lucretius is very hard to Abelard, it gets awkward, and half the commentaries resort to saying he was intermittently insane, to explain the times he gazed away from the True Subject of the universal portrait and started doodling these wacky atoms. As trips to Greece and back brought home more books, Lucretius was far from the only nail that refused to be hammered down.

And Lucretius's arrival in 1417 was nothing to how hard it was to Abelard after 1517, amid the many truth-claims of fracturing Reformation Christianity. Erasmus tried earnestly, our loved-by-all-sides Prince of Humanists, attempting to reconcile Luther with Church Fathers and the Vatican, but the rival readings of both scripture and practice fragmented far beyond the possibility of union.

Also impossible to Abelard is geography, when Ptolemy and old maps have Jerusalem at the center but, *Hello! It's 1492 and there's another continent!* It's also hard to Abelard the new plants and animals arriving from the New World, Asia, and coasts of Africa that *totally contradict* what Aristotle's successor Theophrastus tells us about plants and animals. Medicine is a problem too: thanks to interest in touch, dissection, and anatomy, related to the skill of artists depicting bodies among many other things (see Pablo Maurette's brilliant *The Forgotten Sense*) the 1500s see troublemakers like Andreas Vesalius (1514–64) and Realdo Colombo (c.1515–59) at the University of Padua (yes, Padua's fault *again*), along with France Michael Servetus (c.1509–53) up in Germany, together totally reordering anatomy and proving that blood *circulates throughout the body in a system*, upending the four humors in balance theory. How in Galen's name are we supposed to Abelard that with... well... Galen? Michael Servetus, by the way, had his works condemned and was executed *(the Church picking on science! Just like Bruno!)* for his Unitarian denials of the Trinity *(ah...)* and it was Calvin's regime in Geneva that condemned him, another case of freethinkers whose freethought went in many different directions.

Wait a minute, why do they have to Abelard geography and medicine and New World plants? No one needs to be burned at the stake for growing tomatoes or cantaloupe, do they?

WE CAN'T JUST ABELARD HARDER ANYMORE

Cantaloupe may not seem like a big deal, but it threatened to overturn the entire social order.[9] Really! Theophrastus's work on plants was part of the justification for belief in *The Chain of Being*, the idea—dominant in medieval and Renaissance Europe—that Nature is naturally hierarchical, with a primate (foremost member) in each category: oaks the primate of trees, lions the primate of animals, whales the primate of fish, etc. The nobler members of each category had noble qualities, like being big, tall, strong, enduring, bright, golden, sun-like, and heaven-oriented. The noblest plants were strong, tall trees which reached up toward the Heavens like virtuous souls, and some of which grew bright, round, sun-like fruits, in gold or scarlet (apples, lemons, apricots), plant-made images of celestial force like gold and gems. Below those were short stiff shrubs, then floppy plants which didn't have the moral fiber to reach strongly toward Heaven, then vines which can't even reach for Heaven under their own strength without leaning on another, then, at the bottom, onions and other tubers which grow downward toward Satan instead of up toward God, like base souls bound for Hell. And there was a correspondence between nobility of *people* and the noble qualities of *plants*, not just that Europe's (better-fed) nobility tended to be taller and (from spending days indoors) paler, but they ate nobler foods. Nobles ate noble fruits that grew on noble trees, and noble cuts of meat from the front (head end, Heavenly end) of the animal, while their servants ate base Hellbound onions, garlic, carrots, and hams from the butt end of the animal. And (here's where biology gives us false positives), if a master and servant switched meals *they would both get sick*. As moderns, we understand this is because our stomachs don't keep producing enzymes to digest things we don't eat, so if a long-time vegan suddenly has a hamburger one will be ill afterward, but for Renaissance people this well-known fact *proved* the hierarchy of Nature, that noble people are *biologically different* from their servants, to the degree they must eat nobler foods.

Enter cantaloupe.

Spherical, golden, sun-like, lying basely on the ground. Are noble fruits *not* fed by tall strong trees reaching high toward Heaven? Are plants not differentiable into a hierarchy? What

rank is supposed to eat cantaloupe? If we were wrong about Nature having a hierarchy of plants, are we wrong about other hierarchies? If plants aren't in a hierarchy, and Nature doesn't have hierarchies, then maybe human souls *aren't* fundamentally different, with souls of iron destined to be ruled by souls of gold? Maybe *everyone* can be educated like Poliziano? Maybe we don't need hierarchy at all?[10] Thus it's possible to say that cantaloupe caused the French Revolution—not by itself, but every crack matters.

And—with cantaloupe, and new continents, and the circulation of the blood, and all these new discoveries—there is an even deeper problem. We could no longer Abelard our way out of realizing some authorities are simply wrong. Overturning old truths threatened more than facts, it threatened *epistemology* and *psychology*, attacking Europe's understandings of how thinking works, how truth works, and how to decide what to believe.

As 1600 approached, the growing storm of new (and old) questions drove the quest for new (and old) tools. The scaphe (bowl) sundial design is attributed to Aristarchus of Samos (3rd *c.* BCE); this 1584 Florentine version by Stefano Buonsignori has four integrated dials for checking results, and a magnetic compass in the center for orientation (Museo Galileo).

60

The Presumptive Authority of the Past

Pico was not the only one who believed that all wise people were sketching still lives of the same set of eternal objects. Augustine, following Plato, says that most people are bad at gazing at the Truth, distracted from the thing they *should* be sketching by the many Earthly pleasures spread around the walls (tempting your soul balloon to gaze downward and lose its helium). Augustine adds, from Christianity, that humanity's capacity for Reason is fractured by the *Corruption of the Will*, one of the costs of original sin. Only the wise, the best—for Plato souls of gold, for Aristotle souls whose Reasons master their Passions, for Augustine souls healed by *Grace*—are capable of ignoring the distractions and fixing the soul's eye on Truth. Such are *authorities*. Wisdom was an attribute of the whole human being, a state of balance, the soul's eye directed rightly, so a wise person should be wise *about all things*, not just an expert in one arena. When the heretic Servetus said the blood circulated *but also said* there is no Trinity, his crackpot blood theory could be ignored, since clearly he was gazing in the wrong direction. It was when the more orthodox Realdo Colombo described blood circulating that the theory gained momentum, since in other ways Colombo had been proven *wise*.

In sum, medieval and especially Renaissance Europe valued *authority*. Most people were likely to be wrong most of the time, foolishly guided by the appetites, passions, and corrupted will. The senses were untrustworthy, overwhelmed by matter's base illusions—if you doubt this, put a stick half-way in water and your eyes will lie to you and say it's bent; how can you trust them about anything once you see that? While the average castle guard

would not use the words *epistemology* and *psychology* to describe this, he understood perfectly well the ubiquitous belief that most people are liable to be wrong a lot of the time, and that the best guide away from error is *authority*, whether accepting what the castle doctor says wise Galen said, or going to fetch Horatio to talk to the ghost because he's a scholar, nursed on wise books by wise men, and likely to be more helpful than relying on your own eyes and ears and common judgment.

We can call this phenomenon *the presumptive authority of the past*—a name given to it by my beloved undergraduate mentor and fellow historian of atheism Alan C. Kors.[11] The logic ran thus: the older and more renowned an authority was, the more scholars and wise people had tested it, confirming its correctness and authority. No major error in a still life could pass through the hands of hundreds of others gazing at the same objects and not be spotted, and no one would have spent the cost of a house to copy over a text that was not depicting something valuable. When an authority says something, that authority is the *strongest* form of evidence, and overrides the two other (weaker) forms of evidence: logic and observation.

For example, Aristotle says bears are born as shapeless lumps of flesh until their mothers lick them into having limbs and faces. You say, "I saw a bear in the woods being born and it had a face." Well, *who do you think you are!*, little no-name random person, to disagree with a wise, white-bearded intellectual giant like Aristotle, whose name has been celebrated in a hundred kingdoms for 2,000 years! You say you *saw* the bear? You can *see* that this stick immersed half-way in water looks broken, but it's not! That these mushrooms look and taste almost the same but this one kills you! That the difference between this way of sowing seed and that one is invisible but this one works and that one brings starvation! And that this communion wafer looks like nothing happened to it even though it just became the flesh of God! Do you want to believe what your fallible senses tell you of this world of shadow and illusion? Or do you want to believe the wise authorities vetted by two millennia of scholars?

The presumptive authority of the past was part of a hierarchy of evidence. Fundamentally there are three kinds of evidence:

observation (I saw it!), logic (I deduced it), and authority (the textbook said it, Einstein said it, *Nature* published it). When we say the modern age has a scientific worldview, that means we strive to put observation at the top, and if a new study, or even an experiment done by an undergrad in Friday afternoon lab, appears to contradict what we believed was true, it is our duty to study that new result and, if confirmed, adjust our understanding of reality to accept it, even if a hundred authorities have said the opposite. There are, of course, plenty of people in the modern world who reject new studies and put authority first, but when you remember that even creationists and Biblical literalists excitedly share scientific studies of things like stone samples that appear to point to a young Earth, and the ridge in the Red Sea that makes Moses' parting of it plausible, you see how even those who personally put authority on a pedestal crave observation to back it up with.

The Renaissance hierarchy of evidence put authority foremost, logic second, and observation at the bottom, the *weakest* form of evidence for a claim. In the *Summa Theologica*, each time Thomas Aquinas completes one of his tours de force of syllogism, he crowns his glorious logic with the ultimate nail in doubt's coffin: a quotation from some Church Father-type dude. Even logic trumped observation, leading to such fascinating beliefs such as the (not universal but present) medieval belief, illustrated on many a painted church ceiling, that the tiny stars on the *sphere of the fixed stars* beyond the constellations of the Zodiac may *appear* to be scattered around irregularly, but we know *logically* that the Heavens are perfect, that everything beyond the moving planets is ideal and ordered, and thus *logically* those stars must actually be in a perfect regular grid (as on church ceilings). Why do they look random? Clearly because the sphere of fire, which surrounds the sphere of air around the world (we all know fire rises; that fire must accumulate somewhere!) causes *heat distortion*, the same phenomenon which makes distant objects seem to wave and wiggle on a hot day making the straight lines of stars appear as a distorted chaos. This wasn't the only theory—another said the seemingly-jumbled stars were graffiti messages in the language of angels, waiting for humans to grow wise enough to translate

them—but both theories agreed that something as important and eternal as the stars can't just be random, and such logic was *more persuasive to the Renaissance mind* than unreliable, untrustworthy sensory observation…

…unless the observation in question is *really really* obvious and undeniable. Like that the New World is actually there. Like that the blood is circulating, they can demonstrate it in big amphitheaters. Like that these cantaloupes they brought from the New World are sweet and orange (noble fruit) but grow on the ground on an ignoble vine—this isn't like a baby bear glimpsed in the woods where you might be mistaken, it's *right there* in the garden on a vine. Authorities say Theophrastus lists the qualities of every bird? Well, have a *real live turkey* staring back at you, clearly not in the book. Authorities—Ptolemy, Galen, Aristotle—were wrong.

And meanwhile there were so many more rival truth-claims. In the mid-1500s, when the new maps and the circulation of the blood were hitting, so were the ever-more-innumerable truth-claims of incompatible Protestantisms, and the ever-broadening palette of Greek and Latin classics (and Hebrew and Arabic ones too).

Even Abelarding works that Pico and Ficino had managed to combine was getting harder. Renaissance scholars retranslated Aristotle (hey, our old compatible-with-Christianity translations were totally wrong!) and Plato (wrong too!) and the Bible (guess what! we were wrong!), each transformation of an old authority becoming more alarming. The classics were getting easier to read, which made it harder to claim that Lucretius didn't actually deny the soul, or that the Stoics and Aristotle might have believed in an immortal soul. Early *umanisti* thought their manuscripts would all be sketches of the same eternal objects, and the first copies they found were very hard to read, full of obscure vocabulary, rare grammar, and scribal errors. When you find an old painting covered with caked-on grime, it's easy to look at a dark smear and *think* you recognize a familiar subject, but, when you clean it up, what looked like the same golden platter you thought you recognized from a familiar still life might turn out to be half a cantaloupe. Just so our *umanisti* thought they saw the same things Aquinas and Abelard believed, but as they dedicated lifetimes to

de-obscuring the classics (correcting errors, tracking down rare words, adding marginal glosses), the shapes became impossible to mistake. The Stoics *do not* agree with Christianity, nor with Epicurus, nor with Plato, nor with Aristotle; they all say different, incompatible things about big basics of the cosmos (what objects are made of, what the self is, how the sun moves, everything), and by the 1550s it was getting impossible to pretend all these authorities might still agree. You couldn't just keep Abelarding harder.

Returning to my scholars who read Lucretius, *distribution and correction* was the miracle needed to let the poem's scientific ideas change the world. In 1417 Poggio brought *one* copy back to Italy, which Niccolò Niccoli hogged to himself until his death twenty years later (we have two decades of angry Poggio letters asking for it back).[12] For the next fifty years there were only manuscripts, about thirty copies *total*, each costing more than a year's salary for the average teacher. Only scholars full of cash and *grace* could get their hands on Lucretius in the 1400s, and only master philologists like Ficino and Pomponio Leto could even read it, since the copies were full of incredibly confusing scribal errors, and unfamiliar grammar and vocabulary. In an age without dictionaries, only a few dozen people in Europe *could* read Lucretius in that state, and of course their annotations focused on grammar and rare new words, they were Petrarchan Latin nerds, reading to seek the words that sting and bite. It's no wonder the annotations left by Machiavelli—focused on atomic motion and the nature of freewill—stand out like a physics textbook misshelved in the poetry section. From the 1490s to 1510s the first few print editions appeared, meaning there were a few hundred copies of Lucretius, some substantially corrected, even a 1511 version with a big, expensive commentary, but, as my perusal of marginal notes shows, these few hundred copies still ended up in the hands of a few hundred *umanisti* mainly excited to underline the parts that sound like Seneca or Vergil.

It was only after 1550 that hundreds of copies became 20,000, mainly produced in France and northern Europe for university use, with cleaned-up texts, helpful commentaries, and margin notes explaining the hard words. It was then that you didn't need to be a master Latinist to read Lucretius: the functional passable

Latin of a doctor or law student was enough to make the atoms, swerve, and vacuum comprehensible. And—by Jove!—that's when I started finding annotations about evaporation, medicine, epilepsy, the plague, how roosters' eyes work, reproduction and contraception, even atoms and vacuum; notes unique in Machiavelli's day were common seventy years later. The *book* had changed. Remember my German scholar friends focusing on *the transformation of antiquity*? Poggio announcing—*We've rediscovered Lucretius!*—did not mean it was on bookstore shelves next week, it took 150 years to clean up the text, and develop tools like printed margin notes and glossaries. By 1590 there were 30,000 copies, many of them cheap, just in time for med students—shocked by the discovery of the circulation of the blood!—to look to them for new ideas of how the body's health might work. We celebrate Lucretius as a contributor to science, but it took 150 years of *umanisti* to make texts like his legible, and to convince ambitious families of Europe that a library of classics was the best route to (A) peace (B) legitimacy, and (C) a decent salary. It was that process which—by 1590—finally got Lucretius's science into the hands of what we can at last call *scientists*.

That broke the camel's back.

Not Lucretius specifically, but the proliferation of rival truth-claims: classical authorities, *and* medieval authorities, *and* new discoveries, *and* the learned theologians of the Reformation's many rival sects, *and* all the new translations of Church Fathers who turned out (with stricter ways of reading Latin) very much to *not* agree with one another.

This too was Ever-So-Much-More-So. If we think of each new authority as a strand one was required to braid into one's rope, new strands had been appearing constantly throughout the Middle Ages (Abelard was one, Abelard's opponent Bernard of Clairvaux another), and each addition made the rope thicker, harder to braid. A few strands had dropped out (the lost classics) but came back as texts resurfaced: Heloise living to braid in Aristotle's *Ethics*, Petrarch to see the first clumsy translations of *Homer*, Ficino's readers to see all of Plato, readers of 1559 to read Marcus Aurelius at last. Pico's rope had needed to wrangle many more strands than Abelard's, as Abelard had grasped more

strands than earlier theologians. *Umanisti* added new strands themselves: Pontano's political thought, Valla's skepticism, Old Nick's new ethics, even weirder things like the *forged* Marcus Aurelius published in 1528 by Franciscan *umanista* Antonio de Guevara (1480–1545), and snapped up by a public hungry for the words of the famous philosopher emperor whose *real* work had not yet resurfaced.[13] Pico was already struggling to braid Europe's thickest-ever rope *before* the New World brought its paradigm-shifting cantaloupe, and the Reformation added a hundred more competing strands (the strand that is Calvin *will not bend* the same way as the strand that is Thomas More!). By 1590, all the king's thinkers and all the king's men could not grapple and braid a mass of strands too unruly and fat for Atlas and Hercules together to get their arms around it. Innovations made in the not-dark, not-static Middle Ages were just as thick and important a section of the braid as the ancient, Renaissance, or Reformation strands. No one could Abelard enough to reconcile all this. The belief that all authorities were sketching the same still life shattered; these were clearly all depicting different things.

The multiplication of *libraries* mattered as much to this age as the multiplication of *authorities*. In the 1380s, Petrarch collecting a thousand books was a feat meriting pan-European fame, but by 1610 the tutors and schoolteachers who trained Descartes could buy a book for the price of one month's salary, thanks, not just to Gutenberg, but to the library-building craze swelled by the promise of the *umanisti* that classical education was a road to power. The slow teamwork of monks preserving what they could over the centuries had transitioned through Ficino and Pontano translating and correcting them to Erasmus and Raffaello Maffei Volterrano condensing them into encyclopedias and digests. Easy textbooks meant that every merchant's child could read and see that Aristotle's account of animal reproduction sounds totally bonkers, that Ptolemy's geography is nothing like the real maps of real places where real boats were finding real turkeys, that Galen's medical system doesn't mesh with what you see inside a real human body, and that the other great, wise ancients bicker and contradict each other just as much as competing Reformation theologians. Ideas were also ever-so-much-more-accessible decade by decade,

books constantly cheaper, in more people's means, so the audience who realized just how impossibly fat the braid of authorities had become was also an order of magnitude bigger than the audience when Abelard's efforts to wrestle it had drawn Woodstock-scale crowds 450 years before. The presumptive authority of the past wasn't just broken by Ptolemy and Galen turning out to be wrong, but by the sheer number of authorities accumulating via Ever-So-Much-More-So for a thousand years, coming to a head in 1600 for everyone to see. It took all of them together, all those years, to get us to one of the most powerful sentences in the history of humankind:

"If Aristotle were alive today, he would change his mind."

—Galileo

61

The New Philosophy

Socrates was the wisest person in the world because he realized he knew nothing. There's a second half to that wisdom: realizing no one else knows anything either.

Intellectual historians call it the *skeptical crisis* of the late 1500s.[14] By 1590—decades into the Reformation, a full century after the Columbian contact, and two centuries after Petrarch's Cicero-reading buddy circle, the onslaught of Stoics and Aristotelians, Calvinists and Socinians, cantaloupes and bloodstreams, new books in old-fashioned Latin and old books translated into new Latin, all added up to make reconciling them impossible. *An authority said so* could no longer be Europe's default winning argument. Too much was too much, and soon classrooms in Paris and Padua alike saw students interrupting lectures to demand that the professor answer whether a tree which falls with no one there to hear it makes a sound, or to prove that the classroom, textbook, chairs, and trees outside the window actually exist.*

Montaigne (1533–92) was the avatar of this moment, his enchanting *Essais* (a word meaning walks, meanders, essays in the motion sense) taking the reader on a winding path through

* It is this kind of impulse, multiplied in the next century, which was satirized by Byron: "When Bishop Berkeley said 'there was no matter,' And proved it—'twas no matter what he said." (*Don Juan*, XI.i), and by Ronald Knox's famous double limerick: "There was a young man, who said: 'God,/ Must think it exceedingly odd, / To find that this tree/ Continues to be / When there's no one about in the quad'. // 'Dear Sir, your astonishment's odd. / I am always about in the quad. / And that's why the tree / Continues to be / When observed by, Yours faithfully, God.'"

gorgeously written discussions of the ethics of the ancient Stoics, the good deeds of an obscure saint, the tragic sufferings of persecuted heretics, and the personal experience of blacking out from a concussion, until the reader reached the end with a vague sense of having tasted wisdom and deep kindness and humanity, but with the sense that everybody—ancient and modern, Protestant and Catholic, famous authority and surnameless valet—is equally good and bad and blessed and cursed to move through the confusing wonders of the world without real certainty. We have Montaigne's copy of Lucretius, by the way, his notes a beautiful mixture of the philological/poetic and the scientific/philosophical, sharing Petrarch's love of language and Machiavelli's recognition that the world needed great change. Montaigne's work—so loving yet so modest and so raw—tapped deep into the aquifer of doubt accumulating underneath the mental fields of Europe. The fountain was unstoppable, and—to we moderns—exquisitely familiar.

Science.

There are three kinds of evidence, so when *authority* breaks, it's time for *logic* and *observation* to have their day. Time to reject the presumptive authority of the past, and find a new way to determine what is or is not true, and then subject *all* the authorities to this new scrutiny. Time for a new *method*.

Confusingly, thinkers in the period called this movement the "New Philosophy"—not a moniker that stays useful long, another reason I prefer to say the Try Everything Age. It is also (often mid-1600s) the moment that historians start to debate: *Is this still Renaissance, or should we call this the early Enlightenment?*

The biggest names are Galileo, Descartes, and Francis Bacon, but they were, like Petrarch, names that became big, while hundreds like them were trying the same things. King Kristina and her friends and tutors grew up on scholasticism and the *studia humanitatis*, but concluded that, if Galen, Ptolemy, and Aristotle could be wrong, it's time to start from scratch and question everything, from Plato and Cicero to chemistry and the divining rod. The seventeenth century was when much of Europe gave up Abelarding and started throwing noodles at the wall to see what stuck. We celebrate the noodles that stuck, as we celebrate Lucretius's atoms and vacuum but not his giant placentas that

grow from the ground. The Try Everything Age *tried everything*, meaning that it was super mega wrong about a *lot* of things, just like its medieval and Renaissance predecessors, so don't forget Julia the Sibyl was just as welcomed by our science-loving King Kristina as Descartes. In 1600, reconciling all authorities was no longer a Herculean labor but an impossible one, and the number of people who realized that *and had access to books and could thus join in trying new things* was far larger than in any past crisis of European thought. Innumerable small names are the true fiber of this crisis, reading, experimenting, testing, trying, but just as the Renaissance big names were worth visiting—Petrarch, Michelangelo, Machiavelli—so are the big names of this new age.

Galileo focused, as you know, on mathematics and observational astronomy—we mostly think about the astronomy, but his university position (the University of Padua, of course) was in mathematics, and if you read his tenure file in Venice's Secret Archive, it's for math they gave it to him; the committee didn't think the telescope would be worth much. The trial of Galileo is infamous, but not so well-known is the aftermath in which innumerable scientists, both in and beyond Italy, began using more instruments and measurements to test hypotheses, experimental science flourishing, both among those who thought Galileo was right *and* among those who thought he was wrong but, more and more, set out to prove it *using Galileo's methods*.[15] Believe it or not, there are robust and valuable experiments and useful findings even in works like Giorgio Polacco's 1644 *Anticopernicus Catholicus*, subtitled *On the Stationary Earth and On the Moving Sun*.[16] In fact, as historian of science Daniele Macuglia demonstrated, 1600s Italy was so saturated with experiment that even members of the Roman Inquisition set up experimental science laboratories in Rome to test the findings of books they were tasked to censor, considering it their job to fact-check publications, not only against doctrine, but by all means: philology, checking footnotes, and testing in the lab.[17] When Julia and Kristina of Sweden were in Rome, the largest and best-funded experimental laboratory in Europe was very likely the Roman one run by inquisitors, and if your brain is reeling from how counter-intuitive that is, welcome to the Try Everything Age when *even censors* were gung-ho to try everything.

Descartes, meanwhile, was interested in experiment, but focused on *logic*, on chains of reasoning much like those of the earliest scholastics, but applied to the skeptical questions Montaigne-reading college smart alecs were nagging their professors with: *How do I know that anything I perceive really exists? What if the whole world is an elaborate illusion created by an omnipotent demon to deceive me? What if this is the* Matrix *movie? Well, I'm wondering if anything exists. If I'm wondering, thinking, the subject of a verb, then I must exist to be* doing *the wondering.* Dubito ergo sum *I doubt therefore I am*; cogito ergo sum *I think therefore I am*.

Descartes also—once he used raw logic to prove that Nature exists—looked at observations, developing new theories for big questions, like the motion of the planets, the operations of magnetism, and the interface between body and soul.[18] His method only admitted the existence of things that could be established by strict logic, or (subordinate to logic but still helpful) observation. Plato says most people are born with souls of iron, and only a few have reason-guided souls of gold—Plato is not enough; it must be proved! Plotinus and Aquinas say there are five layers of reality—Aquinas is not enough; it must be proved! Dante says rocks sink in water because they're morally inferior and move toward Satan at Earth's core—Dante is not enough; it must be proved! To prove these things, Descartes used many familiar scholastic arguments, like Saint Anselm's famous ontological proof of God's existence, but Descartes framed it all in simpler, more approachable vocabulary, his signature *clear and distinct ideas*, since he wanted logic to be a tool for everyone—with Europe's intellectual world already swarmed by contradictory Christian truth-claims, there was no point in continuing scholasticism's practice of using super technical language to keep non-experts from approaching theology's deadly nuclear enriched uranium, the whole world had already been exposed.

The Cartesian system Descartes developed took off in France, and its adherence to logic *over* evidence had many effects, great and strange and even comic. Descartes agreed with Aquinas and Aristotle that the sentence *nihil est (nothing is)* is nonsensical, nothing *isn't*, you can't say nothing *is*, thus that nothingness, i.e. the possibility of vacuum was logically nonsensical. He also

judged that force at a distance was a logical impossibility, so things which seem to be force at a distance (magnets, for example) must really function via invisibly tiny moving objects (atoms?). All this resulted in such fantastic contrasts as Cartesians ferociously denouncing Newtonian cosmology (Vacuum in space? Never!) while crashing witch trials to insist that curses can't be real because there's no force at a distance (this *genuinely* got the French witch trial craze to fade out sooner than in many other regions).[19]

Finally, we have Francis Bacon. Like Galileo, he made observation supreme over logic; if we see it, *even if it doesn't make sense*, it's real, and it's on us to figure out the cause. Bacon—a statesman as well as a philosopher—was not himself much of a scientist. He was a *theorist* of sciences, a writer and rhetorician, shaped by his days as a lawyer, politician, and royal courtier (and his nights as a regular at Shakespeare's theater) into a man who *wrote about* and *popularized* this newly brewing thing we would soon call the scientific method: how the best way to seek truth is to make many observations, and from those observations work out patterns, *deductive* reasoning. Empiricism. While he did a few experiments, Bacon isn't a man you should imagine putting in long hours in the lab like Newton; imagine him instead at a podium, in a meeting, at court, on the floor of a parliament, or at a desk with pen and ink producing the pamphlets which would encourage *others* (including young Newton) to put in those hours in the lab.

And—around 1600—Francis Bacon invented *progress*.

Let me unpack that.

62

A Brief History of Progress

Ideas of societal change over time have existed in Europe since antiquity. Classical sources talk about a Golden Age of peaceful, pastoral abundance, followed by a Silver Age, when jewels and luxuries made life more opulent but also more complicated. There followed a Bronze Age, when the hierarchy of haves and have-nots caused the invention of weapons and soldiers to defend luxuries and property, leading to the Iron Age of blood and war and burning Troy. Some ancients added more detail, notably Lucretius whose description (in Book IV) of the transition from rural peace to urbanized hierarchy is explicitly *developmental*, caused, not by a divine plan, but by human invention: as *people* invented luxuries they needed new tools—technological and social—to produce, defend, and control them, leading to sophistication and its discontents.

Lucretius's model has several components of the concept of progress, but not all of them. It has the human condition vary over time. It is *anthropogenic*, with humanity as the agent of change, primarily through technological innovation causing social change. It does not have (A) intentionality behind this change, (B) a positive arc to this change, (C) an infinite or unlimited arc to this change, nor (D) the expectation that *more* change will occur now that the Iron Age has been achieved—for Lucretius we live in the Iron Age until the Earth erodes into what he did not yet call entropy. Ancient thinkers like Lucretius contrasted their pasts and presents, but did not expect the experiences of future generations to be fundamentally different too. Details might change—Rome's empire might grow or shrink, or fall and be replaced—but cities will be cities, plows will be plows, empires will be empires, and

in a thousand years bread will still be bread. Lucretius and also Lucan (39–65 CE) speculate about such things a lot, but they do not live in our world where bread is already pop-tarts, and will be something even more outlandish in the next generation's hands.

Medieval Christian Europe realized (and if you grant their starting premises they're right) that, given that the entire world is a temporary construct designed by God for the purpose of teaching humans about salvation and damnation, it's madness to look to Earth for cause-and-effect chains: there is one omnipotent Cause of all effects. As Dante tells us, God wanted Christ to be lawfully executed by all humanity together, so the guilt and salvation would be universal, so He created the Roman Empire in order to have a government large enough to represent the whole world and then order the Crucifixion. Nothing in such a worldview is anthropogenic. The empire didn't develop, it didn't rise or fall due to Caesar's genius or economic policy, it was crafted by God for God's Plan alone: Act II scene iii the Roman Empire rises, scene v it fulfills its purpose, scene vi it falls. Applause.

Did the Renaissance have our concept of progress? Not in Petrarch's, Bruni's, Ficino's, or Machiavelli's lifetimes, but they were closer. When early *umanisti* proposed their golden age, God and humanity were *both* agents in the project: God who planned it and His human tools who would gather the books, translate the Greek, measure the aqueducts, and raise the philosopher princes. Advocates of virtue politics fused ancient and medieval ideas of history when they proposed to create *an intentional positive trajectory* for their era (sounds like progress?), but it was not an *ongoing* trajectory. The Renaissance would regain excellent things its past had lost, climbing out of a pit back to a mountaintop. The change would be glorious, but finite, and when Renaissance people spoke of *surpassing the ancients* they spoke of painting more realistic paintings, sculpting more elaborate sculptures, or inventing new devices like Leonardo's battle tank, which was intended to interact with *not replace* cavalry. For its supporters in the 1400s, the *studia humanitatis* was going to make a golden age *right now*, teach people to be Ciceros *right now*—they aimed to sustain that golden *now* as long as possible, but did not expect each generation to be more advanced. Changes would be in scale

and quality: bread might become more abundant bread, ships better ships, cities might be marble instead of brick, but surpassing the ancients lay in execution, not fundamentals, and better ships were supposed to bring back gold and glory, not cantaloupe to overthrow Theophrastus. *Umanisti* envisioned positive change, and (major major moment!) they proposed that people could collaborate to intentionally (!!) cause large-scale social change, but they did not envision *ongoing, constant anthropogenic* change. Their focus was a one-time restoration of a better age, within a world presumed to be governed by a Divine Plan with its cycles, rises and falls, good kings and bad, all scripted from beyond.

This had started to change by the time long-lived Michelangelo turned from a quarrelsome young man to a quarrelsome old man. Thinkers of the generation of Machiavelli's children and grandchildren, like Loys le Roy (1510–77) and Jean Bodin (1530–96), discussed how certain individual innovations like gunpowder, printing, and changes in navigation and medicine—some of which they discussed as new inventions, others as imports from China—had done precisely what their 1400s predecessors didn't think innovations could: changed the human condition *fundamentally*, with second-order and third-order consequences saturating all parts of life (what one wore, what one ate, how one built, how wars were lost or won). Such things made the generations that had them different from all generations before, even the Romans, a fact which stimulated—indeed required—new ways of thinking about historical change, and how human actions caused it, shaped it... possibly *were* it?

Then, around 1600, Francis Bacon invented progress.

You know what the trigger was: the multiplication of rival truth-claims—some from antiquity, some from fracturing Christianity, some from exploration or discoveries—until we couldn't just keep Abelarding anymore. Bacon *invented* progress in the same sense one might say Petrarch *invented* the Renaissance: he was the rhetorical firebrand whose flashy, persuasive rhetoric, those *words that sting and bite,* gave fame and momentum to a *collective* project already in progress, and made wealthy patrons take it seriously.

Bacon portrayed the new science as the launching of a ship—the *Great Instauration*, the launching of a Great Project. If we

work together, he said, if we observe the world around us, study, share our findings and collaborate, we can uncover, as a human team, the invisible causes and hidden motions of Nature, and base new inventions on that knowledge which will, in small ways, bit by bit, make human life a little easier, a little better: warm us in winter, shield us in storms, make our crops fail less often, give us some way to heal our ailing child. We can make every generation's experience on this Earth a little better.

There are, Bacon said, three kinds of scholar: the ant, the spider, and the honeybee (a simile he took from Petrarch, who took it from Seneca, who took it from Plutarch, but each used it to describe different things). For Bacon, the three represent different ways of seeking knowledge. The ant is the encyclopedist, who roams the Earth gathering crumbs of knowledge into a huge pile, raising the ant mound higher and higher, competing to have the greatest pile to sit and gloat upon, but *making* nothing. The spider is the theorist or system-weaver, who spins elaborate, entrancing webs out of the stuff of his own mind, in which it is so easy to be entangled, but there's nothing there but the produce of that one mind. And then there is the honeybee, who gathers from the fruits of nature and, processing them through the organ of his own being, produces something good and useful for the world—this was the newborn third knowledge-seeking mode, the scientist. Let us be honeybees, said Bacon. Let us give to the world learning and learning's fruits, which will make each generation's time upon this Earth a bit better and kinder than the last. Let us found a new method—the scientific method—and with it dedicate ourselves to the advancement of knowledge of causes and the secret motion of things, and the expansion of the bounds of human empire to the achievement of all things possible. He gave his explanation of this method the most audacious book title in history: *The New Organon*, proposing to replace that backbone of Aristotelian logic which *umanisti*, scholastics, and their predecessors back to Boethius in Ostrogothic Rome had all treasured.

As for the ancients, Bacon adds, these white-bearded giants whose wisdom has so long loomed over us, they are children! They lived at the beginning of the Great Project, the generations which knew least and had the least experience of Earth and her wonders! *We* are the ancients! *We* the giants! *We* who stand upon

thousands of years of accumulated knowledge, ready to take the next great steps! Bacon is a gifted wordsmith, and knows how to make you ache to be the noble thing he says you can become.

This too was the rejection of the presumptive authority of the past. The key to creating a golden age lay, not in imitating the ancients, but in testing all their claims, finding their errors, observing and learning all we can about Nature, and sharing its sweet fruits with humankind. Let us observe, question, experiment, test, test again, treating the claims of text and eye as data to be analyzed for patterns, just as Machiavelli advocated using history a hundred years before. And let us share the fruits of these labors with everyone.

This is where I get to startle you with the controversial claim that *Leonardo da Vinci was not a scientist!* Not in the modern, Baconian sense in which science aims to permanently improve the human condition. Leonardo wrote down his innovations in mirror writing so no one else could do it, and boasted to his bosses that he would give *them* innovation *no one else* would have. He and his employers *wanted* his techniques to be lost after he (or a limited set of apprentices) used them, so his fame and those of his patrons would be eternal. Brunelleschi guarded his methods and burned many of his notes and diagrams for the same reason: *There shall be only one best dome, and 500 years from now tourists will stand in line to see it and my tomb within!* Brunelleschi and Leonardo got the lasting fame they wished for, but Bacon proposed something different: the glory of this new science would not be *having* the marvel but *gifting* the means to make marvels to all humanity.[20] Rather than secretive Leonardos and Brunelleschis, who jealously guard their methods so their works will still be wonders in a thousand years, the scientist's glory will lie in publishing, sharing techniques, the measure of achievement not one looming monument, but the useful invention which enters every home and improves every life. Bacon died from an illness contracted while shoving snow into chickens to experiment with refrigeration to help people preserve food—science for everyone.

Of course, Bacon himself was not the kind of scientist he described. As peers were magnifying fleas, measuring densities, mapping stars, and mixing chemicals, he spent his days drafting laws and speeches, barely dabbling in the experimental methods

which spread like wildfire after 1600, aided by Galileo's fame. But Bacon's rhetoric was key in turning this into a self-conscious and celebrated movement, one kings and dukes believed could bring wealth and *legitimacy* to their families and realms. This was a long dream for Bacon. Much of his interest in invention came from meeting it bureaucratically, while working with patent law as inventors tried to patent their newly improved chisel blade, or glue formula, or spindle, making Bacon aware of how much inventing was (often quietly) underway across his world.[21] Well before he wrote his more famous articulations, for the winter revels of 1594–5, when London's theaters had just reopened after another bout of plague (and at which Shakespeare probably put on his *Comedy of Errors*) Bacon wrote a set of semi-humorous speeches in which mock courtiers competed to convince their carnival king which was the best way to bring honor (and *legitimacy*) to a nation. Most are familiar: (A) conquests and war, (B) erecting grand eternal monuments, (C) cultivating wealth and stability within one's borders, (D) pursuing virtue and gracious government, (E) games and revels (the winning speech given the venue) or (F) pursuit of philosophy through constructing a grand academy of sciences.[22] Even on comedy night, Bacon had the glories of Team Science on the brain.

Just as Petrarch was not a master linguist like Valla, Leto, or Poliziano, so much so that his Latin embarrassed his later followers, so Bacon's skills as a scientist, and even his articulation of the scientific method, were crude by the standards of Newton and Galileo. As Voltaire put it in his letter "On the Lord Bacon," philosophical *Letters on England* (1778):

> The most singular and the best of all [Bacon's] pieces is that which, at this time, is the most useless and the least read, I mean his *Novum Scientiarum Organum*. This is the scaffold with which the new philosophy was raised; and when the edifice was built, part of it at least, the scaffold was no longer of service.
>
> The Lord Bacon was not yet acquainted with Nature, but then he knew, and pointed out, the several paths that lead to it. He had despised in his younger years the thing called philosophy in the Universities, and did all that lay in his power to prevent those societies of men instituted to improve human reason from

depraving it by their quiddities, their horrors of the vacuum, their substantial forms, and all those impertinent terms which not only ignorance had rendered venerable, but which had been made sacred by their being ridiculously blended with religion.

He is the father of experimental philosophy.[23]

Thus, it was Bacon's *rhetoric* which convinced the British Crown to create the Royal Society—founded 1660 with the original name Royal Society of London for Improving Natural Knowledge—now the oldest continuously-operating scientific academy in the world (and still publishing such useful things as the DNA study that let us track Norse Greenland's walrus ivory!).[24] Other kingdoms quickly did likewise, normalizing the revolutionary practice of rulers and aristocrats supporting scientists, not just in their work, but in sharing their discoveries with each other in a public, collective project. Just as Voltaire did not draft the *Declaration of the Rights of Man*, nor Thomas Paine the US constitution, Petrarch and Bacon are examples of moments when a change already simmering came to its raging boil triggered by a charismatic wielder of words (in fact, thanks to *words that sting and bite*). These word-wielders became big names in the stories we tell, and their works became the paperbacks we use to teach their movements, because one elegant treatise is a lot easier to grapple with than an anthology of the highly-technical writings of those specialists who really did correct the Latin, compare the densities, define the rights, and separate the powers.

But how, Chancellor Bacon, do we know that we can change the world for the better with this new scientific method thing? No one has ever tried it before, so you have no evidence that the things that your community of scientists reveal will actually be useful, or that each generation's experience can be better than the one before.

It's not an easy task to prove that science works when you have no examples of science working yet. Bacon does not have steam engines, or pasteurization, or vaccines to point at and say: look at what science did! Even the circulation of the blood was not a *useful* finding, not without a lot of other steps (hygiene, etc.).

Bacon's answer—which made kingdom and crown shower support upon his honeybees and birthed the first academies of sciences—may surprise the twenty-first-century reader, accustomed

as we are to hearing science and religion framed as enemies. We know science will work, Bacon replied, because of God. There are a hundred thousand things in this world which cause humans pain and suffering, and a hundred thousand unmet desires that bring us grief. But God is Good. He gave the cheetah speed, the lion claws, built in survival gifts to every crab, beetle, and humming-bird. A Maker so benevolent would not have sent humanity naked into this wilderness without a way to meet our needs, and end our pain. He would not have made us hope forever for a better world without the means to make it. He gave us Reason. So, from God's Goodness, we know Reason must be able to achieve all things that God designed us hope for. God gave us science, and it is *an act of Christian charity*, an infinite charity toward all posterity, to use it.

They believed him.

Europe at the time was desperately aware that the Renaissance *had not made* a golden age—in the glory of palaces perhaps, but not in the sense of peace, survival, or stability. They were also desperate for a tool to sort through rival truth-claims—Aristotle, Galen, Ficino, Luther, Maimonides—and unburden the camel's broken back. And here was Bacon saying God gave us a way. The hearts of his first readers overflowed with hope. Bacon backed up his claims with the biblical prophecy in Daniel 12:4 that at the end of times "many shall run to and fro, and knowledge shall be increased," which he quoted on the title page of his *Great Instauration*,[25] but in many ways he did not need it; his pious rhetorical portrait of the kindness of God and potential of Reason was profoundly moving on its own.* (When I delivered this as a lecture to a college classroom in Texas, several students

* Bacon thus also greatly popularized making arguments about the *psychology* of God based on observation or logic (deducing things about the Maker from His work), paving the way for the Enlightenment's proliferation of theopsychology, moments such as Leibniz's famous argument that we know an omnipotent, omniscient, omnibenevolent God would only create the best of all possible worlds, while similar arguments appear in Voltaire's refutation thereof, in Rousseau's religiosity, Sade's satires, Diderot's efforts in *Jacques the Fatalist* to depict a world devoid of Author, etc. This is also part of why Bacon's one-time amanuensis Thomas Hobbes so horrified seventeenth-century Europe, since he was a master of Bacon's persuasive and inductive methods, but used them to advance horrifying portraits of both God and humanity.

told me they had never heard that science and religion could be anything but enemies, so pernicious is the Faith vs. Reason myth, a myth born largely post-Darwin, and now projected onto the centuries before.)*[26]

Bacon's articulation was a big step toward the modern sense of progress. He got all Europe talking about technological progress, medical progress, and also the small social progresses those would create, not just glories for prince and cathedral, but food for the shepherd, rest for the farmer, balm for the bruise, little by little, progress. The Try Everything Age was already undertaking this, but Bacon's popularization triggered those decades in the 1600s when the gentleman's sword-cane gained a flashier competitor, the gentleman's barometer-cane. In these years Descartes and other practitioners of the new science joined the *umanista*, prophet, and lute-player as ornaments of King Kristina's court—*joined*, not replaced. We still had scholastics, *umanisti*; dukes still displayed busts of Caesar, but they displayed barometers too. This is still the Renaissance by most standards, but in this later part, post-1600, the Try Everything project, and the dream of the Baconian honeybee, have *joined* virtue politics as a second, parallel, flourishing effort to make a golden age.

The rhetoric of Bacon and his friends—like that of Descartes and his friends—is often hyperbolic, claiming to throw out *everything* and start from scratch, which they did not. The true core was to *question* things, to test received wisdom and see what stood

* Bacon was also drawing on a tradition which my wonderful colleague Fredrik Albritton Jonsson and his co-author Carl Wennerlind aptly call *cornucopianism*, an attitude already prevalent before Bacon, which believes there will always be enough resources to satisfy human wants. Versions of this ideology sometimes drew on religious arguments about Providence or the goodness of God, sometimes on the belief that humans are capable of a mastery of Nature sufficient to guarantee that any need will be met; Bacon's version combined religion and confidence in the excellence of humanity (*humanism?*) to paint a potential future in which all wants could be met, and all scarcities supplied. This widespread and centuries-old ideology is a major factor in cultural resistance to ideas of climate change and climate fragility; see Fredrik Albritton Jonsson and Carl Wennerlind, Scarcity (2023).

up to experiment. They tested logic chains, re-observed animals, stars, stones, retooled medical practice, and developed shiny new machines, which you see in museums like the Museo Galileo in Florence: thermometers, hygrometers, syphons, models of joints and muscles, ramps and spirals for measuring acceleration, ladies' telescopes carved in delicate ivory, devices which measured angles by bouncing balls off of porphyry (putting the imperial stone's extreme hardness to useful work!), and an enormous gilded model of the heavens completed in 1593 for Ferdinando de Medici (1549–1609), a son of the Duke Cosimo who had defeated the last holdouts of the Last Republic, to whose wife Christina Galileo would soon address his revolutionary letter.

Completed in 1593? Isn't that before your date for when Bacon invented progress?

Yes. The Try Everything Age was not *because of* Bacon, any more than the Renaissance was *because of* Petrarch—their names became shorthands for the spirit of their age, but if we zoom in we find thousands of scientists, in Oslo, Warsaw, Dublin, Budapest, Lisbon, Padua, everywhere, exchanging findings. The enthusiasm was intoxicating, more so after Bacon turned the simmer up to boil. It's a bit later, but *The Gentleman's Magazine*, the first publication to call itself a magazine (founded 1731), collected news and articles about all kinds of things, and amid reports of the first hot air balloon flight, and which works of Voltaire were newly banned, it published letter columns, in which curious amateurs did backyard science, writing to the editor with their findings on questions like whether spiders shoot their threads out with force like a dart or merely extrude them without momentum like a dough.[27] There is a joy in reading their precise descriptions of the actions of household spiders (it proceeded a thumb's width along the pencil, then descended like a pendulum), humble readers doing with their pencils, books, and twigs what court scientists did with shiny brass machines. Museums like the Museo Galileo also have many electrostatic generators, brass-framed contraptions as large as a sofa, in which a glass or ceramic disk rotated by a crank would spin in contact with a brush, building up electrostatic charge, until a brass conducting rod was held near it, attracting—*zap!*—a bolt of electricity.

Those electrostatic generators sure... demonstrate electrostatics (or in the language of the 1660s summon and concentrate cosmic virtues).

One striking—indeed moving—fact about the Try Everything Age is that it took 200 years for the new methods to develop anything visibly useful in the sense of raising everyone's standard of living. There was a lot of dissecting animals, measuring angles, and exploding metal spheres, and Newton refracting light and describing gravity was very, very exciting—the scaffold of the *Novum Organum* did indeed raise a great cathedral. Many new findings were correct, and solved the skeptical crisis, sorting through rival authorities to find new foundations for common agreement. But even Newton's discoveries weren't particularly *applicable* short-term, and certainly weren't what sent inventors to the patent office with improved chisel blades or spindles, those were developed through manual experience, not understanding physics. As Jim Hankins put it to me once, it was actually the nineteenth century that finally paid Bacon's IOU, his promise that, if you give us an unfathomable research budget, and channel the eager youths of your society into science, someday we'll be able to do things we fundamentally can't do now, like cure rabies, anesthetize, and make more stable refrigeration than a snow-packed root cellar. Medical textbooks were getting worlds better at illustrating the body, but with the germ theory of disease still demonized by doctors (*you think our hands are making our patients sick?! Slander!*) even well-conceived surgeries still usually caused infection and death. A steady stream of new and profitable inventions was changing agriculture and industry, but most of it was made by people in those industries who observed their own work and made improvements, a method of innovation which had little debt to the *Philosophical Transactions of the Royal Society*.[28] Other innovations were arrivals from the East. Such novelties did not, from the public point of view, appear to improve the whole human condition: they made specific crafts more efficient, specific inventors rich, and navigation speedier (and war and pirates with it), but none of this matched the grand rhetoric about science as a divine tool to meet all human needs. The crowning step, the first Baconian invention which actually entered every home, improved

every life, and felt like a true fruit of mastering the secret motion of things came along 150 years into the project: Ben Franklin's lightning rod. But for a full 200 years, even as workmen's hands-on invention continued as it always had, most fruits of the new deep investigation of scientific principles were contraptions with no function beyond demonstrating said scientific principles.

Two hundred years is a long time for a vast, society-wide project to keep getting support—funding laboratories and observing spiders—fed by nothing but pure hope that these discoveries streaming out of Royal Society papers would someday do something. It may remind us of *another* project to create a golden age, which got support from royal courts and merchant princes for 200 years before Valentino Borgia looked Machiavelli in the eye and made him think they needed something different. And, yes, supporting fashionable science and having one's court full of erudite inventors and sparkly scientific instruments provided *legitimacy*, the statue of a satyr giving way to a statue of a satyr with a celestial sphere on top.

As the Try Everything Age reexamined biology, astronomy, medicine, and so much more, it didn't take long for some—like Bacon's terrifying apprentice Thomas Hobbes—to apply the principle that we should test everything with Reason and observation to *social* questions: law, judicial systems, customs, social mores, social class, religion, all those *worldly* inquiries that *umanisti* made a bigger slice of philosophical activity than in ages before. The scientific method—observe, describe, theorize, test—proved effective in causing social change long before it generated useful technology. Effectively the sequence was: *Science will improve our technology! It's... it's not doing anything yet, so let's try it out on society? Yeah, that's doing... something! Whoa! Oh, and now the tech's doing stuff too!* Except that sequence took 300 years, and the *Whoa* in the middle was the French Revolution.

But!

But?

Talk of the revolution reminds us: we know now, as Earth learned the hard way, that progress can also cause *bad* effects, even atrocious ones. Our honeybees did craft technologies, yet life expectancies in cities fell even further as industrialization spread

soot, pollutants, cholera, arsenic wallpaper, and lead-whitened bread through a booming Europe. And the social applications also yielded terrors: Thomas Hobbes, the guillotine, the horrors of colonialism, and environmental devastation, to name a few. Shouldn't that make us question Bacon's promise, just as Julius and Valentino made Machiavelli question Petrarch's?

63

Progresses

We now use the word "progress" in many senses: *technological* progress, *economic* progress, *civil rights* progress, *medical* progress. When we ask, *Is there such a thing as progress?* we no longer mean (as the Try Everything Age did) *Is anthropogenic change possible?* We mean, *Is the change that's happening actually making things better?* And within that, *Are we in control of progress, or is it controlling us?*

As early as a century and a quarter after Bacon, Jean-Jacques Rousseau (1712–78) stunned and fascinated Europe by arguing (like Lucretius before him) that humanity was happier before we developed all the complex arts and sciences which build our filthy cities and take humanity away from simple living in the fields and trees.[29] Freud—who first helped Ada Palmer realize that ideas affect events—revisits the question brilliantly in *Civilization and Its Discontents* (1929), when he discusses how the wonder of the telegraph means he can be in Vienna or London and communicate with his daughter across the ocean in Philadelphia almost in real time—but if not for progress she would not *be* across the ocean in Philadelphia, she would be with him at home.

It is no small change that we can use the word *progress* in a negative sense. The concept as the 1600s crystallized it was positive, and to use it in a negative sense would have been nonsensical to Bacon and King Kristina, like using *healing* in a negative sense. But now along with *Great progress this year!* We say *swallowed up by progress*, or the ironic shrugging *Welp, that's progress!* We recognize poor Charlie Chaplin trapped within the great geared cogs of *Modern Times*, and that's progress.

This is a revolutionary change, enabled by two differences between ourselves and the Try Everything Age. First, we have observed several more centuries. If, for Bacon, the ancients were children, to us Bacon's era are still teenagers. In our experience, progress is sometimes the first heart transplant and footprints on the Moon, and sometimes it's the innumerable atrocities committed in the Belgian Congo. On the social side, sometimes it's Geraldine Roman (b. 1967) the Philippines' first transgender congresswoman, and sometimes it's Cristina Calderón (1928–2022) the last native speaker of the Yaghan language. Sometimes it's the eradication of smallpox, and sometimes it's diseases spreading *faster* because of airport hubs and mega-capitals. Polio is a perfect example, an endemic disease which became *worse* as a result of sanitation, because children who are exposed to the virus while still breastfeeding share the mother's antibodies and gain immunity themselves, but when sanitation improved (reducing cholera and other things), for the first time many children weren't exposed until after they stopped nursing, when polio ravaged their unprotected systems. The polio epidemic was a side effect of progress, its victims claimed by the gap between our partial understanding of the secret motions of things (germ theory for cholera) and the more complete understanding necessary to avoid the bad effect (antibodies, immune systems). Progress has yielded fruits much more complex than honey, which makes sentences like *the prison of progress* make sense to us.

Also, Bacon and his peers thought progress was *new*. It was a *choice*. If you asked him *Was there progress in the past?* he would have said, *No, we're just starting to have progress now.* For him it was an option, something people were designed by God to be able to do, as bees were designed to visit flowers, but bees *can* sit around drinking the dregs out of a can of Coca-Cola, and humans *can* live without doing science. We agree with Bacon that *self-aware* progress was new to Europe in the Try Everything Age, but we believe there was technological and social change long before 1600, including changes that improved standards of living (better plows, better chimneys, better spinning wheels). The progress we believe in always was, and always will be, we don't turn it on and off. As our concept of anthropogenic progress broadened

from believing progress only happened when a big movement intentionally pushed for it, and as we recognized that constant technological and social development defines the human condition, only then could the idea of an inescapable momentum join the implications of the term.

Ideas of inevitable progress raise red flags for historians, because of the legacy of Whig history, a twentieth-century vein of historical thought which posited that history is an inevitable progression toward a *specific end state*, i.e. that all societies do and should move inevitably toward modern liberal democracy and Enlightenment values. Within this framework, societies are caterpillars which must either die or become butterflies—any society that isn't becoming a modern liberal democracy is stuck in its chrysalis, and it is a *good* act for those who have already reached the end state to crack open that chrysalis, usually by (this is a framework born of European imperialism) conquering the society in question, erasing its culture, and replacing it with the values of the modern West.

The destructive Eurocentrism of this view is obvious to us, but this approach has a second distorting effect, familiar from meeting our Renaissance friends: this is a big part of what makes histories focus on figures who were *right* or took a step *forward*. Such people and changes are *good* or *correct* while others are *dead ends*, or *backward*. We are all familiar with how histories shaped by such ideas denigrated whole regions (Asia, Africa, the pre-Columbian Americas), but they also shaped those histories of Europe which celebrate radical freethinker Machiavelli as a step *forward*, demonize mystic visionary Camilla Rucellai as *backward*, distort genius Pico into something comfortably modern, sideline tediously pious Raffaello Maffei Volterrano as a wrong-headed holdout, and don't know what to do with guru Ficino. Only heroes or villains fit, so Lorenzo de Medici and Savonarola must become one or the other.

Teleological histories (histories that presume society is developing toward some specific end) are also particularly prone to *presentism*, i.e. magnifying things that look like us, and sometimes projecting them onto the past, as when the *Medici: Masters of Florence* TV show has Cosimo de Medici call himself a "job

creator"—Reaganomics was not in the conceptual sphere of 1433. Sometimes things in the past *did* stand out in their day, like Machiavelli's annotations on Lucretius, but we in the History Lab are very wary of saying things are *ahead of their time*, since it risks spawning yet another distorted biography where Galileo is fundamentally an oppressed Bill Nye the Science Guy. (Spoiler: Galileo was not Bill Nye; he was Galileo.)

Unfortunately, the bathwater of Whig history is hard to separate from an important baby. We need vocabulary to discuss historical change over time. We need ways to talk about change, to compare societies, even to discuss how some changes might be genuinely positive or negative (more torture bad, less torture good). While avoiding narratives of a triumphant West advancing backward neighbors toward looking like them, we must find ways to talk about things like the eradication of smallpox, and our efforts against malaria and HIV, as steps in a positive process over time. Post-colonialism, post-industrialization, post-polio epidemic, post-Hobbes, we can no longer talk about progress as a unilateral good. When Bacon thought there would be only honey, he was wrong, and progress now more often feels to us like Keats's honey "turning to poison while the bee-mouth sips," or, at a minimum, like the disgusting honey the Smithsonian Natural History Museum staff ended up with when they added a live beehive exhibit, only to learn that bees in a great modern capital find few flowers but lots of rancid trashcan Coke.[30] But we can't abandon the idea of progress because, during these same centuries, each generation's experience *has* been different from the last. Science, and big social projects like virtue politics and the Try Everything Age, are clearly accelerating anthropogenic change.

But if Cosimo de Medici was not a job creator, Galileo was not Bill Nye the Science Guy, Giordano Bruno was not a modern atheist, Camilla Rucellai had more real power than Alessandra Scala, and Florence's Last Republic was less interested in being guided by Machiavelli than by nuns relating instructions from the ghost of Savonarola, *and yet* the result of this was Bacon and the scientific method, how do we answer Machiavelli when he tells us to look at history for chains of cause and effect? It seems like *no one* in our hard-working, high-aiming Renaissance

got the future they wanted. Petrarch's plea for peace and the humanities went out into the world and triggered 200 years of nonsense as we slowly realized everyone was wrong and had to start over? If there was no freethinking underground trying to push things toward modernity (as Whig historians would love to find) *but we got modernity anyway*, then what we got *was not* what Petrarch-loving future-builders tried to make. If the grip of a corrupt Church wasn't broken by brave freethinkers, but by bad popes getting worse and worse until Luther happened to meet the printing press revolution when the porridge was just right—if that's how history works, is there no point in us trying to change the world?

Is the message of the Renaissance that we should give up on shaping the future?

Did the Try Everything Age show us that trying everything still doesn't help?

Do we, in fact, have any power over history at all?

PART VI

Conclusion

Who Has Power in History?

The Renaissance was like the Wizard of Oz, and now we troublemakers have gone and looked behind the curtain.

This isn't the first time we've heard it had bad sides (we all knew the grim glitter of the Borgias), but if from early childhood we've known the Renaissance was glittering and dramatic, when we saw a bare patch where the glitter came off, we thought that bare patch was the aberration, that the still sparkly parts were the real thing. Scraping more glitter off to reveal the imperfect and violent David underneath is an assault on our understandings of our past and present, on what it means to be ourselves, even on our sense of how present becomes future.

Post-2020, the feelings of helplessness, exhaustion, and despair that Petrarch voiced in the Black Death feel too familiar. We also recognize Machiavelli's frustration at seeing decades of his best efforts end in no one listening to him. But helplessness and despair are questions, as well as feelings: *Am I powerless? Can I personally do anything to change the bad parts of the world? Do individuals have any power to shape history? Are we just swept along by the vast tides of social forces? Are we just cogs in the machine? Is it just chaos?* The Renaissance's Age of Genius catches our eye with its masterpieces, and when we turn to it, one of the things we want is to see Great People whose ideals, efforts, and innovations changed the world, which prove that, if they changed their

world for the better, we can too. Our optimism suffers when we're told that, under all the glitter, the Renaissance was just a mess of Ever-So-Much-More-So, whose dream of peace and efforts to improve their world instead produced Battle Pope II (All Shall Love Me and Despair!).

Beyond the X-Factors and melodrama, two *contradictory* hopes brought us to this confrontation with the Renaissance. One was the hope voiced so often by journalists post-2020, that, if the Black Death made a golden age, COVID will cause an economic boom, and we can sit back in the coming decades and expect the rising wages and increasing glories of a golden age. The other was our excitement at these awesome people who achieved so much: Leonardo, Michelangelo, Machiavelli, the Renaissance women who wielded complex and subtle power; they gave us the hope that individuals do have the power to change the world. But if the Renaissance *was not* a golden age, and neither the geniuses nor this huge project—classicism, the *studia humanitatis*, virtue politics—got the world they wanted, then are both hopes wrong?

Or are both hopes partly and preciously *right*?

64

Great Forces History vs. Individual Choice History

There are often two big ways we in the History Lab look at what changes the world.

Some scholars study what I call *Great Forces history*. Economic historians, social historians, environmental historians, and others examine how vast forces, whether incremental or rapid, shape history. When you hear people comparing our current wealth gap to the eve of the French Revolution, that is Great Forces history. When a Marxist discusses the tensions of proletariat and bourgeoisie, or a Whig historian the march of progress, those are kinds of Great Forces history. Studies of the dissemination of a technology, the growth of cities, wages rising or falling, the interactions between finance and employment, these are histories of great forces.

This kind of history is invaluable. It lets us draw illuminating comparisons, and helps us predict, not what will happen, but what is likely, by looking at what has happened in similar circumstances (Machiavelli would be proud!). For example, the excellent Brian Sandberg, a historian of violence during the French Wars of Religion,[1] once pointed out to me that France during the Catholic-Protestant religious wars was about 10 percent Protestant, somewhat comparable to the African American population of the US today, which is around 13 percent. It's a striking comparison, and with telling differences. For example, France's Protestant population was disproportionately rich and powerful, comprising 10 percent of the population but 30 percent of the ruling class, in contrast with Black Americans who, thanks to systemic inequality

and racist infrastructure, tend to be disproportionately poorer and politically disempowered. These parallels and differences let us use Reformation France to help us understand the similar-yet-different ways tensions are manifesting in America's present, and may manifest in our near future. They let us consider questions like the horrors which came in France with the 1685 revocation of the Edict of Nantes, which help us see more clearly the vital good work being done by the many checks and balances in modern government which make it hard for bad actors to roll back rights like that, and how vital it is that we defend those checks and balances. This is Great Forces history.

But are we all, then, just statistics? Water droplets, with no power beyond our infinitesimal contribution to the tidal forces of our history?

History departments also have biographers, intellectual historians, and micro-historians, who churn out brilliant tales of how one town, one woman, one café, one invention, one idea reshaped our world. We talk of Petrarch's virtue politics, how cantaloupe's arrival sparked the French Revolution, how Bacon popularized the scientific method, how Voltaire and Beccaria persuaded Europe to end judicial torture, and how figures like Marie Curie or Sojourner Truth transformed so much. Such histories are just as true as Great Forces histories, but if the Great Forces approach makes us feel like helpless drops in a great wave, *Human Agency histories* give us hope that our individual power can act meaningfully upon our world.

Human Agency history can also be harmful. The old, bad version was Great Man history, epitomized by Thomas Carlyle's *On Heroes, Hero-Worship and the Heroic in History* (1841) which presents humanity as a kind of inert but rich medium, like potting soil ready for a seed. Onto this great and ready stage, Nature (or God or Providence) periodically sends a Great Man, a leader, inventor, revolutionary, or other firebrand, who makes empires rise or fall, or drives back the shadows of ignorance. Great Man history is very prone to erasing everyone outside a narrow elite, erasing women, erasing people of color, erasing queer people, and also prone to erasing the bad sides of the actions of Great Men, justifying atrocities as the collateral damage of greatness.

GREAT FORCES HISTORY VS. INDIVIDUAL CHOICE

Great Man history is also prone to making us feel like only *special* people have power. Even as Great Man history gives way to Great Person history, and we celebrate heroines, trans and non-binary heroes, heroes of color, indigenous heroes, gay heroes, disabled heroes, etc., we still end up with heroes, just a more diverse array of them. Great Person history tells us that *special* people change the world, but that such world-changers are not like us. So many books show geniuses, resolute and never swaying, burning midnight oil, all their flaws *heroic* flaws, so overcoming them is one more part of being *special*. That makes us feel just as powerless as Great Forces history, since it shows a world shaped only by people *Time Magazine* might make their Person of the Year. Great Person history erases the Machiavelli who fretted about laundry, the Voltaire who had chronic illness, the Cicero who got snitty over real estate.

I haven't told that story yet, have I? How Cicero broke Petrarch's ankle, and his heart. It's in Petrarch's letters: a big, heavy, costs-as-much-as-a-house volume of Cicero fell off the shelf onto Petrarch's ankle, hurting it badly, and it got infected and swelled up, so Petrarch was laid up for months, but that didn't hurt as much as *reading* Cicero. Petrarch had long loved Cicero's philosophical dialogs, the Cicero who modeled the examined life, who taught tranquility of the soul, that inner mastery in which the philosophic self rises above the slings and arrows of outrageous fortune. That Cicero taught Petrarch to write *Remedies Against Fortune*, to battle pride by remembering that property, a handsome face, a lofty reputation, these are fleeting shadows. That Cicero modeled deep philosophy, moments like when Diogenes the cynic—who owned few objects but had a bowl to drink from—saw boys by the river drinking from their hands, so Diogenes threw his bowl away, rejoicing that he no longer had to worry about losing it. To paraphrase a Stoic maxim: Think of yourself as a guest in a banquet, with many platters moving around, which guests are reaching for, taking good things. If one of the platters that comes to you is empty, all the bacon-wrapped scallops gone before they got to you, why should you be angry about something that was not *yours* to begin with? It was a gift you might have received, and there are many other gifts and platters (friendship,

nature, contemplation) offered by the great, unending banquet we call life. In his worst days, when even trust in Providence failed him, Petrarch, who *kept* losing friends to plague long after 1348, turned to his teacher Cicero and smiled.

And then, in questing for more! more! more! books, Petrarch found Cicero's letters, in which Cicero frets and shouts and grouches about petty things, obsessed after his daughter's death with real estate lawsuits over building her tomb, succumbing wholly to the bitterness of grief that Petrarch had thought Cicero could teach him to resist. Cicero failed. He couldn't live by his own good advice. Petrarch, who had thought he could learn to face grief if he just practiced Ciceroing harder, found that even Cicero had failed the test. It broke his heart. In many ways it broke his hope. If even Cicero was not the Great Man Petrarch had aspired to be, and to teach others how to be, then is there nothing in this world but Fortune's helpless fools?

We too had a hope like Petrarch's, when we turned to the Renaissance, a hope to find people who made a dark world bright, a rough world glorious, people that we could emulate, or hope to find versions of in our day, Great People who can make a golden age. Isn't that what the Renaissance's flowering of individualism promised to show us? If they still failed like Cicero, then is Great Forces history—with us as droplets helpless in the tide—the only truth?

No.

65

The Papal Election of 2016

I said before that, every year in my Italian Renaissance class, I run a simulation of a Renaissance papal election, modeled on 1492.

Each student is a different participant. Some are ambitious cardinals dead set upon the throne (Battle Pope II vs. very very very…). Some are lesser cardinals hoping to leverage their votes to achieve other goals: the Visconti Sforza cardinal to protect Milan, Cardinals Orsini and Colonna to defeat each other, young Cardinal de Medici to secure his family and Florence, young Ippolito d'Este to collect courtiers and help his aunt Queen Beatrice stabilize Hungary. Some—in their own space outside our mock Sistine—are crowned heads of Europe trapped in the papal prisoner's dilemma: Queen Isabella of Castile, Duchess Anne of Brittany, Emperor Maximilian, King Charles of France, Queen Beatrice of Hungary, and Henry VII of England, all competing to elect a pope who'll favor them. Yet others are functionaries in the Vatican, trying to get raises or help their families or cities: you'll recognize choir director Josquin des Prez, secretaries Annius of Viterbo and Raffaello Maffei Volterrano, and the vice-chancellor's young assistant Cesare Valentino Borgia.

Each student receives a long packet with details about their childhood, friendships, ambitions, enemies, and each has free rein to support whichever papal candidate they choose, within the constraints of what their character wants (and needs, and *hates*). Each student also gets resources, colored cards representing money, titles, treasures, armies, artists one can use to boost one's influence or trade to others as commodities: *I'll give you Leonardo if you give me Poliziano and send an army to guard my city from the*

French. Some cards are relatives one has to marry off: Juan Borgia, Isabella d'Este, Catherine of Aragon, Alessandra Scala, Ruxandra of Wallachia the Vampire Raven Princess (granddaughter of Vlad the Impaler and niece of Matthias Corvinus the Raven King, about whom, through some unfathomable injustice, there is not yet a single YA fantasy romance!). With all these tools—plus orchestrators representing outside powers (King Casimir of Poland!) or disruptive chance (a flood!)—my students meet, negotiate, form factions, then elect a pope and fight a war, our own version of the Italian Wars, complex and terrible.

I designed the simulation with no pre-set outcome. I gave each historical figure resources and goals that I felt accurately reflected that person's real historical resources and actions. I also moved some characters in time, including some cardinals and political issues which did not quite overlap with each other, in order to make it a slightly alternate history, not a mechanical reconstruction, so those students already familiar with what happened to Italy in 1492 know they can't quite get the *correct* outcome even if they try, which makes everyone feel free to explore the range of what could happen without feeling locked in to trying for the "real" outcome. I set up the situation, then step back and let it flow.

I have now run the simulation more than ten times. Each time some outcomes are similar, enough that they are clearly locked in by the greater political webs and economic forces. The same few powerful cardinals are always top candidates for the throne, backed by the big power blocs: France, Spain, and the Empire. There is also always a *wildcard* candidate, someone who has rarely if ever been one of the top contenders, but circumstances bring a coalition together behind someone unpredictable, who rallies those united by their fear and hatred of the other top contenders. Often one of the political juggernauts wins, one of those who began with a strong power base, but it's usually very, very close. Sometimes the wildcard candidate wins, but even if he loses, the coalition that formed around that wildcard has a powerful effect on the new pope's policies and first actions, who's in the inner circle and who's out, what opposition parties form, how strong they are. That, in turn, determines which city-states rise and which burn as Italy erupts in war.

And the war is Always. Totally. Different.

Because as the monarchs and their favorites race to make alliances, they get pulled back and forth by the ricocheting consequences of small actions: a marriage, an insult, a bribe, a letter gone astray, a whisper overheard by a secretary, someone paying off someone else's debts, someone taking a shine to a bright young thing. Sometimes France invades Spain. Sometimes the Empire and Spain both invade France. Sometimes England and Spain team up to keep the French out of Italy. Sometimes France and the Empire team up to keep Spain out of Italy. Once they made a giant pan-European peace treaty, with a set of marriage alliances which looked likely to permanently pacify all crowns, but it was shattered by the sudden assassination of a royal heir. And, inevitably, Italy burns. Sometimes it's Milan that burns. Sometimes it's Naples. Sometimes it's Genoa, Forlì, Urbino, sometimes Rome itself. Once a Borgia papacy was shattered by an overconfident ally letting the Borgia Kingdom plan leak out too soon. Once a Sforza papacy, that would have meant a safe, united Italy, was thwarted by Sforza refusing to take a mistress from a powerful family determined to control the pope. Almost always small city-states are shaken, while smug Ippolito d'Este of Ferrara sits back safe and rakes in profits coasting on his family's nobility. Almost always a good man comes close to winning the papacy, but the campaign withers because the candidate that the cardinals *love* can't guard their families and homelands from the great powers they *fear*. Almost always someone goes too far, and slips from being *feared* to being *hated*, and then burns. After it's over, only then I let my students read Machiavelli's letters and *The Prince*, and recognize themselves, their deeds, their fears, their choices, and they *understand*.

When I tell people about this simulation, they often ask: *Does it usually have the same outcome?* Yes *and* no.

The Great Forces are powerful, and real. The strong factions are strong. Money is power. Blood is thicker than promises. Virtue is manipulable. Love rarely beats fear. In the end, a bad man will be pope, and he will do bad things. The war is coming, and the land will burn—some land somewhere, in Italy and often outside too. But the details are always different. A cardinal needs sixteen votes

Raffaele Riario (Lyric Ciarlo), Giuliano della Rovere (Ben Indeglia), and the Franciscan leader Francesco "Samson" Nanni (Zachary Kurland) watch in hope for the white smoke, 2019 (photo by Tamara Vardomskaya).

Gherardo, Mario, and Raffaello Maffei (Connor Williams, Elise Darragh-Ford, and Grace Geraghty) tally votes as the cardinals scheme below.

THE PAPAL ELECTION OF 2016

to get the throne, but it's never the *same* sixteen votes that come together, so it's never the same sixteen people who get papal favor, whose agendas are strengthened, whose homelands prosper while their enemies fall. I have never seen a pope elected in this simulation who did not owe his victory to at least ten people, not just the voting cardinals but also humble functionaries, who repeated the right whisper at the right moment, which gave the throne to Bad Pope A instead of Bad Pope B. From that young secretary's tiny actions flow the consequences. There are always several kingmakers in the election, who often do more than the candidate himself to get him on the throne, but what they do, and who they help, and which kingmaker ends up most influential, that can change a war in Genoa into a war in Burgundy, a marriage between France and Spain into another generation of fire and steel, or determine which decrees the new pope signs. Those decrees often matter more than whether war strikes Burgundy or Genoa, since papal pronouncements shape such issues as: Who gets the New World? Will there be another crusade? Will the Spanish Inquisition get to escalate unchecked? Will Hungary remain independent or become part of the growing empire? All these big outcomes are completely different every time, all happening between the Great Forces, shaped by the choices of individuals.

Often the most explosive action is the night after we first elect our pope, when the Great Forces lift a new bad man to Saint Peter's throne. As orchestrator, I can tell when our great and somber stage is set for war, when the peace movements are failing beneath the weight of incentives pushing my student monarchs to send their troops into the field, but that's the moment that small human actions do the most. I get text messages at 2 a.m.: *Secret meeting 9 a.m. Economics cafe. Make sure no one sees you. Sforza, Medici, d'Este, Piccolomini, Maffei bros, Venice all coming. Borgia will not be master of Italy!* And together, these brave, haste-born allies both fail and succeed. They give it all they have: diplomacy, force, bags of florins, guile. They strike. The bad pope rages, sends forces to smite his enemies. The kings and great thrones take advantage, launch invasions. Chance plays its role as storms and outbreaks disrupt battle plans. The armies clash. Two rebel cities burn, but four survive, and Borgia (that year) is not Master of Italy.

We feel it, the students and myself, as we emerge from our Italian Wars. The Great Forces were real. The dam was about to break; no one could stop it. The Italian Wars were going to happen, the likely popes were too warlike, the incentives for the great thrones of Europe too strong. But the human agents—even the junior clerk, grateful that someone gave him one florin to fix his parents' roof, who passes on a whisper—they shaped what happened, each having consequences, intertwined but real. The dam was about to break, but every person there got to dig a channel to try to direct the waters. Those channels determined the flood's shape, its path, its damage, whether it burned Burgundy, or Genoa, or fragile Florence. No one *controlled* what happened, no one could *predict* what happened, but those who worked hard, who dug their channels the best they could, succeeded in diverting *much* of the damage, achieving *many* of their goals, preventing the worst. It wasn't perfect. Often Florence is *almost* sacked or conquered, but survives, usually by throwing someone else under the bus, capitulating to the French or Spain or the ambitious pope, funding their wars, and sacrificing Pisa, Siena, poor Volterra, but even there, *which* other city Florence sacrifices to protect itself depends on the tiny actions of *each* city's native sons. Each channel moves the water.

What I see in the simulation I see in real history.

Both kinds of history are true. There are Great Forces: economics, class, wealth gaps, prosperity, stagnation; these make some historical moments ripe for change, war, wealth, crisis, healing, transformation, or peace. But individuals also have real agency, and our actions determine the consequences of Great Forces as they shape our world. We have to understand both, study both, and act within our world remembering that both are real.

And I phrased all this as floods and channels in my class one day, *and only afterward* went home and remembered that someone else had put it much the same:

Machiavelli, *The Prince*, Chapter XXV: "I judge it that Fortune is arbiter of half our actions, but still she leaves the other half, or nearly half, for us to govern. I compare her to one of those

violent rivers, which when swelled up floods the plains, sweeping away trees and buildings, carrying the soil away from one place to another; everyone flees before it, all yield to its violence without any means to stop it; and yet, though floods are like this, it is not the case that men, in fair weather, cannot prepare for this, with dikes and barriers, so that if the waters rise again, they either flow away via canal, or their force is not so unrestrained and destructive. So it is with fortune, who demonstrates her power where virtue has not prepared to stop her, and turns her forces where she knows dikes and dams have not been built to restrain her. If you consider Italy, the seat of these changes [i.e. the recent wars] and which gave them their momentum, you will see a countryside wide open, without dam or dike."

Living through it, simulating it, we felt it: Machiavelli, my students, me.

Isabella of Castile (Gwyneth Turner), Ferdinand of Aragon (Michael Mellas), and other European notables witness the Obedience Orations, 2019 (photo by Eliana Melmed).

Johannes Burchard (Max Goldberg), Pope Alexander VI (Squid Tamar-Mattis), Micheletto Corella (Irina Bercu), Alessandro Farnese (Monica Brown), and others watch as Cesare Borgia (Raphael Hillis) takes his oath of fealty to his father, 2019.

Can human beings control progress? Yes *and* no.

The most powerful iteration of the election so far was the one I ran in 2016. On Tuesday we elected a terrible pope. On Thursday he burned Europe. The next week Donald Trump won the US presidential election. The day after, the students in my other class came in sullen, exhausted, filled with bitter spite, their pre-class chatter focused on people being *stupid*: *Voters are so stupid! How can people be so stupid! This system is stupid!* Many colleagues said their classes came in like that too. But my Renaissance class, the class who'd just burned down imaginary Europe, was all energy: *It's the system! The incentives! Structures of power! We need to analyze the structures that make people support a candidate they know won't actually be good for the position, but which gets them what they want, or think they need. Let's study the system! Systemic analysis will teach us how to make better results in future!* Instead of bitterness, they had questions. Instead of blame, they knew they had to examine our world deeply, and seek to understand the secret causes and hidden motions of things. To act. To build new dikes against new coming storms. *And Machiavelli smiled.*

66

Which Horseman of the Apocalypse?

Few things have taught me more about the world than keeping a fish tank. You get some new fish, put them in, everything's fine. You get some more new fish, the next morning one of the originals has killed the other originals—why? Another time you get a new fish and it's gasping and pumping its gills hard, because it's from alkaline waters, so you put in a little pH adjusting powder and… all the other fish get sick from the ammonia and die. Another time one of your fish gets sick, so you put antibiotics in the water, aaaand… they kill all the symbiotic bacteria in your filter and the water gets filled with rotting bacteria, and the fish die. Another time you do absolutely nothing, and the fish die.

What's killing my fish? The same thing that caused the polio epidemic: the system is more complex than it seems. A change which achieves its intended purpose throws off vital forces you did not realize were dependent on it. The acidity buffer increases the nutrients in the water, which causes an algal bloom, which uses up the oxygen and suffocates the bottom feeders. The marriage alliance between Milan and Ferrara makes Venice friends with Milan, which makes Venice's rival Genoa side with Spain, and pretty soon there are Scotsmen fighting Englishmen in Padua. An ancient surgeon realizes that cataracts are caused by something white and opaque appearing in the eye so he removes it, not yet understanding it's a lens you really need. It's all the hidden causes and secret motions of things.

So when I hear, *Has social progress failed?* my zoomed-in self, my scared self living in these terrifying years, does feel afraid, but my zoomed-out self, my historian self, answers easily. Progress

has done wonders! But it has also done what all change does in a dynamic system: had complicated consequences. Petrarch, Bacon, Marie Curie, all added something to the fish tank with *many* results. The same celebration of classical education which popularized the Platonic idea that sometimes humble parents produced kids with souls of gold *both* resulted in the Enlightenment ideal of universal equality, *and* fed the *no columns, no culture* side of European supremacy which enabled the atrocities of colonialism.

But if the consequences of our actions are completely unpredictable, would it be better to say that change over time is real, but that anything like human-controlled progress is an illusion?

No.

Why?

Because I gradually got better at understanding my fish tank.

Because my mother's cataract surgery—after 2,000 years of practice—saved her sight.

Because some of our civil rights have come by blood and war, but more recently more and more have come by negotiation and agreement.

Because my students who burn down imaginary Europe every year understand better afterward how to avoid collateral damage, and avoid burning things down in their own world. A lot of them even volunteer to come help with the next simulation, advising their peers on how to see the patterns, giving advice much more prudent than when they braved 1492's Scylla and Charybdis the first time.

Humanity is getting better at observing—and knowing we must look for!—the secret motions of things. We have achieved some of what Machiavelli and Bacon wanted: a new method to make the next generation's experience on this Earth a little better, and to help us avoid those moments when we lose so much so quickly. In my mock papal election, the dam does break, but those students who work hard to dig their channels can direct the flood, and most of them achieve *some* of their goals, even as they cause other things too. Petrarch cried out: "Peace! Peace! Peace!" and in a century Hungarian warlords were using the classics against the grandkids of Vlad the Impaler, *and* we had an educational revolution which birthed the modern humanities, ethics, political science, and history.

WHICH HORSEMAN OF THE APOCALYPSE?

Is progress still blowing up in our faces?
Yes.
Did it blow up in the Renaissance's face?
Yes.
Did it blow up in Bacon's face? And the Enlightenment's?
Yes.
Is it going to keep blowing up in our faces, over and over?
Yes.
Is it going to blow up so much that, sometimes, it doesn't seem like things are getting any better?
Yes.
Are the stakes growing higher every year, as our population rises, and our power to both reshape and harm our world grows greater compared to Earth's fragile fish tank?
Yes.
Is that still progress?
Yes.
Why?
Because Petrarch sent *Italia Mia* out into the world to try to drive back the Dire Horseman War, and instead of peace he got a burst of library-building and philology, which triggered the Reformation and the proliferation of rival truth-claims, which triggered the skeptical crisis and rejection of the presumptive authority of the past, which created the scientific method and vaccines and antibiotics. Plague wasn't the Horseman of the Apocalypse Petrarch hoped to defeat, but the man whose *Remedies Against Fortune* offered consolation, even for those who lose their homelands to war, would weep such happy tears to hear the plague *for which he had no consolation* is defeatable. And he helped us get there. He *also* encouraged us to start asking more worldly, social questions, and helped birth Machiavelli and the modern social sciences, which let us apply new methods to those questions, as we study wealth gaps and class tensions, and the Great Forces that we can dig our channels to direct. And he *also* helped birth modern humanistic education, virtue politics, expanded by our modern confidence that all souls can be educated, not just rare children of gold. That humanistic education lies behind our efforts to reduce torture, spread education, increase rights, reduce atrocities; it

created the UN and its UNESCO lists of world heritage sites that all the world has vowed we must protect. We needed all of it. The attack on Aristotle by those who preferred Galileo hatched from the attack on Aristotle by those who preferred Cicero.

If Petrarch were here now, would he be satisfied with what the Renaissance achieved? Hell, no! He'd still be horrified by all our wars, and keep striving for peace, and telling us to be more virtuous, and build more schools, ask more worldly questions, so someday we can have real peace like the *Pax Romana* of the good gay emperors. But he would say it with new hope beyond his former hope, born of realizing that he and his friends aided an achievement—*beating back the deadly Horseman Plague!*—far beyond his loftiest imagining, that humanity can aim for even better than climbing out of a pit back to antiquity's high hill— we can keep climbing.

There was a baby in the bathwater of Whig history. We can find metrics for comparing times and places which don't privilege particular ideologies. Metrics like infant mortality. Metrics like malnutrition. Metrics like the frequency of massacres. As I said, one of my favorite questions to ask an era is: *What portion of the population can be murdered by a different portion and have the murderer suffer no meaningful consequences?* The answer, in my homeland of America today, is not zero percent, but it's not ninety percent, the way it was in the patronage-dominated Renaissance, when Benvenuto Cellini could stab you in the back and, if he's working for the pope, there won't be justice. That is progress. That, and infant mortality, and the conquest of smallpox, and soon of polio, and broadening access to education, these are genuine improvements of the sort the Try Everything Age believed would come if they kept striving to reveal the secret motions of things.

The slowness of social progress is painful, I think especially because it's the aspect of progress that seemed it would come fastest. During that first century, when Bacon's followers were waiting for their medical discoveries to actually save lives, social progress was already working wonders. The Enlightenment did extend the franchise, end torture in most of Europe, it had this heady feeling of victory and momentum.[2] It seemed like social progress was already half-way done before tech got started. But

Charles Babbage kicked off programmable computing in 1833 and now my pocket contains 100x the computing power needed to get Apollo XI to the Moon, so why, if Olympe de Gouges wrote *the Declaration of the Rights of Woman and the Citizen* in 1791, do we still not have equal pay?

Because society is a very complicated fish tank.

We still have a lot to learn about the secret motions of things, but if there is a dam right now, ready to break and usher in a change, Great Forces are still shaped by human action. Our action.

Progress is both a concept and a phenomenon.

The concept is the hope that collective human effort can make every generation's experience better. That is itself a mighty force shaping the human experience, making us *try* things we would not, making us know we can aim high.

Progress is not inevitable, but it is happening.

It is not safe, but it is beneficial.

It is not linear, but it is ongoing.

It is not simple, but it can be studied.

It is not controllable, but it is us. In fact, it is nothing but us.

Progress is natural, not in the sense of inevitable improvement, but in the sense that the human animal is part of nature, as Aristotle said, so *The Declaration of the Rights of Man* is as natural as a bird's nest or a beaver dam. There is no correct ending, but we are learning to understand bad side effects, to mitigate, prevent, make safety nets. We're getting better. Slowly, but we are. And we realize we need to.

I mentioned earlier a debate, in the History Lab, between my friends Chris Celenza and Rocco Rubini, about whether Machiavelli is a modern man. Chris had just published his biography of Machiavelli, and he, much like me, described Machiavelli as the product of a desperate time, shaped by the profoundly un-modern violences and chaos of his day.[3] Rocco objected that there are more murders in Chicago now than in Florence back then, so does the violence really make Old Nick un-modern? It is an important question, especially since so much of our own era's daily violence tends to be erased or pushed off-camera, so to speak, by the social apparati which perpetuate it (racism, systemic inequality), in contrast with the grim glitter of Renaissance

violence which TV dramas love to magnify. But there are also differences. It would have been easy for Chris to cite population, to say modern Chicago has thirty times the population of 1500s Florence, that our bloodshed is *proportionately* smaller. But Chris didn't. Instead, pausing, smiling warmly, thinking through, Chris answered that we today believe the murder rate in Chicago is not acceptable, or natural, or immovable, that we believe *we can fix it* if we study and try, that we aspire to change it for the better. That we feel a humane duty to do better. Machiavelli didn't think that was possible.

Machiavelli urged Florence's rulers to study the secret motions of history, so they could rule better and protect Florence in an age when saving Florence usually meant throwing another city-state into the flood, as my students so often do, and as real Florence did, befriending King Charles instead of standing strong to let the rest of Italy gather its troops. Machiavelli hoped studying Livy and Valentino would reveal the best channels to dig to guide the flood waters away from Florence *onto someone else;* he did not have the hope that it might someday be possible to guide the flood so skillfully that no one drowned. We do. We feel we can (Bacon, Machiavelli) and also we feel we should (Petrarch, Cicero, Voltaire, Bentham, Kant). That's progress. There was no hope of change until we realized, both that we can, and that we should.*

* In fact, since Machiavelli saw war and conquest as essential to the health of a state (see *Discourses* II), if you had presented to him the idea that the flood of Fortuna might be diverted to harm no one, he would probably have said it's better to direct it against enemies, and use it to advance your nation's conquests and defenses. We had a very long way to go from Machiavelli to ideals of universal good, global human collaboration, and rejecting empire.

67

What Did the Black Death Really Cause?

Change, and a chance to dig our channels, and each direct that change a little bit.

In summer 2020 I watched a SpaceX launch on my computer while cops were harassing peaceful protesters outside my window, with a gun-wielding vigilante standing vigil on the corner—it felt a lot like Leonardo painting the *Mona Lisa* while cities around Italy were burning, and rich merchants' private troops guarding their palaces. It was the first time our present reminded me of the Renaissance. But we aren't the Renaissance—we aim higher.

The Black Death didn't cause the Renaissance; no one thing did. It was a conjunction of gradual and complicated changes: banking, legal reform, centralization of power, urbanization, technology, insurance, education, political thought. The studies that suggested wages went up after the Black Death have given way to better ones, showing that, in some places workers were empowered, and in others they were further bound by harsher laws. What the Black Death did cause was a moment when policy and local power could reshape whole regions, both creating opportunities and taking them away. The Norse Greenlanders who managed to get on those last boats and leave found many empty farms in Norway, eager for more hands, and prospered in new, richer circumstances; those who did not get on the boats saw boats stop coming, as the trade which had once been their lifeline went away. Collapse and growth, busts for one industry, booms for another, sudden wealth collecting in some hands as elsewhere whole communities collapsed, a million parts all moving as the complicated world went Ever-So-Much-More-So-ing along. We understand

that now. That's why our own pandemic in 2020 had no automatic outcome. The flood waters poured out, and each country, city, corporation, neighborhood, family, and individual dug what channels we could to guard what we held precious. We all shaped the outcomes, and are still shaping them (the consequences of pandemics are measured in decades, not in years), just as every version of the wars my students fight when they elect a pope is shaped by every one of them. There is no one room where it happens—or if there is, it is the whole planet Earth.

Learning to understand the secret causes of things was hard. It took us a long time. If Franklin's lightning rod made a first payment on Bacon's IOU 150 years later, it was a tiny payment. Centuries feel long while we live through them, but we didn't really realize Earth's fish tank was so unstable, that our well-intended interventions had bad side effects, until the twentieth century; if it took 150 years from Petrarch's plan for a few men to realize it wasn't working (Machiavelli, Savonarola, Luther), a century is not very long for us to learn to mitigate the bad side effects of progress. Of course, we still mess up—that doesn't mean we *give* up, or that we aren't getting better. The year 2020 was the first time this planet faced a pandemic knowing what it is, and how to act. Forget 1348, even in 1918 we didn't understand how influenza moved, and hand washing was still controversial. We didn't take perfect action with COVID, and we should be condemning the failures, but I'm not just a historian of the plague of 1348, I'm a historian of the plagues of 1435, 1485, 1494, 1503, 1596, 1630, and 1656, those many generations who lived without hope that it could ever stop. We do have hope. Within two years we learned how to treat and vaccinate, achievements any other age in history would hail as miracles. All Petrarch had in 1348 was the advice that, the next time the plague comes back, we should console ourselves by thinking of it as dying with good company.

We also know about mental health now. We're studying the mental health costs of pandemic, poverty, racial injustice, fear. The concept of *mental health* alone empowers us, as do related concepts: *social safety net, welfare, social services*, tools for thinking about how society can put structures in place to relieve suffering. There were social services in 1348, hospitals, city grain supplies, orphanages, but Florence's public health response to the Black

Death was to double the fine for selling meat from male and female animals in the same butcher's booth, thinking that the mix of generative juices birthed disease. In Florence's orphanage there hangs a painting by Michelangelo's teacher Ghirlandaio, an *Adoration of the Magi* with the Virgin and Child and city's patron John the Baptist, all surrounded by the *Innocenti*, dead babies and toddlers from the Massacre of the Innocents, tiny kids still in their swaddling clothes standing among the city's patrons in poses of power—they're there as role models to teach the orphans how to imagine their dead friends still watching over them, and how to imagine their place in the world after their deaths, since most of these kids *would not survive to leave the orphanage*. Our child services are far from perfect, but we aim higher than preparing kids for death.

That's why we can do better than the Renaissance.

The *studia humanitatis*, virtue politics, they failed to stop the disasters of 1494, just as my students in our simulation fail to stop bad popes from rising, but the simulation doesn't end when we elect a pope, and the Renaissance didn't end when Machiavelli realized educating Europe's princes was not fixing the future *by itself*. Renaissance Europe was a complicated fish tank. Virtue politics was a project to teach those with the power to influence the fate of people how to rule better, more humanely, and more successfully. We still aim at that, but virtue politics needed more tools to achieve the stability and humaneness it aimed at: Petrarch's humanities needed Machiavelli's social sciences, Bacon's science, and the Enlightenment's realization that all people are created, not just equal, but *educable*, all equally capable of what Plato believed was open only to rare souls of gold. Rather than expecting virtue to drip down from elites, today's democratized version of virtue politics aims to teach every one of us humaneness, custodianship, historical reflection, and an understanding of the hidden motions of society, aiding and empowering our myriad decisions as we dig the crisscrossing channels to protect our world. Ercole Bentivoglio did get his wish, Old Nick did complete his history of how bad it was. We read. We listened.

What's under the glitter? David is a youth preparing to take on a giant, sculpted for a frightened city by a frightened

Michelangelo—Michelangelo who twice failed virtue's test and abandoned his homeland in its time of need, but the second time he worked his courage up and went back home, to guard the great dome whose foundations were laid out by builders *who did not know how to finish what they started*, but began their project trusting future generations would keep working on it, and find a way. Their efforts didn't make a golden age in the 1400s. Or the 1500s. Or the 1600s, 1700s, 1800s, or 1900s. But Renaissance people didn't shy away from starting things that take 500 years.

Some say of science that Bacon built the scaffolding and Newton raised the cathedral, but it wasn't as quick as that. Petrarch's generation started us gathering materials, precious libraries, making worldly and social questions central to human inquiry at last. A century later, Machiavelli laid out the foundations, proposing a new way of using those libraries, and challenged the myth that there was nothing to be learned from that long, ever-changing Middle Age that followed Rome. Century three, Thomas Hobbes was starting on the ground floor, mixing Machiavelli with Bacon's empiricism and social analysis. A century later Enlightenment voices—Voltaire, Beccaria, Montesquieu, dear Diderot—raised the upper sections of the wall, convincing people and nations to try changing their world on a large scale. It took another 100 years to realize big social experiments often had collateral damage, and readjust those upper sections to be safer and better, so they didn't make the rain runoff flood other parts of town. Hope of a golden age *to live in* is still underway: it's our job now to do the hardest part and build the dome. It took a long time to raise this cathedral, to get from *Italia Mia* via *The Prince* and the *New Organon* to RNA vaccines, but it's the same project. Will we do it perfectly? No. Will we finish in our lifetimes and enjoy our golden age? No. We will add our layer to the structure, but there's more to come, the trim, the lantern and the ball on top. Florence's cathedral, begun 1296, *is still not done today*. But it is a wonder, as is every hand that helped to build it. We have tools in our hands now—tools that Machiavelli, Petrarch, and Alessandra Scala would have given anything to have. We can aim for better than the Renaissance, which is what our Renaissance friends did too.

Let's try.

Sources and Recommended Reading

Recommended Reading

Eager for another book like this? Here is a short list of books—selected from the hundreds that shaped this project—that are readable, affordable, and offer either more delight and drama like the story-focused parts of this book, or more depth and detail about core topics or debates I touched on only briefly. All of these, I promise, you'll enjoy. A full list of sources (many of which you would also enjoy!) follows.

Allen, Don Cameron, *Doubt's Boundless Sea: Skepticism and Faith in the Renaissance* (Baltimore: Johns Hopkins Press, 1964).

Atkinson, Niall, *The Noisy Renaissance: Sound, Architecture, and Florentine Urban Life* (University Park, Pa.: The Pennsylvania State University Press, 2016).

Baker, Nicholas Scott, *The Fruit of Liberty: Political Culture in the Florentine Renaissance, 1480–1550* (Cambridge, Mass.: Harvard University Press, 2013).

Celenza, Christopher S., *The Intellectual World of the Italian Renaissance: Language, Philosophy, and the Search for Meaning* (New York: Cambridge University Press, 2018).

Cochrane, Eric W., *Florence in the Forgotten Centuries, 1527–1800: A History of Florence and the Florentines in the Age of the Grand Dukes* (Chicago: University of Chicago Press, 1973).

Copenhaver, Brian, *The Book of Magic: From Antiquity to the Enlightenment* (London: Penguin Books Limited, 2015).

Darnton, Robert, *The Great Cat Massacre and Other Episodes in French Cultural History* (New York: Basic Books, 2009).

———, *The Business of Enlightenment: A Publishing History of the Encyclopédie, 1775–1800* (Cambridge, Mass.: Belknap Press, 1979).

Findlen, Paula and Suzanne Sutherland eds., *The Renaissance of Letters: Knowledge and Community in Italy, 1300–1650* (Abingdon: Routledge, 2020).

Fubini, Riccardo, *Humanism and Secularization: From Petrarch to Valla* (Durham: Duke University Press, 2003).

Gabriele, Matthew and David M. Perry, *Bright Ages: A New History of Medieval Europe* (New York: HarperCollins, 2023).

Gay, Peter, *The Enlightenment, an Interpretation* (New York: Knopf, 1966).

Gill, Anton, *Il Gigante: Michelangelo, Florence and the David, 1493–1504* (London: Review, 2002).

Hale, Sheila, *Titian: His Life* (New York: HarperCollins, 2012).

Hankins, James, *Virtue Politics: Soulcraft and Statecraft in Renaissance Italy* (Cambridge, Mass.: Harvard University Press, 2019).

Hibbert, Christopher, *The House of Medici: Its Rise and Fall* (New York: Morrow, 1975).

Johns, Adrian, *Piracy: The Intellectual Property Wars from Gutenberg to Gates* (Chicago: University of Chicago Press, 2009).

Kaborycha, Lisa, *A Corresponding Renaissance: Letters Written by Italian Women, 1375–1650* (Oxford: Oxford University Press, 2016).

Kelly, John, *The Great Mortality: An Intimate History of the Black Death, the Most Devastating Plague of All Time* (New York: HarperCollins, 2005).

King, Ross, *The Bookseller of Florence: Vespasiano da Bisticci and the Manuscripts that Illuminated the Renaissance* (New York: Atlantic Monthly Press, 2021).

Kors, Alan C., *The Birth of the Modern Mind: The Intellectual History of the 17th and 18th Centuries* (sound recording; Chantilly, VA: The Teaching Company, 2003).

Launay, Robert, *Savages, Romans, and Despots: Thinking About Others from Montaigne to Herder* (Chicago: University of Chicago Press, 2018).

Lev, Elizabeth, *The Tigress of Forlì: Renaissance Italy's Most Courageous and Notorious Countess, Caterina Riario Sforza De' Medici* (Boston: Houghton Mifflin Harcourt, 2011).

MacCulloch, Diarmaid, *The Reformation: A History* (New York: Penguin Books, 2005).

Machiavelli, Niccolò (James Atkinson and David Sices eds.), *Machiavelli and His Friends: Their Personal Correspondence* (Dekalb: Northern Illinois University Press, 1996).

Marenbon, John, *Later Medieval Philosophy (1150–1350): An Introduction* (Abingdon: Routledge, 1987).

McKitterick, D., *Print, Manuscript and the Search for Order, 1450–1830* (Cambridge: Cambridge University Press, 2003).

SOURCES AND RECOMMENDED READING

Mitchell, R. J., *The Laurels and the Tiara: Pope Pius II, 1458–1464* (Garden City, N.Y.: Doubleday, 1963).
Origo, Iris, *The Merchant of Prato* (London: J. Cape, 1960).
Pettegree, Andrew, *The Invention of News: How the World Came to Know About Itself* (New Haven: Yale University Press, 2014).
Price, Neil S., *The Viking Way: Magic and Mind in Late Iron Age Scandinavia* (Oxford: Oxbow Books, 2019).
Ross, Janet, *Lives of the Early Medici as Told in Their Correspondence* (Whitefish: Kessinger Publishing, 2006).
Ruggiero, Guido, *The Renaissance in Italy: A Social and Cultural History of the Rinascimento* (Cambridge: Cambridge University Press, 2014).
Slauter, Will, *Who Owns the News?: A History of Copyright* (Stanford: Stanford University Press, 2019).
Stevenson, Jane, *The Light of Italy: The Life and Times of Federico da Montefeltro, Duke of Urbino* (London: Head of Zeus, 2021).
Tomas, Natalie, *The Medici Women: Gender and Power in Renaissance Florence* (Aldershot: Ashgate, 2003).

If you would like to enjoy some historical fiction that uses these periods well, try Dorothy Dunnett's *House of Niccolò* series, Hilary Mantel's *Wolf Hall*, Jo Walton's *Lent*, *Thessaly* and *Or What You Will*, the *Borgia: Faith and Fear* TV series (Canal+ not the same as Showtime's *The Borgias*), or Shakespeare's histories, especially the *Henry VI* & *Richard III* sequence, ideally Jane Howell's brilliant 1983 BBC Television Shakespeare version.

Primary Sources

Alberti, Leon Battista, *The Albertis of Florence: Leon Battista Alberti's Della Famiglia* (Guido A. Guiarino trans.) (Lewisburg: Bucknell University Press, 1971).
Bembo, Pietro (Robert W. Ulery trans.), *History of Venice* (Cambridge, Mass.: Harvard University Press, 2007).
Cassirer, Ernst, Paul Oskar Kristeller, and John Herman Randall eds., *The Renaissance Philosophy of Man* (Chicago: University of Chicago Press, 1956).
Cellini, Benvenuto (Julia Conaway Bondanella and Peter E. Bondanella eds.), *My Life* (Oxford: Oxford University Press, 2002).
Corio, Bernardo, *Patria historia* (Venezia: Giorgio de' Caualli, 1565).
Un crudele et compassioneuol caso, occorso nella città di Padua. De un gentil'huomo il quale hauendo per inganno de una serua ucciso il

seruitore, velenata la moglie, et cauato il core alla detta fantesca, si è finalmente appiccato lui medesimo. Con il lamento che ha fatto la gentildonna innanzi la sua morte, cosa veramente inaudita degna di pietà ([Milan?]:[late 1500s]; Biblioteca Apostolica Vaticana Stamp. Cappon.V.681 (int.106)).

An Elegie Upon Mr. Thomas Hobbes of Malmesbury, Lately Deceased. 1679. Huntington Library, HEH 133310; English Broadside Ballad Archive EBBA 32133. http://ebba.english.ucsb.edu/ballad/32133

d'Este, Isabella (Deanna Shemek trans.), *Selected Letters* (New York: Iter Press, 2017).

Dolfo, Floriano, *Lettere ai Gonzaga* (Roma: Edizioni di storia e letteratura, 2002).

Fedele, Cassandra (Diana Robin trans.), *Letters and Orations* (Chicago: University of Chicago Press, 2000).

Ficino, Marsilio (Hankins et al. eds.), *Platonic Theology* (Cambridge, Mass.: Harvard University Press, 2006).

—— (Clement Salaman ed.), *Meditations on the Soul: Selected Letters of Marsilio Ficino* (Rochester, Vt.: Inner Traditions, 1997).

——, *The Letters of Marsilio Ficino* (London: Shepheard-Walwyn, 1975–).

Filelfo, Francesco (Jeroen De Keyser and Scott Blanchard trans.), *On Exile* (Cambridge, Mass.: Harvard University Press, 2013).

—— (Diana Robin trans.), *Odes* (Cambridge, Mass.: Harvard University Press, 2009).

French and English Philosophers: Descartes, Rousseau, Voltaire, Hobbes: with Introductions and Notes. The Harvard Classics (New York: P.F. Collier, 1910), v. 34.

Gordan, Phyllis Walter Goodhart ed., *Two Renaissance Book Hunters: The Letters of Poggius Bracciolini to Nicolaus De Niccolis* (New York: Columbia University Press, 1991).

Kallendorf, Craig ed., *Humanist Educational Treatises* (Cambridge, Mass.: Harvard University Press, 2002).

Knox, Ronald Arbuthnott (Shane Leslie ed.), *The Miracles of King Henry VI: Being an Account and Translation of Twenty-Three Miracles Taken from the Manuscript in the British Museum (Royal 13 C. VIII)* (Cambridge: University Press, 1923).

Kors, Alan C. and Edward Peters eds., *Witchcraft in Europe, 400–1700: A Documentary History* (Philadelphia: University of Pennsylvania Press, 2001).

Landucci, Luca, *A Florentine Diary from 1450 to 1516* (London: J.M. Dent & Sons, 1927).

Maffei, Raffaele, *Commentariorum Urbanorum* (Rome: [Besicken] 1506).
Manetti, Giannozzo (Brian Copenhaver trans.), *On Human Worth and Excellence* (Cambridge, Mass.: Harvard University Press, 2018).
Manuzio, Aldo (John N. Grant trans.), *Humanism and the Latin Classics* (Cambridge, Mass.: Harvard University Press, 2017).
—— (N. G. Wilson trans.), *The Greek Classics* (Cambridge, Mass.: Harvard University Press, 2016).
Marullo Tarcaniota, Michele (Jacques Chomarat trans.), *Hymnes naturels* (Genève: Librairie Droz, 1995).
——, *Inni Naturali* (Firenze: Le Lettere, 1995).
—— (Benedetto Croce ed.), *Michele Marullo Tarcaniota, le elegie per la patria perduta ed altri suoi carmi* (Bari: G. Laterza & figli, 1938).
—— (Charles Fantazzi trans.), *Poems* (Cambridge, Mass.: Harvard University Press, 2012).
Medici, Lorenzino de' (Andrew Brown trans.), *Apology for a Murder* (London: Hesperus Press, 2004).
—— (Richard Stapleford trans.), *Lorenzo De' Medici at Home: The Inventory of the Palazzo Medici in 1492* (University Park, Pa.: Penn State University Press, 2013).
Morris, William and Eiríkr Magnússon trans., *The Story of the Volsungs, (Volsunga Saga) With Excerpts from the Poetic Edda* (London: Walter Scott Press, 1888).
Petrarch, Francesco (Elaine Fantham trans.), *Selected Letters*, two vols. (Cambridge, Mass.: Harvard University Press, 2017).
—— (Aldo Bernardo trans.), *Letters (Letters on Familiar Matters and Letters of Old Age, Nine Volumes)* (New York: Italica Press, 2009).
—— (David Marsh trans.), *Invectives* (Cambridge, Mass.: Harvard University Press, 2003).
—— (Conrad Rawski trans.), *Petrarch's Remedies for Fortune Fair and Foul* (Bloomington: Indiana University Press, 1991).
—— (Conrad Rawski trans.), *Four Dialogues for Scholars* (Cleveland: The Press of Western Reserve University, 1967).
Pico della Mirandola, Giovanni, *Lettere* (Firenze: L. S. Olschki editore, 2018).
—— (Lane Cooper and Henry Kaplan eds.), *On the Imagination* (Oxford: Oxford University Press, 1930).
Pius II, Pope (Margaret Meserve and Marcello Simonetta eds.), *Commentaries* (Cambridge, Mass.: Harvard University Press, 2003).
Polacco, Giorgio, *Anticopernicus Catholicus, Seu De Terrae Statione, Et De Solis Motu, Contra Systema Copernicanum, Catholicæ Assertiones* (Venetiis: Apud Guerilios, 1644).

Poliziano, Angelo (Shane Butler ed.), *Letters* (Cambridge, Mass.: Harvard University Press, 2006).

———, *Silvae* (Firenze: L. S. Olschki, 1996).

Savonarola, Girolamo (Martin Luther ed.), *Meditatio pia et erudita Hieronymi Sauonarolae: a Papa exusti, super Psalmos Miserere mei et In te Domine speraui* (Wittenberg: [Johann Rhau-Gunenberg], 1523).

Sforza, Ippolita Maria (Diana Robin and Lynn Westwater trans.), *Duchess and Hostage in Renaissance Naples: Letters and Orations* (Toronto: Iter Press, 2017).

Shakespeare, William, *The First Part of Henry the Sixt [Sic]* (Jane Howell director), BBC Television, Time-Life (New York: Ambrose Video, 1987).

Shelley, Mary Wollstonecraft (Marilyn Butler ed.), *Frankenstein, or the Modern Prometheus: The 1818 Text* (London: William Pickering, 1993).

Strozzi, Alessandra (Heather Gregory trans.), *Selected Letters of Alessandra Strozzi* (Berkeley: University of California Press, 1997).

Walton, Jo, *Thought Against Tomorrow* (Montreal: Is There a Green Iguana In This Forest?, 2020).

Secondary Sources

Abraham, Anna, *Leonardo Da Vinci* (Boston: New Word City, 2016).

Ady, Cecilia M., *The English Church and How It Works* (London: Faber and Faber Ltd., 1940).

———, *The Bentivoglio of Bologna: A Study in Despotism* (London: Oxford University Press, 1937).

Ady, Julia Mary Cartwright, *Italian Gardens of the Renaissance, and Other Studies* (London: J. Murray, 1914).

———, *Raphael* (London: Duckworth, 1914).

———, *Baldassare Castiglione the Perfect Courtier, His Life and Letters, 1478–1529* (London: John Murray, 1908).

———, *The Painters of Florence from the Thirteenth to the Sixteenth Century* (London: John Murray, 1908).

———, *A History of Milan under the Sforza* (London: Methuen & Co., 1907).

———, *The Painters of Florence from the Thirteenth to the Sixteenth Century* (New York: E.P. Dutton & Co., 1906).

———, *Beatrice d'Este, Duchess of Milan, 1475–1497: A Study of the Renaissance* (London: J.M. Dent, 1903).

———, *Isabella d'Este, Marchioness of Mantua, 1474–1539: A Study of the Renaissance* (London: John Murray, 1903).

Åkerman, S., *Fenixelden: Drottning Kristina Som Alkemist* (Stockholm: Gidlunds förlag, 2013).

Albritton Jonsson, Fredrik and Carl Wennerlind, *Scarcity: A History from the Origins of Capitalism to the Climate Crisis* (Cambridge, Mass. Harvard University Press, 2023).

Allen, Michael J., *Synoptic Art: Marsilio Ficino on the History of Platonic Interpretation* (Firenze: L. S. Olschki, 1998).

Ames-Lewis, Francis, *Isabella and Leonardo: The Artistic Relationship between Isabella d'Este and Leonardo da Vinci, 1500–1506* (New Haven: Yale University Press, 2012).

Aron-Beller, Katherine and Christopher Black, *The Roman Inquisition: Centre Versus Peripheries* (Leiden: Brill, 2018).

Azzolini, Monica, *The Duke and the Stars: Astrology and Politics in Renaissance Milan* (Cambridge, Mass.: Harvard University Press, 2013).

Bairoch, Paul, *La Population des villes européennes, 800–1850: Banque de données et analyse sommaire des résultats* (Genève: Droz, 1988).

Baker, Nicholas Scott and Brian Maxson eds., *Florence in the Early Modern World: New Perspectives* (New York: Routledge, 2020).

———, *After Civic Humanism: Learning and Politics in Renaissance Italy* (Toronto: Centre for Reformation and Renaissance Studies, 2015).

Baker, Patrick, *Italian Renaissance Humanism in the Mirror* (Cambridge: Cambridge University Press, 2015).

Baker, Patrick, Johannes Helmrath and Craig Kallendorf eds., *Beyond Reception: Renaissance Humanism and the Transformation of Classical Antiquity* (Berlin: De Gruyter, 2019).

Bakos, Ágnes et al., *Matthias Corvinus, the King: Tradition and Renewal in the Hungarian Royal Court, 1458–1490* (Budapest: Budapest History Museum, 2008).

Banfi, Florio, "Raffaello Maffei in Ungheria," *L'Europa Orientale*, 17 (1937), pp. 462–88.

Barkan, Leonard, *Unearthing the Past: Archaeology and Aesthetics in the Making of Renaissance Culture* (New Haven: Yale University Press, 1999).

Barker, Hilary, "Encountering Antiquity in Renaissance Rome: the Social and Economic Origins of the Classicizing Style, 1400-1550" (PhD dissertation, University of Chicago, forthcoming).

Bar-Lavi, Benny, "Politics against God: Judaism and Islam in the

Political Theological Discourses of Sixteenth- and Seventeenth-Century Spain" (PhD thesis, University of Chicago, 2022).

Baron, Hans, *The Crisis of the Early Italian Renaissance: Civic Humanism and Republican Liberty in an Age of Classicism and Tyranny* (Princeton: Princeton University Press, 1955).

———, *Leonardo Bruni Aretino. Humanistisch-philosophische* (B. G. Teubner, 1928).

Barzyk, Fred and Eugen Weber, *The Western Tradition* (video series) Metropolitan Museum of Art (Santa Barbara, CA: Annenberg/CPB Project, 1989).

Bauer, Stefan et al., *A Renaissance Reclaimed: Jacob Burckhardt's Civilisation of the Renaissance in Italy Reconsidered* (Oxford: Oxford University Press, 2022).

Bedini, Silvio A., *The Pope's Elephant* (Manchester: Carcanet Press Ltd., 1997).

Belozerskaya, Marina, *Medusa's Gaze: The Extraordinary Journey of the Tazza Farnese* (Oxford: Oxford University Press, 2012).

———, *The Medici Giraffe: And Other Tales of Exotic Animals and Power* (Boston: Little, Brown, 2009).

———, *To Wake the Dead: A Renaissance Merchant and the Birth of Archaeology* (New York: W.W. Norton & Company at Benner, 2009).

———, *Luxury Arts of the Renaissance* (Los Angeles: J. Paul Getty Museum, 2005).

Beltramini, Guido et al., *Pietro Bembo e l'Invenzione del Rinascimento* (Venezia: Marsilio, 2013).

Benedict, Philip, *The Faith and Fortunes of France's Huguenots, 1600–85* (Aldershot: Ashgate, 2001).

Benner, Erica, *Be Like the Fox: Machiavelli's Lifelong Quest for Freedom* (New York: W.W. Norton & Company, 2017).

Bertucci, Paola, *Artisanal Enlightenment: Science and the Mechanical Arts in Old Regime France* (New Haven: Yale University Press, 2017).

Bietenholz, Peter G. and Thomas Brian Deutscher, *Contemporaries of Erasmus: A Biographical Register of the Renaissance and Reformation* (Toronto: University of Toronto Press, 1985).

Black, Christopher, *The Italian Inquisition* (New Haven: Yale University Press, 2009).

Black, Robert, "Machiavelli and the Militia: New Thoughts," *Italian Studies*, v. 69, n. 1 (2024), pp. 41–50.

———, *Humanism and Education in Medieval and Renaissance Italy: Tradition and Innovation in Latin Schools from the Twelfth to the Fifteenth Century* (Cambridge: Cambridge University Press, 2001).

SOURCES AND RECOMMENDED READING

Black, Robert and John Law eds., *The Medici: Citizens and Masters* (Florence: Villa I Tatti, 2015).

Blair, Ann, *Too Much to Know: Managing Scholarly Information before the Modern Age* (New Haven: Yale University Press, 2010).

Blanchard, W. Scott, "Patrician Sages and the Humanist Cynic: Francesco Filelfo and the Ethics of World Citizenship," *Renaissance Quarterly*, 60 n. 4 (2007), pp. 1107–69.

Bondeson, Jan, *The Two-Headed Boy, and Other Medical Marvels* (Ithaca: Cornell University Press, 2000).

Bonsanti, Giorgio, *Palazzo Strozzi: Cinque Secoli Di Arte E Cultura* (Firenze: Nardini, 2005).

Bossy, John, *Christianity in the West, 1400-1700* (Oxford: Oxford University Press, 1985).

Bouchard, Michel Marc (Linda Gaboriau trans.), *Christina, the Girl King* (Vancouver: Talonbooks, 2014).

Boulting, William, *Æneas Silvius (Enea Silvio De' Piccolomini—Pius II) Orator, Man of Letters, Statesman, and Pope* (London: A. Constable & Co. Ltd., 1908).

Boyer, John W., *The University of Chicago: A History* (Chicago: University of Chicago Press, 2015).

Bradford, Sarah, *Lucrezia Borgia: Life, Love and Death in Renaissance Italy* (New York: Viking, 2004).

———, *Cesare Borgia, His Life and Times* (New York: Macmillan, 1976).

Brewer, Keagan, *Wonder and Skepticism in the Middle Ages* (Abingdon: Taylor & Francis, 2016).

Brown, Alison, *Piero Di Lorenzo De' Medici and the Crisis of Renaissance Italy* (Cambridge: Cambridge University Press, 2020).

———, "Philosophy and Religion in Machiavelli", in John M. Najemy ed., *The Cambridge Companion to Machiavelli* (Cambridge: Cambridge University Press, 2010), pp. 157–72.

———, *The Return of Lucretius to Renaissance Florence* (Cambridge, Mass.: Harvard University Press, 2010).

———, "Insiders and Outsiders: The Changing Boundaries of Exile", in William J. Connell ed., *Society and Individual in Renaissance Florence* (Berkeley: University of California Press, 2002), pp. 337–83.

———, "Lorenzo, the Monte and the Seventeen Reformers: Public and Private Interest", in *The Medici in Florence: The Exercise and Language of Power* (Florence: L. S. Olschki, 1992), pp. 151–211.

———, *Bartolomeo Scala, 1430–1497, Chancellor of Florence: The Humanist as Bureaucrat* (Princeton: Princeton University Press, 1979).

Brown, David Alan et al., *Virtue and Beauty: Leonardo's Ginevra De' Benci and Renaissance Portraits of Women* (Princeton: Princeton University Press, 2001).

Brown, Pamela Allen, "The Mirror and the Cage: Queens and Dwarfs at the Early Modern Court", in *Historical Affects and the Early Modern Theater* (New York: Routledge, 2015), pp. 137–47.

Brucker, Gene, *Living on the Edge in Leonardo's Florence: Selected Essays* (Berkeley: University of California Press, 2005).

———, *The Civic World of Early Renaissance Florence* (Princeton: Princeton University Press, 1977).

———, *Renaissance Florence* (New York: Wiley, 1969).

Brundin, Abigail, Deborah Howard and Mary Laven, *The Sacred Home in Renaissance Italy* (Oxford: Oxford University Press, 2018).

Buckley, Michael J., *At the Origins of Modern Atheism* (New Haven: Yale University Press, 1987).

Buckley, Veronica, *Christina, Queen of Sweden: The Restless Life of a European Eccentric* (New York: Fourth Estate, 2004).

Bullard, Melissa, *Lorenzo Il Magnifico: Image and Anxiety, Politics and Finance* (Firenze: L. S. Olschki, 1994).

———, *Filippo Strozzi and the Medici: Favor and Finance in Sixteenth-Century Florence and Rome* (Cambridge: Cambridge University Press, 1980).

Burckhardt, Jacob (S. G. C. Middlemore trans.), *The Civilization of the Renaissance in Italy* (New York: Oxford University Press, 1937).

Butters, H. C., *Governors and Government in Early Sixteenth-Century Florence, 1502–1519* (Oxford: Clarendon Press, 1985).

Caferro, William, *John Hawkwood: An English Mercenary in Fourteenth-Century Italy* (Baltimore: Johns Hopkins University Press, 2006).

Campbell, Stephen J., *The Cabinet of Eros: The Studiolo of Isabella D'Este and the Rise of Renaissance Mythological Painting* (New Haven: Yale University Press, 2006).

Cantimori, Delio, *Machiavelli, Guicciardini, le idee religiose del Cinquecento* (Pisa: Edizioni della Normale, 2014).

———, *Humanism and Religion in the Renaissance* (Torino: Collana Piccola Biblioteca, 1975–1980).

———, *Italian heretics of the sixteenth century. Ricerche storiche* (Florence: Sansoni, 1939).

Carrió-Invernizzi, Diana, "A New Diplomatic History and the Networks of Spanish Diplomacy in the Baroque Era," *The International History Review*, 36 n. 4 (2014), pp. 603–18.

SOURCES AND RECOMMENDED READING

Celenza, Christopher S., *The Italian Renaissance and the Origins of the Modern Humanities: An Intellectual History, 1400–1800* (Cambridge: Cambridge University Press, 2021).
———, *Petrarch: Everywhere a Wanderer* (Chicago: University of Chicago Press, 2017).
———, *Machiavelli: A Portrait* (Cambridge, Mass.: Harvard University Press, 2015).
———, *The Lost Italian Renaissance: Humanists, Historians, and Latin's Legacy* (Baltimore: Johns Hopkins University Press, 2004).
Christian, Kathleen and Bianca De Divitiis eds., *Local Antiquities, Local Identities: Art, Literature and Antiquarianism in Europe, C. 1400–1700* (Manchester: Manchester University Press, 2019).
Ciccolella, Federica, *Donati Graeci: Learning Greek in the Renaissance* (Leiden: Brill, 2008).
Ciccolella, Federica and Luigi Silvano eds., *Teachers, Students, and Schools of Greek in the Renaissance* (Leiden; Boston: Brill, 2017).
Clark, Frederic, *The First Pagan Historian: the Fortunes of a Fraud from antiquity to the Enlightenment* (Oxford: Oxford University Press, 2020).
Clark, Robert, *Dark Water: Flood and Redemption in the City of Masterpieces* (New York: Doubleday, 2008).
Corfiati, Claudia and Mauro De Nichilo eds., *Angelo Poliziano E Dintorni: Percorsi Di Ricerca* (Bari: Cacucci, 2011).
Cipolla, Carlo M., *Before the Industrial Revolution: European Society and Economy, 1000–1700* (New York: Norton, 1976).
Clemons, G. Scott, H. George Fletcher and Jerry Kelly eds., *Aldus Manutius: A Legacy More Lasting Than Bronze* (New York: The Grolier Club, 2015).
Cockram, Sarah, *Isabella D'Este and Francesco Gonzaga: Power Sharing at the Italian Renaissance Court* (Farnham: Ashgate, 2013).
Cohen, Elizabeth Storr and Thomas V. Cohen, *Daily Life in Renaissance Italy* (Westport, Conn.: Greenwood Press, 2001).
Cohen, Rachel, *Bernard Berenson: A Life in the Picture Trade* (New Haven: Yale University Press, 2013).
Connell, William J., "Le molestie del Machiavelli", *Interpres*, 28 (2009), pp. 226–7.
Connell, William J. and Giles Constable eds., *Sacrilege and Redemption in Renaissance Florence: The Case of Antonio Rinaldeschi* (Toronto: Centre for Reformation and Renaissance Studies, 2005).
Connors, Joseph et al. eds., *Italy & Hungary: Humanism and Art in the Early Renaissance* (Firenze: Villa I Tatti, 2011).

Coonin, Arnold Victor, "The Most Elusive Woman in Renaissance Art: A Portrait of Marietta Strozzi," *Artibus et Historiae*, 30 n. 59 (2009), pp. 41–64.

Copenhaver, Brian, *Magic and the Dignity of Man: Pico Della Mirandola and His Oration in Modern Memory* (Cambridge, Mass.: Belknap Press, 2019).

Corona, Aylin, "Balancing Acts: Domestic Careers and Enforced Reproduction for Female Court Dwarfs in Early Modern Europe", (MA thesis, University of Chicago, 2021).

Costambeys, Marios, Matthew Innes and Simon MacLean, *The Carolingian World* (Cambridge: Cambridge University Press, 2011).

Cotts, John D., *Europe's Long Twelfth Century: Order, Anxiety and Adaptation, 1095–1229* (Hampshire: Palgrave Macmillan, 2013).

Cox, Virginia, *Lyric Poetry by Women of the Italian Renaissance* (Baltimore: Johns Hopkins University Press, 2013).

Crabb, Ann Morton, *The Strozzi of Florence: Widowhood and Family Solidarity in the Renaissance* (Ann Arbor: University of Michigan Press, 2000).

———, *A Patrician Family in Renaissance Florence: The Family Relations of Alessandra Macinghi Strozzi and Her Sons, 1440–1491*, 1980).

Cummings, Anthony M., *Lion's Ear: Pope Leo X, the Renaissance Papacy, and Music* (Ann Arbor: University of Michigan Press, 2022).

Cummins, Neil, "Lifespans of the European Elite, 800–1800", *The Journal of Economic History*, 77 n. 2 (2017), pp. 406–39.

Curran, Andrew S., *Diderot and the Art of Thinking Freely* (New York: Other Press, 2019).

D'Amico, John, *Renaissance Humanism in Papal Rome: Humanists and Churchmen on the Eve of the Reformation* (Baltimore: Johns Hopkins University Press, 1983).

"Papal History and Curial Reform in the Renaissance: Raffaele Maffei's 'Breuis Historia' of Julius II and Leo X", *Archivum Historiae Pontificiae*, 18 (1980), pp. 157–210.

D'Elia, Anthony, *Pagan Virtue in a Christian World: Sigismondo Malatesta and the Italian Renaissance* (Cambridge, Mass.: Harvard University Press, 2016).

Dall'Aglio, Stefano (Donald Weinstein, trans.), *The Duke's Assassin: Exile and Death of Lorenzino De' Medici* (New Haven: Yale University Press, 2015).

——— (John Gagné trans.), *Savonarola and Savonarolism* (Toronto: Centre for Reformation and Renaissance Studies, 2010).

Damianaki, Chrysa, Paolo Procaccioli and Angelo Romano eds., *Ex*

marmore: pasquini, pasquinisti, pasquinate nell'Europa moderna: atti del Colloquio internazionale, Lecce-Otranto, 17-19 Novembre 2005 (Rome: Vecchiarelli, 2006).

Davidson, Nicholas, "Lucretius, Atheism and Irreligion in Renaissance and Early Modern Venice", in David Norbrook, Stephen Harrison and Philip Hardie eds., *Lucretius and the Early Modern* (Oxford: Oxford University Press, 2015), pp. 123–34.

Davies, Martin, *Aldus Manutius: Printer and Publisher of Renaissance Venice* (Malibu: J. Paul Getty Museum, 1995).

Davis, Natalie Zemon, *The Return of Martin Guerre* (Cambridge, Mass.: Harvard University Press, 1983).

de Beer, Susanna, *The Poetics of Patronage: Poetry as Self-Advancement in Giannantonio Campano* (Turnhout: Brepols, 2013).

———, "The Roman 'Academy' of Pomponio Leto: From an Informal Humanist Network to the Institution of a Literary Society", in Arjan Van Dixhoorn and Susie Speakman eds., *The Reach of the Republic of Letters: Literary and Learned Societies in the Late Medieval and Early Modern Europe* (Leiden: Brill, 2008), pp. 181–218.

de Divitiis, Bianca, *Architettura e Commitenza nella Napoli della Quattrocentro* (Venice: Marsilio, 2007).

der Weduwen, Arthur and Andrew Pettegree, *Library: A Fragile History* (London: Profile Books, 2021).

Dinges, Martin et al., *Medical Practice, 1600–1900: Physicians and Their Patients* (Leiden: Brill, 2016).

Dionisotti, Carlo, *Gli Umanisti e il Volgare fra Quattro e Cinquecento* (Firenze: Felice Le Mounier, 1968).

Dooley, Brendan, *Morandi's Last Prophecy and the End of Renaissance Politics* (Princeton: Princeton University Press, 2002).

Downing, Ben, *Queen Bee of Tuscany: The Redoubtable Janet Ross* (New York: Straus and Giroux, 2013).

Dressen, Angela, *The Intellectual Education of the Italian Renaissance Artist* (Cambridge: Cambridge University Press, 2021).

Dupâquier, Jacques ed., *Histoire De La Population Française* (Paris: Presses universitaires de France, 1988).

Durin, Karine, "El epicureísmo y las heterodoxias españolas: propuestas para un estado de la cuestión", *Las razones del censor. Control ideológico y censura de libros en la primera edad moderna* (Barcelona: Universitat Autònoma de Barcelona, 2013), pp. 177–91.

Edelheit, Amos, *Ficino, Pico and Savonarola: The Evolution of Humanist Theology 1461/2–1498* (Leiden: Brill, 2008).

Elders, Willem, *Josquin Des Pres and His Musical Legacy: An Introductory Guide* (Ithaca: Cornell University Press, 2021).
Eliot, Simon and Jonathan Rose eds., *A Companion to the History of the Book* (Malden, Mass.: Blackwell Pub., 2007).
Enenkel, Karl A. E., *Ambitious Antiquities, Famous Forebears: Constructions of a Glorious Past in the Early Modern Netherlands and in Europe* (Leiden: Brill, 2019).
Epstein, Steven, *Speaking of Slavery: Color, Ethnicity, and Human Bondage in Italy* (Ithaca: Cornell University Press, 2001).
———, *Genoa and the Genoese, 958–1528* (Chapel Hill, N.C.: University of North Carolina Press, 1996).
Faietti, Marzia et al., *Raphael, 1520–1483* (Milano: Skira, 2020).
Faini, Marco, *Pietro Bembo: A Life in Laurels and Scarlet* (Cambridge: Legenda, 2017).
Falco, Maria ed., *Feminist Interpretations of Niccolò Machiavelli* (University Park: Pennsylvania State University Press, 2004).
Falk, Seb, *The Light Ages: The Surprising Story of Medieval Science* (London: W. W. Norton & Company, 2020).
Farinella, Vincenzo, *Alfonso d'Este: Le Immagini e il Potere: da Ercole de' Roberti a Michelangelo* (Milano: Officina libraria, 2014).
Febvre, Lucien (Beatrice Gottlieb trans.), *The Problem of Unbelief in the Sixteenth Century: The Religion of Rabelais* (Cambridge, Mass.: Harvard University Press, 1982).
Fera, Vincenzo and Mario Martelli eds., *Agnolo Poliziano: Poeta, Scrittore, Filologo* (Firenze: Le lettere, 1998).
Feros Ruys, Juanita, John O. Ward and Melanie Heyworth eds., *The Classics in the Medieval and Renaissance Classroom: The Role of Ancient Texts in the Arts Curriculum as Revealed by Surviving Manuscripts and Early Printed Books* (Turnhout: Brepols, 2013).
Findlen, Paula, *Possessing Nature: Museums, Collecting, and Scientific Culture in Early Modern Italy* (Berkeley: University of California Press, 1994).
Findlen, Paula and Hannah Marcus, "Science under Inquisition: Heresy and Knowledge in Catholic Reformation Rome", *Isis*, 103 n. 2 (2012), pp. 376–82.
Findlen, Paula and Kenneth Gouwens, "Introduction: The Persistence of the Renaissance", *The American Historical Review*, 103 n. 1 (1998), pp. 51–54.
Fletcher, Stella and Christine Shaw, *The World of Savonarola: Italian elites and perceptions of crisis: papers from the conference held at the University of Warwick, 29-31 May 1998, to mark the fifth centenary of the death of Fra Girolamo Savonarola* (Aldershot: Ashgate 2000).

SOURCES AND RECOMMENDED READING

Folger, Tim, "Why Did Greenland's Vikings Vanish?", *Smithsonian Magazine* (March 2017).
Fornaciari, Gino, Valentina Giuffra, Sara Giusiani et al., "The 'gout' of the Medici, Grand Dukes of Florence: a palaeopathological study", *Rheumatology*, 48 n. 4 (2009), pp. 375–7.
Forster, Leonard, *The Icy Fire: Five Studies in European Petrarchism* (London: Cambridge University Press, 1969).
Franckenstein, Christian Gottfried (attributed), *Istoria degli intrighi galanti della Regina Cristina di Svezia e della sua corte durante il di lei soggiorno a Roma* (Roma: Fratelli Palombi, 1979).
——— (attributed), *The History of the Intrigues & Gallantries of Christina, Queen of Sweden, and of Her Court Whilst She Was at Rome* (London: 1697).
Frazier, Alison ed., *The Saint between Manuscript and Print in Italy, 1400–1600* (Toronto: Centre for Renaissance and Reformation Studies, 2015).
———, *Possible Lives: Authors and Saints in Renaissance Italy* (New York: Columbia University Press, 2005).
———, "The First Instructions on Writing About Saints: Aurelio Brandolini (C. 1454–1497) and Raffaele Maffei (1455–1522)", *Memoirs of the American Academy in Rome*, 48 (2003), pp. 171–202.
Freely, John, *The Grand Turk: Sultan Mehmet II – Conqueror of Constantinople and Master of an Empire* (London: Bloomsbury, 2009).
———, *Jem Sultan* (London: HarperCollins, 2005).
Frick, Carole Collier, *Dressing Renaissance Florence: Families, Fortunes, and Fine Clothing* (Baltimore: Johns Hopkins University Press, 2011).
Fubini, Riccardo, "The Italian League and the Policy of the Balance of Power at the Accession of Lorenzo De' Medici", in Julius Kirshner ed., *The Origins of the State in Italy, 1300–1600* (Chicago: University of Chicago Press, 1996), pp. 166–199.
Fuller, Timothy ed., *Machiavelli's Legacy: The Prince after Five Hundred Years* (Philadelphia: University of Pennsylvania Press, 2016).
Gagné, John, *Milan Undone: Contested Sovereignties in the Italian Wars* (Cambridge, Mass.: Harvard University Press, 2021).
Gaisser, Julia Haig, "The Rise and Fall of Goritz's Feasts", *Renaissance Quarterly*, 48 (1995), pp. 41–57.
Gallello, Gianni et al., "Poisoning Histories in the Italian Renaissance: The Case of Pico Della Mirandola and Angelo Poliziano," *Journal of Forensic and Legal Medicine*, 56 (2018), pp. 83–9.
Garin, Eugenio, *Italian Humanism: Philosophy and Civic Life in the Renaissance* (New York: Harper & Row, 1965).

———, *Giovanni Pico Della Mirandola, vita e dottrina*, Università degli studi di Firenze, Facoltà di lettere e filosofia. 3. ser., v. 5 (Firenze: F. Le Monnier, 1937).

Garofano, L., G. Gruppioni and S. Vinceti, *Delitti e misteri del passato* (Milan: Rizzoli Libri, 2011).

Gentilcore, David, *Food and Health in Early Modern Europe: Diet, Medicine and Society, 1450–1800* (London: Bloomsbury Academic, 2016).

Ghadessi, Touba, "Lords and Monsters: Visible Emblems of Rule", *I Tatti Studies in the Italian Renaissance*, 16 n. 1 (2013), pp. 491–523.

———, "Inventoried Monsters: Dwarves and Hirsutes at Court", *Journal of the History of Collections*, 23 n. 2 (2011), pp. 267–81.

Ghirardo, Diane Yvonne, "Lucrezia Borgia as Entrepreneur", *Renaissance Quarterly*, 61 n. 1 (2008), pp. 53–91.

Gies, Frances and Joseph Gies, *Cathedral, Forge, and Waterwheel: Technology and Invention in the Middle Ages* (New York: HarperCollins Publishers, 1994).

Gilbert, Felix, *Machiavelli and Guicciardini; politics and history in sixteenth-century Florence* (Princeton: Princeton University Press, 1965).

Ginzburg, Carlo, *The Cheese and the Worms: The Cosmos of a Sixteenth-Century Miller* (Baltimore: Johns Hopkins University Press, 1980).

Godman, Peter, *From Poliziano to Machiavelli: Florentine Humanism in the High Renaissance* (Princeton: Princeton University Press, 1998).

Goldthwaite, Richard A., *The Economy of Renaissance Florence* (Baltimore: Johns Hopkins University Press, 2009).

Gouwens, Kenneth, *Remembering in the Renaissance: Humanist Narratives of the Sack of Rome* (Leiden: Brill, 1998).

———, "Perceiving the Past: Renaissance Humanism after the 'Cognitive Turn'", *The American Historical Review*, 103, n. 1 (1998), pp. 55–82.

Grafton, Anthony, *Inky Fingers: The Making of Books in Early Modern Europe* (Cambridge, Mass.: Belknap Press, 2020).

———, *What Was History?: The Art of History in Early Modern Europe* (Cambridge: Cambridge University Press, 2007).

———, *Leon Battista Alberti: Master Builder of the Italian Renaissance* (New York: Hill and Wang, 2000).

———, *Commerce with the Classics: Ancient Books and Renaissance Readers* (Ann Arbor: University of Michigan Press, 1997).

———, *Defenders of the Text: The Traditions of Scholarship in an Age of Science, 1450–1800* (Cambridge, Mass.: Harvard University Press, 1991).

Grafton, Anthony and Lisa Jardine, *From Humanism to the Humanities: Education and the Liberal Arts in Fifteenth- and Sixteenth-Century Europe* (Cambridge, Mass.: Harvard University Press, 1986).

Grafton, Anthony and Nancy G. Siraisi eds., *Natural Particulars: Nature and the Disciplines in Renaissance Europe* (Cambridge, Mass.: MIT Press, 2000).

Greenblatt, Stephen, *The Swerve: How the World Became Modern* (New York: Random House, 2009).

Gregorovius, Ferdinand, *Lucrezia Borgia: Nach Urkunden und Correspondenzen Ihrer Eigenen Beit* (Stuttgart: J.G. Cotta, 1875).

Grendler, Paul F., *The European Renaissance in American Life* (Westport, Conn.: Praeger Publishers, 2006).

———, *The Universities of the Italian Renaissance* (Baltimore: Johns Hopkins University Press, 2002).

Grieco, Allen J., *Uses of Food in Late Medieval Europe* (Oxford: Blackwell, 2006).

———, "Food and Social Classes in Late Medieval and Renaissance Italy", in *Food: A Culinary History from Antiquity to the Present* (New York: Columbia University Press, 1999), pp. 301–12.

Groom, Angelica, *Exotic Animals in the Art and Culture of the Medici Court in Florence* (Leiden: Brill, 2019).

Gundersheimer, Werner, *Ferrara: The Style of a Renaissance Despotism* (Princeton: Princeton University Press, 1973).

Gurevich, Aron (K. Judelson trans.), *The Origins of European Individualism* (Oxford: Blackwell, 1995).

Hales, Dianne, *Mona Lisa: A Life Discovered* (New York: Simon & Schuster, 2014).

Hall, Alexander W., *Medieval Skepticism, and the Claim to Metaphysical Knowledge* (Cambridge: Cambridge Scholars Publishing, 2011).

Hankins, James, "Religion and the Modernity of Renaissance Humanism", in Angelo Mazzocco ed., *Interpretations of Renaissance Humanism* (Leiden: Brill, 2006), pp. 137–53.

———, "The 'Baron Thesis' after Forty Years and Some Recent Studies of Leonardo Bruni", *Journal of the History of Ideas*, 56 n. 2 (1995), pp. 309–38.

———, *Plato in the Italian Renaissance*, 2 vols. (Leiden: E.J. Brill, 1990).

———, "Cosimo de Medici and the Platonic Academy", *Journal of the Warburg and Courtauld Institutes*, 53 (1990), pp. 144–62.

Hankins, James et al., *Renaissance Civic Humanism: Reappraisals and Reflections* (Cambridge; New York: Cambridge University Press, 2000).

Harrington, Joel, *The Executioner's Journal: Meister Frantz Schmidt of the Imperial City of Nuremberg* (Charlottesville: University of Virginia Press, 2016).

———, *The Faithful Executioner: Life and Death, Honor and Shame in the Turbulent Sixteenth Century* (New York: Farrar, Straus and Giroux, 2013).

Haskell, Yasmin, "The Tristia of a Greek Refugee: Michael Marullus and the Politics of Latin Subjectivity after the Fall of Constantinople (1453)", *Proceedings of the Cambridge Philological Society*, 44 (1999), pp. 110–36.

Haskins, Charles, *The Renaissance of the Twelfth Century* (Cambridge, Mass.: Harvard University Press, 1927).

Heck, Paul L., *Skepticism in Classical Islam: Moments of Confusion* (Abingdon: Taylor & Francis, 2013).

Heil, John-Paul, "Virtue and Vice in the Political World of Renaissance Naples" (PhD thesis, University of Chicago, 2022).

Henderson, John, *Piety and Charity in Late Medieval Florence* (Chicago: University of Chicago Press, 1997).

Henderson, John, Fredrika Herman Jacobs and Jonathan K. Nelson eds., *Representing Infirmity: Diseased Bodies in Renaissance Italy* (Abingdon: Routledge, 2021).

Heng, Geraldine, *The Global Middle Ages: An Introduction* (Cambridge: Cambridge University Press, 2021).

Herlihy, David, *The Black Death and the Transformation of the West* (Cambridge, Mass.: Harvard University Press, 1997).

Herzig, Tamar, *Savonarola's Women: Visions and Reform in Renaissance Italy* (Chicago: University of Chicago Press, 2008).

Hibbert, Christopher, *The Borgias and Their Enemies: 1431–1519* (Orlando: Harcourt, 2008).

Hinch, Jim, "Why Stephen Greenblatt Is Wrong—and Why It Matters", *Los Angeles Review of Books*, December 2012.

Hollingsworth, Mary, *Princes of the Renaissance* (New York: Pegasus Books, 2021).

———, *The Family Medici: The Hidden History of the Medici Dynasty* (New York: Pegasus Books, 2018).

———, *Patronage in Renaissance Italy: From 1400 to the Early Sixteenth Century* (London: John Murray, 1994).

Howlett, Sophia, *Re-Evaluating Pico: Aristotelianism, Kabbalism, and Platonism in the Philosophy of Giovanni Pico Della Mirandola* (Cham: Palgrave Macmillan, 2021).

Huizinga, Johan, *Herfsttij der Middeleeuwen* (Haarlem: H.D. Tjeenk Willink, 1919).

Hunter, Michael and David Wootton, *Atheism from the Reformation to the Enlightenment* (Oxford: Clarendon Press, 1992).
Iordanou, Ioanna, *Venice's Secret Service: Organizing Intelligence in the Renaissance* (Oxford: Oxford University Press, 2019).
Jacob, Margaret, *The Radical Enlightenment: Pantheists, Freemasons and Republicans* (New York: Cornerstone Books, 2006).
Jardine, Lisa, *Erasmus, Man of Letters: The Construction of Charisma in Print* (Princeton: Princeton University Press, 1993).
———, "'O Decus Italiae Virgo', or the Myth of the Learned Lady in the Renaissance", *The Historical Journal*, 28 n. 4 (1985), pp. 799–819.
Johnston, David, Nadia Urbinati and Camila Vergara eds., *Machiavelli on Liberty and Conflict* (Chicago: University of Chicago Press, 2017).
Jones, Ann Rosalind and Peter Stallybrass, *Renaissance Clothing and the Materials of Memory* (Cambridge: Cambridge University Press, 2000).
Jones, Jonathan, *The Lost Battles: Leonardo, Michelangelo, and the Artistic Duel That Defined the Renaissance* (New York: Knopf Doubleday, 2014).
Jouanna, Arlette, *La France du XVIe siècle: 1483–1598* (Paris: Presses universitaires de France, 1996).
Jurdjevic, Mark, *A Great and Wretched City: Promise and Failure in Machiavelli's Florentine Political Thought* (Cambridge, Mass.: Harvard University Press, 2014).
Jurdjevic, Mark, Natasha Piano and John P. McCormick eds., *Florentine Political Writings from Petrarch to Machiavelli* (Philadelphia: University of Pennsylvania Press, 2019).
Kallendorf, Craig, *The Virgilian Tradition II: Books and Their Readers in the Renaissance* (Abingdon: Routledge, 2022).
———, *The Protean Virgil: Material Form and the Reception of the Classics* (Oxford: Oxford University Press, 2015).
———, *The Virgilian Tradition: Book History and the History of Reading in Early Modern Europe* (Aldershot: Ashgate, 2007).
Karafel, Lorraine, *Raphael's Tapestries: The Grotesques of Leo X* (New Haven: Yale University Press, 2016).
Keller, Vera, *The Interlopers: Early Stuart Projects and the Undisciplining of Knowledge* (Baltimore: Johns Hopkins University Press, 2023).
Kent, Dale V., *Cosimo De' Medici and the Florentine Renaissance: The Patron's Oeuvre* (New Haven: Yale University Press, 2000).
Kent, Francis W., *Princely Citizen: Lorenzo de Medici and Renaissance Florence* (Turnhout: Brepols, 2013).

———, *Lorenzo de' Medici and the Art of Magnificence* (Baltimore: Johns Hopkins University Press, 2004).
Ker, James, *The Deaths of Seneca* (Oxford: Oxford University Press, 2009).
Kidwell, Carol, *Pietro Bembo: Lover, Linguist, Cardinal* (Montreal: McGill-Queen's University Press, 2004).
King, Ross, *Michelangelo & the Pope's Ceiling* (New York: Bloomsbury, 2014).
———, *Brunelleschi's Dome: How a Renaissance Genius Reinvented Architecture* (New York: Penguin Books, 2001).
Kors, Alan C., *Epicureans and Atheists in France, 1650–1729* (Cambridge: Cambridge University Press, 2016).
———, *Naturalism and Unbelief in France, 1650–1729* (Cambridge: Cambridge University Press, 2016).
———, *Atheism in France, 1650–1729: The Orthodox Sources of Disbelief* (Princeton: Princeton University Press, 1990).
Kors, Alan Charles and Paul J. Korshin, *Anticipations of the Enlightenment in England, France, and Germany* (Philadelphia: University of Pennsylvania Press, 1987).
Kraye, Jill ed., *Classical Traditions in Renaissance Philosophy* (Aldershot: Ashgate, 2002).
Krebs, Verena, *Medieval Ethiopian Kingship, Craft, and Diplomacy with Latin Europe* (Cham: Palgrave Macmillan, 2021).
Kristeller, Paul Oskar, "The Myth of Renaissance Atheism and the French Tradition of Free Thought", in *Studies in Renaissance Thought and Letters* (Berkeley: University of California Press, 1993), pp. 541–54.
———, *Renaissance Thought and its Sources* (New York: Columbia University Press, 1979).
———, *The Philosophy of Marsilio Ficino* (New York: Columbia University Press, 1964).
Kristeller, Paul Oskar et al., *Catalogus Translationum et Commentariorum* (Washington, D.C.: Catholic University of America Press, 1960).
Kuehn, Thomas, *Heirs, Kin, and Creditors in Renaissance Florence* (Cambridge: Cambridge University Press, 2008).
La Sizeranne, Robert de (Noël Fleming trans.), *Beatrice D'Este and Her Court* (London: Brentano's, 1926).
Laayouni, H. et al., "Convergent Evolution in European and Rroma Populations Reveals Pressure Exerted by Plague on Toll-Like Receptors", *Proceedings of the National Academy of Sciences*, 111 n. 7 (2014), pp. 2668–73.
Labalme, Patricia ed., *Beyond Their Sex: Learned Women of the European Past* (New York: New York University Press, 1980).

Lagerlund, Heinrik, *Rethinking the History of Skepticism: The Missing Medieval Background* (Leiden: Brill, 2010).
Le Roy Ladurie, Emmanuel, *Montaillou: The Promised Land of Error* (New York: G. Braziller, 1978).
Lee, A., *Machiavelli: His Life and Times* (London: Pan Macmillan, 2021).
Lekeby, K., *I Lejonets Hjärta: Drottning Kristina Och Stjärntydarna* (Stockholm: Pleiaderna, 2001).
Levy, Allison M., *House of Secrets: The Many Lives of a Florentine Palazzo* (London: Tauris Parke, 2020).
Lingo, Estelle, "The Evolution of Michelangelo's Magnifici Tomb: Program versus Process in the Iconography of the Medici Chapel", *Artibus et Historiae*, 16 n. 32 (1995), pp. 91–100.
Lippi, Donatella, Philippe Charlier and Paola Romagnani, "Acromegaly in Lorenzo the Magnificent, Father of the Renaissance," *The Lancet*, 389 n. 10084 (2017), p. 2104.
Lockwood, Lewis, *Music in Renaissance Ferrara, 1400–1505: The Creation of a Musical Center in the Fifteenth Century* (Oxford: Oxford University Press, 2009).
Long, Pamela O., *Engineering the Eternal City: Infrastructure, Topography, and the Culture of Knowledge in Late Sixteenth-Century Rome* (Chicago: University of Chicago Press, 2018).
———, *Artisan/Practitioners and the Rise of the New Sciences, 1400–1600* (Corvalis, Or.: Oregon State University Press, 2011).
———, *Openness, Secrecy, Authorship: Technical Arts and the Culture of Knowledge from Antiquity to the Renaissance* (Baltimore: Johns Hopkins University Press, 2001).
Looney, Dennis, "Translations from the Greek of Angelo Poliziano (1454–1494)", *The Classical Outlook*, 88 n. 2 (2011), p. 57.
Lubkin, Gregory, *A Renaissance Court: Milan under Galeazzo Maria Sforza* (Berkeley: University of California Press, 1994).
Lucas, Emma, *Lucrezia Borgia* (Boston: New Word City, 2014).
Luizo, Alessandro and Rodolfo Renier, *Delle relazioni di Isabella D'Este Gonzaga con Ludovico e Beatrice Sforza* (Milano: 1890).
McCloskey, Robert, *Centerburg Tales* (New York: Puffin Books, 1977).
McCormick, John P., *Reading Machiavelli: Scandalous Books, Suspect Engagements, and the Virtue of Populist Politics* (Princeton: Princeton University Press, 2018).
McCormick, Michael, *Origins of the European Economy: Communications and Commerce A.D. 300–900* (Cambridge: Cambridge University Press, 2001).

Macuglia, Daniele, "Calculus and Newtonianism in Italy, 1689–1742: People, Ideas, Institutions" (PhD thesis, University of Chicago, 2017).

McGrath, Alister E., *The Intellectual Origins of the European Reformation*, 2nd ed. (Oxford: Blackwell, 2004).

Mainoni, Patrizia, *Con animo virile: donne e potere nel mezzogiorno medievale, secoli XI-XV* (Roma: Viella, 2010).

Malaguzzi-Francesco, *La corte di Lodovico il Moro: la vita privata e l'arte a Milano nella seconda metà del quattrocento* (Milano: U. Hoepli, 1913).

Mallett, Michael Edward, *Mercenaries and Their Masters: Warfare in Renaissance Italy* (Barnsley: Pen & Sword Books, 2019).

Mansfield, Harvey, Jr., *Machiavelli's Virtue* (Chicago: University of Chicago Press, 1996).

Marenbon, John ed., *The Many Roots of Medieval Logic: The Aristotelian and the Non-Aristotelian Traditions* (Leiden: Brill, 2007).

Margolis, Oren J., *Aldus Manutius: the Invention of the Publisher* (London: Reaktion Books, 2023).

———, *The Politics of Culture in Quattrocento Europe: René of Anjou in Italy* (Oxford: Oxford University Press, 2016).

Mariotti Masi, Maria Luisa, *Elisabetta Gonzaga, Duchessa d'Urbino: nello splendore e negli intrighi del Rinascimento* (Milano: Mursia, 1983).

Marks, David F., "Investigating the Paranormal", *Nature*, 329 n. 6134 (1987), p. 10.

———, "Investigating the Paranormal", *Nature*, 320 n. 6058 (1986), pp. 119–24.

Martin, John Jeffries, *Myths of Renaissance Individualism* (New York: Palgrave Macmillan, 2004).

Martines, Lauro, *Fire in the City: Savonarola and the Struggle for Renaissance Florence* (New York: Oxford University Press, 2006).

———, *April Blood: Florence and the Plot against the Medici* (Oxford: Oxford University Press, 2003).

Matthews-Grieco, Sara F. ed., *Erotic Cultures of Renaissance Italy* (Abingdon, Oxon: Routledge, 2010).

Mattingly, Garrett, *Renaissance Diplomacy* (Boston: Houghton Mifflin, 1955).

Matytsin, Anton M., *The Specter of Skepticism in the Age of Enlightenment* (Baltimore: Johns Hopkins University Press, 2016).

Maurette, Pablo, *The Forgotten Sense: Meditations on Touch* (Chicago: University of Chicago Press, 2018).

Maxson, Brian, *A Short History of Florence and the Florentine Republic* (London: Bloomsbury Academic, 2023).

———, *The Humanist World of Renaissance Florence* (Cambridge: Cambridge University Press, 2014).

———, "Establishing Independence: Leonardo Bruni's History of the Florentine People and Ritual in Fifteenth-Century Florence", in Maarten Delbeke and Minou Schraven eds., *Foundation, Dedication and Consecration in Early Modern Europe* (Leiden: Brill, 2012), pp. 79–98.

Mayer, Thomas, *The Roman Inquisition: Trying Galileo* (Philadelphia: University of Pennsylvania Press, 2015).

Mazzocco, Angelo and Marc Laureys, *A New Sense of the Past: The Scholarship of Biondo Flavio (1392–1463)* (Leuven: Leuven University Press, 2016).

McIver, Katherine A., *Cooking and Eating in Renaissance Italy: From Kitchen to Table* (Washington, D.C.: Rowman & Littlefield, 2015).

McLean, Paula D., *The Art of the Network: Strategic Interaction and Patronage in Renaissance Florence* (Durham: Duke University Press, 2007).

McManus, Stuart, *Empire of Eloquence: The Classical Rhetorical Tradition in Colonial Latin America and the Iberian World* (Cambridge: Cambridge University Press, 2021).

Merkley, Paul, *Music and Patronage in the Sforza Court* (Turnhout: Brepols, 1999).

Meserve, Margaret, *Papal Bull: Print, Politics, and Propaganda in Renaissance Rome* (Baltimore: Johns Hopkins University Press, 2021).

———, *Empires of Islam in Renaissance Historical Thought* (Cambridge, Mass.: Harvard University Press, 2009).

Meyer, Edith Patterson, *First Lady of the Renaissance: A Biography of Isabella d'Este* (Boston: Little, Brown, 1970).

Mirrer, Louise et al. eds., *Upon My Husband's Death: Widows in the Literature and Histories of Medieval Europe* (Ann Arbor: University of Michigan Press, 1992).

Mitchell, Rosamond Joscelyne, *A History of the English People* (London: Pan, 1967).

———, *A History of London Life* (London: Penguin, 1963).

———, *The Medieval Feast. The Story of the Coronation Banquet of King Henry Iv in Westminster Hall* (Longmans: London, 1958).

Mitchell, Rosamond Joscelyne and M. D. R. Leys, *A History of the English People* (London: Pan, 1967).

Mitchell, Rosamond Joscelyne and Mitchell Arnold, *Life and Adventure in Medieval Europe* (London: Longmans, Green, 1934).

Monfasani, John, "From the Liner Vulcania to the Martin Memorial

Lectures: Paul Oskar Kristeller's First Fifteen Years in America", *Mediterranea*, 5 (2020), pp. 373–92.

———, "Popes, Cardinals, and Humanists: Notes on the Vatican Library as a Repository of Humanist Manuscripts", *Manuscripta*, 62 n. 2 (2018), pp. 213–48, color plates 5–7.

———, *Renaissance Humanism: From the Middle Ages to Modern Times* (Surrey: Ashgate, 2015).

Murphy, Caroline, *The Pope's Daughter* (Oxford: Oxford University Press, 2005).

Murray, Jacqueline and Nicholas, Terpstra, *Sex, Gender and Sexuality in Renaissance Italy* (Abingdon: Routledge, 2019).

Najemy, John M. ed., *The Cambridge Companion to Machiavelli* (Cambridge: Cambridge University Press, 2010).

———, *A History of Florence 1200–1575* (Hoboken, N. J.: Wiley, 2008).

———, *Between Friends: Discourses of Power and Desire in the Machiavelli-Vettori Letters of 1513–1515* (Princeton: Princeton University Press, 1993).

Nalezyty, Susan, *Pietro Bembo and the Intellectual Pleasures of a Renaissance Writer and Art Collector* (New Haven: Yale University Press, 2017).

Nauta, Lodi, *In Defense of Common Sense: Lorenzo Valla's Humanist Critique of Scholastic Philosophy* (Cambridge, Mass.: Harvard University Press, 2009).

Nedkvitne, Arnved, *Norse Greenland: Viking Peasants in the Arctic* (Abingdon: Routledge, 2019).

Newman, William R., *Atoms and Alchemy: Chymistry and the Experimental Origins of the Scientific Revolution* (Chicago: University of Chicago Press, 2006).

———, *Secrets of Nature: Astrology and Alchemy in Early Modern Europe* (Cambridge, Mass: MIT Press, 2001).

Nirenberg, David, *Neighboring Faiths: Christianity, Islam, and Judaism in the Middle Ages and Today* (Chicago: University of Chicago Press, 2014).

Nitti, Francesco, *Leone X e la sua politica* (Bologna: Il Mulino, 1998).

Noreña, Carlos G., *Studies in Spanish Renaissance Thought* (The Hague: Nijhoff, 1975).

Nummedal, Tara, *Anna Zieglerin and the Lion's Blood: Alchemy and End Times in Reformation Germany* (Philadelphia: University of Pennsylvania Press, 2019).

———, *Alchemy and Authority in the Holy Roman Empire* (Chicago: University of Chicago Press, 2007).

Nutton, Vivian, *Renaissance Medicine: A Short History of European Medicine in the Sixteenth Century* (London: Routledge, 2022).

SOURCES AND RECOMMENDED READING

Origo, Iris, *A Need to Testify: Portraits of Lauro De Bosis, Ruth Draper, Gaetano Salvemini, Ignazio Silone and an Essay on Biography* (San Diego: Harcourt Brace Jovanovich, 1984).

———, *War in Val d'Orcia, 1943–1944* (Boston: D.R. Godine, 1984).

———, *The World of San Bernardino* (New York: Harcourt, Brace & World, 1962).

———, "The Domestic Enemy: The Eastern Slaves in Tuscany in the Fourteenth and Fifteenth Centuries", *Speculum*, 30 n. 3 (1955), pp. 321–66.

———, *The Last Attachment: The Story of Byron and Teresa Guiccioli as Told in Their Unpublished Letters and Other Family Papers* (London: Cap, 1949).

———, *Tribune of Rome: A Biography of Cola Di Rienzo* (London: Hogarth Press, 1938).

———, *Leopardi: A Biography* (London: H. Milford, 1935).

Palmer, Ada, "Pomponio Leto's Lucretius, the Quest for a Classical Technical Lexicon, and the Negative Space of Humanist Latin Knowledge", *Erudition and the Republic of Letters*, 8 (2023), pp. 221–78.

———, "The Persecution of Renaissance Lucretius Readers Revisited", in Philip R. Hardie, Valentina Prosperi and Diego Zucca eds., *Lucretius Poet and Philosopher: Background and Fortunes of De Rerum Natura* (Berlin: De Gruyter, 2020), pp. 167–97.

———, "The Effects of Authorial Strategies for Transforming Antiquity on the Place of the Renaissance in the Current Philosophical Canon", in Patrick Baker, Johannes Helmrath and Craig Kallendorf eds., *Beyond Reception: Renaissance Humanism and the Transformation of Classical Antiquity* (Berlin: De Gruyter, 2019), pp. 163–94.

———, *Censorship & Information Control from Printing Press to Internet, an Exhibit Catalog* (Chicago: University of Chicago Special Collections Research Center, 2018).

———, "Humanist Lives of Classical Philosophers and the Idea of Renaissance Secularization: Virtue, Rhetoric, and the Orthodox Sources of Unbelief", *Renaissance Quarterly*, 70 n. 3 (2017), pp. 935–76.

———, "Lucretius after *The Swerve*", *Modern Philology*, 115 n. 2 (2017), pp. 289–97.

———, "The Active and Monastic Life in Humanist Biographies of Pythagoras", in Almut-Barbara Renger and Alessandro Stavru eds., *Forms and Transfers of Pythagorean Knowledge: Askesis – Religion – Science* (Berlin: De Gruyter, 2016), pp. 211–26.

———, "The Recovery of Stoicism in the Renaissance", in John Sellars ed., *Routledge Companion to the Stoic Tradition* (London: Routledge, 2016).

———, 'The Use and Defense of the Classical Canon in Pomponio Leto's Biography of Lucretius', in *Vitae Pomponianae: Lives of Classical Writers in Fifteenth-Century Roman Humanism.* i 9 (2015), pp. 87–106.

———, *Reading Lucretius in the Renaissance* (Cambridge, Mass.: Harvard University Press, 2014).

Parker, Geoffrey, *The Military Revolution: Military Innovation and the Rise of the West, 1500–1800* (Cambridge: Cambridge University Press, 1996).

Parks, Tim, *Medici Money: Banking, Metaphysics, and Art in Fifteenth-Century Florence* (New York: W.W. Norton & Company, 2005).

Pastorino, Cesare, "The Philosopher and the Craftsman: Francis Bacon's Notion of Experiment and its Debt to early Stuart Inventors," *Isis*, 108 n. 4 (2017), pp. 749–68.

———, "Weighing Experience: Experimental Histories and Francis Bacon's Quantitative Program", *Early Science and Medicine*, 16 n. 6 (2011), pp. 542–70.

Pesenti, Giovanni, "Alessandra Scala: una figurina della Rinascenza Fiorentine", *Giornale Storico della Letteratura Italiana*, 22 n. VIII (1925), pp. 241–67.

Pettegree, Andrew, *The Book in the Renaissance* (New Haven: Yale University Press, 2010).

Pitkin, Hanna Fenichel, *Fortune is a Woman: Gender and Politics in the Thought of Niccolò Machiavelli* (Berkeley: University of California Press, 1984).

Platen, Magnus von ed., *Queen Christina of Sweden: Documents and Studies* (Stockholm: National Museum Sweden, 1966).

Polizzotto, Lorenzo, *The Elect Nation: the Savonarolan Movement in Florence, 1494-1545* (Oxford: Clarendon Press, 1994).

Pomata, Gianna and Nancy G. Siraisi eds., *Historia: Empiricism and Erudition in Early Modern Europe* (Cambridge, Mass.: MIT Press, 2005).

Popkin, Richard H., *The History of Scepticism from Savonarola to Bayle* (Oxford: Oxford University Press, 2003).

Power, Eileen, *Medieval People* (Boston: Houghton Mifflin, 1927).

Prajda, Katalin, "Manetto Di Jacopo Amannatini, the Fat Woodcarver: Architecture and Migration in Early Renaissance Florence", *Acta Historiae Artium*, 57 (2016), pp. 1–19.

Principe, Lawrence, *The Secrets of Alchemy* (Chicago: University of Chicago Press, 2013).

Prosperi, Valentina, "Iliads without Homer. The Renaissance Aftermath of the Trojan Legend in Italian Poetry (Ca 1400–1600)", in Adam J.

Goldwyn ed., *The Trojan Wars and the Making of the Modern World* (Uppsala: Uppsala Universitet, 2015), pp. 15–34.

———, *Di soavi licor gli orli del vaso: la fortuna di Lucrezio dall'Umanesimo alla Controriforma* (Torino: N. Aragno, 2004).

Rahe, Paul Anthony, *Against Throne and Altar: Machiavelli and Political Theory under the English Republic* (Cambridge: Cambridge University Press, 2008).

Raman, Shankar, *Renaissance Literature and Postcolonial Studies* (Edinburgh: Edinburgh University Press, 2011).

Rampling, Jennifer, *The Experimental Fire: Inventing English Alchemy, 1300-1700* (Chicago: University of Chicago Press, 2020).

Rankin, Alisha, *Panaceia's Daughters: Noblewomen as Healers in Early Modern Germany* (Chicago: University of Chicago Press, 2013).

Raphael, Renée, *Reading Galileo: Scribal Technologies and the Two New Sciences* (Baltimore: Johns Hopkins University Press, 2017).

Ravenscroft, Janet, "Dwarfs – and a Loca – as Ladies' Maids at the Spanish Habsburg Courts", in Nadine Akkerman and Birgit Houben eds., *The Politics of Female Households: Ladies-in-Waiting across Early Modern Europe* (Leiden: Brill, 2014), pp. 147–77.

Reeves, Eileen, *Evening News: Optics, Astronomy, and Journalism in Early Modern Europe* (Philadelphia: University of Pennsylvania Press, 2014).

Reynolds, Leighton Durham and Nigel Guy Wilson, *Scribes and Scholars: A Guide to the Transmission of Greek and Latin Literature* (Oxford: Clarendon Press, 1991).

Rice, Eugene F. and Anthony Grafton, *The Foundations of Early Modern Europe, 1460–1559* (New York: W.W. Norton, 1994).

Ridley, Griffin, "Restoring Order: The Papal Monarchy, Republicanism, and Political Thought in Italy, 1220-1300" (PhD thesis, University of Chicago, 2024).

Robichaud, Denis J.-J., *Plato's Persona: Marsilio Ficino, Renaissance Humanism, and Platonic Traditions* (Philadelphia: University of Pennsylvania Press, 2018).

Robin, Diana, "A Reassessment of the Character of Francesco Filelfo (1398–1481)", *Renaissance Quarterly*, 36 n. 2 (1983), pp. 202–24.

Rocke, Michael, *Forbidden Friendships: Homosexuality and Male Culture in Renaissance Florence* (Oxford: Oxford University Press, 1996).

Roick, Matthias, "Back on the Job? German Studies on Renaissance Humanism", *Storica* 17 n. 51 (2011), pp. 83–95.

Ross, Janet, *The Story of Lucca* (London: J.M. Dent, E.P. Dutton, 1912).

———, *The Story of Pisa* (London: J.M. Dent, 1909).

———, *Florentine Palaces & Their Stories* (London: J.M. Dent, 1905).

———, *Florentine Villas* (London: J.M. Dent, 1901).
———, *The Land of Manfred, Prince of Tarentum and King of Sicily. Rambles in Remote Parts of Southern Italy, with Special Reference to Their Historical Associations* (London: John Murray, 1889).
Roth, Cecil, *The Last Florentine Republic* (London: Methuen, 1925).
Rothfield, Lawrence, *The Measure of Man: Liberty, Virtue, and Beauty in the Florentine Renaissance* (Lanham: Rowman & Littlefield, 2021).
Rubini, Rocco, *Posterity: Inventing Tradition from Petrarch to Gramsci* (Chicago: University of Chicago Press, 2022).
Ruegg, Walter, *Cicero und der Humanismus* (Zürich: Rheinverlag, 1946).
Ruggiero, Guido, *Machiavelli in Love: Sex, Self, and Society in the Italian Renaissance* (Baltimore: Johns Hopkins University Press, 2007).
———, *Binding Passions: Tales of Magic, Marriage, and Power at the End of the Renaissance* (Oxford: Oxford University Press, 1993).
Rummel, Erika, *Erasmus* (London: Continuum, 2004).
———, *The Confessionalization of Humanism in Reformation Germany* (Oxford: Oxford University Press, 2000).
Rundle, David ed., *Humanism in Fifteenth-Century Europe* (Oxford: Society for the Study of Medieval Languages and Literature, 2012).
Sacks, David Harris, "On Mending the Peace of the World: Sir Francis Bacon's Apocalyptic Irenicism", *New Global Studies*, 16 n. 2 (2022), pp. 193–214.
Sandberg, Brian, *War and Conflict in the Early Modern World: 1500–1700* (Cambridge: Polity Press, 2016).
Schiffels, Stephan et al., "Iron Age and Anglo-Saxon Genomes from East England Reveal British Migration History", *Nature Communications*, 19 n. 7 (2016), ref. 10408.
Schmidt, Justin O., *The Sting of the Wild* (Baltimore: Johns Hopkins University Press, 2018).
Seigel, Jerrold, *Rhetoric and Philosophy in Renaissance Humanism: the Union of Eloquence and Wisdom, Petrarch to Valla* (Princeton: Princeton University Press, 1968).
Shaw, Christine, *Isabella d'Este: A Renaissance Princess* (Abingdon, Oxon: Routledge, 2019).
———, *The Politics of Exile in Renaissance Italy* (Cambridge: Cambridge University Press, 2000).
———, *Julius II: The Warrior Pope* (Oxford: Blackwell, 1993).
Shearman, John K. G., *Raphael in Early Modern Sources: 1483–1602* (New Haven: Yale University Press, 2003).
Sheppard, Kenneth, *Anti-Atheism in Early Modern England 1580–1720: The Atheist Answered and His Error Confuted* (Leiden: Brill, 2015).

Sherr, Richard et al., *The Josquin Companion* (Oxford: Oxford University Press, 2000).
Shotwell, Alexis, *Against Purity: Living Ethically in Compromised Times* (Minneapolis: University of Minnesota Press, 2016).
Simonetta, Marcello, *The Montefeltro Conspiracy: A Renaissance Mystery Decoded* (New York: Doubleday, 2008).
———, *Rinascimento segreto: il mondo del segretario da Petrarca a Machiavelli* (Milano: F. Angeli, 2004).
Simonetta, Marcello and J. J. G. Alexander eds., *Federico Da Montefeltro and His Library* (Milano: Y.Press, 2007).
Siraisi, Nancy G., *History, Medicine, and the Traditions of Renaissance Learning* (Ann Arbor: University of Michigan Press, 2007).
———, *Medieval & Early Renaissance Medicine: An Introduction to Knowledge and Practice* (Chicago: University of Chicago Press, 1990).
Small, Brendan, "Praise and Blame: The Politics of Virtue in Early Sixteenth-Century Rome" (PhD thesis, University of Chicago, 2024).
Spiller, Elizabeth, *Reading and the History of Race in the Renaissance* (Cambridge: Cambridge University Press, 2011).
Spitz, Lewis. *Johannes Sturm on Education: The Reformation and Humanist Learning* (St. Louis, MO: Concordia Pub. House, 1995).
Star, Bastiaan et al., "Ancient DNA Reveals the Chronology of Walrus Ivory Trade from Norse Greenland", *Proceedings of the Royal Society B (Biological Sciences)*, 285 n. 1884 (2018), ref. 20180978.
Steinmetz, Greg, *The Richest Man Who Ever Lived: The Life and Times of Jacob Fugger* (New York: Simon & Schuster, 2015).
Stephens, J. N., *The Fall of the Florentine Republic, 1512–1530* (Oxford: Oxford University Press, 1983).
Stok, Fabio, "Why Was Virgil Called 'Parthenias'?" *Giornale Italiano di Filologia*, 69 (2017) pp. 157–70.
———, "Virgil Between the Middle Ages and the Renaissance," *International Journal of the Classical Tradition*, 1 n. 2 (1994), pp. 15–22.
Strathern, Paul, *Death in Florence: The Medici, Savonarola, and the Battle for the Soul of a Renaissance City*: (New York: Pegasus Books, 2015).
Strocchia, Sharon T., *Nuns and Nunneries in Renaissance Florence* (Baltimore: Johns Hopkins University Press, 2009).
Svenbro, Jesper et al. eds., *A History of Reading in the West* (Amherst: University of Massachusetts Press, 1999).
Swain, Elizabeth Ward, "The Wages of Peace: The Condotte of Ludovico Gonzaga 1436–1478", *Renaissance Studies*, 3 (1989), pp. 442–52.
Tanner, Marcus, *The Raven King: Matthias Corvinus and the Fate of His Lost Library* (New Haven: Yale University Press, 2008).

Targoff, Ramie, *Renaissance Woman: The Life of Vittoria Colonna* (New York: Farrar, Straus and Giroux, 2018).

———, *John Donne, Body and Soul* (Chicago: University of Chicago Press, 2009).

Taruskin, Richard, "Chapter 14: Josquin and the Humanists", in *The Oxford History of Western Music Vol. 1 Music from the Earliest Notations to the Sixteenth Century* (Oxford: Oxford University Press, 2005).

Taylor, Barry and A. Coroleu eds., *Latin and Vernacular in Renaissance Spain* (Manchester: Manchester Spanish & Portuguese Studies, 1999).

Tedeschi, John, *Intelletualli in Esilio: Dall'Inquisitione Romana al Fascismo* (Rome: Edizioni di storia e letteratura, 2012).

Terpstra, Nicholas, *The Art of Executing Well: Rituals of Execution in Renaissance Italy* (Kirksville, MO: Truman State University Press, 2008).

———, *Lay Confraternities and Civic Religion in Renaissance Bologna* (Cambridge: Cambridge University Press, 1995).

Terpstra, Nicholas, Adriano Prosperi and Stefania Pastore eds., *Faith's Boundaries: Laity and Clergy in Early Modern Confraternities* (Turnhout: Brepols, 2012).

Torch, Barry, "'Do I Have a Book for You!' the Friendship of Theodore Gaza and Giovanni Bussi, and a Gifted Book", in John Christopoulos and John M. Hunt eds., *Making Stories in Early Modern Italy and Beyond: Essays in Honour of Elizabeth S. Cohen and Thomas V. Cohen* (Toronto: CRRS, 2024), pp. 31–47.

———, "Pius II and the Andreis (1462): Textual Circulation, Crusade Promotion and Papal Power", *Renaissance Studies*, 36 n. 4 (2022), pp. 590–609.

Trexler, Richard, *Public Life in Renaissance Florence* (Ithaca: Cornell University Press, 1991).

Tuan, Yi Fu, "Slaves, Dwarfs, Fools", in *Dominance and Affection: The Making of Pets* (New Haven: Yale University Press, 1984), pp. 132–61.

Tutaev, David, *Der Konsul Von Florenz Die Rettung Einer Stadt* (Düsseldorf: Econ, 1967).

Tylus, Jane, *Siena: City of Secrets* (Chicago: University of Chicago Press, 2015).

Unger, Miles, *Michelangelo: A Life in Six Masterpieces* (New York: Simon & Schuster, 2014).

———, *Magnifico: The Brilliant Life and Violent Times of Lorenzo De' Medici* (New York: Simon & Schuster, 2008).

Vacalebre, Natale ed., *Five Centuries Later: Aldus Manutius: Culture, Typography and Philology* (Firenze: L. S. Olschki, 2018).

SOURCES AND RECOMMENDED READING

Valazzi, Maria Rosaria et al., *Lo studiolo del duca: il ritorno degli uomini illustri alla corte di Urbino* (Milano: Skira, 2015).

Van Dixhoorn, Arjan and Susie Speakman Sutch eds., *The Reach of the Republic of Letters: Literary and Learned Societies in the Late Medieval and Early Modern Europe* (Leiden: Brill, 2008).

Van Rooy, Raf, "Ippolita Maria Sforza, Student and Patron of Greek in Milan", *Renaissance Quarterly*, 76 n. 3 (2023), pp. 848–92.

Vaughan, Herbert M., *The Medici Popes: (Leo X and Clement VII.)* (London: Methuen, 1908).

Villa, Luisa, "Victorian Uses of the Italian Past: The Case of Camilla Rucellai in George Eliot's *Romola*", in *The Victorians and Italy: Literature, Travel, Politics and Art* (Lima: Polimetrica, 2009), pp. 193–210.

Villari, Pasquale (Leonard Horner trans.), *The History of Girolamo Savonarola and of His Times* (London: Longman, Roberts, & Green, 1863).

Wagner, D. M. et al., "Yersinia Pestis and the Plague of Justinian 541–543 AD: A Genomic Analysis", *The Lancet Infectious Diseases*, 14 n. 4 (2014), pp. 319–26.

Walden, Justine A., "Muslim Slaves in Early Modern Rome: The Development and Visibility of a Laboring Class", in Matthew Coneys Wainwright and Emily Michelson eds., *A Companion to Religious Minorities in Early Modern Rome* (Leiden: Brill, 2020), pp. 298–323.

Walker, Paul Robert, *The Feud That Sparked the Renaissance: How Brunelleschi and Ghiberti Changed the Art World* (New York: William Morrow, 2002).

Waller, John, *The Dancing Plague: The Strange, True Story of an Extraordinary Illness* (Naperville, IL: Sourcebooks, 2009).

Warsh, Molly A., *American Baroque: Pearls and the Nature of Empire, 1492–1700* (Chapel Hill: University of North Carolina Press, 2018).

Webster, Charles, *The Great Instauration: Science, Medicine, and Reform, 1626-1660* (Oxford: Peter Lang, 2002).

Weinstein, Donald, *Savonarola: The Rise and Fall of a Renaissance Prophet* (New Haven: Yale University Press, 2011).

Welch, Evelyn, *Shopping in the Renaissance: Consumer Cultures in Italy 1400–1600* (New Haven: Yale University Press, 2005).

Whitfield, John Humphreys, *The Pathos of Palla Strozzi* (Birmingham: J.H. Whitfield, 1994).

Williams, Gareth, *Pietro Bembo on Etna: the Ascent of a Venetian Humanist* (Oxford: Oxford University Press, 2017).

Wilson, Catherine, *Epicureanism at the Origins of Modernity* (Oxford: Oxford University Press, 2008).
Wood, Jeryldene, *Ippolita Maria Sforza: The Renaissance Princess Who Linked Milan and Naples* (Cambridge: Cambridge University Press, 2020).
Woolfson, Jonathan et al. eds., *Reassessing Tudor Humanism* (New York: Palgrave, 2002).
Wootton, David, "Lucien Febvre and the Problem of Unbelief in the Early Modern Period", *The Journal of Modern History*, 60 n. 4 (1988), pp. 695–730.
Zarri, Gabriella, *Le sante vive: cultura e religiosità femminile nella prima età moderna* (Torino: Rosenberg & Sellier, 1990).
Zinsser, Judith P., *Emilie du Châtelet: Daring Genius of the Enlightenment* (New York: Penguin Books, 2007).

Notes

These notes are in brief citation form; complete citations appear in the bibliography.

Notes to Prologue and Chapter 1

1. Niccolò Machiavelli, *Machiavelli and His Friends* (1996), letter 106, February 25, 1506, from Ercole Bentivoglio.
2. On the modern popularity of the Renaissance, costume festivals, etc., see Paul F. Grendler, *European Renaissance in American Life* (2006).
3. *Canzoniere* 205, "Dolci ire, dolci sfegni et dolci paci…" See the responding sonnet "Dear Petrarch," by Jo Walton, *Thought Against Tomorrow* (2020).
4. Steven Epstein, *Genoa and the Genoese* (1996), pp. 92, 117, 30, 32, 85.
5. See Verena Krebs, *Medieval Ethiopian Kingship* (2021).
6. See Paul Bairoch, *Population des villes* (1988).
7. On Italian mercenaries, see William Caferro, *John Hawkwood* (2006); Michael Mallett, *Mercenaries* (2019).
8. Recently, see Robert Black, "Machiavelli and the Militia," *Italian Studies* (2024), pp. 41–50.
9. Machiavelli, *Machiavelli and His Friends* (1996), letter 90, from Cardinal Francesco Soderini, May 29th, 1504; letter 169, from Filippo Casavecchia, June 17th, 1509.
10. Ibid., letter 203, after September 15, 1512. On the conquest, see H. C. Butters, *Governors and Government* (1985), ch. 6–7.
11. On exile, see Christine Shaw, *Politics of Exile* (2000).
12. Machiavelli, letter 224, undated 1513.
13. On secretaries, see Marcello Simonetta, *Rinascimento segreto* (2004).
14. See such sentiments in *Discourses* I.6, 9, 42–3, II.6–9, III. 1–5, etc.

Notes to Part I: Why You Shouldn't Believe Anyone (Including Me) About the Renaissance

1. Stephen Greenblatt, *The Swerve* (2009). See my review essay, Ada Palmer, "Lucretius after *The Swerve*", *Modern Philology* (2017). For

a sample of the book's reception, see Jim Hinch, "Why Stephen Greenblatt Is Wrong—and Why It Matters", *LA Review of Books* (2012).
2. See Brian Maxson's chapter in Nicholas Scott Baker and Brian Maxson eds., *Florence in the Early Modern World* (2020).
3. See Robert Clark, *Dark Water* (2008), ch. 5.
4. See Johan Huizinga's *Herfsttij der Middeleeuwen* (1919) translated as *The Waning of the Middle Ages*; also Charles Haskins, *Renaissance of the Twelfth Century* (1927).
5. See Arnved Nedkvitne, *Norse Greenland* (2019), esp. pp. 1–13.
6. See the superb opening chapter of Neil Price, *Viking Way* (2019).
7. Thomas McGovern, "Why Did Greenland's Vikings Vanish?", *Smithsonian Magazine* (2017).
8. Justin Schmidt, *The Sting of the Wild* (2018), p. 226.
9. For Holmes's knowledge of literature as nil see *Study in Scarlet* (1887), the "pocket Petrarch" in "The Boscombe Valley Mystery" (1889).
10. For example, in Christie's 1926 Mr Quin story "The Love Detectives" (original title "At the Crossroads").
11. Burckhardt, *Civilization of the Renaissance in Italy* (1860), Conclusion to Part I.
12. Burckhardt, Part II "The Development of the Individual" ch. 1: "The Italian State and the Individual".
13. Burckhardt, conclusion of Part I "The State as a Work of Art".
14. Brian Copenhaver, *Magic and the Dignity of Man* (2019).
15. Burckhardt, conclusion to Part I.
16. Burckhardt, I.1.
17. Stefan, Bauer, et al. eds., *A Renaissance Reclaimed* (2022).
18. Christopher Celenza, *Lost Italian Renaissance* (2004).
19. Alexis Shotwell, *Against Purity* (2016).
20. Martin argues for a five-fold understanding of the self in the period, with five separate selves: the socially-conforming, prudential, performative, possessed, and sincere selves, each operating in different contexts and relationships; John Jeffries Martin, *Myths of Renaissance Individualism* (2004). For another effort to understand constructions of the self in the period, see the works of Aron Gurevich, especially *The Origins of European Individualism* (trans. K. Judelson, 1995).
21. Niethammer used the term to discuss the value of the classics in education, arguing against trends toward a focus on vocational and scientific training. For the influence of this term on histories of the Renaissance, see Paul Oskar Kristeller, *Renaissance Thought and its Sources* (1979), p. 22; Walter Ruegg, *Cicero und der Humanismus* (1946).

22. See David Wootton, "New Histories of Atheism", in *Atheism from the Reformation to the Enlightenment*, ed. Michael Hunter and David Wootton (1992), pp. 13–55.
23. It appears in Hans Baron, *Leonardo Bruni Aretino* (1928).
24. See John Boyer, *University of Chicago: A History* (2015), ch. 4–5.
25. Hans Baron, *Crisis of the Early Italian Renaissance* (1955).
26. James Hankins, *Virtue Politics* (2019), ch. 2 "What Was a Republic in the Renaissance?", pp. 63–102.
27. John-Paul Heil, "Virtue and Vice in the Political World of Renaissance Naples" (PhD thesis, University of Chicago, 2022).
28. James Hankins, "The 'Baron Thesis' after Forty Years", *JHI* (1995), pp. 309–38.
29. I am indebted for this excellent analysis to the opening pages of Butters, *Governors and Government* (1985).
30. See John P. McCormick, *Reading Machiavelli* (2018).
31. James Hankins et al. eds., *Renaissance Civic Humanism* (2000); Nicholas Scott Baker and Brian Maxson eds., *After Civic Humanism* (2015). Baron's thesis is not even mentioned in my dear friend Christopher Celenza's wonderful *The Intellectual World of the Italian Renaissance* (2018), yet is alive and well in the work of many political scientists like my equally dear friend John McCormick.
32. See Guido Ruggiero, *Renaissance in Italy* (2014), ch. 3.
33. For less technical studies of the Black Death, see John Kelly, *Great Mortality* (2005); David Herlihy, *Black Death* (1997).
34. On Italy's economic developments, see Richard Goldthwaite, *Economy of Renaissance Florence* (2009). For broader statistics, see Carlo M. Cipolla, *Before the Industrial Revolution* (1976). For the Middle Ages, see Michael McCormick, *Origins of the European Economy* (2001).
35. David Tutaev, *Konsul Von Florenz* (1967). See also Rachel Cohen, *Bernard Berenson* (2013).
36. Clark, *Dark Water* (2008).
37. *Siena* is designed by Mario Papini, published by Z-Man Games. As an example of the overcomplicated ones, *Florenza* (Stefano Groppi; ElfinWerks and Golden Egg Games) is a loving recreation of Florentine great families competing to put their coats of arms on the most art, with mechanics for labor and materials shortages, and special rules for Savonarola and Saint Anthony of Padua.
38. Lorenzo de Medici, *Ricordi*, 1472–84.
39. See Leonardo Bruni's *De Militia*; on this and the Donatello see Hankins, *Virtue Politics*, pp. 246–54.
40. Butters, *Governors and Government*, pp. 3–4.

41. Lawrence Rothfield, *Measure of Man* (2021), p. 50.
42. On such groups, see Nicholas Terpstra et al. eds., *Faith's Boundaries* (2012); Terpstra, *Lay Confraternities* (1995).
43. Burckhardt, Part VI "Morality and Religion", ch. V "General Disintegration of Belief", and final section 'Italian Thei'.
44. Pasquale Villari, *History of Girolamo Savonarola* (1863), p. 50.
45. Tim Parks, *Medici Money* (2005); Lauro Martines, *Fire in the City* (2006) and *April Blood* (2003); Paul Strathern, *Death in Florence* (2011); Christopher Hibbert, *House of Medici* (1975); Miles Unger, *Magnifico* (2008); Ruggiero, *Renaissance in Italy* (2014); John Najemy, *History of Florence* (2008); Mary Hollingsworth, *Family Medici* (2018). For overviews, I most recommend Ruggiero, Najemy, or, for humanizing gossip, Janet Ross, *Lives of the Early Medici* (1910).
46. Robert Black and John E. Law eds., *Medici: Citizens and Masters* (2015).
47. Greg Steinmetz, *Richest Man* (2015).
48. Goldthwaite, *Economy of Renaissance Florence* (2009), p. 393; Alison Brown, "Lorenzo, the Monte", in *Medici in Florence* (1992), pp. 151–211.
49. Thomas Kuehn, *Heirs, Kin, and Creditors* (2008).
50. For a recent sympathetic reexamination, see Alison Brown, *Piero Di Lorenzo* (2020).
51. Mallett, *Mercenaries* (2019), p. 148.
52. *Florentine Histories*, 7.11, 800: "perché colui non vuole i suoi cittadini per parenti gli vuole per servi, e per ciò e ragionevole che non gli abbia amici."
53. On him see Jane Stevenson, *Light of Italy* (2021); Valazzi Maria Rosaria et al. eds., *Lo studiolo del duca* (2015); Marcello Simonetta, J. J. G. Alexander eds., *Federico da Montefeltro* (2007).
54. Hollingsworth, *Family Medici*, p. 163.
55. Rothfield, *Measure of Man* (2021), p. 82.
56. Najemy, *History of Florence* (2008), p. 348.
57. Marcello Simonetta, *Montefeltro Conspiracy* (2008), p. 49.
58. Hibbert, *House of Medici* (1975), p. 127.
59. Ross, *Lives of the Early Medici* (1910), p. 145.
60. Ruggiero, *Renaissance in Italy* (2014), p. 315.
61. See Stevenson, *Light of Italy* (2021).
62. Described by Nicodemo Tranchedini, sent to Florence by Francesco Sforza, cf. Hibbert, *House of Medici* (1975), p. 97.
63. For another book where political innovation is the X-Factor and Lorenzo plays the role of villain, see Erica Benner, *Be Like the Fox* (2017), pp. 42–3.

64. Donatella Lippi, Philippe Charlier and Paola Romagnani, "Acromegaly in Lorenzo the Magnificent", *Lancet* (2017), p. 2104.
65. F. W. Kent, *Lorenzo De' Medici* (2004), pp. 90–2.
66. Brian Maxson, *Short History of Florence* (2023). The comments cited here are from personal conversations with Brian in autumn 2023 as I was finishing this book.
67. Benner, *Be Like the Fox* (2017).
68. 1922, "The Problem of Thor Bridge"; 1914, *Valley of Fear*.
69. Ross, *Lives of the Early Medici* (1910); *Land of Manfred* (1889); *Story of Pisa* (1909); *Story of Lucca* (1912); *Florentine Villas* (1901); *Florentine Palaces* (1905). On her life see Ben Downing, *Queen Bee* (2013).
70. Iris Origo, *Need to Testify* (1984); *War in Val d'Orcia* (1984); *Last Attachment* (1949); *World of San Bernardino* (1962); *Tribune of Rome* (1938); *Leopardi* (1935).
71. Iris Origo, *Merchant of Prato* (1960).
72. Her works include Julia Mary Cartwright Ady, *Baldassare Castiglione* (1908); *Painters of Florence* (1906); *Beatrice D'Este* (1903); *Isabella d'Este* (1903); *Italian Gardens* (1914); *Raphael* (1914).
73. Cecilia M. Ady, *Bentivoglio of Bologna* (1937); *English Church* (1940).
74. Rosamond Joscelyne Mitchell, *Laurels and the Tiara* (1963); *Medieval Feast* (1958); *History of London Life* (1963); *History of the English People* (1967); *Life and Adventure* (1934).
75. Scanning my shelves: Sheila Hale, *Titian* (2012); Elizabeth Lev, *Tigress of Forlì* (2011); Anna Abraham, *Leonardo Da Vinci* (2016); Marina Belozerskaya, *Wake the Dead* (2009); Benner, *Be Like the Fox* (2017); Sarah Bradford, *Lucrezia Borgia* (2004) and *Cesare Borgia* (1976); Emma Lucas, *Lucrezia Borgia* (2014); Dianne Hales, *Mona Lisa* (2014); Caroline Murphy, *Pope's Daughter* (2005); Stevenson, *Light of Italy* (2021); Ramie Targoff, *John Donne* (2009) and *Renaissance Woman* (2018).
76. Monica Azzolini, *Duke and the Stars* (2013); Marina Belozerskaya, *Medici Giraffe* (2009); Abigail Brundin et al. eds, *Sacred Home* (2018); Elizabeth Storr Cohen, *Daily Life* (2001); Virginia Cox, *Lyric Poetry* (2013); Carole Collier Frick, *Dressing Renaissance Florence* (2011); Mary Hollingsworth, *Patronage in Renaissance Italy* (1994); Ioanna Iordanou, *Venice's Secret Service* (2019); Allison Levy, *House of Secrets* (2020); Katherine McIver, *Cooking and Eating* (2015); Nancy G. Siraisi, *Medieval & Early Renaissance Medicine* (1990); Sharon Strocchia, *Nuns and Nunneries* (2009); Jane Tylus, *Siena* (2015).
77. Christopher Celenza, *Petrarch* (2017) and *Machiavelli* (2015); Martines, *Fire in the City* (2006); Strathern, *Death in Florence* (2015);

Donald Weinstein, *Savonarola: The Rise and Fall of a Renaissance Prophet* (2011); John Freely, *Grand Turk* (2014). I currently have five books by men that are structurally biographies, but published to not look like biographies, as if trying to avoid association with the (romantic) world of biography: three of feuding artists (Brunelleschi and Ghiberti, Leonardo and Michelangelo), one of a mercenary, and only Ross King's *Bookseller of Florence* (2021) touching material culture. These are Paul Robert Walker, *Feud That Sparked the Renaissance* (2002); Jonathan Jones, *Lost Battles* (2014); Anthony D'Elia, *Pagan Virtue* (2016); Ross King, *Brunelleschi's Dome* (2001).

78. Ada Palmer, *Perhaps the Stars*, vol. 1 of *Terra Ignota* (2021), ch. 1.
79. Fred Barzyk and Eugen Joseph Weber, *Western Tradition* (1989).
80. See Dante *Inferno* xiv, *Paradiso* vi 1–111.
81. On Renaissance use of history, see Anthony Grafton, *What Was History?* (2007); Patrick Baker, *Italian Renaissance Humanism in the Mirror* (2015).
82. Translation by A. S. Kline, 2002.
83. Leonardo Bruni, *History of the Florentine People*, ed. James Hankins (2001). See also Hankins, *Virtue Politics* (2019), ch. 8–10.
84. For a recent-as-could-be example, see the magnificent analysis of the sophisticated political thought expressed in thirteenth-century chronicles in Griffin Ridley's PhD dissertation, "Restoring Order: The Papal Monarchy, Republicanism, and Political Thought in Italy, 1220-1300" (completed at the University of Chicago in May 2024, just as this book was being rushed to the printers, advised by my superlative colleagues Jonathan Lyon, David Nirenberg and myself).
85. Maxson, *Short History of Florence* (2023), p. 76; Maxson, "Establishing Independence: Leonardo Bruni's History of the Florentine People and Ritual in Fifteenth-Century Florence", in *Foundation, Dedication*, Maarten Delbeke et al. eds. (2012), pp. 79–98.
86. Celenza, *Machiavelli* (2015). See also Rocco Rubini, *Posterity* (2022).
87. Robert Black, *Humanism and Education* (2001); John Monfasani, *Renaissance Humanism* (2015).

Notes to Part II: Desperate Times and Desperate Measures

1. Machiavelli, *Machiavelli and His Friends* (1996), letter 107.
2. Burckhardt, *Civilization of the Renaissance*, end of Part 1.
3. On this crisis see Ruggiero, *Renaissance in Italy* (2014) and Hankins, *Virtue Politics* (2019), ch. 1 "A Civilization in Crisis", pp. 1–30.

NOTES

4. Machiavelli., letter 78.
5. Cipolla, *Before the Industrial Revolution* (1976), p. 131.
6. H. Laayouni et al., "Convergent Evolution…", *NAS Proceedings* (2014); D. M. Wagner et al., "Yersinia Pestis", *Lancet Infectious Diseases* (2014).
7. See Brian Sandberg, *War and Conflict* (2016).
8. On military development in this period, see the works of Geoffrey Parker, esp. *Military Revolution* (1996).
9. For the best numbers see Cipolla, *Before the Industrial Revolution* (1976); Herlihy, *Black Death* (1997); Kelly, *Great Mortality* (2005).
10. Neil Cummins, "Lifespans of the European Elite", *JEH* (2017).
11. On such changes see *Medical Practice*, ed. Kay Peter Jankrift et al. (2016); Vivian Nutton, *Renaissance Medicine* (2022); Anthony Grafton et al. eds., *Natural Particulars* (1999); Gianna Pomata and Nancy G. Siraisi eds., *Historia: Empiricism and Erudition* (2005); Nancy G. Siraisi, *History, Medicine* (2007); Pablo Maurette, *Forgotten Sense* (2018); David Gentilcore, *Food and Health* (2016).
12. Azzolini, *Duke and the Stars* (2013), p. 28.
13. Cummins, "Lifespans of the European Elite" (2017).
14. See Caferro, *John Hawkwood* (2006).
15. Ruggiero, *Renaissance in Italy* (2014). This is my top recommendation of a general Italian Renaissance overview to read and enjoy.
16. www.parteguelfa.it
17. Machiavelli, *Machiavelli and His Friends* (1996), letters 213 and 25. Many thoughts which shape *The Prince* appear in letters 211–13 and 215–16. See also John Najemy, *Between Friends* (1993).
18. Machiavelli, letter 70.
19. Marios Costambeys, *Carolingian World* (2011); John D. Cotts, *Europe's Long Twelfth Century* (2013).
20. For overviews of the dynamic Middle Ages, see Matthew Perry and David M. Gabriele, *Bright Ages* (2021); Frances Gies, *Cathedral, Forge, and Waterwheel* (1994); Janina Ramirez, *Femina* (2022); Geraldine Heng, *Global Middle Ages* (2021).
21. Keagan Brewer, *Wonder and Skepticism* (2016); Alexander W. Hall, *Medieval Skepticism* (2011); Paul L. Heck, *Skepticism in Classical Islam* (2013); Heinrik Lagerlund, *Rethinking the History of Skepticism* (2010); Seb Falk, *Light Ages* (2020).
22. Robert McCloskey, *Centerburg Tales* (1977).
23. For a more formal version, see Hankins, *Virtue Politics* (2019), ch. 5 "The Triumph of Virtue: Petrarch's Political Thought", pp. 153–73.
24. See Michael Rocke, *Forbidden Friendships* (1996), and for a primary source example the autobiography of Benvenuto Cellini.

25. On how the Medici used art and objects to establish reputation, see Melissa Meriam Bullard, *Lorenzo Il Magnifico* (1994).
26. Andrew Pettegree and Arthur Der Weduwen, *Library* (2021).
27. On humanist book-collecting see Anthony Grafton, *Defenders of the Text* (1991) and *Commerce with the Classics* (1997).
28. See the delightful letters between Poggio and Niccolò in Phyllis Walter Goodhart Gordan ed., *Two Renaissance Book Hunters* (1991), especially letters III–IV, XI, XXX, XLIX–L, LXXX, and appendix letter IV of Francisco Barbaro.
29. See for example Oren J. Margolis, *Politics of Culture* (2016); Kathleen Christian and Bianca De Divitiis eds., *Local Antiquities* (2019); Jonathan Woolfson et al. eds., *Reassessing Tudor Humanism* (2002); David Rundle ed., *Humanism in Fifteenth-Century Europe* (2012); Barry Taylor et al. eds., *Latin and Vernacular* (1999); Carlos G. Noreña, *Studies in Spanish Renaissance Thought* (1975).
30. Margaret Meserve, *Papal Bull* (2021).
31. Vespasiano da Bistecci's diary records the anxiety of Giannozo Manetti (1396–1459), best known for his very Burckhardtian *On Human Worth and Excellence* (1452-3), when he was invited to give his obedience oration in the special chamber at the election of Nicholas V in 1447, see Brian Maxson, *Humanist World* (2014), ch. 4. Bruni also discusses the importance of such orations in his sample letter for *Innocent VII*, letter I.1 *Romam veni* in Bruni's collected letters.
32. Mitchell, *Laurels and the Tiara* (1963); William Boulting, *Æneas Silvius* (1908); Pius II, *Commentaries*, ed. Margaret Meserve and Marcello Simonetta (2003).
33. On Vergil in education, see the work of my inestimable mentor (and one of the warmest people you could ever meet) Craig Kallendorf, *Classics in the Medieval and Renaissance Classroom* (2013); *Virgilian Tradition* (2007); *Protean Virgil* (2015); *Virgilian Tradition II* (2022).
34. On transmission of the classics, see Paul Oskar Kristeller et al., *Catalogus Translationum et Commentariorum* (1960–); Leighton Durham Reynolds and Nigel Guy Wilson, *Scribes and Scholars* (1991).
35. That paper is unpublished, but on the same see Ada Palmer, "The Use and Defense of the Classical Canon in Pomponio Leto's Biography of Lucretius", *Vitae Pomponianae, Renaessanceforum* 9 (2015).
36. On scholasticism, see John Marenbon ed., *Many Roots* (2007); *Later Medieval Philosophy* (1987); *Scholastic Miscellany* (1956).
37. For good introductions to book history, including the costs of books, see Eugene F. Rice and Anthony Grafton eds., *Foundations*

of Early Modern Europe (1994), pp. 1–10; Reynolds and Wilson, *Scribes and Scholars* (1991), esp. pp. 80–122; David McKitterick, *Print, Manuscript* (2003); Simon Eliot and Jonathan Rose eds., *Companion to the History of the Book* (2007); Andrew Pettegree, *Book in the Renaissance* (2010); Svenbro Jesper et al. eds., *History of Reading* (1999).

38. Petrarch, *Invectives*, ed. David Marsh (2003).
39. See Christopher Celenza, *Italian Renaissance and the Origins of the Modern Humanities* (2021); Anthony Grafton and Lisa Jardine, *From Humanism to the Humanities* (1986).
40. Mary Wollstonecraft Shelley, *Frankenstein*, ed. Marilyn Butler (1993), pp. 131–2.
41. You can get selections of Petrarch's letters in two lovely recent bilingual volumes edited by Elaine Fantham, *Selected Letters* (2017) or e-books from Italica Press, 2009.
42. For English, see *Petrarch's Remedies*, ed. Conrad H. Rawski (1991).
43. Petrarch's hilarious dialogs about having too many books constitute the charming *Four Dialogues for Scholars*, ed. Conrad Rawski (1967).
44. On this see Patrick Baker, *Humanism in the Mirror* (2015), p. 48; Alison Frazier, *Possible Lives* (2005); John Henderson, *Piety and Charity* (1997); Celenza, *Lost Italian Renaissance* (2004), ch. 4 "Orthodoxy: Lorenzo Valla and Marsilio Ficino", pp. 80–114; Hankins, *Virtue Politics* (2019), especially p. 21 on Petrarch.
45. Ada Palmer, "Recovery of Stoicism in the Renaissance", *Routledge Companion to the Stoic Tradition* (2016); James Ker, *Deaths of Seneca* (2009).
46. Ada Palmer, "Humanist Lives", *RQ* (2017).
47. On Renaissance popular reception of the letters of *umanisti*, see Maxson, *Humanist World* (2014).
48. Plato, *Republic* VIII 547.
49. *Familiares*, especially VIII.7 and VIII.9.
50. See the excellent Margolis, *Aldus Manutius* (2023).
51. See the brilliant article by Jill Kraye, "Lorenzo and the Philosophers", in *Classical Traditions in Renaissance Philosophy* (2002), pp. 151–66.
52. Joseph Connors, et al. eds., *Italy & Hungary* (2011); Marcus Tanner, *Raven King* (2008); Ágnes Bakos et al. eds., *Matthias Corvinus* (2008).
53. Stuart M. McManus, *Empire of Eloquence* (2021); Andrew Laird, *Aztec Latin* (2024).
54. Recent scholarship on the African discovery of Europe shows this vividly, see for example Krebs, *Medieval Ethiopian Kingship* (2021).
55. Prologue to the *Prose Edda*.

56. Robert Launay, *Savages, Romans, and Despots* (2018). On the development of categories of race, see David Nirenberg, *Neighboring Faiths* (2014); Shankar Raman, *Renaissance Literature and Postcolonial Studies* (2011); Elizabeth Spiller, *Reading and the History of Race* (2011).
57. See McManus, *Empire of Eloquence* (2021); Laird, *Aztec Latin* (2024).
58. See Margaret Meserve, *Empires of Islam* (2009).
59. On Viking historiography, see the first chapter of Price, *Viking Way* (2019).
60. William Morris and Eiríkr Magnússon trans., *Story of the Volsungs* (1888), ix-xi.
61. Valentina Prosperi, "Iliads without Homer", in *Trojan Wars*, ed. Adam J. Goldwyn (2015), pp. 15–34.
62. Maxson, *Humanist World* (2014).
63. On the careers and financial triumphs of court dwarfs in the period, see Pamela Allen Brown, "The Mirror and the Cage", in *Historical Affects*, ed. Ronha Arab et al. (2015), pp. 137–47; Janet Ravenscroft, "Dwarfs – and a Loca – as Ladies" Maids…', in *Politics of Female Households*, ed. Nadine Akkerman and Birgit Houben (2014), pp. 147–77; Yi Fu Tuan, "Slaves, Dwarfs, Fools", in *Dominance and Affection* (1984), pp. 132–61; Touba Ghadessi, "Lords and Monsters: Visible Emblems of Rule", *I Tatti Studies* (2013); "Inventoried Monsters", *Journal of the History of Collections* (2011). See also forthcoming work on dwarfism and monstrosity by Pablo Maurette, and the excellent 2021 University of Chicago MA thesis by Aylin Corona, "Balancing Acts".
64. Belozerskaya, *Medici Giraffe* (2016).
65. Alas, we need more books in English on Milan; see Cecilia Ady, *History of Milan* (1907); John Gagné, *Milan Undone* (2021); Gregory Lubkin, *Renaissance Court* (1994); also Stevenson, *Light of Italy* (2021); Mary Hollingsworth, *Princes of the Renaissance* (2021).
66. While there are several books about his nephew Cardinal Ippolito d'Este II, there is little in English on Ippolito I, see Werner L. Gundersheimer, *Ferrara* (1973); Vincenzo Farinella, *Alfonso I d'Este* (2014), also biographies of his sister-in-law Lucrezia Borgia, notably in Christopher Hibbert, *Borgias and Their Enemies* (2008); Sarah Bradford, *Lucrezia Borgia* (2005).
67. Goldthwaite, *Economy of Renaissance Florence* (2009), table 7.6.
68. Marina Belozerskaya, *Luxury Arts* (2005).
69. For these numbers, see letters transcribed in Julia Cartwright Ady, *Isabella d'Este* (1903), ch. IV, XX.

70. Isabella d'Este, *Selected Letters* (2017), p. 356, February 3, 1512.
71. Richard Stapleford ed., *Lorenzo De' Medici at Home* (2013).
72. Marina Belozerskaya, *Medusa's Gaze* (2012).
73. On Renaissance collecting, see Paula Findlen, *Possessing Nature* (1994).
74. Cartwright Ady, *Isabella d'Este* (1903), p. 72. See also Isabella d'Este, *Selected Letters*, ed. Deanna Shemek (2017).
75. Paul F. Grendler, *Universities of the Italian Renaissance* (2002), pp. 225–7. See also Diana Robin, "A Reassessment of the Character of Francesco Filelfo (1398–1481)," *RQ* (1983).
76. Given in Cellini.
77. See Anthony M. Cummings, *Lion's Ear* (2022).
78. Elizabeth Ward Swain, "The Wages of Peace", *RS* (1989); cf. Hollingsworth, *Princes of the Renaissance* (2021), p. 121.
79. Stevenson, *Light of Italy* (2021), p. 249.
80. On Qaitbay, see John Freely, *Jem Sultan* (2005), pp. 59, 199.
81. Ruggiero, *Renaissance in Italy* (2014), ch. 5.
82. Ibid.
83. See the PhD thesis by my wonderful student John-Paul Heil, ch. 4 "Diomide Carafa's Imitative Virtue Politics in the Foreign Diplomacy of King Ferrante and His Children", pp. 140–225.
84. Many discuss this; for a great read see King, *Bookseller of Florence* (2021), p. 201.
85. See James Hankins, "Cosimo de Medici and the Platonic Academy", *Journal of the Warburg and Courtauld Institutes* (1990).
86. For a magnificent, deep study of piety in Cosimo's patronage see Dale Kent, *Cosimo de' Medici* (2000).

Notes to Part III: Let's Meet Some People from This Golden Age

1. For great, in-depth studies of this, see Hollingsworth, *Patronage* (1994); Paula D. McLean, *Art of the Network* (2007).
2. Butters, *Governors and Government* (1985), p. 13.
3. Richard Trexler, *Public Life* (1991), p. 90. On Marietta Strozzi, see Arnold Victor Coonin, "The Most Elusive Woman in Renaissance Art: A Portrait of Marietta Strozzi," *Artibus et Historiae* (2009).
4. Ross King, *Michelangelo & the Pope's Ceiling* (2014), ch. 5.
5. The letter in which King Louis XI grants Piero permission to use the fleur-de-lis is translated in Ross, *Lives of the Early Medici* (1910),

p. 112. See also Hibbert, *House of Medici* (1975), p. 104; Hollingsworth, *Family Medici* (2018), p. 130.

6. The Acciaiuoli crest featured a blue lion sometimes holding a gold fleur-de-lis or flag, the Pandolfini crest three gold fleurs-de-lis between red pendants in the top left corner, while the Pandolfini and Pazzi both used the gold dolphin on blue associated with the French Dauphin. The city's use of the French fleur-de-lis (gold on blue) is very visible now, not only in the stained glass windows of the Bargello, but on the restored painted crests on the outside of the Palazzo Vecchio, which show, along with the crests of the city, *signoria*, *popolo* Church, and Guelph Party, the golden fleur-de-lis arms of the early French leader Charles of Anjou (1226/7–85) whose crest is often used as a Guelph symbol, and of Charles's later cousin Robert of Naples (1276–1343) who likewise led the Guelphs, settled a faction war in Florence for a time, and was so admired by Petrarch. In Florence, and other Guelph centers like Bologna, the French lily (so often carried in battle against the Emperor and his Ghibellines) invoked city tradition and loyal Guelphness as well as the protection of a major royal house. On the Palazzo Vecchio crests see Ross, *Florentine Palaces* (1905).
7. Rocke, *Forbidden Friendships* (1996).
8. Nicholas Davidson, "Lucretius, Atheism and Irreligion", in *Lucretius and the Early Modern*, David Norbrook, Stephen Harrison and Philip Hardie eds. (2015), pp. 123–34; "Unbelief and Atheism in Italy 1500–1700", in *Atheism from the Reformation to the Enlightenment*, Michael C. W. Hunter and David Wootton eds. (1992), pp. 55–86.
9. See Nicholas Terpstra, *Art of Executing Well* (2008). For more detail on what executions were like for those involved, see Joel Harrington, *The Faithful Executioner* (2013), and *The Executioner's Journal* (2016).
10. Machiavelli, *Machiavelli and His Friends* (1996), letter 22, July 16, 1501.
11. Cartwright Ady, *Isabella d'Este* (1903), p. 88.
12. Isabella d'Este, *Selected Letters* (2017), pp. 122–3.
13. Letter translated in Ross, *Lives of the Early Medici* (1910), p. 201.
14. On the Inquisition's response to science and its concentration circa 1600, see Paula Findlen and Hannah Marcus, "Science under Inquisition: Heresy and Knowledge in Catholic Reformation Rome", review of *Catholic Church and Modern Science*, Ugo Baldini; Leen Spruit, *Isis* 103, n. 2 (2012), pp. 376–82.

15. See Davidson, "Lucretius, Atheism" in *Lucretius and the Early Modern* (2015).
16. On celestial patronage, see histories of early modern Christianity, such as John Bossy, *Christianity in the West, 1400-1700* (1985).
17. *Inferno*, ii, 94–135.
18. William J. Connell, *Sacrilege and Redemption* (2005).
19. Salisbury in *Henry VI Part 1*, I.iv; York in *Henry VI Part 3*, I.iv.; *Richard III*, V.iv.
20. Ronald Arbuthnott Knox and Shane Leslie eds., *Miracles of King Henry VI* (1923), pp. 9–11.
21. Excellent studies of Alessandra's letters include Melissa Meriam Bullard, *Filippo Strozzi* (1980); Ann Crabb, *Strozzi of Florence* (2000); Ann Morton Crabb, *Patrician Family* (1980); Gene Brucker, *Living on the Edge* (2005), ch. 10; Ann Morton Crabb, "How Typical Was Alessandra Macinghi Strozzi" in *Upon My Husband's Death*, ed. Louise Mirrer et al. (1992), Part 1, ch. 2.
22. Goldthwaite, *Economy of Renaissance Florence* (2009), p. 43. See also John Humphreys Whitfield, *Pathos of Palla Strozzi* (1994).
23. Goldthwaite, Table 7.3.
24. Machiavelli, *Discourses,* especially I.12–13.
25. McLean, *Art of the Network* (2007); Shaw, *Politics of Exile* (2000); Alison Brown, "Insiders and Outsiders", in *Society and Individual*, ed. William J. Connell (2002).
26. Alessandra Macinghi Strozzi, *Selected Letters of Alessandra Strozzi*, ed. Heather Gregory (1997).
27. Melissa Bullard, *Filippo Strozzi*; Giorgio Bonsanti ed., *Palazzo Strozzi* (2005).
28. Cateruccia is discussed in Alessandra's letters of December 6, 1450, July 20, 1459, and September 13 and November 2, 1465. On slavery in Italy in the period, see Steven Epstein, *Speaking of Slavery* (2001); on galley slavery, see Epstein's *Genoa and the Genoese*, ch. 4 "Between the Devil and the Deep Blue Sea, 1204–57"; on enslavement of non-Christians in Italy at the time see Justine A. Walden, "Muslim Slaves in Early Modern Rome", in *Companion to Religious Minorities*, ed. Matthew Coneys Wainwright and Emily Michelson (2020); for earlier scholarship by our often-excluded ladies, see Iris Origo, "The Domestic Enemy", *Speculum* (1955). Isabella d'Este's letters about this are in *Selected Letters* (2017), pp. 41–2.
29. See Parks, *Medici Money* (2005), ch. 3; Goldthwaite, Economy of Renaissance Florence (2009).

30. On the pearl trade, see Molly A. Warsh, *American Baroque* (2018).
31. Katalin Prajda, "Manetto Di Jacopo Amannatini, the Fat Woodcarver", *Acta Historiae Artium* (2016).
32. Azzolini, *Duke and the Stars* (2013), p. 28; Maurette, *Forgotten Sense* (2018).
33. See Diana Robin, "Reassessment of the Character of Francesco Filelfo,"' *RQ* (1983); W. Scott Blanchard, "Patrician Sages and the Humanist Cynic", *RQ* (2007); Francesco Filelfo, *Odes* (2009); *On Exile* (2013); Hankins, *Virtue Politics* (2019), *Virtue Politics* (2019) ch. 15 "Francesco Filelfo and the Spartan Republic", pp. 351–63.
34. See Paul Grendler, *Universities of the Italian Renaissance* (2002), p. 226.
35. The bunny is described in her early letters, see Ippolita Maria Sforza, *Duchess and Hostage*, ed. Diana Maury Robin and Lynn Lara Westwater (2017).
36. Jeryldene Wood, *Ippolita Maria Sforza* (2020), p. 55.
37. Bernardo Corio, *Patria historia* (1503); in the 1565 Venice edition, printed by Giorgio de' Caualli, the accounts of Galeazzo Maria's tyranny center on page 982.
38. Martines, *April Blood* (2003), ch. 9 "A Soldier Confesses", esp. p. 150.
39. See the excellent Christine Shaw, *Julius II: The Warrior Pope* (1993); not to be confused with the book of the same title released as an Amazon e-book in 2019 by Michael Hone, an author of homoerotic pop history.
40. Riccardo Fubini, "The Italian League and the Policy of the Balance of Power at the Accession of Lorenzo De' Medici", in *Origins of the State*, ed. Julius Kirshner (1996).
41. Dale Kent, *Cosimo de Medici* (2000), p. 68.
42. See, for example, Ficino's letter to Riario recommending Francesco Petrucci for a job, which speaks of how Ficino and Riario parted, Letter VI.34 *Commending a Friend,* Marsilio Ficino, *Letters of Marsilio Ficino* (1975), v. 5, pp. 53–4.
43. Wood, *Ippolita Maria Sforza* (2020); Ippolita Maria Sforza, *Duchess and Hostage... letters* (2017).
44. On her Greek study see Raf Van Rooy, "Ippolita Maria Sforza", *RQ* (2023), pp. 186–9.
45. Wood, *Ippolita Maria Sforza* (2020), color plate 1.
46. Ibid., pp. 4–5.
47. Ibid., p. 147 and following.
48. Ross, *Lives of the Early Medici* (1910), p. 241.
49. On the Pazzi War see Martines, *April Blood* (2003), pp. 186–9.

50. Ross, *Lives of the Early Medici* (1910), letter of November 16, 1484.
51. Richard Sherr, et al. eds., *Josquin Companion* (2000); Willem Elders, *Josquin Des Pres* (2013); Paul Merkley, *Music and Patronage* (1999); Lewis Lockwood, *Music in Renaissance Ferrara* (2009); Richard Taruskin, "Chapter 14: Josquin and the Humanists", in *Oxford History of Western Music Vol. 1* (2005).
52. For examples of histories which work to access the lives of the humblest, see Cohen & Cohen, *Daily Life* (2001); Brundin et al., *Sacred Home* (2018); Guido Ruggiero, *Binding Passions* (1993); Carlo Ginzburg, *Cheese and the Worms* (1980); John Waller, *Dancing Plague* (2009); Natalie Zemon Davis, *Return of Martin Guerre* (1983); Emmanuel Le Roy Ladurie, *Montaillou* (1978). Savonarola's sermons have a lot of windows on the poor and those who fell out of patronage networks, see Weinstein, *Savonarola: the Rise and Fall* (2011).
53. Alexander Lee, *Machiavelli* (2021), p. 27.
54. On the local Renaissance of the region, see the brilliant study by Karl A. E. Enenkel, *Ambitious Antiquities, Famous Forebears* (2019).
55. Gundersheimer, *Ferrara* (1973).
56. *The Prince*, ch. II, "Of Hereditary Monarchies".
57. Cartwright Ady, *Isabella d'Este* (1903), p. 88. For more such colorful details see d'Este and Shemek, *Selected Letters* (2017).
58. Francis W. Kent, *Lorenzo de Medici and the Art of Magnificence* (2004), p. 79.
59. Robert de La Sizeranne, *Beatrice D'Este* (1926).
60. Alberti, *Della Famiglia* (1971), p. 148. On Alberti see Anthony Grafton, *Leon Battista Alberti* (2000).
61. The dissertation is now an excellent book, McManus, *Empire of Eloquence* (2021).
62. For recent bog body DNA research, see Stephan Schiffels et al., "Iron Age and Anglo-Saxon Genomes from East England Reveal British Migration History", *Nature Communications* (2016).
63. Nedkvitne, *Norse Greenland* (2019); McGovern, 'Why Did Greenland's…', *Smithsonian Mag.* (2017).
64. Bastiaan Star et al., "Ancient DNA Reveals the Chronology of Walrus Ivory Trade from Norse Greenland", *Proceedings of the Royal Society B* (2018).
65. Angelo Poliziano, *Silvae* (1996); *Letters*, ed. Shane Butler (2006); *Angelo Poliziano e Dintorni*, ed. Claudia Corfiati and Mauro De Nichilo (2011); *Agnolo Poliziano*, ed. Vincenzo Fera and Mario Martelli (1998).

66. On the recovery of Greek, see the work of my brilliant friend Federica Ciccolella: *Donati Graeci* (2008); Federica Ciccolella and Luigi Silvano eds., *Teachers, Students* (2017).
67. Unger, *Michelangelo: a Life in Six Masterpieces* (2014), ch. xix.
68. Herbert M. Vaughan, *Medici Popes* (1908). There is more recent scholarship on Leo, but each study tends to focus on one facet of his life, such as Cummings, *Lion's Ear* (2022); Lorraine Karafel, *Raphael's Tapestries* (2016); Francesco Nitti, *Leone X e la sua politica* (1998).
69. Copenhaver, *Magic and the Dignity of Man* (2019); Amos Edelheit, *Ficino, Pico and Savonarola* (2008); Sophia Howlett, *Re-Evaluating Pico* (2021); Giovanni Francesco Pico della Mirandola, *On the Imagination*, ed. Harry Caplan (1930).
70. The quotations come from letters I.vii, III.xvii, and I.v respectively in Poliziano, *Letters* (2006).
71. Michelangelo remembered this detail, which Vasari quotes in his life of Michelangelo.
72. These letters are all included in Ross, *Lives of the Early Medici* (1910).
73. Wikipedia contributors, "Poliziano," *Wikipedia*, accessed August 14, 2020, https://en.wikipedia.org/wiki/Poliziano.
74. The most recent reassessment of Piero does not address the question of the murder at all; Brown, *Piero di Lorenzo de Medici* (2020).
75. Martines, *Fire in the City* (2006); Edelheit, *Ficino, Pico and Savonarola* (2009); Weinstein, *Savonarola: the Rise and Fall* (2011); Paul Strathern, *Death in Florence* (2011).
76. Machiavelli, *Machiavelli and His Friends* (1996), letter 3, March 9, 1498.
77. For the technical forensics, see Gianni Gallello et al., "Poisoning Histories in the Italian Renaissance: The Case of Pico Della Mirandola and Angelo Poliziano", *Journal of Forensic and Legal Medicine* (2018); the main publication was L. Garofano, G. Gruppioni, and S. Vinceti, *Delitti e misteri del passato* (2011).
78. On the fascinating language of Florence's bells, I highly recommend Niall Atkinson, *Noisy Renaissance* (2016).
79. Weinstein, *Savonarola: the Rise and Fall* (2011).
80. Luca Landucci, *Florentine Diary* (1927).
81. Accessed May 2, 2020.
82. See the brilliant and deliciously readable Natalie Tomas, *Medici Women* (2003).
83. Lisa Jardine, "'O Decus Italiae Virgo', or the Myth of the Learned Lady in the Renaissance", *Historical Journal* (1985); Giovanni Pesenti, "Alessandra Scala", *Giornale Storico della Letteratura Italiana* (1925).

84. For the poems exchanged between Scala and Poliziano, see Dennis Looney, "Translations from the Greek of Angelo Poliziano (1454–1494)", *Classical Outlook* (2011). On Fedele, see M. L. King, "Book-lined cells", in *Beyond Their Sex*, ed. Patricia H. Labalme (1980), pp. 66–90.
85. Pesenti, "Alessandra Scala" Giornale Storico (1925).
86. See David Alan Brown et al. eds., *Virtue and Beauty* (2001).
87. Alison Brown, *Bartolomeo Scala* (1979).
88. Michele Marullo Tarcaniota, *Michele Marullo Tarcaniota*, ed. Benedetto Croce (1938); *Inni Naturali* (1995); *Hymnes naturels*, ed. Jacques Chomarat (1995); Yasmin Haskell, "The Tristia of a Greek Refugee", *Proceedings of the Cambridge Philological Society* (1998).
89. Poem E III, 7, Michele Marullo Tarcaniota, *Poems*, ed. Charles Fantazzi (2012).
90. Pesenti, "Alessandra Scala", *Giornale Storico* (1925).
91. See the excellent elaboration of different categories of Renaissance love poetry in Leonard Forster's *The Icy Fire* (1969).
92. See the excellent edition, Cassandra Fedele, *Letters and Orations*, Margaret. L. King, Albert Rabil, Jr., and Diana Maury Robin eds. (2000).
93. The word in question is *culex*, and Poliziano's epigram LVII *On Mosquitoes* was written to correct Scala, see Brown, *Bartolomeo Scala* (1979), p. 215.
94. Isabella d'Este, *Selected Letters* (2017), pp. 51–2, letter to Federico di Casalmaggiore, December 19, 1492.
95. See the brilliantly enjoyable Lev, *Tigress of Forlì* (2011).
96. Strocchia, *Nuns and Nunneries in Renaissance Florence* (2009).
97. The bust, a pair with one of Matthias, survives in a nineteenth-century copy in the Hungarian National Museum in Budapest; the historian's comment thereon I happily consign to *damnatio memoriae*.
98. From Bruni's treatise on female education, *De Studis et Litteris*, in *Humanist Educational Treatises*, ed. Craig Kallendorf (2002), p. 105.
99. Raffaele Maffei, *Commentariorum urbanorum* (1506).
100. On him see, Florio Banfi, "Raffaello Maffei in Ungheria", *L'Europa Orientale* 17 (1937), pp. 462–88; Carlo Dionisotti, *Gli Umanisti e il Volgare fra Quattro e Cinquecento* (1968), especially ch. 4; John F. D'Amico, "Papal History and Curial Reform in the Renaissance", *Archivum Historiae Pontificiae* (1980), and *Renaissance Humanism in Papal Rome* (1983); Alison Frazier, "The First Instructions on Writing About Saints", *Memoirs of the American Academy in Rome* (2003); Frazier, *Possible Lives* (2005).

101. See Lodi Nauta, *In Defense of Common Sense: Lorenzo Valla's Humanist Critique of Scholastic Philosophy* (Cambridge, Mass.: Harvard University Press, 2009).
102. Susanna de Beer, "The Roman 'Academy' of Pomponio Leto: From an Informal Humanist Network to the Institution of a Literary Society", in *Reach of the Republic of Letters*, ed. Arjan Van Dixhoorn and Susie Speakman Sutch (2008), pp. 181–218.
103. See the detailed study of Carafa's artistic patronage by Bianca de Divitiis, *Architettura e Commitenza nella Napoli della Quattrocentro* (Venice: Marsilio, 2007).
104. On Julius see Shaw, *Julius II: the Warrior Pope* (1993).
105. Palmer, "Use and Defense" (2015). For a deeper analysis of what Leto is doing in that sentence and in general, see Ada Palmer, "Pomponio Leto's Lucretius", *Erudition and the Republic of Letters* (2023).
106. For good introductions to Erasmus see Erika Rummel, *Erasmus* (2004); Lisa Jardine, *Erasmus, Man of Letters* (1993).
107. See Michael J. B. Allen, *Synoptic Art* (1998); Benny Bar-Lavi, "Politics against God: Judaism and Islam in the Political Theological Discourses of Sixteenth- and Seventeenth-Century Spain" (PhD thesis, University of Chicago, 2022); the Epictetus is discussed in Palmer, "Humanist Lives", *RQ* (2017).
108. On radical science and materialism disseminating in commentaries on Seneca, see the work of the inestimable Karine Durin.
109. For statistics showing how this affects Renaissance reception, see Ada Palmer, "The Effects of Authorial Strategies for Transforming Antiquity on the Place of the Renaissance in the Current Philosophical Canon", in *Beyond Reception*, ed. Patrick Baker, Johannes Helmrath, and Craig Kallendorf (2019), pp. 163–94.
110. Diane Ghirardo, "Lucrezia Borgia as Entrepreneur", *RQ* (2008); Hibbert, *House of Medici* (2008); Bradford, *Lucrezia Borgia* (2004).
111. Including my own student John-Paul Heil's newly finished dissertation, Heil.
112. Vaughan, *Medici Popes* (1908).
113. *Henry VI Part 2*, I.i.
114. Margaret Meserve, *Papal Bull* (2021).
115. On both Alfonso d'Este and Anna Sforza see the massive study by Farinella, *Alfonso d'Este: Le Immagini e il Potere* (2014).
116. Bradford, *Lucrezia Borgia* (2004), p. 143.
117. For more such lush details, see the excellent Evelyn Welch, *Shopping in the Renaissance* (2005).
118. Edith Patterson Meyer, *First Lady of the Renaissance* (1970); Christine

Shaw, *Isabella d'Este* (2019); Stephen J. Campbell, *Cabinet of Eros* (2006); Sarah Cockram, *Isabella D'Este and Francesco Gonzaga* (2013); Francis Ames-Lewis, *Isabella and Leonardo* (2012); Francesco II Gonzaga, *Selected Letters*, ed. Deanna Shemek (2017).
119. On Guidobaldo, see the brilliant new biography of his father, with details about him, Stevenson, *Light of Italy* (2021). See also Maria Luisa Mariotti Masi, *Elisabetta Gonzaga* (1983).
120. The letter is dated June 30, three days after Cesare Borgia reached Mantua after the sack; see the text in Cartwright Ady, *Isabella d'Este* (1903), ch. xiii.
121. Isabella's letter sending the masks is in Isabella d'Este, *Selected Letters* (2017), pp. 218–19, January 15, 1503.
122. Carol Kidwell, *Pietro Bembo: Lover, Linguist, Cardinal* (2004); Guido Beltramini et al. eds., *Pietro Bembo e l'Invenziona del Rinascimento* (2013); Susan Nalezyty, *Pietro Bembo and the Intellectual Pleasures of a Renaissance Writer and Art Collector* (2017); Marco Faini, *Pietro Bembo: a Life in Laurels and Scarlet* (2017); Gareth Williams, *Pietro Bembo on Etna* (2017); Pietro Bembo, *History of Venice*, ed. Robert W. Ulery (2007).
123. Oren J. Margolis, *Aldus Manutius: the Invention of the Publisher* (2023); Martin Davies, *Aldus Manutius: Printer and Publisher of Renaissance Venice* (1995); G. Scott Clemons, *Aldus Manutius: A Legacy More Lasting than Bronze* (2015); Natale Vacalebre ed., *Five Centuries Later* (2018); Aldo Manuzio, *Greek Classics*, ed. N. G. Wilson (2016); Aldo Manuzio, *Humanism and the Latin Classics*, ed. John N. Grant and Randall McLeod (2017).
124. The source for Alfonso's naked exploit is a period diary, *I diarii di Marino Sanuto* [Sanudo], ed. Rinaldo Fulin et al. (Venice, 1879–1903), v. 1 (1879), col. 706, August 6, 1497; cf. Farinella, p. 740 n. 89.
125. Ghirardo, "Lucrezia Borgia as Entrepeneur", *RQ* (2008).
126. Ferdinand Gregorovius, *Lucrezia Borgia* (1875).
127. *The Borgias* (Showtime, 2011–13) and *Borgia: Faith and Fear* (Canal+, ZDF, ORF, Sky Italia, 2011–14).
128. On Camilla, see Luisa Villa, "Victorian Uses of the Italian Past", in *Victorians and Italy* (2009), pp. 193–210; Tamar Herzig, *Savonarola's Women* (2008).
129. Herzig, *Savonarola's Women* (2008), pp. 18–25.
130. See the work of Gabriella Zarri, especially *Le sante vive: cultura e religiosità femminile nella prima età moderna* (1990).
131. Herzig, *Savonarola's Women* (2008), ch. 2.
132. Ibid., pp. 22–4.

133. Ibid., pp. 18–25.
134. On Savonarola's legacy, see Dall'Aglio, *Savonarola and Savonarolism* (2010), Herzig, *Savonarola's Women* (2008) and Lorenzo Polizzotto, *Elect Nation* (1994).
135. Dall'Aglio, *Savonarola and Savonarolism* (2010), pp. 70–1.
136. Ibid., p. 70.
137. Herzig, *Savonarola's Women* (2008), pp. 55–8, 75, 85, and ch. 4.
138. Ibid., pp. 82–89 and ch. 4.
139. Ibid., pp. 101–5.
140. Ibid., pp. 133–6.
141. Ibid., esp. p. 146.
142. Dall'Aglio, *Savonarola and Savonarolism* (2010), ch. 7.
143. Polizzotto, *Elect Nation* (1994), pp. 318–19.
144. On the sack, see the brilliant Kenneth Gouwens' *Remembering in the Renaissance* (1998).
145. Ibid., pp. 332–51.
146. Martin Luther ed., *Meditatio pia et erudita Hieronymi Sauonarolae: a Papa exusti, super Psalmos Miserere mei et In te Domine speraui* (1523).
147. See Eric Cochrane, *Florence in the Forgotten Centuries* (1973); Nicholas Scott Baker, *Fruit of Liberty* (2013); Cecil Roth, *Last Florentine Republic* (1925); Rothfield; J. N. Stephens, *Fall of the Florentine Republic* (1983); and the Savonarola books by Dall'Aglio, especially *Savonarola and Savonarolism* (2010), as well as Herzig, *Savonarola's Women* (2008), and Polizzotto, *Elect Nation* (1994).
148. Dall'Aglio, *Savonarola and Savonarolism* (2010), p. 110.
149. Ibid., p. 109. For details on this period see Polizzotto, *Elect Nation* (1994), ch. 7.
150. Discussed in Baker, *Fruit of Liberty* (2013), ch. 3; Ross, *Florentine Palaces* (1905), Palazzo Vecchio chapter.
151. See Weinstein, *Savonarola: the Rise and Fall* (2011), p. 87.
152. I owe this delightful joke to my grad adviser Jim Hankins.
153. For a life of Michelangelo, I recommend Anton Gill, *Il Gigante* (2002). Other good choices include King, *Michelangelo & the Pope's Ceiling* (2014); and Miles Unger, *Michelangelo: a Life in Six Masterpieces* (2014).
154. On the education of Renaissance artists see the wonderful Angela Dressen's *Intellectual Education of the Italian Renaissance Artist* (2021).
155. See Pamela O. Long, *Engineering the Eternal City* (2018). Long's use of the term "trading zone" draws on the work of historian of science Peter Galison.

156. Hilary Barker, "Encountering Antiquity in Renaissance Rome: the Social and Economic Origins of the Classicizing Style, 1400-1550" (PhD thesis, University of Chicago, forthcoming).
157. See Unger, *Michelangelo: a Life in Six Masterpieces* (2014), ch. 4.
158. Jones, *The Lost Battles* (2014).
159. See Rocke, *Forbidden Friendships* (1996). For more on Renaissance sexuality see the excellent Jacqueline Murray and Nicholas Terpstra, *Sex, Gender and Sexuality* (2019), Guido Ruggiero, *Machiavelli in Love* (2007), and Sara F. Matthews-Grieco ed., *Erotic Cultures* (2010).
160. On Machiavelli's sex life, see Ruggiero, *Machiavelli in Love* (2007).
161. *Inferno* v and xv–xvi, *Purgatorio* xxv–xxvii.
162. On sex and power in Venice see Guido Ruggiero, *Binding Passions* (1993).
163. Sarah Bradford, *Lucrezia Borgia* (2004), p. 217.
164. Rocke, *Forbidden Friendships* (1996), p. 100.
165. On the sexuality of Donatello's *David* see Gill, *Il Gigante* (2002).
166. Such details are more commonly included in older histories from the *romantic* days of history writing, see Alessandro Luizo and Rodolfo Renier, *Delle relazioni di Isabella D'Este* (1890); Francesco Malaguzzi-Valeri, *La corte di Lodovico Il Moro* (1913); Cartwright Ady, *Beatrice d'Este* (1903).
167. Floriano Dolfo, *Lettere ai Gonzaga* (2002), pp. 211–14, n. 426. See Molly Bourne, "Mail humour and male sociability in the epistolary domain of Francesco Gonzaga" in Matthews-Grieco, *Erotic Cultures* (2010), pp. 199–222.
168. Bourne in Matthews-Grieco, *Erotic Cultures* (2010), pp. 204–5; cf. Shaw, *Isabella d'Este* (2019), p. 30.
169. Unger, *Michelangelo: a Life in Six Masterpieces* (2014), p. 22.
170. See the poems and letters in John Shearman, *Raphael in Early Modern Sources* (2003).
171. See Silvio Bedini, *Pope's Elephant* (1997); Angelica Groom, *Exotic Animals* (2019); Belozerskaya, *Medici Giraffe* (2016).
172. On Pasquino, see Julia Haig Gaisser, "The Rise and Fall of Goritz's Feasts", *RQ* (1995); Brendan Small, "Praise and Blame: The Politics of Virtue in Early Sixteenth-Century Rome" (PhD thesis, University of Chicago); Leonard Barkan, *Unearthing the Past* (1999); Chrysa Damianaki, Paolo Procaccioli, and Angelo Romano, *Ex marmore* (2006).
173. These colorful details are gathered by Burckhardt, Part 2, ch. 4 "Modern Wit and Satire".

174. See Unger, *Michelangelo: a Life in Six Masterpieces* (2014), p. 257; Targoff, *Renaissance Woman* (2018), p. 183.
175. A finding made by the editors of Pico's letters, see Giovanni Pico della Mirandola, *Lettere*, ed. Francesco Borghesi (2018).
176. See Lorenzino's text justifying the deed, Lorenzino de' Medici, *Apology for a Murder*, ed. Tim Parks et al., Hesperus Classics (2004). See also Stefano Dall'Aglio, *Duke's Assassin* (2015).
177. Cellini I.30.
178. On this see the truly extraordinary thesis by Katya Kukucka "Violent Delights and Violent Ends…" (B.A. University of Chicago, 2021).
179. Estelle Lingo, "The Evolution of Michelangelo's Magnifici Tomb", *Artibus et Historiae*, 16 n. 32 (1995), pp. 91–100.
180. Credit for this observation to Paul Robert Walker, *Feud That Sparked the Renaissance* (2002), p. 226.
181. On Julia, see the introduction to the Italian translation, Christian Gottfried Franckenstein, J. B. Odier, and G. Morelli, *Istoria degli intrighi galanti della Regina Cristina* (1979). She is also treated in K. Lekeby, *I Lejonets Hjärta* (2001); S. Åkerman, *Fenixelden: Drottning Kristina* (2013).
182. On Kristina of Sweden in English (also spelled Christina) see the documents in Magnus von Platen, *Queen Christina of Sweden* (1966). Recent treatments in English have focused on her gender nonconformity, see Michel Marc Bouchard, *Christina, the Girl King* (2014); Veronica Buckley, *Christina, Queen of Sweden* (2004).
183. Judith P. Zinsser, *Emilie Du Châtelet* (2007), ch. 3.
184. Christian Gottfried Franckenstein (attributed), *History of the Intrigues & Gallantries of Christina* (1697), pp. 303–8.
185. Brendan Dooley, *Morandi's Last Prophecy* (2002).
186. On this problem see the studies by William R. Newman, especially his introduction to *Secrets of Nature* (2001), as well as *Atoms and Alchemy* (2006).
187. On alchemy and its contributions, see the several studies by Lawrence Principe, especially his very readable *Secrets of Alchemy* (2013), as well as Jennifer Rampling, *Experimental Fire* (2020); Tara Nummedal, *Alchemy and Authority in the Holy Roman Empire* (2007) and *Anna Zieglerin and the Lion's Blood* (2019); Alisha Rankin, *Panaceia's Daughters* (2013), and generally keep an eye on University of Chicago Press, who published most of the above; my neighbors down the street love alchemy!
188. David F. Marks, "Investigating the Paranormal", *Nature* (1986); "Investigating the Paranormal", *Nature* (1987).

189. On dwarfs see Part II n. 63, or for a readable history of medical marvels Jan Bondeson, *Two-Headed Boy* (2000).
190. There are many Machiavelli books. See John Najemy ed., *Cambridge Companion to Machiavelli* (2010); Mark Jurdjevic, Natasha Piano, and John P. McCormick eds., *Florentine Political Writings* (2019); John P. McCormick, *Reading Machiavelli* (2018); Timothy Fuller ed., *Machiavelli's Legacy* (2016); David Johnston, *Machiavelli on Liberty* (2017); Harvey Mansfield, Jr., *Machiavelli's Virtue* (1996).
191. "The Abbey Grange," 1904.
192. On Beccaria see Alan C. Kors, *Birth of the Modern Mind* (2003).
193. The first one titled *Speculum regum* was written by Godfrey of Viterbo for Frederick Barbarossa and his son Henry in 1183.
194. See Heil, "Virtue and Vice" (PhD thesis, 2022).
195. "Conglobata in nates caro—quam sedendi officio apta!" Giannozzo Manetti, *On Human Worth*, ed. Brian Copenhaver (2018), I.31, pp. 40–1.
196. On unhistorical accounts of Troy, see Frederic Clark, *The First Pagan Historian* (2020).
197. *Orlando Furioso*, canto 46.
198. For a translation, see the phenomenal collection by Lisa Kaborycha, *Corresponding Renaissance* (2016), pp. 73–90.
199. Again see Heil, "Virtue and Vice" (PhD thesis, 2022).
200. Such details come from his father's diary or *Libro di Ricordi* of 1474–87; see Part 1 of Lee.
201. See ibid., pp. 39–40.
202. Ibid., pp. 20–8; William J. Connell, "Le molestie del Machiavelli", *Interpres* (2009).
203. *The Prince*, ch. VII.
204. *The Prince*, ch. XIX, "That We Must Avoid Being Despised and Hated." This follows the better known ch. XVII, "Of Cruelty and Clemency, and Whether it is Better to be Loved or Feared."
205. Machiavelli, *Machiavelli and His Friends* (1996), letter 69, January 9, 1503.
206. Ibid., letter 115, September 6, 1506.
207. *The Prince*, end of ch. VII.
208. This comes from Boccaccio's defense at the end of the *Decameron*.
209. *Discourses*, I.9, I.44.
210. Riccardo Fubini, *Humanism and Secularization* (2003).
211. Credit for the choice to my magnificent colleague Kathleen Belew, and our undergrad history students.
212. *The Prince*, ch. II, "Of Hereditary Monarchies."

213. Letter of September 19, 1467, see Ross, *Lives of the Early Medici* (1910), p. 115.

Notes to Part IV: What Was Renaissance Humanism?

1. On Croce and his influence on Gentile, Garin, and Renaissance historians in general, see Celenza, *Lost Italian Renaissance* (2004), pp. 16–29, and the latter sections of John Tedeschi, *Intelletualli in Esilio: Dall'Inquisitione Romana al Fascismo* (2012).
2. Eugenio Garin, *Giovanni Pico Della Mirandola, vita e dottrina*, Università di Firenze, Facoltà di Lettere e Filosofia. 3. Ser., v. 5 (1937). See also his *Italian Humanism* (1965).
3. For my full analysis, see Palmer, "Effects of Authorial Strategies", in *Beyond Reception* (2019).
4. *Renaissance Philosophy of Man*, ed. Ernst Cassirer, Paul Oskar Kristeller, and John Herman Randall (1956).
5. John Monfasani, "Popes, Cardinals, and Humanists", *Manuscripta* (2018), color plates 5–7.
6. Wikipedia contributors, "humanism," *Wikipedia*, April 20, 2020, https://en.wikipedia.org/wiki/humanism.
7. Wikipedia contributors, "Renaissance humanism," *Wikipedia*, April 20, 2020, https://en.wikipedia.org/wiki/Renaissance_humanism.
8. John Jeffries Martin, *Myths of Renaissance Individualism* (2004). See also Aron Gurevich, *The Origins of European Individualism* (1995).
9. For example, the conference "Speech as Protest: Being Heard and Taking Up Space in the Premodern World", organized by Elisa J. Jones at the Newberry Library, Chicago, October 22, 2020. See also the bibliography of noise and speech in Atkinson, *Noisy Renaissance* (2016).
10. Kaborycha ed., *Corresponding Renaissance* (2016), pp. 73–90.
11. Martin, *Myths of Renaissance Individualism* (2004).
12. Ibid., pp. 91–5.
13. The comment quoted here, as well as Celenza's below, were only spoken aloud, not published, but the result of those delightful days was the rare but precious volume, *Beyond Reception*, ed. Patrick Baker, Johannes Helmrath, and Craig Kallendorf, *Transformationen Der Antike* (2019).
14. For an overview see Matthias Roick, "Back on the Job? German Studies on Renaissance Humanism", *Storica* (2011).
15. Karl Enenkel, *Ambitious Antiquities* (2019); de Beer, *Poetics of Patronage* (2013); Lodi Nauta, *In Defense of Common Sense* (2009).

16. Celenza (2021). For another beautiful portrait of humanist learned culture, try his *Intellectual World of the Italian Renaissance* (2018).
17. On humanist letter culture see Paula Findlen and Suzanne Sutherland eds., *Renaissance of Letters* (2020); Arjan Van Dixhoorn and Susie Speakman Sutch eds., *The Reach of the Republic of Letters* (2008).
18. Letter I.114, "Against liars and impious slanderers (*Contra mendaces et impios detractores*)", Ficino, *Letters* (1975–) vol. 1 revised edition, pp. 139–40.
19. On the popular reception of humanist letters, see Brian Maxson, *Humanist World* (2014).
20. In *Seniles* V.iv and VI.i (1366) Petrarch complains that no less than three important letters from him to Boccaccio had been selfishly held by an intermediary acquaintance for most of a year, so he could boastfully show them to others, without the letters ever reaching their addressee.
21. Margaret Meserve, *Papal Bull* (2021), p. 298.
22. See Heil, "Virtue and Vice" (PhD thesis, 2022).
23. *Contemporaries of Erasmus*, ed. Peter G. Bietenholz and Thomas Brian Deutscher (1985).
24. Barry Torch, "'Do I Have a Book for You!' the Friendship of Theodore Gaza and Giovanni Bussi, and a Gifted Book", in John Christopoulos and John M. Hunt eds., *Making Stories* (2024).
25. Susanna de Beer, *Poetics of Patronage* (2013).
26. Black, *Humanism and Education* (2001).
27. Paul F. Grendler, *Universities of the Italian Renaissance* (2002).
28. See Part II n. 63.
29. See Ann Rosalind Jones and Peter Stallybrass eds., *Renaissance Clothing* (2000).
30. Isabella d'Este, *Selected Letters* (2017), p. 469, letter of December 23, 1522.
31. Cartwright Ady, *Isabella d'Este* (1912), p. 226.
32. Jerrold E. Seigel, *Rhetoric and Philosophy* (1968).
33. Kenneth Gouwens, "Perceiving the Past: Renaissance Humanism after the 'Cognitive Turn'", *AHR* (1998), pp. 55–82. The article responds to the question of the status of the Renaissance as we work to dismantle the supremacy of the Western canon and Western history. See also Paula Findlen and Kenneth Gouwens' introduction to the several important essays on this topic in that focused issue of the journal: "Introduction: The Persistence of the Renaissance", *AHR* (1998).
34. See Allen, *Synoptic Art* (1998); Marsilio Ficino, *Meditations on the Soul* (1997); Ficino, *Platonic Theology*, ed. Michael J. B. Allen, James

Hankins, and William R. Bowen (2006); Paul Oskar Kristeller, *Philosophy of Marsilio Ficino* (1964); James Hankins, *Plato in the Italian Renaissance*, 2 vols. (1990); Hankins, "Religion and the Modernity of Renaissance Humanism", in *Interpretations of Renaissance Humanism*, ed. Angelo Mazzocco (2006), pp. 137–53.
35. Denis J.-J. Robichaud, *Plato's Persona* (2018).
36. Ada Palmer, "The Active and Monastic Life", in *Forms and Transfers of Pythagorean Knowledge* (2016), pp. 211–26.
37. Ficino, *Letters*, LETTER IX.19, September 6, 1489, "An ingenious commendation of a learned man *(Artificiosa commendation docti viri)*", vol. 8, p. 27.
38. Yes, this is a real letter, VI.13, February 28, 1479, "Marsilio Ficino humbly commends himself… *(Marsilius Ficinus reverendissimo…)*", ibid., vol. 5, pp. 23–30.
39. Palmer, "Recovery of Stoicism", *Routledge Companion to the Stoic Tradition* (2016).
40. On the historiography of atheism, see David Wootton, "Lucien Febvre and the Problem of Unbelief", *JHI* (1988); Michael Hunter and David Wootton eds., *Atheism from the Reformation to the Enlightenment* (1992), and Palmer, "Humanist Lives" (2017). If you're wondering whether I will discuss Jonathan Israel's *Radical Enlightenment* (2001), going that far past 1600 is beyond the scope of this project.
41. Palmer, "The Persecution of Renaissance Lucretius Readers Revisited", in *Lucretius Poet and Philosopher*, ed. Philip R. Hardie et al. (2020), pp. 167–97.
42. Davidson, "Lucretius, Atheism", *Lucretius and the Early Modern* (2015).
43. The titular subject of Carlo Ginzburg, *The Cheese and the Worms* (1980), which provides a great window on such ideas in the period.
44. See Palmer, *Reading Lucretius* (2014), ch. 1; Davidson, "Unbelief and Atheism", *Atheism from the Reformation to the Enlightenment* (1992); Ginzburg, *Cheese and the Worms* (1980); Wootton, "Lucien Febvre and the Problem of Unbelief", *JHI* (1988).
45. Patrizia Mainoni, *Con animo virile* (2010), p. 447.
46. Kenneth Sheppard, *Anti-Atheism* (2015). On Machiavelli's role in this moment in English thought see Paul Anthony Rahe, *Against Throne and Altar* (2008).
47. Anonymous, *An Elegie Upon Mr. Thomas Hobbes of Malmesbury, Lately Deceased* (1679).
48. See his brilliant three-part treatment, *Atheism in France, 1650–1729* (1990), *Epicureans and Atheists in France, 1650–1729* (2016), and

Naturalism and Unbelief in France, 1650–1729 (2016). Only the first volume existed when I was a student, so my work was shaped very much by the then-in-progress later volumes, as well as the model of the first.

49. See Diderot, *D'Alembert's Dream,* as well as *Jacques the Fatalist* and *Rameau's Nephew*; on Diderot see Andrew S. Curran, *Diderot and the Art of Thinking Freely* (2019); for a loving introduction to Diderot and this period, see Kors, *Birth of the Modern Mind* (2003).
50. See Hunter and Wootton, *Atheism from the Reformation to the Enlightenment* (1992); Wootton, "Lucien Febvre and the Problem of Unbelief in the Early Modern Period", *Journal of Modern History* (1988); Fubini, *Humanism and Secularization*. See also Margaret Jacob, *Radical Enlightenment* (2006); Michael J. Buckley, *At the Origins of Modern Atheism* (1987); Paul Oskar Kristeller, "The Myth of Renaissance Atheism and the French Tradition of Free Thought", in *Studies in Renaissance Thought and Letters* (1993), pp. 541–54; Catherine Wilson, *Epicureanism at the Origins of Modernity* (2008).
51. Febvre, *Problem of Unbelief* (1982).
52. Ibid.
53. Palmer, *Reading Lucretius* (2014), ch. 2.
54. Leto was assembling the tools which would enable *later* discussions of science, see Palmer, "Pomponio Leto's Lucretius", *Erudition and the Republic of Letters* (2023).
55. Katherine Aron-Beller and Christopher Black, *Roman Inquisition* (2018); Christopher Black, *Italian Inquisition* (2009).
56. Black, *Italian Inquisition* (2009), p. 263, Table C.
57. Ibid., p. 264, Table D.
58. Paula Findlen and Hannah Marcus, "Science under Inquisition", *Isis* (2012).
59. Davidson, "Lucretius, Atheism", *Lucretius and the Early Modern* (2015). See also Thomas F. Mayer, *Roman Inquisition: Trying Galileo* (2015).
60. Letter of June 27, 1557, to Inquisitor General de Gênes. Transcript in P. Paschini, "Letterati ed indice nella Riforma cattolica in Italia", *Cinquecento romano*, special ed., 24 (1958), p. 239. On the same see Jesús Martínez de Bujanda, *Index des Livres Interdits* (2002) vol. 8, p. 32 n. 14; for analysis see Valentina Prosperi, *Di soavi licor Controriforma* (2004), ch. 2; Palmer, *Reading Lucretius*, 37, pp. 274–5 n. 108.
61. On Scala and Lucretius, see Alison Brown, *Return of Lucretius* (2010).

62. *Henry VI Part 2*, II.i.
63. Canto XXVI, 1–3: "Godi, Fiorenza, poi che se' sì grande che per mare e per terra batti l'ali, e per lo 'nferno tuo nome si spande!"
64. In Machiavelli, *Machiavelli and His Friends* (1996) see letters 226–230 (December 24, 1513–February 9, 1514) advising on love-affairs, 231 (February 25, 1514) on a prank in which Machiavelli uses a pseudonym discussing a homosexual encounter, and 236 (June 10, 1514) and 238 (August 3, 1514) on love. See also Ruggiero, *Machiavelli in Love* (2007).
65. *Discourses* I.11–15, II.2.
66. Ibid. II.2, "Perché, avendoci la nostra religione mostro la verità e la vera via, ci fa stimare meno l'onore del mondo…"
67. Machiavelli, *Machiavelli and His Friends* (1996). The sequence is letters 269–74; the comments are in Letter 269, May 17, 1521.
68. On the histories of atheism and skepticism, including treatments of Rochester, see Don Cameron Allen's deliciously written, *Doubt's Boundless Sea* (1964); the invaluable Richard H. Popkin, *History of Scepticism* (2003); and the brilliant three-part treatment by Alan C. Kors, *Atheism in France* (1990), *Epicureans and Atheists in France* (2016a), and *Naturalism and Unbelief* (2016b).
69. Palmer, "Humanist Lives", *RQ* (2017); 'Active and Monastic Life' in *Forms and Transfers of Pythagorean Knowledge* (2016b).
70. Bouchard et al., *Science*, October 12, 1990, 250, n. 4978, pp. 223–8.
71. Hankins, *Virtue Politics* (2019).
72. Celenza, *Italian Renaissance at the Origins of the Modern Humanities* (2021).
73. The letter is much reproduced, see the chapter in *Raphael, 1520–1483*, ed. Marzia Faietti et al. (2020).
74. On humanism and the Reformation, see Erika Rummel, *The Confessionalization of Humanism in Reformation Germany* (2000), Lewis Spitz, *Johannes Sturm on Education* (1995), and for a broader introduction Diarmaid MacCulloch, *The Reformation* (2004) plus on the intellectual side Alister E. McGrath, *The Intellectual Origins of the European Reformation*, 2nd ed. (2004). On Erasmus, see Erica Rummel, *Erasmus* (2004).

Notes to Part V: The Try Everything Age

1. For an excellent Reformation overview, see MacCulloch, *Reformation* (2005) listed in Recommended Reading.

NOTES

2. See the delightfully fun biography by Sheila Hale, *Titian: His Life* (2012).
3. See *Companion to the History of the Book*, ch. 15 "The Gutenberg Revolutions", pp. 207–19 and ch. 16 "The Book Trade Comes of Age: the Sixteenth Century." For a deeper study of book history see McKitterick, *Print, Manuscript* (2003).
4. On this ongoing information revolution, see Ann Blair, *Too Much to Know* (2010); Anthony Grafton, *Inky Fingers* (2020); Adrian Johns, *Piracy* (2009).
5. Eileen Reeves, *Evening News* (2014); Andrew Pettegree, *Invention of News* (2014); Will Slauter, *Who Owns the News?* (2019).
6. *History of Reading* (1999), ch. 8 "Protestant Reformations and Reading," pp. 213–37.
7. *Un crudele et compassioneuol caso, occorso nella città di Padua. De un gentil'huomo il quale hauendo per inganno de una serua ucciso il seruitore, velenata la moglie, et cauato il core alla detta fantesca, si è finalmente appiccato lui medesimo. Con il lamento che ha fatto la gentildonna innanzi la sua morte, cosa veramente inaudita degna di pietà* ([Milan?]: [late 1500s]; Biblioteca Apostolica Vaticana Stamp. Cappon.V.681(int.106)). This publication was introduced to me by Kevin Stevens in his talk "'Did You Read about the Gentleman in Padua who Killed His Servant and Poisoned His Wife?'… Newssheets in Sixteenth-Century Italy," presented at "Renaissance Print Culture: an Aldine Quincentennial Symposium", Newberry Library, Chicago, February 7, 2015. For similar pieces see his many excellent articles and book chapters, such as 'Sanctity as Cheap Print: Production, Markets, and Consumers in Early Modern Milan", in *Saint between Manuscript and Print*, ed. Alison Frazier (2015) ch. 12.
8. See the wonderful work on Ficino of Valerie Reese, and on the balance between his secret and his public-facing ones, Pamela O. Long, *Artisan/Practitioners and the Rise of the New Sciences* (2011).
9. Allen J. Grieco, "Food and Social Classes in Late Medieval and Renaissance Italy", in *Food: A Culinary History*, ed. Jean-Louis Flandrin et al. (1999), pp. 301–12.
10. For examples of these questions, see ibid.; *Uses of Food* (2006).
11. Kors, *Birth of the Modern Mind* (2003).
12. Gordan ed., *Two Renaissance Book Hunters* (1991).
13. Palmer, "Recovery of Stoicism", *Routledge Companion to the Stoic Tradition* (2016), p. 119. De Guevara served Emperor Charles V, the grandson of Ferdinand and Isabella.
14. On skepticism in this period see Anton M. Matytsin, *Specter of*

Skepticism (2016); Kors, *Birth of the Modern Mind* (2003), *Atheism in France* (1990), *Epicureans and Atheists in France* (2016a), *Naturalism and Unbelief* (2016b); D.C. Allen, *Doubt's Boundless Sea* (1964).

15. On the adoption of Galileo's methods, see Renée Raphael's *Reading Galileo* (2017).
16. Giorgio Polacco, *Anticopernicus Catholicus*, ed. Galileo Galilei (1644). See Ada Palmer, *Censorship & Information Control* (2018), pp. 122–3.
17. Daniele Macuglia, *Calculus and Newtonianism* (PhD thesis, University of Chicago, 2017).
18. For the skeptical fundamentals, see Descartes's *Meditations*, for body-soul interface see *Passions of the Soul*. For a great introduction to Descartes, see Kors, *Birth of the Modern Mind* (2003).
19. See the excellent examples in Alan Kors and Edward Peters eds., *Witchcraft in Europe* (2001), sections IX and X.
20. On the communal sharing of scientific knowledge, and on "theft of reputation" and other ideas of who owned or controlled ideas before and after Bacon, see Long, *Artisan/Practitioners* (2011).
21. These speeches are preserved in *Gesta Grayorum* (1688); for more look up the "Night of Errors."
22. On Bacon and the patent office, see Cesare Pastorino, "The Philosopher and the Craftsman," *Isis* (2017); and "Weighing Experience: Experimental Histories and Francis Bacon's Quantitative Program", *Early Science and Medicine*, (2011).
23. Voltaire translation from *French and English Philosophers: Descartes, Rousseau, Voltaire, Hobbes*. The Harvard Classics (1910) v. 34.
24. Star et al., "Ancient DNA Reveals the Chronology of Walrus Ivory Trade from Norse Greenland", *Proceedings of the Royal Society B* (2018).
25. See David Harris Sacks, "On Mending the Peace of the World: Sir Francis Bacon's Apocalyptic Irenicism", *New Global Studies* (2022).
26. See Fredrik Albritton Jonsson and Carl Wennerlind, *Scarcity* (2023).
27. The discussion starts in *The Gentleman's Magazine*, v. 35 p. 505 (1766).
28. For more detail on invention in this phase, and how people remained optimistic about science, see Vera Keller's brilliant *The Interlopers* (2023), as well as Pamela O. Long, *Artisan/Practitioners* (2011), Charles Webster, *The Great Instauration* (2002), Paola Bertucci, *Artisanal Enlightenment* (2017).
29. This is Rousseau's *First Discourse* or *Discourse on the Arts and Sciences*.
30. From Keats's 1819 "Ode on Melancholy" verse 3: "She dwells with Beauty—Beauty that must die; / And Joy, whose hand is ever at his lips/ Bidding adieu; and aching Pleasure nigh, / Turning to

poison while the bee-mouth sips: / Ay, in the very temple of Delight / Veil'd Melancholy has her sovran shrine, / Though seen of none save him whose strenuous tongue/ Can burst Joy's grape against his palate fine; / His soul shalt taste the sadness of her might, / And be among her cloudy trophies hung." On the Smithsonian bees, see Laura Higgins Palmer telling her daughter stories of working at the Smithsonian (Washington D.C.: Ada Palmer's childhood, 1988 or so).

Notes to Part VI: Conclusion

1. See Philip Benedict, *Faith and Fortunes* (2001), ch. 2 "The Huguenot Population of France, 1600–85" esp. pp. 39–42, 92–5; Arlette Jouanna, *France du Xvie siècle* (1996), pp. 325–40; Jacques Dupâquier ed., *Histoire De La Population Française* (1988), vol. 2 "De la Renaissance à 1789," pp. 81–94. See also Sandberg, *War and Conflict* (2016).
2. On the Enlightenment's continuation of these projects, see Peter Gay, *Enlightenment* (1966), and Kors, *Birth of the Modern Mind* (2003). On Enlightenment books, printing, and censorship see the ever deliciously readable Robert Darnton, *Business of Enlightenment* (1979); *Poetry and the Police* (2010); *Great Cat Massacre* (2009).
3. Celenza, *Machiavelli: A Portrait* (2015).

Acknowledgments

Questions, not facts, are the great shapers of scholarship, study a process of widening the kinds of questions we know enough to ask.

In early years, the biggest openers and shapers of my questions were my truly extraordinary parents Doug and Laura Palmer, still very close to me and incredibly supportive (even workmen coming by tell me "Your parents are really great. No, I mean, *your* parents are *really great!* You're lucky!" I know).

Next came the principal advisers of my studies, James Hankins, Alan Kors, and Ann Blair, plus my wise and wonderful academic siblings Liz Mellyn, Patrick Baker, and Michael Tworek (same PhD adviser), and then my transition from student to *also* teacher (for we are forever students). I always feel learning is *with* not *from*, I learn *with* my students, they with me, and so much in this book I learned with my magnificent graduate students, especially John-Paul Heil and Brendan Small whose dissertation projects have gifted me many new questions over our years together, which weave throughout this book braided with those of my teachers. Just as much I owe to whole classrooms of students, who teach me constantly, as smiles of understanding or frowns of perplexity tell me what framing worked, what didn't. Many of the liveliest parts of this book are versions of my best lectures, polished over years thanks to feedback from reviewers far more sensitive than those whom publishers hire: undergrads. Special thanks too to my 2022 Graham School continuing education course, whose enthusiastic older learners used a draft of this as our textbook, and gave me much feedback.

Extraordinary thanks to my invaluable friends Brian Maxson, Larry Rothfield, and Barry Torch whose meticulous comments on the manuscript let me put this book through unofficial peer

ACKNOWLEDGMENTS

review despite coming from a non-academic press—like all books it is much better for the peer review! Thanks as well to Dylan Montanari and the anonymous peer reviewer at University of Chicago Press who put it through a second round, which made it even better. Several friends whose advice and models in publishing this kind of public-facing scholarship were also invaluable, especially David M. Perry, Eleanor Janega, Cory Doctorow, and, from a greater distance—as acquaintances and models of the kind of history I hoped to write—Robert Darnton and Guido Ruggiero. The readers of my blog ExUrbe.com were also core to encouraging me to keep writing in this unorthodox style, and helped me realize my overgrown summer 2020 blog post about the Black Death and COVID should be a book.

One joy of scholarship's multigenerational nature is how teachers, mentors, and grad students blur over time into the category of collaborators in the Great Project, so I must thank, for conversations which shaped this project, numerous colleagues older and younger, including Michael I. Allen, Michael J. Allen, Elizabeth Asmis, Niall Atkinson, Leora Auslander, Benny Bar-Lavi, Hilary Barker, Kathleen Belew, Cynthia Bouton, John Boyer, Federica Caneparo, Christopher Celenza, Paul Cheney, Federica Cicollella, Joseph Connors, Guy Consolmagno, Brian Copenhaver, Aylin Corona, Roisin Cossar, Line Cottegnies, Brian Curran, Lilian Datchev, Nicholas Davidson, Eva Del Soldato, Daisy Delogu, Rocco Di Dio, Angela Dressen, Tom Dunlap, Karine Durin, Lars Engle, Mordechai Feingold, Cornell Fleischer, Reginald Foster, Alison Frazier, John Gagné, Julia Gaisser, Greer Gilman, Peter Gordon, Anthony Grafton, Steven Greenblatt, Allen Grieco, Hal Holladay, Adrian Johns, Edward Johnson, Christopher Jones, Timothy Harrison, Paul Hecht, Craig Kallendorf, Hilaire Kallendorf, Mark Kishlansky, Arnold Krammer, Matthew Kruer, Katya Kukucka, Thomas Leinkauf, David Lines, Jonathan Lyon, Ellen MacKay, Daniele Macuglia, Armando Maggi, Hannah Marcus, David Marsh, Miguel Martínez, Pablo Maurette, Helen McCarthy, John McCormick, Michael McCormick, Bruce Chapman McCuskey, Alison McManus, Stuart McManus, Paula McQuade, Margaret Meserve, John Monfasani, Lodi Nauta, Jonathan Nelson, Elena Nicoli, David Nirenberg, John Padgett,

Samuel Eldwine Pell, Lino Pertile, Alexandra Peters, Valentina Prosperi, Michael Reeve, Chris & Valery Rees, Denis Robichaud, Andrea Aldo Robiglio, Michael Roche, Ingrid Roland, Jim Rosenheim, Rocco Rubini, Brian Sandberg, Valerio Sanzotto, Daniel Schwartz, William & Eric Slauter, Jim Sparrow, Richard Strier, John Shearman, Alexis Shotwell, Justin Steinberg, Julia Tomasson, Molly Warsh, Margo Weitzman, Tali Winkler, Carla Zecher, and many others whom, doubtless, I will kick myself for leaving out in the marathon intensity of book preparation's final days.

I must, of course, thank the more than seventy volunteers (former students, colleagues, friends) who help bring the world of 1492 to life each year in my papal election simulation, especially my long-time Vatican veterans Ari Dorsey, Isabella Jackson-Saitz, Marc Loeb, Hannah Trower, Gwyneth Turner, my tireless War Master Ben Indeglia, and my ingenious Master of Arms Thomas Noriega, but also many, many more (I'd name everyone from 2014 Annie to 2023 Zach if I had space) who keep joining and returning as our many 1492s intersect in their infinite variety. Nerdy friends from the LARP world were also core to the game's development, especially HRSFA friends Warren Tusk, Elisabeth Cohen, Kristen Hendricks, and Matthew Granoff, and gaming friends Jonathan Sneed, Michael Mellas, Joseph Mastron, Michael Lueckheide, and Lindsey Nilsen. The staff of Rockefeller Chapel (my Sistine) especially Matthew Dean are also invaluable every year.

The staff at Head of Zeus have been magnificent, giving as enthusiastic a home to this odd and not-at-all-little book as they did to my odd and not-at-all-little *Terra Ignota* novels, and I must especially thank Neil Belton, Simon Michele, Kathryn Colwell, Louise Tingle and Anne Rieley, my agent Cameron McClure, and my foreign rights agents Katie Shea Boutillier and Harry Illingworth, who worked so hard to matchmake a peculiar project with a press that could help it thrive. Thanks also to Dylan J. Montanari, Nathan Petrie, and the other staff at University of Chicago Press who partnered with us for the American release.

Special thanks too to Emma Mungall, whose assistance kept me going through the difficult last months of revisions, to

ACKNOWLEDGMENTS

"Surprised Eel Historian" John Wyatt Greenlee who designed the family trees, and to those friends who helped me track down elusive sources: Sarah Bond, Judith Pascoe, Kevin M. Stevens, and Camilla Lindelöw, who was invaluable for Julia the Clairvoyant. No scholarship exists without librarians, so I must thank the staff of the Newberry Library in Chicago, especially Jill Gage, Lia Markey, and Paul Gehl; at the University of Chicago's SCRC especially Elizabeth Frengel, Patti Gibbons, and Catherine Uecker; and at the Texas A&M Cushing Library, especially Jeremy Brett, Cait Coker, and Todd Samuelson.

Lauren Schiller too is a librarian, my dear friend and undergraduate roommate at Bryn Mawr College and still my roommate in our little academic commune after more than twenty years—let me tell you, a live-in librarian (help, I can't find this reference!) is the greatest boon a researcher could have! And just as indispensable is Lauren's ever-generous presence caring for me on my pain days. I have chronic pain and chronic illness, and this book was written during a particularly bad extended bout of illness, which, for years, not only kept me from archives and research travel, but often from rising from my bed, and even from reading, due to cognitive and sensory disruption. This forced me to pause my planned research and seek something I could write that would be valuable to the field but draw on older notes and books familiar enough from past reading to bypass the brain fog barrier. That I produced anything at all in those years was due to help from many friends and colleagues, from my Patreon supporters whose help let me purchase assistive tech so I could work in bed, and especially my housemates Lauren and Jonathan, who so generously gave me the daily support a long illness requires. If you are a scholar wondering why I did not use and cite a particular book or article, especially recent publications or things in languages other than English, I'm sure you're right that this book would indeed be better if I had used that source too, so I must beg your understanding when I say the spirit was willing but the flesh (which, alas, includes the reading center of the brain) was weak, and did its imperfect best.

Penultimately, I don't think I have ever found a scholarly publication in English on the Italian Renaissance published since its

foundation that did not thank the Villa I Tatti, proof of Bernard Berenson's astounding legacy, and it was my time there—as a PhD student, then Fulbrighter, then postdoc—that opened historic Florence for me, and taught me to open it for others. The Fulbright Program, NEH, ACLS, Mellon Foundation, U Chicago's Franke Institute, IFK, and Neubauer Collegium, and TAMU's Glasscock Center also helped make my studies possible, as did, in my stays in Italy, my ever-precious friends at the incomparable Gelateria Perchè no...!

Finally, no one did more to help this book be its best self than my incomparable friend Jo Walton. A fellow novelist and vocateur reader, Jo has been part of this book at every step: sharing tidbits from her own reading, hunting for references, reviewing drafts, helping bring 1492 to life each year, expressing the very different questions of someone who reads about the period for fun not work, and talking Renaissance with me practically every day for years, thanks to the miraculous internet. Jo's omnivorous reading of popular nonfiction commixed with scholarship and fiction was what first turned my mind to the gradients of different Renaissances presented in different kinds of books, and made me want to help readers to understand why those many Renaissances do not make one smooth image, but, like a mosaic, create shapes yet with friction and cracks between each piece. I only knew Jo slightly back in 2011 when I invited her to visit the little apartment where I spent my I Tatti year, on the top floor of a medieval tower with abominable stairs but a roof terrace facing the Duomo, where Michelangelo would have loved to spend eternity. Florence and the Renaissance have saturated both of us ever since, in prose, in verse, in learning, and in delight.

May they do so henceforth, reader, for you too.

Image Credits

p.14: Ada Palmer
p.31: *(above)* Corinne Gloss
p.31: *(below)* Hansrad Collection / Alamy Stock Photo
p.53: Ada Palmer
p.55: Ada Palmer
p.73: Peter Horree / Alamy Stock Photo
p.83: Peter Horree / Alamy Stock Photo
p.130: Ada Palmer
p.136: Ada Palmer
p.138: Photo by © Arte & Immagini srl/CORBIS/Corbis via Getty Images
p.158: ARTGEN / Alamy Stock Photo
p.175: Photo by DeAgostini/Getty Images
p.180: *(top)* Azoor Photo / Alamy Stock Photo
p.180: *(bottom)* Azoor Photo / Alamy Stock Photo
p.203: Ada Palmer
p.263: Ada Palmer
p.285: Mondadori Portfolio / Getty Images
p.290: Ada Palmer
p.308: The Picture Art Collection / Alamy Stock Photo
p.347: Ada Palmer
p.373: Ada Palmer
p.385: Ada Palmer
p.390: Adam Eastland Art + Architecture / Alamy Stock Photo
p.396: akg-images / Ghigo Roli
p.409: Ada Palmer
p.424: The Picture Art Collection / Alamy Stock Photo
p.434: Museo Galileo
p.496: GRANGER - Historical Picture Archive / Alamy Stock Photo
p.523: *(top)* Ada Palmer

p.523: *(bottom)* akg-images / Rabatti & Domingie
p.594: Museo Galileo
p.636: *(top)* Tamara Vardomskaya
p.636: *(bottom)* Tamara Vardomskaya
p.639: Eliana Melmed
p.640: Ada Palmer

Index

Page numbers in bold refer to the chapter devoted to the individual.

Abelard, Peter 148, 152, 153, 277, 443, 449, 498, 511, 532, 534, 568, 569, 591–4
 and the presumptive authority of the past 598, 600–1, 602
Adrian VI, Pope 370, 401–2, 403
Adriana de Mila 327–8
Ady, Cecilia Mary 91
Ady, Julia Cartwright 91
Aeneas 169
Africa 173
African slaves 223
Agincourt, Battle of 17–18, 117
Alberti, Leon Battista 268, 362, 416
Alexander the Great 23
Alexander VI, Pope 8, 252, 263–4, 265, 266, 279, 293, 304, 309, 315–18, 330–1, 347, 384, 459–63, 478
 death 267, 317–18
Alfonso, Crown Prince of Naples 248, 249, 313, 333, 338, 452
Alfonso the Magnanimous, King of Naples 169, 170, 182–3, 188, 189–90, 218, 225, 248, 254, 326–7
 and Filelfo 235, 240
 and humanism 497, 512, 513–14
Alfonso, Prince of Salerno 337–8
Alidosi, Cardinal Francesco 387, 397, 399

Amanatini, Manetto **227–30**, 232, 257, 258, 269, 313, 456, 484
Ambrose of Milan 528–9
Amsterdam 7
anatomy 592
Angelico, Fra 296
Anne of Beaujeu 255, 265
Anne of Brittany 337, 458, 633
Annius of Viterbo 317, 325
Anselm, Saint 148, 606
Antiquari, Jacopo 275
antiquity xix, 6, 142–7, 170–7, 178
 and humanism 502–3, 557
 and Machiavelli 573
 preservation of 577
 reviving 134–41
 and virtue politics 579–80
Antoninus, Saint 190
Aquinas, Thomas 43, 104, 129, 144, 148–9, 152–3, 154, 190, 214, 314, 520, 521, 531, 572, 598–9, 606
 and Descartes 606
 Summa Theologica 597
Aragona, Cardinal Giovanni d' 313
architecture
 European classical style 172
Aretino, Pietro 35
Argyropoulos, John 271, 273
Ariosto 114, 182, 206, 261, 342, 345, 569

Orlando Furioso 453, 496, 551
Aristarchus of Samos 594
Aristippus of Catania, Henry 143
Aristotle 143, 164, 214, 480, 498, 531, 535, 591, 595, 644
 and atheism 551, 560, 569
 deontology and virtue ethics 439–40, 442
 and Descartes 606
 and the Inquistion 548
 and the "New Philosophy" 604
 Organon (The Instrument) 149–50, 151–2
 on political participation 45–6
 and the presumptive authority of the past 596, 598, 599, 602
 and virtue ethics 450
art-state symbiosis 36–7
Assisi 59
astrology 432, 485
astronomy 432, 433, 605
atheism 44, 534–71
 and deism 561–5
 foolish atheism 537
 and the Inquisition 534–5, 546, 547–54
 and Machiavelli 534, 546, 554–67, 568
 malicious atheists 537
 practical atheism 536
 and scientific questions 539–42
 study of 567–71
Atkinson, Niall 382
atomism 541–2, 543, 546, 550
Augustine, Saint 43, 97, 152, 210, 518, 526–9, 532, 568
Augustus Caesar 3, 162
Aurispa, Giovanni 139, 143, 217, 511–12
authority
 presumptive authority of the past 595–602
Averroes (Ibn Rushd) 551, 569
Aztecs 174

Babbage, Charles 645
Bacon, Francis 480, 563, 604, 607, 610–17, 619, 620, 621, 622, 624, 642, 644, 649
Bacon, Roger xviii
banking 24, 52, 53, 54–5, 131
 Medici bank 76, 79
Barker, Hilary 382
Barlaamo, Bernardo 272
Baron, Hans 57, 92, 105, 189, 257, 479, 580
Baron thesis 45–51, 53, 497, 498–9, 556, 572
Bayezid II, Ottoman Sultan 171, 173, 218, 252, 387
Bazzi, Giovanni Antonio (Sodoma) 395–6
 Wedding of Alexander the Great 395–6
Beatrice of Naples, Queen of Hungary 170, 181, 218, 249, 307, 308, 313, 339, 382, 484, 633
Beaufort, Cardinal 18, 47, 102, 168, 179, 218, 515–16
Beccaria, Cesare 294, 448–9, 650
Belisarius 189
Bellini, Gentile 171
Bellini, Giovanni 183
Belozerskaya, Marina 183
Bembo, Pietro 342, 345, 353, 354, 357, 381, 413, 496, 511, 515
 History of Venice 325
Benci, Ginevra 298, 301
Benci, Maddalena 298–9
Bentham, Jeremy 437
Bentivoglio, Ercole 113, 114–15, 217, 324, 353, 649

Bentivoglio family 232–3
Bentivoglio, Giovanni 284
Bentivoglio, Sante 114–15, 217, 233, 284, 501
Berenson, Bernard 78, 90
Bernandino of Siena, St 90–1, 283, 291
Bernardino of Siena 283
Berruguete, Pedro 83
Bessarion, Cardinal 500–1, 507
Bible translations 598
Bicci, Giovanni di 75
Bilhères de Lagraulas, Jean 383
Biondo, Flavio 100
Bisticci, Vespasiano da 190, 275
Black Americans 629–30
Black, Christopher 547, 548
Black Death xix, 4, 27, 99, 115–16, 135, 142, 217, 259, 272, 585, 591, 627, 628, 647–50
 and economic change 52–3, 54
 and the Italian wars 124
 Petrarch's letters 166–7
Black, Robert 106, 179, 510, 515, 533
blood, circulation of 595, 598
Blount, Charles 561–2, 568, 569
 The Oracles of Reason 562–3
Boccacio, Giovanni 217, 272, 560
 Decameron 12–13, 90, 292, 476–7
Bodin, Jean 610
Boethius 149, 151, 527, 529
 Consolation of Philosophy 524–7, 530
Boleyn, Anne 458
Bologna 7, 47, 58, 65, 115, 217, 232–3, 284–5, 387, 397
Bona of Savoy 249–50, 264–5
Boniface VIII, Pope 347
books 75, 139, 143–4, 154, 171, 173

Borgia, Angela 181, 350
Borgia, Cesare (Valentino) 8, 9, 10, 33, 305, 310, 315, 316–17, 318, 327, 329, 331, 336, 337, 338–9, 341–2, 345, 346–7, 348, 349–50, 351, 357, 633
 and humanism 494, 495–6, 499–500, 503
 and Machiavelli's *The Prince* 463–8, 470–5, 476, 483
 and virtue politics 575
Borgia family 8, 9
Borgia, Francis 357
Borgia, Giovanni 336
Borgia, Jofré 328, 329, 333, 336, 346, 347, 356
Borgia, Juan 327, 330, 332, 336, 347, 357, 412, 462–3, 634
Borgia kingdom project 264, 266, 341–2, 384, 469, 471–3, 474, 635
Borgia, Lucrezia 33, 89, 91, 267, **326–60**, 367, 400, 452, 463, 473
 and humanism 495, 496, 499, 575
Borgia, Rodrigo 252, 327–30, 345
 see also Alexander VI, Pope
Borja, Alfons de *see* Callixtus III, Pope
Botticelli 91, 246, 275, 292, 312
Bracciolini, Jacopo 245
Bracciolini, Poggio *see* Poggio Bracciolini
Brahe, Tycho 433
Bramante 114
British Isles 269–70
Brittany 126, 255, 265
Brocadelli, Lucia 366–8, 374
Brown, Alison 80
Browning, Elizabeth Barrett 300
Brunelleschi, Filippo 88, 146, 202, 217, 228–9, 274, 392, 612

Bruni, Leonardo 98, 100–1, 147, 168, 188, 217, 218, 308, 498, 499, 511, 538
 History of the Florentine People 100–1, 163
Bruno, Giordano 207, 548–9, 551, 553, 560, 562, 570, 624
Brutus, Lucius Junius 2, 134, 482
Buonaccorsi, Biagio 467
Buonsignori, Stefano 594
Burgundy 126, 141, 259–60, 267–8
 polyphonic music 146
Burkhardt, Jacob 44, 50, 53, 57, 63, 90, 91, 92, 97, 123, 140, 193, 280, 497, 499–501, 501
 on Lorenzo de Medici 76–7
 The Civilization of the Renaissance in Italy 33–7, 38, 39, 113–14, 292
Bussi, Giovanni Andrea 510
Byron, Lord 91, 345
Byzantine Empire 224, 259
 see also Constantinople

Caesar, Julius 3, 5, 12, 41, 98, 134, 169
Calderón, Cristina 622
Calderón, Peretto 336
Caligula, Roman Emperor 536
Callixtus III, Pope 310, 326–7, 327
Calvin, John 425, 550
Calvinists 547, 548, 564
Cambrai, War of the League of 10, 12, 125, 142, 197, 351–2, 354, 387–8, 397, 482
Campofregoso, Paolo, Archbishop of Genoa 252
Capece, Scipione 552
capitalism
 proto-capitalism 52–5
Capponi, Niccolò 372
Capponi, Piero 289
Carafa, Cardinal Giovanni 314, 368, 402, 459
Carafa, Diomede 189, 452, 455
Cardano, Gerolamo 38
Carlyle, Thomas 630
Casimir of Poland, King 634
Cassirer, Ernst 492
Castellani Sanuti, Nicolosa 455, 500–1
Castiglione, Baldassare 91, 114, 381, 577
castrati singers 259
Catherine of Aragon 634
Catherine of Siena 258, 364, 365, 375
Catholic Church 38
 and atheism 535, 539, 542, 550
 see also Inquisition
Catholicism
 and humanism 44, 490
Cattanei, Vanozza dei 327, 328, 330, 356–7
Celenza, Christopher 38, 106, 504, 645–6
Cellini, Benvenuto 11, 38, 215, 385, 395, 408–10, 499, 512, 552, 553, 644
 Perseus 409–10, 435
Cereta, Laura 501
César *see* Borgia, Cesare (Valentino)
Charlemagne, Emperor 122, 123, 135, 139
Charles the Bold, Duke of Burgundy 259–60
Charles V, Emperor 86, 330, 371, 377, 401, 402, 403–4
Charles VIII, King of France 218, 255, 264–6, 267, 288–9, 316, 458, 633, 646

INDEX

Italian wars 333–5, 337, 346, 469
Charlotte of Naples, Princess 337
Chaucer, Geoffrey 18
 Troilus and Criseyde 453
chemistry 427, 431, 432, 604
China 7
chivalry
 the Nine Worthies 452–3
cholera 622
Christianity 173
 and atheism 535, 536–9, 543
 Christian virtue and pagans 162–3
 deontology and virtue ethics 440–1
 and Ficino's secular revelation theory 519
 justice and patronage 203–4, 207–14
 and Machiavelli 565–6
 Machiavelli on 559
 and the Middle Ages 97–8
 and philosophy 277, 524–9, 533
 the Reformation 213–14
 and the Roman Empire 97, 98, 609
 and scholasticism 152–3
 syncretism 524
Christie, Agatha 33
Chrysoloras, John 232
Chrysoloras, Manuel 273
Chrysoloras, Theodora 232, 239
Cicero 3, 4, 5, 12, 15, 23, 37, 42, 72, 99, 100, 131, 134, 211, 233, 455, 568, 582, 644
 and Great Person history 631–2
 and *studia humanitatis* 43, 144, 156, 159, 161, 162
 Young Cicero Reading 496
Cipolla, Carlo 115

city-states 6–10, 36–7
 civic participation 45–6
civic humanism xix, 46, 49–51, 189, 257, 479, 498–9, 556, 572, 580
classical revival 174
Clement VI, Pope 259
Clement VII, Pope 329, 370, 372, 377, 403–4, 405, 406
climage change
 and Viking Age Greenland 29, 30–1
Cold War 53, 108, 125, 142
Collevecchio, Simonetta de 400
Colombo, Realdo 592, 595
colonialism 174, 642
Colonna family (Rome) 2, 253, 315, 316, 345, 459
Colonna, Lorenzo Oddone 254, 427
Colonna, Vittoria 306, 412
Columbus, Christopher 28
Commedia dell'Arte 126, 145
communism 53
computer programming 645
Comte, Auguste xviii, 41, 42, 44, 492
Condivi, Ascanio 380
Confucius 439
Conio, Alessandro di 206–7
consequentialism/utilitarianism 437, 446–51
 in *The Prince* 477–8
Conspiracy of the Barons 253–5, 256, 263, 314, 469
Constantine, Roman emperor 121, 311
Constantinople 1, 7, 70, 143, 171, 218, 232, 239, 248, 251
Coperhaver, Brian 544
Corella, Micheletto 339, 476

Corio, Bernardino 239
Cortesi, Caterina 312
Cosimo de Medici 11
Cossa, Baldassare 252
Costa, Cardinal de 118
Counter-Reformation 322, 405, 406, 415
COVID pandemic xix, 628, 648
creationism 540, 597
crime and punishment 204–6
 executions 204, 205–6, 210, 210–11
 burnings at the stake 206, 208
Croce, Bendetto 487, 490–1
cultural history 33–4, 93
Cummins, Neil 118
Curie, Marie 642
Cybo, Franceschetto 315, 332–3

da Costa, Jorge 258
Dall'Aglio, Stefano 295
d'Amboise, Cardinal George 460
D'Amico, John 325
Dante Alighieri 11, 18, 19, 35, 57, 100, 147, 212, 216, 606, 609
 and the Guelph-Ghibelline feud 123
 Inferno 209, 394, 473, 554–5
 Paradiso 572
 and virtue ethics 440, 450
Dark Ages, Don't Call Them the xviii, xix, 25, 46, 96, 98, 132
Darth Vader 444, 445–6
Darwin, Charles xviii, 541, 554, 569
Davidson, Nicholas 204, 534, 542, 546, 549
de Beer, Susanna 510

Declaration of the Rights of Man 62, 645
Declaration of the Rights of Woman and the Citizen 645
deism 560, 561–5
della Rovere, Bianca 254
della Rovere, Francesco *see* Sixtus IV, Pope
della Rovere, Francesco Maria 354, 397, 399, 402
della Rovere, Giovanni 332, 343
della Rovere, Giuliano 460–2
 see also Julius II, Pope
della Rovere, Leonardo 242
democracy 36, 47, 48, 49
Democritus 541
Denmark
 and Greenland 28, 129
deontology 437, 438–42, 444–6, 447, 451
Descartes, René 43, 423, 425, 604, 605, 606–7, 616
deterrence-based justice 448–9
Dewey, John 491, 492
Diderot, Denis xviii, 425, 540, 542, 558, 560, 650
Diodato, jester 206
Diogenes the Cynic 631
Dionysius 529–30
diseases 116
 see also Black Death
division of labour 46
Dolfo, Floriano 394
Dominicans 129, 153, 190, 191, 284, 293, 314, 375
Donà, Guido 534
Donatello 217–18, 228, 229, 392
 David 137, 138, 274, 384, 395
 Judith and Holofernes 290
 Saint George 72–3, 140, 146, 575

Doyle, Arthur Conan
 Sherlock Holmes stories 32, 33,
 61, 89, 446
Duns Scotus 104, 132, 148, 153, 154
dwarfs 4333

early modern period 102, 104
economic change 52–5, 79
Edward IV, King of England 249
Egypt 6, 169
Einstein, Albert 597
Eleanor, Princess of Naples 339
Eliot, George 374
Elizabeth I, Queen of England
 424, 426
 the Empire 6, 122
 and Florence 73, 74
 and Italian city-states 64
empiricism 607
England 6, 9–10, 17–18, 23, 49, 102,
 140, 168, 179, 217–18
Enlightenment 24, 79, 560, 604,
 644, 650
 and humanism 42–3, 163, 165,
 578
Enriquez de Luna, Maria 332
Epictetus 162, 324, 558
Epicureanism 577
Epicurus 520, 534, 541, 543
epistemology 596
Erasmus 321, 322–3, 504–5, 507,
 573, 583, 592
Este, Alfonso d' 267, 339–40, 344,
 345–6, 348–9, 350–1, 356, 357,
 452
Este, Beatrice d' 266, 342, 353, 396
Este, Bianca Maria 288
Este, Ercole d', Duke of Ferrara
 261, 339, 344–5, 346, 348, 349,
 452
Este, Ferrante d' 349

Este, Giullo d' 181, 350
Este, Ippolito d', Cardinal 181–2,
 206, 218, 261, 262, 283, 344, 345,
 349, 350, 633, 635
Este, Isabella d' 91, 200, 206, 218,
 223, 224, 259, 261, 304, 340–1,
 342–3, 350, 358, 396, 499, 634
 spending sprees 183–4, 355
Ethiopia 6
Eugene IV, Pope 70, 310, 327, 507
Eurocentrism 623
European Renaissance 168–9
executions 204, 205–6, 210, 212
 burnings at the stake 206, 207

Falconcini, Bishop Benedetto 322
Farnese, Alessandro (Pope Paul
 III) 307–8, 330, 406, 408, 413
Farnese, Giulia 315–16, 331, 334,
 338, 339, 401, 459
Farnese, Pier Luigi 412
fascism 45, 46
Febvre, Lucien 543
Fedele, Cassandra 297, 298, 300,
 301, 303, 304, 307, 308, 375, 412,
 492, 493, 501, 506–7, 508, 575
Ferdinand of Aragon, King 6,
 170, 218, 307, 329, 335, 346, 548,
 549, 639
Ferrante, King of Naples 170, 189,
 218, 248, 249, 250, 251, 253, 254,
 264, 265, 266, 279, 326, 329,
 332–3, 349, 452, 459
Ferrara 47, 124, 261–2, 339–42,
 348–9
 visionary women 366–8
Ficino, Marsilio 140, 168, 179, 180,
 191, 207, 245, 276, 277, 324, 389,
 451, 508, 558, 584
 De sole 590
 and the death of Cosimo de

Medici 192, 193–5, 278
 and the Inquisition 549, 551
 letters 505, 507
 and philosophy 489, 553
 and Poliziano 271, 272, 274
 and Savonarola 282, 285, 293, 295
 theory of the secular revelation 518–22, 533
Filelfo, Francesco 181, **231–40**, 248, 257, 258, 280, 309, 335, 498, 512
First World War 97, 107, 123, 142
Florence xxi, 6, 35, 56–60, 135–7
 Albizzi family 70
 art treasures 56–60
 Bargello fortress 2
 and the Black Death 648–9
 cathedral 136–7, 140, 145, 146, 383–4, 650
 Charity depictions 158, 159
 civic participation 45, 47, 48–9, 50–1
 dowry fund 79–80
 families
 elites 48, 49, 71, 73–4, 87, 140, 202
 popolani 72, 80, 290
 flood (1966) 59
 Gates of Paradise 88
 Ghirlandaio and chapel frescoes 379
 Guelph-Ghibelline feud 121–2
 guilds 48–9, 53–4, 71, 74, 79, 227–8
 history 57
 and the Italian Wars 638
 Last Republic 17, 371–7, 413
 libraries 5
 magnates 76
 Medici palace inventory 184–7
 Michelangelo in 378–86, 403–4, 649–50
 Museo Galileo 617–18
 Orsanmichele 53–4, 88, 136, 145–6
 Palazzo Pitti fresco 174, 175
 Palazzo Strozzi 222
 Palazzo Vecchio 8, 14, 15, 66, 69–70, 180, 290, 291, 385
 Hall of Five Hundred 410
 patron saints 209–10
 Pazzi Conspiracy 124, 243–6, 249, 250–1, 275
 podestà (chief of police) 72, 73
 political thought 47
 popolo 49, 65, 66, 76
 San Caterina convent 365, 369–70, 372, 374, 375, 415
 San Lorenzo 403, 404
 San Marco 190, 191, 296
 San Pier Maggiore 305–6, 375
 Santa Maria Novella 284, 373, 376
 and Savonarola 289–96
 and the Second World War 57–8
 Signoria 10, 65–72, 219, 223, 286, 287, 293, 377, 484
 social classes 48–9
 SPQF (Senate and the People of Florence) 2
 taxes 200, 222, 225
 Tornabuoni family 71
 tourism 56–7
 Uffizi Gallery 22, 51, 59, 177
 umanisti 141, 233
 and the unification of Italy 484
 women *Scorpioni* 89–90
 wool trade 224
 Youth Confraternity of Saints Cosmas and Damian 76
 see also Medici family
Florence, Council of (1438–9) 273–4

Foster, Reggie 246
France 6, 138–9, 168
 Anvignon papacy 4, 129–30, 217, 342, 347
 Italian wars 8–10, 12, 125, 129–30, 316–17, 333–5
 Paris 7
 Renaissance 47
Franchi, Raphael 534, 552–3, 565
Francia, Francesco 183
Franciscans 153, 293
Franckenstein, Christian Gottfried 423
Franco, General Francisco 129
Franklin, Benjamin 619, 648
Frazier, Alison 325
French Revolution 619
French Wars of Religion 117, 629–30
Freud, Sigmund 480, 483
 Civilization and its Discontents 107, 142, 621
Fubini, Riccardo 479–80, 556–7, 573

Galen 144, 592, 601, 602, 604
Galileo 416, 422–3, 433, 512, 602, 604, 613, 624, 644
 telescopes 570
 trial 548–9
Garin, Eugenio 43, 488–9, 491, 495, 503, 574
Gaza, Theodore 510
Gazzella, Trogia 333
Genoa 7, 48, 124
genocide 45
Gent, Justus van 83
Gentile, Giovanni 487, 490–1
The Gentleman's Magazine 617
geography 592

Germany 23, 39, 45, 59
 Frankfurt Book Fair 588
Ghiberti, Lorenzo 88, 217, 416
Ghirardo, Diane Yvonne 355
Ghirlandaio, Domenico 275, 379–80
 Adoration of the Magi 649
Ghislieri, Michele 551
Giannotti, Donato 415
Giotto 145
Giovanni delle Bande Nere 407
golden age myth
 of the Renaissance xvii–xviii, xix–xx, xxi, 21–3, 33, 36, 46–7, 133, 147
 of Rome 134–5
Goldthwaite, Richard 54, 80, 183, 220
Gonzaga, Elisabetta 343, 354, 369
Gonzaga, Ferrante 412
Gonzaga, Francesco, Marquis of Mantua 262, 340, 349–50, 353, 357–8, 394, 396, 549
Goths 1
Gouges, Olympe de 645
Gouwens, Kenneth 516
grace and patronage 207–8, 210–11, 213–15, 245, 272
Granada 7
Grand Tour 56
Grassi, Ernesto 490–1, 503–4
Grazella, Trogia 338
Great Forces history 629–30, 631, 632, 637, 638, 645
Great Man history 630–1
Great Person history 627, 631–2
Greece 6, 23, 174
 ancient 43
Greek language 38, 137, 272–4
 and humanism 42
Greenblatt, Stephen 18

Greenland
 Norse settlers 27–31, 39, 79, 129, 177, 270, 647
Gregorovius, Ferdinand 359–60
Gregory the Great, Pope 190
Grendler, Paul 511
Grimm, Jacob 175–6
Guadagnoli of Rieti, Columba 364, 367
Guelph-Ghibelline feud 121–3, 124, 217, 234, 253–4, 271
Guicciardini 559
Guidarelli, Guidarello 33
Guideo, Gian Maria 400
Gutenberg, Johannes 587–8

Hadrian, Roman emperor 130
Hankins, James 108, 618
 Virtue Politics 579, 580
happiness 450
Hawkwood, Sir John 120–1
Hegel, G.W.F. 34, 508
Heidegger, Martin 487, 488, 491
Heil, John-Paul 47
Helmrath, Johannes 502
Heloise and voluntarism 443
Henry V, King of England 17–18, 108, 117, 168, 217–18
Henry VI, King of England 102, 168, 169, 179, 212–13, 217–18, 261, 454
Henry VII, Emperor 123
Henry VII, King of England 6
Henry VIII, King of England 129, 401, 458, 575
Herder, Johann Gottfried 34
Hibbert, Christopher 84
 The House of Medici: Its Rise and Fall 78
Hippocratic Oath 232
historiography 25–6

History Lab xx–xxi, 19, 27, 34, 38, 39, 40, 106, 268–9
 and civic humanism 50, 51
 and Florence 59
 and humanism 105–6, 183
 and the Medicis 78–9, 80, 82–4, 86–7
 medievalists 132
 and women's histories 90, 91, 92–5
Hitler, Adolf 22, 45, 46, 177
Hobbes, Thomas 19, 43, 423, 439, 561–2, 569, 571, 615, 619, 620, 650
 Leviathan 477, 538–9
Hollingsworth, Mary 78, 82
Holy League 352
Holy Roman Empire *see* the Empire
Holyoake, George 41
Homer 272, 273, 504, 578, 586
homosexuality 391–7
Horne, Herbert P. 90
Hudson, Jeffrey 258
Human Agency histories 630–1
humanism xix, xx, 2, 41–4, 62, 105–6, 139, 485–546
 and antiquity 502–3
 and Bruni 100
 civic humanism xix, 46, 49–51, 189, 257, 479, 498–9, 580
 defining 497–501
 Renaissance humanists 493–6
 and Ficino's secular revelation theory 518–22
 letters 504–8, 573, 575
 and Luther 583–4
 and Machiavelli 8, 42, 484, 489, 498, 503, 515, 522, 572–3, 581–4
 manuscripts 170

and the Medicis 79
modern humanistic education
 643–4
and progress 609–10
and secularization 44, 62, 105,
 106, 534–46, 553, 556–8
studia humanitatis 135, 154–5,
 156–67, 173
umanisti 42–3, 44, 141, 144–5,
 178–9, 179, 181, 188–90, 454–5,
 493
 Filelfo 181, **231–40**
 payments to 510–17
 Poliziano 77–8, 165, **271–81**
and virtue politics 574–80
Humanist Manifesto 491
Humanity, Church of 41
Hume, David 43
Humphrey of Gloucester 168,
 218
Hundred Years' War 6, 250
Hungary 6, 47, 170, 181, 218,
 229–30, 232, 313, 484
Hunter, Michael 542

Iceland 177
Iliad 178, 272
India 174
indigenous cultures 174
individualism 34–6, 40, 41, 50
industrialization 619–20
infant mortality 118, 644
information revolution 586,
 587–90
Innocent VIII, Pope (King Log)
 252–3, 254, 263, 277, 309, 314,
 315, 327, 329–30, 332, 469,
 471
 death 279, 330, 457, 510
 tomb 413
innovation 39

Inquisition 44, 204–5, 207, 323,
 605
 and atheism 534–5, 546, 547–54
 and Savonarola 282
international Renaissance 268–70
Inuit-Norse Project 29
Iron Age 608
Isaac, Heinrich 262
Isabella of Castile, Queen of
 Spain 6, 170, 218, 307, 329,
 548, 549, 633, 639
Isabella of Naples 264
Isabelle of Clermont 251
Islam
 and atheism 547, 548
Italian city-states 6–10, 36–7, 64
 life expectancy 117–19
Italian culture 576–7
Italian unification 24–5, 411, 484
Italian Wars 7–10, 36, 121–3,
 124–6, 131, 590, 634, 638
Izzard, Eddie 174

Japan 342
Jardine, Lisa 298, 306
Jerome, Saint 147, 152
Jews
 in Florence 58
Joan of Arc 258, 375
João, King of Portugal 459
John the Baptist 209–10, 649
John II, King of Naples 218
John VIII Palaeologus, Byzantine
 Emperor 232
John XXII, Pope 259
Josquin des Prez 114, **257–70**, 295,
 315, 335, 633
Judaism
 and the Inquisition 547, 548,
 551
Julia the Sibyl **422–34**, 605

Julius II, Pope (Battle Pope 2)
 128, 252, 254, 263, 265, 267,
 318–19, 320, 327, 330, 333, 335,
 343, 346–7, 348, 351–2, 353–4,
 355, 358, 628, 633
 and humanism 494, 495,
 499–500
 and Machiavelli 469–81
 and Michelangelo 384, 386–8,
 393
 bronze statue 387, 397
 Sistine Chapel ceiling 389–90
 tomb 386, 387, 398, 399, 402,
 404, 411, 412–13, 416
 and virtue politics 579, 580
Julius III, Pope 414
justice
 deterrence-based 448–9
 and patronage 203–15

Kant, Immanuel 43, 44
Keats, John 624
Kempen, Ludwig van 166
Kent, F.W.
 *Lorenzo and the Art of
 Magnificence* 86–7
Knights Hospitaller 161
Kors, Alan C. 539, 542, 596
Kristeller, Paul Oskar 105–6, 139,
 487–9, 491–2, 494, 497, 503, 515,
 532, 572, 574
Kristina of Sweden, King 422,
 423–31, 561, 569, 604, 605, 616,
 621
Kukucka, Katya 412
Kyeser, Konrad 117

labor, empowerment of 52–3
Lady Philosophy 524, 525–6,
 531–2, 591
Laertius, Diogenes

Lives of the Philosophers 520
Lamont, Corliss 491
Landino, Cristoforo 271
Landucci, Luca 292
languages 38–9
Lascaris, Constantine 248
Lascaris, Janus 381
Lassus, Orlande de 32
Latin 38–9, 168, 179, 190
 and humanism 42, 43, 144–5
Launay, Robert 174
le Roy, Loyd 610
legitimacy
 and the golden age myth 21–2,
 24, 25
 and the Grand Tour 45
 Renaissance quest for 585–6
 and Viking Age Greenland 28
Leibniz, Gottfried 43, 108
Leo III, Pope 121–2, 315, 320–1
Leo X, Pope 275–6, 307, 353, 354–5,
 356–7, 368–9, 370, 371, 410,
 511, 512
 and Michelangelo 379, 380,
 397–8, 398–401
Leonardo da Vinci 24, 35, 62,
 114, 117, 193, 258, 260, 261,
 499, 512
 Last Supper 269
 Mona Lisa xvii, 119, 647
 and progress 609, 612
Leto, Pomponio 145, 311–12, 321,
 322, 545, 551–2, 554
Leys, Mary Dorothy Rose 91
liberal democracies 623
life expectancy 117–19
lightning rod 619, 648
lingua franca 39
Liombeni, Luca 206
Lippi, Filippino 284, 389
 Annunciation 285

INDEX

Little Ice Age 29, 30–1, 39, 142
Livy 482, 522, 573, 646
Locke, John 43, 154, 423, 439, 569, 577
Lodi, Peace of 124–5, 243, 248, 252, 256, 313
London 7, 54, 55, 57
Long, Pamela 381
Louis IX, King of France 454
Louis of Orleans 266, 267
Louis of Toulouse, St 454
Louis VII, King of France 267
Louis XI, King of France 249, 250, 251, 254–5
Louis XII, King of France 240, 337, 346, 352, 384, 397, 398–9, 470
Louis XIV, King of France 117
Lucan 609
Lucretius 108, 145, 573, 604–5
 and Aberlard 591–2
 and atheism 534, 541, 542–6, 547, 548, 549, 550, 551–2, 552–3, 554, 560, 562, 569
 and progress 608–9
Luther, Martin 211, 213, 214, 276, 282, 321, 371, 400, 432, 585–6, 625
 and atheism 537–8, 548, 550, 552
 and Machiavelli 583–4
 and the printing press 589, 590
Lutheranism
 and the Inquisition 547

McCloskey, Robert 132
McCormick, John 50, 482, 483
Macedonia 23
McGovern, Thomas 29, 30, 114
Machiavelli, Bernardo 298, 456–7
Machiavelli, Lodovico 13
Machiavelli, Niccolò xvii, xx, 1, 2–3, 5–6, 8–16, 17, 24, 40, 48, 87, 98, 197–8, 217, 257, **435–84**, 610, 624–5, 627
 and astrology 432, 485
 and atheism 534, 546, 554–67, 568, 570, 571
 Bentivoglio's letters to 113, 114–15
 death 13
 Decennale 113, 115, 324, 483
 Discourses 13, 71, 221, 325, 376, 453, 483, 558–9, 573, 582
 ethics 436–51
 exile from Florence 10–11, 79, 221, 475–6, 478–9
 family background 456–7
 and Florentine civic participation 47, 49
 Florentine Histories 71, 483
 and Great Person history 631
 hat 92
 and humanism 8, 42, 484, 489, 498, 503, 515, 522, 572–3, 581–4
 and the Italian Wars 8–10
 on Lorenzo de Medici 81, 84
 Machiavellian political science 13, 436
 The Mandrake 558
 on Milan 235, 236
 and Modern Man 645–6
 and the "New Philosophy" 605
 patronage 200
 political thought 69
 The Prince 11–12, 13, 50, 119, 262, 372, 424, 451–84, 503, 572, 635, 638–9
 reputation 14–16
 on Savonarola 282
 Vespucci's letter to 205–6
 and warfare 121, 126
Machiavelli, Primavera 456

Machiavelli, Totto 115, 129
Macinghi family 219
McManus, Stuart 269
Macuglia, Daniele 605
Madalena, Sister 364
Maffei, Antonio 311, 312
Maffei, Gherardo 310, 312, 318
Maffei, Mario 311, 314, 316, 320, 321
Maffei, Raffaello (il Volterrano) 309–25, 476, 478, 494, 499, 506, 557, 558, 579, 623
 Commentaria Urbana 319, 322–3, 324, 325
Magiolini, Laura 239
Manetti
 On Human Worth and Excellence 325
Manetti, Giannozzo *On Human Worth and Excellence* 452
Manichaeism 527–8
Manirola, Teodora 254
Mantua 7
Manutius, Aldus 345
Mappelli, Gianmaria 304
Marcellus II, Pope 414
Marcus Aurelius 450
Maria Eleaonora of Brandenburg 433
Marlowe, Christopher
 Doctor Faustus 537
Martin, John Jeffries 40, 500, 501
Martines, Lauro 78, 295
Marullo, Michele Tarcaniota 299–300, 301, 303–4, 305, 307, 317
Marx, Karl 480, 569
Mary, Duchess of Burgundy 260, 267
mathematics 605
Mattei, Lucilla 314

Matthias Corvinus, Raven King of Hungary 170, 171, 218, 229, 252, 308, 313, 521, 634
Matuzzi, Aurelio 328
Matuzzi, Pier Giovanni 328
Maximilian, Emperor 260, 265, 267, 351, 482, 633
Maxson, Brian 50, 87
Medici: Masters of Florence TV show 623–4
Medici, Alessandro de, duke of Florence 369, 371, 377, 406–7
Medici, Anna Maria Luisa de 56
Medici, Cardinal Giulio de *see* Clement VII, Pope
Medici, Catherine de 370, 400, 407–8
Medici, Clarice Orsini de 81, 207, 251, 254, 275–6
Medici, Cosimo de 64, 67–8, 69–76, 85, 86, 137, 139, 140, 168, 188, 190, 217, 221, 222, 272, 273–4, 303, 623–4
 death 191–2, 193, 194–5
 and Filelfo 233, 240
 and humanism 493–4, 495, 496
 and virtue politics 577
Medici, Cosimo I de, Duke of Florence 407, 408, 409, 410, 411, 431
Medici family 8, 11–12
 bank 76, 79
 crest 201, 202, 203, 210, 250
 expenditure 75–6
 and Filelfo 233
 and gout 84–6, 87
 patronage 200, 201
 popes 414
 tombs 401, 413, 416
Medici, Fernandino de 617
Medici, Gian Gastone de 56

INDEX

Medici, Giovanni de (son of Cosimo) 85, 457
see also Leo X, Pope
Medici, Giuliano de 75, 243, 244, 245, 275, 329, 353, 368, 369, 393–4, 406, 456, 510–11, 513
Medici, Giuliano Mariotto de 277
Medici, Ippolito de, Cardinal 406
Medici, Lorenzino de 406, 410, 415
Medici, Lorenzo de Piero de (Lorenzo the Magnificent) 44, 64, 68, 75–88, 139, 169, 217, 623
 adoption of cousins 80–1
 and antiquity 174–5
 assessments of 76–84
 books on 78
 death 278–9, 457
 education 75
 expenditure 75–6
 and Filelfo 240
 giraffe 179, 180, 184, 188
 gout 84–6
 and humanism 499, 506, 523
 and Ippolita Maria Visconti Sforza 248–9, 253
 marriage to Clarice Orsini 81, 207, 254
 and Michelangelo 380–1
 patronage 199, 207
 and the Pazzi Conspiracy 243–5, 249–50, 251, 312, 356
 and Pico della Mirandola 278
 and Poliziano 272, 274–5
 and Raffaello 312, 313
 and the sack of Volterra 81–4, 86
 and Savonarola 283, 285, 286
 and *umanistas* 179, 180
 and virtue politics 575
Medici, Lorenzo di Piero de, duke of Urbino 354–5
Medici, Lorenzo di Piero de (son of Piero the Unfortunate) 369, 400
Medici, Lorenzo and Giovanni di Pierfrancesco de 80–1, 302–3, 380, 383
Medici, Lucrezia de 293, 499
Medici, Maddalena de 315
Medici, Nannina 362
Medici, Piero the Gouty (Lorenzo's father) 64, 85, 202, 217, 250
Medici, Piero (Lorenzo's son), the Unfortunate) 75–6, 253, 278, 280–1, 286–7, 288–9, 302, 354–5, 368, 397
 and Michelangelo 382, 383, 384
medicine 84–6, 118–19, 592, 601, 610, 618, 624
 polio epidemic 622, 641, 644
Mediterranean Franca 38
Mehmet, Ottoman Sultan 86, 171, 218, 239, 252
mercenaries 6, 7, 120–1, 131, 234
 see also Montesecco, Giovanni Battista
merchant class 24
Meserve, Margaret 141
Mexico 7, 171
Michelangelo 24, 32, 114, 202, 228, 275, 319, **378–416**, 489, 499, 610
 Capitoline Hill, Rome 411
 David xvii, xxi, 50, 384–5, 395, 408, 409, 410, 415, 649–50
 Deposition 414, 415
 early life 378–80
 Genius of Victory 296

735

Medici tombs 401
and the "New Philosophy" 605
Pietà 383
and Pope Julius II 384, 386–8, 389–90, 393
and Pope Leo X 379, 380, 397–8, 398–401, 399–401
Prisoners 398, 415, 416
in Rome 411
and Savonarola 296
sculpting 380, 415
sexuality 391–7, 404–5
Sistine Chapel
 ceiling 388–91, 397–8
 Last Judgment 405–6, 410, 411
tomb of 416
and Tommaso dei Cavalieri 404–5
unfinished work 415
Michelet, Jules 32
Middle Ages xix, xxi, 4, 17, 25, 39–40, 53, 131–3, 585, 650
and antiquity 143–4
city republics 47
invention of 96–104
Milan 7, 47, 57, 58, 264
 Filelfo in 233–6
 Golden Ambrosian Republic 235–8
 Visconti-Sforza dynasty 74, 234–8
Milton, John 433
 Paradise Lost 536
Minucci, Tita di Bartolomeo 314, 320
Mitchell, Rosamond Joscelyne 91
modern, definitions of 102–4
Modern Man 40, 53, 79, 90, 645–6
modernity xx, 18, 34–6, 62–3, 96, 131
 and Renaissance humanism 106

monarchies and the Renaissance 47
Monfasani, John 106, 179, 495
Monleone, Luchina 242
Montaigne, Michel de 603–7
Montefeltro, Federico da 82, 83, 84, 244, 250, 312, 343
Montefeltro, Guidobaldo da 83, 86, 343–4, 369, 466, 495
Montesecco, Giovanni Battista **241–7**, 251, 257, 303, 509
Montesquieu 650
Morandi, Orazio 431–2
Morgante, Nano 258
Morris, William 176
Murad II, Ottoman Sultan 232
music 258
music *see* polyphonic music
Mussolini, Benito 22, 46, 177, 411, 487–8, 490

Najemy, John 78, 82
Naples 7, 47, 49, 57, 58, 125, 130, 135, 169, 189, 218
 and the Conspiracy of the Barons 253–4, 255, 314
 Pazzi Conspiracy 124
nationalism 25, 35, 36, 37–8, 39, 45, 90, 174
Nazi Germany 57–8, 487–9, 490–1
Neoplatonism 528
Netea, Mihai 116
New World 592, 598, 601
news economy 589
Newton, Isaac xviii, 108, 423, 541, 554, 613, 618
Niccoli, Niccolò 75, 139, 217, 233, 493, 494, 500, 501
Nicholas V, Pope 310, 494–5, 575
niethammer, Friedrich 41
Nietzsche, Friedrich xviii

INDEX

Nine Dudes in a Tower *see*
 Signoria, Florentine
nine *priori see Signoria*,
 Florentine
Nine Worthies 452–3
Normanni, Lucrezia 327
Norse settlers in Greenland
 27–31, 39, 79, 129, 177, 270, 647
northern paganism 175–6
Norway
 and Greenland 28
Noves, Laura de 4

Odyssey 178, 272
Old Nick *see* Machiavelli, Niccolò
oligarchies 47
olive oil 6, 7, 224
Oliverotto da Fermo 467
Origen 521–2
Origo, Iris 90–1, 94
Orsini, Archbishop Rinaldo 549
Orsini family (Rome) 2, 253–4,
 315, 316, 332–3, 345, 459, 472
Orsini, Ludovico 327–8
Orsini, Orsino 327–8, 331, 339
Osnaga, Orsina 239
Otranto, Battle of 124, 251–2
Ott, Dr Ludwig 161
Ottoman Empire 6, 10, 23, 124,
 171, 174, 218, 232, 239, 582
 invasion of Italy 251–2, 255–6
Ovid 143, 144, 161

Padua 7
Paganino da Milano 166
Paine, Thomas 560, 614
pamphlets 589, 590
papacy
 elections 127–8, 140–1, 241–2
 in France 4
 and the Guelph-Ghibelline
 feud 122
 in Rome 1–2, 127–30
 tombs of the popes 412–13
papal election (mock, 2016)
 633–40, 642
Papal States 124, 243, 341
Parenti family 223, 225
Paris 7, 57
 Sainte Chapelle 388
 University Library 154
Parks, Tim
 Medici Money 78, 79
Pater, Walter 90
patronage 198, 199–215, 230, 245,
 552
 humanists 512–13
Paul II, Pope 241–2, 243, 310, 312,
 315, 322, 324, 330, 347
Paul III, Pope 307–8, 330, 406,
 408, 410–12, 413
Paul IV, Pope 414
Paul, St 530
Pazzi Conspiracy 124, 243–6, 249,
 250–1, 255–6, 257, 275, 303, 309,
 312–13, 316, 329, 352, 354, 356,
 362, 400, 457
Pazzi family 73, 87, 140, 202
Pazzi, Piero de 245
Perini, Gherardo 404
Petrarch
 and Great Person history
 631–2
Petrarch, Francesco xx, 3–5, 11, 17,
 18, 32, 35, 37, 40, 72, 97, 98–100,
 105, 126, 131, 135, 139, 144, 145,
 146, 148, 168, 178, 211, 218, 268,
 276, 625, 642–3
 and Bacon 613, 614
 and the Black Death 648
 Christianity 147, 543
 and humanism 485, 508, 558, 569

Italia Mia 98–100, 115, 134, 643
letters written during the Black Death 166–7
and Machiavelli 573
and the "New Philosophy" 605
and the papacy 130
and Poliziano 272, 273
and Raffaello Maffei 321
Remedies Against Fortune Fair and Foul 159–61, 167, 631, 643
and *studia humanitatis* 156, 157, 159, 160–1, 165
and virtue ethics 451
and warfare 121
Philip the Handsome, Duke of Burgundy 267–8
philosophy 487–92, 524–33
the New Philosophy 603–7
see also humanism
Piccolomini, Enea Silvio *see* Pius II, Pope
Pico, Anton 288
Pico della Mirandola, Gianfranco 363
Pico della Mirandola, Giovanni 34, 77, 155, 276–8, 328, 521–2, 553
and atheism 566, 568–9
death 279, 280–1, 287–8, 316, 362, 363
and the Inquisition 551
and Michelangelo 381
Nine Hundred Theses 277
Oration on the Dignity of Man 35–6, 42, 44, 276, 325
and philosophy 488–9, 532
and Savonarola 283–4, 285–6, 287–8, 293
Piombo, Sebastiano del 399
Piovanelli, Cardinal Silvano 294
Pisa 7, 243

Guelph-Ghibelline feud 122, 123
Pius II, Pope 91, 141, 310, 318, 327, 329
Pius III, Pope 318, 346, 384, 413, 471, 473
Pius IV, Pope 414–15
plague 7
Plague of Justinian 127
Republic 165
see also Black Death
plants 592–4
Platina, Bartolomeo 552
Plato 4, 72, 77, 79, 99, 108, 137, 140, 143, 161, 163, 184, 480, 489, 528, 530–3, 569, 595, 606
and Ficino's secular revelation theory 519–20, 521
Neoplatonism and Christianity 528, 529–31, 561
Republic 438
on the soul 210
Symposium 5
Timaeus 191–2, 195
translations of 598
and virtue 450, 455
Plethon, Gemistus 273
Plotinus 519–20, 531, 606
Plutarch 157, 510
Poetic Edda 176
Poggio Bracciolini 18, 47, 102, 108, 139, 140, 143, 146, 168, 179, 217, 218, 233, 273, 498, 499
Polacco, Giorgio 605
Poland 6, 256
Polatus, Leonitus 272
polio epidemic 622
political participation
and the Baron thesis 45–51
Poliziano, Angelo 77–8, 165, **271–81**, 285–6, 309, 310, 312, 320, 323, 329, 345, 465, 506

and Alessandra Scala 297, 299, 300, 301, 302, 306, 307, 308
death 279–81, 288
and humanism 558
and Michelangelo 381, 382
Polizzotto, Lorenzo 370–1
polyphonic music 24, 32, 36, 146, 258, 259, 268
Pomponazzi, Pietro 550–1, 560, 563
Pontano, Giovanni 455–6, 464, 507, 575, 601
Porphyry 519–20, 531
Portinari Altarpiece 269
Portugal 6, 10, 47, 126, 169
power 64–5
Prague 7
Praja, Katalin 227
Prajda, Katalin 230
Presenti, G. 300, 307
presentism 623–4
printing press 587–90
progress 607, 608–35, 641–6
 scientific 612–19
Prosperi, Valentina 178
Protestantism
 and atheism 538–9, 542, 547, 548, 552
 and the French Wars of Religion 629
 and humanism 44
proto-capitalism 52–5
proto-democracy 45–51, 79
Prussia 6
Pseudo-Dionysius the Areopagyte 529–32
psychology 596
Ptolemy 592, 602, 604
Pulci, Luigi 292
Pulci, Raffaello 206
Puyllois, Johannes 513
Pythagoras 520, 532

Qaitbay, Egyptian Sultan 184, 188
Quintilian 42

Raphael 32, 91, 114, 399–400, 410, 513, 515, 577
 School of Athens 319
rationalism 35, 39
Reformation 213–14, 322, 584, 643
religion 36
 and humanism 44
 see also Christianity
Remirro de Orco 464–5, 468, 473
René of Anjou 169, 189, 260
republican civic participation 46–9, 79, 131
revolutions of 1848 41
Riario, Cardinal Raffaele 245, 254, 354, 356, 383, 400, 427, 434, 507
Riario, Girolamo 243
Riccobaldi, Paolo del Bava 314
Rienzo, Cola di 91
Robert, King of Naples 135, 161, 169, 218
Rochester, John Wilmot, 2nd Earl of 562
Rocke, Michael 204, 391, 394–5
Roman Empire 1, 2–3, 4, 5, 23, 38, 64, 99–100, 126, 134–5
 and Christianity 97, 98, 609
 eastern and western empires 70
 and Italy 121–2
Roman, Geraldine 622
Roman Republic 1
romance and the Renaissance 89–95
Rome 57
 ancient Roman religion 558–9
 Capitoline Hill 411
 Castel Sant'Angelo 130
 Conspiracy of the Barons 253–4

Filelfo in 239–40
great families 2
King Kristina in 426–7
papacy 1–2, 47, 127–30
Pasquino statue 402
Sack of (1527) 329, 371, 403
St Peter's Basilica 411
Sistine Chapel 51, 379, 388–91, 538
Ross, Janet 84, 90, 94, 193
Rothfield, Lawrence 82, 295
Rousseau, Jean-Jacques 43, 560, 621
Royal Society 614, 618, 619
Rubini, Rocco 106, 645–6
Rucellai, Bernardo 376, 505
Rucellai, Camilla Bartolini 361–77, 499, 623
Rucellai family (Florence) 87, 361–2
Rucellai, Ridolfo 361–2
Rucellai, Ridolpho 361–2, 363
Ruggiero, Guido 78, 84, 124, 189
Russell, Bertrand 504
Ruxandra of Wallachia 634

Saga of Eric the Red 27, 28
Salutati, Coluccio 188, 189
Sancha of Aragon 333, 338
Sanseverino, Galeazzo 266–7, 333, 342, 396
Sanuti, Nicolosa Castellani 507, 533
Sartre, Jean-Paul 44, 491
Savonarola, Girolamo 77, **282–96**, 312, 316, 322, 336–7, 367, 371, 382, 522, 559, 571, 623
 Bonfire of the Vanities 291–3
 and ethics 432, 449
 and humanism 494, 495
 and the Last Republic 372–5
 and Machiavelli 583, 584

and women visionaries 362–3, 363–6, 368, 369, 374–5
Savonarola, Maurelio 366
Savonarola, Veronica 367
Scaevola, Gaius Mucius 2–3
Scala, Alessandra **297–308**, 309, 324, 345, 376, 377, 381, 532, 634
 Electra performance 297, 299, 300, 301, 308, 503
 and humanism 492, 493, 495, 498–9
Scala, Bartolomeo 86, 298–9, 302–3, 323, 381, 551
Scala, Giuliano 297, 299
Schmidt, Justin 30
scholars of the Renaissance 61–3
scholasticism 42, 148–55, 156, 214, 532, 604
 and *studia humanitatis* 154–5, 156–7, 160–1
science xix, xx, 650
 and the "new philosophy" 604–6
 progress in 612–19
 scientific questions and atheism 539–42
Scientific Revolution 422–3, 431
Second World War 17, 57–8, 97
secular humanism 44, 62, 105, 106, 534–46
secular revelation, theory of 518–22
secularism 41–2
secularization xix, xx, 42, 44, 132
Seghieri, Lucia di Giovanni 310
Seigel, Jerrold 515–16
self-fashioning 35, 39, 499–501, 572
Seneca 3, 5, 156, 162, 450
Senigallia massacre 466–7, 472, 572

INDEX

Servetus, Michael 592, 595
Sforza, Alessandro 343
Sforza, Anna Visconti 339
Sforza, Ascanio *see* Visconti
 Sforza, Cardinal Ascanio
Sforza, Battista 343
Sforza, Caterina 304–5, 306, 374,
 407, 482
Sforza d'Aragona, Giovanni
 331–2, 335–6
Sforza, Duke Galeazzo Maria
 201, 217, 238, 239, 249, 264
Sforza, Filippo Maria 261
Sforza, Francesco, duke of Milan
 82, 115, 178, 181, 201, 217, 234–5,
 237
and Cosimo de Medici 74–5
marriage to Bianca Maria
 Visconti 74, 102, 115, 217, 235,
 248
Sforza, Ginevra 115, 217, 284–5
Sforza, Ippolita Maria *see*
 Visconti Sforza, Ippolita
 Maria
Sforza, Ludovico, Duke of Milan
 86, 117, 217, 238, 264–5, 266–7,
 396, 549
Shakespeare, William 5, 18, 24, 59,
 62, 211, 516, 554, 564, 586
 All's Well that Ends Well 125–6
 Comedy of Errors 613
 Hamlet 88, 211–12, 443, 520
 Henry VI 15, 213, 247
 King John 128
 Love's Labour's Lost 145, 453
 The Merchant of Venice 52,
 108–9, 203–4
 Much Ado About Nothing 425
 Richard III 208–9, 211, 330, 556,
 578
 Romeo and Juliet 122, 163, 199,
 200, 201, 254, 332
 The Taming of the Shrew 43
 The Tempest 444–5
 Troilus and Cressida 453
Shelley, Mary
 Frankenstein 157–9
Sheppard, Kenneth 536
Shotwell, Alexis 39
Sicily 548
Siena 7
 Guelph-Ghibelline feud 122,
 123
Siena board game 65, 66, 67–8, 76,
 79, 274
Sigismund, King of Poland 256
Sigismund of Luxembourg,
 Emperor and King of
 Hungary 222, 229, 232
Signoria, Florentine 10, 65–72,
 219, 223, 286, 287, 293, 377, 484
Simonetta, Marcello 82–3
Sixtus IV, Pope (Battle Pope) 124,
 239–40, 242–5, 247, 253, 254,
 262–3, 264, 309, 312, 314, 315,
 319, 327, 332, 339, 343, 347, 467
 death 252
 and humanism 510
 and Michelangelo 379
 and the Pazzi Conspiracy
 244–5, 246, 250, 251, 275
skeptical crisis 603
slavery 206–7, 222–3
 galley slavery 4, 223
Small, Brendan 580
smallpox 644
Socrates 23, 108, 159, 191–2, 554,
 603
Soderini, Piero 9, 10, 92
sodomy 204, 205–6
Solon 169
sortion, government by 69

Spain 6, 9, 169, 218
 and the papacy 129–30
 Renaissance 47
Speroni, Sperone 551
Spinoza, B. xviii
Spirito, Fra 370
SPQR (the Senate and the People of Rome) 1–2
Squarcialupi, Antonio 275
state-fashioning 36–7
Stoicism 536, 560, 564, 604, 631–2
Strathern, Paul 78
Strozzi, Alessandra **219–26**, 227, 229, 251, 257, 272, 273, 293, 303, 310, 340, 374, 375
Strozzi, Caterina 223–5
Strozzi, Ercole 345, 352–3
Strozzi family 11, 70, 73, 87, 220–1, 233
Strozzi, Filippo 222, 251, 382
Strozzi, Marietta 201, 222
Strozzi, Matteo 220, 221, 222
Strozzi, Palla 220, 222, 233
Sturluson, Snorri 173
Suleiman the Magnificent, Ottoman Sultan 183
sundial 594
Switzerland 6, 10, 36, 48
Symonds, John Addington 90, 405
syncretism 524
Szilágyi, Elizabeth 307

Tasso, Torquato 357
Tea with Mussolini 89–90
Terence 573, 584
Theodoric 524
Theophrastus 592, 593, 610
timing of the Renaissance 417–21
Titian 32, 118, 410, 513, 586
Tommaso dei Cavalieri 404–5, 411, 415
Torch, Barry 247, 510
Torelli, Barbara 352–3
Tornabuoni family 241
Tornabuoni, Lucrezia 84–5
torture
 ending of 644
 ethical objections to 449
Trent, Council of 411–12
Trexler, Richard 200–1
Trojan War 453
Trump, Donald 640
Tuchman, Barbara
 The Guns of August 107
Tyson, Neil deGrasse 44

Unger, Miles 78
United States 22, 23
 the Baron thesis and proto-democracy 46–7
 Declaration of Independence 108
 universities 511–12
Urban VIII, Pope 431
Urbino 7, 37, 47, 343–4, 344, 354–5
utilitarian ethics 437, 446–51, 475, 479

Valentino *see* Borgia, Cesare (Valentino)
Valentinois, Duke of *see* Borgia, Cesare (Valentino)
Valla, Lorenzo 311, 479, 499, 507, 512
van der Goes, Hugh
 Portinari Triptych 260–1
Varchi, Benedetto 48
Vasari, Giorgio 282
 Lives of the Artists 32, 114, 380, 400
Veneto, Bartolomeo 359

INDEX

Venice 6, 7, 10, 35, 124, 125, 128, 141, 232, 397
 civic participation 45, 47, 48
 and Cyprus 141
 exiles in 70
 and Ferrara 261–2
 gondoliers 223
 prostitutes 394
 tourism 57
 war with Milan 234
Vergil 4, 143, 144, 160, 161, 272, 324, 325, 485, 518, 545, 578, 586
 Aeneid 178
 Georgics 23
Veronesi, Giovanni 287
Verrocchio 395
 Doubting of Saint Thomas 55, 435
Vesalius, Andreas 592
Vespasiano da Bisticci 35
Vespucci, Agostino 205–6
Vettori, Francesco 126, 457
Viking settlements 176–7
 Greenland 27–31, 39, 79, 129, 177, 270
Villari, Pasquale 90, 91, 98, 193, 280, 374
 Girolamo Savonarola and His Times 77–8, 294
Vinland Saga 28
Virgil *see* Vergil
Virgin Mary 205, 209, 210, 212, 238, 454
virtue
 and *studia humanitatis* 161, 162–4
virtue ethics 437, 438, 439–43, 444–6
virtue politics 454, 574–80, 581, 590, 609, 649
Visconti, Bianca Maria 74, 181, 217, 234, 235, 237, 238, 248

Visconti, Filippo Maria Visconti, Duke of Milan 101–2, 234–5
Visconti, Gian Galeazzo, Duke of Milan 101–2, 188, 217, 249, 255, 261, 265, 333
Visconti Sforza, Bona Maria, Queen of Poland 256, 308
Visconti Sforza, Cardinal Ascanio 181, 182, 217, 234, 238, 248, 260, 262, 330, 333, 334, 335, 336, 459, 470, 482, 483, 496, 500, 503, 511
Visconti Sforza family 233–8, 240, 243, 249–50, 255
Visconti Sforza, Galeazzo Maria 275, 304, 536
Visconti Sforza, Ippolita Maria 234, **248–56**, 257, 260, 306, 353, 484, 499
Visconti Sforza, Ludovico 255, 333, 334, 335, 338, 342, 384, 460–2
Viterbo 366–7
Vlad the Impaler 178, 299, 577, 634, 642
Voigt, Georg 39
The Volsunga Saga 176–7
Voltaire 294, 425, 448, 449, 560, 650
 "On the Lord Bacon" 613–14
Volterra, sack of 81–4, 86, 244, 312
voluntarism 442–3, 444–6

warfare 115, 116–17, 119, 120–3, 225–6
 First World War 97, 107, 123, 142
 Guelph-Ghibelline feud 121–2
 Italian wars 7–10, 36, 121–3, 124–6, 131

743

mercenaries 6, 7, 120–1, 131, 234
 and the papacy 128
Wars of the Roses 6, 126
Weber, Eugen 97
Weber, Max 24
Weinstein, Donald 295
Whig history 644
William of Ockham xviii, 104, 132, 148, 153–4, 442–3
witch trials 607
witchcraft 535, 548
Wittgenstein, Ludwig 504
Wolf, Gerhard 57–8, 78
Wolsey, Cardinal 401

women
 dowries 219
 and humanism 498–9, 501–2, 506–7
 and virtue politics 575
women writers 89–95
Woodville, Elizabeth 249
wool trade 224
Wootton, David 542

Young Nick *see* Machiavelli, Niccolò

Zita, Saint 449

About the Author

ADA PALMER is an internationally acclaimed science fiction and fantasy novelist, historian, and composer, best known for her award-winning *Terra Ignota* series, beginning with *Too Like the Lightning* (2016). She attended Simon's Rock and Bryn Mawr colleges, and completed her PhD at Harvard focusing on the Renaissance, radical thought, atomism, and the reception of the classics. Her current research focuses on the history of censorship and the motives which make people support it. She teaches history at the University of Chicago, running her (in)famous papal election simulation and a study abroad program in Florence, and works with the Renaissance Studies Program, the Office of Research and Teaching Innovations, the Institute on the Formation of Knowledge, and the Parrhesia Program for Public Discourse. She blogs and podcasts at ExUrbe.com, studies and consults for the anime and manga industry, especially on feminist and postwar manga and Osamu Tezuka, and composes close harmony a cappella music with science fiction and mythological themes—notably her Norse mythological song cycle *Sundown: Whispers of Ragnarok*—which she performs with the group Sassafrass. She is disabled (chronic illness, chronic pain), and is a disability and free speech activist. Her video seminar project "Censorship and Information Revolutions from the Inquisition to the Internet," co-run with Adrian Johns and Cory Doctorow, can be watched in full online at voices.uchicago.edu/censorship. Many seeds of this book originated on her blog *ExUrbe.com*, or in essays now collected in *Trace Elements: Conversations on the Project of Science Fiction and Fantasy*, co-authored with Jo Walton, with whom she co-runs the podcast *Ex Urbe Ad Astra*.